D0223500

Asian Art

DORINDA NEAVE
Senior Lecturer of Art History
Capilano University

LARA C. W. BLANCHARD
Luce Associate Professor of East Asian Art
Hobart and William Smith Colleges

MARIKA SARDAR
Associate Curator of Southern Asian and Islamic Art
San Diego Museum of Art

with the Southeast Asian chapter contributed by Miranda Bruce-Mitford

PEARSON

Boston Columbus Indianapolis New York San Francisco Upper Saddle River
Amsterdam Cape Town Dubai London Madrid Milan Munich Paris Montréal Toronto
Delhi Mexico City São Paulo Sydney Hong Kong Seoul Singapore Taipei Tokyo

Editor in Chief: Sarah Touborg
Senior Sponsoring Editor: Helen Ronan
Editorial Assistant: Victoria Engros
Vice-President, Director of Marketing: Brandy Dawson
Marketing Manager: Kelly May
Marketing Assistant: Paige Patunas
Managing Editor: Melissa Feimer
Project Manager: Marlene Gassler
Senior Operations Supervisor: Mary Fischer
Operations Specialist: Diane Peirano
Media Director: Brian Hyland
Senior Media Editor: David Alick
Media Project Manager: Rich Barnes
Pearson Imaging Center: Corin Skidds
Printer/Binder: LSC Communications
Cover Printer: LSC Communications

This book was designed by
Laurence King Publishing Ltd, London
www.laurenceking.com

Editorial Manager: Kara Hattersley-Smith
Production Manager: Simon Walsh
Picture Researchers: Julia Ruxton, Miho Koga-Browes, Xiaohan Li
Copy Editor: Angela Koo
Indexer: Vicki Robinson

Cover image: Art Collection 2/Alamy Stock Photo

Credits and acknowledgments borrowed from other sources and reproduced, with permission, in this textbook appear on the appropriate page within the text or on the credit pages in the back of this book.

Copyright © 2015 by Pearson Education, Inc.
All rights reserved. Printed in the United States of America. This publication is protected by Copyright and permission should be obtained from the publisher prior to any prohibited reproduction, storage in a retrieval system, or transmission in any form or by any means, electronic, mechanical, photocopying, recording, or likewise. To obtain permission(s) to use material from this work, please submit a written request to Pearson Education, Inc., Permissions Department, One Lake Street, Upper Saddle River, New Jersey 07458 or you may fax your request to 201-236-3290.

Library of Congress Cataloging-in-Publication Data

Neave, Dorinda.
 Asian art / Dorinda Neave, Senior Lecturer of Art History, Capilano University; Lara C.W. Blanchard, Luce Associate Professor of East Asian Art, Hobart and William Smith Colleges; Marika Sardar, Associate Curator of Southern Asian and Islamic Art, San Diego Museum of Art ; with the Southeast Asian chapter contributed by Miranda Bruce-Mitford. -- 1st edition.
 pages cm
 Includes bibliographical references and index.
 ISBN-13: 978-0-205-83763-2
 ISBN-10: 0-205-83763-8
 1. Art, Asian--Textbooks. I. Blanchard, Lara C. W., author. II. Sardar, Marika, author. III. Bruce-Mitford, Miranda, author. IV. Title.
 N7260.N38 2015
 709.5--dc23
 2013028675

29 2023

Prentice Hall
is an imprint of

www.pearsonhighered.com

Student Edition
ISBN 10: 0-205-83763-8
ISBN 13: 978-0-205-83763-2

Brief Contents

Contents

PART TWO
China 124

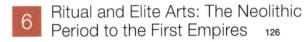

Preface

A book, tight shut, is but a block of paper.

Chinese proverb

Asia is the largest and most densely populated continent in the world, and Asian art, spanning thousands of years, is breathtaking for its richness, ingenuity, and diversity. Magnificent temples, lavish tombs, ritual bronzes, exquisite gold crowns, beautifully crafted ceramics, sumptuous textiles, fine calligraphy and paintings, colorful woodblock prints, and artfully designed gardens fall under the umbrella of Asian art. In addition to these traditional arts, Asia's dynamic contemporary art scene provides an abundance of innovative, thought-provoking works.

Since the 1960s, and particularly during the last decade, Asian art history has undergone a radical transformation in scholarship, methodology, and pedagogy. Remarkable new archaeological discoveries, dramatic developments in contemporary Asian art, and revised methods of studying/teaching art history have contributed to this overhaul. This book is a response to the need for a new Asian art survey text.

As with any survey text, the authors' challenge is to avoid overwhelming the student with an encyclopedic deluge of information or reducing the content to a dry list of art works. We have drawn upon our experiences teaching Asian art history courses and our own scholarly research to distill the subject's richness into an accessible narrative that provides a starting point for the study of Asian art. For purposes of clarity, the material is organized according to region and chronology. The arts of South and Southeast Asia, China, Korea, and Japan—positioned within their societal contexts—provide the focus of the book. Relationships between the various regions are discussed, for example, the diffusion of Buddhism from India to other parts of Asia, and its widespread impact on the arts. Artworks in a broad range of media are carefully selected and examined to illuminate culturally important images and diverse viewpoints. The text balances formal considerations with contextual issues.

Examples of Asian art and architecture are examined against a backdrop of religious, political, historical, economic, and social issues. *Asian Art* provides clear explanations of religious beliefs and philosophies that inform the art, for example, Hinduism, Buddhism, Jainism, Islam, Daoism, Confucianism, and Shinto. The latest developments in Asian scholarship are discussed, including contemporary art and current trends and the contributions of women artists and patrons. The representation of women in Asian art highlights roles assigned to Asian women throughout history and the underlying conditions for women within Asian societies. Consideration is given to neglected areas of scholarship relating to indigenous Asian peoples, such as the Ainu and their culture in Japan.

SPECIAL FEATURES

The text includes high-quality color images, maps, diagrams, site plans, a glossary, and a bibliography. Online audio pronunciations of personal and geographical names and terms are included for instructors and students unfamiliar with Asian languages. A series of Cross-cultural Explorations questions at the end of each chapter encourages students to explore the interconnections between the artistic and cultural traditions across Asia. Also incorporated into the text are box categories that allow the student to pause in order to go more in-depth, or encourage critical thinking about key concepts they have just learned:

■ **CLOSER LOOK** focuses on one artwork in each chapter, examining it in detail with explanatory labels that point out the work's specific features. In Chapter 5, an early twentieth-century Burmese lacquerware bowl is the highlighted artwork, and attention is given to the materials comprising the object and the imagery of palace life decorating its surface. In Chapter 11, the painting of a festival, Tano Day, by the Korean artist Sin Yunbok (1758–?) is examined and an explanation provided as to why it was a controversial painting for the period.

■ **COMPARE** introduces and discusses two artworks, placed side by side. A list of questions invites the reader to make their own comparisons between the two works based on what they have learned in the chapter. In Chapter 8, two Chinese landscape paintings created hundreds of years apart, one by Fan Kuan (ca. 960–1030) and the other by Wang Meng (1308–1385), are presented for comparison. In Chapter 15, two nudes, one a multi-media work by the contemporary Japanese artist Morimura Yasumasa (b. 1951), and the other, a nineteenth century oil painting by French artist Édouard Manet (1832–1883) are placed side by side to underscore connections between modernity and the past, and Asia and Europe.

■ **TECHNIQUES** explains and illustrates key techniques used by the artists to create their masterpieces. In Chapter 6, the process of piece-mold casting used to make ancient Chinese bronzes is explained, and in Chapter 15, the techniques developed to create an eighteenth-century Japanese woodblock print are revealed.

■ **CONTEXT** provides important background information that enriches the understanding of the artworks in the main discussion. In Chapter 1, which includes an introduction to Buddhism and Buddhist art in India, various symbolic elements and hand gestures (*mudras*) that convey the Buddha's exalted state are highlighted, and in Chapter 7, a discussion of Chinese cosmology and Daoist religious practice illuminates the interpretation of many Chinese artworks.

■ **POINT OF VIEW** features an extract from original source materials to highlight the content discussed in each chapter. For the discussion of seventeenth-century Mughal art in India in Chapter 3, a section from the Mughal emperor Jahangir's writings on art is provided. This supplementary material may also address the chapter's content from a contemporary perspective to emphasize connections between the past and present. Chapter 12 discusses the influence of shamanism in early Japanese art, and Point of View provides a reading on current shamanic practices in Okinawa.

> The Pearson eText available within MySearchLab lets students access their textbook any time, anywhere, and any way they want. Online audio pronunciations of personal and geographical names and terms are included in the eText for instructors and students unfamiliar with Asian languages. Instructor PowerPoints for most images in the book are available to adopting instructors. Note that every effort has been made to obtain digital permissions for all images used in the printed book, but there are some images sources that have denied all electronic rights. To learn more, please visit www.pearsonhighered.com/art.

THE COLLABORATIVE PROCESS

A book of this size and breadth is the result of teamwork. Marika Sardar wrote the chapters on Indian art, while Miranda Bruce-Mitford composed the one on Southeast Asia. Lara C. W. Blanchard wrote the Introduction and the section on Chinese art, and Dorinda Neave contributed the section on the arts of Korea and Japan.

One of the great privileges of writing a book on the history of Asian art is to experience doors opening both on personal and professional levels, and to meet extraordinary people thousands of miles away who contribute their time and expertise to the project. All four authors of this text experienced multiple examples of this type of collaboration, an essential component of scholarly research. One such encounter involved a quest to decipher a complicated Chinese script accompanying the sixteenth-century painting of the Zen Buddhist nun Shun'oku-Soei, by Tosa Mitsumochi (see Chapter 14, FIG. 14-21). This hanging scroll is housed in Daiji-in temple, Kyoto. At first I asked Kyoto-based researcher Mineko Matano for assistance. The enigmatic classical Chinese characters proved too complicated for her and Toda Jitsuzan, the head priest at Daiji-in temple, to decode, so she enlisted the help of Kyoto University professor Ken Mikata. He also found the inscriptions difficult to decipher, not only because of the old-fashioned writing but also because of the esoteric Zen Buddhist terms contained within the text. Mikata forwarded the text to Sotetsu Abe, a retired president of Hanazono, a Zen Buddhist University in Kyoto, for his scholarly input. Abe was able to decipher the text, and independent scholar Ms. Toki Okada researched the difficult Zen Buddhist terms. Finally, Mikata, Okada, and Matano gathered to discuss the results of their collaborative efforts and Matano translated the text into English. She gave the head priest of Daiji-in temple the decoded text in Japanese and English, much to his delight, because the portrait had always been a fascinating mystery for him.

FUTURE DIRECTIONS

Asian Art History is a discipline that has undergone many changes since its emergence in the early 1900s, partly in response to geo-political shifts. Asia today, in all its facets, offers a wealth of visual material for the art historian to reassess as new discoveries come to light and fresh ways of studying the arts emerge. In the twenty-first century, popular questions debated by scholars include:

– What is Asian art?
– How is Asian art exhibited in museums and galleries?
– How should it be taught in schools, colleges, and universities to address the realities of our changing world?

We hope that this text will provide a starting point for further discussion of these issues and above all ignite students' interest in the art and cultures of Asia.

Dorinda Neave

Acknowledgments

We would like to begin by thanking Ian Jacobs, Daniel Ehnbom, and Kuiyi Shen, who contributed their expertise to the book's development. And a very big thank you to Sarah Touborg and Helen Ronan at Pearson Education, as well as Marlene Gassler, Corin Skidds, Melissa Feimer, Bryan Hyland, and Victoria Engros. And also to the team at Laurence King Publishing in London: Kara Hattersley-Smith, Donald Dinwiddie, Julia Ruxton (picture research), Angela Koo (copy-editing), Blokgraphic (design), and Simon Walsh (production).

The authors and Pearson Education are also grateful to the following academic reviewers who helped shape the book: Janet Carpenter, City College of San Francisco; Robert DeCaroli, George Mason University; So Kam Ng Lee, DeAnza College; Elizabeth Brotherton, State University of New York, New Paltz; John Listopad, California State University, Sacramento.

FROM DORINDA NEAVE: In addition, I would like to extend thanks to Mineko Matano, Toda Jitsuzan, Ken Mikata, Toki Okada, and Sotetsu Abe (who have already been mentioned in the Preface), and a very special thanks go to Patricia Fister for her encouragement of the project and careful scrutiny of the chapters on Japanese art. Capilano University generously funded research trips to Japan. Thank you to the helpful librarians and staff at Nichibunken (International Research Centre for Japanese Studies) in Kyoto. Thanks also to Professor Ro Myoungho of Seoul National University for his generous sharing of visual images.

Family members Venetia Halstead, Barry, Samuel, and Davina Shell offered steady encouragement throughout this project, which was years in the making from conception to publication.

FROM LARA C. W. BLANCHARD: I am happy to acknowledge the Provost's Office at Hobart and William Smith Colleges for a sabbatical leave that provided time to write. I thank my colleagues in the Art and Architecture Department, and my students; interactions with them over a dozen years have helped shape my own introductory course on Asian art history, and much of what is written here would doubtless be familiar to them. I am especially indebted to Roslyn Hammers of the University of Hong Kong, who generously agreed to read drafts of the chapters on Chinese art, providing invaluable suggestions for improvement. Finally, I am grateful for the unflagging support and encouragement of many friends and family members, particularly Steve, Daria, and Shirley Blanchard; Audrey and Pat Thompson; and Douglas Williams.

FROM MARIKA SARDAR: I would like to thank colleagues (and friends) Navina Haidar, Deborah Hutton, Laura Weinstein, Dipti Khera, and Tamara Sears.

FROM MIRANDA BRUCE-MITFORD: I would like to thank Drs Ian Glover and Fiorella Rispoli for kindly answering my questions on prehistoric items, and Dr. Peter Sharrock for his helpful comments on the table of major groups. Thanks, too, to him and to Narisa Chakrabongse for all their support.

Introduction

I have a wife as
familiar to me
as the hem of this well-worn robe
and thus these distant travels
darken my heart with sorrow.

Ariwara no Narihira

There is no single Asian aesthetic, just as there is no such thing as an essentially Western aesthetic. Any assessment of the style, purpose, or meaning of art must consider an object's historical context: The arts of Asia differ according to their regional cultures in a particular period and the social groups of their makers. Still, certain elements are seen repeatedly in examples of the arts of South, East, and Southeast Asia. Asian artists tend to foreground the meaning of imagery, particularly as developed in literary, religious, or philosophical texts. In creating visual representations, an artist may employ **naturalism** (making the subject look as it does in nature—a rhetorical stance that affirms meaning by showing things as they actually are), exaggeration (calling viewer's attention to particular qualities of an object), or both simultaneously, and these choices help convey an artist's intent to the viewer. In addition, Asian artists often rely on a demonstrably subjective viewpoint, an approach that represents a counterpoint to the objectivity sought in some art traditions, such as the scientific interest in anatomy seen in the drawings of the Italian Renaissance, or the French Impressionists' interest in the qualities of light. For these reasons, Asian art is often understood as expressive: It insists upon its link to creative practice and upon the importance of the maker's imagination and/or perception.

The Japanese painter Ogata Korin's (1658–1716) *Irises at Yatsuhashi (Eight-Plank Bridge)* exemplifies the importance of both meaning and expression in Asian art (**FIG. I-1**). At first glance, these irises are undeniably beautiful: The artist renders the blossoms in indigo and blue, and the leaves in emerald green, against a background of glimmering gold leaf. More importantly, though, this subject, which Korin painted many times, is profoundly meaningful. Korin's irises grow in clumps near a low wooden bridge, alluding to a particular moment in the *Tales of Ise*, written by the poet and courtier Ariwara no Narihira (825–880). Narihira recorded how, after he was banished from the capital, Kyoto, he and his companions paused beside a marsh and composed poetry about irises growing beside an eight-planked bridge. His own poem is cited above: a lament about parting from his beloved wife that ostensibly does not concern irises, yet contains a hidden reference to them. In Japanese, the poem reads:

> Karagoromo
> kitsutsu nare ni shi
> tsuma shi areba
> harubaru kinoru
> tabi o shi zo omou.

The first syllable of each line—*ka-ki-tsu-ha-ta*—echoes the Japanese word for the rabbit-ear iris, *kakitsubata*. Since the ninth century, the subject of irises beside a planked bridge has

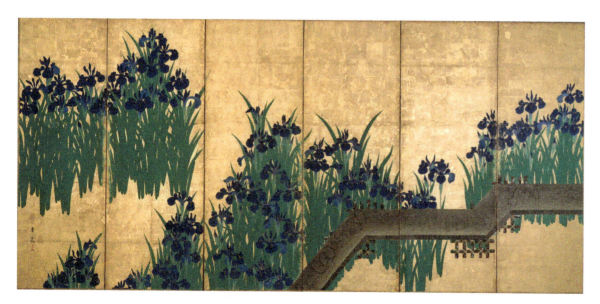

I-1 • Ogata Korin
IRISES AT YATSUHASHI (EIGHT-PLANK BRIDGE)
Japanese, Edo period, ca. 1709–1716. One of a pair of six-panel screens, ink, color, and gold leaf on paper, 5′ 4⁷⁄₁₆″ x 11′ 6¾″ (163.7 x 352.4 cm) each. Metropolitan Museum of Art, New York. Purchase, Louisa Eldridge McBurney Gift, 1953, 53.7.1 & 53.7.2.

reminded those familiar with Japanese literature of Ariwara no Narihira's sorrow. Ogata Korin's painting embodies this emotion through its references to the witty court culture of the Heian period (794–1185).

CULTURES AND LANGUAGES

The multiple regional cultures within Asia (**MAP I-1**) have undeniable connections, particularly in the realms of religions, philosophies, and languages, yet the distinctive qualities of each culture reveal the fallacy of perceiving Asia as a monolithic entity. Trade, travel, and invasion served as major mechanisms for the transmission of cultural elements. Commonalities between cultures increase with geographical proximity: Thus, East Asian cultures, for example, share certain practices that do not appear in South or Southeast Asia. The ensuing chapters detail many of the defining elements of the separate cultures of these regions; here, we consider those elements that are shared.

Numerous religions originated in Asia, including Hinduism, Buddhism, and Jainism in India (all responses to the earlier Vedic tradition); ancestor worship and Daoism (both a religion and a philosophy) in China; **shamanistic** practices in both Korea and Japan; and Shinto in Japan. Some of these religions spread throughout Asia. Asian societies also accommodated the practice of foreign religions. To cite only a few examples, the capital of Tang dynasty China (618–907) was home to practicing Nestorian Christians, Jews, and Muslims, while Islam was the faith of the rulers of India's Mughal dynasty (1526–1858). Shinto shrines were constructed in Korea during the Japanese occupation, and Christianity remains a significant religious practice in Korea today.

Of all these religions, Buddhism comes closest to a unifying element in Asian cultures, although the practice includes two major traditions—Theravada and Mahayana—and distinct schools such as Pure Land, Esoteric, and Chan or Zen Buddhism. From its origins in northern India and Nepal, Buddhist practice spread southward as far as Sri Lanka and thence to Myanmar (Burma), Cambodia, Thailand, Laos, Vietnam, and Indonesia. It also traveled north to Central Asia and from there, via the Silk Road, to China; transmission of Buddhist practice also occurred between Tibet and China. Ultimately, exchanges between China and Korea, Korea and Japan, and China and Japan ensured that Buddhism thrived throughout East Asia, even as it disappeared from India. Still, the introduction of Buddhism to such disparate cultures meant that in each case, the local practice of Buddhism developed distinctive characteristics through interaction with indigenous religions and philosophies. Chinese society saw significant tensions between followers of Buddhism, practitioners of Daoism, and adherents of Confucian philosophy. In Japan, on the other hand, a more eclectic approach to religion meant that an individual could practice both Shinto and Buddhism. Compared to Buddhism, Hinduism proved to be a more enduring practice in India and also developed a following in Southeast Asia, but did not spread beyond these regions.

MAP I-1 • ASIA

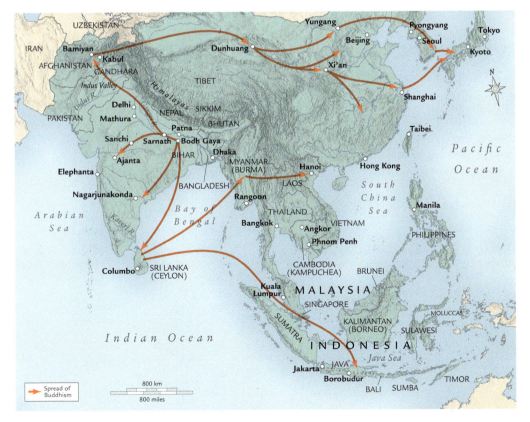

Multiple languages are spoken in India, but perhaps the most important was Sanskrit, an Indo-European language. Most Buddhist and Hindu names and terms are rendered in this language, and Sanskrit captions are sometimes found in works of art. Sanskrit also became the basis for written languages in Southeast Asian cultures, despite the dissimilarity of the region's spoken languages. (An exception is northern Vietnam, which because of its proximity to China developed a written language based on Chinese characters.) In India, Arabic and Persian scripts emerged as decorative elements in art and architecture, reflecting connections with both the Islamic world and Persian culture.

East Asian cultures had multiple links beyond the adoption of Buddhist practice. Perhaps most important were the linguistic connections, despite the fact that the many dialects of Chinese (actually more like separate languages) belong to the Sino-Tibetan language family, and Korean and Japanese, which appear to be related to each other, are sometimes classified among the **Altaic** languages. The Chinese dialects have shared a standard written language of characters (*hanzi*) since the early imperial period, with pictograms and ideograms used to write literary and, later, vernacular forms of the language. Chinese characters also served as the basis for the written forms of both Korean and Japanese. Koreans used Chinese characters (known there as *hanja*) exclusively until the development of an alphabetic system—now known as **hangul**—in the fifteenth century. *Hangul* became increasingly popular, particularly among certain social groups, and became the official writing system in the late nineteenth century; now the use of Chinese characters in Korean writing is rare. The Japanese also adopted Chinese characters (known in Japanese as **kanji**) and modified them to create two syllabaries, *hiragana* and *katakana*, which are phonetic systems for writing Japanese syllables and collectively referred to as **kana**. Today, the Japanese mix *kanji* and *kana* in everyday writing, with characters and *hiragana* representing native Japanese words and *katakana* used for the approximation of loan words from other languages. In the early periods, however, the educated Japanese elite wrote in Chinese characters, women used *hiragana* to write vernacular Japanese, and Buddhist monks developed *katakana* as a phonetic shorthand (see Pronunciation of Asian Languages, below).

The use of Chinese characters in both Korea and Japan meant that education included classical Chinese texts. Consequently, elements of Daoist cosmology became familiar throughout East Asia (although neither the Korean nor the Japanese peoples adopted the practice of religious Daoism). Aspects of Confucian philosophy, which originated in China and became the basis for its political bureaucracy, informed Korean and Japanese governing systems and social practices. Members of the Korean and Japanese elite also studied Chinese literature, especially poetry. Perhaps most significantly, in all these cultures the attention to brushwork found in both calligraphy and painting meant that writing directly on a work of art enhanced it, and many Chinese, Korean, and Japanese works of art include writing as an essential part of the composition.

Naming conventions are distinctive in the different cultures. In India, there are multiple naming conventions corresponding to different regions. In some areas people use only a single name, but where multiple names are the custom, the general order is given name first, followed by the middle name or patronymic, and then the family name. In China, Korea, and Japan,

Pronunciation of Asian Languages

Linguists have developed multiple systems to render Sanskrit, Chinese, Korean, and Japanese words in the Roman alphabet. This book uses a modified version of the International Alphabet of Sanskrit Transliteration (without the diacritical marks that indicate vowel length or aspirated consonants), as well as the Hanyu Pinyin system for Chinese words in the Mandarin dialect (known in mainland China as *putonghua*), the Revised Romanization system for Korean, and Modified Hepburn Romanization for Japanese (but without the macrons that indicate doubled vowels).

SANSKRIT – modified International Alphabet of Sanskrit Transliteration

Vowels	English equivalents	Consonants	English equivalents	Consonants	English equivalents
a	mother or father	k	kite	p	butter
i	fit or feet	kh	kite + hat	ph	pay
u	wood or food	g	go	b	boy
r	butter or bird	gh	go + hat	bh	book
l	turtle	n	no or sing	y	young
e	cake	c	jay	r	red
ai	like	ch	chalk	l	law
o	bone	j	jug	v	vine
au	cloud	jh	jug + hat	s	song
		t	done	sh	shall or should
		th	tan	h	hat
		d	dog		
		dh	dog + hat		

CHINESE – Hanyu Pinyin romanization

Initials	English equivalents	Finals	English equivalents	Finals	English equivalents
b	boy	a	father	o	ought
p	pie	ai	pie	ou	rose
m	may	ao	cloud	ong	rose + song
f	fan	an	want	u (after b, p, m, f, d, t, n, l, g, k, h, zh, ch, sh)	too
d	dog	ang	father + song		
t	toy	e	bird	u (after j, q, x)	chew
n	no	ei	eight	ü	chew
l	lie	en	fun	ua	want
g	go	eng	lung	uai	wine
k	king	i (after b, p, m, d, t, n, l, j, q, x)	feet	uan	went
h	hay	i (after z, c, s)	hidden	uang	want + song
j	jingle	i (after zh, ch, sh)	burr	ue	wet
q	cheap	ia	yacht	ui	way
x	sheet	ian	yen	uo	sword
zh	joy	iang	yacht + song	un	wood + run
ch	chalk	iao	yowl		
sh	should	ie	yet		
r	run	iu	yo-yo		
z	buzz	in	seen		
c	pets	ing	sing		
s	snake	iong	yo-yo + song		
w	wood				
y	yacht				

Apostrophes can be used to separate syllables in romanized words where the division would otherwise be unclear.

KOREAN – Revised Romanization system

Initial consonants	English equivalents	Vowels	English equivalents	Final consonants	English equivalents
g	go	a	father	k	took
kk	great	ae	may		
n	no	ya	yacht	n	on
d	do	yae	yea	t	pet
tt	date	eo	young		
r	rose	e	end	l	pal
m	may	yeo	young	m	stem
b	ball	ye	yet	p	map
pp	boy	o	oh		
s	song	wa	water		
ss	say	wae	way		
		oe	bird	ng	song
j	jay	yo	yo-yo		
jj	just	u	food		
ch	cheap	wo	wonder		
k	king	we	wet		
t	tall	wi	we		
p	pet	yu	you		
h	hat	eu	good		
		ui	with		
		i	sheet		

JAPANESE – Modified Hepburn Romanization

Consonants	English equivalents	Consonants	English equivalents	Vowels*	English equivalents
k	king	j	jay	a	father
g	go	n	no	i	feet
s	song	h	hay	u	too
z	zoo	p	pay	e	end
sh	sheet	b	bay	o	oh
t	tall	m	may	ya	yacht
ch	cheap	y	young	yu	you
ts	pets	r	rose	yo	yo-yo
d	day	w	wood		

*Vowels can appear in combination (as in the word aoi, "blue") but are always pronounced individually rather than as diphthongs.

names include both a family name and a given name, and the proper order is family name first, followed by the given name. In premodern China, artists could adopt style names—a courtesy name, literary name, or both; in contemporary society, it is usual to refer to someone by his or her full name. Japanese names operate somewhat differently; artists could take nicknames, but artists sometimes also changed their surnames to indicate affiliation with teachers. It is common to refer to a Japanese figure of the premodern era by the given name only (thus, Korin for Ogata Korin).

ARTISTS AND PATRONS

One key to understanding the historical implications of a work of art is to consider the artist's intentions, whether he or she is following a personal inclination or working on behalf of a patron—in which case the patron's wishes also require consideration. In East Asia, it became common for scholars who created art to write an account of the circumstances that led them to make it. In later periods of Asian history, artists' names were often recorded, as signatures on works of art and sometimes in historical texts. This practice suggests a concern with the artist's identity, a circumstance that often dovetails with a culture that values the artist's perspective. (On occasion, a signature is meant to ensure accountability, as with the **terra-cotta** figures produced for the tomb complex of the First Emperor of the Chinese Qin dynasty, r. 221–210 BCE;

see FIG. 6-1.) Even in cases where an artist is wholly unknown, one may draw conclusions about the artist's intentions through an analysis of the work itself, and this represents a means of determining a work's historical significance.

If an artist is unrecorded but the patron's identity is known, this suggests that the patron's desires were paramount. Sometimes patrons were so involved in the conception of a project that they were represented visually in a work of art or at a site. A representation of the Angkor ruler Suryavarman II (also known as Paramavishnuloka, r. 1113–1150), for example, appears at Angkor Wat (**FIG. I-2**; see also Chapter 5, FIG. 5-18)—significant because the ruler was the temple's patron, the temple was dedicated to the Hindu god Vishnu, and the ruler identified himself with Vishnu. These connections help reveal the political implications of the site. Of course, in some cases both artist and patron were known—a situation that suggests a relatively autonomous artist and a patron attracted by the artist's reputation. For example, a painting thought to be a copy after Xie Huan (ca. 1370–ca. 1452), *Literary Gathering in the Apricot Garden*, demonstrates the erudition of a group of Ming dynasty (1368–1644) court officials. Xie Huan was a court artist specializing in figure painting. The likely patron of his original work (which still survives in China) is the Grand Secretary Yang Rong (1371–1440), who hosted the depicted gathering on April 6, 1437. An unidentified court artist may have produced the version illustrated here for a second Grand Secretary, Yang Shiqi (1365–1444). Both

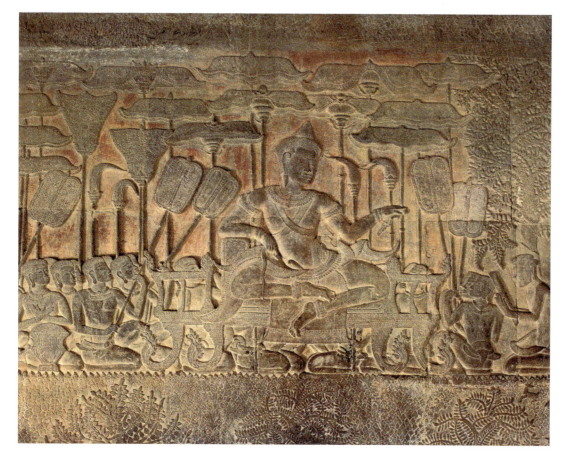

I-2 • KING SURYAVARMAN II HOLDS COURT
Cambodian, ca. 1113–1150. Sandstone relief. Inner walls of southern side of third gallery, Angkor Wat, Angkor.

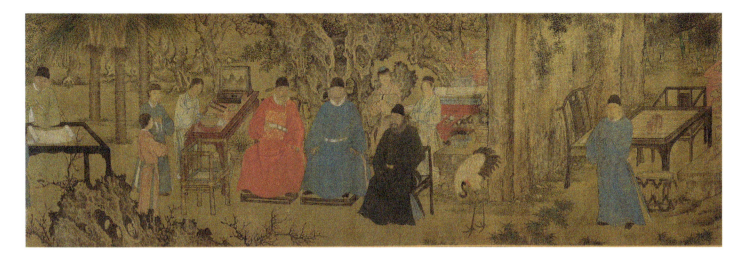

I-3 • After Xie Huan *LITERARY GATHERING IN THE APRICOT GARDEN* **(DETAIL)**
Chinese, Ming dynasty, ca. 1437. Handscroll, ink and color on silk, 14⁹⁄₁₆″ x 7′ 11¾″ (37 x 243.2 cm). Metropolitan Museum of Art, New York. Purchase, The Dillon Fund Gift, 1989, 1989.141.3.

Yang Rong and Yang Shiqi are included among the participants, with the former in red and the latter next to him in blue (**FIG. I-3**). Interestingly, Xie Huan's painting includes a self-portrait, a patron-approved addition that reveals the role of the court artist in the promulgation of the officials' status; the copyist did not include the figure of Xie Huan in the second version.

Generally, Asian artists can be divided into two broad groups: professionals and amateurs. Professional artists typically work for compensation, often in response to a patron's commission or the taste of the art market, whereas the amateur artist usually did not, nor did he or she receive the same sort of training. Because professional artists were generally highly skilled, they often attained high status. An exception occurs in middle-to-late imperial China, where the art of the scholar-amateurs—also known as the **literati**—came to be privileged among their own social group and at court. These artists regarded painting and calligraphy as an intellectual pursuit. A detail of Qian Xuan's (ca. 1235–before 1307) painting *Wang Xizhi Watching Geese* (**FIG. I-4**, see also Chapter 8, **FIG. 8-25**) shows the esteemed calligrapher contemplating the movements of geese swimming in a pond, a scene that emphasizes the importance of the artist's inspiration in a context where there is no patron.

Asian artists worked in a wide range of media, formats, and genres. Often an artist's training would predispose him or her to working in a particular medium—as a mural painter, for example, or a maker of objects for the tea ceremony—although some were sufficiently versatile that they could work in multiple media. (Ogata Korin, for example, was both a textile designer and a painter.) In addition, an artist usually gained a reputation as a specialist in a particular genre.

Religious art and architecture was a predominant specialty, particularly in the early period of Asian art history, although the names of many architects of tombs, temples, and shrines were not recorded. Sculptors or painters of icons or narrative cycles that relate religious content often worked in conjunction with other artists at a religious site, or out of a workshop or studio that specialized in such subjects. The architects, sculptors, and painters who created religious art needed a firm grasp of the visual elements that conveyed aspects of belief, including **iconography**.

Many artists worked directly for Asian rulers or with prominent members of society to create art with political content, such as court painters in both India and China. For example, *Literary Gathering in the Apricot Garden* attests to the education (including connoisseurship of art) that allowed the patron, an official, to attain a prominent place at court. In India's Mughal era, the approximately 50 artists who created the illustrated *History of Akbar* (*Akbarnama*) also show how artists could glorify a ruler, in this case the emperor Akbar (r. 1556–1605). His *History* records his life and much of his long reign, written in courtly Persian by the historian Abu'l-Fazl. One page of the illustrated manuscript

I-4 • Qian Xuan *WANG XIZHI WATCHING GEESE* **(DETAIL)**
Chinese, Yuan dynasty, ca. 1295. Handscroll, ink and color on paper, 9⅛ x 36½″ (23.2 x 92.7 cm). Metropolitan Museum of Art, New York. Ex coll.: C. C. Wang Family, Gift of The Dillon Fund, 1973, 1973.120.6.

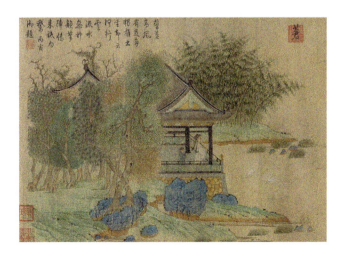

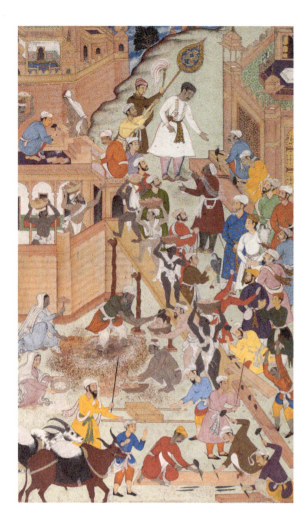

I-5 • AKBAR BUILDING FATEHPUR SIKRI, HISTORY OF AKBAR (AKBARNAMA)
Indian, Mughal dynasty, ca. 1590–1600. Manuscript page, ink and color on paper, 12⅞ x 7⅝″ (32.7 x 19.5 cm). Victoria and Albert Museum, London.

(**FIG. I-5**) shows Akbar supervising a number of workers as they construct the city of Fatehpur Sikri, which served as the capital from 1569 to 1585. The teams of craftsmen and builders working together to create the structures of the imperial city attest to Akbar's power, just as the intricately rendered scene that depicts them demonstrates the wealth of the court.

Connoisseurs often treated female artists as a separate social group, primarily because of the biased view that their work was inherently different from that of men. In fact, female artists can easily fit into the categories established to describe male artists. A case in point is the Japanese artist Tokuyama Gyokuran (also known as Ike Gyokuran, 1727/8–1784). Gyokuran had an artistic upbringing: Her mother and grandmother, proprietors of a teahouse in Kyoto, were accomplished *waka* poets. In her youth, Gyokuran studied with the literati painter Yanagisawa Kien (1706–1758), and perhaps through him met her husband, the artist Ike Taiga (1723–1776). Gyokuran's paintings belonged to the literati mode and demonstrated her knowledge of Chinese literature. Her painting *Peach Blossom Idyll* (**FIG. I-6**) is a visual

reinterpretation of a well-loved Chinese poem, "The Peach Blossom Spring," written by the recluse Tao Qian (literary name Yuanming, 365–427; see also Chapter 9, **FIG. 9-18**). She executes the painting in a sketchy, abstracted style that showcases different types of brushstroke—a hallmark of Chinese and Japanese literati paintings—and, unusually, colors it with hues of green, gold, blue, brown, and peach. The painting does not betray the painter's sex, nor is the subject gendered feminine.

MEDIA AND FORMAL ANALYSIS

The art forms considered in this book include examples of two-dimensional art, such as painting, woodblock prints, and calligraphy; three-dimensional art, such as sculpture, ceramics, examples of the decorative arts, installations, and performances; and architecture. As in other art traditions, meaning and function are encoded in formal qualities of these arts, and thus formal analysis provides a key to understanding Asian art and architecture. In order to understand what an artist intended to convey, or

I-6 • Tokuyama Gyokuran (also known as Ike Gyokuran) *PEACH BLOSSOM IDYLL*
Japanese, Edo period, ca. 1750–1784. Hanging scroll, ink and color on paper, 44 x 19½″ (111.7 x 49.5 cm). Asian Art Museum, San Francisco. Museum purchase B76D3.

the values of those for whom a work of art was made, it is useful to think of the choices that the artist made—or, alternatively, the options that the artist rejected.

The traditional media for two-dimensional Asian art include the use of ink or color (either mineral pigments or vegetable dyes), sometimes with the addition of gold or silver, on silk, paper, hemp, or plaster. Analyzing two-dimensional art requires careful consideration of multiple elements. It is logical to begin with composition, or the overall layout of forms, including whether the artist has left areas of negative space and the ways that a viewer's eye is encouraged to move. To create forms, artists could use both line and color, or focus on one to the exclusion of the other. Lines might be even in width or modulated, changing from thin to thick; the media used to make lines might be wet or dry, creating different effects. Artists applied hues of color in tints or in shades, lightly or in saturation; the approach to color might be painterly (not dependent on the use of outline). The artist could make forms that appear flat, or alternatively create a sense of mass or volume through

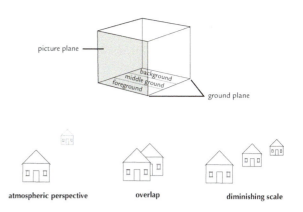

I-7 • TECHNIQUES USED TO CREATE A SENSE OF THREE-DIMENSIONAL SPACE IN A TWO-DIMENSIONAL WORK OF ART.

the use of shading or modeling. Related to the latter idea is the problem of creating a sense of three-dimensional space or depth (**FIG. I-7**). Rendering recession into depth depends on some combination of techniques, including the delineation of foreground, middle ground, and background; the creation of an angle of recession; the use of atmospheric perspective (with objects in the distance appearing fainter); the use of overlap; and the use of diminishing scale (with objects in the distance appearing smaller). The viewer's vantage point might be stable, but often in Asian art the vantage point shifts, simulating the experience of looking at something from multiple angles. Proportion and scale within an artwork might be naturalistic, but Asian artists commonly use **hieratic scale**, a system in which the most important figure is rendered largest.

Several of these techniques appear in Abu'l Hasan's (fl. 1600–1630) *Jahangir Embracing Shah 'Abbas* (**FIG. I-8**), depicting a fictional encounter between the Mughal emperor Jahangir (r. 1605–1627) and his rival Shah 'Abbas (r. 1587–1629) of Iran. The richly colored composition is arranged so that Jahangir's head is at the center and placed against a large expanse of gold, an abstract representation of the sun whose blazing glory emanates from the emperor. A hieratic scale makes Jahangir, who stands astride a lion, appear larger than the weak-looking 'Abbas, paired with a meek lamb. The use of these two symbolic animals and the placement of the rulers on top of a globe to represent the extent of their respective realms are borrowed from English royal portraits; here, the artist

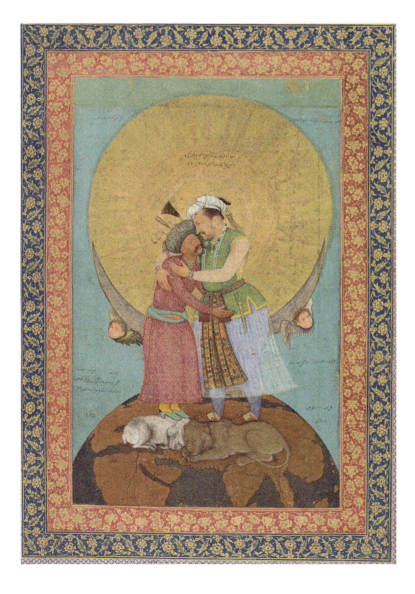

I-8 • Abu'l Hasan *JAHANGIR EMBRACING SHAH 'ABBAS*

Indian, Mughal dynasty, ca. 1618. Opaque watercolor, ink, silver, and gold on paper, 9 3/8 x 6 1/16″ (23.8 x 15.4 cm). Freer Gallery of Art, Smithsonian Institution, Washington, D.C. Purchase, (F1945.9a).

employs allegorical devices to show that Jahangir's kingdom is larger, and, significantly, the lion pushes the lamb away from border territories disputed between the two. The fact that the picture depicts a symbolic rather than an actual event means that the artist has chosen not to create a convincing three-dimensional space, and according with conventions of Indian painting, the bodies of the figures appear flat, their interaction a bit awkward. Adhering to the strict rules of Mughal portraiture, however, the faces are rendered with great detail and with delicate shading that gives them a more three-dimensional appearance. Furthermore, Jahangir is shown in strict profile, while his rival's face is turned in a three-quarter view, which indicates Jahangir's exalted status.

A different approach to painting appears in the Chinese artist Wang Zhenpeng's (1280–1329) *Vimalakirti and the Doctrine of Nonduality* (**FIG. I-9**). This painting is rendered in ink on silk with no use of color, and the artist depicts the scene using various brush techniques. Thin, even lines serve to define forms, while thicker, modulated lines describe swirling drapery. A couch is represented using fine lines that create a subtle pattern as well as broad washes of dilute ink. Wang Zhenpeng manipulates the tonal qualities of the ink to create a sense of mass and space, and, additionally, uses orthogonal lines and overlapping forms to indicate recession into depth. Hieratic scale reveals the prominence of the figure elevated on the couch—the layman Vimalakirti, whose understanding of Buddhist doctrine approached that of an enlightened being.

Three-dimensional examples of Asian art are typically made with media that require the subtractive process of carving, such as wood, stone, or jade, or media that can be formed using an additive process, such as metal, clay, or lacquer. The representation of mass or void in a three-dimensional object is one of the most important considerations. For a sculpture, the viewer's vantage point is significant: Objects sculpted "in the round" can be viewed from front, back, and sides, while a **relief**—an image carved into the surface of a slab of stone or wood—is viewed only from the front. Texture becomes an important quality of surface treatment, along with color and line.

An Indian sculpture from Sarnath in the Gupta period (320–647) known as *Buddha Preaching the First Sermon* (**FIG. I-10**) suggests the Buddha as a tranquil figure. The unknown sculptor used sandstone, a relatively soft, easily carved stone. The Buddha sits cross-legged on a throne, with his head and knees forming the three points of a triangle—a shape that inherently implies stability. Behind the head, the perfectly round halo suggests the cycles that are an important element of Buddhist philosophy. The smooth texture of the body contrasts with the intricately carved halo, reminding the viewer that the figure represents the beliefs of a school of Buddhism in which the Buddha is regarded as something like a supreme deity, while ideal proportions and beautiful facial features indicate the Buddha's perfection. The figure's gesture and the images on the base of the throne are part of the iconography of the Buddha's first sermon. The figure and throne are not carved in the round; the back of the sculpture is a flat slab, suggesting that the preferred vantage point was from the front, and that the sculpture may have been placed against a wall.

A tea bowl (**FIG. I-11**), made by the Japanese artist Raku Ichinyu (1640-1696), exemplifies the subtlety of the wares made by the Raku lineage of potters, which originated in Kyoto with the son of a Korean immigrant. This bowl is remarkably

I-9 • Wang Zhenpeng *VIMALAKIRTI AND THE DOCTRINE OF NONDUALITY* (DETAIL)
Chinese, Yuan dynasty, 1308. Handscroll, ink on silk, 15⁷/₁₆ x 85¹⁵/₁₆" (39.2 x 218.3 cm). Metropolitan Museum of Art, New York. Purchase, The Dillon Fund Gift, 1980, 1980.276

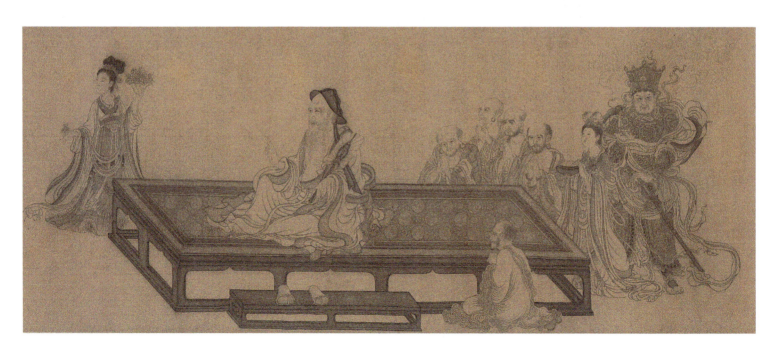

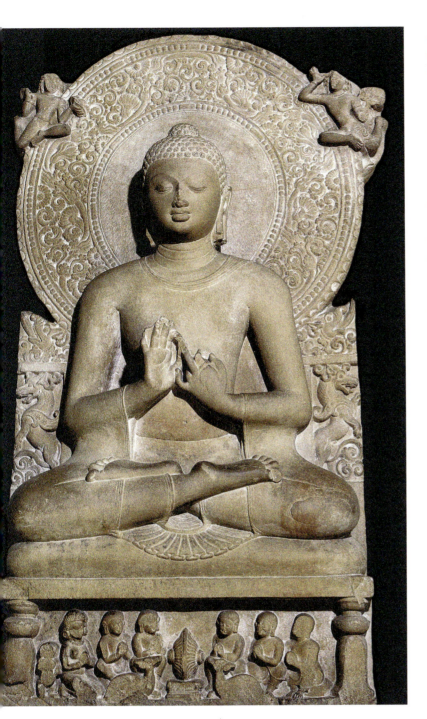

I-10 • BUDDHA PREACHING THE FIRST SERMON
Indian, Gupta period, ca. 475. Chunar sandstone, height 63″
(160 cm). Sarnath Museum, Sarnath.

first) and then shocking the piece in some way—immersing it in cold water, perhaps, or thrusting it into a pile of organic matter such as straw, or transferring it into a smoky reduction kiln. The rapid change in temperature leads to spontaneous, uncontrolled effects that reflect the aesthetic of Zen Buddhism; it is perhaps significant that Ichinyu became a lay Buddhist late in life and resided at a temple. Cracks in the bowl were repaired using a technique that involved wet lacquer sprinkled with gold powder, simultaneously drawing attention to the bowl's imperfections and revealing how highly valued this seemingly unassuming object was.

In analyzing architecture, it is necessary to consider materials (in premodern Asia these often included some combination of earth, wood, stone, masonry, plaster, paper, ceramic tile, and thatch), the disposition of masses and voids, and elements of surface treatment, as one would in three-dimensional art. One must also, however, consider distinct aspects of architectural sites, such as the plan of a building, the layout of the entire site, how the site is integrated into the local geography, whether it is oriented to the cardinal directions or to some other feature, the way that a viewer is supposed to approach the site, as well as the relationship of inner and outer both in terms of a structure and in the site as a whole.

The site of Katsura Imperial Villa in Kyoto reveals much about the values of the branch of the imperial family who built it, the Hachijonomiya family. The site is on the Katsura River, the location of a fictional mansion owned by the titular character

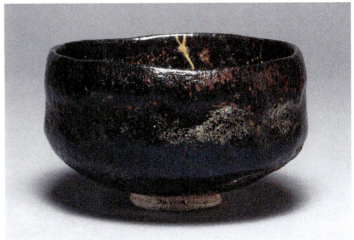

different from the refined ceramics produced in a comparable era in China (see, for example, Chapter 9, FIGS. 9-8, 9-9, and 9-10)—a deliberate choice on the part of the artist. In accordance with the aesthetic of the tea ceremony, the bowl is rustic—made of **earthenware** dipped in a matte glaze, with a pocked surface that hints at the rough texture of the raw clay—and hand-built, perhaps through coiling, rather than created on a potter's wheel. Ichinyu may have invented the black glaze mottled with red seen here, and the bowl's small foot is a hallmark of his style. The Raku potters fired ceramic wares in single-chamber kilns at relatively low temperatures, typically removing an object from the kiln while it was still hot (rather than letting it cool

I-11 • Raku Ichinyu TEA BOWL
Japanese, Edo period, late 17th century. Raku ware, earthenware with black glaze and gold lacquer repairs, diameter 4⅞″ (12.5 cm). British Museum, London.

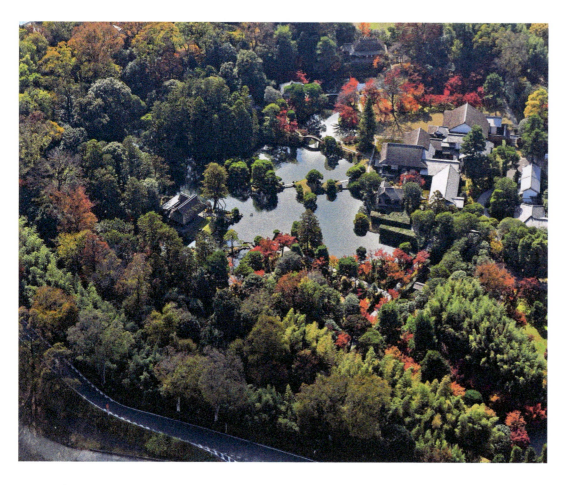

I-12 • KATSURA DETACHED PALACE (ALSO KNOWN AS KATSURA IMPERIAL VILLA) Japanese, Edo period, ca. 1620–1663. Aerial view. Kyoto.

in a classic novel, Murasaki Shikibu's (ca. 970–ca. 1015) *The Tale of Genji*. An aerial view of the site (**FIG. I-12**; see also **FIGS.** 15-3 and 15-4) reveals modest wooden buildings and extensive gardens focusing on a pond. Rather than using the geometric, symmetrical layout common to Buddhist temples, the more organic Katsura site blends into the surroundings, a reminder of the importance of nature in the Shinto religion associated with the imperial family. All of the buildings have sliding doors that open out to the gardens. The site is fenced; once inside, visitors pass through a series of modest gates and can explore the site via a winding path that leads around the pond and through the gardens. Nevertheless, it is important to keep in mind that the site is carefully manipulated to give an impression of idealized nature.

ART HISTORY IN ASIA

China, Japan, India, and Korea all had written discourses about art. Of these, the Chinese discourse may be the most extensive. The Chinese art tradition has included works of connoisseurship, criticism, and theory on calligraphy and painting—the forms of visual art most highly valued—as well as catalogues of bronze vessels, ceramics, and other antiquities. Since ancient times, different voices—including artists, collectors, and connoisseurs of the imperial court and the elite classes—have written about examples of art and visual culture. Anecdotes and comments about painting,

including some that considered the significance of visual representation, were recorded beginning in the third century BCE. By the Six Dynasties era (220–589), painters were writing essays about the criteria for assessing both figure painting and landscape, and other texts recorded painters' biographies and presented a classification system for artists. The ninth century witnessed Zhang Yanyuan's compilation of a comprehensive painting history, *Record of Famous Painters of All the Dynasties*. In subsequent eras, artists and collectors continued to write critically and theoretically about art, in histories of painters and calligraphers, catalogues of important collections of art and visual culture, or individual musings on art jotted down spontaneously. *Letter about a Coral Tree* (**FIG. I-13**), by the scholar-artist Mi Fu (1051–1107), is an example of a note on a beautiful object he had acquired; indeed, Mi Fu created inventories of his art collection and authored critical commentary on important artists and paintings. A coral tree is a found object and thus stretches the definition of what can be considered art, and Mi Fu's sketch and calligraphy would be regarded as art in and of themselves. The advent of printing by the Tang dynasty ensured that the collected knowledge of Chinese art history could be disseminated and studied, and connoisseurship became an important element in elite culture, as seen in Wen Zhenheng's (1585–1645) *A Treatise on Superfluous Things*.

Although Japanese writers allude to art-making from a relatively early period—eleventh-century examples include *The Tale of Genji* and Sei Shonagon's (ca. 965–ca. 1025) *The Pillow*

Book—the fact that comprehensive histories of Japanese art did not appear until the late nineteenth century (through the efforts of Okakura Kakuzo, 1862–1913, and Ernest Fenollosa, 1853–1908) suggests that what historians now refer to as art might actually be better understood as examples of visual or material culture. Buddhist sculptures, for example, were valued as religious artifacts, and the monk Kukai (774–835) included images in his *Catalogue of Imported Items*. Still, many Japanese artists received training in styles of earlier eras: The Kei School sculptors of the Kamakura period (1185–1333), for example, created Buddhist images in the style of the sculptures made in the eighth-century capital, and artists of the Muromachi (1392–1573) and later periods who illustrated *The Tale of Genji* often deliberately adopted the style of the classic illustrations of the earlier Heian era when the novel was written. Moreover, elite patrons amassed collections of art. A member of the artistic San'ami family, who took responsibility for the art collection of the Ashikaga shoguns in the fifteenth century, produced the first Japanese text devoted to art criticism: a 1476 catalogue of Chinese paintings titled "A Treatise on the Scrolls in the Lord's Watchtower."

In India, the situation was similar. There were treatises on art-making, such as the *shilpashastras* concerning elements of Hindu iconography, as well as texts that detailed the process whereby deities could be visualized (clearly a related phenomenon). The seventh-century *Chitrasutra* described artistic criteria known as the six limbs of Indian painting. These were said to have been formulated in ancient times, and included such elements as naturalism, similitude, and authenticity; in addition, artists used particular techniques and sought to infuse art with emotion and grace. The *Chitrasutra* also set out key terms that clarify the commonalities between the visual and performing arts and their connections to aesthetics and poetics. In the ancient and medieval periods, moreover, critical texts provide insight into the artist–patron relationship. A comprehensive history of Indian art appeared in the nineteenth century with the arrival of European colonists.

The writing of art history today often takes into consideration the ways that art and architecture link to their cultural and historical context. To do this effectively, art historians must delve into art's relationship to social history and be aware of concurrent developments in other modes of human expression, such as literature, religion, philosophy, and politics—all of which are reflected in the writing of even the earliest connoisseurs of Asian art. This book focuses on certain highlights of artistic practice throughout Asia, seeking to illuminate the diversity of the region's artistic traditions. In so doing, we consider various aspects of the role of art in Asian cultures, including why the creation of art was a meaningful form of expression for both artists and patrons, how art encompasses the values of individual Asian cultures, and how art provides another means of understanding developments in Asian history.

I-13 • Mi Fu *LETTER ABOUT A CORAL TREE*
Chinese, Northern Song dynasty, ca. 1100. Handscroll, ink on paper, 10½ x 18½″ (26.6 x 47.1 cm). Palace Museum, Beijing.

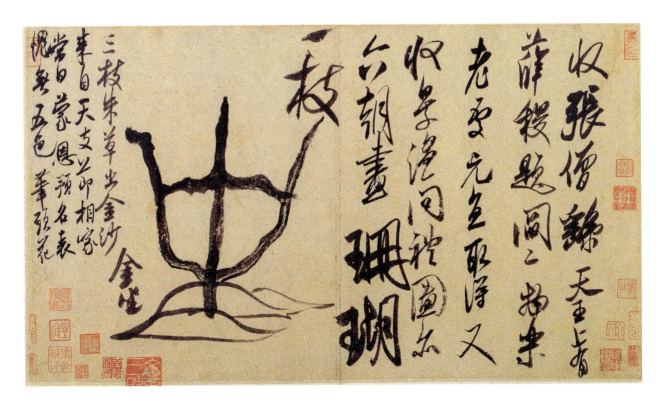

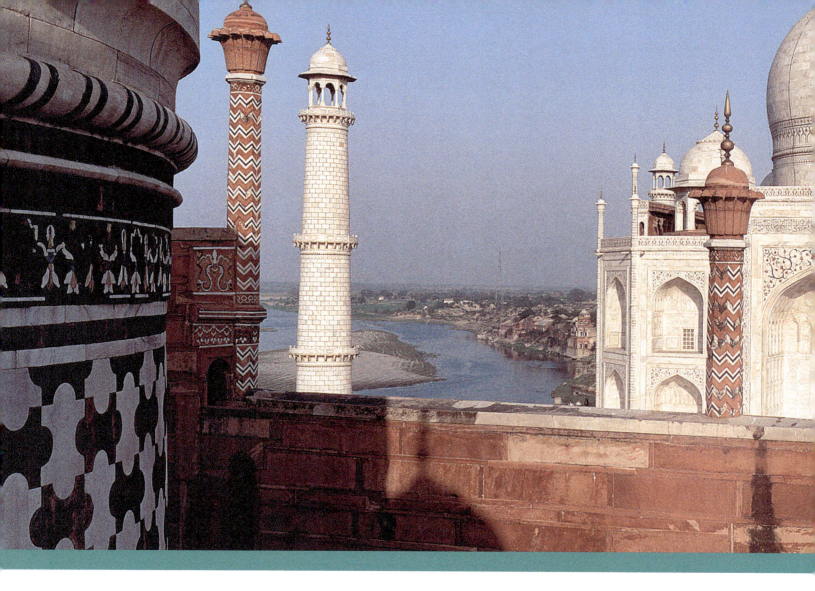

PART ONE
South and Southeast Asia

VIEW OF THE TAJ MAHAL FROM THE GREAT GATE
Agra, 1631–1643.

The geographic regions of South and Southeast Asia cover a vast territory as linguistically diverse as Europe and containing many independent countries. South Asia (often referred to as the subcontinent) is made up of India, Afghanistan, Pakistan, Nepal, Bhutan, Bangladesh, and the island of Sri Lanka, while mainland Southeast Asia includes Myanmar (Burma), Laos, Thailand, Cambodia, Vietnam, and Malaysia, while the multiplicity of islands and archipelagoes are divided up between Indonesia, Malaysia, the Philippines, Brunei, Singapore, and East Timor.

These regions are often studied together because certain strong cultural traits linked one end of the continent to the other. Trade connected South Asia to Southeast Asia from at least the early centuries CE, and played an important part in spreading the religions of Buddhism and Hinduism throughout the subcontinent and then into mainland Southeast Asia and the islands. Later, Islam would take root across the region as well, often following the same trade routes. The visual methods for conveying religious concepts spread with these religious doctrines, and certain aesthetic preferences lend a similarity, at a basic level, to artistic production across the region. Literary

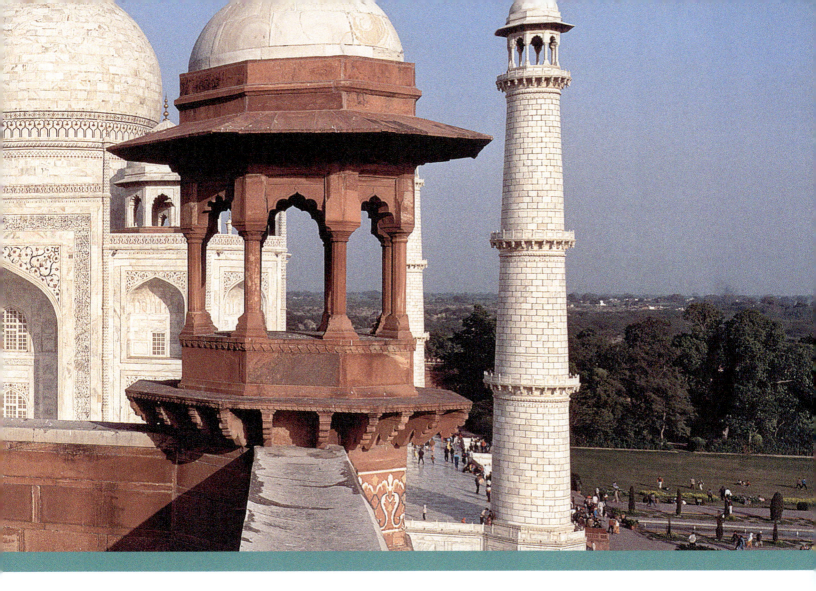

epics such as the *Ramayana* became popular wherever Hinduism spread, providing another layer of cultural commonality. And many cultures in Southeast Asia would use Indian scripts as the foundation from which they would develop their own written languages.

Nevertheless it is also incredibly important to acknowledge the diverse individual histories, languages, literatures, and values of each area within the vast extent of South and Southeast Asia if we are to understand the artistic legacy left to us today. The range of climates and topographies in this area is immense. To the north of the Indian subcontinent, harsh and cold conditions prevail in the Himalaya and Karakoram mountains (boasting the highest peaks in the world). Northwestern India features hot and dry deserts, while the east and south of India is lush and wet with tropical jungle, as are Sri Lanka and Southeast Asia. The multiplicity of languages is astonishing. Starting with Persian-inflected languages in the west, they evolve into the Indo-Aryan and Dravidian idioms of India, and the entirely distinct linguistic families of Southeast Asia, some with distant origins in China to the north, others in the islands of the Pacific. These differing conditions contributed to the development of many unique artistic traditions that were further shaped by the materials available locally.

No one work of art could encapsulate the entire artistic legacy of this region, but the Taj Mahal represents the level of refinement that could result from its characteristic multicultural blend. It is a tomb built by the emperor Shah Jahan (r. 1627–1656) for his wife in the northern Indian city of Agra. It combines the domes and decorative calligraphy prevalent in the architecture of Iran and Central Asia with Indian white marble and red sandstone, and decorative details made possible only when the imagination of its architects, designers, and craftsmen were encouraged by an expansive patron. It is one of modern India's most beloved monuments.

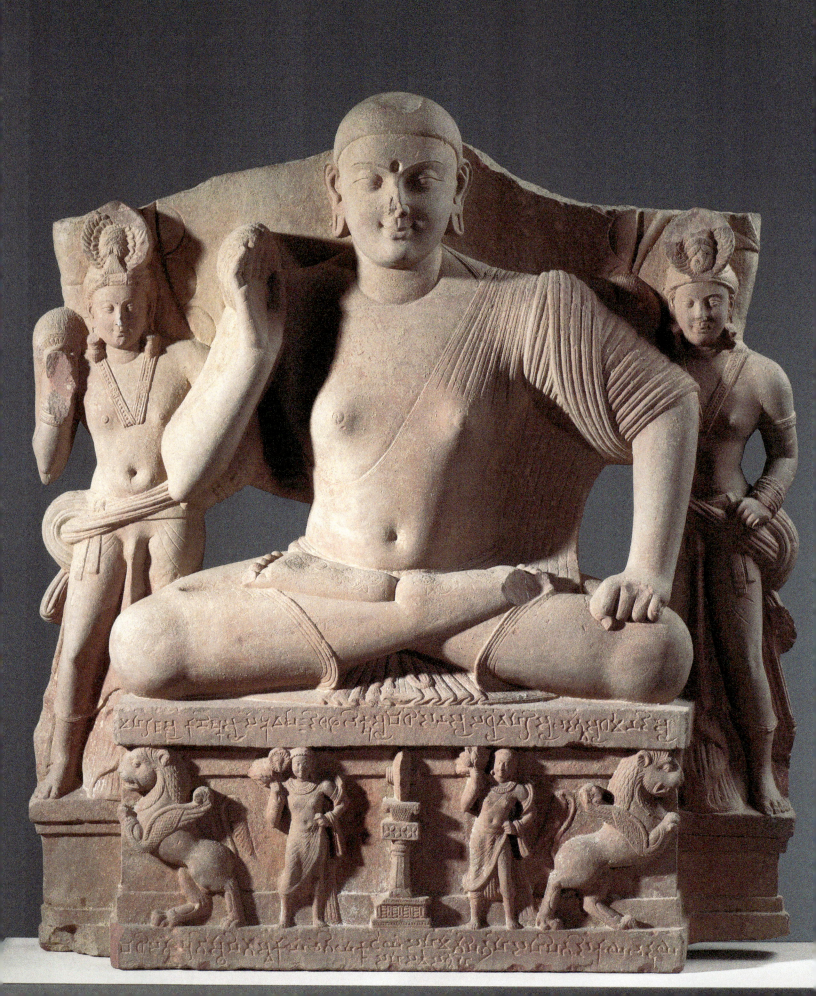

The Rise of Cities and Birth of the Great Religions: Early Indian Art

The entire universe, all movables and immovables, emanated from an image …the universe is an image, and an image is the universe.

Aparajitapriccha **of Bhuvanadeva** (ca. eleventh century)

South Asia's earliest artistic traditions developed over a 3,000-year span between around 2600 BCE and 500 CE. In the first part of this period, the transition from a nomadic to a settled lifestyle occurred, with the establishment of some of the world's earliest known cities. In the later part, the great religious traditions of Hinduism, Buddhism, and Jainism flowered. At their core is the belief that the soul is caught in a cycle of death and rebirth until it realizes that this world is an illusion. Once that realization is achieved, the soul is released; but exactly what the soul is released into is one of the key differences between the three. So compelling was the power of these beliefs that they would shape the region's cultural formation, and their influence would spread far beyond the subcontinent into Central, East, and Southeast Asia.

While most of the surviving **artifacts** (man-made objects) from India's first cities are not obviously religious in nature, the art that survives from the later period is focused almost entirely on the ritual needs of its religions. The overriding concern for the artist at this time was how to depict the divine—that

1-1 • SEATED BUDDHA WITH TWO ATTENDANTS
Kushan period, 82 CE. Red sandstone, 36⅝ × 33⅝ × 6⁵⁄₁₆″ (93 × 85.4 × 16 cm). Mathura; Kimbell Art Museum, Fort Worth.

more enlightened entity who has broken the cycle of death and rebirth, and can help guide the believer toward that goal. Although each religion had distinct interpretations of such a being, all three would base it on the human form (**FIG. 1-1**).

THE HARAPPAN CIVILIZATION

South Asia's first known civilization emerged around 2600 BCE, and was characterized by a distinct urban and social structure that had formed over several centuries. Many cities of this civilization were located in the Indus Valley—a part of the Punjab region of Pakistan, where five rivers originating in the Himalayan Mountains converge and create the mighty Indus River (**MAP 1-1**). The Indus Valley city of Harappa was the first to be discovered, and gave the entire civilization its present-day name, but related settlements once covered a vast part of the Indian subcontinent. Archaeologists have begun to uncover new sites and cities along a second major river called the Saraswati, which ran to the east of the Indus, and additional sites are known in Makran and Baluchistan, farther west into Pakistan, in neighboring Afghanistan, and in Rajasthan, Sindh, and Gujarat in India. It seems likely that similar cities also existed in southern India, and that they lie awaiting excavation under still-inhabited settlements and cities.

EMERGING CITYSCAPES: MOHENJO DARO AND HARAPPA
The process of urban development started around 6500 BCE, with the growth of villages comprising simple mud-brick houses surrounded by nomadic camps. The peoples of this period used tools, had domesticated animals, and possessed the basic principles of

features, including a written language and a standard system of weights and measures. Images on **seals** and other objects suggest a common belief in a male horned deity and a mother goddess to whom **terra-cotta** figurines were offered.

The two best-known sites are in Pakistan, near the border with India: Mohenjo Daro on the banks of the Indus, and Harappa farther north near the ancient Ravi River (the course of which has since changed). These cities were built on large mud-brick foundations that would have protected them against flooding, and accommodated populations of approximately 35,000 to 40,000 people. Each featured a raised **citadel** to the west and a lower city to the east, both surrounded by massive brick walls. Both settlements also had a number of large public buildings, market areas, workshops, and residences. These structures were built along wide roads that ran roughly north–south and east–west, as well as along smaller interconnecting lanes and alleys (**FIG. 1–2**).

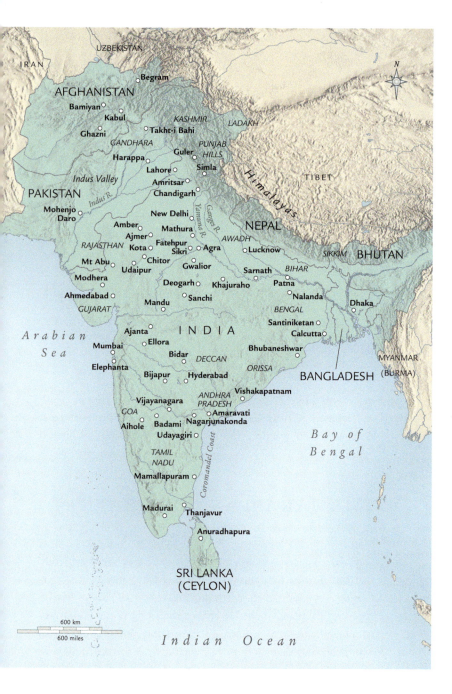

MAP 1–1. SOUTH ASIA

1–2 • AERIAL VIEW OF MOHENJO DARO
ca. 2600–1900 BCE.

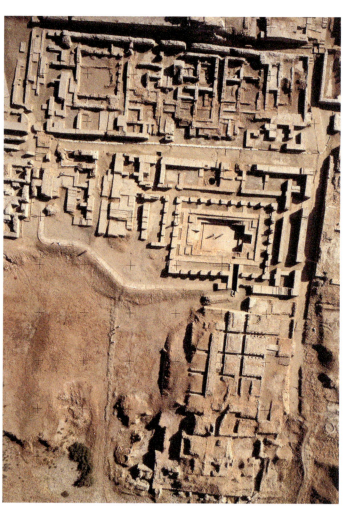

agriculture. Between 5000 and 2600 BCE, these villages coalesced into towns with defensive walls and large-scale buildings that may have served as palaces and temples. Their inhabitants developed crafts, including **pottery** painted with geometric designs and images of animals. They had beads made from precious stones that must have been imported from Central Asia.

Between 2600 and 1900 BCE the process of urban development picked up pace. Approximately 1,500 sites are associated with this era. These ranged from villages to small cities, all located at a distance of one day's walk from one another and surrounded by farms and seminomadic communities raising livestock. Although spread across a large area, these sites were all part of a hierarchical, tax-paying society sharing many cultural

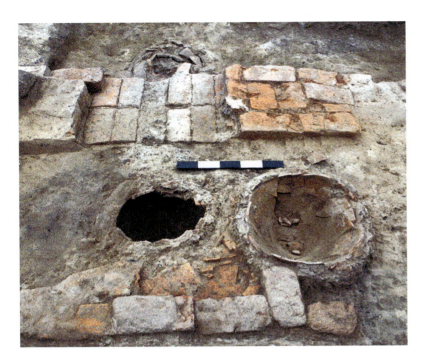

1–3 • SUMP POTS IN LATRINES AT HARAPPA
ca. 2600–1900 BCE.

Houses were typically two-storied and constructed from uniformly-sized bricks that must have been made in organized workshops. Many had private wells and bathing platforms with watertight floors; some of the baths were located on upper floors and were serviced by pipes built into the walls of the houses.

Most residences also had separate toilets consisting of large jars buried in the floor, which were connected to city-wide drainage systems that removed dirty or polluted water from each house and kept it away from the clean water supply (**FIG. 1–3**).

The monumental architecture of these cities is varied. At Mohenjo Daro, a large structure with stairs leading to a high platform was probably a temple. In the citadel is a tank known as the Great Bath. Once surrounded by a **colonnade** (series of columns) and measuring approximately 39 by 23 feet (12 by 7 meters), it has a brick floor and its sides were specially sealed to prevent the leakage of water (**FIG. 1–4**). It is unlikely that the Great Bath was merely an oversized bathtub; it was probably used for ceremonies, such as those for ritual purification. The act of purification before prayer would remain an important feature of later South Asian religions, and water reservoirs for cleansing are still found at most sacred sites. Around the Great Bath were large buildings that have been identified either as granaries or as great halls that may have served the administrators or priestly class who oversaw the city.

THE REMAINS OF DAILY LIFE

In addition to architecture, the excavations of Harappa and Mohenjo Daro revealed pottery, cooking vessels, and implements made of metal, bone, and shell. Also found were gaming pieces,

1–4 • THE GREAT BATH AT MOHENJO DARO
3rd–2nd century BCE.

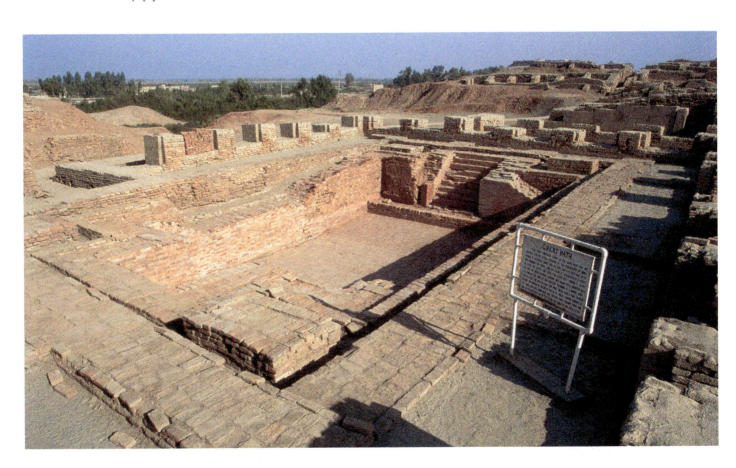

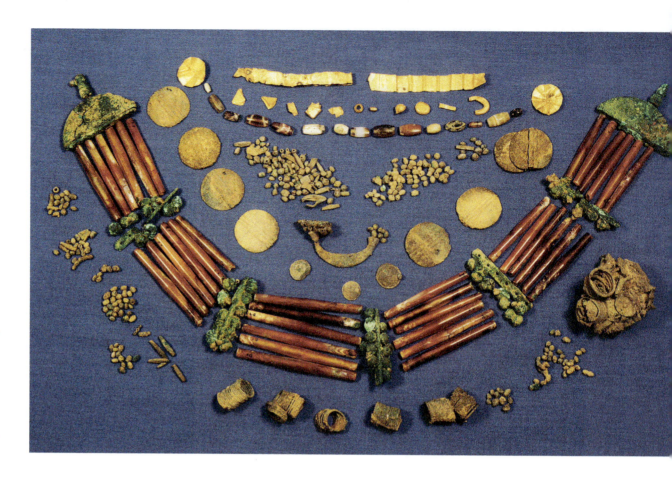

1-5 • JEWELRY FROM MOHENJO DARO AND HARAPPA
ca. 2600–1900 BCE. Gold, bronze, agate, carnelian, and turquoise, various dimensions. Mohenjo Daro Museum.

inlay for furniture, and necklaces and belts made from beads of **carnelian**, lapis lazuli, and turquoise (**FIG. 1-5**). It is clear that some of these objects were imported from other Indus Valley centers, and fossilized cart tracks and toy-size models of carts provide evidence for travel and trade by land. Representations of ships on seals and **amulets** (charms worn for protection against harm) show that trade must have also occurred by sea—markets may have existed as far away as Mesopotamia to the west, where contemporary written sources mention a land called Meluhha, which can be plausibly identified with the Indus Valley.

More than 2,000 seals were also found during excavations. They typically consist of a line of writing and a drawing, most often of an animal. They are made of a soft stone called **steatite**, which was carved, covered with an alkali, and hardened in a kiln. These seals were probably applied to documents or to closed bags of goods to certify their contents, but they are interesting from an art historical perspective because of the images they bear. A horned animal, whose identification scholars dispute, occurs in the hundreds (**FIG. 1-6**). While some equate it with the mythical unicorn that would later figure in European **iconography** (symbolic imagery), others say it is simply a bull

whose horns, shown in profile, have been merged into one long projection emanating from the animal's head.

The representation of an unidentified deity on a seal from Mohenjo Daro is also intriguing (**FIG. 1-7**). A three-headed figure with curling horns sits on a throne in a **yogic** posture, legs folded under and arms outstretched to touch the knees. He is surrounded by animals, including small deer. Elements of this imagery coincide with later depictions of the Buddha preaching in a deer park, as well as of the Hindu god Shiva as Lord of Beasts—although again, whether these connections can be made

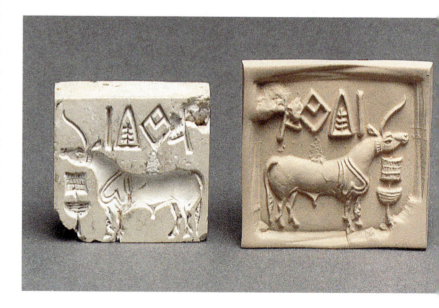

1-6 • STAMP SEAL AND IMPRESSION WITH A "UNICORN" AND A RITUAL OFFERING STAND
ca. 2600–1900 BCE. Burned steatite, 1½ × 1½ × ⅜″ (3.8 × 3.8 × 1 cm). Metropolitan Museum of Art, New York. Dodge Fund, 1949 (49.40.1).

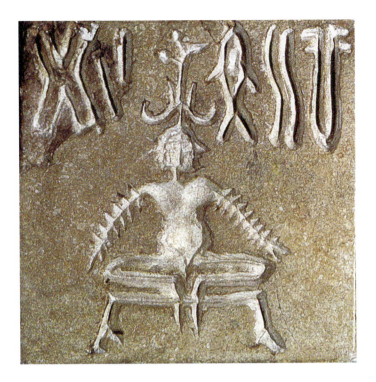

is highly controversial. The script found on the seals remains undeciphered; to date, scholars have been able to determine only that it was written from right to left.

The numerous crudely made terra-cotta female figures found at these sites, wearing headdresses and elaborate jewelry, are thought to represent a mother goddess and were probably a kind of **votive offering** (token of worship) to her. One particular clay figurine found at Mohenjo Daro (**FIG. 1-8**) wears a fan-shaped headdress, and once had long braided hair. She wears heavy necklaces over bare breasts, a wide belt on curvaceous hips, and would have had bracelets at her wrists. These ornaments would probably have looked like those illustrated opposite (see **FIG. 1-5**). It is assumed that the figurine's female attributes are accentuated because this goddess was associated with fertility; her devotees probably placed similar figurines at **altars** or temples in order to receive her divine assistance in that regard. Of slightly different proportions, but with breasts, hips, and jewelry also emphasized, is a metal figurine from the same site (**FIG. 1-9**). This unique find has been called a "dancing girl," and is

1-7 • STAMP SEAL WITH A SEATED MALE FIGURE
ca. 3000–1500 BCE. Steatite, 1 1/16 × 1 1/8 × 3/8" (2.6 × 2.7 × 1 cm). National Museum, Karachi.

1-8 • FIGURINE OF A MOTHER GODDESS
ca. 2600–1900 BCE. Terra-cotta, height 7" (18 cm). National Museum, Karachi.

1-9 • FIGURINE OF A DANCING GIRL
ca. 2500. Bronze, height 4" (10 cm). National Museum, New Delhi.

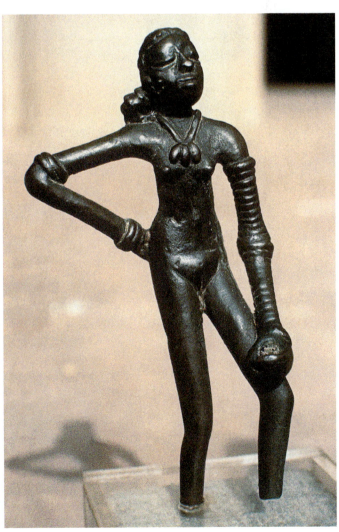

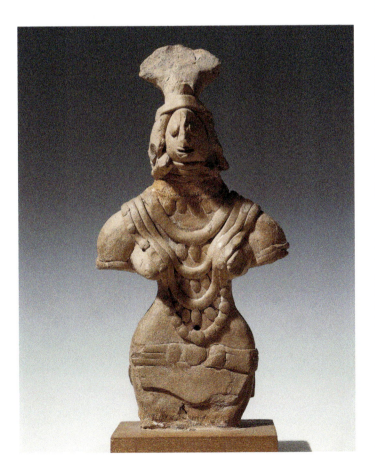

not considered an offering in the same sense as the terra-cottas—her posture, and the fact that she was made from bronze, hint at a different purpose.

A male figure from Mohenjo Daro belongs to a separate class of sculpture (**FIG. 1-10**). Made of steatite like the seals, this object would also have been hardened by heating at a very high temperature before being painted, adorned with gold jewelry, and set with shells for the eyes. Although he is still commonly referred to as a "priest-king," scholars today think he may represent a clan leader or revered ancestor. Quite different in character, but foreshadowing future developments in sculpture,

is a torso of a male statue from Harappa (**FIG. 1-11**). Beautifully modeled, and the most **naturalistic** of all the Indus Valley sculptures, this figure represents a departure from the other excavated material and its dating has been called into question. Most do still place it within the Harappan civilization, though, because in common with other statues of the period its arms and head were attached to the torso using dowels (rods). As with many other artifacts of its era, however, the identification and purpose of this miniature statue remain a mystery.

How the great Harappan civilization came to an end, and why its cities were abandoned between 1800 and 1700 BCE, are still unsolved puzzles. Current scholarship suggests environmental reasons—most likely the shifting or silting of the region's rivers, which in turn would have upset local agricultural and economic systems. It is possible that the populations of these cities simply migrated to more stable climates in the subcontinent.

1-10 • TORSO OF A "PRIEST-KING"
ca. 2600–1900 BCE. White, low-fired steatite, 6⅞ × 4⅜″ (17.5 × 11 cm). National Museum, Karachi.

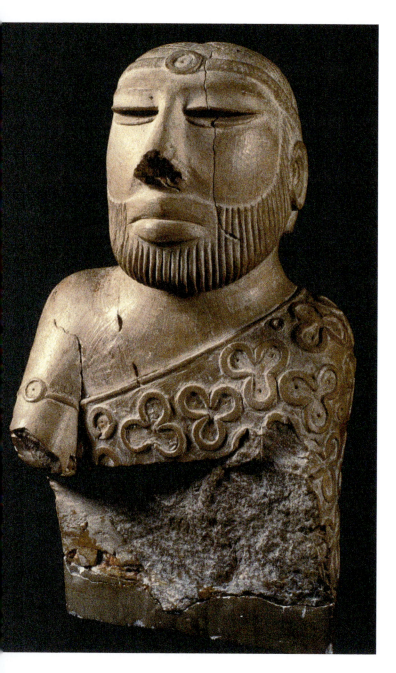

1-11 • MALE FIGURE
ca. 2600–1900 BCE. Red sandstone, height 3⅔″ (9.3 cm). National Museum, New Delhi.

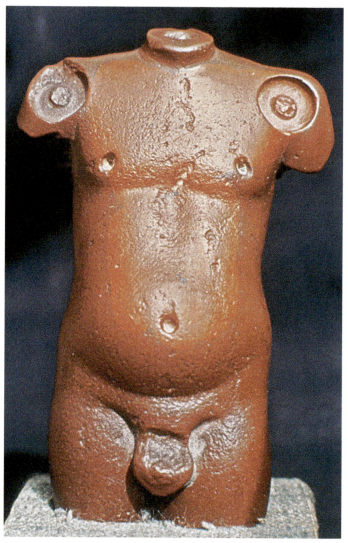

THE VEDIC PERIOD AND THE ORIGINS OF HINDUISM

Around 1500 BCE, groups of **Aryan** tribes from the Caucasus region to India's northwest started moving into the Indus Valley region and, from there, into the heart of the subcontinent. The language, traditions, and religious rituals of these newcomers would become an integral part of South Asian culture and belief. Previously characterized as bringing a violent end to the Harappan cultures, the process of Aryan settlement in the Punjab and Rajasthan is now understood as a more peaceful integration that took place after the Indus Valley cities had already been abandoned.

As more archaeological evidence of Aryan culture awaits discovery, literature remains our main source of information about the society of this period. The major works attributed to the Aryans are the four *Veda Samhitas* (*Collections of Knowledge*), written in the ancient and still-living language of Sanskrit. The **Vedas** are believed to be the revelations from **Brahman**, the supreme universal spirit, to a group of sages, and they constitute the core of what would later become the Hindu scriptures. The written form in which the Vedas are known today is probably not the result of a single transmission; the content and the style of the texts suggest the verses were compiled over a 700-year period between 1500 and 800 BCE.

The Vedas refer to numerous gods, of whom there are echoes in the later Hindu pantheon, as well as in Buddhist and Jain texts. They also provide evidence of a codified body of prayers, offerings, and sacrifices required by the gods. It was believed that only priests (*brahmins*) had direct contact with the gods, and so could perform the necessary ceremonies on behalf of individuals. As a result, their role in society became increasingly important.

Also embedded in the Vedas is a great deal of information about the Aryans' history and the makeup of their society. The texts seem to describe, for instance, varied types of interaction between the Aryans and the peoples they encountered in India, ranging from armed conflicts to the adoption of vocabulary from Indic languages. The Vedas also reveal the stratification of society into different social groups, or **castes**. The priestly class was at the top of this hierarchy, followed by the warriors (*kshatriya*), the farmers and merchants (*vaisyha*), and the peasants (*shudra*). The definition of these four groups, their rights, and the rules encoding their behavior are fundamental to the way society on the subcontinent has been conceived up to the present day.

BUDDHISM AND BUDDHIST ART

Possibly in reaction to the autocracy of the *brahmin* priests of the Vedic period and the hierarchical caste system they enshrined, two new religions arose in northeastern India during the sixth century BCE: Buddhism and Jainism. From the mid-first millennium BCE to the end of the first millennium CE, both of these religions played a major role, along with Hinduism, in the ethical, social, and cultural life of the whole subcontinent.

At the heart of Buddhism is the story of Siddhartha Gautama, who is believed to have lived from ca. 563 to 483 BCE. He was born into a royal family in the area of India bordering Nepal, but the conception and birth of this historical figure have since become shrouded in legend. A six-tusked elephant is said to have impregnated his mother, who gave birth to the baby from her side. Raised in a palace, Siddhartha renounced his comfortable life at the age of 29 in order to search for the solution to human suffering. After six years and much meditation, he finally attained enlightenment and became known as the Buddha, which translates as "The Enlightened One." He started preaching what he had learned—that enlightenment could be reached not with the intervention of priests, but through the realization of the Four Noble Truths: that life is suffering; that the reason for this suffering is desire; that freedom from suffering is the end of desire; and that there is a path to this freedom, called the Middle Way, which negotiates between the extremes of self-indulgence and self-mortification.

THE STUPA AND ITS DECORATION

In the centuries following the Buddha's death, his philosophy was further developed and spread throughout the region. This early Buddhism stressed both the teaching and the moral codes of the Buddha himself. Popular worship developed around the **stupa**, a structure in the shape of a hemispherical mound that functioned as a funerary monument to the Buddha. It was developed from the Buddha's request that his followers cremate him and build a memorial at a place where people could gather. His wishes were partly respected—his ashes were enshrined, but only after being split into eight portions and placed within eight separate stupas at sites across northern India associated with key moments in his life. Later, during the reign of Emperor Ashoka (r. 272–231 BCE) of the Maurya dynasty (ca. 323–185 BCE), the **relics** were further divided and distributed to additional sites—84,000, according to the traditional reckoning.

The first stupas were simple structures, shaped as rounded mounds representing the curving form of the universe. Initially, their main function was to allow **pilgrims** access to the Buddha's remains, but over time they evolved into larger monuments decorated with religious imagery, and were often surrounded by monasteries and other buildings. In addition, symbolic features were added to the structure. A square railing at the top represented the Buddhist heavens, while a mast with umbrellalike tiers emerging from the center of the stupa referred to the axis of the universe. As the Buddhist faithful circled the building on foot (**circumambulation**), passing the gateways (*toranas*) marking the cardinal directions (north, south, east, and

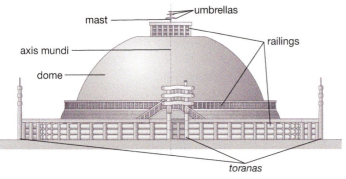

1-12 • THE STUPA

west), it was believed that they were re-enacting the rotational movement of the celestial bodies around this axis (**FIG. 1–12**).

THE MAURYA EMPIRE: ASHOKA AND HIS COLUMNS

Unlike for the Harappan period, records exist that document the many regional dynasties ruling over South Asia during the Buddha's lifetime. We can therefore chart their dates and the geographical spread of their domains. In the fourth century BCE, the Mauryas (ca. 323–185 BCE) emerged as the most powerful of these dynasties and, over the next 150 years, united much of India under their rule.

The emperor Ashoka, mentioned above, is the best known of this line. After leading a particularly bloody invasion down India's eastern coast—a region now known as Orissa—and witnessing its violent outcome, Ashoka decided to adopt the peaceful beliefs of Buddhism. He performed a great pilgrimage to all 32 sites associated with the Buddha, and created numerous new stupas.

Ashoka also set up tall columns at many of the stupa sites. The columns are **monolithic** (made of a single piece of stone) and stand 45 to 50 feet (14 to 15 meters) tall (**FIG. 1–13**). They were each originally capped with a separately carved **capital** and animals, usually a bull, elephant, or lion. Most are also inscribed with Ashoka's edicts, prescribing ethical behavior for his subjects. These impressive monuments, visible from afar and associated with religious sites, linked Buddha's *dharma* (moral law) with Ashoka's law of the mortal world. Their distribution throughout Ashoka's vast empire also conveyed the symbolic presence of the emperor to each part of his realm, though his capital was in Pataliputra (modern Patna) in northeastern India.

1-13 • COLUMN ERECTED BY ASHOKA
246 BCE. Polished buff sandstone. Lauriya-Nandangarh.

1-14 • LION CAPITAL FROM AN ASHOKA COLUMN
ca. 250 BCE. Sandstone, height 84″ (215 cm). Archaeological Museum, Sarnath.

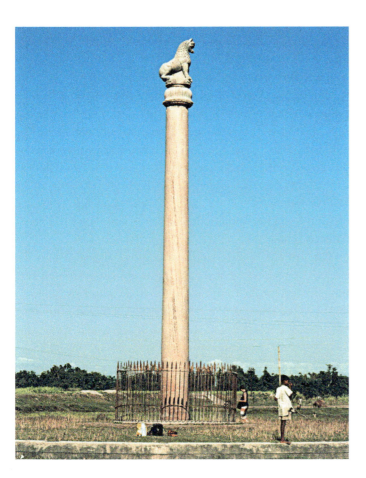

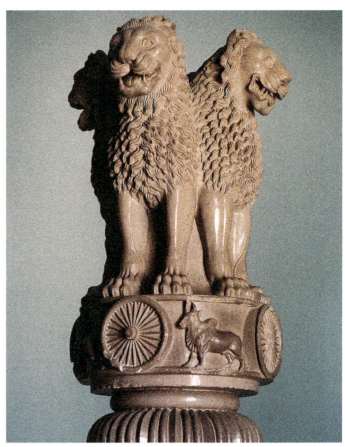

The capitals are crisply carved and many have been buffed to a high polish. An example from Sarnath, where the pillar to which it was attached still stands, is comprised of several symbolic elements (**FIG. 1-14**). It has a lotus-bell base, a drum with small *chakras* (wheels), and four lions positioned back to back; on top would have been a large *chakra*. The *chakras* allude to the Buddha's first sermon, in which he was metaphorically described as "turning the wheel of the law" for the first time. The lions simultaneously represent royal power and the Buddha, who was described as the lion of his clan and whose speech was likened to a lion's roar.

THE DEVELOPMENT OF STUPA DECORATION

As Buddhist devotional ritual and the notion of pilgrimage developed in the centuries following the Buddha's death, stupas were built ever larger and came to be adorned with ever more elaborate sculptural programs. This represents a major shift from the early origins of Buddhism—there is almost no evidence for the use of images or icons from this period. Sculpted images started to appear in the first century BCE, with scenes from the Buddha's life providing appropriate material for meditation. The artist's challenge was to depict narrative while conveying the moral message of each episode.

The site of Sanchi in central India was among the most important pilgrimage sites of the era (**FIG. 1-15**). Ashoka founded the main stupa there as a simple brick structure in the third century BCE; surrounding it now are 50 additional buildings dating as late as the thirteenth century CE. Around the middle of the first century BCE, this stupa was built up with additional earth and rubble and covered with dressed stone in order to create a structure with a diameter of almost 120 feet (37 meters), encircled by a stone railing to guide pilgrims around it.

At Sanchi, both the main stupa and the railings around it are plain, but the *toranas* are exquisitely decorated with images relating to the Buddha and his veneration, as well as some of the *jataka* tales, which tell the story of the previous lives of the Buddha (see Closer Look and Point of View, pp. 12 and 13). The selection does not form a fully coherent program, as some stories are repeated or are shown out of chronological order. This may be the result of the collective manner in which the additions were made—through the contributions of several hundred donors, including many women, each of whom is named in inscriptions on the element of the building they funded. These individuals might have chosen the stories that appealed most to them, even if they already existed elsewhere on the monument.

Another stupa once stood at Amaravati, in the modern state of Andhra Pradesh. This is believed to have been founded by

1-15 • STUPA I, SANCHI, MADHYA PRADESH
Original stupa, ca. 250 BCE; enlarged and renovated ca. 50–25 BCE.

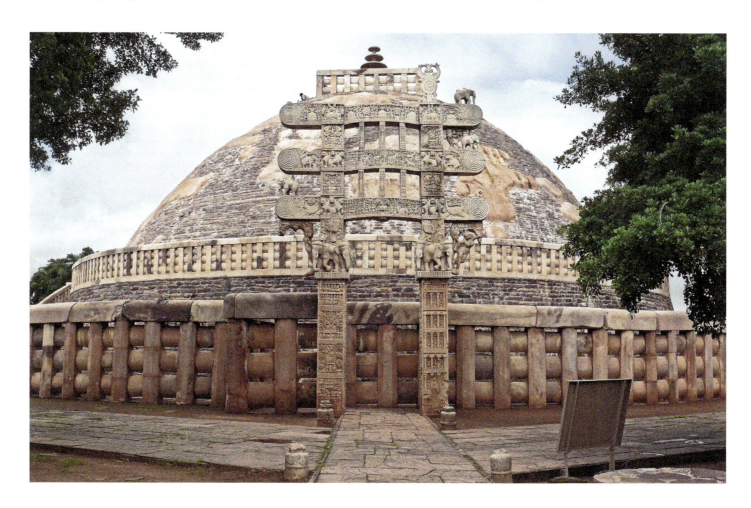

A relief is a type of sculpture that is only partially free of its background rather than freestanding and carved on all sides. At early Buddhist stupas, stone panels carved in relief were located on the gateways and railings of the stupa, and sometimes the exterior of the building as well. These panels presented the past lives of the Buddha and his historical life, provided for pilgrims to reflect upon while ritually circumambulating the structure. Using only images, they tell stories in different ways. Some show just one moment from a longer tale, while others show several moments together in one scene—a pictorial device called **continuous narrative**.

The relief below is located on the east gateway of the main stupa at Sanchi, and is about 8 feet (2.5 meters) long. Known as the *Great Departure of the Buddha*, it tells the story of Prince Siddhartha's exit from his palace, as he started his life of meditation and poverty.

You will notice that while there is a mass of people represented, not one of these figures represents the prince. In an **aniconic** (meaning "without image") interpretation of the scene, this would be because it was considered inappropriate to depict the Buddha physically (although later on this would change). Thus such symbols as the saddled horse and footprints indicate his presence indirectly. Another explanation for his absence could be that the relief depicts a re-enactment of the event by Buddhist pilgrims.

GREAT DEPARTURE OF THE BUDDHA
ca. 50–25 BCE. Stone, height 21³/₁₆″ (53.75 cm), depth 12¹/₅″ (31 cm). Central architrave, east gateway, Sanchi, Madhya Pradesh.

The story unfolds from left to right. This is the palace that Siddhartha is leaving.

Shown here is the horse that Siddhartha is riding. We do not actually see the prince—just a bare saddle and a parasol shading it. In an aniconic reading, these symbols indicate the Buddha's presence, while the figures lifting the horse are the gods who do not want the horse's footsteps to sound out and alert anyone to the prince's departure. In another interpretation, these represent an effigy of the Buddha's horse being borne aloft by pilgrims.

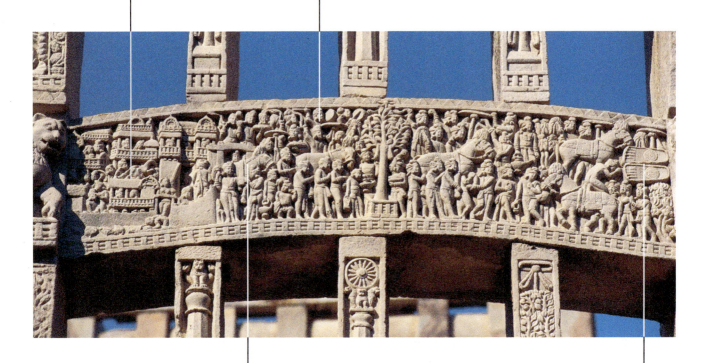

The horse is depicted many times in this relief, shown at several points during the prince's progress.

After traveling a safe distance from the palace, the prince relinquishes his horse, and sets out to complete his quest on foot. Siddhartha's groom kneels before him to say a final goodbye. The footprints with a parasol above indicate either the Buddha or a shrine at this significant location.

Ashoka, and so would have been the first major Buddhist monument of this region. Over time, the simple original Ashokan structure was expanded and stone cladding and railings were added, including elements that were carved with **relief** scenes similar to those at Sanchi. By the end of the decades-long transformation of the site in the second century CE, the stupa was approximately 193 feet (59 meters) in diameter. It was surrounded by a railing marking a circular path for pilgrims, with entrances to this path at the cardinal directions. This extensive work was funded by a community of lay worshippers, monks, and nuns; no inscriptions from royal donors are known. Sadly, today, after excavations at the site, nothing remains of the stupa itself.

What do survive are many of the stone relief panels that once covered its railings and exterior. The range of subject matter and method of conveying narrative are comparable to the reliefs at Sanchi, despite the distance in time and space that separates their completion. In a scene from the *Mandhata jataka* (**FIG. 1–16**)—presented within the confines of a circular medallion on a crossbar between two pillars of the railings—the king Mandhata shares a throne with the god Shakra (known as Indra in the Hindu tradition). To understand and interpret this scene

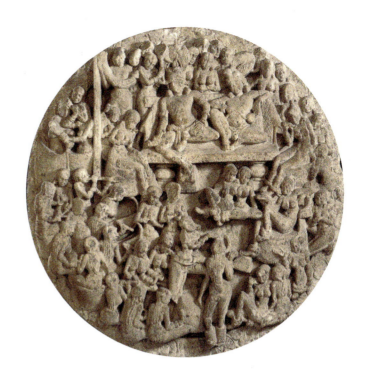

1–16 • *MANDHATA JATAKA* CROSSBAR MEDALLION
2nd century CE. Limestone, diameter 21⅛″ (53.75 cm). Great Stupa at Amaravati, Andhra Pradesh; British Museum, London.

POINT OF VIEW | A Story from the Past Lives of the Buddha

Part of Buddhist belief is the concept that it may take many lifetimes before ultimate enlightenment is attained. The Buddha himself was supposed to have lived 550 lives before he achieved this state of mind. The stories of these previous lives are known as the *jataka* tales, and they were revealed to the Buddha on the night he finally attained enlightenment. In some of these *jataka*s, the Buddha was human, but in many he was an animal or a god.

The *jataka* stories are an important part of Buddhist teaching as each provides an example of self-sacrifice. In Mahayana Buddhism, the Buddha is characterized in these stories as the Bodhisattva,

emphasizing his compassion in not proceeding immediately to enlightenment but rather spending these lives helping others on their way.

These stories were also presented as a subject for contemplation at stupas, especially those built between the first century BCE and the second century CE. Below is an extract adapted from *Jataka Tales*, edited by H. T. Francis and E. J. Thomas (1916). This is part of a commonly depicted story, in which the Buddha is born as the king of monkeys, whose actions demonstrate to a human king how he must behave.

Once upon a time the Buddha was born as a monkey king with a retinue of eighty thousand monkeys. They lived near the bank of the Ganges River where stood a mango tree, whose fruit the monkey king predicted would one day bring them harm. Despite his precautions, the king of Varanasi came across one of the tree's mangoes. He ate it, and desiring more, he asked where the mango came from. In due course his foresters found the place where the tree was located, and having prepared a bed at the foot of the tree, the king lay down after eating the mango fruit and enjoying its excellent flavor. After the men had fallen asleep, the monkey king and his retinue came to eat the mangoes. The king roused his men, and calling his archers said, "Surround these monkeys that eat the mangoes so that they may not escape, and shoot them: tomorrow we will eat mangoes with

monkey flesh." The monkeys were scared but their king said, "Do not fear, I will give you life." He stretched himself across the river, and told the monkeys to escape by climbing along his back to the opposite bank. The eighty thousand monkeys escaped thus. Devadatta [an ungrateful follower of the Buddha who appears in many of the jatakas] thought, "This is a chance for me to see the last of my enemy," and he jumped on the monkey king's back. The monkey king's heart broke and he was in great pain. The human king, witnessing everything, reflected on how his counterpart had risked himself for his subjects. When the monkey king died, the human king arranged his funeral and built a shrine in his honor. He then started following the Buddha's teaching and, ruling his kingdom righteously, became destined for heaven.

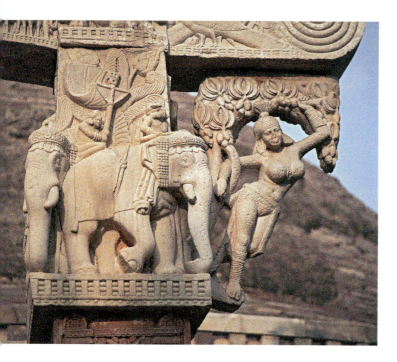

1-17 • BRACKET OF A WOMAN AND A MANGO TREE
ca. 50–25 BCE. East gateway, Stupa 1, Sanchi, Madhya Pradesh.

discussed above (see FIG. 1-8). They wear fan-shaped headdresses, heavy jewelry, and banded belts, and the emphasis is on their sexual attributes. In the context of the Buddhist stupa, however, their function is different. These women were auspicious, providing protection for the stupa and its visitors. A similar female type also appears on a terra-cotta plaque (FIG. 1-18). This particular medium conveys all the details of the woman's adornment wonderfully, down to the tiny animal buckles on her waist sash and the granulated beads of her necklace. But what purpose this plaque served—or who the subject is—remains unknown. Suggestions have ranged from a mother goddess to a royal figure.

THE ORIGINS OF THE BUDDHA IMAGE: MATHURA AND GANDHARA

The reliefs at Sanchi and Amaravati depict the Buddha in many of his incarnations, such as a scholar, a monkey, or an elephant, but it does not seem that he is ever shown in his final incarnation as

the viewer would have needed to be familiar with the original story. Mandhata, who had ruled for thousands of years, desired to add the heavens to his realm. Being a good ruler, he was invited by Shakra to the Heaven of the Thirty-three Gods, but after spending time there, Mandhata became dissatisfied even with the splendors of this heavenly court. He was sent back to earth and died soon afterward. The moral of this tale: All desire leads to suffering. Mandhata and Shakra are the two seated figures on the platformlike throne at the top of the **roundel** (disc); they are surrounded by a score of beautiful female dancers and musicians, playing drums, flutes, and harps.

There was a long interlude between the Harappan era and the period of early Buddhist monuments, with only a few known sculptures to provide information on the developments in between. The reliefs from Sanchi, Amaravati, and other related sites are therefore the largest body of evidence for the continuation of a sculptural tradition. The profusion of these reliefs, their connection to an architectural setting, and their ability to convey narrative all demonstrate an ocean of development from the earlier period. How and why these developments came about is still unclear. But some points of connection show a clear link between the traditions. For instance, female figures are found on the Buddhist stupas (FIG. 1-17) who appear to be the direct descendants of the Harappan terra-cotta mother goddess images

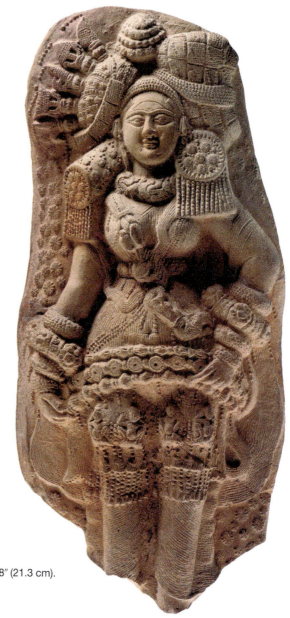

1-18 • ROYAL WOMAN OR GODDESS
ca. 200 BCE. Molded terra-cotta plaque, height 8″ (21.3 cm).
Tamluk, Bengal; Ashmolean Museum, Oxford.

Siddhartha. Instead, some people believe that the use of certain symbols, such as royal parasols or footprints, is a way of indicating the Buddha's presence in his final earthly form (see Closer Look, p. 12). This line of interpretation, in which Buddha is represented in an aniconic manner (meaning "without image"), is based on the suggestion that in early Buddhist belief it would have been inappropriate for one who had finally attained release from his earthly body to be depicted in human form. However, others read these reliefs as depicting Buddhist pilgrim sites associated with the Buddha's life rather than episodes from it: The Buddha does not appear because the action depicted takes place long after his death, and the symbols that appear are either his relics, or objects being used by his followers in re-enactments of events from his life. They also believe that some images of the Buddha may date to as early as the first century BCE.

Whichever theory is correct, it was only in the second century CE that there was a flowering of images of the Buddha. This was during the reign of the Kushan kings (first to third century CE), the major ruling dynasty after the Mauryas, whose empire united northern India with a vast area stretching west though Pakistan and Afghanistan. In creating their images, Kushan-era sculptors drew on Buddhist texts that describe the 32 special features of a Buddha's body—such as long, webbed toes and fingers, golden skin, a torso like a lion, a third eye symbolizing spiritual insight (*urna*), a bump on the head signaling wisdom (*ushnisha*), and the possession of 40 (rather than the usual 32) very white teeth. To this, sculptors added other features that became standard elements of the Buddha's iconography: elongated ears caused by the heavy earrings he would have worn as a prince, and the Wheel of Law (*chakra*) that appears on his soles and palms. They also positioned the Buddha's hands in certain gestures (*mudras*) to convey different messages (see Context, p. 16).

Mathura, capital of the Kushan dynasty, was one important center for the production of Buddhist sculpture. Mathura sculptors of this time were also involved in the emerging tradition of creating icons for Jain worship, and there is some evidence for their creation of early Hindu statues as well (see p. 21).

One of the earliest Mathura Buddhist sculptures bears an inscription stating that it was the donation of a monk (see FIG. 1-1). It is made of the red sandstone characteristic of all Mathura sculpture. As in the majority of Buddha images, the Buddha is depicted in a monastic guise, wearing a thin robe draped over one shoulder and raising his right hand in a gesture of reassurance (*abhaya*). He has several features that reinforce his enlightened status—the (now-missing) *ushnisha*, the *urna* (represented as the dot between his eyebrows), the *chakra* that appears on his soles and raised palm, and the **nimbus**, the halolike element behind his head that indicates his divinity. The *chakra* also appears on top of the pillar depicted on the Buddha's throne. At the same time, there is evidence of his former royal status, including the lions supporting his throne and the two attendants holding fly whisks, who stand on either side of the Buddha.

A province at the far western end of the Kushan empire was a second center for creation: Gandhara, bridging northern Pakistan and southeastern Afghanistan. Gandharan sculpture is immediately recognizable by its use of grey schist stone, and a manner of depicting the body that many have related to the sculpture of the Hellenistic world. In 330 BCE, Alexander the Great conquered much of West Asia, bringing the sculptural traditions of the classical Greek world right to the borders of the Indian subcontinent, and making a noticeable imprint on Gandhara's own sculptural traditions for the next several centuries.

A Buddha from the Takht-i Bahi monastery site (FIG. 1-19) gives us some context for how these newly developed images were used. Several domed shrines, each housing a statue, were located around the main stupa. Some of the statues were up to 16 feet (5 meters) tall, and they alternated with smaller statues,

1-19 • STANDING FIGURE OF BUDDHA
2nd–3rd century CE. Schist, height 40½″ (103 cm). Takht-i-Bahi, Gandhara; British Museum, London.

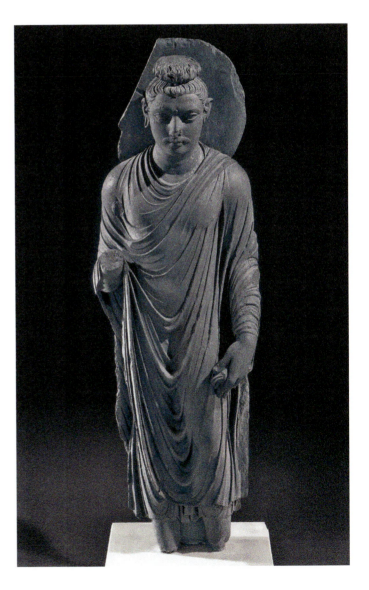

An icon of the Buddha is comprised of several symbolic elements that together convey his exalted spiritual state. These were added to the basic form of a male human and would have been understood by the Buddhist faithful as signs of specific meaning. For instance, some features symbolize his attainment of enlightenment, while others refer to the lifestyle of privilege and wealth that he gave up. **Lakshanas** are the symbols that fall in the first category, and include the *ushnisha*, or bulge at the top of his head; the *urna*, or whorl of hair between his eyebrows (sometimes depicted as a dot); and the webbing of his fingers and toes. In the second category are the Buddha's long earlobes, stretched by the weight of the gold earrings he wore as a prince, and his curled hair, representing the long locks he cut off to live as an ascetic. Other signs found on Buddhist sculpture include the *chakra* (wheel), which can appear on the Buddha's soles and on the base of the icon as an emblem of his law, and the lotus, which symbolizes purity.

Hand gestures called *mudras* (signs) reinforce the message of Buddhist sculptures; some also appear as part of Jain and Hindu iconography. There are many different *mudras* but the following six are the most common. The *dharmachakra mudra*—literally turning the wheel (*chakra*) of the law (*dharma*)—indicates teaching and is particularly associated with the Buddha's first sermon. Both hands are held at chest level, making circles with the thumb and forefinger (see Chapter 2, FIG. 2–31). The *dhyana mudra* indicates meditation and balance, the paths to enlightenment. The hands are placed palm up in the lap, the right on top of the left (see FIG. 1–28). The *vitarka mudra* indicates intellectual debate with one hand raised to shoulder level, the thumb and forefinger forming a circle (see Chapter 2, FIGS. 2–16 and 2–21).The *abhaya mudra* indicates reassurance, blessing, and protection, with the right hand raised to shoulder level, palm facing out (see FIGS. 1–1 and Chapter 2, 2–16). The *bhumisparsha mudra* is associated with a specific event, commemorating the moment the Buddha touched the earth, calling it to witness his enlightenment. This gesture has the hand held downwards, the palm facing inward (see Chapter 5, FIG. 5–23). The *varada mudra* indicates charity, and the fulfillment of all wishes. The hand is held downwards, with the palm facing out. It is made with the right hand when alone, but with the left hand when it is combined with another *mudra* (see Chapter 2, FIG. 2–21).

Buddhist symbols

ushnisha

urna

elongated ears

chakra

marks of the Buddha

lotus flower

double lotus flower

chakra

Mudras (hand gestures)

dharmachakra mudra

dhyana mudra

vitarka mudra

abhaya mudra

bhumisparsha mudra

varada mudra

1-20 • BODHISATTVA MAITREYA

Kushan period, 3rd century CE. Schist, height 43⅛ × 15 × 9″ (109.5 × 38.1 × 22.9 cm). Gandhara; Museum of Fine Arts, Boston. Helen and Alice Colburn Fund, 37.99.

like this one, that were around 3 feet (1 meter) tall. This Buddha stands in the **contrapposto** pose typical of Hellenistic sculpture: One leg is slightly bent so that his weight rests on the other leg, and his torso curves so as to bring one arm slightly forward. His robe, draped over both shoulders, is rendered in a much more naturalistic fashion than in Mathura sculpture. But otherwise he has the usual iconography of Buddha sculptures: the pendulous earlobes, the *ushnisha*, and the *urna*.

Around the beginning of the common era, Buddhist practice began to focus more on the enlightenment of all beings than just that of the individual. This came to be known as the Mahayana ("Greater Vehicle"), while earlier Buddhist practice was termed the Hinayana ("Lesser Vehicle"). Mahayana texts speak not just of Siddhartha Gautama, who became the Buddha, but of many other Buddhas of the past and those still to come. In addition, they mention beings known as **bodhisattvas**, who have held themselves back from Buddhahood in order to help bring all beings to enlightenment.

The rise of Mayahana practice also witnessed the expansion of Buddhist imagery to include the bodhisattvas. A commonly depicted figure was the Bodhisattva Maitreya, the Buddha of the Future—the counterpart of the Buddha of the current era—who waits in heaven for the time of his next and final birth (**FIG. 1-20**). In contrast to the depictions of the Buddha as a monk in austere garb, the images of the Bodhisattva Maitreya show a figure decked in rich clothing and jewelry (note the necklaces and armbands), in addition to the *urna*, *ushnisha*, and other markers of divinity. In the sculptures from Gandhara, the Maitreya is also given a beribboned turban and a twirling mustache.

In central India, south of the Kushan empire, another school of sculpture was based at Nagarjunakonda, in the state of Andhra Pradesh. Working in limestone, sculptors produced Buddhist images for the approximately 30 monasteries in the region, each of which had stupas, *chaitya* (chapel) halls, and residential complexes. Although works made here incorporate many of the same features as art from the north and west, they are distinctly a product of their local environment. The panel illustrated here would have been placed on the drum of a stupa, and in fact depicts a stupa (**FIG. 1-21**). A statue of the Buddha stands in its doorway, and on either side, and above it, are carved stone reliefs decorating the structure. Two small devotees raise their hands in reverence at the foot of the statue, and two attendants with fly whisks flank it. The long limbs of these figures, and the slight fleshiness of the Buddha, are considered stylistic features of the Nagarjunakonda school.

1-21 • RELIEF OF THE BUDDHA STANDING IN THE GATEWAY OF A STUPA

Second half of the 3rd century CE. Limestone, 48 × 29⅜ × 6¾″ (121.9 × 75.6 × 17.1 cm). Nagarjunakonda, Andhra Pradesh; Metropolitan Museum of Art, New York. Rogers Fund, 1928 (28.31).

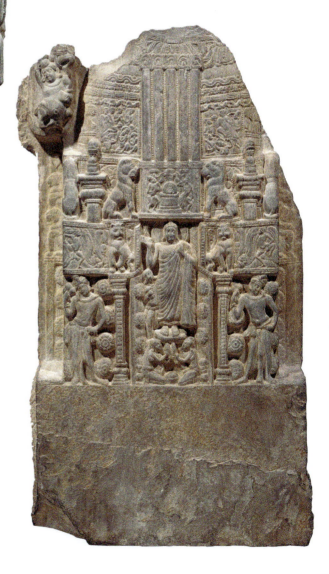

EARLY BUDDHIST CAVES AND MONASTIC COMPLEXES: AJANTA AND BAMIYAN

An important feature of Buddhism from its very beginning were those adherents who chose to separate themselves from the world to concentrate on finding the path to enlightenment. Known as *bhiksu* (usually translated as "monks"), these individuals came together to form monastic communities, often at places associated with the Buddha's life, and where the stupas to which the Buddhist pilgrims flocked were also situated. However, some Buddhist monastic communities retreated to more isolated spots—often caves carved out of cliff faces, perhaps because the Buddha was known to have used a cave for meditation. The earliest known cave monasteries were excavated in the third century BCE in eastern India, and were initially funded by individuals who donated what they could to the effort. Eventually, however, local rulers and the elite came to predominate in **patronage**.

The work of creating these cave complexes was immense. Rock cutters were used to give the initial shape to each cave by splitting and removing the rock, starting from the top of each cave and working down. Workers with more specialized skills perfected the architectural elements within the cave, such as columns, doors, and arches. Sculptors then gave life to the narrative reliefs and devotional icons. The most elaborate sites consisted of systems of caves serving different functions.

More than 20 of these cave complexes are known today, Ajanta being perhaps the most famous (**FIG. 1-22**). Located in the Deccan, inland from the city of Mumbai, the first five caves were carved out of the horseshoe-shaped cliffside between ca. 200 BCE and 100 CE. An additional 25 caves were excavated in the fifth century BCE after an influx of donations from the king Harishena (r. ca. 460–477 CE), his ministers, and officials.

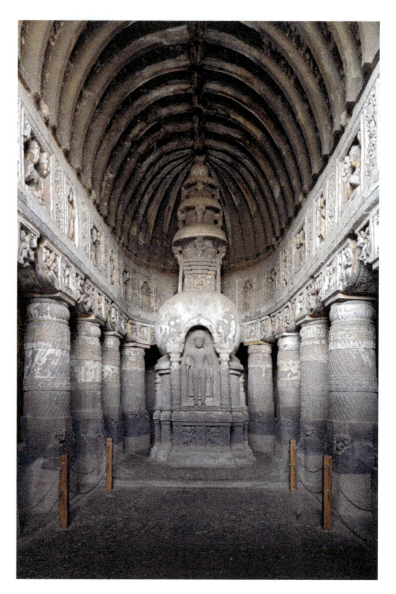

1-23 • *CHAITYA*
Cave 19, Ajanta, ca. 462–500 CE.

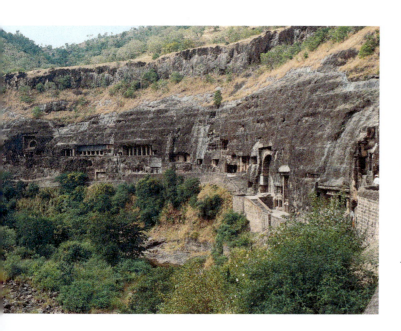

1-22 • AJANTA, GENERAL VIEW
2nd–1st century BCE and 5th–6th century CE.

At Ajanta, some of the caves functioned as *chaityas*, with a rounded end housing a miniature stupa and a space to circumambulate it, similar to the great stupas (**FIG. 1-23**). A vaulted hall would have extended in front of these stupas, providing a place where the faithful could gather. *Viharas* (monastic residences) consisted of several small rooms surrounding a square court; at Ajanta, many of the *viharas* included shrines with images of the Buddha (**FIG. 1-24**).

Several of the Ajanta caves are also covered with **murals**. Bodhisattvas appear prominently in both these and the relief sculptures of the *chaityas* and shrines at this site, demonstrating their rising importance in fifth-century Buddhist belief. The *jataka* tales also remained a popular subject. In Cave 17, covering one 46-foot (14-meter) wall of the interior, is a vast mural depicting the story of the Buddha's previous life as Vessantara, a king of legendary generosity (**FIG. 1-25**). Episodes are

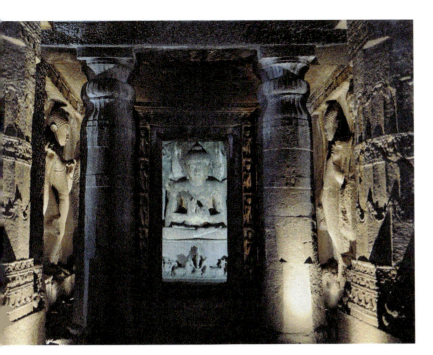

1-24 • BUDDHA SHRINE IN THE *VIHARA*
Cave 4, Ajanta, ca. 462–500 CE.

ordered from left to right, showing Vessantara giving the state treasure—a rain-bringing elephant—to a neighboring kingdom suffering drought, his banishment by his people for this act, and his later giving away of his possessions (horses, chariots, children, and even his wife). At the end of the story, and the wall, the family is reunited by the god Indra, and Vessantara is reinstated to his throne by his people—one of the few instances in which the Buddha's self-sacrifice did not result in his death.

From the Deccan, the proliferation of cave temples and monasteries spread west and south, and beyond India to Buddhist communities in Central Asia and China along the trade route

1-25 • WALL PAINTING (DETAIL)
Cave 17, Ajanta, ca. 462–500 CE.

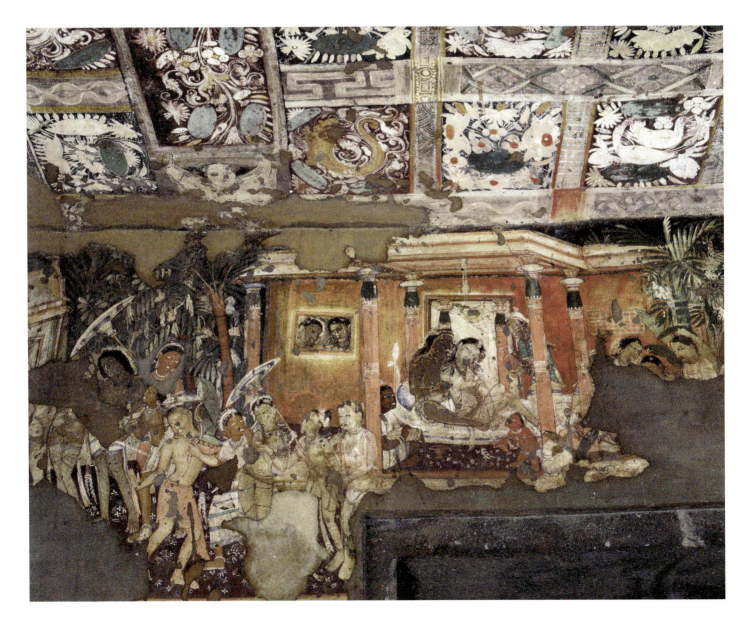

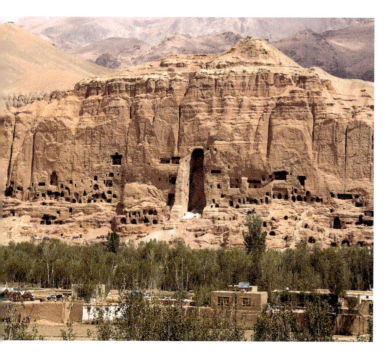

known as the Silk Road. The Silk Road trading post of Bamiyan (in present-day Afghanistan) was developed in the fifth century CE at approximately the same time that the last major development was taking place at Ajanta (**FIG. 1-26**). Here, a large complex of caves carved into a cliffside surrounded several colossal statues of the Buddha—at least two standing and three seated, as well as an image of the Buddha on his deathbed. The *chaityas* and *viharas* here were connected by passageways and stairs that were decorated with murals in a style related to the ones at Ajanta.

The largest of the Bamiyan statues was 180 feet (55 meters) tall, and its size conveyed the spiritual enormity of the Buddha compared to the human worshippers who stood before him, reflecting the beliefs of the Mahayana Buddhist sect that established the site (**FIG. 1-27**). These monumental sculptures were first roughly carved from the stone of the cliff. Large folds in the drapery were then created by attaching ropes to the stone surface; the ropes were then covered with a mud plaster mixed

1-26 • GENERAL VIEW OF BAMIYAN

1-27 • STANDING BUDDHA (NOW DESTROYED)
Bamiyan, 5th century CE. (Photographed previous to 2001)

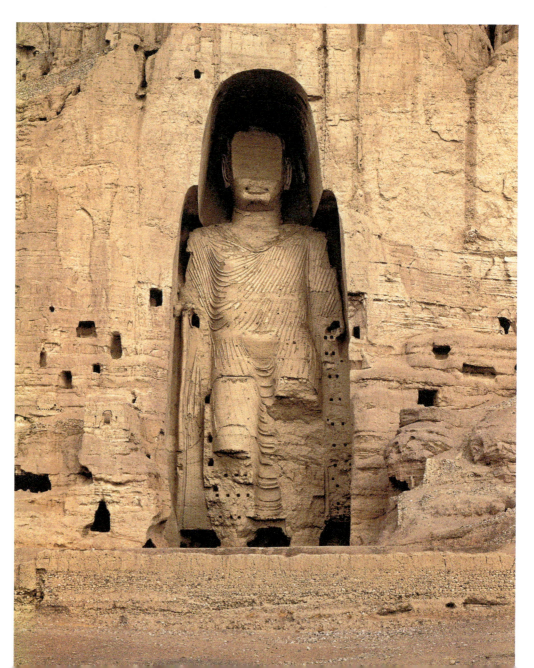

with straw. Other details were built up from molded mud set with lime plaster. The entire figure was then painted. A passage for circumambulating the icons was located at the head level, approached by a very long set of stairs. Unfortunately the site has been the victim of Afghanistan's difficult recent history; in the 1980s, murals from Bamiyan preserved in the Kabul Museum were destroyed in the civil war, and in 2001 the Taliban destroyed the Buddhas with dynamite.

JAINISM AND THE DEPICTION OF THE DIVINE

The figure known as the Mahavira ("Great Hero"), the modern founder of the Jain religion, is believed to have been a contemporary of the Buddha (ca. 599–527 BCE). According to Jain belief, he is the last in the line of 24 **Jinas** (victors) to have conquered all desire and attained enlightenment; their life spans date back many millions of years, placing the original foundation of this religion far back in time.

Like the Buddha, the historical Mahavira was a prince who left his comfortable home, turning from the brahmanical practices of his era and giving up everything to wander as a **mendicant**. After 12 years, he reached a state of infinite knowledge (*kevalajnana*), but what occurred at this point is disputed between the two sects that developed within the religion. According to the Digambara, or "sky-clad," who wore no clothes in the belief that owning anything was a hindrance to attaining enlightenment, the Mahavira was released from all the worries of earthly life and remained fixed in a posture of meditation in an assembly hall built by the gods. Disciples gathered around him and listened to the heavenly sound emanating from his body; they divined his teachings from this sound and passed them to others. The Shvetambara, or "white-clad," who wore simple robes, believed that the Mahavira emerged from this state to travel and teach his followers himself. In both cases, the essential message was the same: There is in every living being a soul that is subject to endless rebirth or that can be liberated from this cycle depending on one's actions—a notion that can also be found in the Vedas. Just as for Buddhists, meditation and austerity were the means to liberation from this cycle, but whereas the Buddha chose the middle path between indulgence and extreme asceticism, the Mahavira insisted on the complete renunciation of the world of possessions.

JAIN TEMPLES AND THEIR SCULPTURE

Jain temples are meant to be replicas of the heavenly hall (*samavasarana*) built by the gods when the Mahavira reached enlightenment (see Chapter 2, FIGS. 2-24 and 2-25). In texts the *samavasarana* is described as either a circular or a square structure, with a platform in the middle where the Mahavira sits meditating. This hall is reached by four roads at the cardinal directions.

A tradition of Jain rock-cut caves, similar to Buddhist and Hindu ones, also developed (see Chapter 2, FIG. 2-19).

Within a temple, icons of the Jinas are presented for the adherent to approach. He or she regards the icon, circumambulates it, and then makes eight offerings while reciting hymns. In common with icons of the Buddha, those of the Jinas are presented as an ideal to which the faithful aspire, and as a reminder of what they hope to attain. The Jinas are not believed to respond to their devotees, since they have attained complete liberation and no longer exist. However, in a development similar to that of the bodhisattvas in Buddhism, other divinities who could fulfill wishes and who protected their followers became a part of the Jain pantheon. For instance, the Jinas are believed to reside in a heaven under the control of the god Indra (Shakra), and the goddess Sarasvati is associated with learning and knowledge. It is often impossible to identify the specific Jina depicted, as they are often portrayed in the same way. In the sacred literature each has an associated emblem and tree, but these attributes are generally not included in the icons. The only two who sometimes have distinctive physical features are Rishabhanatha, shown with long, loose hair, and Parshvanatha, shown with a snake canopy above his head.

The depictions of the Mahavira and the other Jinas seem to have developed at Mathura, where some of the earliest **anthropomorphic** images of the Buddha were made, and the two traditions are related in many ways. Like the Buddha, the Jinas are serene figures modeled on the human form, and they are distinguished from other men by particular marks or attributes. However, since the Jinas are no longer active in the world and are shown only on reaching enlightenment, their images show complete perfection and are symmetrical. In Digambara temples the icons are nude, while the Shvetambara icons have loincloths. The two sects also display the icons differently: In a Digambara setting, icons remain unadorned, while in the Shvetambara context they may be decorated with gold, jewels, and flower garlands. Most significantly, Shvetambara icons have eyes painted in or set with crystal. These differences relate to the diverging conception of the Jina as a king of the spiritual world, on the Shvetambara side, as opposed to one who has renounced the material world to achieve spiritual perfection, on the Digambara side.

The Jinas are shown in one of two states of meditation. When seated (**FIG. 1-28**), they are shown in the classic pose of meditation, with legs crossed and soles turned upward. The right palm rests on the left one, and both hands are placed in the lap. Similar to images of the Buddha, the Jina illustrated here has short, curly hair, elongated earlobes indicating princely origins, and a nimbus behind his head. Both types of image also feature lotus flowers carved on the feet and an auspicious mark on the chest called the *shrivasta*. What distinguishes this icon from Buddhist ones, however, is that the Jina is completely nude and in a state of meditation.

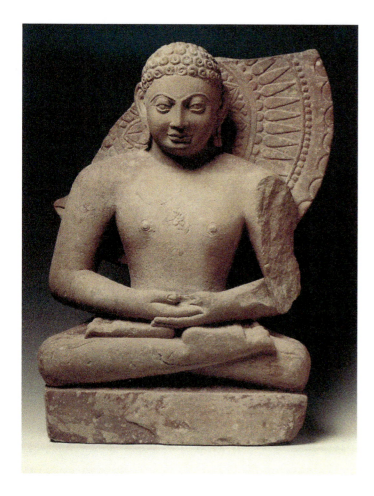

1-28 • JINA
2nd–3rd century CE. Sandstone, height 17½″ (44.5 cm). Mathura; Frei Collection, Switzerland.

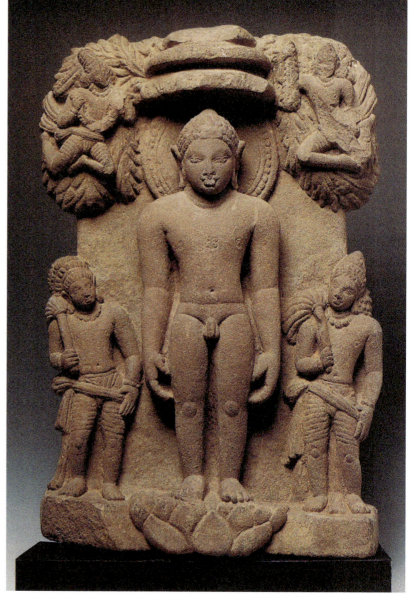

1-29 • JINA WITH ATTENDANTS
ca. 500 CE. Sandstone, height 19⅜″ (49 cm). Mathura; Frei Collection, Switzerland

When standing, Jinas are depicted as being as erect as columns, with very long arms and legs, in a posture of "body abandonment" (**FIG. 1-29**). By assuming this posture, the Jina is assured of doing no harm to other living creatures. The iconography of the Jina is otherwise the same as when they are shown seated (see **FIG. 1-28**): Both have long earlobes, marks on their chests, and beatific expressions of enlightenment on their faces. But this standing Jina is also shaded by three parasols stacked above the nimbus and is accompanied by attendant figures: Two heavenly beings in the sky offer garlands, while two servants below carry fly whisks. These figures are a development typical of the later Gupta period (see Chapter 2, pp. 34–35), from when this second image dates.

OTHER TRADITIONS OF SCULPTURE

One of the few hints we have for the production of art outside the realm of religion is a group of ivory plaques that were excavated at the site of Begram, in present-day Afghanistan. These plaques were originally attached to pieces of wooden furniture, such as chairs and footstools, which had been locked with other treasures in two storerooms of the first to early second century CE. The motifs carved on the plaques include mythical beasts, floral vines, geometric bands, and courtly scenes. Many feature women engaged in various activities—sitting, adjusting their hair, speaking (**FIG. 1-30**). This figural type is by now a familiar one, for these women have much in common with those depicted on the Buddhist stupas illustrated above (see **FIG. 1-17**), but the **medium** of ivory and the wholly royal nature of the objects are not attested to in the record of religious works. Parts of the plaques were originally colored; traces of blue, red, and black pigment have been found.

Much debate about the Begram ivories' place of origin and date arose after their discovery, but the style of carving has convincingly been attributed to India. The fact that Begram was on one of

1-30 • TWO WOMEN
2nd–4th century CE. Ivory, 5¾ × 5⅛ × ½″ (14.6 × 13.5 × 1.3 cm). Begram, Afghanistan; Musée Guimet, Paris.

a truly remarkable flowering of the arts. It is clear that South Asia had already become home to well-developed societies with rich traditions in the arts by the time of the Harappan civilization. Abstract religious concepts and ideals then led to the development of a unique visual vocabulary that was able to convey a state of mind through a set group of physical attributes. Wherever Buddhism, Jainism, and Hinduism spread throughout Asia, artists would continue to draw from these beginnings.

CROSS-CULTURAL EXPLORATIONS

1.1 Many of the objects excavated at Mohenjo Daro and Harappa have confounded exact interpretation. Can you think of alternative explanations or uses for such objects as the seals (FIGS. 1-6 and 1-7) and the terra-cotta figurines (FIG. 1-8) found in abundance at these sites? Do you think we use comparable objects in our daily lives?

1.2 The emperor Ashoka commemorated his religious epiphany by placing inscribed pillars with animal capitals at significant locations throughout his kingdom. Are there similarities to other types of memorial monument built in other cultures, such as the obelisks in Egypt or the Arc de Triomphe in Paris? What form do they take? Do they make use of inscriptions or symbols to express their message?

1.3 Compare the depictions of the Buddha and the Jinas to the depiction of divinities in other religions. Do any others celebrate the attainment of wisdom in the same way? Which attributes are valued in other traditions?

1.4 Try to convey the story of the monkey *jataka* (see Point of View, p. 13) in pictures. Would you choose one moment from the story to illustrate, or several? What is the moral of the story and how would you present it to your audience?

the trade routes connecting the eastern and western halves of Asia, and was within Kushan domains, would explain how they ended up there and fortuitously survived in that very arid climate.

Considering that so much early South Asian **material culture** is lost to us, what has survived is undeniable testament to

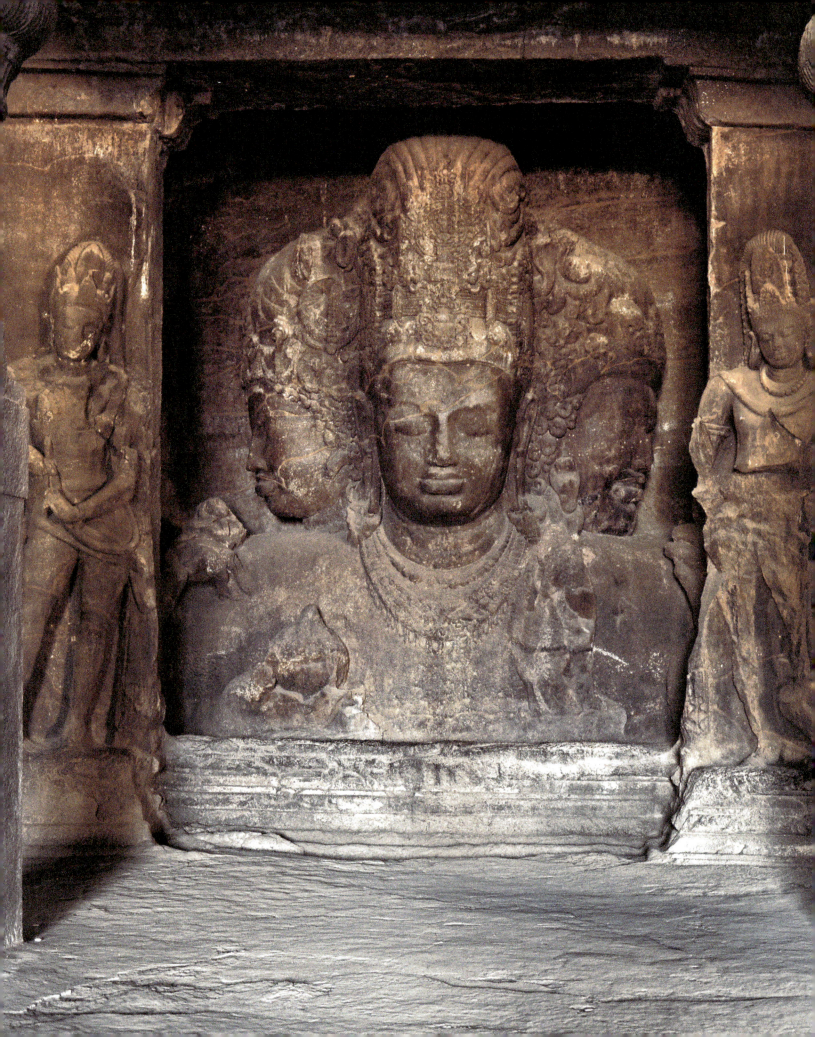

Religious Art in the Age of Royal Patronage: The Medieval Period

Without a form, how can God be meditated upon?
Where will the mind fix itself?
When there is nothing for the mind to attach itself to,
it will slip away from meditation or will glide into a state of slumber.
Therefore the wise will meditate on some form.

Vishnu Samhita (Chapter 29, verses 55–57)

As Hinduism, Buddhism, and Jainism continued to develop through the early centuries CE, their theologies became more diverse and complex, as did their rituals, the structures in which the rituals were performed, and the icons on which the rituals focused. Hinduism in particular was transformed, as individual worshippers became more involved in performing rites and in making a personal connection to the gods—privileges that had previously been accorded only to the priestly class. This movement inspired the creation of icons that were a focus of meditation and contemplation. Gods that had in earlier periods been worshipped in abstract form came to be represented in human and animal manifestations that made them accessible, yet also stressed their superhuman qualities and their manifold facets. These elements are embodied in a relief sculpture of the god Shiva that depicts his

2-1 • SHIVA RELIEF
South wall of the Great Cave, Elephanta, Maharashtra, ca. 535–550 CE.

multiple opposing personalities (**FIG. 2-1**). Another defining characteristic of this period is the **patronage** of religious art by kings, queens, and their ministers. As the construction of ever more elaborate and imposing buildings became linked to the simultaneous expression of piety and royal strength, temples grew in size, and their sculptural programs were often linked to concepts that their royal patrons wanted to convey.

THE RITUAL AND ARTISTIC DEVELOPMENTS OF HINDUISM

As already discussed, the core beliefs of Hinduism and many of its sacred texts were developed in the Vedic period (see Chapter 1, p. 9), but its practices continued to evolve over time, coalescing into something closer to its current form around the start of the first millennium CE. The religion is founded on the belief expressed in the **Vedas** that souls are locked in an endless cycle of rebirth (*samsara*) until release from the cycle is attained by one's own actions and beliefs (*karma*). However, the role of Hindu deities in attaining this goal is what distinguishes this belief system from Buddhism and Jainism. Worship of, and a close personal connection to, a deity can bring rewards in this and subsequent lives, but will also ultimately lead to the release from the cycle of rebirths.

GODS AND GODDESSES
Encompassing a constellation of minor divinities and spirits, worship centers on two male gods—Shiva and Vishnu—and a female Great Goddess; each takes on many forms and incarnations. **Shiva** is considered the creator of life, but he is also the destroyer of the evil forces that threaten man and the gods; he is the divine ascetic

probably a lotus seed (**FIG. 2-3**). Additionally, he wears a jeweled crown, has a mark on his chest that symbolizes good fortune (*shrivasta*), and bears a garland around his neck.

Vishnu also takes on ten different forms, called **avatars** (incarnations), in which he has come down to earth and saved it from a series of disasters. He has appeared as a fish, a tortoise, a boar, a man-lion, and a dwarf. In human form he has been the three warrior-princes Parashurama, Rama, and **Krishna**. The Buddha is considered one of his avatars, and his final one will be Kalki, whose appearance will signal the destruction of the current age.

There are many depictions of Vishnu as each of these avatars. In one terra-cotta plaque, which would have decorated a temple, he takes the form of the great hero Krishna (**FIG. 2-4**). He is shown slaying Keshi, a demon who has taken the form of a horse. The heroic struggle is conveyed by the dynamic pose of Krishna, who pushes the beast back with his foot while choking it with one arm and preparing to strike it with his (now missing) other arm.

The **Great Goddess** is the counterpart of these male figures. Like them she appears in many guises—in fact all female Hindu deities are manifestations of the one Goddess—and as such she embodies many opposing energies. On the one hand

2-2 • *LINGA* WITH FACE OF SHIVA (EKAMUKHALINGA)
Gupta period, first half of the 5th century. Sandstone, height 6⅞″ (17.5 cm). Madhya Pradesh; Metropolitan Museum of Art, New York. Samuel Eilenberg Collection, Gift of Samuel Eilenberg, 1987 (142.323).

2-3 • *VISHNU*
Gupta period, late 4th–early 5th century. Sandstone, 27 × 16½ × 5¾″ (68.6 × 41.9 × 14.6 cm). Northern central India; Brooklyn Museum of Art, New York. Gift of Amy and Robert Poster (81.203).

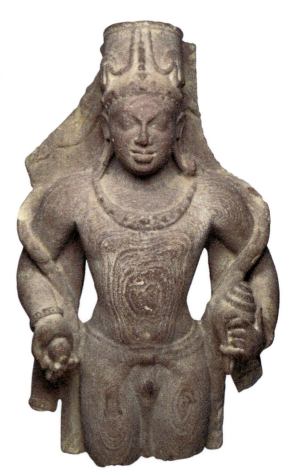

who meditates on the nature of the universe while seated on the peak of the sacred mountain, Kailasa. The practice of **yoga**, which is predicated on bodily control and meditation, relates to this contemplative aspect of Shiva.

In the inner sanctum of temples dedicated to Shiva, the god is represented in the form of an erect phallus (*linga*; **FIG. 2-2**). While many *lingas* are plain and undecorated, others might show the visage of Shiva as he begins to manifest himself from the *linga*. In other parts of the temple, Shiva is represented in fully manifest human form, with a third eye and long locks of matted hair. He typically wears a tiger skin, and carries a trident and a small drum (see Closer Look, p. 43). Each god is also accorded a vehicle—an animal that they ride, and which can also act as an intercessor between the god and his devotees. Shiva's vehicle is the bull, Nandi.

Vishnu embodies the qualities of mercy and goodness; he is the savior of man and creator of the universe. His vehicle is the eaglelike Garuda. When shown in human form, Vishnu has four arms that bear a conch shell, a disc, a **mace**, and a lotus flower or seed. In a sandstone sculpture of the late fourth or early fifth century, Vishnu holds a conch shell and a round object that is

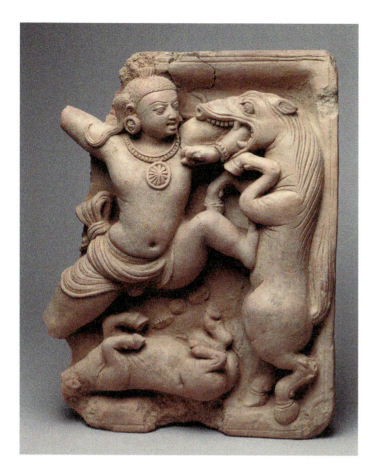

2-4 • KRISHNA KILLING THE HORSE DEMON KESHI
Gupta period, 5th century. Terra-cotta, 21 × 16 × 4¼″ (53.3 × 40.6 × 10.8 cm). Uttar Pradesh; Metropolitan Museum of Art, New York. Purchase, Florence and Herbert Irving Gift, 1991 (1991.300).

she gives and nourishes life, is the mother of all, and may appear as the "seven goddesses" (*saptamatrika*), who are the wives of the seven principal gods. In several of her manifestations, such as Parvati (consort of Shiva), Gauri, and Uma, she embodies peace and benevolence. On the other hand, she may also appear as Durga, the fierce and relentless destroyer of the buffalo demon who threatened the gods (**FIG. 2-5**), and as the dreadful Chamunda, named for the demons Chanda and Munda, whom she decapitated.

Another god who frequently appears in temple sculpture is **Ganesh** (**FIG. 2-6**). He was the human son whom Parvati created from her body one day when Shiva was away. Parvati asked Ganesh to stand guard while she bathed, but Shiva returned and was so enraged that this unknown guard prevented him from seeing his wife that he cut off the boy's head. When Parvati pointed out his mistake, Shiva hastily replaced the head with that of a passing elephant. Ganesh is considered auspicious; he removes obstacles and therefore is invoked before starting any undertaking. Ganesh's vehicle is the rat.

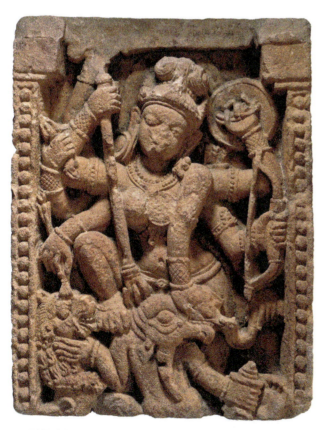

2-5 • DURGA KILLING THE BUFFALO DEMON MAHISHA
8th century. Sandstone, 17 × 11⅜″ (43 × 29 cm). Orissa; British Museum, London.

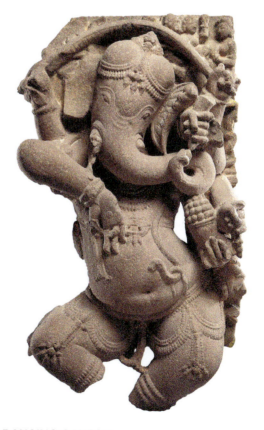

2-6 • DANCING GANESH
10th century. Mottled red sandstone, height 36″ (91.4 cm), width 20″ (50.8 cm). Kalachuri, Madhya Pradesh; Metropolitan Museum of Art, New York. Gift of Florence and Herbert Irving, 2007 (2007.480.2).

LITERATURE

Alongside the body of sacred texts surrounding the Hindu gods and goddesses grew a collection of literary works that also provide instruction. While the Vedas were studied within the priestly milieu, other texts, such as the *Mahabharata* and the *Ramayana*—two epics in Sanskrit—were more widely popular. The *Mahabharata* embodies precepts of moral law through its tales of battle, heroism, and love. The main subject is the war between two groups of cousins, the Pandavas and the Kauravas, although its many sections discourse on a variety of subjects. However, many consider a section called the *Bhagavad Gita*, in which Krishna and the Pandava hero Arjuna discuss a variety of theological issues, to be at the very heart of the epic (see Chapter 4, p. 96). The *Ramayana* tells the tale of the prince Rama (another avatar of Vishnu), his wife, Sita, her capture by the demon king Ravana, and her rescue by Rama with the aid of the monkey Hanuman and a monkey army. Both of these epics became common subjects in art and theater, spreading throughout Southeast Asia as well.

THE HINDU TEMPLE AND ITS SCULPTURE

As Hindu beliefs evolved, a sacred art and architecture developed to meet the ritual and devotional needs of the religion. In the earliest form of Hinduism—during the Vedic period—deities were worshipped at simple outdoor shrines or small caves that held icons. From the second century BCE onward, there is evidence that these icons were often carved in stone, although the shrines themselves continued to be made out of perishable materials. As the Buddhist practice of using rock-cut caves grew more widespread through the fourth and fifth centuries CE, similar caves were also used for Hindu worship. However, from the fifth century on, freestanding temples built in durable brick and stone also start to appear. Eventually this kind of structure would become the pre-eminent temple type, with the excavation of rock-cut caves ceasing after about the tenth century.

The production of temples and their sculpture was not a means of self-expression on the part of the architect or sculptor; it was governed by a strict set of rules. Since the gods were thought to inhabit the temples dedicated to them, and make contact with their devotees through the icons representing them, temples and sculptures had to please and attract these gods.

The rules that govern how a temple should be constructed were recorded in sacred texts that were, in turn, based on concepts embedded in the Vedas. Taken from the term *shastra*, meaning "treatise," these are known as *shilpashastras* (treatise on architecture and/or the making of images). They describe the series of purifications that must take place on the land where a temple will be built, and they provide the **mandalas** (diagrams representing the cosmos) on which different parts of the temple and its subsidiary shrines must be laid out. These texts also specify the different elements of a temple, their relative proportions, and their decoration (see Context, opposite). Priests involved in the construction of temples would have assisted the architect and builders in adhering to these prescriptions, but craftsmen must also have passed this body of knowledge from one generation to the next orally and by practice.

The guidelines for creating the images on and inside a temple are also contained in the sacred texts that instruct on temple architecture (see Point of View, p. 35). The gods are depicted in human form so that devotees may relate to them; however, they have great beauty, and often have superhuman characteristics, such as multiple heads and arms, which convey their power and the multiple aspects they encompass. Before commencing work, the sculptor underwent mental preparation and ritual purification. He then carved the image in the form and proportions, and with the individual attributes (**lakshanas**), dictated by the *shastras*. In modeling the image, the artist also sought to imbue the figure with a vital energy or breath (*prana*). After the image was complete, it was placed inside the temple and consecrated, including a final step in which its eyes were symbolically "opened" by painting in the pupils. The priest then summoned the god to inhabit the image by reciting specific hymns.

Despite the existence of a highly prescriptive body of literature, there are variations in temple form and sculptural style that distinguish the work of different regions and different periods. But these variations occur more in terms of surface decoration or appearance than in terms of structure and proportion. There is a strong degree of homogeneity within each regional or chronological school, reflecting the importance of certain ideals and strictures over the expression of the individual artist.

EARLY HINDU TEMPLES

From the fifth through the ninth century there was a certain amount of variation in the Hindu temple form—rock-cut cave temples were still common and the elements of the freestanding temple were yet to be codified (see Context, opposite). Much of this experimentation took place during the reign of the Gupta dynasty (ca. 320–550), which controlled extensive territories in the northern and north-central parts of India. Although its kings are not known to have been the patrons of any extant temples, the dynasty name is strongly associated with the buildings and sculpture of this era, which are termed Gupta in style. In the Deccan—the plateau at the center of the Indian subcontinent—and in the south, other ruling families, such as the Kalachuris (ca. 550–620) and Pallavas (early fourth century to late ninth century), can be more directly connected to temple construction.

NORTH INDIAN TEMPLES OF THE GUPTA ERA

The 20 Hindu cave temples at Udayagiri, in central India, date to the late fourth to early fifth century. Although approximately contemporary to the Buddhist caves of Ajanta (see Chapter 1, FIGS. 1-22–1-25), they take a different form. They do not include the **chaityas** with **stupas** or **viharas** found at that site, but instead

Freestanding Hindu temples are structured around an inner sanctum called the *garbhagriha* (literally "womb chamber"). The icon of the deity to whom the temple is dedicated stands here. In a Shiva temple, the icon is a *linga*; in a Vishnu temple it is a depiction of Vishnu as one of his avatars. There are fewer temples dedicated to the Goddess than to either Shiva or Vishnu, but in them the *garbhagriha* houses either an icon of one of her many forms or a *yoni*, an oval-shaped altar that represents the vagina. Most often, however, the Goddess appears in temples of Vishnu and Shiva as the consort of these gods: Lakshmi for Vishnu, and Parvati for Shiva.

The *garbhagriha* of any temple is a small, dark room with space for the devotee to circle the icon, in a rite similar to the circumambulation of the Buddhist stupa. Sometimes this is a corridor within the temple, and sometimes it is a space outside the building on the platform on which it is raised.

Directly above the divine image of the *garbhagriha* is the imagined axis of the world that links the center of the earth to the human realms and, above them, the heavens. The axis travels upward through the *garbhagriha*'s towering roof—called a *shikhara* in the north and a *vimana* in the south. This roof represents the heavenly mountain abode of the gods. The walls on the exterior of the temple are typically composed of multiple projections that replicate the form of the temple as a whole, and which may be understood as representing the energy radiating from the sanctum.

Devotional acts may also be performed at home, but worshippers come to the temple for a specific experience: *darshan*, the act of mutual seeing, when the god inhabiting an icon and the worshipper view each other. Thus Hindu ritual does not necessarily call for communal worship, but over time, spaces where communities could gather for festivals and ceremonies became a part of the standard temple form. These could be either pillared halls (*mandapas*) or porticos (*ardhamandapas*), which enclosed the temple precinct and demarcated the space and buildings as sacred within the surrounding town or village.

Temples developed different regional styles in the sixth to eight centuries, and contemporary texts named these the Nagara (northern), Dravida (southern), and Vesantara (mixed). The most distinctive difference between the northern and southern styles is the shape of the tower above the *garbhagriha*. In the north it is more fluted, and is topped with a round, ribbed finial, while in the south the tower is made up of several stepped-back stories, culminating in a dome-shaped structure. In the Deccan in central India, temples of each type were built, and some temples incorporated elements of both. The term Vesantara is thought to refer to these mixed-style buildings.

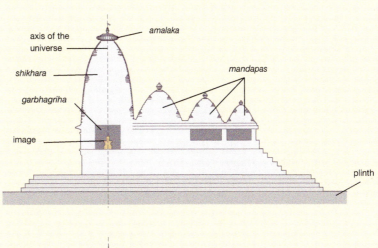

Northern-style temple

axis of the universe
amalaka
shikhara
garbhagriha
image
mandapas
plinth

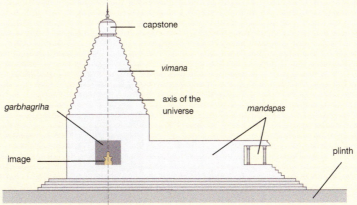

Southern-style temple

capstone
vimana
garbhagriha
axis of the universe
mandapas
image
plinth

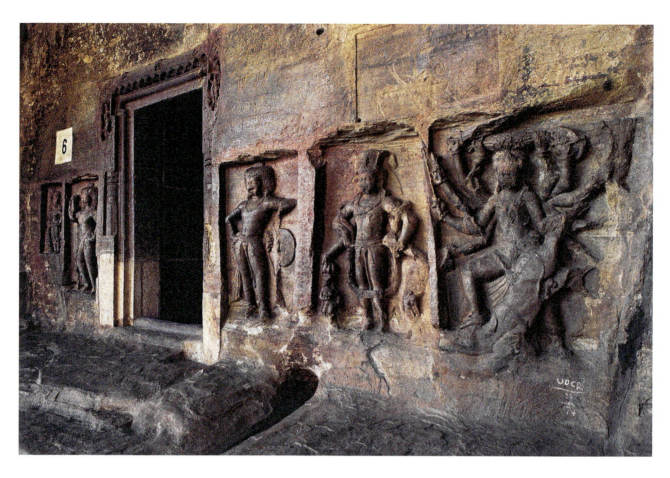

comprise a small *garbhagriha* (shrine) in which the image of the deity is located, or shallow niches onto which narrative **reliefs** are carved. Of the Gupta-era monuments, the Udayagiri caves provide at least some connection to a Gupta king, for an inscription at the site states that a minister of Chandragupta II (r. ca. 380–ca. 415) visited the site with this monarch.

Cave 6 at Udayagiri has a *garbhagriha* fronted by a porch with reliefs bearing images of the gods, their female consorts, and other divine beings (**FIG. 2-7**). As a group these reliefs demonstrate the advanced state that Hindu **iconography**, and the relationship of image to ritual, had achieved by this period. The elephant-headed Ganesh, usually invoked at the start of prayer, appears to the left of the door. Continuing to the right, the worshipper passes a small relief of Vishnu, followed by the guardians that flank and protect the doorway to the sanctum, another image of Vishnu, and finally one of the Goddess as Durga. She grasps weapons in 11 of her hands, while holding aloft the defeated buffalo demon in the twelfth. To the right of this image, on the wall facing Ganesh, is a relief of the *saptamatrikas*. The order and arrangement of subjects would later be replicated in freestanding temples, guiding the faithful from the beginning of prayer with Ganesh to images of Durga's victory, as a metaphor for spiritual victory.

Functioning in the same manner but with an entirely different form is the Vishnu temple at Deogarh, dating to the early sixth century (**FIG. 2-8**). This building is among the earliest freestanding temples to survive. It is a simple square structure that stands on a square plinth; the building's original roof and the four corner shrines are now missing. On one side of the structure is a doorway into the sanctum, and on each of the other three sides is a relief panel with images presented, like those in the cave temples, for contemplation by the devotee. Usually one circles a temple in a clockwise direction, but the contents of the

2-8 • DEOGARH TEMPLE
Deogarh, Uttar Pradesh, ca. 530.

reliefs here suggest an atypical counterclockwise progression. On the south side of the temple is a scene of Vishnu reclining on the serpent of infinity, Ananta (FIG. 2-9), and to its left is an image of Ganesh. The relief relates the story of the creation of the universe, which the recumbent Vishnu dreams into existence. Holding Vishnu's right foot is his consort, the goddess **Lakshmi**, representing the female energy that inspired Vishnu's act, and below him are the coils of Ananta, whose multiple heads frame Vishnu's sleeping visage. Seated above him on a lotus is the first being to be created—the god Brahma (alternate form of Brahman, see Chapter 1, p. 9), here a four-headed figure flanked by other gods and goddesses. The lotus is meant to grow from Vishnu's navel, but for reasons of composition the stalk of the blossom instead rises behind the sleeping figure.

Next, the worshipper would have encountered a relief of the sages Nara and Narayana on the east side of the temple. These are two of the minor incarnations of Vishnu embodying austere

devotion. The north side of the temple features the story of a king turned elephant, who must be rescued from the water beast that has caught his leg. The story of his eventual rescue after praying represents release through devotion. Finally, in arriving at the doorway to the *garbhagriha* on the fourth side of the temple, there is a composition of multiple **jambs** (doorframe sides) and **lintels** (horizontal beams at the top of a doorway) adorned with guardian figures, and the river goddesses Ganga and Yamuna—an ensemble of motifs and figures that would become standard at the entrance to temple sanctums in both the Hindu and Jain contexts (FIG. 2-10).

THE TEMPLES OF THE DECCAN

Contemporary to the Guptas a number of independent dynasties were located throughout central and southern India, and both rock-cut and freestanding temples were established in these areas. During the reign of the Kalachuri dynasty (ca. 550–620), many Hindu and Buddhist cave sites were built across the Deccan. Also interesting is the mid-sixth-century group at Elephanta, an island off the western coast and today near the city of Mumbai.

Of the five Hindu and two Buddhist caves on the island, the so-called Great Cave is the most impressive. It has a central space, approximately 130 feet (40 meters) long, that functions as a pillared *mandapa* (hall), with a freestanding *garbhagriha* on the west and subsidiary shrines on either end. The *garbhagriha* has

2-9 • *VISHNU RECLINING ON THE SERPENT ANANTA*
ca. 530. Sandstone, height 5′ (1.5 m) (approx.). Back wall, Deogarh temple, Uttar Pradesh.

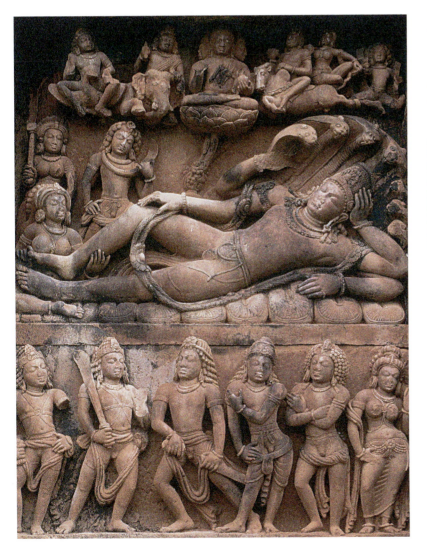

2-10 • SANCTUM DOORWAY
ca. 530. Deogarh temple, Uttar Pradesh.

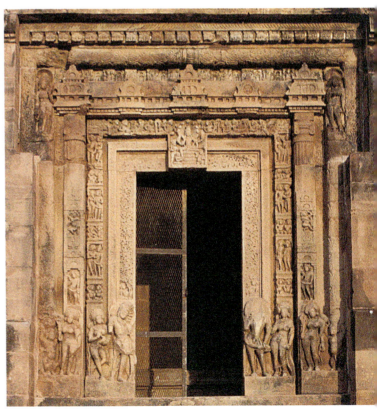

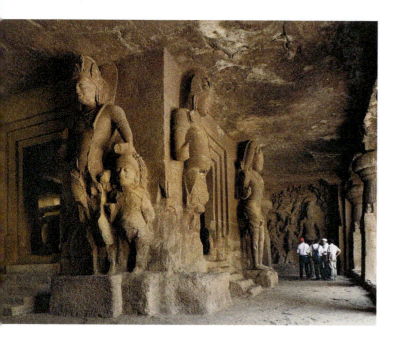

2-11 • GREAT CAVE, ELEPHANTA
ca. 535–550. Maharastra.

entrances on all four sides that are guarded by greater than life-size attendants supported by dwarves (**FIG. 2-11**).

This temple is dedicated to Shiva, and a series of reliefs relating to this god and his worship adorn the walls of the cave. At the center of the south wall, facing the entrance to the cave, is a multifaced image of Shiva that represents the god's different aspects, as described in sacred texts (see **FIG. 2-1**). The visage directly facing the viewer is the serene Sadyojata. On the left is the fierce Bhairava, and on the right is Vamadeva, symbolizing selfhood. The two last faces are implied; on top, Ishana, representing esoteric mysticism, and behind, the wrathful Kapila. The imposing composition measures over 18 feet (5 meters) tall—almost the entire height of the cave. To its right another relief depicts Shiva receiving the River Ganges in his hair to prevent its gushing from destroying the earth. To the left, Shiva appears in his half-male, half-female form. On other walls Shiva is shown with his consort, Parvati, and destroying the demons Andhaka and Gaja.

As at the Deogarh temple, the reliefs in the Great Cave work together as a cohesive set of ideas on which to meditate. Here, the iconographic program stresses the unity of different aspects of creation in Shiva: male and female, protector and destroyer, serene

2-12 • DURGA TEMPLE
late 7th–early 8th century. Aihole, Karnataka.

and fierce. In style, the Elephanta reliefs represent a development from the more austere Gupta-era images seen above, prefiguring the more ornate forms of sculpture that would become popular in the seventh century and later.

Contemporary to the Kalachuris, and controlling territories just to their east, were the Chalukyas (r. ca. 543–twelfth century). Their capital shifted frequently, and so four cities were successively built up by royal patrons—including Aihole and Badami, where large sacred precincts with numerous rock-cut and freestanding temples were established next to one another. The freestanding temples were built on a range of plans. The unusual Durga temple, for instance, has an **apsidal**, or curved, end around the inner sanctum (**FIG. 2-12**). The building is raised on a platform with multiple **moldings** (decorative strips). On the east side, a porch with massive columns and a heavy roof leads into a hallway with the shrine at the rear, with a narrow passageway for **circumambulating** the icon. Another passageway surrounds this inner core on the outside of the building; it is decorated with relief panels depicting Durga killing the buffalo demon, Vishnu as the boar Varaha, and the sun god Surya. The temple is thought to be dedicated to Surya, despite its popular name mistakenly associating it with the goddess Durga. A tower in the northern style (see Context, p. 29) once rose above the sanctum; now only the lower levels remain, although the ribbed **finial** that capped the tower lies on the ground nearby.

MAMALLAPURAM IN SOUTH INDIA

In southern India, the Pallava kings (early fourth century to late ninth century) are associated with dozens of temples in the northern part of Tamil Nadu state, many of which are in the royal capital, Kanchipuram. At Mamallapuram, the kingdom's port city, a series

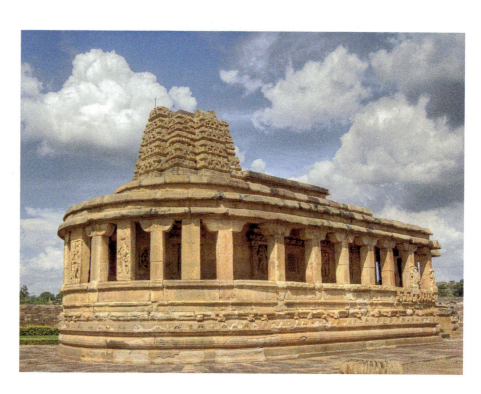

of these kings added their mark to a site that now contains several cave temples, **monolithic** structures, and large relief **tableaux** (pictures). While some scholars have assigned these works to specific Pallava rulers, others hesitate to rely so heavily on the site's inscriptions, which use epithets that were adopted by several different monarchs. Instead, they more generally date work at the site to between the mid-seventh and the mid-eighth century, with a period of intense activity under Narasimhavarman I (r. 630–668), who added substantially to the site in commemoration of a victory in 642 against the rival Chalukya dynasty. In sum, the site includes seven cave temples, a large relief on an outcrop facing the ocean, a freestanding temple close to the shoreline, and several rock-cut temples—each hewn from a single boulder—that are located about half a mile from the main hill.

The narrative reliefs adorning these structures are their most remarkable features. These reliefs include mythical stories about Vishnu, Durga, and Shiva, some of which incorporate images of Narasimhavarman and his forefathers. One intriguing composition covers a massive rock formation made up of two boulders with a cleft between them. It measures 98 feet (30 meters) across

and 49 feet (15 meters) high, and faces those arriving at Mamallapuram by sea (**FIG. 2-13**). On the left side of the composition the largest figure is Shiva, who presents something to an emaciated ascetic who stands on one leg with his arms raised. Below them is a domed temple inside which an icon of Vishnu is visible. In the cleft are serpent-bodied figures representing the snake deities associated with water. On the right are numerous figures above a family of elephants. Also shown is a cat whose posture mimics that of the ascetic on the left.

It seems that an interpretation of these images was left intentionally open to the viewer, for the story can be read either as that of Arjuna, the Pandava hero of the *Mahabharata*, who tries to get aid from Shiva by retreating to the wilderness and living as an ascetic, or of Bhagiratha, who begs Shiva to protect the earth from the descent of the River Ganges by catching the water in his hair (a scene also represented at Elephanta). In either reading, elements of the story are not laid out in a side-by-side or regular fashion, but instead, successive anecdotes are found in different parts of the composition.

The monolithic temples at Mamallapuram are technically exercises in rock-carving, but replicate freestanding temple types of the distinctly southern style of architecture, including several **barrel-vaulted** examples. The so-called Dharmaraja shrine was probably intended as a temple to Shiva, although it was never completed. Each of the four sides was intended to

2-13 • RELIEF SHOWING EITHER *THE DESCENT OF THE GANGES* OR *ARJUNA'S PENANCE*
Early–mid-7th century. 49 × 98′ (15 × 30 m). Mamallapuram, Tamil Nadu.

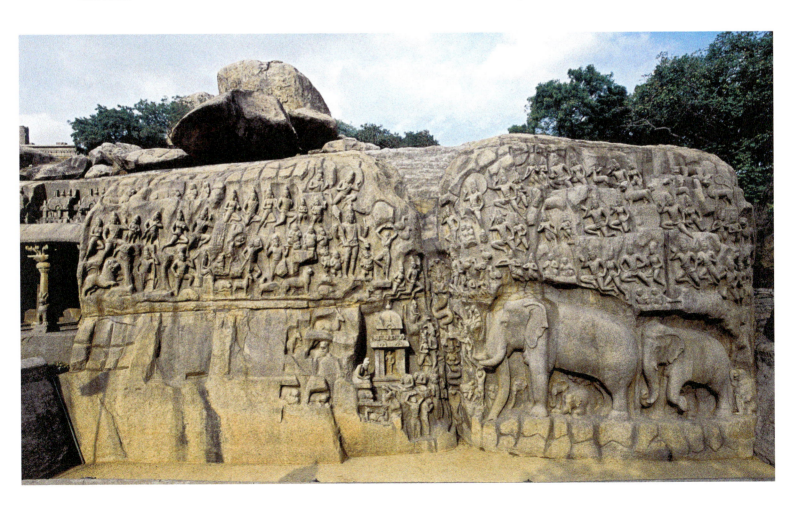

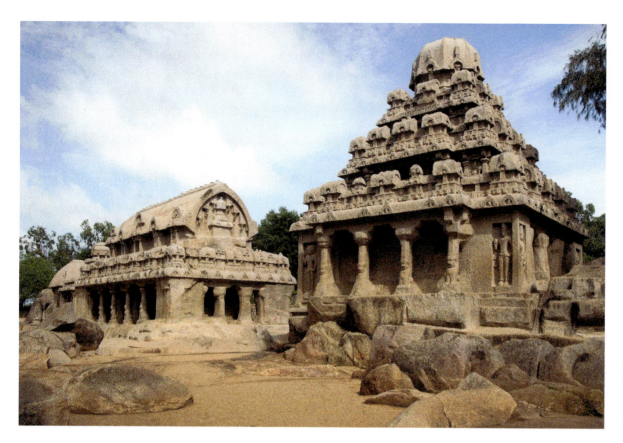

2-14 •
DHARMARAJA SHRINE
mid–late 7th century. Mamallapuram, Tamil Nadu.

have a porch supported by pillars framing niches with sculpture (FIG. 2-14). The roof that rises above the structure has three stories of diminishing size, each comprised of a row of miniature barrel-vaulted shrines, culminating in an octagonal **cupola**, or domelike structure.

THE CONVERGENCE OF JAIN, BUDDHIST, AND HINDU TRADITIONS

During this period, a sizable Buddhist and Jain population still existed in India, and works of art relating to the practice of these faiths continued to be made. In comparing the production of architecture and icons, and even the devotional developments of the three religions, many similarities emerge.

SCULPTURE OF THE GUPTA ERA

In northern India under the Gupta kings, two centers for sculpture—Mathura and Sarnath—were particularly renowned. Statues from these centers were often sent to outlying temples and stupas, and in turn inspired locally made works in the same styles. This resulted in a certain homogeneity in the works produced in different parts of the subcontinent.

Sculpture of the Gupta era retained some elements of the iconography developed in the first and second centuries, and especially that produced at Mathura itself (see Chapter 1, FIGS. 1–1, 1–28, and 1–29). A Buddha image from the fifth century thus represents the maturation of the Mathura style after many centuries of development (FIG. 2-15). The Buddha's robe covers both shoulders and is depicted as a body-hugging sheath, the folds of which appear as regularly spaced strings. His body is full and fleshy beneath this garment. His hair has become a mass of snail-shell curls. His feet (now missing) are widely spaced. In addition to these stylistic changes, a new spiritual dimension is also present in the Gupta-period works that differentiates them from earlier Mathura sculptures. Instead of regarding the viewer with open eyes, this Buddha directs his gaze downward, a sign of his transcendent mental state. He appears in a flawless state, with no trace of passion, egotism, or doubt.

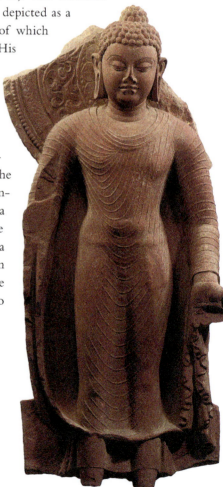

2-15 • *STANDING BUDDHA*
Gupta period, ca. 319–500. Mottled red sandstone, 33$\frac{11}{16}$ × 16$\frac{3}{4}$″ (85.5 cm × 42.5 cm). Mathura; Metropolitan Museum of Art, New York. Purchase, Enid A. Haupt Gift, 1979 (1979.6).

The *Vishnudharmottarapurana* is a treatise compiled over many years by many authors. It deals with a great number of subjects, including astrology, geography, rhetoric, dance, and the arts. It is believed that Part III, the section on painting, was probably written in the seventh century. This work is useful in helping modern viewers of ancient Indian painting and sculpture understand how artists approached their work: Gods and humans were to be presented in idealized form, and artists had to work within a set of strict rules that regulated the proportions and iconography of any visual image. In the text, these values are conveyed to the reader as a series of instructions from the sage Markandeya to the king Vajra.

Below is an extract from Stella Kramrisch's *The Vishnudharmottara Part III: A Treatise on Indian Painting and Image-Making* (1928).

Markandeya said: As there are five types of men according to the measurement of the various limbs and their parts, so, oh best of men [meaning Vajra], it must be noted that there are five types of women. Each one should be placed near her man. Every one of them should be made to reach the shoulders of the man in proper proportion. The waist of a woman should be made two angulas (a unit of measurement) thinner than that of a man. The hip, on the other hand, should be made wider, by adding four angulas. The breasts should be made charming and proportionate to the measurement of the chest. All kings should be endowed with the marks of mahapurushas and all sovereign rulers should be made with webbed hands and feet. And a circle of hair should be drawn auspiciously between their eyebrows. On the hands of kings should certainly be drawn three beautiful auspicious lines slenderly curving and resembling the scratches made by a hare. The hair should be represented auspicious, fine, resembling the deep blue sapphire, adorned by its own greasiness and with the undulation of that essential requisite. An eye should be a form of a bow or like the abdomen of a fish or like a petal of the blue lotus or of the white lotus. The eye assumes the shape of a bow when looking at the ground in meditation. An eye of the form of a fish-abdomen should be painted in the case of women and lovers. An eye of the shape of the blue lotus petal is said to be of the ever-calm. An eye of the white lotus petal befits the frightened and crying. An eye of grindstone shape is in its place with the angry and woe-stricken. The face beautiful all over should be fully developed: well-finished, benignant, marked with all the auspicious marks, not triangular and not crooked.

Gods should be represented according to the Hamsa-measure. They should have hairs on their eye-lashes and eye-brows only, their body should be entirely devoid of hairs. Those who live in heaven have always smiling faces and smiling eyes, and look like youths of the age of sixteen.

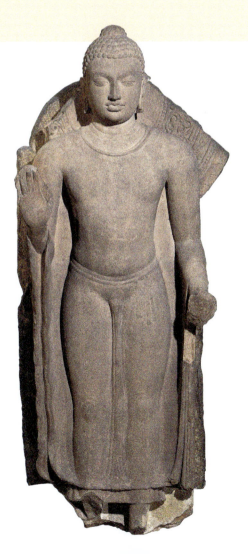

The output of Sarnath shares several stylistic features with Mathuran works, such as the body type, the tightly curled hair, and the wide-legged stance (**FIG. 2-16**). But the Sarnath robe of this Buddha has no folds, and it ends in a protruding shelflike hem (now lost). Certain statues, including this one, are also distinguished by the belt worn only by the Sarvastivadin sect of Buddhist monks who were based at Sarnath. The two schools can further be distinguished from each other by the material used—red sandstone in Mathura and tan sandstone in Sarnath.

While Sarnath, as home to the revered site where the Buddha started teaching, produced only Buddhist sculpture, Mathura also produced Hindu and Jain icons. This phenomenon was not uncommon, as sculptors and craftsmen are known to have traveled from construction site to construction site, sculpture to sculpture without regard to the religious affiliation of the project or indeed to their own beliefs. Thus the manner of carving Buddhist figures at Mathura was also applied to Hindu and Jain icons and to the sculpture on temples throughout the Gupta

2-16 • BUDDHA
Gupta period, first half of the 5th century. Sandstone, height 4′8¹¹⁄₁₆″ (1.44 m). Sarnath; British Museum, London.

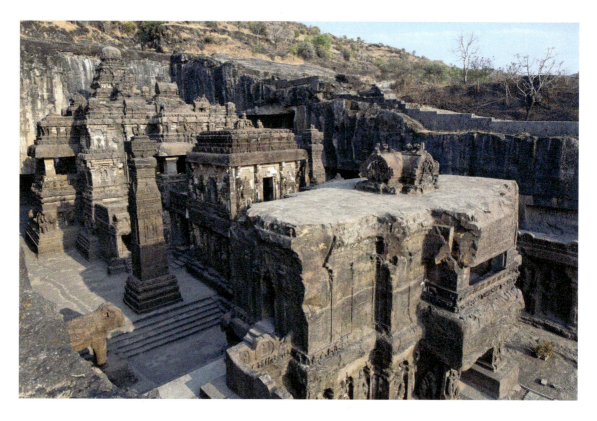

2–17 •
KAILASHANATH
TEMPLE
mid–late 8th century.
Ellora, Aurangabad,
Maharashtra.

cultural sphere. When comparing the Gupta Buddha to the roughly contemporary sculpture at Deogarh (FIG. 2-9), or Vishnu holding a conch (FIG. 2-3), the shared traits of smooth body contours and graceful poses, peaceful expressions, minimal jewelry, and elegant hairstyles immediately come through. Faces tend to be broad, with thick pursed lips, and waists are slim. In the use of certain features, such as **mudras** (see Chapter 1, Context, p. 16), iconography was also shared across the religions.

THE THREE RELIGIONS OF ELLORA

The convergence of traditions may also be found in the form of sacred spaces, especially at the cave and rock-cut temples of Ellora, near Ajanta in the Deccan. Ellora started as a Buddhist pilgrimage center, and then several caves dedicated to Shiva were excavated in the late sixth century, close to the waterfall that dramatically defines the site. As the final cave of this group was finished, work started on 12 Buddhist caves to their south. Their excavation is usually dated to between 600 and 730. After this, between the mid-eighth and tenth century, a final set of Hindu and Jain caves were added. These excavations were funded by a combination of royal patrons and ordinary citizens. The main Hindu temple—the Kailashanath—was the donation of the Rashtrakuta king Krishna (r. 757–773), while the construction of the Jain caves was supported by monks and laypeople (in some cases, husbands and wives), who appear as small human figures venerating the Jain deities. A similar cross-section of the population appears to have patronized the Buddhist caves.

The impressive Kailashanath temple represents the third phase of work at the site, in the mid- to late eighth century. Although rock-cut, it replicates a freestanding temple complex

(FIG. 2-17). It has a gateway leading into a court measuring 295 by 173 feet (90 by 53 meters). On axis with the gateway is a small pavilion (the Nandi shrine) that houses a statue of Nandi, the bull vehicle of Shiva, and a shrine dedicated to Shiva himself (FIG. 2-18) with a richly decorated exterior surface. The courtyard also contains two life-size elephants and two monumental

2–18 • SHIVA TEMPLE OF THE KAILASHANATH TEMPLE
mid–late 8th century. Ellora, Aurangabad, Maharashtra.

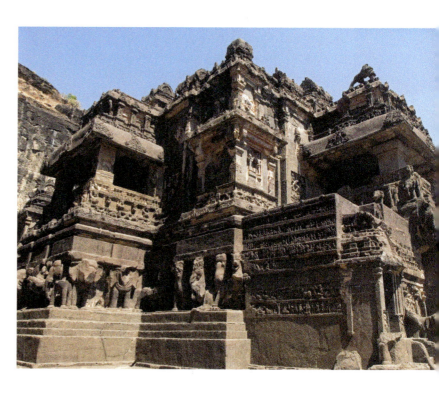

columns. All these elements have been hewn from the top down out of the living rock—a process that took 15 years.

The temple is named after Shiva's mountain home. It includes a pillared hall preceding the sanctum enshrining a *linga*, and a corridor (open to the air) that surrounds the sanctum and provides access to five additional shrines. The exterior of the temple is covered with numerous deities, human couples (considered auspicious in this setting), and other figures. The relief panels and additional caves surrounding the temple are all decorated with imagery primarily relating to Shiva in one of his numerous aspects.

A complex called the Indhra Sabha is the main focus of the Jain caves. Like the Kailashanath, it consists of a courtyard entered by a gateway, with a freestanding temple, a monumental pillar, and a monolithic elephant at the center (**FIG. 2–19**). The temple at the heart of the complex contains an image of the *sarvatobhadra*, a sculpture of four **Jinas** placed back to back so that they face the four cardinal directions. After entering this shrine, the devotee would have visited the surrounding caves arranged on two stories. Each one has a different decorative program, featuring icons of the Jinas, frequently shown with smaller monks, nuns, and laypeople in the act of worship. Some of the caves replicate the *samavasarana*, the celestial meeting hall built for the Mahavira's first sermon after attaining enlightenment (see Chapter 1, p. 21), and are filled with numerous worshippers of different social strata—and in some places, animals—in reliefs surrounding a central shrine.

The Buddhist caves at Ellora, which represent the final phase of the Buddhist rock-cut tradition in central India, include many forms that had evolved in response to the developments of Mahayana Buddhism. Cave 5, for instance, consists of a central hall surrounded by small cells and three shrines. The hall includes two long lines of benches, attached to the cave floor, where monks may have sat during ritual recitations. A three-story structure, also preceded by a courtyard with a gateway, is the most massive excavation (**FIG. 2–20**). Each of its floors is

2–20 • TIN THAL
Ellora, Cave 12, Aurangabad, Maharashtra.

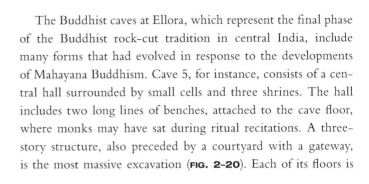

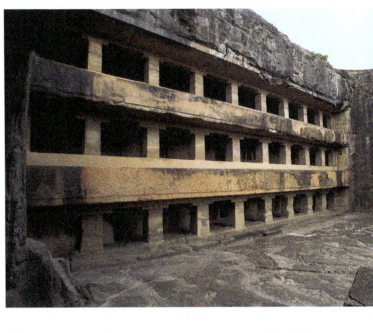

2–19 • INDHRA SABHA
Ellora, Aurangabad, Maharashtra.

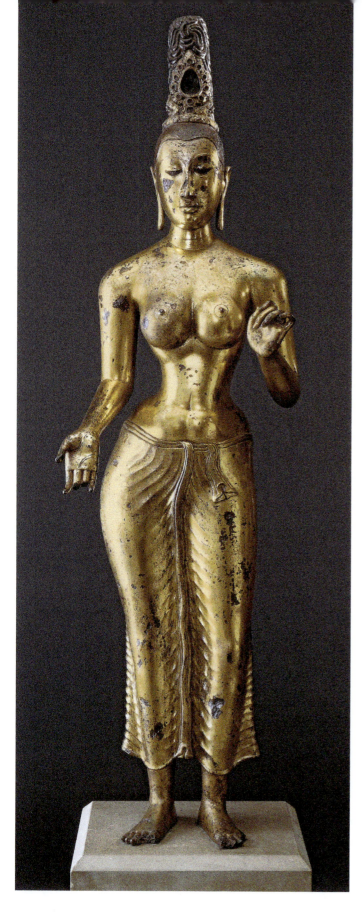

larger than any of the caves at Ajanta (see Chapter 1, pp. 18–19). The shrines in this structure include the Buddha with the **bodhisattvas** Avalokiteshvara and Vajrapani, and a group of eight bodhisattvas, each identified by an attribute. The structure of this cave was possibly meant to serve a monastic rite that had three separate stages and would have been performed on each of the three floors of the cave.

In practice each type of space functioned differently, but certain iconographic elements used throughout the site attest to the confluence of symbolism across the three religions practiced at Ellora. Most common is the imagery of mountains, representing Mount Meru to the Jains and Buddhists, and Mount Kailasa to the Hindus. Also widespread were semidivine figures of *yakshas* and *yakshis*, and the amorous couples called **mithunas** considered auspicious in all three beliefs. Most interesting is the appearance in some of the mid- to late ninth-century Hindu reliefs of small images of devotees next to the gods—a device seemingly adopted from the Jain caves built just prior.

BUDDHISM IN SRI LANKA

While on the wane by this point in India, Buddhism would flourish across Southeast Asia, where it had spread via routes of trade and commerce (see Chapter 5, pp. 110–120). In Sri Lanka, the religion had become prevalent in the period of the great Maurya king Ashoka (r. 272–231 BCE), and, because of this ancient association and the location of important Buddhist **relics** there, the island became an important locus for pilgrimage, particularly from Burma, Thailand, and Cambodia.

At the capital Anuradhapura, numerous monastic complexes and large stupas on a scale even larger than those in India were constructed, and they were adorned with iconographic programs, giving rise to a great tradition of sculpture. Alongside images of the Buddha were many bodhisattvas, the saviors of Mahayana Buddhist belief. Of these, the bodhisattva Avalokiteshvara was the most popular because of his vow to defer enlightenment until all beings had attained it. His companion Tara is the supreme goddess of Buddhism—illustrated here in a gilded bronze icon from Anuradhapura (**FIG. 2-21**). Tara is typically depicted as a voluptuous woman standing with one hip thrust provocatively forward. She raises her left hand in the *vitarka mudra*, a variant of the gesture of teaching, while her right hand suggests the fulfillment of wishes, *varada mudra*.

LATER DEVELOPMENTS IN TEMPLE ARCHITECTURE

After the early period of experimentation, as the freestanding temple became the dominant temple type, the different regional styles of the sixth to eighth century crystallized into distinct and

2-21 • TARA
8th century. Cast and gilded bronze, height (not including plinth) 56¼ × 17⁵⁄₁₆ × 11³⁄₈″ (143 × 44 × 29.5 cm). Anuradhapura, Sri Lanka; British Museum, London.

codified traditions: the Nagara (northern), Dravida (southern), and Vesantara (mixed) styles (see Context, p. 29). In each, the projections on each side of the temple radically multiplied over time, increasing the complexity of these structures as well as the available wall space for ever more ambitious programs of sculpture.

ORISSA AND EASTERN INDIAN TRADITIONS

In the eastern Indian state of Orissa, a variant of the northern style of architecture developed that featured many unique elements and an entirely local vocabulary. Key to this evolution was the town of Bhubaneshwar, where temples dating from the seventh century set strong foundations for the later developments of this region. Today it is home to dozens of temples dating to between the seventh and the thirteenth century.

Coming at a later stage and epitomizing the fully evolved Orissan tradition is the elaborate Lingaraja temple of the mid-eleventh century (**FIG. 2-22**). The complex to which this temple belongs includes a central temple, along with other temples and shrines, contained within a walled, rectangular compound. The Lingaraja temple itself consists of four separate but linked elements that are aligned from east to west. Built first, in the last part of the eleventh century, were the shrine with a tall tower and the adjoining hall. Halls for offerings and for dance, both dating to the mid-twelfth century, were later attached in front of these.

Each unit is successively taller, with roof shapes culminating in the curvilinear tower over the sanctum that reaches a

2-22 • LINGARAJA TEMPLE
mid-11th century. Bhubaneshwar, Orissa.

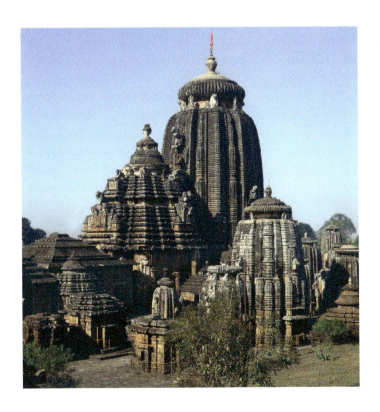

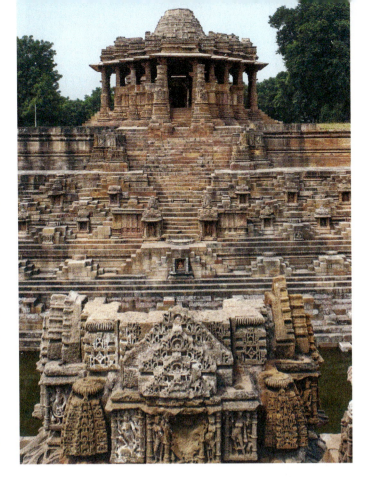

2-23 • SUN TEMPLE
ca. 1026 CE. Modhera, Gujarat.

height of over 125 feet (38 meters). This tower is characterized by a series of closely laid horizontal courses, capped by a massive ribbed finial. The temple is said to enshrine a self-manifesting Shiva *linga* that miraculously appeared under a mango tree. On the exterior of the temple, the female figure abounds, as do *mithunas*. This type of imagery was applied to later temples in Orissa, and to others elsewhere in India, such as the temples at Khajuraho, where erotic imagery is even more prevalent.

JAIN AND HINDU TEMPLES IN GUJARAT

In western India, the Solanki dynasty (mid-tenth to mid-thirteenth century) controlled a kingdom of extraordinary wealth, owing mostly to its ports with their connections to the sea lanes linking the Middle East with the rest of Asia. Their lands extended across several present-day states, from northern Rajasthan into southern Gujarat and the western part of Madhya Pradesh. The temples built during this dynasty have a profusion of carved detail, and numerous projections along each side, mirrored in the construction of the tower above, with one central spire surrounded by several smaller spires.

At Modhera is an eleventh-century temple dedicated to the sun god Surya that is oriented due east, positioning the shrine to receive the full force of the sun's rays during the equinoxes (**FIG. 2-23**). Its construction is attributed to the early part of the reign

of Bhima I (r. 1022–1063), as an inscription suggests the building was in use by 1026. The temple has three separate units, a freestanding pillared porch, and an adjoined assembly hall and sanctum, which has an enclosed passage for circumambulation. The tall tower that would have stood above the shrine has collapsed, leaving the sanctum's interior ceiling structure visible. Physically even larger than the temple is the reservoir in front of it, which is lined with stone stairs and numerous shrines.

Bhima's minister Vimala was responsible for an equally spectacular temple at Mount Abu (in the neighboring state of Rajasthan), devoted to Jain worship. The Mahavira is supposed to have visited this site, and so it was already an important place of pilgrimage when Vimala chose it for his temple. His building, built in black stone, was mostly destroyed in a late thirteenth-century attack that left only the sanctum of the eleventh-century building standing. However, the entire temple was rebuilt in white marble ca. 1300.

Vimala's temple—as the building is still known—is enclosed within a wall lined with 52 shrines with icons of the Jinas, each seated under a stone-carved canopy of a different design (**FIG. 2-24**). The temple itself is oriented east–west, with three halls

2-25 • CEILING IN THE VIMALA TEMPLE
completed 1032, repaired ca. 1300. Mount Abu, Rajasthan

2-24 • CELL CONTAINING A JAIN *TIRTHANKARA*
Vimala temple, completed 1032, repaired ca. 1300. Mount Abu, Rajasthan.

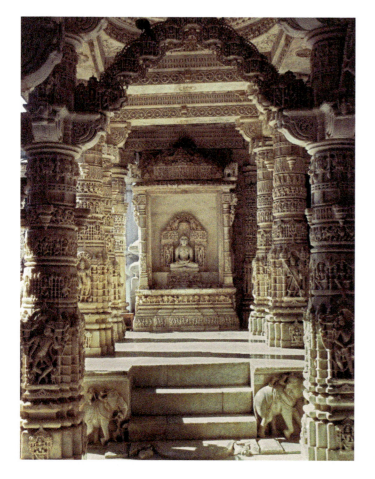

leading up to a sanctum. The first and second halls are open, while the third hall is enclosed and is connected to the sanctum. A separate pavilion in front of the temple has a ceiling depicting the cosmos (**FIG. 2-25**), shown as made up of concentric rings of animals and peoples, with the images of 12 goddesses of esoteric knowledge positioned across them.

EROTICISM AND KHAJURAHO IN CENTRAL INDIA

Between about 954 and 1150, the Chandella kings of central India built up the approximately 5-mile (13-kilometer)-square site of Khajuraho, comprising numerous temples set next to bathing tanks and artificial lakes. Legend recounts that the city once held 85 temples, but today only 25 are known, and they are dedicated to Shiva, Vishnu, the Goddess, and the sun god Surya. After the Chandella ruler Yashovarman (r. 925–950) captured a statue of Vishnu from his Pratihara overlord Devapala, work at the site commenced with a new temple for this statue, which was brought to completion during the reign of Dhangadeva (r. 950–999) in 954. Subsequent kings continued to add to the complex, building ever bigger monuments. At the same time that work started on the Hindu temples, at least six Jain temples were constructed at the site, funded by the local Jain community. As well as adding glory to the Chandella crown, this concentration of magnificent temples may have served as a center for religious scholarship.

In style, the Kandariya temple is typical of Khajuraho, though on a grand scale. Built by the king Vidyadhara (r. 1004–1035) in ca. 1030, it stands on a raised platform with an entrance on the east, and comprises various units—portico, assembly

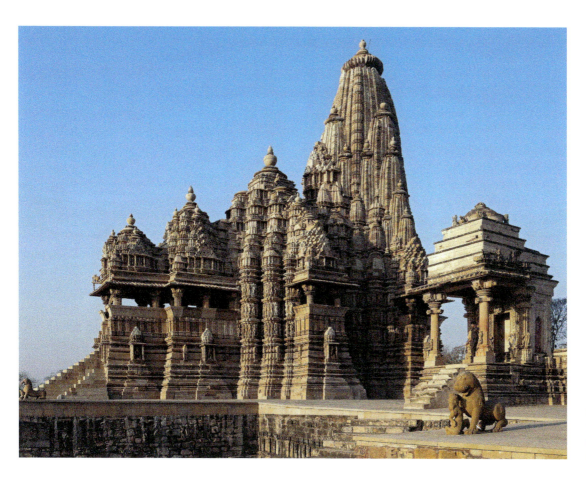

2-26 • KANDARIYA TEMPLE
ca. 1030. Khajuraho, Madhya Pradesh.

hall, vestibule, sanctum—all joined with successively higher roof towers (**FIG. 2-26**). Around the sanctum, also within the enclosed space of the temple, is a passage for circumambulation that has its own decorated moldings and rows of divine figures. The temple is dedicated to Shiva in the form of Sadashiva, the Eternal Shiva, depicted with three heads facing different directions, symbolizing the contradictory nature of the divine. Inside the *garbhagriha* is a *linga* representing Shiva in his most primordial form, framed by an entrance evolved from the basic sanctum doorway form as seen at Deogarh, composed of multiple jambs and lintels, images of the river goddesses Ganga and Yamuna, door guardians, and auspicious motifs (**FIG. 2-27**). On the exterior of the temple, the walls are conceived as a series of projections and recesses, and they are divided into multiple horizontal registers, including bands of moldings, filled with figures.

Although the iconography of the temple encompasses many subjects, the erotic sculpture here has gained the most notice. Scholars of the nineteenth and early twentieth century believed the images of curvaceous women with their breasts bared and couples engaged in acrobatic acts of intercourse reflected the sexual mores of the Chandella kings under the sway of the Kapalika sect of Hinduism. However, a more nuanced study of the subject matter of the sculpture and its placement on and in the buildings

2-27 • DOORWAY AND SANCTUM WITH A SHIVA *LINGA*
Kandariya temple, ca. 1030. Khajuraho, Madhya Pradesh.

suggests these images had a specific role in activating the power of the temple. As a *shilpashastra* (this one from Orissa) explains, "As a house without a wife, as a frolic without a woman, so without a figure of a woman the monument will be of inferior quality and bear no fruit." The images of women and couples also provided protection, averting evil and misfortune. Moreover, it appears that the images of couples are specifically deployed at the juncture of the sanctum and the preceding hall in a punning of their "joining," while the numerous figures of women represent auspicious displays of fertility, prosperity, and abundance, in much the same way female images did on earlier monuments (see Chapter 1, FIG. 1-17). This theory is supported by the use of different types of "joined" figures at other temple sites.

CHOLA TEMPLES AND THEIR BRONZES IN SOUTHERN INDIA

In the Chola lands of southernmost India, temple towers grew ever more massive. The Rajarajeshwara temple, completed in 1010 in Thanjavur, is several times larger than those in Gujarat or Orissa, and it is rendered even more monumental by the walls that frame it and the gateways that allow entrance to its sacred precinct. The temple and a nearby palace (no longer extant) were built by the Chola king Rajaraja (r. ca. 985–1014), who conquered large territories in southern India, as well as in the Maldive Islands and Sri Lanka, and whose portrait appears twice in his eponymous temple.

The major construction project also involved diverting the waters of the nearby river to run past the buildings.

The temple is raised on a tall platform and consists of a long roofed *mandapa* leading to a square sanctum. The sanctum, housing a Shiva *linga*, may be circumambulated in passages at the ground and second-story levels of the building. On the outside, the elevation reflects this division into two stories, with two rows of niches, each containing a single divine image. Eschewing the erotic imagery found more commonly in the north, sculpture at this and other southern temples is restricted to the gods and the stories associated with them. The top-level niches each hold an identical statue of Shiva in his form as Tripurantaka, the destroyer of forts, who must have been chosen in connection with Rajaraja's military successes. Below, Shiva appears in many other manifestations (FIG. 2-28). The two windows in the center of the rear wall of the temple correspond to the location of the sanctum, and allow light and air into the passages that surround it. On the lower level, the windows are flanked by two massive and fierce door guardians. Inside the temple, the walls of the passage around the sanctum bear murals with further imagery relating to Shiva and his mythology. They

2-28 • RAJARAJESHWARA TEMPLE
1010. Thanjavur (Tanjore), Tamil Nadu.

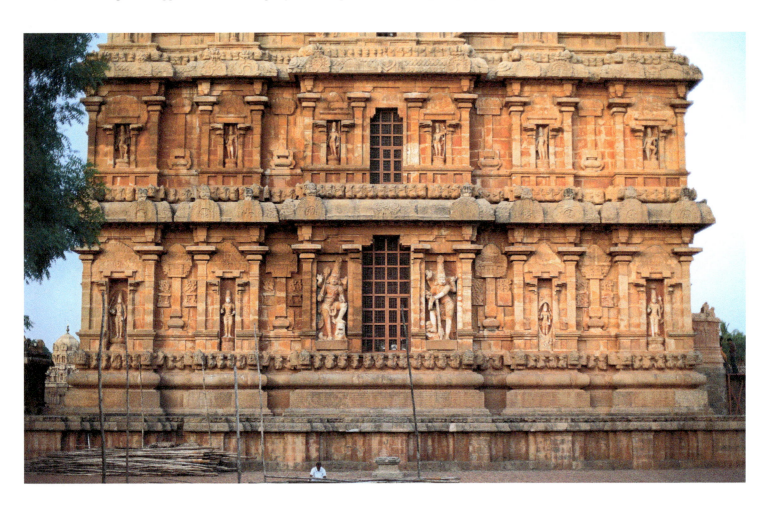

In southern India, the art of bronze sculpture was developed to great heights, especially in the late tenth and early eleventh centuries. These sculptures were used during festivals when images of a deity would be taken out on parade, or for special ceremonies on auspicious days. Particularly associated with this tradition is the image of Shiva dancing at the center of the universe in his simultaneous aspects of Creator, Preserver, and Destroyer. These aspects are conveyed by the objects he carries—a drum and fire—and by his act of trampling a dwarf. A seventeenth-century hymn in Tamil provides one explanation for the choice of these symbols and the significance of the god's posture:

> O Lord, thy sacred drum has made and ordered the heavens and earth and other worlds of innumerable souls. Thy lifted hand protects both the conscious and unconscious order of thy creation. All these worlds are transformed by Thy hand bearing fire. Thy sacred foot, planted on the ground, gives an abode to the tired soul struggling in the toils of causality. It is thy lifted foot that grants eternal bliss to those who approach Thee. These five actions are indeed Thy handiwork.

Within modern museum environments, Chola bronzes are admired in plain, unadorned form, but in temples they would have been dressed in silk cloths, garlanded, and painted.

SHIVA AS THE LORD OF DANCE (NATARAJA)
Chola period, ca. 11th century. Copper alloy, 26⅞ × 22¼″ (68.3 × 56.5 cm). Tamil Nadu; Metropolitan Museum of Art, New York. Gift of R. H. Ellsworth Ltd., in honor of Susan Dillon, 1987 (1987.80.1).

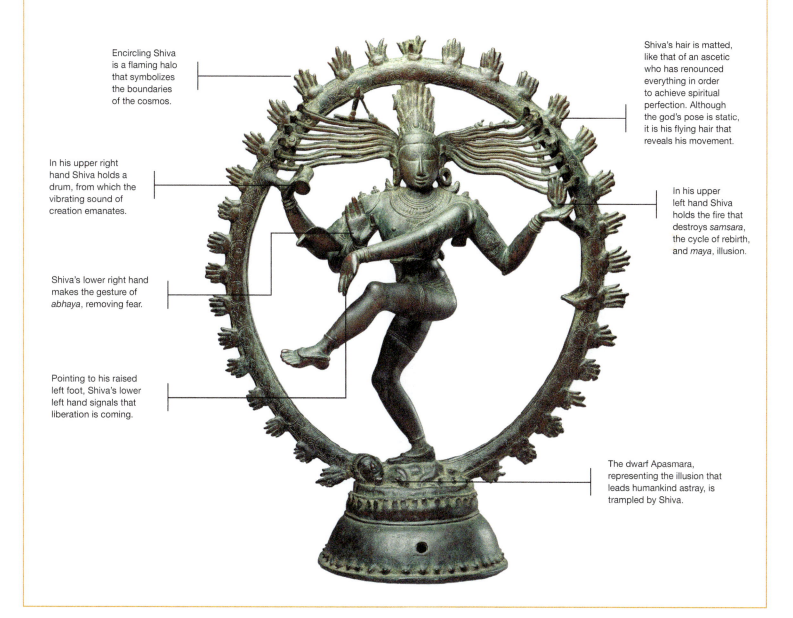

Encircling Shiva is a flaming halo that symbolizes the boundaries of the cosmos.

Shiva's hair is matted, like that of an ascetic who has renounced everything in order to achieve spiritual perfection. Although the god's pose is static, it is his flying hair that reveals his movement.

In his upper right hand Shiva holds a drum, from which the vibrating sound of creation emanates.

In his upper left hand Shiva holds the fire that destroys *samsara*, the cycle of rebirth, and *maya*, illusion.

Shiva's lower right hand makes the gesture of *abhaya*, removing fear.

Pointing to his raised left foot, Shiva's lower left hand signals that liberation is coming.

The dwarf Apasmara, representing the illusion that leads humankind astray, is trampled by Shiva.

include groupings of Shiva, Parvati, Nandi, and Vishnu, in addition to saints and images of the king and queen.

In addition to painted murals and stone sculptural reliefs, bronze statues were also displayed at Chola temples. As at Rajarajeshwara, they include groupings of Shiva, Parvati, Nandi, and Vishnu, in addition to Shaivite saints and images of the king and queen, but the image of Shiva Nataraja is among the most iconic images of Indian art (see Closer Look, p. 43). These sculptures were made using the **lost-wax casting** process, so-called because the original wax model used during the process gets melted and is "lost." Known to artists around the world, the technique involves first making a model out of wax. A metal-worker would then cover the wax image with layers of clay that would act as the mold for the bronze image. The model was fired in a kiln, causing the wax to melt and run out from the spouts in the clay covering. Hot, liquefied metal would then be poured into the mold through the same spouts, and be allowed to cool inside it. Once the metal had completely cooled and hardened, the mold would be broken to reveal the metal sculpture inside.

MEDIEVAL PAINTINGS AND MANUSCRIPTS

Examples of art to this point have been dominated by objects and buildings executed in durable materials, especially stone. Although **illustrated manuscripts** must have long been an important medium, and relief sculptures at temples from at least the seventh century show figures holding books, their fragile nature does not allow us to trace their history back any earlier than the tenth century. These early books differ from the ones read today: They have pages made of palm leaf that are horizontally oriented and

2-29 • DETAIL OF COVER AND LEAF OF AN ILLUSTRATED COPY OF THE *ASHTASAHASRIKA PRAJNAPARAMITA*
Produced at the Buddhist monastery of Nalanda, Bihar, ca. 1097. Pigments on palm leaf. Bodleian Library, Oxford (MS. Sanskrit a.7 cover and f.187b).

tied together with a cord running through the center of each page, rather than a binding along one edge. The pages of these books were placed between wooden covers that were wrapped in cloth for storage.

BUDDHIST PALM-LEAF MANUSCRIPTS OF INDIA AND NEPAL

In common with other art forms of this time, the surviving production is religious in nature—in this case, Buddhist and Jain. The former come primarily from eastern India and Nepal, where books like the one illustrated here (**FIG. 2-29**) were created in monasteries. The text is a Buddhist **sutra** (sacred script), the *Prajnaparamita*, which translates as *The Perfection of Wisdom* (also known as the Heart Sutra). Concerning the nature of Buddha- and bodhisattva-hood, the subject matter does not readily lend itself to narrative illustration. Nevertheless a series of 18 images routinely accompany such books: paintings of different Buddhas, bodhisattvas, gods, and goddesses, as well as the eight great events of the historical Buddha's life.

The images are usually arranged in groups of three, on six of the pages in the manuscript. This copy, signed with the useful information that it was completed at the famous Buddhist university at Nalanda in the late eleventh century, has the layout typical of these books. In the center is an image of the Buddha, hands in the *dharmachakra mudra*, teaching Indra. This scene is

2-30 • *THE BODHISATTVA SAMANTABHADRA*
(at left) from an illustrated copy of the *Ashtasahasrika Prajnaparamita*, 1015 CE. Pigments on palm leaf, height 2″ (5.25 cm) (approx.). Nepal; Cambridge University Library (Add. 1643, folio 127a).

flanked on the right by the female bodhisattva Jaliniprabha, shown holding a net of wisdom.

The covers of these books often have a more expressive style of painting, where the artist was freed from the rules for depicting the deities within. The covers of this book were made in Nepal in the twelfth century. It is likely that the book traveled to Nepal in the hands of monks fleeing the upheaval caused by the invasions from Afghanistan into northern India in the eleventh century (see Chapter 3, p. 53). The back cover shows the subject of the text, the bodhisattva Prajnaparamita, embodying all wisdom and seated on a lion-throne with her **adepts** (accomplished beings), including Tara, surrounding her. This bodhisattva is depicted with four arms—two in the gesture of teaching, the other two holding a rosary and a palm-leaf book.

With the arrival of monks from northern India, the existing practice of painting further blossomed in Nepal, although a copy of the *Prajnaparamita*, dated 1015 (**FIG. 2-30**), is proof that this was already a well-developed tradition. It has 85 illustrations depicting the eight great events of the Buddha's life and the different Buddhist entities, and includes images of the important Buddhist sites of India, Sri Lanka, China, and Java. As the scribe was copying out the text, he left spaces for inserting illustrations, and labeled each **cartouche** (segment containing an image) with the name of the deity, event, or location to be depicted later by the illustrator. The painting style is distinctive and suggests the independent nature of this school of painting. The Nepalese works are often described as softer and more elegant than their Indian counterparts. The faces and bodies are rounder, with more subtle shading, than in the paintings from eastern India.

JAIN MANUSCRIPTS OF WESTERN INDIA

In western India, the earliest known books are Jain texts, most often copies of the *Kalpasutra*, which describes the lives of the 24 Jain *tirthankaras*, and of the *Kalakacharyakatha* (*Story of Kalaka*), which is about the famous first-century Jain monk Kalaka. In a folio dated to the late thirteenth century, a monk seated on a throne preaches to a male devotee, who clasps his hands in veneration (**FIG. 2-31**). In the register below are two nuns in the center,

2-31 • *A SHVETAMBARA MONK INSTRUCTING A PRINCELY FIGURE*
Folio from an illustrated copy of the *Kalakacharyakatha*, 13th century. 2³⁄₁₆ × 11⁷⁄₈″ (5.6 × 30.2 cm). Gujarat; San Diego Museum of Art. Edwin Binney 3rd Collection (1990.179).

flanked by two other followers. As this painting demonstrates, the depictions of the Jinas and Jain divinities that accompany the text of these books were highly regulated, as was also the case with the Buddhist illustrations. Even the monks and worshippers are standardized types who appear again and again in many other manuscripts: figures with weak chins, sharply pointed noses, and protruding eyes. These kinds of image, which do not in fact relate to the text, and seem instead to have a magical function, elevate the book to a sacred status.

SOUTH ASIAN TEXTILES AND THE INTERNATIONAL TRADE MARKET

Textiles are another class of material that does not preserve well in the Indian climate, and the earliest group dates to the ninth century. Indian textiles were famed around the world from a much earlier date, however, and a longer history of their production can be gleaned from indirect sources from Europe and China. Mural paintings also give a sense of the variety of fabrics that must have been used for clothing and furnishings from ancient times. Depicted on the walls of Ajanta, for instance, are textiles in a variety of patterns made through the processes of tie-dyeing, embroidery, and *patolu* (see p. 47). At a monastery in Ladakh, in northernmost India, are images of even more cloths (**FIG. 2-32**). They were originally painted onto the ceiling of the Sumstek Lhakhang ("Three-Tiered Temple") in the eleventh and twelfth centuries, and show an amazing range of designs incorporating human figures, animals, and geometric patterns. It is thought that

2-32 • PAINTED PANELS ON THE CEILING OF THE SUMSTEK LHAKHANG
11th–12th century. Alchi, Ladakh.

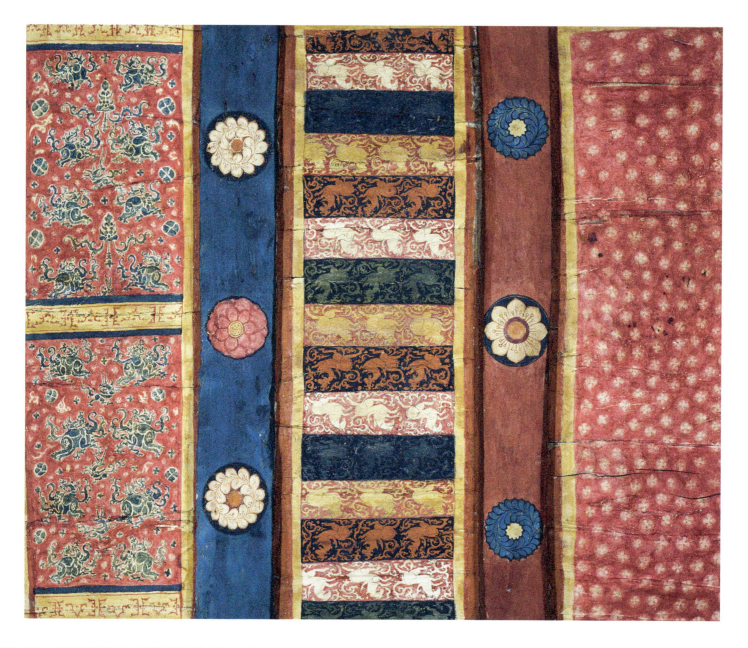

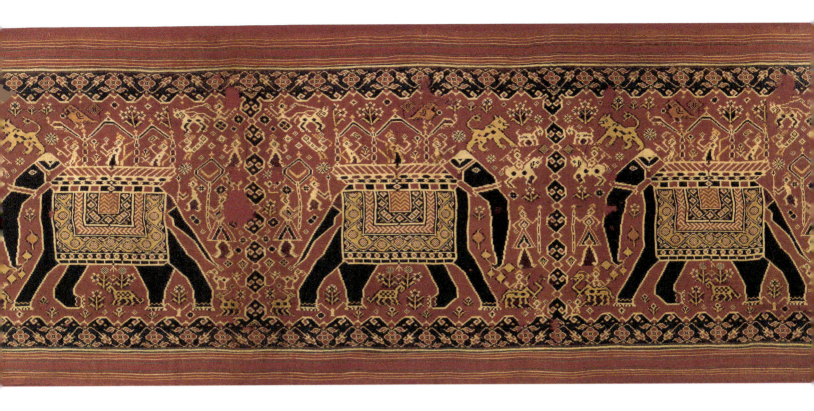

2-33 • *PATOLU* CLOTH (DETAIL)
Late 18th century. Resist- and mordant-dyed silk, overall 3'6⅞"
× 15'1⅞" (1.09 × 4.62 m). Gujarat (for the Indonesian market);
Metropolitan Museum of Art, New York. Purchase, Friends of
Asian Art Gifts, 2012 (2012.164).

the paintings represent Indian textiles made by dyeing (see FIG. 2-32, left and right panels) and by using the weaving process of **brocade** (see FIG. 2-32, center panel).

DYED TEXTILES AND THEIR PRODUCTION

The known textiles all have patterns created by dyeing and printing plain-woven cotton and silk cloths. For cotton, the dyeing process was complicated, involving multiple steps, many different materials, and much time and labor. The centers for making this kind of cloth were located in Andhra Pradesh and Tamil Nadu, on the east coast, where fabrics with hand-drawn designs were called *kalamkari*, or "pen-work" (see Techniques, Chapter 3, p. 71). In Gujarat, on the west coast, patterns were printed with wooden blocks carved with the desired patterns.

Gujarat also specialized in a special kind of dyed silk fabric called *patolu*. For these cloths, the patterns were dyed into the threads before they were woven. Threads were set up on a loom, and groups bound together with string; these areas would not take color when the threads were dipped in a dye vat. These threads were then placed on the loom in the same arrangement in which they were dyed so that the pattern was maintained when woven. This method gave the highly desirable result of a cloth with equally strong colors on both sides of the fabric. Unlike the dyed cotton cloths, *patolu* survive only from the eighteenth century onward, despite a much longer history of production. The long piece of fabric shown here, with

its imagery of royal elephants (FIG. 2-33), would have been intended for use at court ceremonies or for clothing of the elite.

CONNECTIONS TO EGYPT AND SOUTHEAST ASIA

The early Indian textiles are best known in the context of their trade abroad, because they have survived in such places as Egypt, where the dry environment helped to preserve cloths used in burial, and throughout Southeast Asia, where they were specially cared for and passed from one generation to the next. In both regions, Indian fabrics were valuable because of their complex patterns in multiple colors that, most importantly, did not fade with repeated washing.

Although written records suggest that trade started even earlier, the cloths discovered in Egypt date from the ninth to the seventeenth century. Merchants' letters from the Egyptian city of Fustat state that they were carried both by Indian ships departing from the Gujarati ports of Cambay and Surat, and by Arab traders who had settlements along India's western coastline. The oldest surviving mosque in India, built in the

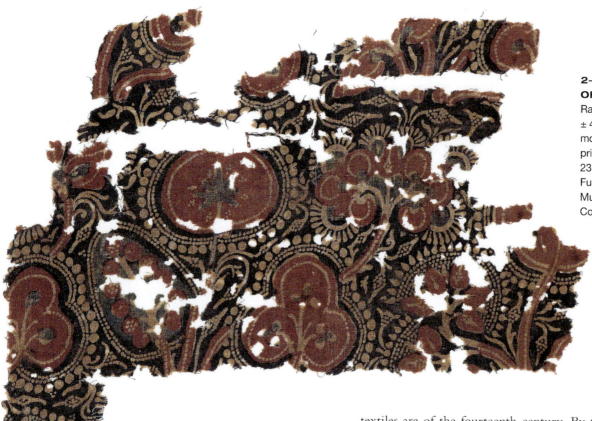

2-34 • FRAGMENT OF AN INDIAN CLOTH
Radiocarbon-dated 1340 ± 40 years. Resist- and mordant-dyed cotton, block-printed, 15½ × 9″ (39.5 × 23 cm). Gujarat (found in Fustat, Egypt); Ashmolean Museum, Oxford. Newberry Collection, EA1990.1129.

mid-twelfth century and located at Bhadresvar, Gujarat, is in fact associated with one of these trading communities.

The cloths themselves were from Gujarat, and were decorated with repeating floral and geometric patterns (**FIG. 2-34**), as well as animals, such as the elephant and goose. Their applications were utilitarian—they were made into clothes, covers, curtains, and, when worn out, were employed to wrap bodies for burial.

In the case of Southeast Asia, trade appears to have started at least as early as the first century, but the earliest remaining textiles are of the fourteenth century. By this date, they were being exchanged for spices that could fetch very high prices in markets around the world. As in the trade to Egypt, merchants of many ethnicities were involved: Indians, Arabs, and from the seventeenth century on, Europeans. Aside from the western Indian ports mentioned above, ports on the eastern coast such as Mamallapuram and Pulicat served as the departure point for ships bound for Southeast and East Asia.

In contrast to their commonplace role in Egypt, Indian textiles enjoyed a high status in Southeast Asia, and each market demanded specialized patterns—traders remarked that even a slight deviation in the desired design of a cloth would lead to

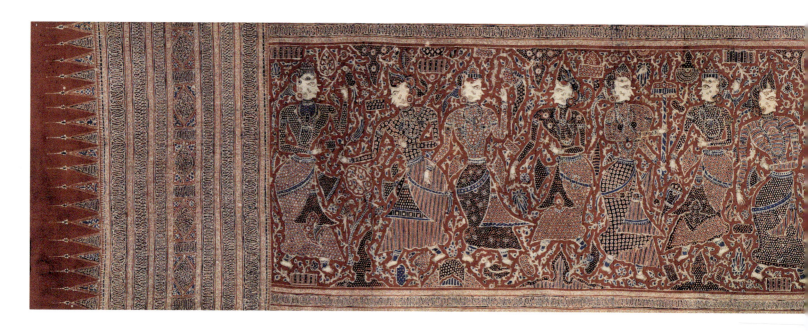

a sharp decrease in its price. This was because the fabrics were used for specific items of dress and in religious and court ceremonies. For instance, in Indonesia, Indian cloths such as the fourteenth-century example shown here were hung from tall bamboo poles during ceremonies performed to protect a settlement from evil (**FIG. 2-35**). While this textile features rows of women (probably dancers), others depict trees and plants. Both types have a central field enclosed at either end with several bands of designs, and finally a row of triangular motifs called *tumpal*. This format seems to have been one specific to the Indonesian market, although its significance is no longer understood. Entirely different types of cloth were made for the markets in Burma, Thailand, and even Japan.

During the period between the fifth and twelfth century, the architectural and sculptural forms first established in early Indian history took monumental form. This development toward the bigger and grander is the result of royal patronage. While it is not always possible to connect monuments and their patrons, and while those outside a royal court could also fund religious art, it is undeniable that the great royal projects spurred the innovation and grandeur of the greatest temple projects. By building or endowing temples, a patron could not only accrue personal religious merit but also attain benefit for the state and its subjects through the god's beneficence.

During this period, India's trade relations with the outside world started to open up, and they would become an even greater factor in subsequent centuries. While at this moment the population of the subcontinent was fairly homogeneous ethnically, trade and other political entanglements in the following centuries would soon bring many new cultures onto Indian soil.

CROSS-CULTURAL EXPLORATIONS

2.1 Do the Gupta-era depictions of **Vishnu** (FIG. 2-9) **and the Buddha** (FIG. 2-15) **share any features? Are there similarities in the physical features of the two types? Can you determine a difference in the ideals the sculptors were trying to convey?**

2.2 Sculptors and architectural masons of the period covered in this chapter tended to work in styles similar to one another. Can you think of other periods of time in which art produced by different artists takes on a similar appearance? Do you think artists of today work in definable regional or international styles?

2.3 The notion of a female goddess is one of long standing in South Asian cultures. How do the understanding and depictions of this being compare from Harappan times (FIG. 1-8) **to the Buddhist** (FIG. 2-21) **and Hindu** (FIG. 2-5) **eras?**

2.4 Textiles from India were prized in the Middle East and Southeast Asia from antiquity. Why did these textiles have such high value? Are there comparable items in our society, imported from far away but made to patterns and formats of use in our lives?

2-35 • CEREMONIAL CLOTH AND SACRED HEIRLOOM (*MAWA OR MA'A*)
Dated by inscription to 1500. Resist- and mordant-dyed cotton, 3′4⅛″ × 17′6¼″ (1.02 × 5.34 m). Gujarat (found in Sulawesi, Indonesia); National Gallery of Australia, Canberra. Gift of Michael and Mary Abbott, 1989.

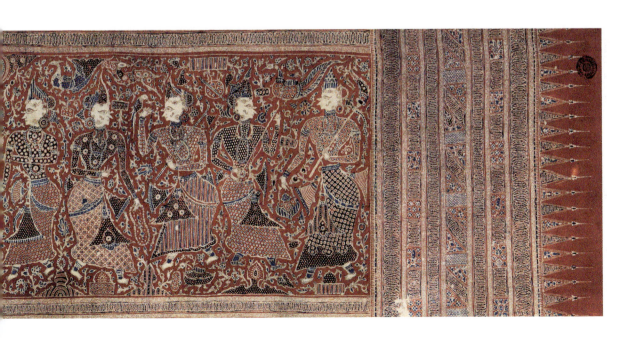

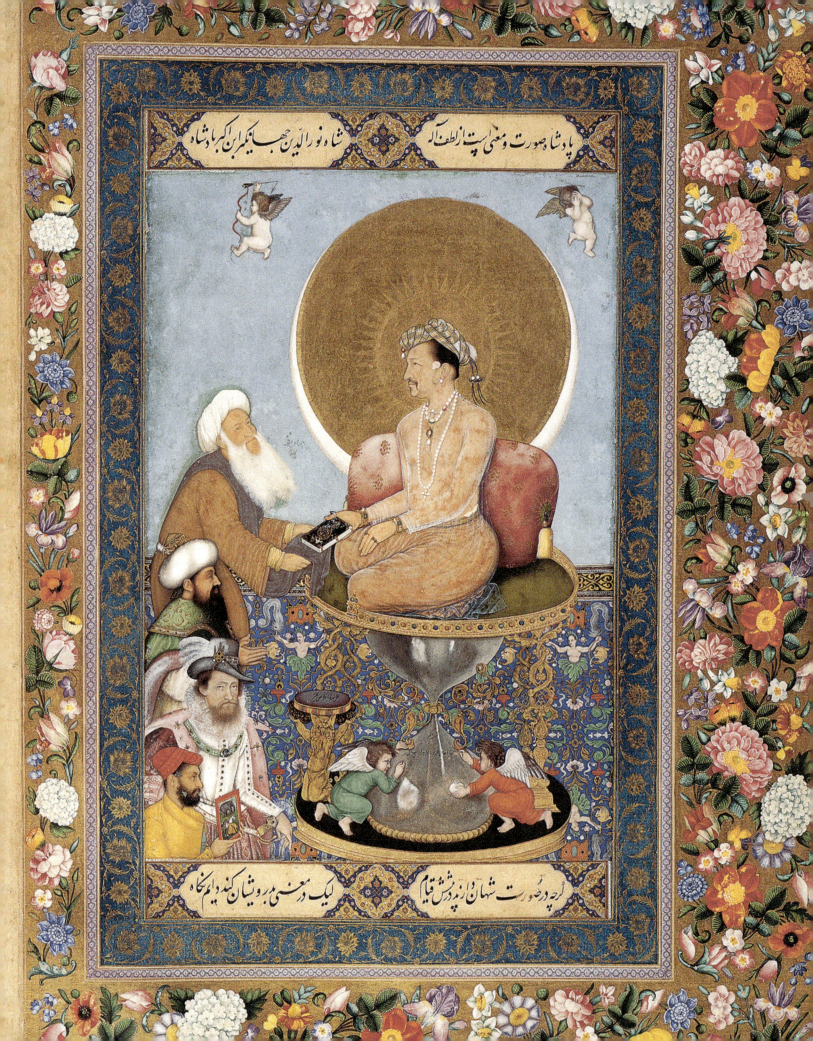

India Opens to the World: The Early Modern Period

If there be a paradise on earth, it is this, it is this, it is this.

Inscribed on a wall of the Private Audience Hall, Shahjahanabad (Red Fort), Delhi

The start of the thirteenth century marked a shift in Indian society, as people of Central Asian, Persian, and European descent arrived and settled throughout the subcontinent. The first group came overland from the region of Afghanistan during the eleventh century, and a series of military campaigns eventually led to foreign rule being established in much of the north. As the courts founded by these Central Asian, ethnically Turkic, rulers flourished, other peoples from the interconnected Persian-speaking world to which the Turks belonged also came to India, culminating in the establishment of the Mughal empire, which at its greatest extent in the seventeenth century ruled over much of the subcontinent. European traders and missionaries began arriving at the end of the fifteenth century. They sought the Indian goods that were valued in Europe, as well as those items that could be profitably traded in exchange for spices in Southeast Asia.

Along with the languages and religions they introduced into the region, these new ethnic groups brought with them new forms of art, which bloomed further in the Indian climate. From this time on, **illustrated manuscripts**, Persian poetry, and domed architecture became an integral part of the Indian **canon** (accepted body of works), flourishing alongside and invigorating traditional art forms. The portrait shown here, of the seventeenth-century emperor Jahangir (**FIG. 3-1**), epitomizes this multicultural blend. Evolving from a form of book illustration common in the Persian cultural sphere, the painting also incorporates elements from European art—such as the hourglass and **putti** (small children with wings, similar to the figure of Eros), and a portrait of the English king James I—and the fine style of portraiture unique to the Mughal workshop. Together they are marshaled to demonstrate this Mughal ruler's spiritual aspirations; ignoring the European and Ottoman sovereigns seated before him, Jahangir showers his attention on the **shaykh**, a religious leader within the Sufi tradition of Islam.

THE ARRIVAL OF PERSIAN COURT CULTURE AND THE SPREAD OF ISLAM

Ruled by indigenous monarchs through the tenth century, India and its riches began to attract the interest of neighboring ruling powers in the eleventh century—in particular, the Ghaznavid (977–1186) and Ghurid (1000–1215) sultans of Central Asia, who saw the Indian territories to their east as full of potential. Although entering an already linguistically and ethnically diverse realm, the initial Ghaznavid invaders, and the later Ghurid settlers, represented a major change to India's cultural and religious landscape. Ethnically, they were Turkic, and the fact that they are called *turuska* in the Indian historical sources suggests that to their adversaries, at least, this was their distinguishing characteristic.

3-1 • Bichitr *JAHANGIR PREFERRING A SUFI SHAYKH TO KINGS*
Mughal dynasty, ca. 1615–1618. Opaque watercolor, ink, and gold on paper, height 18⅞ × 13″ (48 × 33 cm). Freer Gallery of Art, Smithsonian Institution, Washington, D.C. Purchase (F1942.15).

They spoke Persian, which had a vocabulary, grammar, and alphabet distinct from the Indian languages. They also brought with them those courtly rituals that were shared among the Persian-speaking rulers of the contiguous regions of Iran, Central Asia, and Afghanistan.

This royal culture placed a strong emphasis on patronage of the arts, and it introduced new forms of artistic production into India. These included a vast body of literature in Persian and Arabic, and the practice of illustrating works of poetry and prose with narrative paintings. The new rulers also sponsored public or monumental structures of types different from those previously found in India: Arched and domed tombs, mosques, and palaces now became a part of the landscape. This population also introduced different styles of dress, the use of pile carpets, and new methods for weaving textiles.

ISLAM

The Turkic population also brought the religion of Islam with them. Islam comes from a system of belief entirely different from Hinduism, Buddhism, and Jainism, and must instead be understood in the context of Judaism and Christianity, with which it shares roots. The three have a core belief in a single god who takes a single form, who is the creator of life, and who will be the judge of all individuals on Judgment Day. Thus the issue of the soul's rebirth, the very foundation of the Indic religions, has no part in Islam.

In Muslim belief, the nature of this god and the values he embodied were conveyed to mankind by a series of prophets, including Abraham, Moses, Jesus, and, finally, Muhammad, considered the final prophet. Muhammad, born in Arabia in the late sixth century, began to receive his revelations from Allah (meaning "God") in the year 610. Over the next 22 years, until his death in 632, he continued to receive these messages, which he passed to a growing community of believers. These revelations were initially memorized by Muhammad's followers, but after his death they were written down in the late seventh century as the text called the Qur'an. The Qur'an is divided into 114 *suras* (chapters), which are arranged in order of length, except for Sura 1, a brief prayer that was placed at the beginning.

As with the religions previously discussed, Islam required a specific kind of space for worship—in this case the *masjid* (literally "place of prostration"), or mosque, as it is known in English. The requirements for the building are simple. It must provide a roofed space for the congregation (originally, only the males of a community) to gather for individual prayer five times a day, and for a congregational prayer with a sermon at midday on Fridays. The building must be oriented toward Mecca, the location of the Ka'ba, a shrine associated with Abraham, and the holy city where the Prophet received his first revelations. In the ritual of Muslim prayer, the worshippers assemble in parallel rows, reciting prayers and verses from the Qur'an while standing, raising their hands, and prostrating themselves in a prescribed order.

Though initially simple in structure, mosques gradually grew more complex. By the time Islam was introduced to the subcontinent, all mosques were built with a niche, called a **mihrab**, in the wall that faces Mecca (the **qibla** wall), to indicate the direction of prayer. Verses from the Qur'an were used to decorate the building, along with ornamental stone, **stucco** (fine plaster), and woodwork, although never any kind of figural decoration, which was deemed inappropriate in this context. Mosques also grew in size, with ever bigger domes over the prayer hall and larger courtyards attached to the front (**FIG. 3-2**). Most mosques also came to include a **minaret** (tower), from which the call to prayer ('adhan) was sung five times a day.

3-2 • QUTB MOSQUE
Delhi, Ghurid dynasty, 1192 and later.

1. Enclosure with porticos
2. Arched screen
3. Prayer hall
4. Qutb Minar
5. Additions built by 'Ala al-Din Khalji
6. Entrance built by 'Ala al-Din Khalji

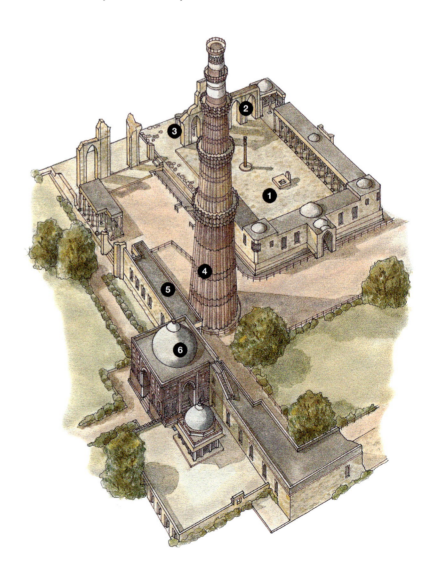

THE DELHI SULTANATES AND THEIR CONTEMPORARIES

The establishment of foreign rule in India had a buildup of more than a century. On learning of the wealth stored in the treasuries of India's palaces and temples, the Ghaznavid ruler Mahmud (r. 998–1030) launched as many as 17 raids into northwestern India in the early eleventh century, attacking and plundering cities such as Mathura and religious complexes like the Jain temple site of Mount Abu (see Chapter 2, p. 40). His victorious armies returned to the capital of Ghazni (in present-day Afghanistan) each time, since Mahmud was not interested in establishing a permanent presence in India.

After Mahmud's death, the Ghurids, former vassals of the Ghaznavids, took over their lands and also their forays into India, but this time with an eye to establishing a more permanent presence there. In 1175 Muhammad Ghuri initiated a major campaign of conquest, and after several key victories in 1192, he established a commander at the settlement of Delhi. After Muhammad's death, this commander—Qutb al-Din Aybak—established an independent court, and his successors continued to rule from Delhi until 1290, after which time additional dynasties succeeded them.

Once established in Delhi in 1192, Qutb al-Din Aybak started a transformation of the city. Delhi had been founded in the tenth century by the Tomar Rajput dynasty from western India, but it had remained a relatively minor settlement. From the Ghurid occupation onwards, however, it would become one of the region's major metropolises, serving as the capital for a succession of dynasties and rulers, and for the modern nation of India today.

THE QUTB MOSQUE

One of Qutb al-Din's earliest works was a mosque; mosque construction had followed many, if not all, of the Ghurid conquests across Pakistan and India. The Qutb Mosque is popularly known as the Quwwat al-Islam, or "Power of Islam," Mosque, although this label seems to have been attached to the building only in the nineteenth century (see FIG. 3-2). As with the Ghurid mosques that had been built upon military victories, this one signaled the authority of a new ruling power and its religious affiliation—a message underscored by the addition of a tall and highly visible minaret next to the building. However, the building also served as the congregational mosque for Delhi's new Muslim population, a place of gathering, and the focus of Qutb al-Din's new city.

The site today includes many additions made after the 1190s, but the original mosque consisted of a rectangular enclosure with **porticos** on three sides and a prayer hall with a *mihrab* on the fourth side. The prayer hall is only partially preserved today, but was once crowned by a central dome, with smaller domes to either side. An elevated chamber was included at one end for the sultan to pray in.

After construction was completed, Qutb al-Din sponsored further changes to the mosque: A new northern entrance was added in 1195, and an arched screen was constructed in front of the prayer hall in 1198. This screen, now better preserved than the prayer hall to which it once provided entrance, has a tall central arch framed by an inscription providing the name of the patron and the date of construction. Intricately carved vegetal **motifs** are contained in bands around this and the flanking arches, and additional geometric designs decorate the **spandrels** on either side of the main arch (FIG. 3-3).

3-3 •
ORNAMENTATION ON ARCHED SCREEN, QUTB MOSQUE
Delhi, Ghurid dynasty, 1198. Red sandstone.

Qutb al-Din also started construction of a minaret—called the Qutb Minar—next to the mosque (**FIG. 3–4**). The first story of this **flanged** (ridged) structure was built during his reign; the next three were added under the sultan Iltutmish (r. 1211–1236), and the fifth was constructed as part of repairs undertaken in the mid-1400s. Around the minaret's lowest story are bands of inscriptions, including text from the Qur'an, the 99 Arabic names for God, and a historical inscription in praise of the Ghurid ruler.

The form and decoration of the mosque and minaret structures can be related to earlier examples of Ghurid architecture, but their execution relates directly to local building practices. The use of stone, and the fact that the mosque's arches and domes are constructed by **corbelled** (bracketed) rather than a truly **arcuate** (arched), self-supporting system are its main distinguishing features, and identify it as the work of local craftsmen.

Another feature of the mosque that differentiates it from the Ghurid buildings of Central Asia is the reuse of many columns from dismantled Hindu and Jain temples, next to new columns made to match them. An inscription on an entrance to the mosque enclosure suggests that the elements from 27 such buildings were used here. In addition, the entrance to the sultan's private chamber was constructed from the doorframe of a temple, from which the images of deities were chipped away. The meaning of this reuse is still to be explained. Whereas it is

3-4 • QUTB MINAR
Delhi, Ghurid dynasty, 1199 and later.

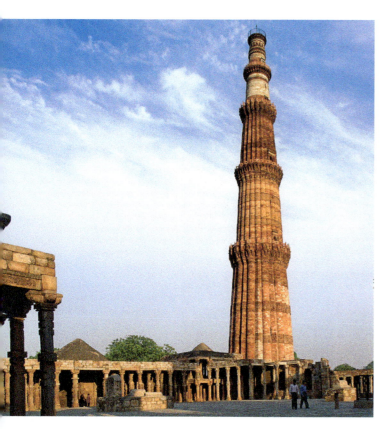

undeniably a charged act aimed at the conquered population, the creation of new columns in the same style as the re-used ones suggests an adoption of local building practices. And it should be noted that even Hindu kings of the time were known to destroy temples when they held a politically symbolic value. This kind of political symbolism could also be attached to the relocation of the Iron Pillar to the mosque's courtyard. Erected by a ruler of the Gupta period, the pillar's original location was perhaps hundreds of miles away.

Palaces or other buildings that may have been built by Qutb al-Din Aybak or his successors, the fully independent Mu'izzi dynasty (1206–1290), no longer survive, so this complex remains the sole legacy of this era. In the subsequent development of Delhi under the Khalji (1290–1320), Tughluq (1320–1413), Sayyid (1414–1451), and Lodi (1451–1526) sultans, distinct walled settlements that included palaces, administrative structures, mosques, and tombs were constructed. But Qutb al-Din's mosque, in the old heart of the city, continued to hold symbolic importance. The most ambitious changes to the Qutb Mosque site were initiated by sultan 'Ala al-Din Khalji (r. 1296–1316), who added a new entrance to the mosque enclosure, expanded the prayer hall to triple its original size, and started construction of a second minaret that would have well overshadowed the Qutb Minar. He also established a *madrasa*, or religious school, within the complex (see FIG. 3–2).

REGIONAL SULTANATES IN THE NORTH

Outside Delhi, much was changing in the structure of society and rule of India, for the reach of the Khalji and Tughluq sultans extended far beyond the northern zone under their direct control. Sultans of both dynasties sent armies south, east, and west from the capital city, and succeeded in overpowering nearly all the regional kings they encountered, moving as far down into the Indian peninsula as the city of Madurai in Tamil Nadu. In some cases the defeated monarch was simply placed back on his throne upon agreement to pay tribute to the sultan in Delhi. In other cases the king was replaced by a governor loyal to the Delhi sultan, and the lands became a province of the Delhi sultanate.

During the course of the fourteenth century, many of these provinces became sovereign powers as political conditions fluctuated in Delhi, particularly after the city was brutally sacked by the conqueror Timur (d. 1405), the ruler of a kingdom based in Samarqand, Uzbekistan. He and his armies swept through Delhi in 1398, causing mass destruction from which the city, and the Tughluq dynasty, never fully recovered. After this point, the process of decentralization quickened and many provinces became fully independent.

Among the provinces most difficult to control was Mewar, in the northwestern state of Rajasthan. It was only briefly, between 1303 and 1323, that Mewar was ruled from Delhi; after this period it came under the control of a local clan—the Sisodias, who claim descent from the great hero Rama. Mewar flourished

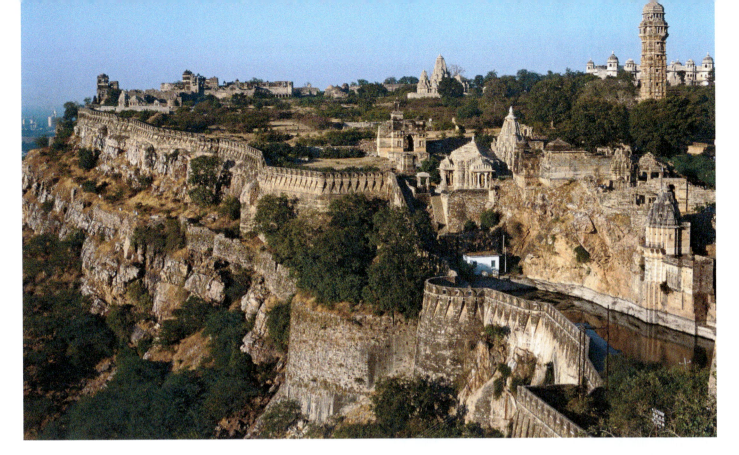

3-5 • FORT AT CHITOR
14th century and later. Mewar, Rajasthan.

particularly under King Rana Kumbha (r. 1433–1468), who expanded the fortress of Chitor, a dramatic site on a cliff several hundred feet high. Chitor had been established by a legendary chieftain in the eighth century (**FIG. 3-5**).

The palatial structures at this site are not located in planned units; rather, individual halls and rooms are placed at different levels according to the terrain, and are often accessible only by stairs or ramps. The main organizational principle was the division of private and public zones, and men's and women's quarters, entry into which was strictly regulated. The buildings themselves were constructed of stone and decorated with carved stucco; many feature a type of projecting balcony, called a *jharokha*, which would be used to great effect in the architecture of the Mughal period.

Also at the site is a unique structure, the Vijay Stambha, completed in 1460 to commemorate Rana Kumbha's victory over the king of Malwa (**FIG. 3-6**). This nine-story tower was probably inspired by a tower at Chitor from the thirteenth century. That tower was built as part of a Jain temple and is dedicated to the first **Jina**; it is carved with images of him and the later Jinas. Covering each story of Rana Kumbha's tower, on the other hand, are reliefs of Hindu gods and goddesses, and battle

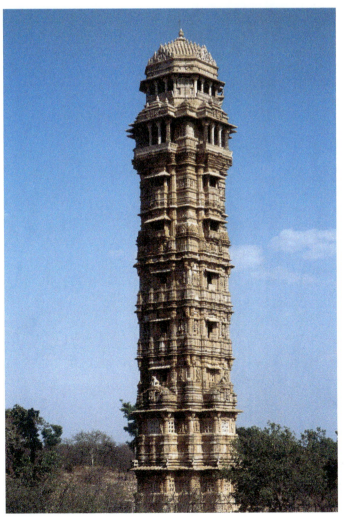

3-6 • VIJAY STAMBHA
Chitor fort, 1440. Mewar, Rajasthan.

scenes from the *Mahabharata* and the *Ramayana* that refer to the structure's function as a victory monument. This message is reinforced by inscriptions referring to Rana Kumba's victories, declaring him an incarnation of Rama. They also mention the king's munificence in providing wells and forts for his subjects, and constructing temples and feeding **brahmins**.

In the western Indian state of Gujarat, rule from Delhi was established in 1304, and just over a century later, in 1407, the governor Zafar Khan declared his independence, establishing a dynasty that would remain in power until 1572. Upon his accession in 1410, Zafar Khan's grandson Ahmad Shah commenced construction of his new capital of Ahmadabad. He located his palace in an elevated citadel, at the base of which was a large triple-arched gate opening onto a royal processional street. This street continued past an open field where ceremonies were held, and terminated at a major congregational mosque, next to which Ahmad Shah constructed his tomb.

In common with the Qutb Mosque in Delhi, the Ahmadabad Mosque, completed in 1411, consists of a prayer hall preceded by a large courtyard surrounded by colonnades. In the middle of the courtyard is a rectangular pool where worshippers can perform the requisite cleansing before going to pray. The **façade** of the prayer hall consists of a central section with three tall arches, flanked by two shorter sections with flat roofs supported by pillars. The bases of two minarets, one on either side of the central arch, are all that remain of these towers, which fell after an earthquake in 1819. Inside, the prayer hall has five aisles, each of which faces a *mihrab* on the *qibla* wall. A forest of 260 pillars divides the space into 15 domed bays of varying size, with the largest preceding the *mihrab* of the central aisle. Balconies where the sultan and members of his court may have prayed overlook the central, tripled-height section.

The construction and decoration of this mosque relate in many fascinating ways to the earlier traditions of this area, as exemplified by the temples at Modhera and Mount Abu, built during the reign of the Solanki dynasty (see Chapter 2, p. 40). The most visible connection is the treatment of the building's exterior as a series of intricately carved horizontal courses, with motifs in the same style and order as on the lower levels of the temple façades. In addition, the repetition of miniature forms of the larger building—common in Hindu temple architecture of the northern style (see Chapter 2, Context, p. 29)—is also found on the mosque; in this case, the *mihrab* niche is repeated on the base of the minaret columns (**FIG. 3–7**).

Gujarat's stone-carving traditions continued to develop in new ways in the following centuries. The pierced stone screens of the Sidi Said Mosque (1573) best symbolize the evolving aesthetic approach (**FIG. 3–8**). This rather small building is distinguished by the screens along the upper part of its side and back walls, and particularly those on either side of the *mihrab*.

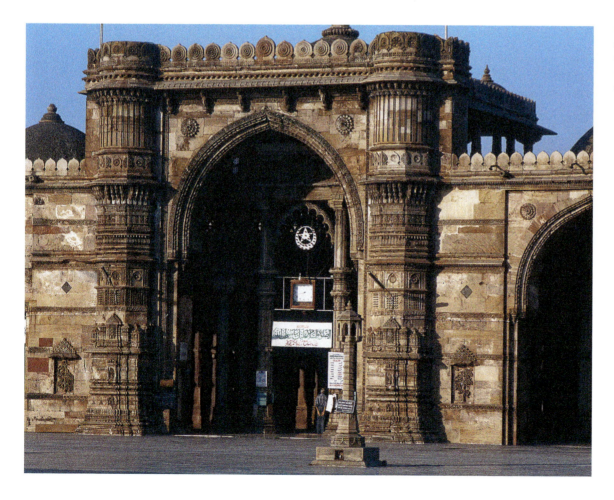

3–7 • CONGREGATIONAL MOSQUE
1411. Ahmadabad, Gujarat.

3-8 • PIERCED STONE SCREEN, SIDI SAID MOSQUE
1573. Ahmadabad, Gujarat.

3-9 • *RUSTAM KILLS THE WHITE DIV*
ca. 1425–1450. Folio from the "Jainesque" *Shahnama*, 12⅝ × 9¹³⁄₁₆"
(32 × 25 cm). Northern India; Museum Rietberg, Zurich. Gift of the
Rietberg Society.

These two screens have graceful trees at their center, from which branches and arabesques spiral out to create a design of the utmost delicacy.

THE PAINTING AND LITERARY TRADITIONS OF NORTHERN INDIA

The emergence of a strong book culture is evident from the variety of texts that have survived from the period between the thirteenth and fifteenth century. The practice of creating illustrated manuscripts had existed in India for many centuries (see Chapter 2, pp. 44–46), but it seems to have been largely limited to religious works. The literary tastes of the Persian-speaking world invigorated this native tradition, as did the Muslim practice of creating special copies of the Qur'an, which, although not illustrated, were enhanced with illumination and **calligraphy**.

The illustrated books of the period vary in style. Some are virtually indistinguishable from contemporary works made in Iran and Central Asia, the result of both artists and manuscripts moving between those regions and India. Other books show quite strong links to earlier local traditions. A manuscript known as the "Jainesque" *Shahnama*, made somewhere in northern India in the mid-fifteenth century, is an example of such a work (**FIG. 3-9**). The text of this manuscript is the Persian poem that recounts the tales of the legendary kings of Iran; composed

ca. 1000, it has been copied and illustrated hundreds of times in the Persian-speaking world.

In the episode shown here, the hero Rustam (the bearded figure with blue helmet and chain mail) kills the white *div* (demon) who has imprisoned and blinded Kay Kavus, the king of Iran. In its layout the page is typical of copies of the *Shahnama* from Iran. A rectangular area in the center is marked out with ruled borders; inside it, the rhyming Persian verses are arranged in columns around a space left for an illustration. Several other features, however, come directly out of earlier Indian styles of painting: The vibrant red background, the eye that projects from the far side of the faces, and the depiction of women with small waists and full breasts can all be traced to the Jain manuscripts. Also unusual are the depictions of Rustam, who is more typically shown wearing a tiger skin, and the white *div*, who appears more like a Hindu ascetic than the fearsome demon he is in Iranian manuscripts.

One of the most charming productions of the period comes from Mandu, the capital city of Malwa in west central India. The *Ni'matnama* (*Book of Delights*) is a series of recipes for food, aphrodisiacs, perfumes, and medical remedies. The language is Urdu, which had developed within the new Persian-speaking population of northern India, and is essentially a form of the Indian language of Hindi written in the Persian alphabet, with many loan words from Persian. The book is illustrated with 50 paintings, all showing the Malwa ruler Ghiyath Shahi (r. 1469–1500) watching as the dishes described in the text are prepared (**FIG. 3–10**). Here, the dish is a kind of minced meat—*qima*, or *keema* as it is spelled today.

3–10 • *THE PREPARATION OF* QIMA
folio 71b from the *Ni'matnama* (detail), ca. 1495–1505. Colors and gold on paper, 4⅞ × 5¼″ (12.5 × 13.5 cm). Mandu; British Library, London.

3–11 • Mahmud Shaban (copyist) *TUGHLUQ QUR'AN*
1399. Paper, ink, watercolor, gold, and leather binding colors, 11⅜ × 8¾″ (28.9 × 22.2 cm). Gwalior; Image courtesy of the Aga Khan Trust for Culture, AKM281 folio 274v-275r.

The manuscript was made between about 1495 and 1505 at the Mandu book workshop, where both Persian and Indian artists were employed. In the illustrations, the influence of the Persian artists is evident in the use of a half-profile for the figures, a tall hill in the background, and the patterning of tilework in the palace structure where the king sits. But the Indian style comes through especially in the depiction of women, as in the *Shahnama* just discussed.

The earliest known Qur'ans from India date to the late fourteenth and early fifteenth century, the same period as the earliest illustrated manuscripts, and, like them, they combine features of books made elsewhere in the Islamic world with uniquely Indian elements.

Immediately notable is the type of script employed in India—unlike the canonical scripts used for copying the Qur'an in other Muslim regions, a unique style of writing called *bihari* was employed through the fifteenth century in India (**FIG. 3–11**). In this style, the letters are tall and angular, and the final letter of each word is extended in either a horizontal flourish to the left or a swooping line that curves to the right, back to the beginning of the word. Also particular to these Qur'ans is the inclusion of Persian commentary, in zigzagging lines of script in the margins of the page, and the use of many colors of ink, such as blue, gold, red, and black. This particular copy, which has an inscription stating it was completed at the city of Gwalior, also has extensive illumination, surrounding the written text in the form of geometric and vegetal bands in jewel-like pigments.

THE DECORATIVE ARTS OF NORTHERN INDIA

Even rarer than the book arts is evidence of decorative works from the thirteenth to fifteenth century. From Orissa in the east,

however, come several pieces of ivory work that explain the fame of carvers from this region. An ivory throne leg is one of several known, each with a fantastic beast—an elephant-headed lion—grasping a defeated warrior who hangs upside-down from his trunk (**FIG. 3-12**). The beast stands astride a rocky outcrop populated with tiny trees and antelopes, rams, and boars. The leg might have come from a throne used in royal ceremonies; similar thrones were also given as gifts to temples, as described by an inscription at a temple in Puri, Orissa.

3-12 • THRONE LEG
Eastern Ganga dynasty, 13th century. Ivory, 13¾ × 6⅛ × 5⅛"
(34.9 × 15.7 × 13.2 cm). Orissa; Freer Gallery of Art, Smithsonian Institution, Washington, D.C. Gift of Charles Lang Freer (F1907.8).

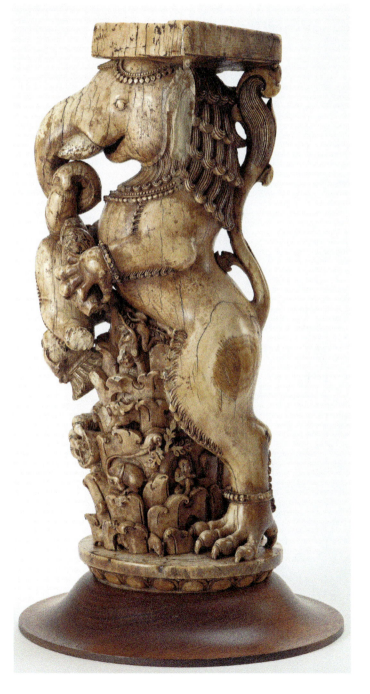

THE DECCAN SULTANATES, VIJAYANAGARA, AND SOUTHERN INDIA

Just as the fragmentation of Tughluq power led to the emergence of new ruling powers in northern India, throughout central and southern India several kingdoms were established during the fourteenth and fifteenth centuries after raids from Delhi upset the local ruling system. In the central region known as the Deccan, power was split between the Muslim Bahmani dynasty (1347–1538) and their five successor states in the north, and the Hindu kings of Vijayanagara (1336–1565) in the south. In the southernmost tip of India, the Nayakas of Madurai (1529–1736) rose to prominence in the sixteenth century.

THE SULTANATES OF THE DECCAN

During the fourteenth and fifteenth centuries, the Bahmani sultans ruled a large swathe of the Deccan, which they divided into four provinces, each ruled by a governor. Over time, as the power of the Bahmani sultans waned, these provincial governors became increasingly autonomous, and by the early 1500s they had each proclaimed their independence.

The territories of these new rulers each comprised a local population that was enriched by Persian and Arab immigrants drawn to the wealth of this agriculturally fertile and prosperous region. Adding to the rich ethnic mix were ministers of African origin who advised the Deccani sultans, and the European traders who settled at the ports along the Deccani coasts. The arts flourished under the patronage of these sultans, at the courts of Bijapur, Golconda, Ahmadnagar, and Ellichpur, as well as at Bidar, where the former ministers of the Bahmanis held sway. These artistic traditions were much influenced by the area's diverse cultural composition; but although a similar mix existed in courts to the north, particularly in the Mughal empire, the resulting artistic production of the Deccan was unique, and quite distinct from northern Indian art.

Several sultans of the 'Adil Shahi dynasty of Bijapur (1490–1686) were remarkable patrons, commissioning portraits and illustrated manuscripts, and building lofty palaces and mosques. The most celebrated is Ibrahim 'Adil Shah II (r. 1580–1627), who was an accomplished poet and musician as well as a fine connoisseur of painting. The portrait of him attributed to the painter Farrukh Husain epitomizes the Deccani aesthetic (see Closer Look, p. 60). Shaded in pastel pinks, purples, and greens, and composed of an evocative landscape with a poetic subject, it differs greatly from the images of royalty promoted by other rulers of the subcontinent (see **FIG. 3-1**).

Ibrahim was buried in a tomb constructed on the orders of his wife, Taj Sultan. The tomb is located within a walled enclosure, on a raised platform opposite a small mosque, with a water tank between them (**FIG. 3-13**). The exterior of the tomb is richly decorated with painted patterns (now very faded) and

In this painting, Ibrahim 'Adil Shah II is shown riding in a verdant forest, a trained hawk perched on his arm. The image of a king on horseback, engaged in the sport of hunting, is a common **trope** (device) of royal portraits—successful in that it portrays the ruler as powerful and virile. In this version of the image, however, a different mood is evoked by the choice of colors and the dreaminess of the landscape setting. It was probably painted by an artist named Farrukh Husain; the word "Farrukh" can be read in a minute signature on the right side of the page, and we know of an artist by that name from a history of Ibrahim's reign. This chronicle describes the artist as such: "The fourth [important] courtier is Maulana Farrukh Husain, than whose painting nothing better can be imagined…. That magical painter has put in motion the breeze which throws aside the veil from the face of the beautiful." (Translated by N. Ahmad in *Zuhuri, Life and Works*, 1953.)

Farrukh Husain **IBRAHIM 'ADIL SHAH II HAWKING** ca. 1590. Opaque watercolor on paper, 11¼ × 6⅛" (28.7 × 15.6 cm). Bijapur; Institute of Oriental Manuscripts, Russian Academy of Sciences, St. Petersburg (Ms. E 14, fol. 2).

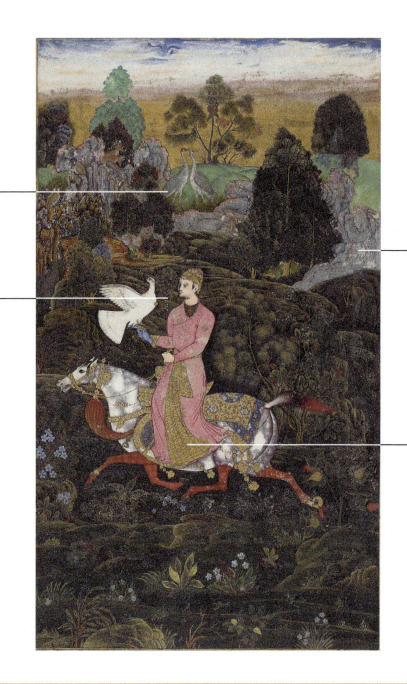

Pairs of birds and animals are a signature of late sixteenth-century works from Bijapur.

In each of his portraits, Ibrahim has a slightly different appearance, but he is most often identified by a rounded face, a slightly hooked nose, and a receding chin.

In contrast to contemporary Mughal portraits, in which the subject is set against a plain ground—usually green—here the background is a lush landscape. The fantastic rock formations in the distance are a common feature of Persian painting, and derive originally from Chinese works.

Ibrahim wears a type of gold brocaded textile that seems to have been a specialty of the Deccan in the late sixteenth century.

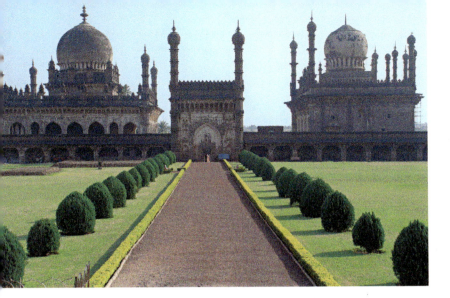

3-13 • TOMB OF IBRAHIM 'ADIL SHAH II
ca. 1627. Ibrahim Rauza complex, Bijapur.

numerous inscriptions carved in relief on the building's surface
(**FIG. 3-14**). The content of the inscriptions is a mix of Qur'anic
quotations, particularly those regarding the prophet Ibrahim
(Abraham), and Persian and Arabic poetry. Many aspects of the
tomb's other decoration, especially the carving of the eaves and

**3-14 • INSCRIPTIONS ON THE TOMB OF
IBRAHIM 'ADIL SHAH II**

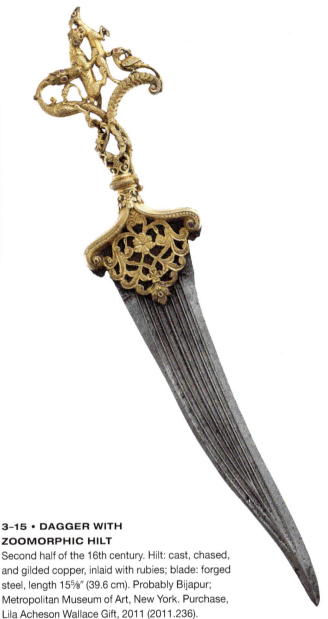

**3-15 • DAGGER WITH
ZOOMORPHIC HILT**
Second half of the 16th century. Hilt: cast, chased,
and gilded copper, inlaid with rubies; blade: forged
steel, length 15⅝″ (39.6 cm). Probably Bijapur;
Metropolitan Museum of Art, New York. Purchase,
Lila Acheson Wallace Gift, 2011 (2011.236).

supporting brackets, and the stone chains that were once sus-
pended from them, relate to earlier traditions of the area, and
can be seen in its surviving temples.

In the Deccan a rich tradition of the decorative arts also
flourished. The dagger illustrated here has a shaped and grooved
blade common to the region, but its hilt is composed of a fan-
tastic grouping of animals with blazing rubies for their eyes: A
dragon attacks a tiger who attacks a deer, whose clenched fore-
legs in turn frame a small bird (**FIG. 3-15**). This unusual type of
dagger features in royal portraits of the 'Adil Shahi sultans and so
can be directly related to that court.

In the neighboring sultanate of Bidar, a special type of metal
inlay work was developed, known as *bidri*, after the place of its
origin. The technique involves casting a vessel in the desired
shape from a special alloy of different metals, including the key
ingredient of zinc. Small channels in the form of the desired
design are then chipped out of the vessel and inlaid with brass

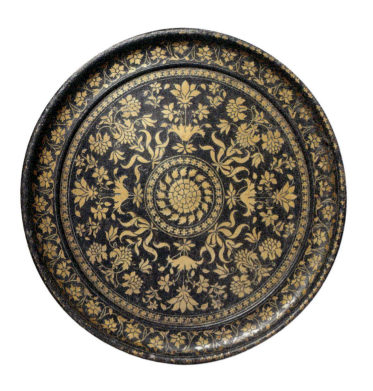

3-16 • *BIDRI* DISH
Second half of the 17th century. Bidri metal inlaid with brass, diameter 12⅔″ (32.2 cm). Deccan; The David Collection, Denmark (16/20110).

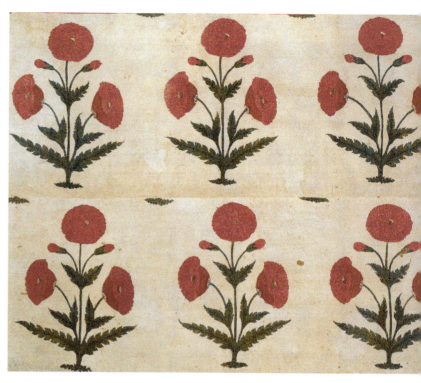

3-17 • FLOOR SPREAD FRAGMENT
Late 17th–early 18th century. Resist- and mordant-dyed cotton, 41¾ × 54″ (106 × 137 cm). Burhanpur; Victoria & Albert Museum, London.

and/or silver. The surrounding vessel is then covered with a special paste that turns the metal a matte black, which contrasts with the shiny yellow and silver inlay. Using this basic device, *bidri* craftsmen of the seventeenth century created a wide variety of designs. The tray shown here has a pattern of flowering plants around a central medallion (**FIG. 3-16**), but geometric motifs and architectural scenes are common as well.

The Deccan was also known for its *kalamkari* textiles, which involved a laborious process of dyeing (see Techniques, p. 71). The dyers producing this work were based along the eastern Coromandel coast, and they produced an astonishing range of fabrics, each designed to suit a particular local market—in northern India, Southeast Asia, or Europe. A floor spread (**FIG. 3-17**) with rows of flowering plants was clearly made for the Mughal tastes of the Shah Jahan period (see pp. 66–67), and contrasts with the figural hangings made for use at the Deccani courts.

THE KINGDOM OF VIJAYANAGARA

At the same time that the Bahmani sultans rose to power, the Hindu Sangama dynasty (1336–1485) established a capital at Vijayanagara, in the southern Deccan. Three further dynasties—the Saluvas (1485–1505), Tuluvas (1491–1569), and Aravidus (1542–1646)—also ruled from this magnificent city on the banks of the Tungabhadra River, a site studded with dramatic rock formations. In 1565, the Aravidus suffered a grievous defeat at the hands of the combined forces of the sultanates to their north. Vijayanagara was sacked, and the Aravidus relocated to Chandragiri and later Vellore, much farther south.

Despite its destruction and subsequent abandonment, Vijayanagara is still impressive today. The expansive site—covering more than 6,000 acres (2,400 hectares)—was originally divided into royal and sacred centers, and an adjacent urban core where the majority of the city's population resided. The royal center houses numerous palatial structures, many ruined but others better preserved. Most, such as the stone platforms with multiple **moldings** that must have once supported structures of wood or brick, continued earlier traditions of courtly architecture. But other buildings show evidence of influence from the Deccani sultans to the north, and, in particular, Bahmani architecture and its carved stucco decoration. For instance, a building known today as the Elephant Stables is constructed of stone, has an arched façade, and multiple domes—relating much more closely to buildings at the Bahmani capitals than to earlier royal traditions of this region (**FIG. 3-18**). Raised above the center of the building is a gallery where musicians once played; above that might have been a platform for the king to watch parades or drills in the plaza in front. His elephants would have been stationed behind the arches below, in the domed rooms that run the length of the first story.

The royal center at Vijayanagara is small in comparison to the much larger sacred center, which is filled with numerous

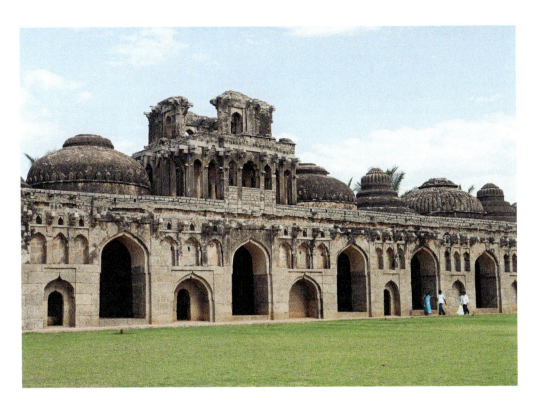

3-18 • ELEPHANT STABLES
Vijayanagara, 14th–early 15th century. Hampi, Karnataka.

temples and shrines. The site had in fact been chosen for its religious associations, for it had long been connected to the goddess Pampa, a personification of the Tungabhadra River and consort of **Shiva** in his form as Virupaksha. It is also associated with the stories of the *Ramayana*, as the location at which Rama met the monkey leaders Hanuman and Sugriva.

The temple architecture of the site reflects both the stylistic and devotional developments of the period between the fourteenth and seventeenth centuries, in which the trends of the Chola era were amplified (see Chapter 2, FIG. 2-28). In this period, temple precincts grew considerably, enclosing multiple structures built to accommodate the many festivals and

ceremonies that had become an integral part of religious life. Further, the roofs of temples and the gateways (*gopura*) into the precincts increased in height.

At Vijayanagara, there are many individual precincts, each with its own temple and set of subsidiary structures. The Virupaksha complex is the largest of these, and it has come back into active use in the present day. At its heart is a temple to Shiva, established in the tenth century; a shrine to Pampa, enlarged in the twelfth century; and various other features that were added when Vijayanagara became the Sangama capital in the fourteenth century. But the most monumental feature of the precinct is its eastern *gopura* (FIG. 3-19). Built in the sixteenth

3-19 •
VIRUPAKSHA TEMPLE
(*gopura* on right) Vijayanagara, 10th century and later. Hampi, Karnataka.

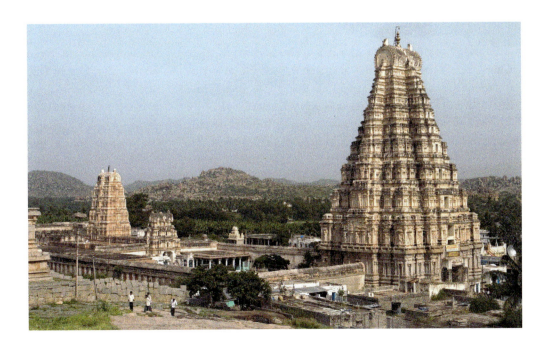

century by the king Krishnadevaraya (r. 1509–1529), it literally towers over the smaller temple to Virupaksha to which it provides an entrance. Its roof is divided into nine horizontal stories, each with numerous projections and **aedicules** (openings), leading up to a **barrel-vaulted** roof, or *sala*. Another distinctive feature of the Vijayanagara temples are the long processional streets, lined with porticos leading out from the temples. These streets were used during festivals, such as that celebrating the marriage of Pampa and Virupaksha, when images of the deities were wheeled out on chariots.

THE NAYAKAS OF MADURAI

In the early sixteenth century, with an expansion of their territories into the south, the Vijayanagara kings chose governors to rule from the provincial capitals of Gingee, Thanjavur, and Madurai. After the defeat in 1565 of the Vijayanagara king, these governors became virtually independent, although they still expressed their power in terms of fealty to their Vijayanagara overlords.

The realms of the Madurai kings, extending down to the southern end of India, prospered in the sixteenth and seventeenth centuries. In their capital city were the twin temples to Shiva as Sundareshvara and his consort Minakshi, established centuries earlier and rebuilt and renovated many times. In the Nayaka period, a huge *gopura* was added on the south side of the Minakshi temple, a donation of a wealthy landowner. This *gopura* is almost 200 feet (60 meters) tall, with nine stories and approximately 1,500 gods, goddesses, demons, and guardian figures modeled from stucco and painted in a vibrant palette (**FIG. 3-20**). This structure gives some idea what the *gopura*s of the Virupaksha and other Vijayanagara temples would have looked in the city's heyday.

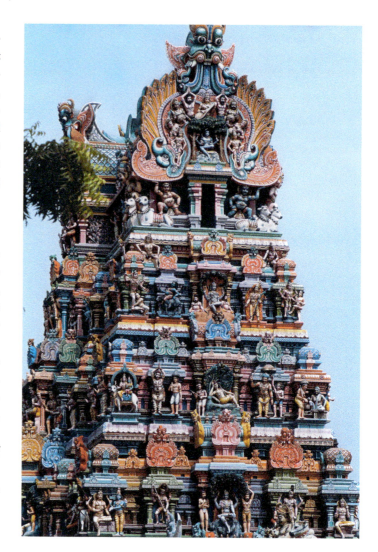

3-20 • THE *GOPURA* AT THE MINAKSHI TEMPLE (DETAIL)
16th century and later. Madurai, Tamil Nadu.

THE MUGHAL EMPIRE

Between the rise of Vijayanagara in the fourteenth century and the flourishing of the Nayakas of Madurai in the seventeenth, great changes were occurring in the northern part of the subcontinent. In the 1520s, the Mughal rulers of Central Asia united a vast part of northern India into a single empire that they ruled over for three centuries. The empire was founded by Babur, a descendant of the legendary conquerors Chinggis Khan (r. 1206–1227) and Timur (1336–1405), who had ambitions beyond the province of Fergana (in present-day Uzbekistan) that his family controlled. Blocked from expanding west by rival cousins, he followed the well-established route southeast into northern India. Babur was rather unimpressed by India—he complains in his diary about the food and the climate—but like many conquerors before him he noted: "The one nice aspect of [India] is that it is a large country with lots of gold and money." After successfully capturing Delhi in 1526, he made it his base, bringing the area between Afghanistan in the east and Bengal in the west under his control.

Babur was succeeded by his son Humayun (r. 1530–1540 and 1555–1556). The dynasty's authority was by no means secure, and in 1540 Sher Shah Suri (d. 1545), the ruler of Bihar and Bengal, forced Humayun to flee India and take refuge at the court of the ruler of Persia, Tahmasp I (1514–1576). Humayun spent 15 years in exile there, and when he reconquered Delhi in 1555, he brought back with him several Iranian artists. His young son Akbar (r. 1556–1605) succeeded him the following year, and, during his long reign, expanded and solidified control over the northern half of the subcontinent, including the regions of Rajasthan, Malwa, Gujarat, and Bengal. He also set up a solid system of administration, establishing a stable network of governors to rule his provinces. During the reigns of Akbar's son Jahangir (r. 1605–1627), grandson Shah Jahan (r. 1627–1656), and great-grandson 'Alamgir (also known as Aurangzeb, r. 1656–1707), the empire would extend farther to cover most of the southern half of the subcontinent as well, swallowing the Deccani sultanates and most of the former territories of Vijayanagara.

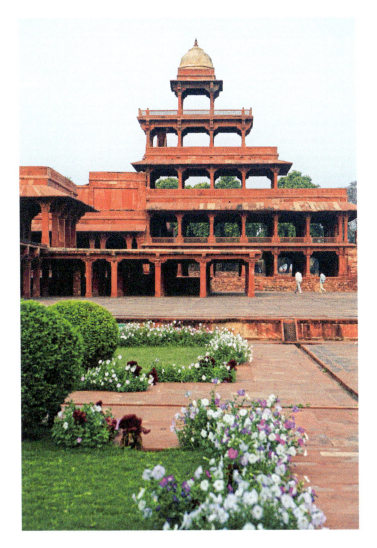

3-21 • PANCH MAHAL
mid-16th century. Fatehpur Sikri, Agra, Uttar Pradesh.

ARCHITECTURE OF THE MUGHAL EMPIRE

After Humayun's return to Delhi, the Mughal court moved repeatedly, according to the seasons and the preference of the emperors, who built numerous palaces, gardens, mosques, and tombs across their vast empire. During his reign, Akbar traveled between several capitals in the Delhi area, including that of Fatehpur Sikri. It was originally a very small settlement, but Akbar decided to build a fortified palace at the site because it was the home of the Sufi shaykh, Salim Chishti, who had predicted the birth of Akbar's son and heir, Jahangir.

FATEHPUR SIKRI Construction started at Fatehpur Sikri in 1569 and continued over the next decade. There are two components to the site: a large mosque with the tomb of Salim Chishti at the southwestern end, and the palace complex at the northeastern end. This side of Fatehpur Sikri is accessed through the impressive Elephant Gate, which opens onto a street once flanked by shops and markets used by the local townspeople, and leading to the Hall of Public Audience. The one place where contact with the emperor could be made, this hall is situated on the dividing line between the public zone of Fatehpur Sikri and the private quarters of Akbar and his court. Behind this audience hall are numerous private structures arranged around open courts, all constructed of red sandstone. Among these is the building known as the Panch Mahal, or Five-Storied Palace, set on the side of a rectangular water tank (**FIG. 3-21**). This open pavilion was probably designed to provide a shaded place of relaxation, freshened by breezes.

Also in the private zone is an audience hall for meetings between the emperor and his closest circle of advisors (**FIG. 3-22**). A rectangular structure with a balcony, pierced stone screens, and corner *chattris* (domed, unwalled pavilions or

However, the long years that Shah Jahan and 'Alamgir spent away on campaign, and the costs of those military conquests, meant the running of the empire suffered. By the end of 'Alamgir's reign, it was in decline. Delhi was sacked in 1739 by Nadir Shah of Persia, and the British East India Company began to take a more active hand in governance. After an anti-British uprising in 1857, the British crown seized direct control of the subcontinent and Mughal rule was officially extinguished in 1858.

Throughout this period, the Mughal court and its provincial governors were committed patrons of all the arts, and they oversaw a dynamic meeting of foreign and local traditions, molding them into a distinctive aesthetic of unparalleled vitality and refinement. It would prove highly influential throughout the Indian world and beyond.

3-22 • CENTRAL PLATFORM OF THE PRIVATE AUDIENCE HALL
mid-16th century. Fatehpur Sikri, Agra, Uttar Pradesh.

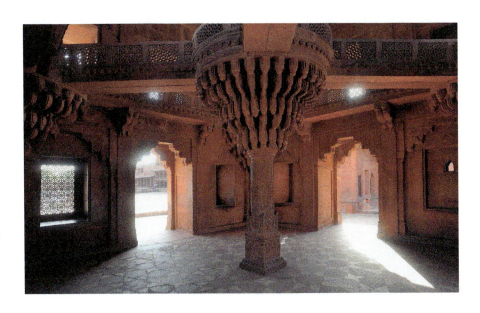

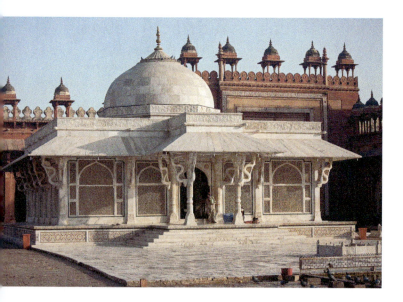

3-23 • TOMB OF SHAYKH SALIM CHISHTI
mid-16th century. Fatehpur Sikri, Agra, Uttar Pradesh.

kiosks) like so many Akbar-period buildings, the interior of this hall is structured like no other. It is dominated by a central pillar supporting a circular platform; the emperor is believed to have sat here when receiving his courtiers. He would have reached the platform by the walkways that connect it to the sides of the building. The massing of sinuous **brackets** at the top of

this pillar gives it a most unusual appearance—a feature never repeated in later buildings.

In contrast to the intimate, decorative spaces of the palace area, the mosque is a massive structure, with a large rectangular courtyard entered by a tall gate, with porticos on three sides and a prayer hall on the fourth. In the middle of this sea of red sandstone sits the elegant white marble tomb of Shaykh Salim Chishti (d. 1572; **FIG. 3-23**). Essentially a square space with a dome on top, it is surrounded on all four sides by pierced screens of varied geometric design (**FIG. 3-24**). The projecting eaves of the roof rest on serpentine brackets so delicate that they hardly seem capable of support.

SHAH JAHAN AND THE TAJ MAHAL The contrast of building materials in different colors, and of robust architectural forms with delicate details, is also a characteristic of the architecture of Shah Jahan's reign. In the 1630s, soon after coming to the throne, he completely renovated the fort at Agra, replacing the palaces built by Akbar and Jahangir with his own. These structures, such as the Musamman Burj ("Octagonal Tower"), had walls built of white marble inlaid with multicolored precious stones or carved with floral motifs in low **relief** (**FIG. 3-25**). The full flowering plant

**3-24 • VIEW INSIDE OF TOMB OF
SHAYKH SALIM CHISHTI**

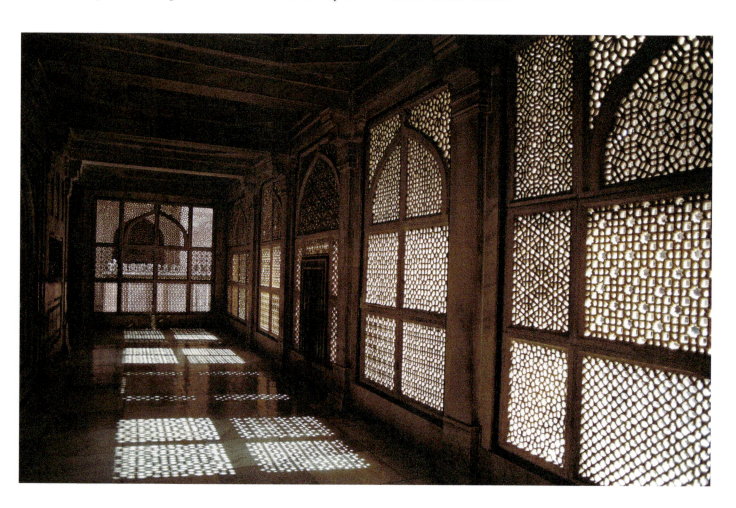

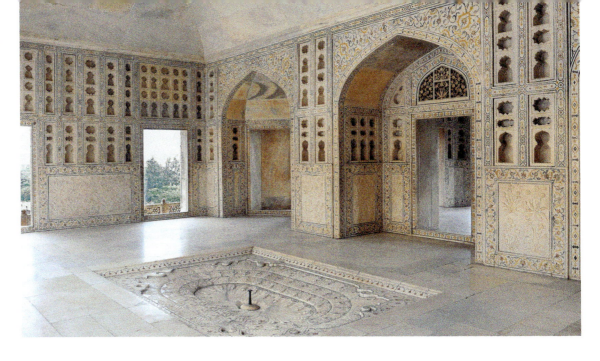

3-25 • INTERIOR OF THE MUSAMMAN BURJ

mid-17th century. Shahjahanabad, Agra Fort, Uttar Pradesh.

seen on the lower part of the walls in this room is a decorative staple of the arts of Shah Jahan's reign and can be found on luxury objects, clothing, and all over architecture of the period.

The culmination of the Mughal architectural aesthetic is the Taj Mahal, constructed between 1631 and 1643 as the funerary monument for Shah Jahan's beloved wife, Mumtaz Mahal (**FIG. 3–26**). The dazzling white tomb is set in a complex that includes a walled garden with lofty entry gateways, further gardens flanking a long central pool, two red sandstone buildings, a mosque, and a guest house. By the time of the Taj Mahal's construction, the riverfront at Agra was lined with the pleasure gardens and palaces of the Mughal court and nobility. As a result, the river acted like a street onto which the structures

faced and from which they were viewed; in this way, the placement of the tomb just by the water, rather than at the center of the garden, makes sense.

The marble masterpiece stands on a raised platform with tall minarets at each corner. The exterior of the building is square in shape, with its corners angled to create an octagon, and it has monumental porches in the center of each side. At the center is an octagonal chamber in which the **cenotaphs** (commemorative monuments erected when the body is buried elsewhere) of Mumtaz Mahal, and later Shah Jahan, were placed. Surrounding it are other, smaller chambers of different shapes and sizes.

The decoration of the building can in many ways be related to that of Shah Jahan's palaces, with a highly refined program of inlaid floral patterns created from precious stones and flowering plants carved in low relief. In this context, the floral motifs refer to the heavenly gardens of Paradise, and the theme of the afterlife is augmented by the calligraphy on the exterior of the building, with extracts from the Qur'an referring to the Day of Judgment (**FIG. 3–27**).

3-26 • TAJ MAHAL
Agra, 1631–1643.

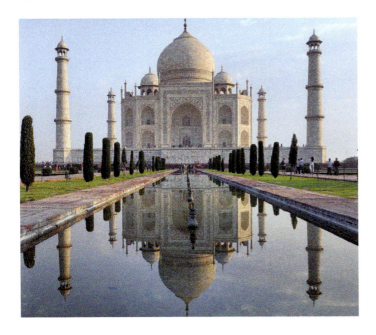

3-27 • DETAIL OF MARBLE INLAY ON THE TAJ MAHAL

PAINTING FOR THE MUGHAL EMPERORS

During the Mughal period, the tradition of manuscript illustration truly took off. Our knowledge of Mughal painting starts with the reign of Humayun, as nothing survives from the time of Babur. Much of what was produced for Humayun was strongly influenced by the work of two Iranian artists who accompanied him back to India—Mir Sayyid 'Ali and 'Abd al-Samad. A painting that represents a yet-to-be-identified event from Humayun's reign is typical of the period (**FIG. 3–28**). Many aspects of this work, such as the landscape with highly sculptured rocks and trees with pink blossoms, come directly from Iranian painting. It also shares with Iranian works the particular manner of depicting **spatial recession** by stacking background features above those in the foreground.

From these beginnings, the artists at the court of Humayun's son Akbar are credited with shaping the style of painting that has come to be considered distinctively Mughal. A manuscript entitled *Hamzanama* (*The Adventures of Hamza*) is a fascinating product of the early part of Akbar's reign, and it is key to this development (**FIG. 3–29**). Production of the *Hamzanama* was a massive undertaking that took dozens of artists more than 15 years to complete: The manuscript originally comprised 14 volumes, each with 100 pages. The paintings in this manuscript are large for Mughal works (approximately 26 × 20 inches/66 × 51 centimeters), and it appears that they were meant to be held up while the stories of Hamza, an uncle of the prophet Muhammad, were recited. These legends, popular throughout the Islamic world, involve a network of heroes, spies, lovers, and villains that extends well beyond the historical facts of Hamza's life.

3–29 • Attributed to Basavana, Shravana, and Tara *ASSAD IBN KARIBA LAUNCHES A NIGHT ATTACK ON THE CAMP OF MALIK IRAJ*
Folio from the *Hamzanama*, ca. 1564–1569. Ink, opaque watercolor, and gold on cloth; mounted on paper, 27 × 21¼" (66 × 54 cm). Metropolitan Museum of Art, New York. Purchase, Rogers Fund, 1918 (18.44.1).

3–28 • Attributed to Dust Muhammad *HUMAYUN AND HIS BROTHERS IN A LANDSCAPE*
ca. 1546. Opaque watercolor on paper, 15¾ × 8⅔" (40 × 22 cm). Staatsbibliothek zu Berlin.

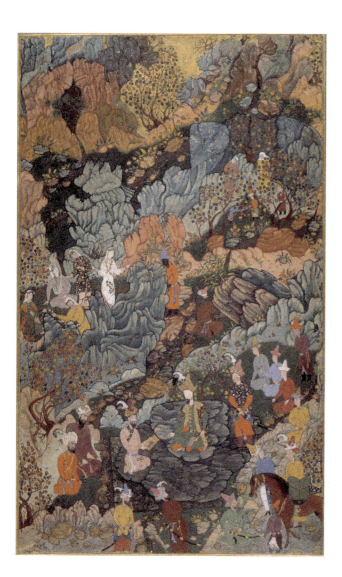

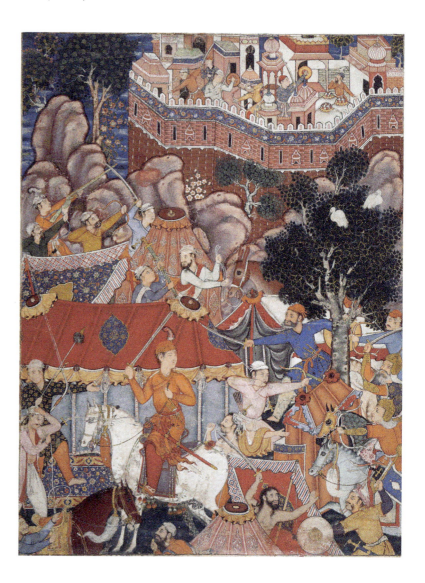

In his memoirs, titled the *Jahangirnama*, the emperor Jahangir (r. 1605–1627) recorded the important historical events and interesting happenings of his reign, along with his personal observations of those episodes. Subjects range from the outcome of battles to comments on the behavior of animals he observes while camping in certain areas. What also comes across in these accounts is his interest in painters and paintings.

The following account is taken from *The Jahangirnama: Memoirs of Jahangir, Emperor of India*, translated, edited, and annotated by Wheeler M. Thackston (1999).

Although his Majesty [Babur] wrote in his memoirs of the shapes and forms of some animals, apparently he did not order the artists to depict them. Since these animals looked so extremely strange to me, I both write of them and ordered the artists to draw their likenesses in the Jahangirnama so that the astonishment one has at hearing of them would increase by seeing them…

On this date Abu'l Hasan the artist, who had been awarded the title of Nadiruzzaman [Rarity of the Time], presented a painting he had made for the opening page of the Jahangirnama. Since it was worthy of praise, he was shown limitless favor. Without exaggeration, his work is perfect, and his depiction is a masterpiece of the age. In this era he has no equal or peer. Only if Master Abdul-Hayy and Master Bihzad [two famous fifteenth-century artists] were alive today would they be able to do him justice…

I derive such enjoyment from painting and have such expertise in judging it that, even without the artist's name being mentioned, no work of past or present masters can be shown to me that I do not instantly recognize who did it. Even if it is a scene of several figures and each face is by a different master, I can tell who did which face. If in a single painting different persons have done the eyes and the eyebrows, I can determine who drew the face and who made the eyes and eyebrows.

What makes these paintings so remarkable is the sense of action that packs each picture—an atmosphere of excitement that has been generated by the use of several different techniques. In the illustration, Assad, one of the tale's heroes, is shown as an orange-clad figure on a white horse, leading an attack against the fortress of an infidel ruler. The color palette is bright, and the figures are large in relation to their architectural and outdoor setting. Their gestures convey movement and emotion—astonishment, fear, concentration—that is reinforced by the dynamic poses of their bodies. On the other hand, the artists use a manner of depicting spatial recession that comes from Iranian paintings, and have taken advantage of it to juxtapose the contrasting patterns of tents, carpets, bricks, and tilework, heightening the visual excitement. This new style is the result of the **ateliers** (workshops) at Akbar's court being staffed by Indian as well as Iranian artists. Their collaboration created a new aesthetic that took elements from each tradition and molded them into a rich and dynamic pictorial vision.

Later in his reign, Akbar became interested in books on history, and commissioned illustrated copies of books that chronicled his own reign, those of his legendary forebears, Timur and Chinggis Khan, as well as the history of earlier Muslim dynasties of Iran, Iraq, and Central Asia. Still other manuscripts were Persian translations of native Hindu epics, such as the *Mahabharata* and the *Ramayana*. The inventiveness of Akbar's painters, and the continuing development of the new painting style, are demonstrated in a page from the *Harivamsa* (*The Legend of Hari* [*Krishna*]) depicting the blue-skinned **Krishna** holding up Mount Govardhan to protect the villagers of Braj from the rains sent by the god Indra (**FIG. 3–30**). The sculptured rocky formation that represents

3-30 • *KRISHNA HOLDS UP MOUNT GOVARDHAN TO SHELTER THE VILLAGERS OF BRAJ*
Folio from the *Harivamsa* ("The Legend of Hari [Krishna]"), ca. 1590–1595. Ink, opaque watercolor, and gold on paper, 11⅜ × 7⅞" (28.9 × 20 cm). Metropolitan Museum of Art, New York. Purchase, Edward C. Moore Jr. Gift, 1928 (28.63.1).

Mount Govardhan is painted in a manner with a long history in Persian painting, with pastel colors and highly articulated ridges. The depiction of the figures, by contrast, has no Persian precedents. The individualized portrayal of each character, with distinct facial features, clothing, and body type, is characteristic of the new painting style at Akbar's court. So, too, is the inclusion of vignettes unrelated to the main subject of the painting—a white-turbaned man overcome by sleep; a woman resting her head on her hand and gazing dreamily out at the viewer.

Under Akbar's successors, Jahangir and Shah Jahan, illustrated manuscripts continued to be produced, but in their reigns it was the development of portraiture that took center stage. Working for Jahangir, artists created a series of **allegorical** (symbolic) images that embodied the emperor's spiritual and temporal aspirations. Such paintings, which were not produced to illustrate the text of a particular manuscript, were pasted onto sheets of paper with beautifully decorated borders and assembled into albums, usually along with samples of calligraphy written by famous calligraphers that had been carefully collected by the Mughal emperors.

While some of Jahangir's portraits show the emperor defeating or overshadowing rival rulers, others play up aspects of his private life and his religiosity. In one metaphor-laden image, Jahangir sits atop an hourglass, presenting a book to Shaykh Husain Chishti, who was head of the Chishti order of Sufis in Ajmer (see FIG. 3-1). The painting intends to demonstrate Jahangir's personal and intellectual connections to the shaykh, which are underscored by the fact that he is ignoring the two other figures in the image—an Ottoman sultan (a generalized image rather than a portrait of a specific monarch) and the English king James I. Aside from the novel subject matter, painting of the Jahangir period can be distinguished from works made for Jahangir's father by a move away from vigorous activity and bright colors to an atmosphere of royal serenity and a more subdued palette.

In the eighteenth century, Mughal court painting took a different turn. Although artists working for the emperor took the names of the famed painters of the Jahangir and Shah Jahan eras, their paintings were quite different in conception and execution. Kalyan Das, who was known as Chitarman II (after a

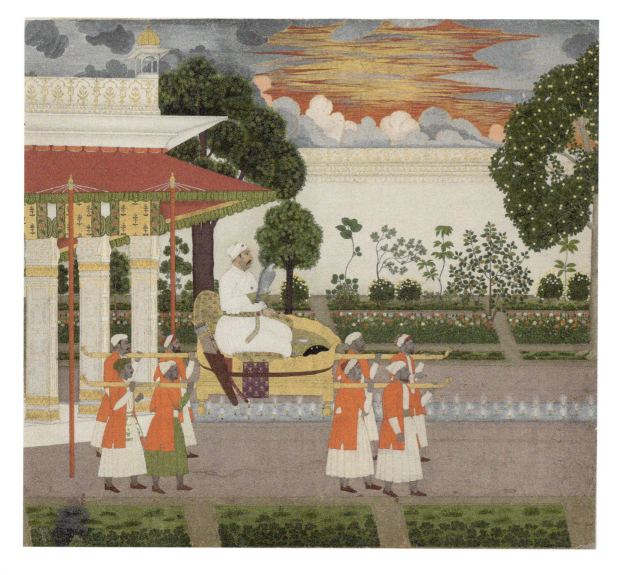

3–31 • Attributed to Chitarman II *MUHAMMAD SHAH IN A PALANQUIN* Mughal dynasty, ca. 1730–1740. Opaque watercolor and gold on paper, 15³⁄₁₆ × 17¹⁄₁₆″ (38.6 × 43.4 cm). Museum of Fine Arts, Boston. Arthur Mason Knapp Fund (26.283).

Cloth woven of cotton must be prepared to accept and retain dyes. In India, this was accomplished by first dipping the cloth into a mixture of water and juice from the myrobalan fruit, wetting and drying the cloth several times. A special material called a mordant, or fixative, was then applied to the cloth with a stylus (called a *qalam* or *kalam*, from the Persian word for "pen"). After the mordant was applied to the cloth, the dye was added to the prepared areas with the same block or penlike tool. By varying the composition of the mordant, the same dye could yield different results. For instance, a dye derived from the roots of the madder plant could make red with a mordant containing alum; black with a mordant containing iron; and violet and brown with a mordant containing a mixture of both. Then wax was applied to the entire cloth except for the areas to be colored blue; these exposed areas would pick up the color when the cloth was dipped in a vat of indigo dye. Areas previously dyed red could also be left exposed so that the blue dye overlaid the red to create the effect of purple. In a similar way, green was created by applying yellow dye to areas already stained blue. At the end of the dyeing process, the colors were fixed by putting the cloth into a vat of water with the root of the chay plant. The textile shown here was once part of a longer hanging with several similar panels, and would have taken weeks to create by this method.

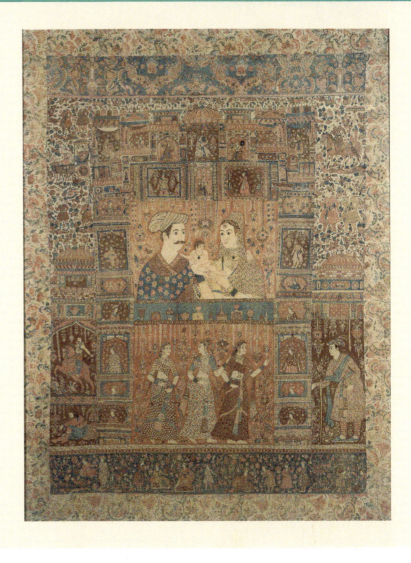

KALAMKARI WITH FIGURES IN AN ARCHITECTURAL SETTING
ca. 1640–1650. Resist-dyed cotton, painted, 8'3½" × 6'5" (2.53 × 1.96 m). Metropolitan Museum of Art, New York. Gift of Mrs Albert Blum (20.79).

mid-seventeenth-century painter of that name, about whom, ironically, we know little today), was in charge of the painting workshop of the emperor Muhammad Shah. His portrait of the emperor being carried on a palanquin embodies this new style (**FIG. 3-31**). Gone are the wealth of details and intimate nature of the allegorical portraits of Jahangir (see FIG. 3-1). This portrait is much larger and makes its impact instead with colors and composition, but in a manner quite different from that of the similarly bold Akbar-period works. Passages of white operate as a foil for the warm golds, oranges, and reds of the flowers and textiles, and the contrasting cool greens of the vegetation. The calm of the activity in the garden is brought into tension by the gold-streaked sunset and gathering clouds on the horizon.

DECORATIVE ARTS FROM THE MUGHAL COURT

The textiles and decorative objects associated with the Mughal court are among the most sumptuous from India: The vast wealth of these emperors matched their expensive tastes for carpets of pashmina silk, clothing woven from gold- and silver-wrapped thread, and objects made of rock crystal and nephrite jade, studded with diamonds and rubies. These are the items we must imagine inside the palaces described above, warming and enlivening their hard stone surfaces.

Carpet production may have existed before the sixteenth century in India, but the evidence is slim, and so the emperor Akbar is usually credited with the development of the tradition. Carpet workshops in the capitals at Lahore, Agra, and Fatehpur Sikri were started in the 1580s and 1590s with the assistance of weavers from Iran, where carpet-making on a commercial scale was well established by this time. The Mughal workshops were responsible for producing carpets for the royal palaces, for the tent encampments used by the emperors when traveling, and, to a lesser extent, for foreign trade. Although the quality and style of Indian carpets were much admired in Europe, commerce was limited because it took several months to produce each one.

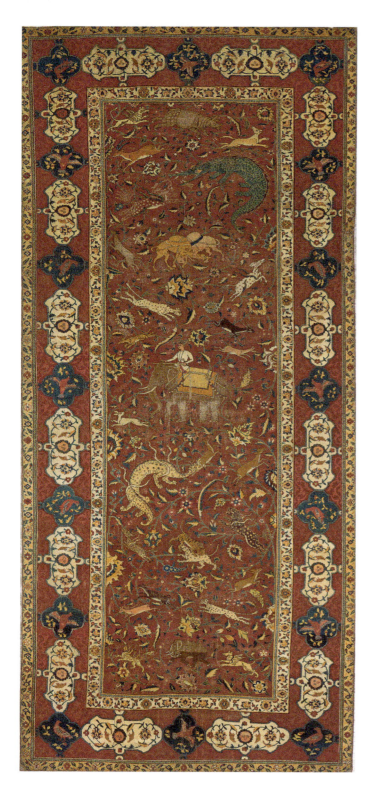

compartments in the border—of a common type of Persian carpet. But the central scrolling vine is inhabited by exotic animals found only in India, such as crocodiles, elephants, and rhinoceroses. The deep red palette also distinguishes the Indian carpets of this era. The modeling of the images on this and other pictorial carpets, with figures, animals, and architectural scenes, can be compared to illustrations in manuscripts of the Akbar period. This makes sense, as the artists who created the paintings had their atelier in the palace and created designs for the whole range of imperial production, from paintings to carpets, and from luxury objects to furniture.

In decorative objects, the Mughals had a taste for jade. This was inspired in part by the fact that their great ancestor Timur had prized this material, a rare **hardstone** that before the eighteenth century was found only in parts of Central Asia and China. The Mughals collected important Timurid jade objects and also commissioned new items that, over time, developed a style very different from their Timurid prototypes. An elegant wine cup belonging to Shah Jahan, sized perfectly to fit in the palm of the hand, derives its shape from Chinese wine cups that have a gourdlike form with a ribbed interior (**FIG. 3-33**). However, the naturalistic ram's head in which the stem of the

3-33 • WINE CUP OF SHAH JAHAN
Mughal dynasty, 1657. White nephrite jade, 7⅜ × 5½″ (18.7 × 14 cm). Northern India; Victoria & Albert Museum, London.

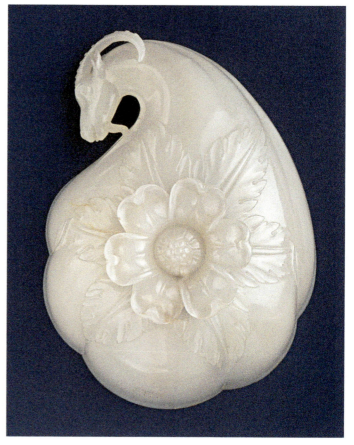

3-32 • CARPET WITH PATTERN OF SCROLLING VINES AND ANIMALS
ca. 1625. Wool pile on cotton warp and cotton weft, 13′7¾″ × 6′3³⁄₁₆″ (4.16 × 1.91 m). Northwest India; National Gallery of Art, Washington, D.C. Widener Collection (1942.9.475).

Because of the connections to weavers from Iran, most of the early carpets from India have Persianate designs. A very large carpet, probably for an audience hall (**FIG. 3-32**), has the basic structure—a scrolling vine in the main field, a patchwork of

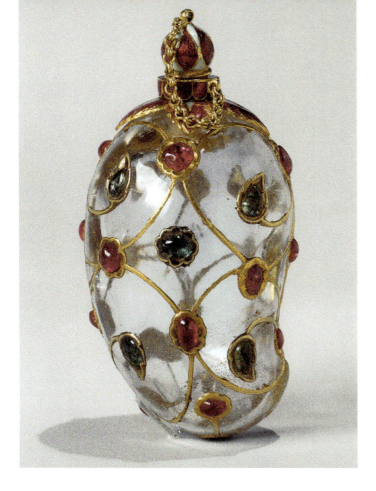

3-34 • MANGO-SHAPED FLASK
Mughal dynasty, mid-17th century. Rock crystal, set with gold, enamel, rubies, and emeralds, height 2½″ (6.5 cm). Metropolitan Museum of Art, New York. Purchase, Mrs. Charles Wrightsman Gift, 1993 (1993.18).

3-35 • WRITING BOX
1587. Lacquered teak and mother-of-pearl, 3⅜ × 4¼ × 14¼″ (8.7 × 10.8 × 36.2 cm). Gujarat; Freer Gallery of Art, Smithsonian Institution, Washington, D.C. (F1986.589-c).

gourd terminates was borrowed from seventeenth-century European decorative arts; this had been a popular type of **finial** in Europe since antiquity. The connection to Timur comes through in a third decorative element of the cup, an inscription giving Shah Jahan's title, "Second Lord of the Conjunction," imitating Timur's title, "Lord of the Conjunction," chosen because his birth was at the exact moment of an auspicious conjunction of two favorable planets.

Rock crystal is another extremely hard material that, like jade, can be shaped only by using abrasives to wear away the excess material. With this in mind, the range of rock crystal vessels created in the Mughal period—hollow in the interior and delicately shaped on the exterior—is all the more impressive. A small mango-shaped flask (**FIG. 3-34**) is embellished with rubies and emeralds set in a bed of specially purified gold called *kundan*. Such gold was refined to the point at which it was soft at room temperature, so that it would adhere to both gems and the object to be inlaid. This flask might have once held perfume.

Outside the court, workshops throughout the country created a variety of goods, with each region specializing in different materials and utilizing unique decorative motifs. From Bengal came monochrome quilts embroidered with mythological scenes, and from the southeastern Coromandel coast came the *kalamkaris* described above (see Techniques, p. 71 and FIG. 3-17). The region of Gujarat produced colorful embroidery and objects inlaid with mother-of-pearl. The individual inlaid elements, the material for which was culled from the interior of mollusk shells, were carved or worn away by acid to achieve the desired shape, and then polished to a shine. The writing box shown here belongs to a larger group, thought to have been made for export to the Middle East (**FIG. 3-35**). The background decoration includes spiraling vines, geometric designs, and small figures; these elements frame Persian verses that refer to pens and writing, and thereby the function of the box.

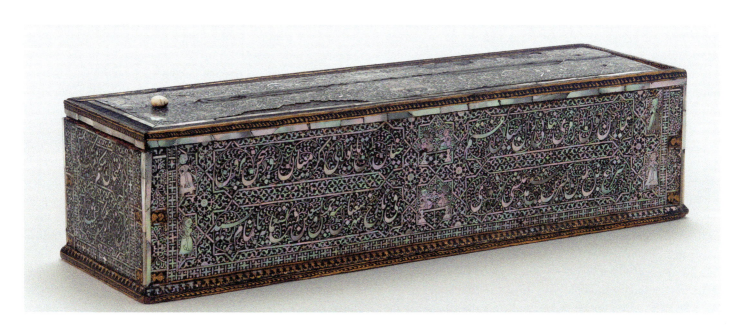

EUROPEANS AND EUROPEAN ART IN INDIA

Another cultural stream introduced into India in the sixteenth century came from Europe, after Portuguese explorer Vasco da Gama's discovery in 1498 of a shipping route directly from Europe to eastern Asia. This route, passing around the southern tip of Africa, greatly facilitated mercantile exchanges between the two regions. It also allowed European trading companies to convey desired Asian goods themselves, rather than awaiting their arrival via overland routes that operated at the mercy of foreign governments and were subject to heavy taxes. As a result, traders and diplomats representing different European nations started arriving on Indian shores to negotiate and coordinate this enormously lucrative trade.

The first to come were the Portuguese, who by 1510 had established a colony at Goa, on India's west coast, not far from Mumbai. Within a few years they had also settled on the east coast near Calcutta at Hughli. Eventually the Portuguese would be eclipsed by the English East India Company, which received its charter in 1600, and the Dutch East India Company, which commenced operations in 1602. The French state sponsored its first voyage in 1603 and eventually established a settlement at Pondicherry, but their commercial presence was limited.

Operating from the permitted ports on the west and east coasts of the subcontinent, some of the major items these traders sought were Indian textiles, particularly the aforementioned types from Gujarat, Bengal, and the Coromandel. These were prized back home as well as in Southeast Asia, where they could be traded for the spices that fetched very high prices in Europe.

Although the role of these European traders changed over the course of the seventeenth century (see Chapter 4, p. 81), the trade agreements were initially mutually beneficial, and the meeting of the two cultures was one of reciprocal curiosity. The quality of Indian handiwork and the splendor of the Mughal court impressed the Europeans, while European religions and habits were of particular interest to the Indians. The emperor Akbar invited Jesuit priests to his court and held debates among Christian, Hindu, and Muslim theologians at a specially built House of Worship at Fatehpur Sikri. European figures, in their distinctive dress, started to appear in paintings, as in a depiction of an event in 1633 at the court of Shah Jahan (**FIG. 3-36**), in which Portuguese men paying obeisance to the emperor are depicted in their distinctive black brimmed hats, collar ruffs, and voluminous breeches.

The art of Europe was another source of fascination. The representatives of the different companies to the various courts of India brought gifts to the rulers with whom they wished to negotiate. The exotic nature of these items was often their most valuable quality: Akbar was sent a pipe organ along with a musician who could play it, while the Portuguese supplicants in the Shah Jahan painting present a box and trays that appear to be

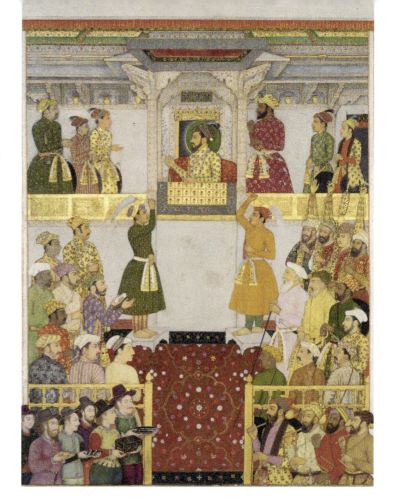

3-36 • EUROPEANS BRING GIFTS TO SHAH JAHAN
Folio from the *Padshahnama*, 1657. Ink, opaque watercolor, and gold on paper, 23$\frac{1}{16}$ × 14$\frac{1}{2}$″ (58.6 × 36.8 cm). Royal Library, Windsor Castle (RL OMS 1621, f.43b).

Japanese black *namban* lacquerware. (*Namban* is a Japanese term for Europeans meaning "southern barbarians." It refers in this case to lacquerware intended for export; for *Namban* screens see also Chapter 14, pp. 346–347.)

However, the many oil paintings and engravings sent from Europe had a more long-lasting effect, eliciting a range of responses from Indian artists. On the one hand, they took an interest in the techniques employed by European artists, such as rendering the volume of objects and people by modeling and shading. Scholars have also attributed a greater interest in accurate portraiture to a study of European paintings, especially the portraits sent by the monarchs of England and the Netherlands.

But just as interesting to local artists was the subject matter of the European works. A Mughal copy of *The Deposition from the Cross* is based on an engraving of a painting by the Italian Renaissance artist Raphael (**FIG. 3-37**). In it we see the Indian artist attempting to capture the emotional tenor of the moment, conveyed by the posture, gestures, and expressions of the figures in the scene. He revels in depicting their flowing drapery, which flutters from every part of the image. Moving from early works

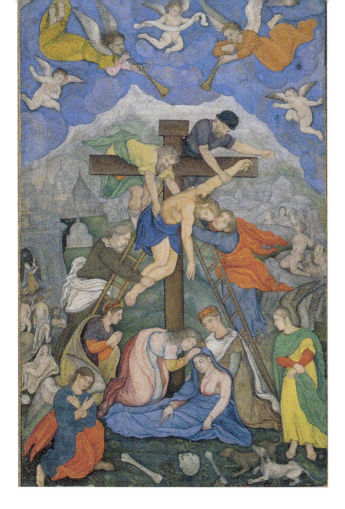

3-37 • THE DEPOSITION FROM THE CROSS
ca. 1598. Opaque watercolor and gold on paper, 7⅝ × 4⅝″ (19.4 × 11.7 cm). Lahore, Pakistan; Victoria & Albert Museum, London.

such as this, Mughal artists continued to experiment, and the impact is apparent in later paintings, such as the allegorical portrait of Jahangir discussed earlier (see FIG. 3-1). This work makes use of **iconography** borrowed from European sources (the *putti*, the hourglass, and the English king), as well as technical devices (most notably, the three-dimensional figures wearing draped and folded clothing). By the Jahangir era, these elements had harmonized into a wholly Mughalized style, quite transformed from the reign of Akbar.

ART AND ARCHITECTURE OF THE RAJPUT COURTS

Surrounding the Mughal court in northern India were a number of satellite princely states, located in the regions of Rajasthan to the west and the Pahari Hills to the north. After Akbar's many mid-sixteenth-century conquests, these states became subject to the Mughal emperors, and the subsequent relationship between the Rajput courts and the Mughal imperial capitals is one of long-standing debate. Today, rather than seeing influence radiating out

from Delhi, Agra, and Lahore, the relationship is understood as being more symbiotic, if not mostly independent.

DRAWING AND PAINTING

In southeastern Rajasthan, artists from the kingdom of Kota produced drawings distinct from anywhere else in India. Kota had been part of the state of Bundi until 1624, when Bundi was divided by decree of Jahangir in order to reduce its power. The division was formalized in 1631, establishing Kota as an independent political power and a center for the patronage of the arts.

Employing a totally different approach to the surface of the page and the application of color from the other Rajput schools, the Kota drawings are dynamic and lively. They use set themes and similar compositions, so there is a coherence to the body of works produced during the decades between the mid-seventeenth and mid-eighteenth century. A painting entitled *An Elephant Hunt* takes up the most common subject in Kota painting and its fascination with the strength and might of the elephant's body (FIG. 3-38). Here, the elephants are set within a larger scene in a wooded landscape, with a lotus-filled pond in the foreground. The elephants are drawn with only black ink, strong shading, and contouring that gives them a tangible heft. Elsewhere, the paper itself is left visible and washes of color, rather than opaque fields of pigment, are used to define foliage and sky. The name of only one Kota artist, Niju, is known, and his name appears on a single painting. The similarity in style between that work and the one illustrated here has led to its attribution to him.

3-38 • Attributed to Niju AN ELEPHANT HUNT
Kota kingdom, ca. 1730–1740. Vellum, 17¾ × 20¼″ (45 × 51.5 cm). Kota, Rajasthan; Chester Beatty Library, Dublin.

The state of Mewar most famously retained a degree of autonomy: Its princes did not have to attend Mughal audiences, and its princesses were not forced to marry into the imperial family. The art of this court also took a route of development independent from painting and architecture made for the Mughal emperors. The rulers (*ranas*) of Mewar were initially based at the fortress of Chitor (see FIGS. 3-5 and 3-6), and moved to their new capital, Udaipur, after Chitor was captured by the Mughals, after repeated attempts, in 1568. The primary subject of Mewar paintings from the sixteenth and seventeenth centuries was traditional literature, and the works are composed of flat, opaque fields of bright color. With the eighteenth century, however, came the development of large-scale portraits of the *ranas* participating in lively festivals, visiting temples, hunting, and sharing intimate moments with the ladies of the court.

The genre blossomed during the reign of Maharana Sangram Singh II (r. 1710–1734), himself depicted in a painting watching wrestlers in the courtyard of the Udaipur City Palace (FIG. 3-39). The Maharana sits on a platform under a canopy at the center of the painting. As in Mughal portraits, his presence is emphasized by the luminous halo around his head, and the fact that he is depicted larger than the surrounding figures. Architecture in white contrasts with splashes of color throughout the scene, as in the near-contemporary paintings

of Muhammad Shah (see FIG. 3-31). However, the size and other features of the Udaipur painting are distinctive of this eighteenth-century Rajput school. The painting's multiple perspectives combine so that several parts of the palace, not just the courtyard, are visible. We are afforded a view of side courtyards where other members of the royal family and retinue watch the proceedings, and service areas where servants toil away. The action is portrayed through the use of **continuous narrative**. Although it initially appears that a group of wrestlers performs for Sangram Singh, it eventually becomes evident that it is the same pair—one wrestler in black-striped shorts and the other in red-striped shorts—who tussle in multiple poses.

ARCHITECTURE

The architecture of the Udaipur City Palace, backdrop of this and so many of the Mewar paintings, demonstrates a similar relationship to contemporary Mughal traditions (FIG. 3-40). While utilizing some of the same architectural vocabulary as Mughal palace architecture—white marble, baluster columns, **cusped arches**, and pierced screens shading windows—it retains many distinctive qualities. The palace was built on the banks of the artificial Lake Pichola, with men's and women's quarters, a temple, and other small pavilions ranging back from the large public courtyard depicted in the painting of Sangram Singh. These are connected by small tunnel passages meant to disorient the visitor (or attacker) and, unlike the Mughal palaces, are not arranged symmetrically.

At the palace complex of the Kacchwaha kings at Amber, developed between the 1590s and 1720s, another facet of the relationship between Mughal and Rajput architecture is demonstrated. This fortress palace in northwestern Rajasthan was placed within mid-twelfth-century walls. Raja Man Singh

3-39 • Rajput school MAHARANA SANGRAM SINGH II AND DURGA DAS RATHORE OF JODHPUR WATCHING JETHI WRESTLERS AT MANEK CHOWK, CITY PALACE, UDAIPUR
1715–1718. Gouache on vasli, 16⅞ × 13″ (43 × 33 cm). City Palace Museum, Udaipur. Image courtesy Pictorial Archives of the Maharanas of Mewar, Udaipur 2012.19.0028.

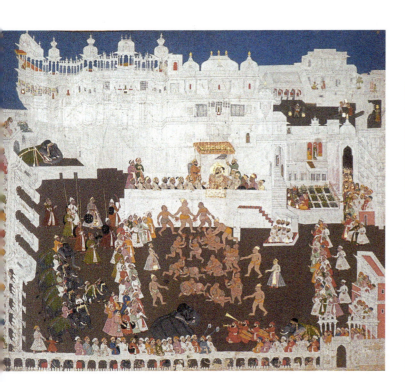

3-40 • CITY PALACE
1559 and later. Udaipur, Rajasthan.

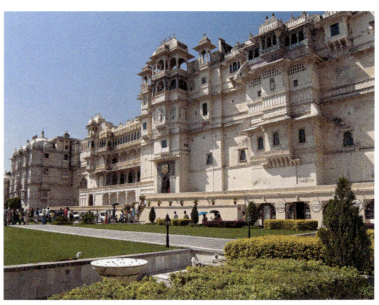

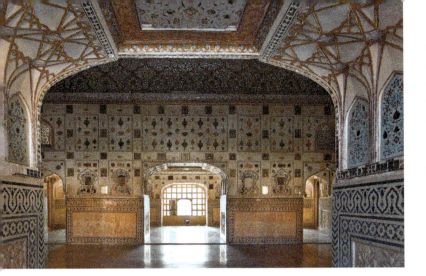

3-41 • INTERIOR OF JESS MANDIR
1635–1640. Amber (Amer) Fort, Amber, Rajasthan.

(r. 1590–1614) started construction at the south end of the citadel, with a set of buildings arranged around a courtyard. Additional courtyards, with their own structures, were built to the north by his successors Jai Singh I (r. 1623–1667) and II (r. 1699–1744), and Raja Man Singh's palaces were transformed into women's quarters.

In many respects, the structure comprising the Jai Mandir and Jess Mandir (1635–1640; **FIG. 3-41**) is similar to contemporary works built for Shah Jahan; the comparison is often drawn to the latter's Anguri Bagh at Agra. Both have pavilions of white marble facing a formal garden, and these pavilions incorporate curving eaves flanked by small domes, cusped arches, and pairs of slender columns on square bases. In addition, the mirror-work decoration of the Amber palaces takes the themes of cypress trees and floral vases also found in Mughal buildings. But the arrangement of the different elements, and the placement of pavilions one atop another, creates a different sense of space.

PAINTING FROM THE PAHARI COURTS

An area called the Punjab Hills, in the foothills of the Himalayas, was home to another series of courts, albeit less powerful than those in Rajasthan. Not much is known about the patronage of the arts here before

the seventeenth century, but a distinct tradition was already evident by this point. Unlike in Rajasthan, where a certain court style dominated the work of the many artists who might have worked there, at the Pahari courts it appears that families of artists developed their own styles. These are recognizable regardless of which **patron** they were for, or what center the artists worked at.

PANDIT SEU, MANAKU, AND NAINSUKH

The work of Pandit Seu (ca. 1680–ca. 1740), his sons Manaku and Nainsukh, and their children serves as an example of this form of transmission. Pandit Seu worked at the court of Guler. His works displayed a fairly conventional style until late in his career, when he started to experiment with portraiture and working with breaking up the background of his paintings into a series of receding planes.

His elder son, Manaku (fl. ca. 1725–1760), appears to have gone through a similar progression, moving toward greater naturalism in his own career at Guler. A painting by Manaku captures an episode from the *Ramayana*, in which Ravana, the multiheaded king of the demons, seen seated on the balcony at the top of the page, sends spies to the camp of the hero Rama (**FIG. 3-42**). Rama allows them to enter, and the two spies stand surrounded by the army of monkeys Rama has assembled to rescue his wife, Sita, from Ravana's clutches. The spies, later seen entering Ravana's palace and reporting back to him, must confess that Rama's army appears terrifyingly strong. Like his father, Manaku has used the conventional composition—a high horizon line, above which is a sky in washes of white and blue, and below which is a monochrome landscape with trees bearing individual leaves shown against a green, tree-shaped mass. But it is believed that by the end of his career, Manaku had started to employ some of the naturalistic devices more associated with his brother Nainsukh's oeuvre.

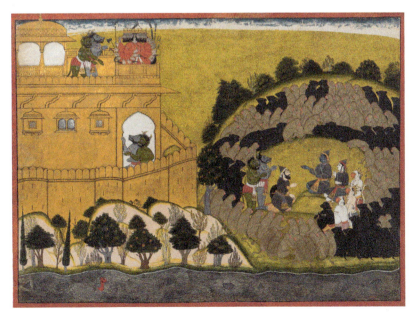

3-42 • Attributed to Manaku RAMA RELEASES THE DEMON SPIES SHUKA AND SARANA
Folio from a *Ramayana* "Siege of Lanka" series, ca. 1725. Opaque watercolor, ink, and gold on paper, 24½ × 32⅝" (62.2 × 82.9 cm). Punjab Hills, Guler; Metropolitan Museum of Art, New York. Rogers Fund, 1924 (19.24.1).

This aspect of Nainsukh's (ca. 1710–1778) work is said to have come from a study of Mughal painting while working for the rulers of Jasrota and, in particular, during the course of a close relationship with the ruler Balwant Singh (r. 17??–1763). Careful likenesses, a plausible depiction of space, cool colors, and a sense of stillness—these attributes of Nainsukh's work might also describe Mughal portraits from the first quarter of the seventeenth century onward. What is notable about Nainsukh's many portraits of Balwant Singh, however, is that he appears without artifice, in private moments and in a solitude that stands in contrast to most official portraits. In comparing *Balwant Singh Relaxing at a Fireplace* (**FIG. 3-43**) to the image of Sangram Singh watching Jethi wrestlers in front of his palace (see **FIG. 3-39**), a certain frailness and loneliness comes through in the former, in which the ruler is surrounded only by servants, with no companions, huddled against the cold.

VISUAL TRADITIONS OF THE SIKH RELIGION

Following in the rich tradition of spiritual innovation in South Asia, yet another religion developed in the fifteenth century. Sikhism was founded by Nanak, born in 1469, and the meaning of its name—"religion of the disciples"—reveals its emphasis on study as the path to an understanding of God and the universe. In Sikhism, there is a single, eternal God, to whom an individual must be devoted in order to overcome a cycle of rebirth. In order to reach God, the individual must learn from the teachings of Nanak and his ten successors, or **Gurus**, with the assistance of learned

men. Thus the place of gathering and worship in the Sikh faith is the *gurudwara* (literally, "door to the Guru"), devoted to the recitation and study of the Adi Granth, a compilation of the teachings of the first five Gurus.

Another distinguishing feature of the religion are the customs instituted by the tenth and final Guru, Gobind Singh (1675–1708), which served to unite the community against official persecution, especially at the hands of the Mughal emperors Jahangir, Shah Jahan, and 'Alamgir. Under his instruction, all Sikh men take the honorific name Singh (Lion) and never cut their hair; they also always carry with them a steel bracelet, a comb, and a dagger, and wear a particular type of undergarment.

THE GOLDEN TEMPLE

The Harimandir, or Golden Temple, in the sacred city of Amritsar (meaning "Pool of Nectar") is the monument most closely identified with the religion (**FIG. 3-44**). The site for this, the most sacred *gurudwara*, is a lake discovered by the second Sikh Guru and used by subsequent Gurus as a location for meditation. The original temple at the site was built in 1604 by the Guru Arjun (1581–1606). After being destroyed several times, it was rebuilt in its current form by Maharaja Ranjit Singh (r. 1801–1839), who consolidated a powerful Sikh kingdom based in Lahore. The gold foil cladding added by him to the structure gives it its popular name.

The building stands in the lake and is reached by a causeway. In form, its white marble exterior inlaid with floral motifs, and its use of corner *chattris* and projecting balconies, is not dissimilar to contemporary Mughal and Rajput palace architecture. In function, the focus of the building is its scriptures, as the building was conceived "as a repository of rational thought" rather than the place of prayer to a god. Thus the front part of the building is dedicated to a shrine housing the Adi Granth, while the back provides access to the holy water of the surrounding lake.

BOOK ARTS

The arts of the book naturally form an important part of the Sikh religious tradition, and special copies of the sacred texts were made for use in the *gurudwara*. The paintings in these books, and other works associated with the court at Lahore, demonstrate the strong connections between the artists working for Sikh patrons in the Punjab and those, such as Manaku and Nainsukh, working at the courts of the Pahari states.

During the eighteenth and nineteenth centuries the Dasam Granth ("Book of the Tenth King") became especially influential. The book is attributed to the Guru Gobind Singh and was compiled in 1730. It contains the Guru's autobiography and several devotional works; as well as being housed in *gurudwaras*, such books were carried by individuals as they traveled and by armies on campaign.

This nineteenth-century copy has a frontispiece with images of the Hindu god Ganesh and goddess Sarasvati, and portraits of the ten Gurus arranged in the form of two lotuses; here, the left

3-43 • Attributed to Nainsukh BALWANT SINGH RELAXING AT A FIREPLACE
ca. 1755–1760. Colors on paper, 10¹⁄₁₆ × 13⅝" (25.6 × 34.8 cm).
Pahari region; Museum Rietberg, Zurich. Gift of Lucy Rudolph.

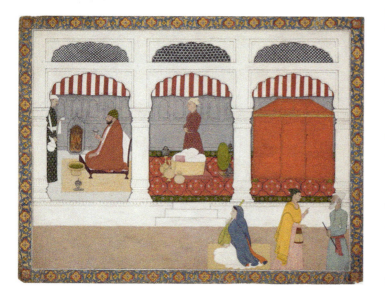

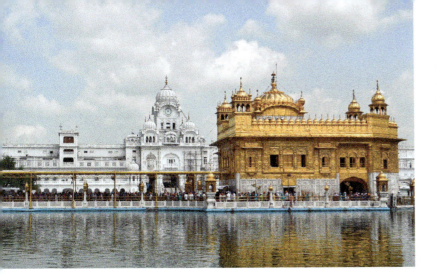

3-44 • GOLDEN TEMPLE
1604 and later. Amritsar, Punjab.

side is shown (**FIG. 3-45**). The Hindu gods were relevant because in both traditions Ganesh is considered the remover of obstacles and is often pictured or invoked at the beginning of books, while Sarasvati is revered as the goddess of learning. Drawing initially on traditional, verbal descriptions, the portraits of the Gurus became standard iconographies of the historical figures. For instance, the first Guru, Nanak, to the left of Ganesh, is always shown as an aged, white-bearded man whose companion Mardana sits next to him, playing the *rabab*. Although taking a more naïve form, these portraits can be related to the portraiture of the Punjab Hills (see p. 77).

3-45 • LEFT SIDE OF A DOUBLE-PAGE FRONTISPIECE TO A DASAM GRANTH MANUSCRIPT DEPICTING THE TEN GURUS
1850. Gouache and gold on paper, 13⅞ × 13″ (35.4 × 33 cm).
Amritsar, Punjab; British Library, London.

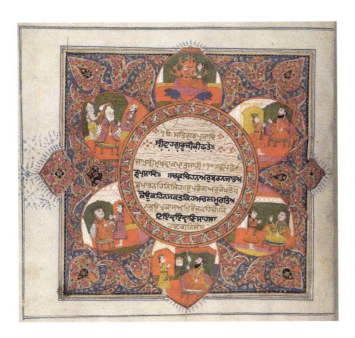

The flourishing of a multitude of traditions set this period apart from those that had preceded it. As India received an influx of populations from across the globe, its internal traditions were invigorated and inspired to take new paths, although still always grounded in the practices specific to each region—a multivalence of expression that would similarly define the period to come, from the eighteenth century to the present. Another significant aspect of this period was the rise of individual artists, whose names are known and whose careers can be traced. The importance of self-expression within the artistic tradition, and a breaking away from the strict rules that defined how buildings or paintings or sculpture could look, would also develop further in the following decades.

CROSS-CULTURAL EXPLORATIONS

3.1 The mosque (FIG. 3-2) and the stupa (FIG. 1-12) represent two very different types of devotional space. Can you describe the form of each and how they were conceived? What kinds of ritual take place at each, and how does the architectural space respond to those needs?

3.2 Discuss the layout of pages from illustrated manuscripts of different traditions, such as the Buddhist *Prajnaparamita* (FIG. 2-30), the Jain *Kalakacharyakatha* (FIG. 2-31), and the Persian-language *Shahnama* (FIG. 3-9). How is the text arranged? Where are the paintings placed? What is the relationship between the content of the writing and the illustration? Do modern books contain illustrations in the same way? Can you think of any authors today who use images as part of their storytelling?

3.3 Compare buildings of the early seventeenth century constructed in the Mughal realms (e.g. FIG. 3-26), in the Deccan (e.g. FIG. 3-13), and in Rajasthan (e.g. FIG. 3-41). Are there any similarities in their decoration? What are the reasons for their similarities and differences?

3.4 In the Mughal sphere, European paintings and engravings inspired artists in different ways. Compare the varied responses of the artists who created the paintings in FIGS. 3-1, 3-30, and 3-37. How are they alike or different? How do they compare to European works of the mid-sixteenth to mid-seventeenth century? Did artists in other parts of Asia also play with artistic conventions from abroad?

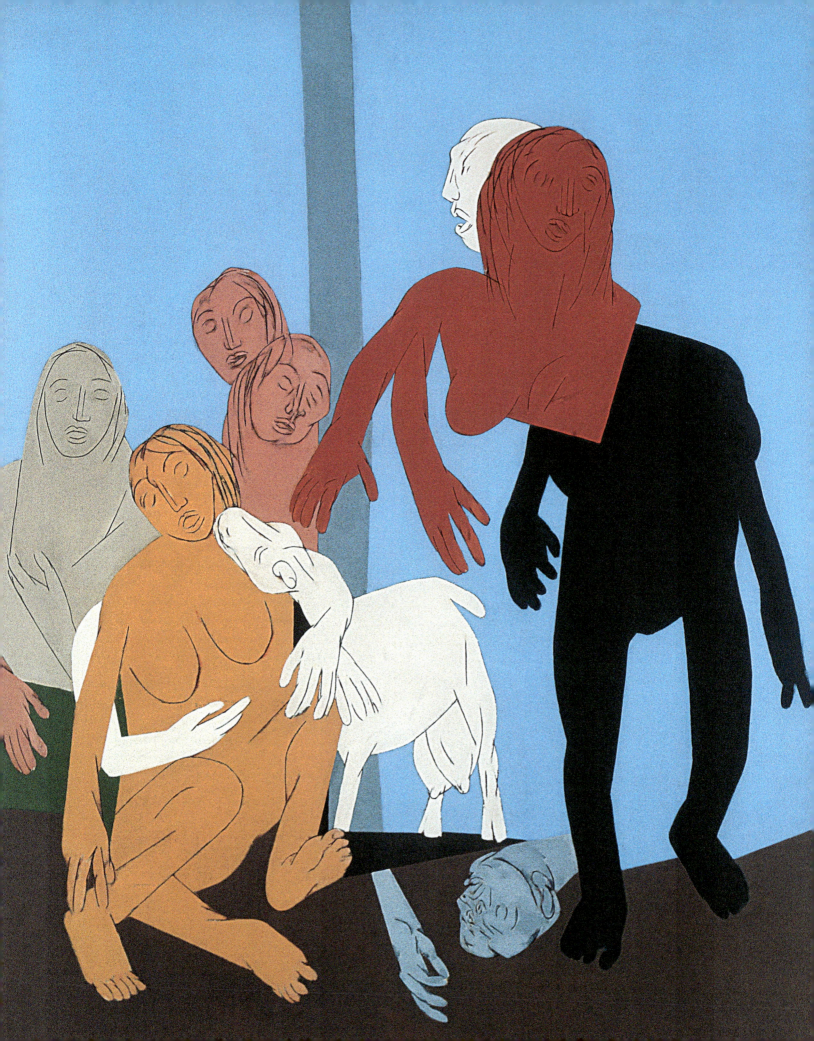

India and the International Scene: The Modern and Contemporary Periods

The art of a people is the true mirror to their minds.

Jawaharlal Nehru (1889–1964)

During the course of the seventeenth century, the new populations from outside the subcontinent became established and mixed with those from within South Asia, and artists started to experiment with forms of art and subject matter far outside the traditional realms of religious sculpture, architecture, and painting. In the eighteenth century, the decline of the centralized Mughal state and the growing presence and influence of Europeans meant that this process accelerated even faster. Europeans settled in the different trading posts along the coasts, becoming patrons of Indian artists and introducing them to the media of nonopaque watercolors and, in the nineteenth century, to oil paints and photography. Indian rulers were also increasingly aware of European arts and architecture, collecting works from abroad and employing foreign artists and architects to work for them.

The art scene evolved radically in the latter half of the nineteenth and twentieth centuries: Artists were freed from court workshops and the necessity of working for wealthy **patrons**, and the art they produced became more a product of self-expression, in line with developments among artists in Europe and America. They investigated different artistic modes, techniques, and theories, experimenting first with the picturesque

4-1 • Tyeb Mehta SANTINIKETAN TRIPTYCH (DETAIL)
1986–1987. Oil on canvas, 6′10¾″ × 14′6¾″ (2.09 × 4.44 m).
National Gallery of Modern Art, New Delhi. Courtesy and © Tyeb Mehta.

(see pp. 87–88) and moving on to constantly evolving concepts of the "modern." In recent decades, Indian artists such as Tyeb Mehta (**FIG. 4-1**) have not only participated in the international art scene, but also made important contributions to the development of an identity for contemporary art in South Asia. Mehta's work molds minimalist and expressionist tendencies into a distinctly Indian formulation, such as this image of a rural festival in Bengal painted while living in Santiniketan, the arts community that acted as a center for new ideas in art and culture in the early twentieth century (see pp. 93 and 95).

A MIXTURE OF TRADITIONS: EUROPEAN AND INDIAN ART IN THE EIGHTEENTH AND NINETEENTH CENTURIES

The decline of the Mughal empire is traditionally dated from the death of the emperor 'Alamgir in 1707; his successors have often been considered weak or ill-suited to their role—but in truth their position had been undermined by 'Alamgir's long campaigns in the Deccan, which had drained the empire's resources and saddled it with yet more provinces under an increasingly tenuous central control. This allowed other rulers to rise to power, from the Nawabs of Awadh (who were nominally still governors to the Mughals) to the entirely independent Asaf Jahis in the Deccan (whose state lasted until 1948) and the sultans of Mysore in the south (who flourished between 1760 and 1799).

The eighteenth century also witnessed the European powers firmly establish their footholds in the subcontinent. The Portuguese had settled at Goa on the west coast as early as 1510. After 1674 the French were based on the east coast, primarily

at Pondicherry. The focus of Dutch commerce was Indonesia and the spice trade, but by the 1660s they had also established important entrepots (trading posts) on India's east coast at Pulicat and then Negapattinam. The English East India Company was formed in 1600, and its agents settled initially at Surat in Gujarat, but soon spread to ports all along the eastern and western coasts. Although these European settlements were initially trading posts, all soon established a military presence in order to protect their settlements and their trading rights.

For the British, this military presence would lead to the absorption of entire states and then to the assumption of rule over the subcontinent. By the 1680s the East India Company had begun collecting taxes from the villages near their fortified settlements in return for protection. Through the 1740s, their involvement deepened as they began to clash with the other European companies—particularly the French—for the right to trade with different Indian courts. The tipping point for the balance of power took place in 1757 with victory over the ruler of Bengal, Nawab Siraj ud-Daula. This sealed their supremacy over all other European powers in the subcontinent, and resulted in the Company's taking over direct rule of Bengal with an administrative capital at Calcutta.

From this point the British were increasingly involved in Indian politics: waging battle with local leaders, placing resident advisors at their courts, and even selecting compliant heirs to the Indian states that came under their influence. In 1773 the role of Governor of Calcutta was elevated to Governor-General, with authority over all British territories in India, and in 1803 the East India Company placed a resident advisor at the court of the formerly all-powerful Mughal emperors in Delhi. In a final war (1817–1819) with the Marathas of Maharashtra, much of central India was added to the possessions of northern India already under British control.

THE BRITISH AT HOME

Although the numbers of British resident in India remained a tiny percentage of the subcontinent's entire population, the transition to ruling class engendered a demographic shift from young, unmarried men to a greater proportion of families. The establishment of proper homes and households in the British settlements then opened up a sideline in painting them (FIG. 4–2). One image was made for Mary Impey, wife of Sir Elijah Impey, who served as chief justice of Bengal between 1774 and 1782. The genre of painting, documenting the homes, possessions, and servants of the British, was a signifier of their success, and would previously have been the preserve of emperors and princes.

For the viewer today, these paintings are fascinating documents of the way the British lived in India; there are some

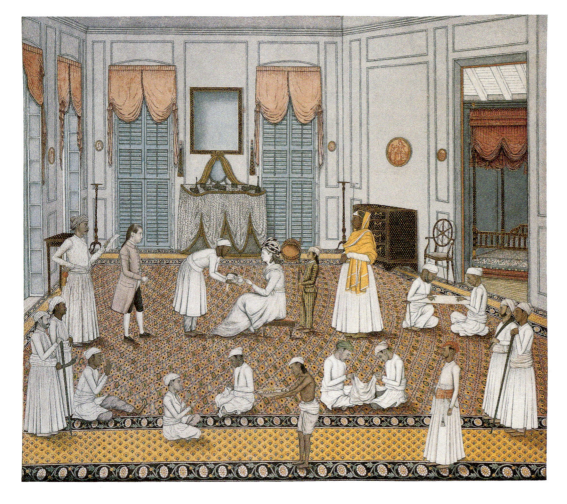

4–2 • Attributed to Shaykh Zayn al-Din *LADY IMPEY SUPERVISING HER HOUSEHOLD*
ca. 1777–1783. Opaque watercolor on paper, 18 × 21″ (45.7 × 53.3 cm). Private collection, UK.

concessions to the environment, but many more impositions that try to mold the Indian climate and customs into northern European patterns. The Impeys' home is furnished with swagged curtains, a dressing table, chair, and bureau; the walls are defined by rectangular **moldings** and are hung with European paintings. But the windows are shuttered, to prevent glare, there is a lightweight covering on the floor rather than a pile carpet, and the furniture is kept to a minimum, pushed to the sides of the room. Lady Impey sits on a short stool, but her Indian servants work on the floor or stand.

The painting also hints at a rising industry in directing traditional Indian handicraft methods toward the creation of household objects and furnishing necessary in European households. Tables, chairs, desks, and storage cabinets were not typically part of Indian rooms, but, from the late 1600s, were made for the Europeans who required them. In the eastern coastal town of Vishakhapatnam (called Vizagapatam by the British), local woodworkers excelled in creating objects out of haldu wood overlaid with ivory. The ivory was incised with highly detailed designs that were filled with black lac (an insect-made resin) that contrasted with the white of the ivory. It seems that Dutch furniture makers provided the initial training in creating European furniture types, and the chair pictured here is of Dutch inspiration (**FIG. 4-3**). Its round seat rotates, and it may have served as a barber's chair. Later in the nineteenth century, it became British policy to encourage Indian craftsmen to create goods for the foreign market as a way of maintaining traditional crafts, but by the late 1800s the British in India tended to favor furniture imported from home to anything made locally.

In terms of fashion, many women maintained European styles but had their clothes made of lightweight cotton to make them more suitable to the Indian climate. Lady Impey's dress reflects this trend. For cooler weather, shawls from Kashmir came into fashion around 1770 (**FIG. 4-4**). In India, men had typically worn these shawls, but among the Europeans only women wore them. The particular specialty of Kashmir were shawls made of very fine wool using a special, time-consuming technique—it could take several months to complete a single shawl. The traditional pinecone-shaped **motif** that typically decorated the borders of Kashmir shawls, called the **boteh**, would in English copies of the nineteenth century become known as "paisley."

4-3 • REVOLVING ROUND CHAIR
1760–1770. Haldu, veneered with ivory engraved with foliate decoration filled with black and red lacquer, with a caned seat, 34⅝ × 30½ × 27½" (88 × 77.4 × 70 cm). Vishakhapatnam; Victoria & Albert Museum, London.

4-4 • KASHMIR SHAWL (DETAIL)
Early 19th century. Woven cashmere, 10'5" × 4'7" (3.18 × 1.4 m). Victoria & Albert Museum, London.

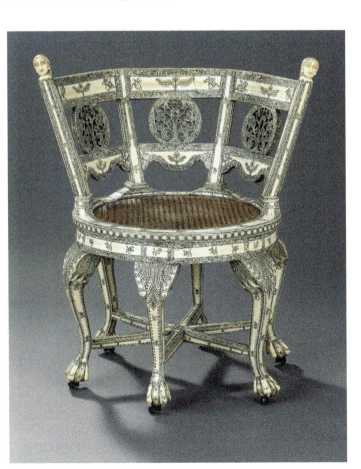

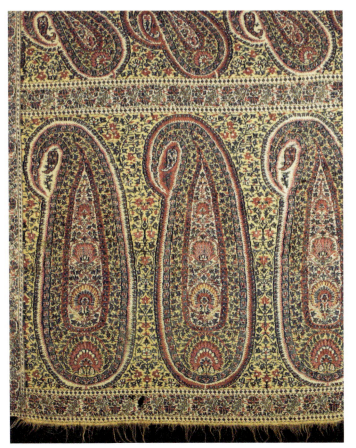

EUROPEAN PATRONAGE OF INDIAN ARTISTS

While in the sixteenth and seventeenth centuries Indian artists had experimented with different facets of European art, such as modeling, **single-point perspective**, and **allegorical** subject matter, the eighteenth century witnessed Indian artists leaning more heavily toward European models. Local artists trained under the European artists who had started coming to India in greater numbers, or under the guidance of European patrons, who hired Indian artists to capture aspects of life in the subcontinent. The paintings of this group are known by the general term "Company Painting," to indicate the connection between the rise of this style of painting and the spread of the East India Company, and the role of its employees as patrons. The paintings are in fact more diverse than this single grouping might suggest: The Company School artists were never closely bound to one another and their styles differed greatly from one region to another.

The province of Bengal, in which the English capital at Calcutta was located, was initially the most active site of production. Among the most important patrons was the previously mentioned Lady Mary Impey, who developed a strong interest in Indian wildlife, collecting birds and animals for study at the Impey estate in Calcutta. During her stay there between 1777 and 1782, she and her husband hired three Indian artists to document the animals in their menagerie; the result was a series of several hundred large-scale watercolors, of which 120 survive today. One painting depicts a shawl goat, known as such because goats like this provided the raw material for the shawls that had become so popular in the European markets (see Closer Look, opposite).

From the inscriptions on the Impey paintings, we learn the names of the artists—Bhawani Das, Shaykh Zayn al-Din, and Ram Das—and that they were from Patna, a town under the control of the court at Murshidabad. In their careful rendering of each aspect of the animal, we see traces of their training in the Mughal style, and the relationship to animal studies made for the Mughal emperors in the seventeenth century. However, the use of watercolor pigments without opacifying agents, and the decision to show no background elements so that the focus is on the specimen at hand, demonstrate the influence of the European scientific records that Lady Mary must have shown the artists and asked them to emulate.

In Delhi, the brothers William and James Fraser hired local artists to paint an entirely different type of subject: the people and villages of the countryside surrounding the capital. William worked for the East India Company as a revenue settlement officer and also served as Resident (1830–1835); in 1814 his elder brother James arrived for a visit, staying until 1820. James was an avid amateur artist, and during the brothers' extended tour through the Himalayas he made numerous sketches that were later published as **aquatints** (a form of etching). The two also hired Indian artists to assist James and, once back in Delhi, another artist helped sketch the city's architectural monuments. At James's request, yet another artist accompanied William on his village tours, such as his trip to the northern state of Patiala in order to negotiate a dispute in 1917 (**FIG. 4–5**).

The paintings made by this as-yet-unidentified artist were originally bound in a large album, facing William's handwritten notes identifying the sitters of the portraits and explaining their names, titles, and caste. This artist shows evidence of some kind of training in English watercolor techniques and a familiarity with English portraiture styles: This painting and the many others in the Fraser collection that can be attributed to him are very fine likenesses in is exactly captured which not only the physical appearance of each person, but also his dress, accessories, and manner of styling his hair and beard. It was these details that James considered of greatest value in the paintings, especially for the audience back in England to which he hoped to market them.

INDIAN PATRONAGE OF EUROPEAN ARTISTS

Rulers at the various courts of India also participated in this intercultural patronage by hiring the British artists who

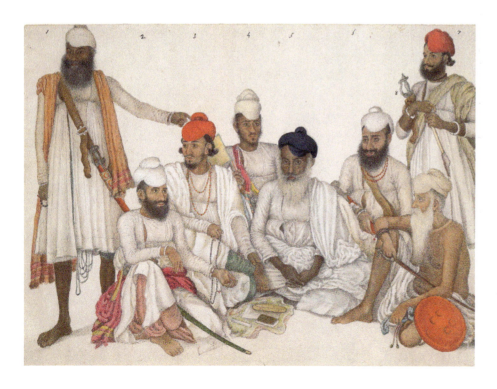

4–5 • *EIGHT SIKH COURTIERS AND SERVANTS OF THE RAJA OF PATIALA*
Folio from the Fraser Album, 1817. Pencil and watercolor on paper, 8⅝ ×12⅛" (22.3 ×30.8 cm). British Museum, London.

The tradition of drawing and painting from nature had existed from the Mughal period—recall Jahangir's instructions to his artists to depict the unusual animals he saw during his travels (see Chapter 3, Point of View, p. 69). In the paintings made for Jahangir, the animals were drawn in minute detail, and were usually shown against a background that evoked their natural habitat. The foundation of those Mughal nature paintings underlies the scientific paintings made for the Impeys

and other British patrons in the eighteenth century, but the genre developed further under their encouragement. The attention to detail is preserved, but as in European scientific treatises, the animal is depicted against a blank ground. Today's system of animal classification was developed in the eighteenth century, and, being among the earliest examples of their kind, these Indian studies form a critical part of this field of inquiry.

Shaykh Zayn al-Din *A SHAWL GOAT*
ca. 1779. Watercolor on paper, 21⅛ × 29½" (53.5 × 75 cm). Calcutta; Victoria and Albert Museum, London.

This painting includes a note on the goat's measurements, since it could not be painted at life size (unlike the other animals in the Impey menagerie, such as birds).

Each individual hair of this goat has been carefully rendered, as have the markings on its face and the peculiar curvature of its horns.

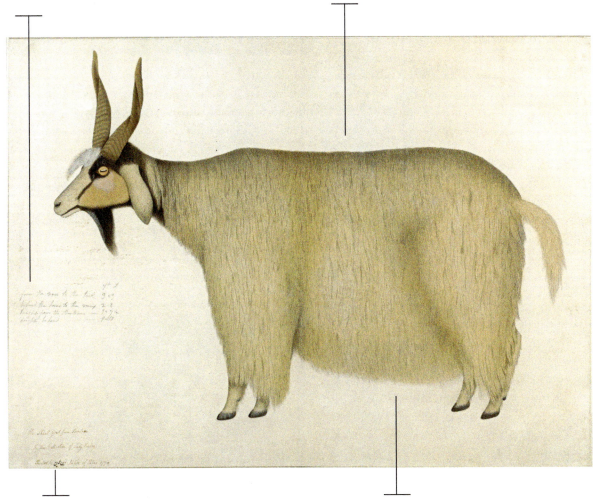

All the paintings in the Impey series were inscribed with the name of the animal in the local language, the name of the artist in Persian letters, and the statement, "In the collection of Lady Impey at Calcutta" in English.

It is believed that the goat depicted here was brought to the Impeys from Bhutan, where it had been collected with other specimens of local life by order of Warren Hastings, the first English Governor-General of India and a friend of Elijah Impey.

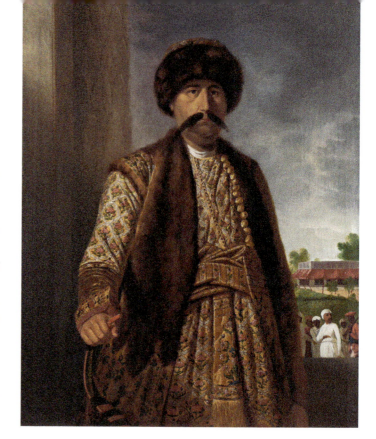

4-6 • Tilly Kettle *SHUJA AL-DAULA, NAWAB OF AWADH, HOLDING A BOW*
1772. Oil on canvas, 4′2⅛″ × 3′4⅛″ (1.27 × 1.02 m). Uttar Pradesh, Faizabad; Yale Center for British Art, Paul Mellon Collection, New Haven.

started arriving in India in greater numbers at the end of the eighteenth century. Their status at home in Britain was relatively low owing to the higher value placed on the work of French and Italian painters, so they traveled abroad to find work—the British in India were especially desirous of portraits, and the Indian rulers were rumored to supply very high salaries to foreign artists. In and around the court of the governor Nawab Shuja al-Daula (r. 1754–1775) of Awadh, in particular, there gathered an eclectic group of artists who worked for both foreign and local patrons.

Of the Mughal provinces, Awadh in the northeast was able to retain a measure of independence through the eighteenth and much of the nineteenth century. While the East India Company had established a mercantile presence in the city in the seventeenth century, and by 1773 had installed an English Resident at the court, the Lucknow nawabs (governors) maintained a high level of authority and wisely managed the province's great wealth. A coterie of foreign artists found employment at the court of Shuja al-Daula. Tilly Kettle (1735–1786) was among the first English painters to arrive, his success inspiring others such as Johann Zoffany (1733–1810) and Ozias Humphrey (1742–1810) to make the arduous journey to India, and to Lucknow in particular. Company employees there—Claude Martin, serving as the Lucknow Superintendent of the Arsenal, and Antoine Polier, appointed as chief engineer—also employed local artists to amass sizable collections. Martin had a series of bird studies made, and the artist Mihr Chand (fl. 1759–1786) compiled a number of albums for Polier, including much of his own work alongside examples of other north Indian and Deccani paintings.

Several of Tilly Kettle's portraits of Shuja al-Daula survive. The nawab routinely appears as a tall, stout man of imposing bearing, with a drooping mustache (**FIG. 4–6**). His carefully chosen dress is unvarying: It is Afghan in origin and consists of an overcoat with fur collar over a calf-length *jama* (robe or tunic) tied with a wide sash. On his head he wears a fur-banded hat and on his feet tall leather boots (not seen in this painting, which has been cut down). While portraiture was a firmly entrenched tradition in India by this point, these images differ from the native tradition in their medium—oil on canvas—and large size, as well as their frontal depiction of the face. Employing a foreign artist such as Kettle enabled Shuja al-Daula to present himself in the way his peers abroad did; no doubt having seen oil portraits of European rulers, it would have seemed natural to have his own portrait made in a style considered the wave of the future.

Mihr Chand copied several of Kettle's compositions at the behest of Lucknow patrons like Polier, who wanted versions of the images for their own collections (**FIG. 4–7**). Mihr Chand also

adopted aspects of English landscape painting for the backdrops of other portraits. His colleague Mir Kalan Khan (fl. 1725–1780), on the other hand, was more interested in the effects

4-7 • Attributed to Mihr Chand *NAWAB SHUJA AL-DAULA, AFTER A PORTRAIT BY TILLY KETTLE, AND TWO PICTURES OF BEAUTIES*
Page from the Lady Coote Album, ca. 1780. Ink, transparent and opaque watercolor, and gold on paper, 17¹¹⁄₁₆ × 24⅛″ (45 × 61.3 cm). Lucknow, Uttar Pradesh; Fine Arts Museums of San Francisco. Museum Purchase, Achenbach Foundation for Graphic Arts Endowment Fund (1982.2.70.1).

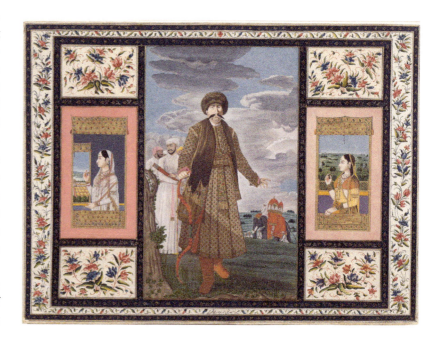

of **chiaroscuro** (contrasting light and shade), and incorporated the frontal facial view into otherwise traditionally Indian compositions.

EUROPEAN AND INDIAN ARTISTS EXPLORE

While in some areas of artistic production Indian artists followed the lead of those from abroad, in other areas, Indian and outside artists explored new modes of expression together. The **picturesque** is an aesthetic mode in poetry, drawing, and painting associated with the last part of the eighteenth century, particularly in England. In visual terms, the picturesque meant celebrating the roughness and irregularity of nature, and favoring views of ruins or humble country architecture over ordered gardens and well-maintained buildings. Human figures appear in small scale, if at all, and lighting is manipulated for dramatic effect.

Notions of the picturesque came to India at exactly the moment they were gaining currency in England. This manner of depicting a landscape can be seen in the works of Thomas Daniell (1749–1840), the English artist who moved to India in 1784 with his nephew William. The sketches they made during their following ten years of travel were turned into a watercolor series, *Oriental Scenery*, published for sale in six volumes between 1795 and 1815. Popular abroad, these paintings depict India in a very particular light. The artist Sita Ram took a similar approach in his own depictions of the Indian countryside. Working for Francis Rawdon, the Governor-General of Bengal from 1813 to 1823, Sita Ram employed many of the devices of the picturesque style in documenting the sites encountered on Rawdon's travels (see Compare, p. 88).

PHOTOGRAPHY Photography was introduced to India soon after its invention in the 1830s, transported by English enthusiasts. At this time, photography required heavy, hazardous, and expensive equipment. The negative images were registered on glass plates coated with light-sensitive salts suspended in a solution called collodion. Collodion prints had to be printed while the glass negative plate was still wet, so photographers also had to set up developing tents next to the sites they were shooting, and carry with them all the requisite chemicals. The cameras themselves were large, to accommodate the glass negatives, and very heavy. Nonetheless photography became very popular; by 1840, there was a studio producing daguerreotypes (an early type of photograph) in Calcutta, and in 1854, a photographic society was formed in Mumbai with Indian and English members. Thus both English and Indian practitioners discovered the possibilities of this new medium together.

Samuel Bourne (1834–1912) arrived in India in 1863 and set up a studio in the northern town of Simla, in the foothills of the Himalayas. From there he traveled higher up into the mountains, trekking with as many as 42 porters to carry his equipment and personal effects. His photographs of these sites demonstrate his interest in the picturesque style that also engaged painters of the time (**FIG. 4-8**). A photograph made during a journey of 1866 documents a brief stop in the Kulu

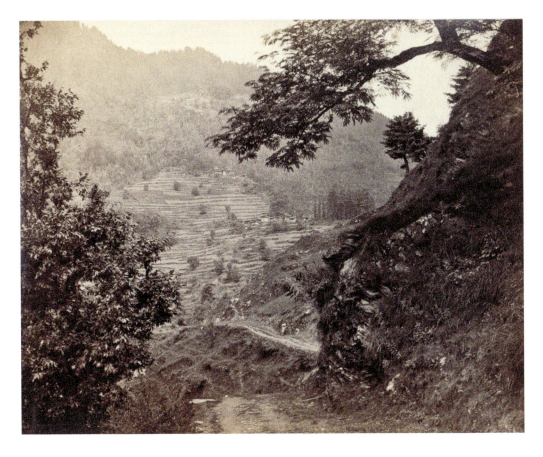

4-8 • Samuel Bourne *VIEW NEAR RUSALA, KULU*
1866. Albumen print from wet collodion glass negative, 9⅛ × 11½″ (23.2 × 29.2 cm). Victoria and Albert Museum, London.

These two paintings, made just a few years apart, show historic monuments and the Indian countryside surrounding them. The view on the left is of the temples at the holy site of Brindaban (now spelled Vrindavan, in Uttar Pradesh). It was painted by the British artist Thomas Daniell. The painting on the right depicts a palace complex near Murshidabad (Bengal) and is by the Indian artist Sita Ram. Both can be considered examples of the picturesque style, since as a viewer, we sense that a particular point of view has been imposed on each scene. Rather than directly conveying what they saw, the artists appear to have chosen to focus on decaying monuments, situating them among a rough-and-tumble landscape in which the sizes of buildings, natural elements, and human figures are out of proportion to one another.

4–9 • Thomas Daniell HINDU TEMPLES AT BRINDABAN ON THE RIVER JUMNA
1795. Aquatint, 18 × 23¼″ (45.7 × 59 cm). Victoria and Albert Museum, London.

4–10 • Sita Ram VIEW OF A MOSQUE AND GATEWAY AT MOTIJHIL
ca. 1820–1821. Opaque watercolor on paper, 13 × 19¼″ (33 × 48.9 cm). Metropolitan Museum of Art, New York. Cynthia Hazen Polsky and Leon B. Polsky Fund, 2002 (2002.461).

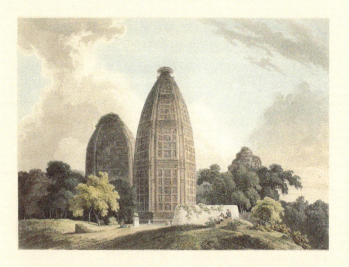

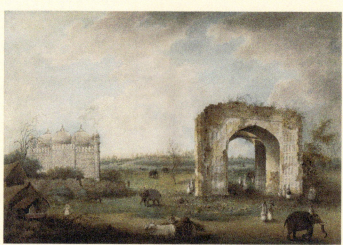

THINK ABOUT IT

1 Which elements of these paintings are shown largest and which are shown smallest? What is the effect of these decisions?

2 What is the source of lighting in these paintings? Does it highlight certain features?

3 Can you compare the depiction of architecture and landscape to that in paintings of the Mughal period (FIGS. 3–28 and 3–29)?

4 Can you tell the difference in authorship between the two paintings?

Valley. It includes Bourne's signature combination of detail, texture, and tonal variation, with an eye for careful composition. The branch overhanging the top right corner of the image, the winding path leading the eye to the terraces and dwellings in the background, and the insertion of a human figure in the middle of the composition, setting the scale of his natural surroundings, are all elements of a picturesque image.

From northern India, Lala Deen Dayal received training in photography as part of his engineering studies, which he completed in 1866. He found work in this field among the British civil servants, participating in a project to document India's ancient monuments, and working for the viceroys (the highest British officials) of India. He eventually traveled to the court of the Nizam of Hyderabad, and in 1885 was appointed state photographer (with the title of Raja) to the sixth Nizam, Mehboob Ali Pasha (r. 1869–1911).

Deen Dayal took photographs of people, hunts, and ancient monuments. However, in a topographical view of the rocky landscape particular to the Hyderabad area, he reveals connections with the picturesque point of view, and its celebration of the wild or unusual in nature (FIG. 4–11). The image was included in an album, *Views of HH the Nizam's Dominions, 1892,*

4-11 • Raja Deen Dayal ***ONE-TREE HILL, SECUNDERABAD***
1880. Photographic print, 7⅞ × 10½″ (19.9 × 26.8 cm). British Library, London.

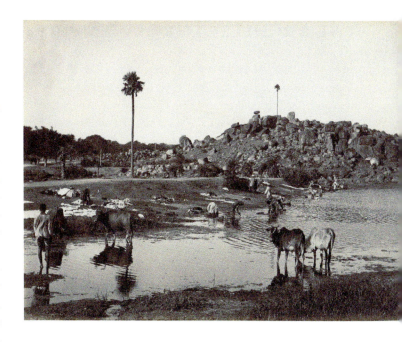

which was presented to Lord Curzon, viceroy of India from 1899 to 1905, during a visit in 1902. This visit was itself documented by Deen Dayal and presented as a special album.

Other photographers took advantage of the reportorial capabilities of the medium in the aftermath of the events of 1857, in which Indian soldiers rose up against their British commanders. The uprising, although quashed after hard-fought battles in several cities, can be viewed as the start of the independence movement, which would have its culmination in the birth in 1947 of the republics of India and Pakistan. Lucknow in particular suffered, with the loss of many lives and important monuments. The sites of significant battles within the city were documented soon afterward by photographers who sold sets of their images to those who had survived the events, as well as the many British tourists who came to visit the sites in order to experience what they viewed as the heroic British stand against the Indians.

Felice Beato (1820s?–1907?), who had previously photographed the Crimean War (1853–1856), arrived in India in 1858, and took his photographs of Lucknow soon after the city was secured by the British in March of that year. He seems to have been in close contact with the British officers involved in the incidents, and recorded the sites that resonated with them.

These grim images convey the city's destruction and document the loss of life. His famous photograph of the walled enclosure of the Secundra Bagh in Lucknow shows, as his caption notes, the place where 2,000 Indians were massacred in retaliation for the killing of British women and children at Kanpur (**FIG. 4-12**). From his notes, however, we know that the scene was staged, and that Beato had asked that the bones visible in the foreground be strewn about for the purposes of his photograph.

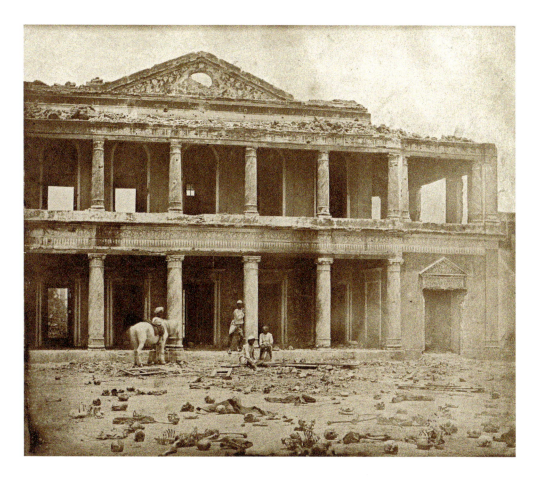

4-12 • Felice Beato ***THE SECUNDRA BAGH AFTER THE SLAUGHTER OF 2,000 REBELS BY THE 93RD HIGHLANDERS AND 4TH PUNJAB REGIMENT. FIRST ATTACK OF SIR COLIN CAMPBELL IN NOVEMBER 1857, LUCKNOW.***
1858. Albumen silver print, 8⅝ × 10¾″ (22 × 27.3 cm). National Army Museum, London.

THE ARCHITECTURE OF EMPIRE

After 1857, rule of India was transferred from the East India Company to the British state, and Queen Victoria (r. 1837–1901) was proclaimed its empress in 1877. This shift of power triggered the need for more formal seats of government than those used by the Governors-General, with buildings and amenities to represent the might of the British Empire.

CALCUTTA

As the primary British capital, Calcutta had been developed in the eighteenth century with impressive government structures as well as rows of mansions, neoclassical in style and plastered in bright white according to the contemporary fashion in Britain. With the switch to crown rule, however, debate arose around what style of building would best represent the British Empire in India. Some championed a purely European architecture, while others felt there should be some reference to the historic styles of India. Identifying and defining what constituted the correct historical reference became caught up in late nineteenth-century inquiries into the history of Indian architecture, concerned with dating monuments, classifying their placement in the development of regional and dynastic styles, and evaluating the qualities of native and Islamicate (traditions stemming from Islamic societies, but not religious in nature) contributions to this heritage.

Over time a preference emerged for a combination of seventeenth-century Mughalized forms and the classicizing elements of contemporary British architecture. This style, termed the **Indo-Saracenic** to signify its combination of native and Islamicate traditions, was generally sober and rational, with a careful selection of decorative elements from Indian architecture and flourishes of the **neo-Gothic** revival then popular in Britain.

BOMBAY

The city of Bombay (present-day Mumbai) had been given by the Mughal emperor Humayun to the Portuguese in the sixteenth century, and a little over a century later came under British control when it formed part of the dowry of Catherine of Braganza when she married Charles II of England in 1661. It grew into a thriving trading city, and by the 1870s it was the subcontinent's primary port and home to the Great Indian Peninsular railway, perhaps the largest infrastructure project undertaken by the British in India. Built to house the offices of the GIP and function as the main station, the Victoria Terminus was completed in 1887 for the fiftieth anniversary of Queen Victoria's ascension to the throne (**FIG. 4–13**). In common with the earlier European buildings it emulates, the train station has a central dome capped with a classical statue (here, representing Progress), and corner turrets with pyramidal spires. Along the façade are pointed arches outlined with stripes of stone in contrasting colors. They rest on slender columns and have windows set with stained glass. Inside, Corinthian columns and **groin-vaulted** ceilings complete the neo-Gothic vision. Very few Indian elements can be found in this iteration of the Indo-Saracenic style, but if this building represents the start of the tradition, the massive governmental center in Delhi marks its culmination, by which point the Indian elements had come to the fore.

4–13 • Frederick William Stevens VICTORIA TERMINUS (NOW THE CHHATRAPATI SHIVAJI TERMINUS) 1887. Mumbai.

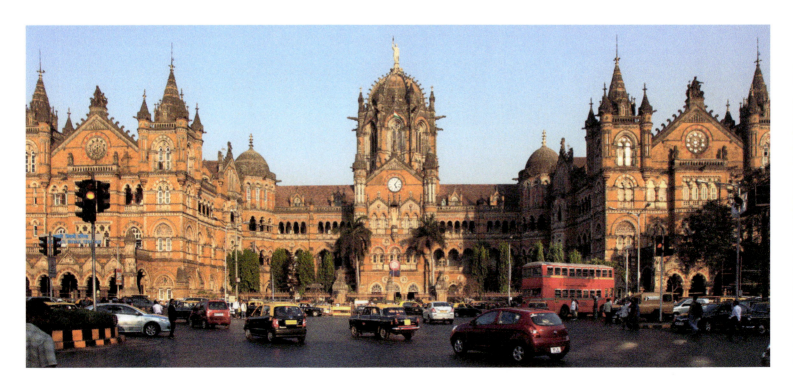

DELHI: THE IMPERIAL CITY OF INDIA

In 1911, when King George V (r. 1910–1936) and Queen Mary of England voyaged to India to be crowned its emperor and empress, a dramatic announcement was made: The British capital would be moved from Calcutta to Delhi with all its earlier imperial associations. It took a further 20 years for the ambitious plan for New Delhi to be completed as the architects Edwin Lutyens (1869–1944) and Herbert Baker (1862–1946) worked out where in the already well-established city to insert the vast new government complex, while they traversed the country to study the historic buildings from which they might draw the appropriate references, and while the mighty construction project was undertaken by Indian laborers.

In the end, a site slightly west of Delhi's other districts was selected—a hilltop location where the residence of the viceroy could be set (**FIG. 4-14**). From this palace a long processional mall extended past flanking secretariat buildings and a round council house (all designed by Baker), passing through the triumphal arch that serves as the All-India War Memorial, to terminate at a hexagonal green where a memorial to George V was later built. Other institutions, and housing for British officials and for the Indian princes, were placed along diagonally laid streets that created a grid of additional hexagons across the open land.

As the crowning monument of the capital, the Viceroy's House, which now serves as the home of the President of India, was designed by Lutyens on a vast scale and is larger than even the palace at Versailles. Among its 340 rooms, the Darbar Hall takes no less than the Pantheon in Rome for its inspiration (**FIG. 4-15**). Just like that building, the Darbar Hall has a high dome, an **oculus** (circular opening), and coffered **apses** (semicircular recesses) to frame the thrones of the viceroy and vicereine.

Along with his classical references, Lutyens also incorporated aspects of Indian architecture in the building. The use of red sandstone, pierced stone screens, and domed kiosks derives from Mughal prototypes, as does the plan of the terraced garden behind the palace. The "Delhi order" capitals, invented by Lutyens, were inspired in part by the third-century BCE pillars erected by the emperor Ashoka (see Chapter 1, FIG. 1.13), while the building's deep **loggias** (open-sided balconies) protect interior rooms from the heat and sun, and are a concession to the Indian climate.

4-15 • Edwin Lutyens **DARBAR HALL OF THE VICEROY'S HOUSE**
1912–1929. New Dehli.

VISIONS OF THE MODERN IN THE EARLY TWENTIETH CENTURY

By the time of New Delhi's completion in 1932, the political situation in both Britain and India had changed dramatically. Cuts to the budget necessitated by World War I and a rising anti-colonialism in Britain itself had already affected plans for the capital and caused a major scaling back. In India, calls for release from British rule were increasing. As intellectuals framed arguments for independence from British rule and what the nature of an independent South Asian nation should be, the question of a modern South Asian art naturally arose. Should it reject any connection to European art? Could it be based on a style of the historical past? Which historical past was appropriate?

RAJA RAVI VARMA

The work of Raja Ravi Varma (1848–1906), although successful on a popular level, came to represent the antithesis of what most considered an acceptable vision of an Indian modernity. Varma was born into the Travancore royal family in southern India, and learned painting from the foreign artists working at that court. He applied their technique of painting with oil on large canvases, and their realist style, to subjects of classical Indian literature. His painting of a woman holding a piece of fruit (FIG. 4-16) is typical of the manner in which Varma painted his images—deriving directly from the style being taught at nineteenth-century British art schools—and of the way he depicted Indian women. Both caused his work to be rejected by artists of the subsequent generation. They objected to the fact that there was very little of an Indian aesthetic present in either the palette or the method of conveying time and space, and that his sexualized portrayal of women pandered to what foreigners wanted to see.

AMRITA SHER-GIL

The slightly later work of painter Amrita Sher-Gil (1913–1941) proposed a different approach to depicting women, although she too worked within a Europeanized style. Sher-Gil was of mixed Indian-Hungarian extraction and trained in Paris in the early 1930s. Returning to India in 1934, she took up the Indian people and their condition as her subject, but she also painted her group of women friends, and worked with the European genres of nudes and still lifes. In a self-portrait (FIG. 4-17), her frank and strong female image (as opposed to Ravi Varma's demure yet sensual depiction) looks back at us from the picture frame.

4-16 • Raja Ravi Varma
WOMAN HOLDING A PIECE OF FRUIT
Late 19th century. Oil on canvas, 23⅔ × 17¾″ (60 × 45 cm). National Gallery of Modern Art, New Dehli.

4-17 • Amrita Sher-Gil **SELF-PORTRAIT (7)**
1930–32. Oil on canvas. 27⅝ × 18⅝″ (70.2 × 47.4 cm). National Gallery of Modern Art, New Delhi.

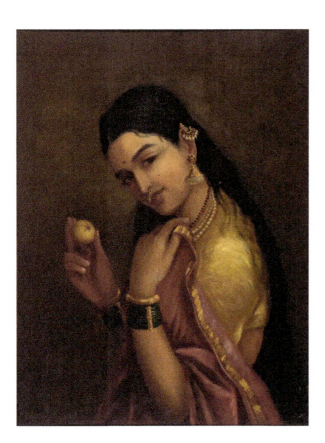

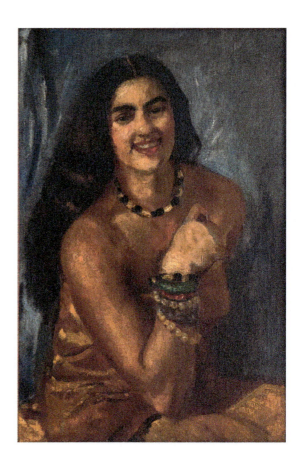

RABINDRANATH TAGORE

The artists and intellectuals of Bengal formed a tightly-knit community who felt their work was inextricably bound to the mission of gaining independence from Britain. Rather than looking west for inspiration, they looked to India's past and to cultures farther east, particularly Japan, in a spirit of pan-Asian political and aesthetic unity. At the heart of this community was Rabindranath Tagore (1861–1941). Although best known for his poetry, for which he won a Nobel Prize in 1913, he founded an arts school at Santiniketan in rural Bengal, with an emphasis on handicrafts and the traditional arts. He also took up drawing and painting in his sixties, creating thousands of images. Once described as "grotesque and gestural," they reveal his fascination with the primitive and fundamental (**FIG. 4–18**). His nephews Abanindranath (1871–1951) and Gaganendranath (1867–1938)

4–18 • Rabindranath Tagore *DANCING WOMAN*
1928–1940. Ink on paper, 14⅜ × 10¼″ (36.5 × 26 cm). National Gallery of Modern Art, New Delhi.

also became important painters, and the school at Santiniketan has educated many of present-day India's great political and cultural figures.

INDEPENDENT SOUTH ASIA

On August 15, 1947, the climax of years of debate and political action was reached. The British relinquished rule of the Indian subcontinent, and two independent nations—India and Pakistan—were formed. At this time Pakistan had territories on either side of India; in 1971, that on the east became the separate state of Bangladesh. After independence, the question of how to represent a modern South Asian culture continued to be debated, with the subject of borrowing idioms from abroad still at the heart of the discourse.

ARCHITECTURE

In architecture, the first forays were into a wholly **International Style**. Just as the leaders of the other emerging nations of the mid-twentieth century were inviting architects of the International movement to create their capital cities (most notably Brazil), so too did India's first prime minister, Jawaharlal Nehru (in office 1947–1964). Although the notion was contested, it seemed natural to many that the world's leading architects would design the monuments to symbolize the subcontinent's new republics. Furthermore, India had been participating in the international discourse of modern architecture since the nineteenth century, with buildings in Calcutta, Mumbai, Hyderabad, and others reflecting the contemporary trends worldwide. Charles-Edouard Jeanneret, known as Le Corbusier (1887–1965), was therefore given the highly symbolic commission to design the city of Chandigarh, capital of the state of Punjab—a region that had been split between India and Pakistan.

Le Corbusier's work was associated with buildings made of concrete and with a total lack of ornament, but he had also made forays into urban planning, proposing radical plans to reorganize Paris and Stockholm. Thus the Chandigarh commission fell squarely in his area of intellectual interest. Le Corbusier first created a plan for the entire city, dividing it into sectors for housing, universities, industry, and government, and establishing a hierarchical system of roads for cars and pedestrians. Although thoughtful in its own way, the monumental plan he imposed on the city has ultimately been faulted for its inhuman scale, and especially for the fact that it privileged cars—then costly and rare—over other methods of conveyance.

Le Corbusier was also responsible for the design of several major buildings at Chandigarh. On one large plaza in the north of the city he assembled the governmental structures: the Assembly Hall, the Governor's Palace (not built), and the High Court. The Assembly Hall is a large rectangular block. A pavilion with an upswept, curving roof faces a reflecting pool on one

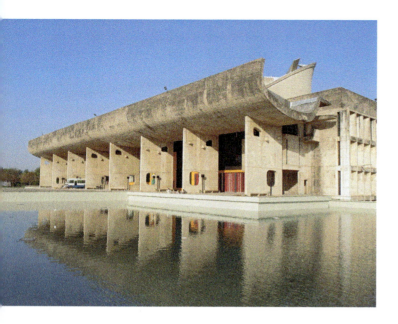

4-19 • Le Corbusier ASSEMBLY HALL
1953–1963. Chandigarh, Punjab.

side to break up the scheme (**FIG. 4-19**). On the other side of the building, several stories of offices surround a central space—the round Assembly Hall itself with its swooping tubular **cupola** (domelike structure). While striking on paper and in photographs, the building is rather unsuited to the local climate.

Working at the same time as Le Corbusier, the American architect Louis Kahn (1901–1974) designed an equally ambitious legislative complex in Bangladesh for the capital Dhaka. It was finally completed after his death in 1982. While working there he was invited to design the campus for the Indian Institute of Management at Ahmedabad (**FIG. 4-20**). The school was a collaboration between Indian industrialists and Harvard Business

4-20 • Louis Kahn INDIAN INSTITUTE OF MANAGEMENT
1962–1974. Ahmedabad, Gujarat.

School, and the Harvard campus's arrangement of class buildings around courtyards in close proximity to dormitories was transferred to the Ahmedabad site. Kahn also attempted to work with some aspects of Indian vernacular construction, building in brick in addition to his usual concrete. The complete lack of any architectural ornament, though, clearly separates the campus from the city's surrounding historical buildings, replete with carved detail (see Chapter 3, FIGS. 3-7 and 3-8).

Although the nonimperialist, egalitarian, and ahistorical aspects of these buildings seemed appropriate ways of representing the new South Asian nations, the buildings of the International Style were simply unsuited to the region, and had to be adapted. The playful gallery designed by B. V. Doshi (b. 1927) to display the work of the painter M. F. Husain exemplifies one path of accommodation (**FIG. 4-21**). Doshi had trained at Le Corbusier's office in Paris in the early 1950s, and then supervised projects for him at Chandigarh and Ahmedabad. Despite using ferrocement (steel-reinforced concrete) and computer-generated plans, the form of the gallery is organic, taking the shape of interconnected caves with domed roofs inspired by tortoise shells. It was placed underground in consideration of the city's heat, and the artist and architect collaborated, with Husain decorating the spaces as they were being constructed.

PAINTING

In painting, artists moved between relating to an earlier heritage and maintaining a dialogue with their contemporaries across the globe. An early work by Vasudeo S. Gaitonde (1924–2001) makes reference to Rajput paintings, with its bright yellow pigment and the convention of depicting the bun as a spiral motif on the side of the head (**FIG. 4-22**). But after traveling to New York in 1965 on a Rockefeller Fellowship and making contact with artists there, Gaitonde changed his approach to the canvas surface, applying the paint in thick coats with a roller and pallet knife. He also moved away from representational art to more conceptual works.

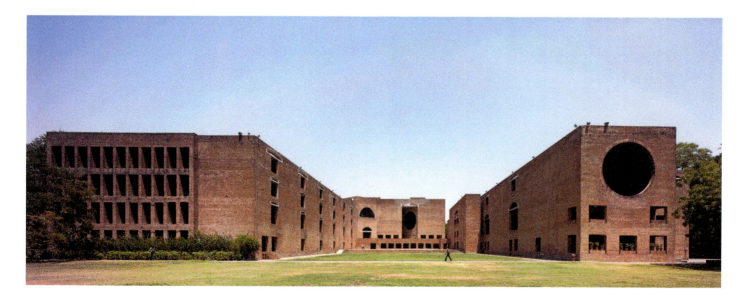

4-21 • B. V. Doshi M. F. HUSAIN GALLERY
1993. Ahmedabad, Gujarat.

4-22 • Vasudeo S. Gaitonde UNTITLED
1954. Oil on paper, 11 × 12″ (28 × 30.5 cm). Private collection, San Francisco.

FILM

Film also became part of the conversation on modernity. Although a large proportion of the movies made in the 1950s were intended purely for entertainment, the medium was also harnessed as part of the nationalist discourse. *Mother India* (1957) made a stand for preserving the nation's traditional values in the face of technological and other advances. In the film, the preserve of India's morality is identified as the village, and in particular its women. It takes as its subject Radha, a poor woman harassed by a money lender against whom she takes a heroic stand. As a further tribulation, she must kill her own son in order to preserve the honor of the village's girls. The first posters for the movie focused on Radha in her role as mother, with the baby she holds representing the new nation. Later versions showed only Radha, foregrounding her labor and perseverance; the plow arranged diagonally across the poster underscores her struggle, while India's terrain and the symbolic cows fill the background (**FIG. 4-23**).

Filmmaker Satyajit Ray (1921–1992) had studied at Tagore's Santiniketan school, created visuals for print ads, and designed

4-23 • Seth Studios MOTHER INDIA MOVIE POSTER
1957, redesigned 1980s. Color lithograph, 42⅛ × 31½″ (107 × 80 cm).

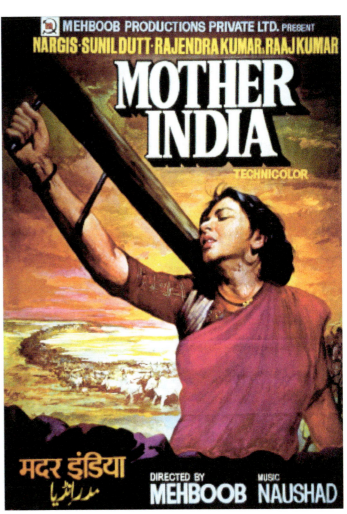

books and typefaces in the 1940s before coming to cinema in the 1950s. His subsequent film career propelled him to international fame, although his films always remained closely tied to the world of rural Bengal, and he used nonprofessional actors—people he met in the street or on trains. Throughout his body of work his original training is evident. Ray sketched the frames and cuts in his movies in detail before filming started; he also created the posters and publicity to accompany each. In the sketches for a documentary on the musician Ravi Shankar (never made), the working process is evident in Ray's vision for each shot—the sequence of moods inspired by the music being played is deepened by the lighting and the angles of the visual image (**FIG. 4-24**).

CONTEMPORARY ART: GLOBALIZATION, DIASPORA, HERITAGE

In the decades since 1947, the discourse among artists has shifted from one of defining a nation and its values, and the charged reactions that choosing certain styles of subject may elicit. The spaces in which artists may work have radically opened—artists practicing today are not bound to working, exhibiting, or selling their work within South Asia. As a result, defining a discrete body of works as South Asian becomes complicated. Furthermore, viewing the work of the contemporary artists discussed here solely through their South Asian heritage would be misleading. But inasmuch as the following artists use the peoples, customs, landscape, and **material culture** of present-day South Asia as a springboard for their works, they are presented here as part of the continuum of South Asian art.

M. F. HUSAIN AND TYEB MEHTA

The work of today's artists grew out of the pioneering works of the 1970s and 1980s. M. F. Husain (1915–2011) had been influenced by the independence movement in his youth, joining the Progressive Artists' Group of Bombay, which was formed in 1947 and also included Tyeb Mehta (see **FIGS.** 4-1 and 4-26). The group had taken a stance against the academic styles traditionally taught at arts schools, and simultaneously positioned themselves counter to the Bengali artists who rejected international movements and the world of artists outside India. Many in the group traveled abroad, often to London or Paris.

Husain himself drew from an eclectic mix of sources, taking an interest in German Expressionism, Gupta sculpture, and Pahari painting, and often turned to traditional Indian subjects as his inspiration. In 1971, he made a series of paintings depicting stories from the national epic the *Mahabharata* (**FIG. 4-25**). In this painting the hero Arjuna appears on the left, driving a chariot and gazing at the hand of **Krishna**, which holds a discus, the weapon associated with this god. It evokes the *Bhagavad Gita*, the section of the *Mahabharata* in which Arjuna seeks the guidance of Krishna before going into battle with his cousins, the enemy Kaurava clan. Like many of Husain's works, this one incorporates two-dimensional figures rendered in earth tones,

4-24 • Satyajit Ray
SCENE SKETCHES FOR DOCUMENTARY ON RAVI SHANKAR
© Ray estate and Society for the Preservation of Satyajit Ray Films, Calcutta.

4-25 • M. F. Husain ARJUNA WITH CHARIOT (MAHABHARATA 15)
1971. Oil on canvas, 6'3" × 4'1¼" (1.91 × 1.23 m). Peabody Essex Museum, Salem, MA. Chester and Davida Herwitz Collection (E301182). © estate of M. F. Husain.

and a painterly—as opposed to a smooth and polished—application of paint.

Tyeb Mehta (1925–2009) was trained in a formal European style of painting at the Sir J. J. School of Art in Mumbai, and lived in London from 1959 to 1964. Then, like Gaitonde, he traveled to the United States on a Rockefeller Fellowship, in 1968. Contact with New York's art scene, and in particular the paintings of Barnett Newman, brought a shift in his work. As Mehta said, "Let's say there must have been a point of saturation in my work before I went to New York, which my confrontation with the contemporary art scene brought to the surface. I was open to new ideas. About the same time, I became interested in using pure color. Normally brush marks suggest areas of directions. I wanted to avoid all this to bring elements down to such a minimal level that the image alone would be sufficient to speak for itself." Despite the change in style, the subjects of his paintings continued to be taken from Indian life. A large-scale painted triptych (three-paneled painting) is based on an experience at the Santiniketan art school in the early 1980s, and his observation of a local spring festival (see FIGS. 4–1 and **4-26**). It reflects the style of his work from the latter part of his career, in which great expanses of color contrast with expressive passages of drawing.

4-26 • Tyeb Mehta SANTINIKETAN TRIPTYCH
1986–1987. Oil on canvas, 6'10¾" × 14'6¾" (2.09 × 4.44 m). National Gallery of Modern Art, New Delhi. © Tyeb Mehta.

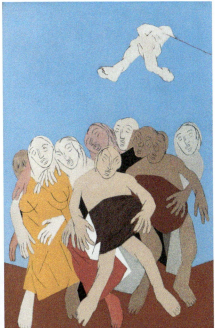

BHUPEN KHAKHAR

A group of artists in Baroda (Vadodara) in Gujarat formed another axis in the arts scene. The university there had been founded in 1950, and therefore had no colonial ties; its arts faculty adopted a progressive curriculum and promoted engagement with the political scene. Then in the 1970s, advocating a return to figuration, these artists placed themselves at odds with those working in abstract styles. Artists of this group also mined the most personal of subjects for their work.

For Bhupen Khakhar (1934–2003), this often meant his feelings about his homosexual identity and the dislocation of the individual in modern society. *Hamam Khana* depicts a nude female in the ruins of a Mughal bathhouse, a lone figure dwarfed by the landscape (**FIG. 4-27**). The landscape itself is composed of large blocks of color; its lack of detail underscores the vulnerability and loneliness of the woman.

Paintings in oil on canvas tended to dominate the work of South Asia's modern artists, but in the 1980s the field opened up to other media. It has broadened to include even a return to the methods of sixteenth-century book illustration, although in a totally reimagined way.

RAGHUBIR SINGH

Raghubir Singh (1942–1999) lived in Paris, London, and New York, but his photographs of life in present-day India, in vibrant color and with compositions chock-full of people and action, show his true connection to this subject. He made several series of photographs traveling through different parts of India; in a view of a street scene in Bombay (Mumbai), the lights from inside a store, reflecting onto the world outside, add illumination to a slice of everyday life (**FIG. 4-28**).

4-27 • Bhupen Khakhar HAMAM KHANA
1982. Oil on canvas, 4 × 4' (1.2 × 1.2 m). National Gallery of Modern Art, New Delhi.

4–28 • Raghubir Singh *ZAVERI BAZAAR, MUMBAI, MAHARASHTRA*
1991. Chromogenic print, 9¹⁵⁄₁₆ × 14¾″ (25.3 × 37.5 cm).
Metropolitan Museum of Art, New York. Purchase, Cynthia
Hazen Polsky Gift (1991.1285).

4–29 • Shazia Sikander *PLEASURE PILLARS*
2001. Vegetable color, dry pigment, watercolor, ink, and tea on
wasli paper, 12 × 10″ (30.5 × 25.4 cm). Collection of Amita and
Purnendu Chatterjee, New York. Artwork © Shazia Sikander. Image
courtesy of the artist and Sikkema Jenkins & Co., New York.

SHAZIA SIKANDER

Shazia Sikander (b. 1969) now lives and works in New York.
Although she completed her training in the historical man-
uscript painting tradition at the National College of Arts in
Lahore, and this grounding still resonates in her work. Many of
her paintings are on the same scale as the manuscript paintings of
the sixteenth and seventeenth centuries, and like them are made
of layers of opaque watercolors, burnished after each application.
The subject matter is personal, though. *Pleasure Pillars* juxtaposes
images of female beauty from Mughal and Rajput paintings, from
Hindu temple sculpture, and from the classical world (**FIG. 4–29**).
Although these historical images had distinct meanings in their
own time, their significance shifts in Sikander's hands.

RASHID RANA

Rashid Rana (b. 1968) is from Pakistan and still works there today, although he has lived in Canada and has an international presence. In a series of 2004 to 2007 he built up an arrangement of stills from pornographic films to create pictures of veiled women (**FIG. 4-30**). They shock in their juxtapositions, and make the viewer question the judgment of the veiled Muslim woman as having lost her identify and selfhood. The pornographic images of women, from a supposedly more liberated society, have the same dehumanizing effect. Also inherent in the work is the notion of contradiction. A related series uses details of boys and men from Lahore to make up the images of the Bollywood film stars they idolize. As Rana states, "Today, every image and idea (whether ancient or contemporary and media-generated) encompasses its opposite within itself. The perpetual paradox, which reigns in the outside world, is a feature for the internal self also."

BHARTI KHER

Bharti Kher (b. 1969) was born and studied in England but is now based in New Delhi, having moved there after meeting her husband, the artist Subodh Gupta. Her work encompasses a wide range of media and forms, and is hard to define; any one image shows but a facet of her output. But one motif with which she has repeatedly toyed is the *bindi*, the dot worn by Indian women on their foreheads—a symbolic third eye that sees the spiritual or conceptual world, but is misinterpreted (or interpreted differently) by many. Fashioned into paintings, applied to sculpture, or, as in this case, stuck to a mirror (**FIG. 4-31**), "the *bindi*," says Kher, "has become many things to me now, after using it for so long: it is a marker of time. It functions as both a material that transforms the surface of a work like text or codes, and reinvents the clarity of a ritual that it signifies and allows you to open your eyes and see."

The development of South Asia's culture of artistic production is as grand and many-stranded an epic as the *Mahabharata*. It moves from the earliest traces of an urban culture and the creation of the first objects, through making the leap from the merely utilitarian to the artistic, up to the present day, with the involvement of South Asia's artists in a sophisticated and highly monetized global art scene. While in the earliest phases artistic expression was harnessed primarily to the goal of religious ideals, over time that expression came to be applied to many areas, and even to the political and personal. This shift was

4-30 • Rashid Rana *VEIL VI*
2007. C-print and DIASEC, 70 × 51⅓″ (177.8 × 130.5 cm).
Courtesy of the artist and Lisson Gallery, London.

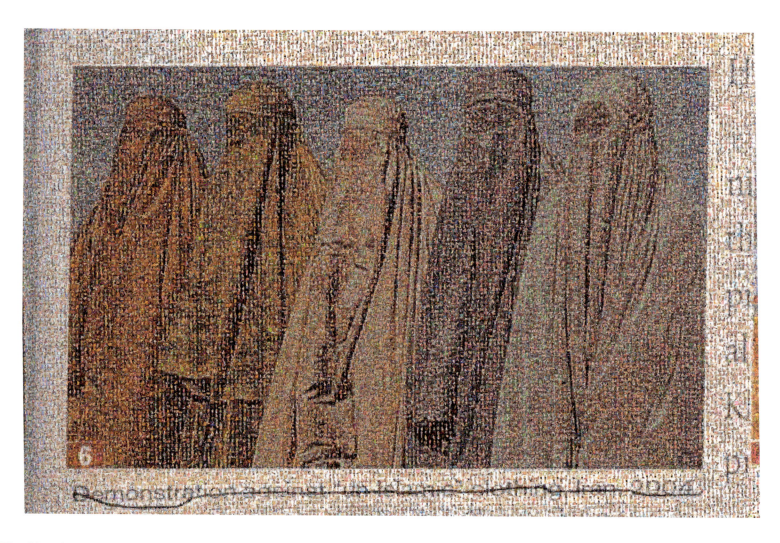

4-31 • Bharti Kher INDRA'S NET MIRROR 1
2010. Bindis on mirror, wooden frame, 75⅝ × 42⅞ × 2½" (192 × 109 × 6.4 cm). Hauser & Wirth, London/New York/Zurich.

CROSS-CULTURAL EXPLORATIONS

4.1 Landscape painting, in which the natural features of a setting are more prominent than buildings or people, was a new development of the eighteenth century. How do paintings such as Sita Ram's (FIG. 4–10) compare to earlier depictions of the Indian outdoor world, such as a Humayun-era work (FIG. 3–28)?

4.2 Compare colonial-era buildings of the nineteenth century (FIGS. 4–13 and 4–14) to the Mughal royal buildings from which they are supposed to take inspiration (such as FIGS. 3–21 and 3–22). Do they have any features in common? Do you see a connection between them?

4.3 Soon after its invention, photography was put to use in documenting wars in many parts of the world. Compare the images of the Indian Uprising of 1857 captured by Felice Beato (FIG. 4–12) with the photographs from near-contemporary conflicts such as the American Civil War, photographed by Mathew Brady, or the Crimean War, photographed by Roger Fenton. What aspects of conflict do they focus on? How do these photographs compare to images being shot of war today?

4.4 Tyeb Mehta and several of his contemporaries acknowledged the inspiration they took from New York artists of the 1950s and 1960s. Do you see connections between Indian and American painting of this period? Can you think of any twentieth-century artists in Europe or America who looked to Asian art to create their own works?

accompanied by a loosening in the rules governing expression. For centuries, artists were bound to work within the strictures of set aesthetic norms, established by tradition, religious belief, or the expectations of the patron. Today, the contemporary artist operates within a global community of artists, all experimenting with new forms and pushing the boundaries of what we consider to be art to their utmost limits.

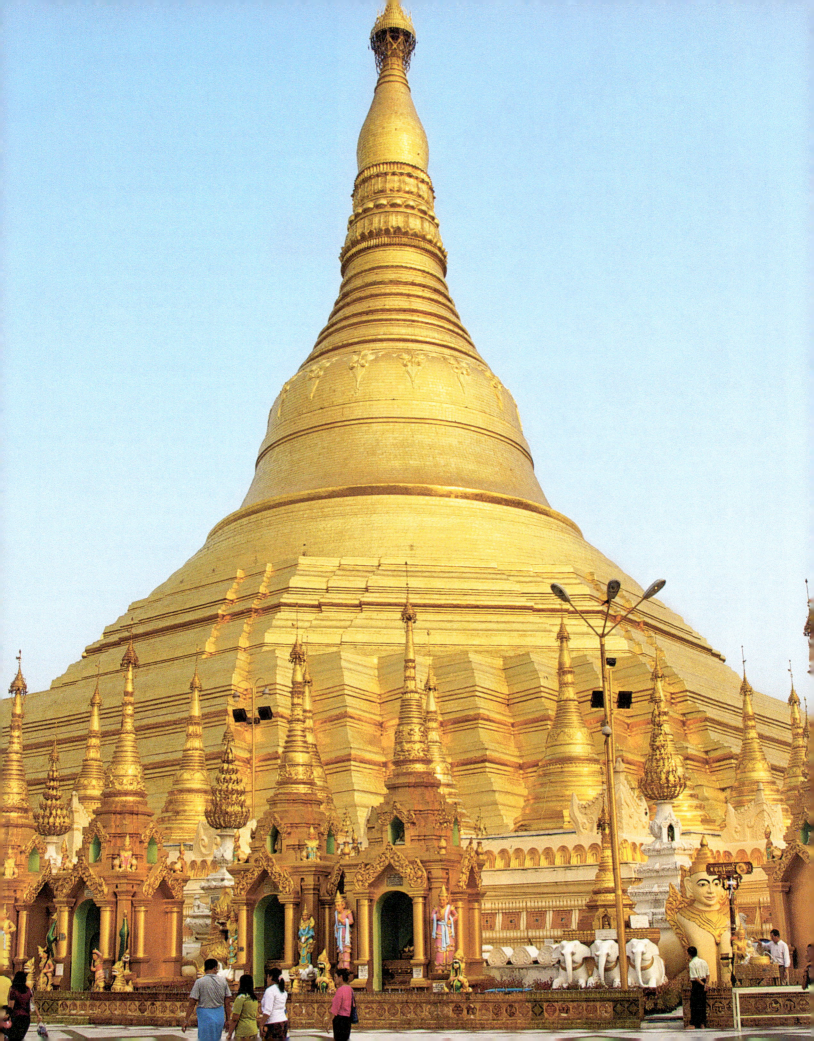

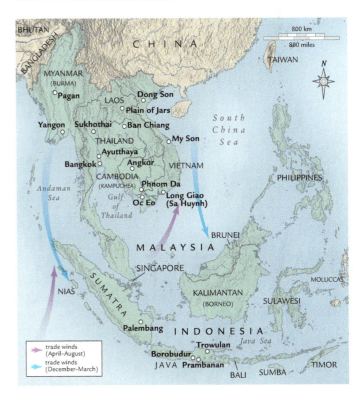

At the Crossroads: The Arts of Southeast Asia

The [Shwe Dagon] rose superb, glistening with its gold, like a sudden hope in the dark night of the soul.

W. Somerset Maugham (1874–1965)

The vast area that is Southeast Asia stretches for almost 4,000 miles (over 6,000 kilometers), from its border with the Indian subcontinent in the northwest to Irian Jaya in the southeast. On the mainland, great river valleys—arteries for trade and cultural exchange—have formed the homeland to major ethnic groups. In the hills, many different tribal groups exist, each with its own language and distinctive art, jewelry, and textiles. Maritime Southeast Asia consists of thousands of islands linked by sea trade with one another, the mainland, India, and China. The region boasts the largest Buddhist monument in the world (Borobudur) and the largest Hindu temple (Angkor Wat), and has produced some of the finest religious architecture and sculpture found anywhere in the world. It also has the largest muslim population. However, Southeast Asian art was not only shaped by three great religions; it also has a rich vein of indigenous styles in **pottery**, textiles, ancestral art, and bronze-working. Ancient beliefs in the spirit world and the ancestors coexist with the great religions, and these many layers are reflected in the art and architecture of the region (**FIG. 5-1**).

The Shwe Dagon pagoda in Burma has been the heart of a nation for over 1,000 years. Its great glittering dome is a towering, fairytale monument to the Buddhist faith. Yet the pagoda

5-1 • SHWE DAGON PAGODA
Yangon, Burma.

also demonstrates how influences and ideas from outside, like Buddhism, were often welcomed and adapted to meet local needs. Southeast Asia's language groups, clothing, house styles, music, and relatively high status of women throughout history (compared to neighboring India and China) are among the factors that create a distinctly Southeast Asian culture.

The region's history has also been greatly affected by its geography and weather patterns (**MAP 5-1**). Positioned on the trade route between India and China and producing precious

MAP 5-1. SOUTHEAST ASIA

spices as well as gold, gemstones, and teak, the region has been involved in trade from earliest times. The trade winds blow for six months from the southwest and for six months from the northeast, so traders would spend long periods in coastal towns, taking local wives and establishing foreign enclaves, waiting for the wind to change and carry them home with their ships laden with trade goods.

PREHISTORY

Human habitation can be traced back between 1.8 and 1.9 million years, with some of the most ancient human fossil remains in the world, notably Solo Man in Java. Evidence of **material culture**, such as chipped stone tools and cave paintings, date from circa 10,000 to 6000 BCE, and has been found throughout the region, including Thailand, Burma, Vietnam, and the Philippines. The movement of peoples around the region is difficult to trace, but there seems to have been a gradual progression from southern China through Taiwan into mainland Southeast Asia and the Philippines, west into Indonesia, and east into the Pacific. This led to the prolonged settlement of some coastal and river valley sites, and to the existence of shifting "slash and burn" tribal communities in hill regions. These migrations were perhaps motivated by changing sea levels and rain patterns, as well as trade and the introduction of new technologies. New evidence regarding the prehistoric period in Southeast Asia is being uncovered almost daily, and a more accurate picture is gradually emerging.

STONE MONUMENTS

A **megalithic** culture (characterized by large stone monuments) existed in parts of the region, commonly associated with the ancient movement of Austronesian-speaking peoples through the eastern part of the mainland and down into Indonesia. Huge stone seats and ancestral figures still stand in many places, such as the Indonesian islands of Sumba and Nias. These almost certainly had a ritual significance.

The Plain of Jars in central Laos is a series of sites covering about 386 square miles (1,000 square kilometers), with clusters of from 1 or 2 to 300 huge jars carved from rock (**FIG. 5-2**). Detailed exploration of the site has proved difficult, as this was one of the most heavily bombed places in the Vietnam War (1955–1975); so far, however, over 3,000 jars have been counted, most of them of sandstone but some of granite or limestone. They vary in size from 3 to 10 feet (1 to 3 meters) in diameter. Although dating is still uncertain, an estimate of the late first millennium BCE to the mid-first century CE is accepted. The mouths of the jars have lips, suggesting the use of a lid, and some huge stone lids decorated with animals have been found, although none in situ. Traces of cremated bodies have been found inside some of the jars, and unburned human bones and fragments of pottery, beads, and iron and bronze objects were placed around many of the jars. Who made these jars is still not known. The jars may be situated along what was once an important trade route linking distant states, and links with the Sa Huynh culture in southern Vietnam (see p. 106) have been suggested, since similar **grave goods** have been found there.

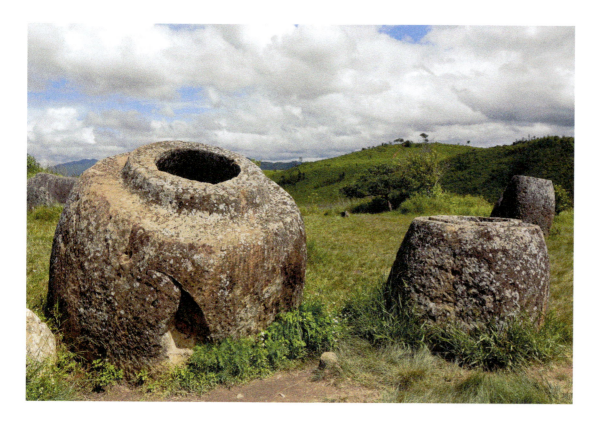

5-2 • STONE JARS
Plain of Jars, 1st millennium BCE–mid-1st century CE. Xieng Khouang province, Laos.

EARLY CERAMICS: BAN CHIANG

Ban Chiang is an important prehistoric settlement in northeast Thailand. Recent estimates, based on the age of human remains found in context at the site, suggest a long period of occupation, from ca. 2000 BCE to ca. 200 CE. Rice was probably cultivated here, and a wealth of objects from the Neolithic, Bronze, and Iron ages have been discovered, mostly in the context of burials. As elsewhere in the region in the late prehistoric period, the dead were buried with a variety of grave goods, including bronze, iron, and glass containers, and ornaments including bracelets and bells. Early ceramic pots were usually built up from coils and slabs of clay and decorated with the use of a cord-marked paddle. Later, painted and incised wide-mouthed pots appeared, as well as pedestal jars with bold, swirling red on buff designs including a distinctive "thumbprint" pattern (**FIG. 5-3**). Designs were painted over a cream **slip** and then fired, in some cases leaving the finished article with a burnished effect. The complexity and beauty of the patterns on this pottery reveal an interest in design, not merely in function, and the fact that so many pots were found in graves tells us that such vessels were highly regarded.

BRONZE CRAFT: DONG SON AND SA HUYNH

The Dong Son culture (ca. 600 BCE–200 CE) was concentrated in the Red, Ma, and Ca river valleys of northern Vietnam. Recent excavation has revealed sophisticated agriculture and large settlements, with some fortified sites—evidence of a need to defend the region from incursions from the north. People of this culture cultivated rice, bred pigs, built canoes, and were masters of fine bronze casting: Hundreds of bronze plowshares have been found dating from this period. Dong Son is particularly famous for the production of bronze drums, some as large as 6½ feet (2 meters) in height. Cast in one piece using the **lost-wax** method, many of them are decorated with scenes depicting life 2,000 years ago:

people plowing with oxen and milling rice; boats and weapons; musical instruments; and festivals and houses on piles similar to those built today in some regions (see FIG. 5-7). The drum head of the Ngoc Lu drum (**FIGS. 5-4 A** and **B**) bears a star at its center, a typical design feature. Three bands encircle this. They are filled with humans and birds. Narrower bands of cross hatching and hook shapes separate them. In a ceremony of some sort, warriors in feathered headdresses march in a counterclockwise direction

5-4A • THE NGOC LU DRUM
Dong Son culture, 600 BCE–200 CE. Bronze, 24⅖ × 30¾" (62 × 78.3 cm). Tanh Hoa, northern Vietnam; Musée Guimet, Paris.

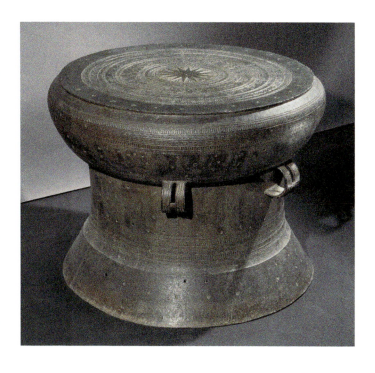

5-4B • LINE DRAWING OF DESIGN ON THE NGOC LU DRUM

5-3 • BAN CHIANG POTS
Middle–late period, Thailand. Ceramic, dimensions variable. Suan Pakkad Museum, Bangkok.

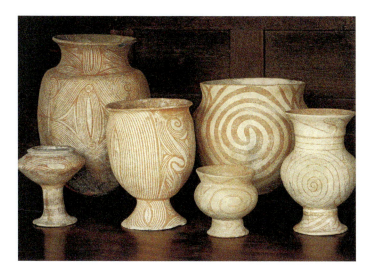

The cultures and peoples listed below have played a major role in Southeast Asia's history. Information about the origins of these groups is constantly changing as excavations continue to uncover more evidence.

Culture/people	Language group	Location	Settlements/sites	Dates
Ban Chiang	uncertain	Northeast Thailand	Ban Chiang	ca. 2000–1500 BCE–ca. 200 CE
Burman	Tibeto-Burman	Northern and Central Burma	Pagan, Ava, Mandalay, Rangoon	ca. 10th century CE–present
Cham	Malayo-Polynesian	Central and Southern Vietnam	My Son, Central Vietnam	ca. 2nd century CE–present
Zhenla	Mon-Khmer	Cambodia, Laos	Sambor Prei Kuk	ca. 6th–late 8th century CE
Funan	uncertain (Mon-Khmer?)	Southern Cambodia and Southern Vietnam	Oc Eo, Angkor Borei	ca. 2nd century BCE–8th century CE
Khmer	Mon-Khmer	Central and North Cambodia	Angkor	ca. 800 CE–present
Mon	Mon-Khmer	Eastern Burma, Central Thailand	Dvaravati	Dvaravati: 7th century or earlier–13th century CE
Pyu	Tibeto-Burman	Central, Eastern, and Northern Burma	Beikthano, Srikshetra, Halin	ca. 2nd century BCE–9th century CE
Sa Huynh	Malayo-Polynesian? Precursors of Cham	Central and Southern Vietnam	Coastal sites and river valleys	ca. 1000 BCE–200 CE
Martaram	Malayo-Polynesian	Central Java	Prambanan	8th–9th century CE
Sailendra	Malayo-Polynesian? Bengali?	Central Java	Borobudur	8th–9th century CE
Srivijaya	Malayo-Polynesian	Southern Sumatra, Malaya	Palembang	7th–13th century CE
Thai	Tai-Kedai	Thailand	Sukhothai, Lanna, Ayutthaya, Bangkok	ca. mid-13th century CE–present
Majapahit	Malayo-Polynesian	Central Java	Majapahit, Trowulan	1292–ca. 1500

behind some kind of vehicle bearing a solitary person—perhaps a man of high status. Two men sit inside a saddle-roofed house on piles, with a bird on the roof, and four figures appear to beat drums. Outside this there is a band of deer and large birds, while another band depicts a series of cranelike birds flying in a counterclockwise direction. Some drums have small frogs welded onto the surface. Frogs are associated with fertility and with water, so could these drums have been used in rain-summoning rituals? Use in death and marriage rites is also likely, as is their use in times of warfare. Clay or bronze models of the drums were also made and placed in graves.

Some 140 of these drums have been found in Vietnam, and others have been found elsewhere in Southeast Asia, indicating a trade in these high-status goods. Some were also manufactured at other sites, such as Java and Bali, using the same technology and decorative **motifs** as the originals. In Karen State in Burma, for example, similar drums were manufactured into the twentieth century. It is thought that the first Karen drums may have been brought from the Yunnan region (in present-day China, to the north of Dong Son)—another indication of the intricacy of trade networks in the region.

The Sa Huynh culture (1000 BCE–200 CE) was centered in southern Vietnam and was an important link in the trade routes between East and Southeast Asia. This culture was also adept at working bronze, as testified by a figure of a pangolin cast from solid bronze (**FIG. 5–5**). The figure displays a craftsman's delight and skill in portraying the animal

5-5 • PANGOLIN
Sa Huynh Culture, 3rd century BCE–2nd century CE. Bronze, height 3 × 14⅝" (7.5 × 37.3 cm). Long Giao, Dong Nai province, southeast Vietnam; Dong Nai Museum.

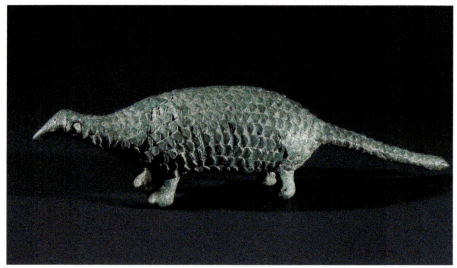

form—a skill still used today, especially in Cambodia, in the production of animal-shaped boxes and bowls. The pangolin, or scaly anteater, is a nocturnal animal. Its scales were thought to have healing powers, so they were hunted for trade. The artist has recreated the animal faithfully, with its short legs and plump body, its long neck and small pointed head balanced by a long tail.

TRADE

It is probable that from at least the fourth to second century BCE, trade networks between Southeast Asia and the kingdoms of central China were active. Chinese records of the first millennium BCE refer to the Sa Huynh culture, and Chinese coins and mirrors have been found at Sa Huynh sites. In 111 BCE, the Chinese Han empire conquered the Viet kingdoms of southeastern China and northern Vietnam, and Chinese domination was to last in that region for 1,000 years.

Aside from China's domination of northern Vietnam, Chinese communities sprang up throughout Southeast Asia, many having been established by Chinese traders settling there. Over time Chinese motifs, such as the **cloud pattern** and stylized rock formations, were introduced into traditional crafts, and in Southeast Asia, many of these items were then created for the Chinese market.

Trade with India was also well established, and early communities were either importing glass and precious stone beads and ornaments from India, or producing them themselves in large quantities using Indian technologies. It has been suggested that Indian craftsmen were present in the area and that techniques were transmitted to local artisans in this way. There is evidence that sea and river trade flourished within the region from very early times, and pots and jewelry, as well as bronze drums, have been found far from their place of origin. An example of this is the jade *ling ling-o*, a distinctive ear ornament that originated in Vietnam. Examples of these, however, have been found far afield in, among other places, the Philippines and Burma (**FIG. 5–6**).

Ling ling-o are ring-shaped, with a gap at one side so that they can be fitted over the ear. They were carved from a jade found on the island of Taiwan. Both the ornaments themselves and uncarved jade "blanks" were traded between around 500 BCE and 500 CE. These blocks of jade have been found far from Taiwan, indicating that *ling ling-o* were known and copied at other points along the trade route. They were probably exchanged between families at marriage ceremonies—as jewelry

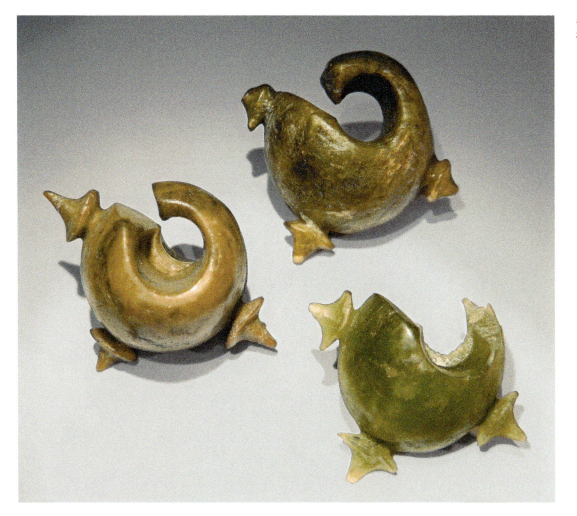

5–6 • LING LING-O
3,000 BCE onwards. Jade.

commonly is today—and have been found in funerary jars or buried with skeletons, close to the head, indicating their use as earrings. These examples, found in Vietnam and the Philippines, have three projections around the curved outer edge. This ancient style of earring is still popular among the Ifugao and Igorot peoples of the Philippines.

INDIGENOUS ART

Southeast Asia has many vibrant artistic traditions that are distinctive to the region, and many of these are to be found among the tribal cultures of the upland regions, where change has come more slowly than elsewhere. These forms often embody a powerful symbolism that is still meaningful today.

HOUSES

Most notable among these traditions is the huge variety of house forms—many are still built on piles or pillars, as they were in prehistoric times. This is partly to protect against flooding, wild animals, and insects, and partly for safety in case of attack, especially in former head-hunting communities. Even in places where houses are now built on the ground, such as Central Java and Vietnam, there is evidence that in the past they were pile-built. The eighth-to-ninth-century reliefs at Borobudur (see FIG. 5–14) depict large-roofed houses on stilts, and the illustrations on the Dong Son drums (see FIG. 5–4) show houses almost identical to those still being built by the Toraja on the Indonesian island of Sulawesi some 2,500 years later (FIG. 5–7).

These big shiplike houses have thatched saddle-backed roofs. The relative size and decoration of the high, exaggerated front gable is an indication of the status of the house owner, or in some cases of the clan. The house of a warrior or a wealthy man would be ornamented with buffalo horns. Buffalo are very valuable and are sacrificed at ceremonies, so the number of horns displayed indicates the household's wealth. Carved buffalo heads may project from the front gable and the gable panels may also be painted in reds, blacks, and yellows, often with images of lizards and birds surrounded by cross hatching, lozenge shapes, and swirling lines. This exaggerated front gable must often be supported by a tall pillar with radiating struts, and the two sides of the gable are joined by cross-beams. Entry to the raised floor of the house is traditionally via a ladder, which is drawn up at night, and the open area beneath it is fenced, to keep the household animals safe.

Although many traditionally held concepts are changing, especially in the cities, Southeast Asia remains a world ruled by spirit. Everything in the cosmos is thought to be imbued with a vital force, which one ignores at one's peril. The world is seen in dualistic terms—a series of complementary opposites: mountain versus sea, male versus female, dark versus light. However, people also traditionally see themselves as fitting into a tripartite division of the universe: the upper world—home of the gods and spirits; the world of men; and the lower world—the place of demons.

The structure of traditional houses reflects this cosmology. The roof is the place closest to the heavens and the spiritual realm. It is here that heirlooms—valuable textiles and jewelry, and heads (in a head-hunting community)—were stored, hung from the ceiling in nets or sacks. The living/sleeping area is the human realm. The area under the house, where the animals are kept, is the realm of the underworld, but also that of the earth and new life.

5–7 • TORAJAN HOUSES
South Sulawesi, Indonesia.

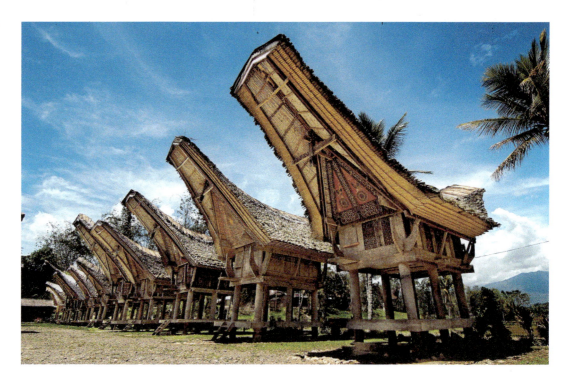

During the building process, offerings to the spirits are hung on the central post, representing the spine, which in turn symbolizes the world axis or tree of life. Indeed, the central post in many cultures has to be cut and erected the right way up—that is, the root end placed into the soil. The house is also equated with the human body. In some places, such as the Indonesian island of Bali, houses are built according to the dimensions of the house owner's body. The man's sleeping area is considered the head section of the house, and is higher than the sitting area, with the cooking space behind and below both.

ANCESTOR WORSHIP AND THE SPIRIT WORLD

Alongside belief in such religions as Buddhism and Islam, man's relationship with the spirit world and with his ancestors has always been a major preoccupation in Southeast Asia. The spirits of the rice, the mountain, the river, and the sea must all be honored and placated if harm is to be averted. The use of ritual in all situations where man interrupts the natural order is vital. In addition to nature spirits, there are the spirits of the upper realm and the spirits of the ancestors. Some are in animal form and can guide and protect if suitably honored. Ancestors are present at rituals, represented in carved form or in masked dance. An ancestral image may be of a relatively recently deceased individual—sometimes carved by an immediate descendent—or of a legendary tribal chief or clan founder. Carvings commonly depict a standing figure with outstretched arms, or a squatting figure with hands resting on knees. An ancestral figure from the Indonesian South Molucca islands shows a man squatting on a low platform, knees bent and feet flat on the ground (**FIG. 5–8**). His long, pointed nose dominates his face and his eyebrows join up with the sweeping planes of his cheekbones. His carved ears are elongated by heavy earrings, and he wears a pointed coronet on his head, indicative of his high status. Riders on horseback or astride a composite animal also occur, as among the Batak of the island of Sumatra. In other communities, such as the Asmat of New Guinea, ancestral totemic poles are erected in the fields.

Ancestors also play a part in funerary rites. Among the Toraja of Sulawesi, effigies of the deceased (*tau tau*) are made and displayed in cliffs above the village, guarding their descendents. The connection between death and fertility is also important in those communities where head-hunting was traditionally practiced. The head of a person killed in this way (believed to contain that person's life source) was carried back to the attacker's community and fields, to help correct the balance when illness or poor crops threatened well-being. Shields and weapons used in the hunt were decorated with protective symbols such as hornbills, cockerels, and human faces, and Southeast Asians are famed for the tattoos, often protective, that traditionally covered their bodies.

Similar concerns with maintaining the cosmic order can be seen in textiles, which often contain protective motifs. There

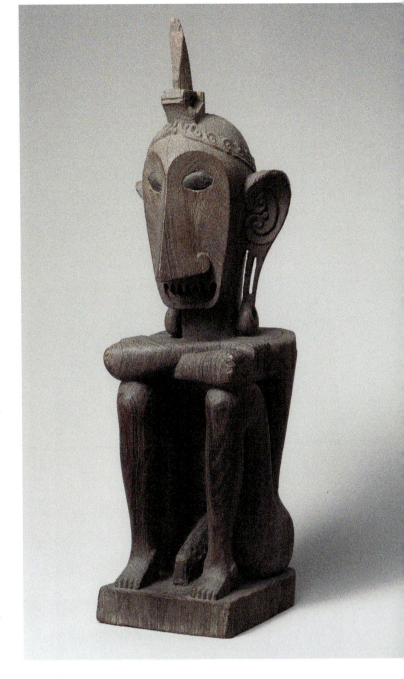

5-8 • ANCESTOR FIGURE (*YENE*)
19th–early 20th century. Wood, 12¾ × 3¼ × 4″ (32.4 × 8.3 × 10.2 cm). South Moluccas, Leti Archipelago, Indonesia; Metropolitan Museum of Art, New York. Gift of Fred and Rita Richman, 1987 (1987.453.5).

is a great variety of textiles in Southeast Asia, and particularly among all the islands that make up Indonesia: from the hand-drawn cotton batiks of Java to the bark cloth of Timor and the elegant silk **ikats**, or tie-dye cloth, of Bali. Color and motif are important: These indicate both the origin and the rank of the wearer and the type of occasion for which a textile is worn or displayed. Textiles represent the female side of the community, and at wedding ceremonies are often exchanged for metal objects such as weapons, which have male associations.

A *hinggi* (man's cloth) from the small island of Sumba (FIG. 5-9) is an ikat worn on ritual occasions. It shows typically bold motifs in rich rust, yellow, and indigo dyes. The piece is made up of two halves—mirror images—identical in design, with a full center band. As is usual in textiles, the number of decorative bands is uneven. Two broad bands display rows of male figures, with narrow bands above and below them depicting cockerels. Bordering the central panel are two vertical bands of stylized

5-9 • MAN'S CLOTH (*HINGGI*)
ca. 1920. Cotton, 88 × 48″ (223.5 × 121.9 cm). East Sumba, Indonesia; Metropolitan Museum of Art, New York. Gift of Anita E. Spertus and Robert J. Homgren, in honor of Doublas Newton, 1990 (1990.335.12).

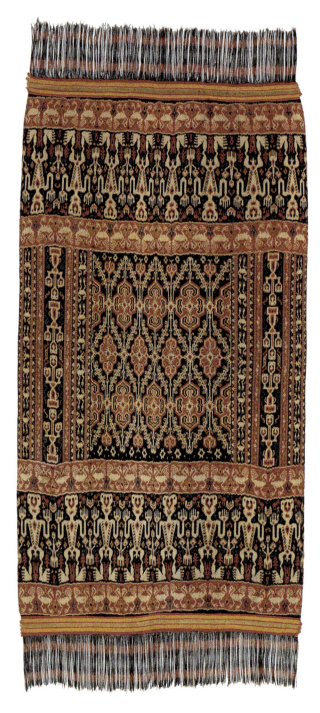

skull trees. Such trees were placed in pots at the entrance to a royal village or noble's house, with human heads taken in battle hanging from the branches. This was a sign of victory over enemies and acted to ward off evil. The center panel is filled with a geometric pattern of diamond shapes filled with stylized flowers, and is clearly influenced by Indian motifs (see Chapter 2, FIG. 2–34). The cockerels, men, tree, and flowers represent the natural order of things and thus play an important role in ritual. Other common motifs include lizards and shrimps, horses and deer.

THE ARRIVAL OF INDIC RELIGIONS

How exactly the transition was made from Iron Age settlements to Indian-influenced Buddhist and Hindu cultures is still unclear. Some very early finds, such as carnelian lion ornaments, may be Buddhist, since the lion is a symbol of the Buddha's teaching. As religious ideas traveled around India, region by region, so they spread to China and Southeast Asia, a process facilitated by long-standing trade routes and the ease of communication across the Bay of Bengal. The earliest inscriptions found to date are the seven fourth-century stone sacrificial posts from East Kalimantan in Borneo, which bear a Sanskrit record of Hindu rituals in connection with a King Mulavarman. The earliest Buddhist and Hindu sculpture, however, does not appear until the late fifth century CE, and not in larger numbers until the late sixth to seventh centuries.

Art of this period displays a similarity of style across the region, influenced by Indian prototypes—according perhaps to which school of Buddhism or Hinduism was adopted, but displaying local variations. The Pyu people of the Irrawaddy Valley of northern Burma inhabited parts of the region from about the second century BCE to the ninth century CE. The earliest remains, including buildings containing urn burials, indicate a possible cult of the ancestors; they must have adopted the new religious ideas in the early centuries CE, however, for later Pyu finds include Buddhist imagery.

THE DVARAVATI CULTURE

Mon-speaking groups were settled in Thailand and possibly eastern Burma perhaps as early as the fourth to fifth centuries CE, and by the seventh century the Central Thai Mon had developed a culture known as Dvaravati in the Menam Chao Phraya Valley. Chinese records of the time mention missions bringing gold, gems, and ivory from Dvaravati, and Buddhist sculpture in the Dvaravati style dates to between the seventh and eleventh centuries CE. Carvings show Gupta influence (see Chapter 2, FIG. 2-16) and were mainly in limestone. Terra-cotta and **stucco** moldings were also produced. Large freestanding stone *dharmachakra* ("Wheel of the Law"), symbolizing the Buddha's First Sermon, have also been found, some with inscriptions in Pali, a northeast Indian language closely associated at this period with

Theravada (or Hinayana) Buddhism (see Chapter 1, p. 17). At its finest, Dvaravati sculpture conveyed great spirituality (**FIG. 5-10**). Following guidelines set down in Indian art manuals, this Buddha has large hair curls and a rounded *ushnisha*, the protuberance on the top of the head and one of the identifying marks of the Buddha, as are the long ears. The eyebrows meet in a sweeping curve, like "a swallow in flight," and the downcast eyes turn down at the inner corners, "like lotus petals." Gupta influence is discernible in the self-contained, meditative posture, which radiates strength and inner calm, but a local essence has been added to the physiognomy. The eyebrows form a distinct ridge, and the strong, fleshy nose with flared nostrils is balanced by the rounded cheeks and the wide, full mouth, in a half-smile.

THE FUNAN CULTURE

Between the second century BCE and the eighth century CE the port of Oc Eo, at the mouth of the Mekong River in northern Vietnam, was the trading center for the culture known to the Chinese as Funan. This extensive network of peoples flourished in part due to careful water management: They controlled the swampy delta region with canals, and practiced intensive rice cultivation. Oc Eo lay on the trade route followed by coast-hugging merchant vessels and also sat across the Gulf of Thailand from the Isthmus of Kra, a narrow overland route to the Andaman Sea, thought to have been a major trade route. Funan thus had access to many exotic trade goods such as Indian and Roman coins, amulets, and tin models of Hindu deities, as well as items brought in from the hinterland for export. Like the Pyu culture, Oc Eo was almost certainly an urban site before becoming Indianized. Funan flourished until about the fifth century CE, after which there is a gap in our knowledge. It is probable that sculpture existed in wood at this time, because when we do see the earliest stone sculpture from the region of Phnom Da, in the north of the Funan region and datable to the late sixth and early seventh centuries, it is of an astonishing level of skill and sensitivity, suggesting a maturity and wealth of experience on the part of the sculptors.

5-10 • *BUDDHA*
Mon period, Dvaravati culture, 8th–9th century. Polished limestone, 5′7⅓″ (1.71 m). National Museum, Bangkok.

A Phnom Da sandstone sculpture of the **bodhisattva** Avalokiteshvara (**FIG. 5-11**), depicts the Buddhist entity who, as the embodiment of compassion, was popular in much of Southeast Asia during the seventh to ninth centuries. This sculpture is dated to the seventh century, and shows the bodhisattva—recognizable because of the image of Amitabha Buddha in his headdress (he is said to be an emanation of Amitabha)—in polished greenish sandstone. His body is smooth, with musculature barely hinted at. He stands on two lotuses and is supported by the two clubs he holds. His weight is distributed slightly more on his right foot and his head, too, is inclined slightly to the right. Clad in a long, pleated lower garment tied at the waist with a girdle, he also wears a crown with large rondels on the brow and an aureole (halo) behind it. His ears are so long that

5-11 • *AVALOKITESHVARA*
Mid-7th–early 8th century. Polished sandstone, height 6′2″ (1.88 m). Phnom Da, Cambodia. Musée Guimet, Paris.

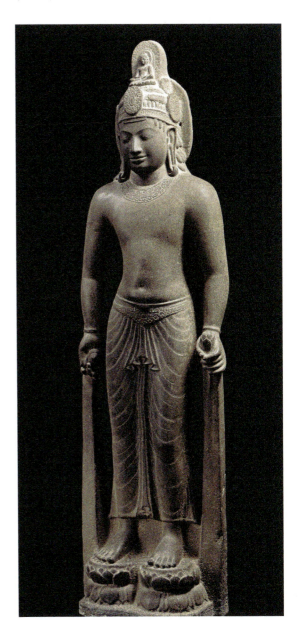

they touch his shoulders. He has downcast, meditative eyes, and displays the gentle and mysterious smile that would later become a feature of Angkorean sculpture (see **FIG. 5-21**).

SRIVIJAYA

In Central Java, Hindu temples were being built on the Dieng plateau by the seventh to eighth centuries, while in southern Sumatra, peninsular Thailand, and the Malay Peninsula, a river and coastal trade confederation known as Srivijaya (Sriwijaya) flourished by the seventh century, with its main port at Palembang in Sumatra. The center of an extensive trade network, Srivijaya extended its influence as far east as Kalimantan and the Philippines. Links with both northern and southern India introduced new artistic ideas, and it was a thriving center of Mahayana Buddhism (see Chapter 1, p. 17) with ties to the great north Indian university of Nalanda. The Chinese Buddhist monk Yi Jing visited Srivijaya between 671 and 695, and mentioned that there were over 1,000 Buddhist priests there. The language of inscriptions was Sanskrit, and Yi Jing was one of many Buddhist scholars who stopped in Srivijaya to study the language. Few architectural remains have been found in Palembang, but aerial photography has revealed a network of canals and the foundations of buildings. In addition, many examples of sculpture remain, both from Srivijaya and from neighboring Malayu, on the mainland.

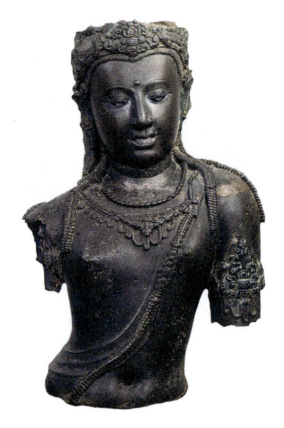

5-12 • BODHISATTVA AVALOKITESHVARA
Chaya, Srivijaya school, 8th–9th century. Bronze, height 27½″ (70 cm). National Museum, Bangkok.

One example in metal is an image of Avalokiteshvara (**FIG. 5-12**). Although it is only a fragment, the sway of the body is evident. The figure has rounded, gentle features and the hair falls in long locks over the shoulders. The bodhisattva wears fine jewelry and a coronet. Stylistically this sculpture has close ties to the sculptural tradition flourishing in nearby central Java.

THE GREAT FLOWERING

It was from these early Hindu and Buddhist communities that the great kingdoms ultimately developed. These were centralized and stratified, and leaders espoused either Buddhism or Hinduism, perhaps as a mechanism for legitimizing their rule. However, it seems that the general population probably always also practiced their own ancient beliefs, too.

BOROBUDUR

In Java in the late eighth century, Buddhist and Hindu traditions coexisted and the Sailendra dynasty—whose origins are uncertain—built a series of Buddhist monuments in central Java, including the great **stupa** of Borobudur. Like Indian stupas (see Chapter 1, **FIGS. 1-12** and **1-15**), Borobudur is a solid mound containing a small enclosed **relic** chamber. The mound is faced with stone carved with images and **reliefs**. Borobudur was actually built around a natural hill, using more than 1 million blocks of andesite, a volcanic stone (**FIG. 5-13**).

Borobudur rises in three sections from a square base succeeded by square terraces with circular terraces at the summit. A staircase at each side leads one on an upward journey, both

5-13 • GREAT STUPA AT BOROBUDUR
Java, 8th–9th century.

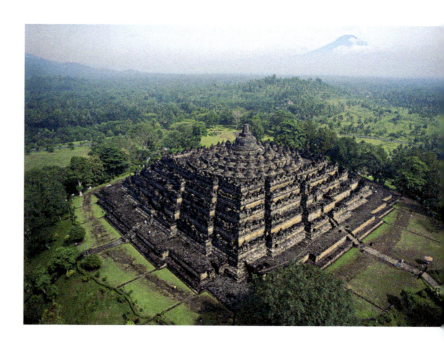

spiritual and physical, through these three sections, which represent the three Buddhist realms—made even more explicit in the 2,760 individual bas (low) reliefs decorating the structure. The base, which is partially hidden, is the realm of desire and attachment (*kamadhatu*), to which most of us are bound. It is decorated with hundreds of these reliefs illustrating the earthly desires, and the regrettable results of living a life ruled by these attachments. The five square galleries above represent the realm without attachment (*rupadhatu*). They are open to the sky, but enclosed on either side by high panelled walls decorated with an upper and lower tier of reliefs. **Circumambulating** these five terraces, one passes through scenes from the final and previous lives of the Buddha before ascending to three circular terraces that represent the realm of formlessness (*arupadhatu*). Completely open and with no relief decoration, the large central stupa form at the summit of this section is instead surrounded by 72 stone Buddha images seated in meditation within small latticework stupas, also carved of stone. The sense of release as one emerges from the relatively confined spaces of the galleries onto the open upper terraces is surely deliberate, illustrating to the pilgrim how, by following a Buddhist path, one can gradually overcome worldly considerations, lose attachments, and reach the realm of formlessness and, ultimately, **nirvana**.

The reliefs are deeply carved into the volcanic stone cladding the stupa. The human figures and bodhisattvas have rounded features and smooth lines. They display a calm air, even in the scenes of hell, and in the details of their clothing and in the architecture, flora, and fauna depicted, they are clearly Javanese.

In one scene the virtuous King Uposadha distributes alms (**FIG. 5-14**). The king sits in the royal posture of ease (*maharaja-lila*) while his male and female attendants distribute food to the aged and infirm. The king and his attendants wear fine girdles and necklaces as well as elaborate headdresses, long earrings, and jewelry on their arms and ankles. Their faces are rounded and their limbs firm and smooth. A servant carrying a jar looks on.

In addition to representing the three Buddhist realms, the stupa represents the temple mountain in the Hindu/Buddhist tradition, its summit being the holy Mount Meru (the traditional abode of the Vedic and Hindu deities) at its center. However, its combination of square, circle and triangle (the stupa outline) forms indicates that the stupa was also built as a giant three-dimensional **mandala**—a diagrammatic aid to meditation. Many such mandalas were known at this time in the Mahayana tradition, which was flourishing at the time in Bengal, which had stong links with the Sailendra dynasty. None can be exactly linked to the form of Borobudur, although the Buddhas in niches and holding their hands in different gestures (**mudras**) on each side could correspond to those surrounding the Buddha in the Diamond World Mandala of Esoteric Buddhism (see Chapter 13, FIG. 13-15).

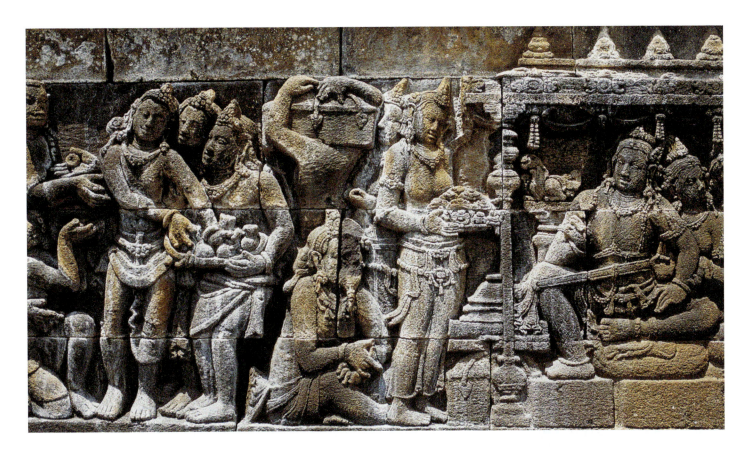

5-14 • *KING UPOSADHA DISTRIBUTING ALMS*
Borobudur, mid-8th century. Volcanic stone.

PRAMBANAN

In the mid-ninth century, a great temple complex was built at Prambanan near present-day Jogjakarta, by the Sanjaya dynasty (**FIG. 5-15**). Within a large compound, three temples, dedicated to **Brahma**, **Shiva**, and **Vishnu**, stand in a row opposite three small temples dedicated to their respective *vahanas* (vehicles). Only Nandi, the vehicle of Shiva, now remains in situ. A further 224 small temples surround the central temples, and small shrines mark the four cardinal directions. Of the three major temples, the one dedicated to Vishnu is the tallest, soaring to 155 feet (47 meters) in height. It is notable for its reliefs depicting scenes from the *Ramayana* (see Chapter 2, p. 52), which continue on the balustrade walls of the Brahma temple. Sculpted in the same volcanic stone as Borobudur, the reliefs are vigorous and full of movement. Many guardians and heavenly beings also adorn the temples.

Like Srivijaya, central Java also had a rich tradition of metal sculpture until the early tenth century, when the court seems to have moved to eastern Java. An exquisitely modeled solid silver sculpture of the Bodhisattva of Wisdom, Manjushri (**FIG. 5-16**), sits with one leg pendent in a variant of the "royal ease" posture seen in the Borobudur relief (see **FIG. 5-14**). In his left hand he holds a lotus surmounted by a book, symbolizing his wisdom. His head is shaven apart from three tufts of hair, one fastened with a clip and two falling onto his shoulders. The youthful bodhisattva wears a necklace with tiger's claws, and his lower garment is clearly incised with a rich floral pattern. The ring on his right foot indicates that the piece was originally attached to a pedestal or throne.

CHAM

In central Vietnam, the people known as the Chams, who may have been inheritors of the Sa Huynh culture, had been developing and expanding a flourishing trading network since at least the fifth century. They left a legacy of fine early temples dedicated to Vishnu. Although the Cham are known to have practiced Hinduism earlier, the earliest remaining temples—at My Son—which are single-cell shrines built mainly of brick, date from the seventh century, as does the earliest Cham sculpture (**FIG. 5-17**). In a carving for a lintel from My Son, Vishnu reclines on the many-headed serpent Ananta, floating on the Milky Ocean (see also Chapter 2, **FIG. 2-9**). From his navel emerges a lotus on which sits the god Brahma, who is creating the world anew. The gods have calm, detached expressions as this great miracle of creation occurs. On either side are images of Garuda, here represented as part bird part man. Garuda is the vehicle of Vishnu, and the figures here are shown seizing serpents, their traditional enemy. Both birds and serpents are associated with Vishnu: The bird is symbolic of the sun and the heavens, and the serpent represents both the earth and waters. The serpent also represents renewal, owing to the perennial shedding of its skin.

ANGKOR

The beginning of the ninth century marked the dawn of the Angkor empire in Cambodia, brought into being by the Khmer king Jayavarman II (ca. 770–850). No inscriptions from his reign have been found, but later records suggest that as a young man he spent some time in Java, perhaps as a result of being taken hostage during a Javanese attack on the Khmer capital. At some point in

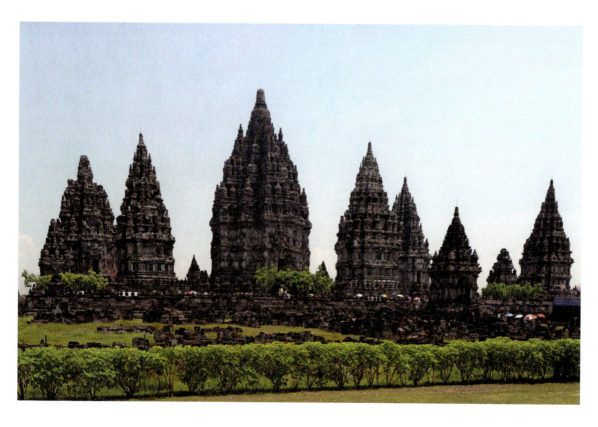

5-15 • PRAMBANAN TEMPLE COMPLEX
Mid-9th century. Central Java.

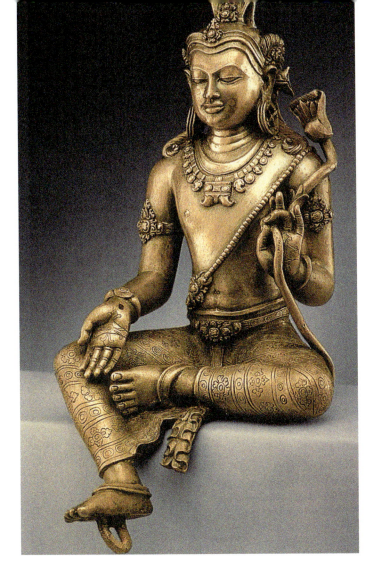

5–16 • MANJUSHRI
Early 10th century. Silver, height 11⅜″ (29 cm). Central Java; Central Museum, Jakarta.

the 790s he returned, united the kingdoms of Funan and Chenla, and proclaimed himself a universal ruler (*chakravartin*), fully independent of the Javanese Sailendra court. The accepted date for the founding of the Angkor empire is 802. On this date, in his capital, Hariharalaya (Roluos in western Cambodia), Jayavarman espoused a new concept, already familiar in Java—the cult of the ***devaraja***, or god-king, which linked him to the god Shiva.

Over the next 300 years Jayavarman's descendants extended the empire and built magnificent temples in different locations to the north of the nearby Tonle Sap lake. The temples were typically dedicated to Vishnu, Shiva, or Buddhist bodhisattvas, and contain statues on which their portraits were often carved, the titles of which show a fusion of their personal titles with the name of the deity. Brick was used for the earlier temples, then increasingly laterite and then sandstone. Angkor is famous for these temple mountains, built to symbolize and mirror the Hindu cosmos, with the central sanctuary representing Mount Meru, and the walls, galleries, enclosures, and moats around it being mountain ranges, continents, and oceans. The greatest

5–17 • VISHNU ANANTASAYANA
Cham culture, 7th century. Lintel from My Son E1-style temple. Sandstone. Quang Nam province, central Vietnam; Cham Museum, Da Nang.

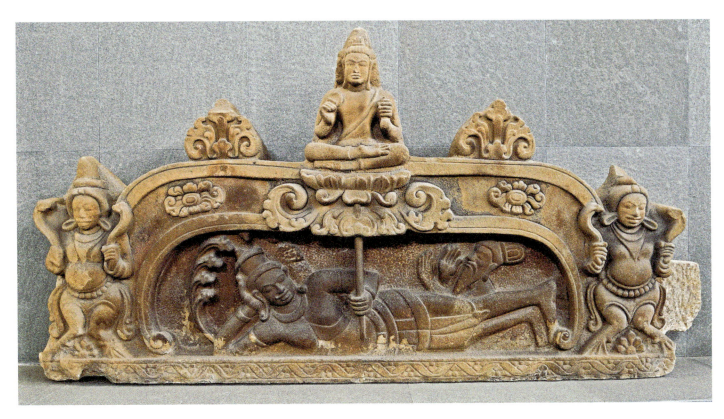

example, and the most famous of the temples, is Angkor Wat, built by Suryavarman II in the first half of the twelfth century (**FIG. 5–18**).

ANGKOR WAT Angkor Wat is an essay in perfection due to its scale, the symmetry of its design, and the beauty of its execution. Dedicated to Vishnu, it may also have been intended as a funerary monument for Suryavarman—its western orientation is normal for Vishnu temples but also for funerary monuments. It stands in a gigantic enclosure of 500 acres (200 hectares), formed by a 660-foot (200-meter)-wide moat. One approaches the temple via a great causeway that crosses the moat and leads to a *gopura* (gateway) to the outer corridor surrounding the temple. Another monumental gate leads to an inner corridor from where one can see a third corridor linking the inner towers making up the symbolic Mount Meru center. The temple is built on three levels, with the central tower rising 213 feet (65 meters) above the ground on a high square platform with four smaller towers at the corners. The tripartite division of the cosmos is made explicit in many of the reliefs that decorate the corridors, with the main scene enacted at the center of a panel, while birds and fish often appear above and below, representing the heavens and the oceans.

The walls of Angkor Wat are covered with more than 4½ square miles (12 square kilometers) of bas reliefs, depicting both Hindu stories and episodes from Suryavarman's wars with the Cham. Nearly 2,000 **apsaras** (female celestial beings) are

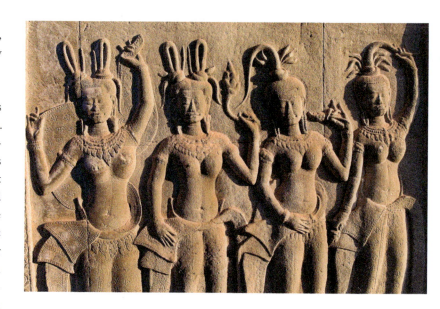

5-19 • APSARAS RELIEF, ANGKOR WAT
early to mid 12th century. Sandstone.

carved into the walls of Angkor Wat (**FIG. 5–19**). Remarkably, each is slightly different, and their coiffures and garments differ from one panel to another. It has been suggested that these apsaras represent not just celestial nymphs in the court of Vishnu but also actual ladies at the court of the king. Their hair is tied up into extraordinary strands, and each wears the heavy necklace, earrings, and waist sashes of the day. They hold fans in their hands and seem to be dancing.

THE BAYON The remarkable city of Angkor Thom was built in the late twelfth and early thirteenth century by the Buddhist ruler Jayavarman VII (1125–1215). He was responsible for restoring morale after Angkor had been sacked by the Chams in 1177, and he carried out a huge program of construction, building roads, hospitals, rest houses, and monasteries as well as temples. Most impressive, however, was the new moated city with its serpent bridges and entrance, towers with enormous faces built into them, and his great temple, the many-towered Bayon, at its heart.

The Bayon is a confusing place to visit, with its 54 towers crammed close together. It is difficult to understand the layout or view the all-seeing faces built into the towers. Although it seems to have been built hurriedly and without the finesse of Angkor Wat, it has many lively and vivid reliefs, depicting both battle scenes—including Jayavarman's defeat of the Cham—and scenes from everyday life. One relief depicts the Khmers going into

5-18 • ANGKOR WAT
First half of the 12th century. Siem Reap province, Cambodia.

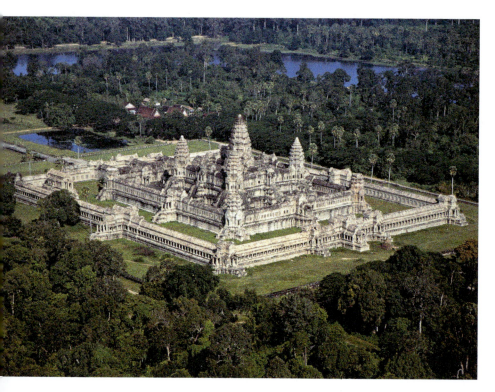

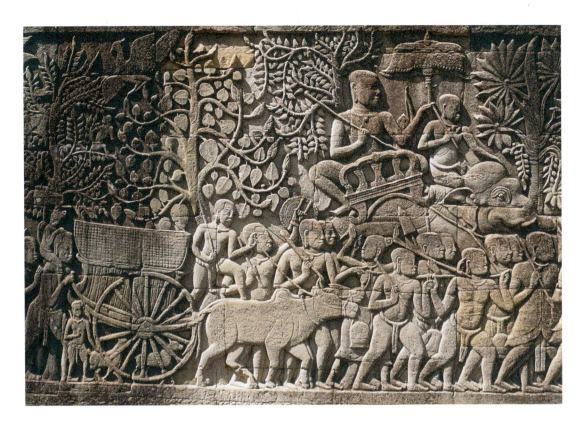

5-20 • BATTLE SCENE
Eastern gallery, south wing, Bayon, ca. 1200. Sandstone bas relief, height ca. 78¾″ (200 cm). Angkor Thom, Siem Reap province, Cambodia.

battle (**FIG. 5-20**). A general on his elephant is flanked by soldiers, marching in unison, and a supply cart pulled by buffalo with what appear to be two sheep beneath it. The animals and the details of the cart with its large wheel and woven roof are realistically portrayed. The trees, too, are identifiable. Notice the shallower carving of this relief in sandstone in comparison to the deeper-carved reliefs in the volcanic stone of Borobudur.

Angkor remained a dominant power in the region until the Thai besieged the city in 1431. What was the secret of Angkor's longevity? Its kings developed a complex system of canals and reservoirs that enabled the hoarding of water during the dry months. A mixture of archaeological data and radar imaging has revealed that this sophisticated system of water control enabled Angkor to spread out over a vast area, with many miles of rice fields, canals, and roads. It has been termed the largest pre-industrial low-density urban complex in the world, covering at its height an area of almost 1,100 square miles (2,900 square kilometers). One possibility for Angkor's decline is that this system failed, following extensive over-exploitation of the landscape and the ensuing deforestation and lack of water. It fell to the Thai in 1431 or 1432 and became a provincial outpost of the Thai Ayutthaya kingdom before being abandoned in the sixteenth century.

A fine sculpture of the Buddha, which is also thought to be a portrait of Jayavarman VII (**FIG. 5-21**), shows both the human features of the king and a deep spirituality, recapturing the essence of earlier pre-Angkor empire (or pre-Angkorean) sculpture like that of Phnom Da (see **FIG. 5-11**). The physiognomy is Khmer: The body is slightly plump, with only the waistband of

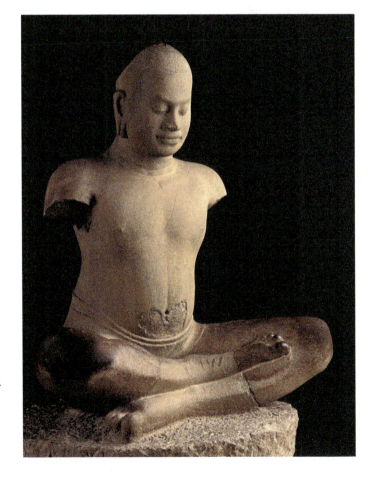

5-21 • THE BUDDHA/JAYAVARMAN VII
Late 12th–early 13th century. Sandstone, height 4′6⅛″ (1.37 m). Krol Romeas, Angkor Thom, Siem Reap province; National Museum of Cambodia, Phnom Penh.

the garment visible. The Buddha's head is slightly lowered and the eyes are closed. The planes of the face and head are smooth and the impression created is one of inner calm and bliss.

PAGAN

In the mid-eleventh century in Burma, the Burman king Anawrahta, like Jayavarman II in Angkor, consolidated existing groups into one kingdom, that of Pagan. Situated on a wide bend in the Irrawaddy River in upper Burma, Pagan was inhabited, it seems, by a mixture of Burman and Pyu peoples—the Burmans being relative newcomers to the region. The *Glass Palace Chronicles* of the later Konbaung dynasty (1752–1885) speak of a long line of Burman kings before Anawrahta, but it was he who united almost the whole of present-day Burma. He formed the first army, introduced the Burmese script, and built a series of fortified settlements to protect his kingdom from threats from the north and east. Although at first a syncretic form of Buddhism was practiced, gradually a form of Theravada Buddhism, heavily stressing the concept of merit-making, became the norm. Both forms of Buddhism overlaid an ancient cult of *nats* (spirits).

On the plain of Pagan an astonishing number of temples and stupas were built—over 13,000, according to one fifteenth-century account, of which some 2,000 remain (**FIG. 5-22**). Many monasteries once stood here, but their wooden buildings have long since disappeared, as have those of the city and its palace (although the palace site is being excavated). Only the brick-built stupas and temples are left. Built by individuals and groups, the largest were erected by kings as a statement of both authority and their divine right to rule. Here, too, the concept of the *deva-raja* existed, but in a Buddhist context.

The temples are very varied in design, ranging from low, dark single-cell structures with an antechamber, to lofty, airy temples on three or four levels, with corridors and four entrances. Certain characteristics are common to most of them, however. They are nearly all made of brick and covered in finely molded stucco. Unique in pre-nineteenth-century Asia, the true arch was used there, allowing for wide corridors to be constructed. Doorways and arches are often surmounted by a flamelike motif. Many of the temples have wall paintings depicting bodhisattvas and scenes from the life of the Buddha.

The earliest stupas are in the Pyu style—simple bulbous domes on a low pediment—but the largest have a bigger bell element, raised on several receding terraces and surmounted by the high metal umbrella (*hti*). Many of the structures have glazed terra-cotta plaques, depicting **jataka** (stories of the Buddha's previous lives) in pockets around the exterior. As elsewhere, Pagan's

5-22 • PAGAN TEMPLES WITH IRRAWADDY RIVER IN THE BACKGROUND, BURMA

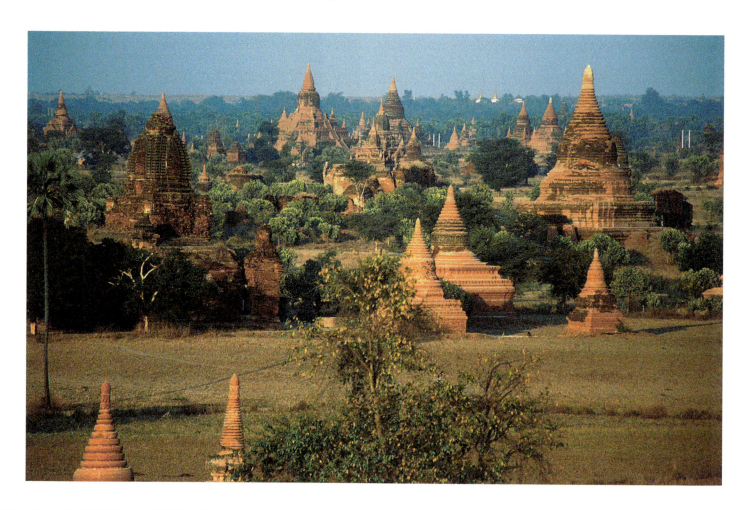

5-23 • *BUDDHA SEATED IN BHUMISPARSHA MUDRA*
12th–13th century. Bronze, 13⅜ × 10″ (34 × 25.5 cm). Pagan, Burma; British Museum, London.

stupas are solid but most contained a small enclosed relic chamber with either relics or sacred items, such as religious texts.

Pagan's cultural tradition is dominated by the image of the Buddha seated in the *bhumisparsha mudra*, the earth-touching gesture that the Buddha made at the moment of his enlightenment (**FIG. 5-23**). One fine example from the late eleventh century has the classic early Pagan features: a heart-shaped face beneath tight curls and a lotus-bud *ushnisha*. The long ears do not touch the shoulder as they do in many later Pagan images, and there is an **urna** (mark of omniscience) on the brow. The eyes are narrow, the nose strong and straight, and the mouth small and fleshy. The hands are naturalistic and the body smoothly delineated with little musculature visible. The robe falls over one shoulder with the hem visible at the ankle and wrist.

At its height the Pagan kingdom extended over a vast area, supplied with food from the rice-growing plains to the north. However, by the late thirteenth century its authority was dwindling, perhaps due to its heavy building over centuries and perhaps because of the growth of competing power centers to the north. In 1287 a Mongol attack from the north fatally weakened Pagan and power shifted elsewhere.

SUKHOTHAI

In northern Thailand, in the first half of the thirteenth century, a distant outpost of the Angkor empire renounced its allegiance to Khmer rule, and the first Thai kingdom was born. The Thai are thought to have arrived in the largely Mon- and Khmer-populated region from about 1200. Both Chiengmai and Sukhothai were Thai cities formed at about this time. The two created a strong alliance against the power of Angkor to the east and China to the north. King Ramkhamhaeng of Sukhothai made a dramatic departure from Khmer religious and architectural norms, espousing Theravada Buddhism and creating not the typical Khmer temple towers, but slim, elegant stupas (*chedi*) with outlines inspired by Sri Lankan and Burmese examples. He also built **viharas** (assembly halls) to house images of the Buddha.

BRONZE WORK Sukhothai sculptors were masters of bronze work, and with their "walking Buddha" they were true innovators (**FIG. 5-24**). The walking Buddha may take its inspiration from

5-24 • WALKING BUDDHA
14th century. Bronze, height 7′2½″ (2.2 m). Sukhothai, northern Thailand; Wat Benjamabophit, Bangkok.

descriptions of the Buddha descending the steps from Tavatimsa Heaven, where he had been preaching to his mother. There is a fine stucco relief of this scene on the walls of Wat Trapang Thong Lang in Sukhothai. An over life-size example in bronze is a remarkable *tour de force* of the bronze-caster's craft. Its depiction of the anatomy is not intended to be realistic but instead emphasizes the supernatural nature of the Buddha. The sculptor has followed closely the directives set down in the ancient Pali texts regarding anatomy: broad shoulders and long arms, an outline like an elephant's head and trunk, thighs like an antelope's, an egg-shaped head, and a mangolike chin. Great skill was required to create equilibrium in such a large unsupported statue, and some much smaller examples do lean at a rather precarious angle.

CERAMICS Sukhothai potters produced large quantities of ceramics for both home consumption and the export market, as is proved by the many bowls and plates recovered, along with Vietnamese and Chinese wares, from shipwrecks in the South China Sea. Both Sukhothai and neighboring Si Satchanalai—famous in particular for its production of **celadon** (green glazed wares)—produced a variety of wares. It was long believed that Chinese potters were brought to the region when the kilns were set up, and that they imparted their knowledge to Thai potters who went on to create their own distinctive pottery. Recent research largely disproves this theory, although the influence of Chinese ceramics is clear. Particularly charming are the fish plates. Sukhothai examples are perhaps freer and livelier than the more formal Si Satchanalai examples. A typical example has a flat lip decorated with chevrons. The cheerful, open-mouthed fish is painted hurriedly, not quite in the center of the plate (FIG. 5-25). The scales on the fish's body are indicated by dots of paint beneath the glaze, and the whole is painted over a creamy slip that covers the grayish clay.

RISE OF ISLAM

From the end of the thirteenth century, maritime Southeast Asia witnessed the gradual rise of Islam. Brought first by Muslim traders from West Asia, Muslim communities first began to appear in northern Sumatra. The religion was not firmly established throughout the islands and the Malay Peninsula until the fourteenth and fifteenth centuries. The Hindu Majapahit kingdom in Java was gradually pushed east and members of the court, priests, and artisans eventually fled into Bali. Islamic concepts produced very different art from those of the earlier Hindu and Buddhist cultures, although culturally Islam was simply another layer partly overlaying existing traditions. Reverence for the ancestors and a love of the Hindu epics continued. Eventually, however, only Bali remained Hindu.

As elsewhere in the Muslim world, artists concentrated on decoration involving floral and vegetal motifs, with human

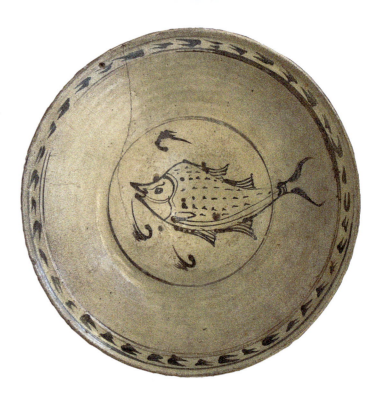

5-25 • PLATE WITH UNDERGLAZE IRON FISH MOTIF
15th–16th century. Ceramic, diameter 12⅛" (30.8 cm).
University of Michigan Museum of Anthropology, Ann Arbor.

figures and animal shapes being often so highly stylized that they are difficult to see. A man's head cloth from Java has two diamond shapes made up of Arabic calligraphy, surrounded by eight doves also formed of **calligraphy** (FIG. 5-26). The rest of the decoration is made up of calligraphy, too, although there may be other hidden shapes—what could be stars are dotted about. The combination of red (female) and white (male) is traditional in both Javanese and Sumatran cloths.

5-26 • MAN'S HEAD CLOTH (KAIN KEPALA)
ca. 1900. Hand-drawn wax resist (batik) with natural dyes on machine-woven cotton, 32⅛ × 55⅞" (81.5 × 141.8 cm). Cirebon, Java; Los Angeles County Museum of Art. Inger McCabe Elliott Collection (M.91.184.502).

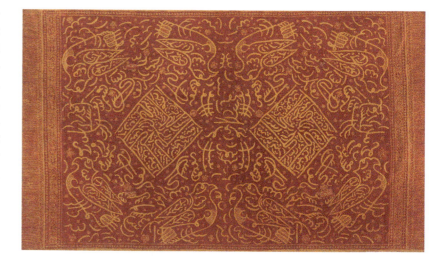

PUPPET THEATER In addition to an old tradition of dance-drama in Southeast Asia, there is also a thriving tradition of puppet theatre (*wayang*) in Java, Bali, and Malaysia. The highly stylized figures may be a result of the Muslim aversion to the portrayal of the human figure (**FIG. 5-27**). In a performance that might last through the night, the puppets are manipulated by a *dalang* (puppeteer). This theater form remains popular despite the often Hindu themes the puppets enact, which involve a mystical world populated by gods, heroes, princes, and ogres. This puppet of a young man in princely garments has the bowed head and slit eyes denoting a noble character. His arms, which reach below his knees, end in a characteristic hook shape. The puppet is manipulated using horn rods.

AYUTTHAYA

With the decline of Sukhothai, another Thai kingdom to the south took power in the region in 1378. With its capital at Ayutthaya (founded in 1350), by the sixteenth century the kingdom had become a cosmopolitan center for trade, due partly to its site at the confluence of three rivers. Many foreigners lived here, including Portuguese, Dutch, British, and French traders. The city was full of marvelous craftsmen and artists, and fine examples of painting, lacquerware, and woodcarving survive from this period. A gold embossed crown or cap is of such fine quality that it was probably

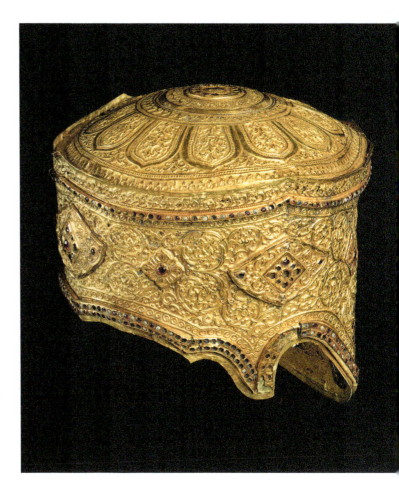

5-28 • CAP
Ayutthaya period, 15th century. Gold with inlay of rubies and glass, 7½ × 8½″ (19.1 × 21.6 cm). Thailand; Philadelphia Museum of Art.

5-27 • *WAYANG* PUPPET
ca. 1900. Buffalo hide, horn, gold leaf, pigments, height 27″ (69 cm). Private collection, London.

made for a princess (**FIG. 5-28**). It is covered with an intricate foliate design interspersed with lozenge- and flower-shaped motifs around the sides. The border, motifs, and lotus flower on the top are inset with rubies and pearls. In 1767, Ayutthaya fell to the Burmese after a series of sieges, and many of its talented craftsmen were carried off to the Burmese court.

BURMA

In Burma power shifted between various city kingdoms after the collapse of Pagan in the late thirteenth century. One of the most long-lived of these was Ava, powerful between the mid-fourteenth and sixteenth centuries. Burmese incursions into Thai cities such as Chiengmai and Ayutthaya resulted in new artistic influences as Thai artisans were brought back as captives, injecting new inspiration into many of the arts. This was a common occurrence over much of mainland Southeast Asia, where captives were usually taken during battles. As a result, art styles at certain periods can show confusing similarities.

Lacquerware was known at Pagan and possibly as far back as Pyu times, but new techniques were probably introduced later from the Thai kingdoms, especially the art of covering

This Burmese bowl depicts a "within the palace" view, in which palace walls and arches divide up the scenes. Every surface is filled with the utmost detail, down to the latticed walls and the pattern on the clothes of the figures.

FINE *YUN* WARE BOWL
1910–1920. Black, red, green, and yellow lacquer on a woven bamboo and horsehair body, 13⅓ × 9″ (34 × 23 cm). Victoria and Albert Museum, London.

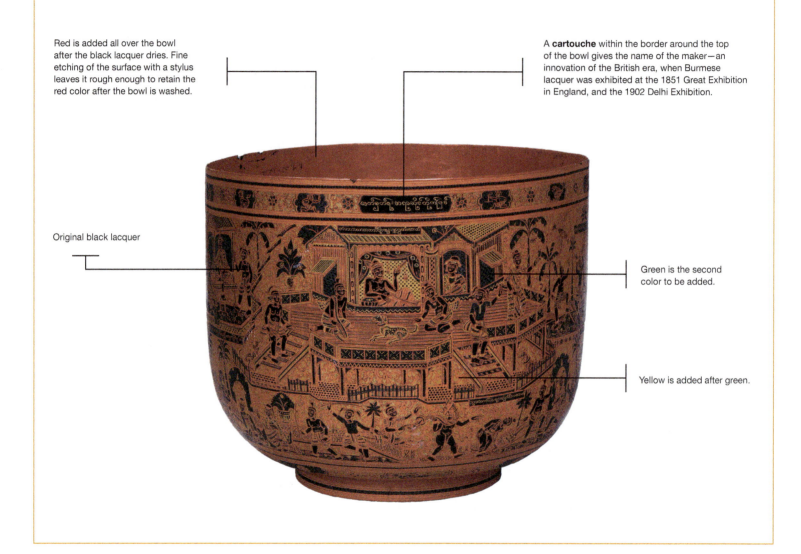

Red is added all over the bowl after the black lacquer dries. Fine etching of the surface with a stylus leaves it rough enough to retain the red color after the bowl is washed.

A **cartouche** within the border around the top of the bowl gives the name of the maker—an innovation of the British era, when Burmese lacquer was exhibited at the 1851 Great Exhibition in England, and the 1902 Delhi Exhibition.

Original black lacquer

Green is the second color to be added.

Yellow is added after green.

lacquerware with gold leaf, often used to cover wooden monastery furniture such as manuscript chests. One style of lacquer particularly popular in Burma was *yun* ware (see Closer Look, above). The object to be lacquered, such as a bowl or a plate, is made first of bamboo, sometimes interwoven with horsehair, giving it lightness and flexibility. A coat of black lacquer mixed with clay or ash is added and allowed to dry before being polished. More coats are added in succession, the lacquer being purer each time. Between coats the lacquer is left to dry in a dark, humid place such as a cellar, as it would crack if allowed to dry too quickly. Once dry, a design is drawn on the surface of the bowl and then incised with a stylus. The object is covered in a mixture of lacquer and red coloring (cinnabar). This is wiped off but the color remains in the incisions, leaving a black background with a red design. Further lines and colors—usually green, then yellow—are applied in a similar manner.

MODERN TIMES

Southeast Asia has a long history of Western dominance owing to its geographical position and because of the importance of its

spices to the European market. The Portuguese recognized the need for a base on the trade route, and in 1511 they seized Malacca on the west coast of Malaya. They went on to take the Moluccas—the Spice Islands—and in the mid-sixteenth century, Spain took control of the Philippines, so-named after Philip II of Spain.

At the start of the seventeenth century, Portuguese power had waned; first the Dutch and then the British entered the arena. The Dutch took control of Indonesia while the British took control of Burma and Malaya, as well as founding the small island city of Singapore. The French, meanwhile, had controlled Vietnam, Laos, and Cambodia. Only Thailand remained unoccupied by a European power.

Contact with colonialism led to the loosening of traditional social structures. In Burma and Vietnam the collapse of the monarchy led to a lack of **patronage** in the arts. The horrors of World War II and Japanese occupation were followed by the fight for independence, war in Indochina, and power struggles within the newly self-governing states. Not surprisingly, artistic expression underwent a major upheaval. Nationalist sentiments and the changing political climate caused artists to challenge not only the colonial powers but also their own traditional cultures.

Before the twentieth century, art in Southeast Asia was created for either utilitarian or religious purposes, not as a means of self-expression. It followed prescribed rules rather than striving to create something unique, and, as anonymity was the rule, artists did not add their names to works of art. As a result, little is known about the creators of such wonderful sculpture and architecture, and sculpture has usually been dated in relation to inscriptions as no other records were kept. A spark of change was struck in Bali with the 1920s art movement inspired by two Europeans, Walter Spies and Rudolf Bonnet, who encouraged artists to express themselves in a way as yet unknown in the region.

The advent of tourism in the latter part of the century brought a renewed demand for many crafts that had been starting to die out. Although old styles continue to be produced, innovation is noticeable, with the introduction of new colors and motifs in lacquer and textiles, for example.

Over the last 50 years or so, Southeast Asian artists have become more self-aware, more self-confident, and more willing to express themselves. Many do embrace themes of the past but view them through modern eyes, often interweaving the old and the new in their work. There is a flourishing art scene in many Southeast Asian countries and artworks by Malay, Vietnamese, Filipino, and Indonesian artists are selling on the international market. Burmese artists, for so long hampered by internal political problems, are also becoming increasingly successful. It is difficult to predict where all these changes will lead, but Southeast Asians have long been adept at absorbing and transforming influences, and this gives hope for the future. A three-dimensional installation by the Indonesian artist Dadang Christanto (**FIG. 5-29**) bears an unsettling resemblance to a heap

5-29 • Dadang Christanto *JAVA*
2011. Terra-cotta, aluminum, oil drum, dimensions variable. Collection of the artist. Courtesy the artist and Gallerysmith, Melbourne.

of dung. On closer inspection, it also references the head-hunting traditions once found in Indonesia. In this work the artist has created a powerful statement about the anti-Chinese riots of 1998 that left thousands dead, injured, or raped. Each discarded head lies open-mouthed and helpless. It is a powerful commentary on the social problems in contemporary Indonesia, and a good example of one of the new roles that art has within Southeast Asian culture.

CROSS-CULTURAL EXPLORATIONS

5.1 To what extent can India be said to have influenced the art of Southeast Asia?

5.2 In what ways does the study of prehistoric sites contribute to our understanding of Southeast Asian art?

5.3 What are the primary themes expressed in indigenous art? Is there a link between these themes and the art of the great religions?

5.4 What were the problems facing Southeast Asian artists during the twentieth century, and how far has modern art developed at the start of the twenty-first century?

5.5 Compare the work of three contemporary artists from Southeast Asia, India, China, Korea, or Japan.

PART TWO
China

Zha Shibiao *PEACH BLOSSOM SPRING* (DETAIL)
Qing dynasty, 1695. Handscroll, ink and color on paper, 13⅞ ×
123⅛″ (35.2 × 312.9 cm). Nelson-Atkins Museum of Art, Kansas City.
Purchase: William Rockhill Nelson Trust 72-4.

The opening scenes of *Peach Blossom Spring*, a painting by Zha
Shibiao (1615–1698), represent the sort of mist-suffused, lush land-
scape that is often regarded as typical of China, which is strongly
defined in art by its mountains and rivers. This scroll reinterprets
a beloved fourth- to fifth-century poem: a fisherman paddles his
boat past a grove of blossoming peach trees (a species native to
China), disembarks, finds a passage through the mountains, and,
still carrying his oar, emerges to find a village cut off from society
(see also FIGS. 1-6, 9-18).

In actuality, China is a region of striking geographic diver-
sity, with climatic zones ranging from tropical to subarctic. The
areas where Chinese civilization arose were those most suit-
able for agriculture: in particular, the plains and deltas of the
two major rivers that flow into the Pacific Ocean—the Yellow
River (Huanghe), winding across the north of China, and the
Yangzi River (Changjiang), coursing through the south. The
Manchurian plain is found to the northeast, and the extreme
southernmost regions of China are quite mountainous. At the
southwest are the Tibetan highlands, bounded by the Himalaya
and Karakoram mountain ranges. The northern periphery

of China today includes grasslands or steppes that were former frontier regions and the homes of nomadic peoples, while the northwest of China encompasses the Taklamakan desert. Modern China shares borders with North Korea, Russia, Mongolia, Kazakhstan, Kyrgyzstan, Tajikistan, Afghanistan, Pakistan, India, Nepal, Bhutan,Myanmar (Burma), Laos, and Vietnam.

Stretching across the Asian continent, Chinese territory today measures 3.8 million square miles (9.7 million square kilometers)—an area comparable to that of the United States—yet is home to over 1.3 billion people, almost four times as many as found in all of North America. Most of China's population reside in the areas to the east and the south, with the former frontier regions at north and west more sparsely populated. Almost 92 percent of Chinese people belong to the dominant Han ethnicity (and are referred to as Han Chinese); some eight percent belong to 55 other ethnic groups, including Tibetans, Mongolians, Manchurians, and Uyghurs. The people of China speak multiple dialects of Chinese, with Mandarin adopted as the official language.

For purposes of administration, China today is divided into more than twenty provinces; five autonomous regions, including Tibet and Inner Mongolia; the special administrative regions of Hong Kong and Macau; and four municipalities (major cities not governed by provinces), including Beijing and Shanghai. In the imperial period, ruling families referred to as dynasties governed China. Some historians have described the government of the Zhou dynasty (ca. 1050–256 BCE) as feudal, with local lords presiding over smaller areas; beginning in the Qin dynasty (221–206 BCE), the emperor ruled with the aid of bureaucrats assigned to the provinces and the court. The last emperor was overthrown in 1911 and since then two different republics have governed the Chinese people.

The variety represented in China's geography and population has given rise to distinctive regional cultures that have undergone significant change over time. In turn, these distinctive cultures have produced arts that reflect the diversity of the Chinese people and provide a window into different aspects of Chinese history.

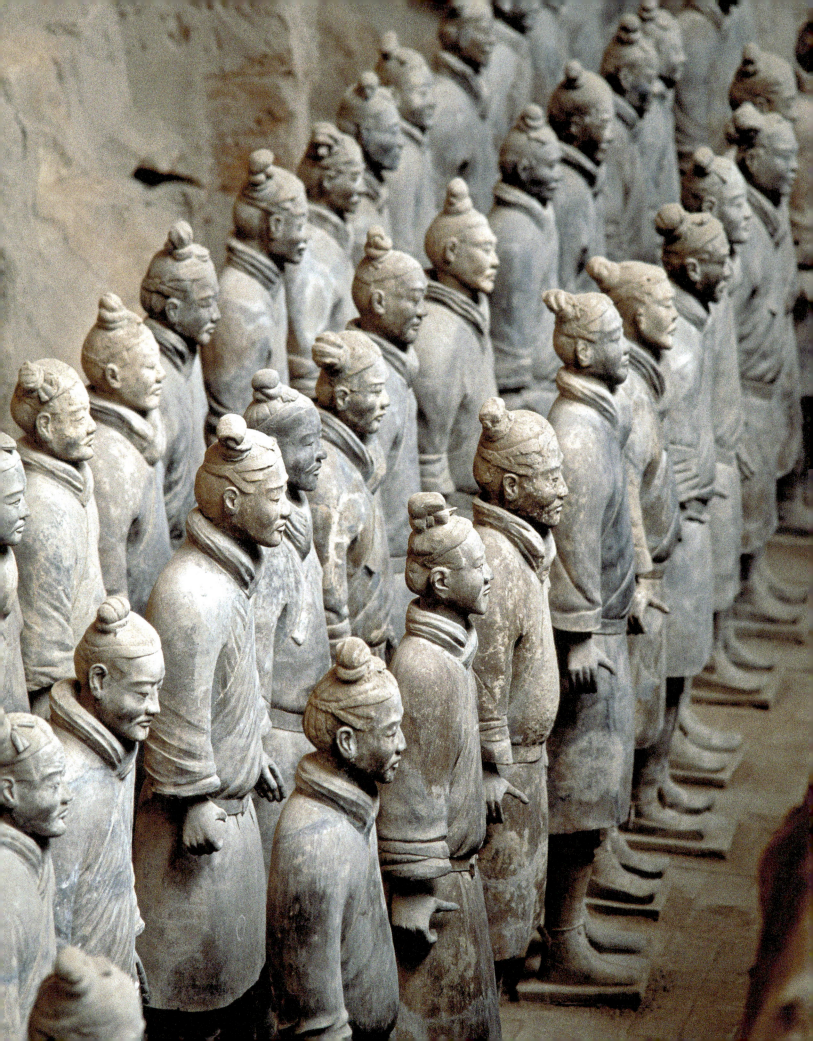

Ritual and Elite Arts: The Neolithic Period to the First Empires

With mercury they made the myriad rivers and ocean with a mechanism that made them flow about. Above were all of the Heavens and below all of the Earth.

Sima Qian (ca. 145–86 BCE)

China is occasionally cited as one of the world's oldest continuous civilizations. While this acknowledges China's long history, it does not account for its many distinct regional traditions. In ancient times, the different threads of Chinese civilization began to be drawn together, a process accelerated under the reign of the first emperor of a unified China, Qin Shihuangdi (r. 221–210 BCE). The quotation above describes his tomb (**FIG. 6-1**) and clarifies how he viewed his position in the world—centrally situated between the earth and the heavens, and ruler of all civilization. His Qin dynasty (221–206 BCE) was the first period in which elements of the different regional cultures were explicitly claimed as Chinese, and, significantly, the English word China derives from the name Qin. Before the first emperor, there were multiple Chinese cultures, and even afterward, it is important to recognize the diversity of Chinese society, which today includes 56 ethnicities, of which Han Chinese form the majority.

Traditional Chinese history begins with the Three Dynasties: the Xia (for which archaeological evidence continues to emerge—perhaps ca. 2000–1600 BCE), Shang

(ca. 1500–ca. 1050 BCE), and Zhou (ca. 1050–256 BCE), all based in the northern-central region known as the Central Plains. The Zhou period subdivides into the Western Zhou (with the capital in present-day Xi'an, ca. 1050–771 BCE) and the Eastern Zhou (with the capital located farther east, in present-day Luoyang, 770–256 BCE). The end of the Eastern Zhou saw the rise of states that broke away from the central authority and vied with each other; this was known as the Warring States period (481–221 BCE). The short-lived Qin dynasty, the capital of which was located in Xianyang (also near Xi'an), quickly gave way to the Han dynasty, subdivided into Western Han (or Former Han, 202 BCE–9 CE) and Eastern Han (or Latter Han, 25–220 CE), again based on the eastern movement of the capital from Xi'an to Luoyang. Chinese history emphasizes the dynasties of the Central Plains as the first Chinese empires. Of course, a number of Neolithic societies with their own distinctive cultures existed throughout Chinese territory before the advent of Chinese history, and other states coexisted with the Shang and Zhou, notably Chu in the south (Hubei, Henan, and Hunan provinces) and Shu in the southwest (Sichuan province).

Gradually, Chinese civilization came to encompass elements from multiple Chinese regions. This chapter examines the connections among the earliest Chinese **artifacts** (man-made objects) of different media produced by these cultures, from the Neolithic era through the end of the Han dynasty. Several important belief systems developed or began to coalesce in this early period, including ancestor worship, Confucianism, and Daoism, and frequently artifacts reflect these beliefs. Many ancient artifacts had ritual functions and were associated with elite individuals, which explains not only the significance accorded to these pieces but also the tendency to bury them inside lavish tombs—conditions ideal for preservation.

6-1 • INFANTRY
Qin dynasty, ca. 210 BCE. Earthenware, life-size Warrior Pit 1, tomb complex of Qin Shihuangdi, Lintong, Shaanxi province.

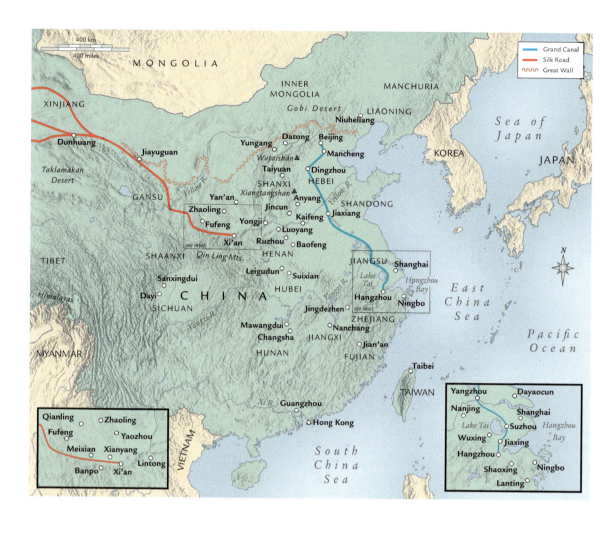

MAP 6-1. CHINA

NEOLITHIC ARTIFACTS

The Neolithic era in China (roughly 5000–1700 BCE) encompassed numerous different cultures, including the Yangshao culture (5000–2750 BCE) in the Central Plains area and the northwest, and the Hongshan culture (4500–2750 BCE) in the northeast. The Liangzhu culture (3300–2250 BCE), in the southeast, and the Longshan culture (3000–1700 BCE), in the east, arose later. Although some artifacts produced by these cultures are similar to Chinese artifacts from later periods, it is premature to describe them as essentially Chinese.

All the Neolithic cultures are known for decorated **pottery** (objects made out of clay, usually **earthenware**, a porous form of pottery fired at low temperatures), which recent archaeological discoveries suggest developed quite early in China, even before the advent of agriculture. An important Yangshao culture site, the Banpo village (east of Xi'an), has yielded numerous examples of pottery. Most of the ceramics found there were not decorated, but some were painted with **slip** (a semiliquid clay, used to join clay elements or, with the addition of pigment, as decoration). The rimmed bowl dating to the fifth millennium BCE (**FIG. 6-2**) is unusual because of the nature of its decoration. It is made of red earthenware and painted with black slip; on the bowl's rim, the potter uses the slip to negatively create geometric **motifs**, while

the interior features line drawings in black slip. The drawings are early representations of humans and animals together: two fish and two human heads. The fish have triangular heads with eyes and whiskers, cross hatching on their bodies to indicate scales, and sketchy fins and tails. The circular human heads represent closed eyes, noses, mouths, headdresses, and more fish where one would expect to find ears. The meaning of this combination of heads and fish remains a matter of speculation.

One of the most intriguing finds from the Neolithic period is a sculpted head (**FIG. 6-3**) associated with the Hongshan culture, excavated in 1983 at the site of Niuheliang, Liaoning province, and dated to the fourth millennium BCE. Archaeologists working in this area have unearthed a 72-foot- (22-meter)-long, cruciform (cross-shaped) building dug into the earth, a nearby platform possibly used as an **altar**, and clusters of tombs built out of mounds of limestone, plus various artifacts: painted pottery cylinders that surrounded the tombs, jade artifacts buried within them, and fragments of many life-size or greater than life-size sculptures of women (identifiable as such because some fragments represent breasts), found in the building. The wealth of jade artifacts suggests that the tombs were built for elite figures, and the representations of women have led scholars to refer to the building as the Temple of the Goddess. The life-size head shown here is made out of unbaked earthenware (rendering

6-2 • BOWL WITH SLIP DECORATION OF MEN'S HEADS AND FISH
Yangshao culture, ca. 5000–4000 BCE. Earthenware, diameter 15½″ (39.5 cm). Banpo, Shaanxi province; Historical Museum, Beijing.

6-3 • HEAD
Hongshan culture, ca. 4000–3000 BCE. Earthenware and jade, height 8⅞″ (22.5 cm). Niuheliang, Liaoning province; Liaoning Institute of Archaeology, Shenyang.

it more fragile), with inlaid eyes of jade, and may once have boasted jade teeth. The modeling of the face is quite **naturalistic**: The proportions of the features are believable, the eye sockets are recessed, and brow bones, cheekbones, and chin all protrude. Although it is unconfirmed that this head actually represents a goddess or a female spirit, the find may suggest the high status of women in Hongshan culture. The nature of any rituals performed at Niuheliang is also unclear, and while some archaeologists see antecedents of ancestor worship here, others draw connections to ritual practices found throughout northeast Asia.

An earthenware vessel possibly made for everyday use is a tripod pitcher from the Longshan culture (**FIG. 6-4**), found in Shandong province. Its form reveals its function. Its feet and generous spout indicate that it was intended for pouring hot liquid, most likely wine (which was served warm). The pitcher is subtly decorated: Its neck has a turned rim, and a small, circular button of raised clay accentuates the point where the spout meets the body. Two lines incised around the body of the vessel and another area of raised decoration enhance its shape. The strap handle has a dramatically twisting coil, and another button of raised clay appears where the handle is attached to the body. Two raised ridges of clay, level with the base of the handle, extend on a slight diagonal around the vessel in a way that accentuates the sudden flaring of the rounded legs. The decoration shows the potter's consideration of its visual appeal.

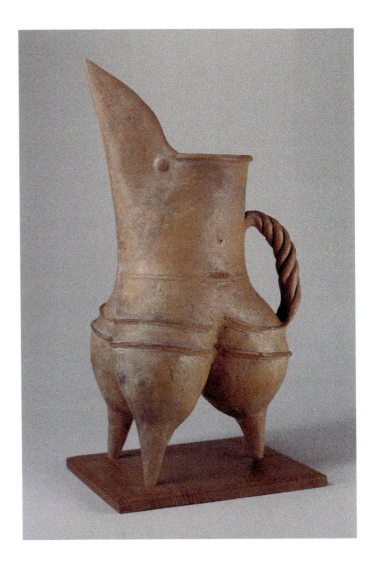

6-4 • TRIPOD PITCHER (GUI)
Longshan culture, ca. 3000–1700 BCE. Earthenware, height 15⅜″ (39 cm). Shandong province; Palace Museum, Beijing.

JADE

The Hongshan and Liangzhu cultures appear to have possessed the most advanced jade-working technology. An example of a jade artifact from Niuheliang, found in a tomb of an adult male of high status, is an ornament described as a cloudlike plaque (**FIG. 6-5**). People prized jade for its toughness, its color (not limited to green hues), and its lustrous surface. The challenge of working with it only increased its worth. This plaque lay on the abdomen of the tomb's occupant, slightly overlapping another jade placed on the chest; the plaque's prominence indicates that it was the most valuable jade artifact in the tomb. Its central motif appears to be a spiral, echoing the movement of clouds in a storm—an auspicious motif, given the importance of rainfall to agriculture, and one that would become especially significant in later eras. Another theory regarding this plaque suggests that it was intended to represent an **abstract** animal motif instead. The use of jade as **grave goods** (items buried with a body to assist them in the afterlife) suggests the wealth of the tomb's occupant and the significance afforded to burials.

A type of jade object that appears frequently in funerary contexts is a hollow tube called a *cong* in the Mandarin dialect. One of the numerous examples from the Liangzhu culture found in the Lake Tai region in southeastern China is typically square on the exterior and round on the interior (**FIG. 6-6**). *Cong* are often paired in burials with a type of artifact called a *bi*, which at its most basic is a round disc with a hole in the middle. *Bi* discs are often placed on and under a body and *cong* tubes added around it. Much later, in the Warring States era, the shapes of the *cong* and *bi* gave rise to an interpretation that they represented the pairing of earth (thought to be square) and heaven (thought to be round), but without records it is difficult to ascertain whether this interpretation would have been valid in Neolithic times.

6-5 • CLOUDLIKE PLAQUE
Hongshan culture, ca. 4700–2920 BCE. Jade, 5⅛″ × 8¼″ (12.9 × 20.9 cm). Niuheliang, Liaoning province; Liaoning Provincial Institute of Archaeology, Shenyang.

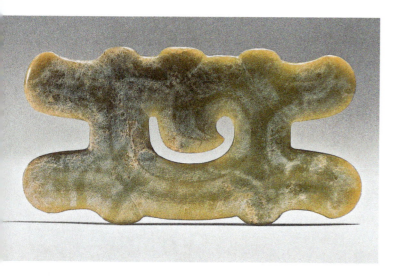

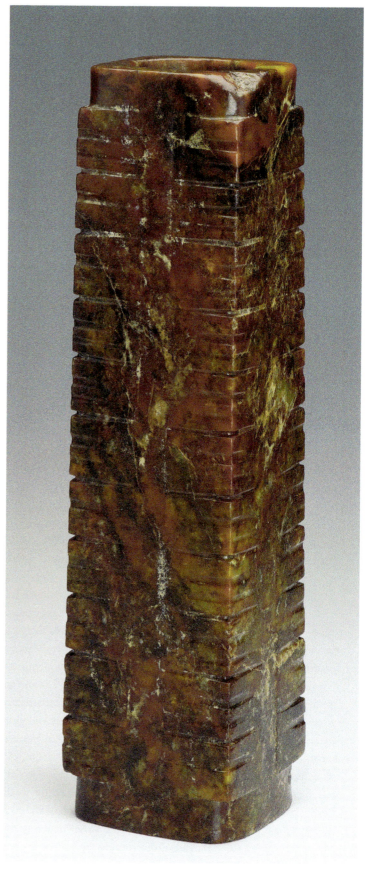

6-6 • SQUARE TUBE (*CONG*) WITH MASKS
Liangzhu culture, ca. 3300–2250 BCE. Jade (nephrite), 11¼ × 2¹⁵⁄₁₆ × 3″ (28.5 × 7.5 × 7.6 cm). Lake Tai region; Freer Gallery of Art, Smithsonian Institution, Washington, D.C. Gift of Charles Lang Freer F1916.410.

This example includes masks carved in **relief** on its corners—yet another motif that would continue to appear in later eras—and fine lines incised in the surface that suggest **registers**, or vertical levels.

ANCESTOR WORSHIP

The widespread institution in the Shang dynasty of the ritual practices of ancestor worship would become so pervasive in the further evolution of Chinese culture that it constitutes a unifying tradition of the Han ethnicity from the ancient era into the modern. The Chinese believed in a supreme god known as Shangdi, who lived in the heavens (the name might literally be translated as "the lord on high"), and in spirits that required sustenance. Some were **animistic** spirits associated with natural phenomena, but others were ancestral. The practices of propitiating these two types of spirit were similar: making offerings or sacrifices (animal or human), and using **divination** to determine how best to appease these spirits and how effective the gifts were. The ancestor cult revolves around ancestral spirits: The Chinese believed that a person's soul split in two halves after death, with one, the *hun*, flying up to heaven and making its home there, and the other, called the *po*, remaining in the tomb. Families made offerings or sacrifices on behalf of the *hun*. The rituals of ancestor worship facilitated communication with Shangdi, as the Chinese believed that *hun* spirits would intercede with Shangdi on their behalf, and thus the practice of making offerings or sacrifices could be regarded as a form of prayer.

BRONZES

An early bronze vessel that may have been used in rituals of ancestor worship is a tripod dating to the thirteenth century BCE (**FIG. 6–7**). This wine vessel's legs, its strap handle, and the possibility that it once had a lid suggest a form appropriate for heating wine. Two capped vertical posts that are placed opposite each other rise from the rim of the vessel and increase its formality; leather thongs could be attached to them to help lift the vessel from the fire. A notable feature of the vessel is the design on its exterior, which is divided into registers. The lowest and largest register features a mask motif called a ***taotie***, which was quite common in Shang dynasty bronzes. The word might be translated as "monster mask," and the motif presents an abstracted creature frontally, beginning at the center with a head composed of a pair of eyes, curling horns, a snout, and fangs, then, off to either side of the face, continuing with the body of the animal, embellished with legs, claws, and tail. The *taotie* could have derived from mask motifs visible on certain Neolithic artifacts, for example from the Liangzhu or Longshan cultures. Although the *taotie*'s significance is not perfectly understood, its association with vessels used in ancestor worship indicates that it has supernatural overtones, and it may represent a composite image of the sorts of animal offered as sacrifice. In this example, the *taotie*'s features are offset by dense spiral motifs carved

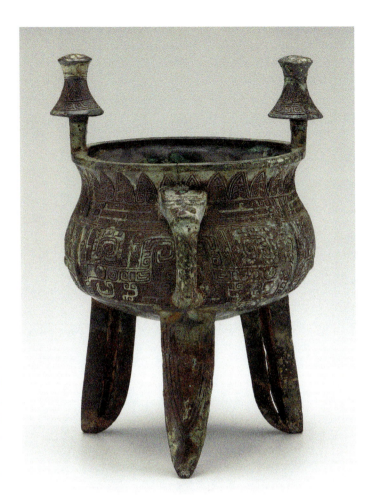

6-7 • TRIPOD WINE VESSEL (*JIA*)
Chinese, Shang dynasty, 1300–1200 BCE. Bronze, height 9⅞″ (25.2 cm). Sackler Gallery of Art, Smithsonian Institution, Washington, D.C. Gift of Arthur M. Sackler S1987.60.

in lower relief. These are referred to as **cloud** or **thunder patterns**, another element frequently seen in Shang dynasty bronzes; in addition to being auspicious, they are thought to represent *qi*, or energy. This particular vessel also has a single character inscribed on the interior of the bowl that may refer to a family name or a place.

Some wine vessels of the Shang period were themselves created in the form of animals. One example is an owl-shaped vessel (**FIG. 6–8**) found in the tomb of Lady Hao, the consort of King Wu Ding (d. ca. 1189 BCE), in Anyang, one of the Shang dynasty capitals. Lady Hao's tomb had never been looted and thus represented an unusually rich find when it was excavated in 1976; this bronze vessel was one of over 200 located in the tomb. The vessel, inscribed with her name, is for pouring heated wine: it includes legs (two that resemble an owl's feet, and one that resembles an owl's tail), a strap handle, a spout (in the form of an owl's beak), and a lid. The artisan who created it also incorporated other animals into the form; thus, the owl's wings, on closer observation, are actually coiled snakes, while knobs on the lid take the shape of a bird and a dragon, and above the owl's

and cloud-pattern motifs seen on Shang bronzes appear on the upper part of the vessel, attesting to interaction between the two cultures. In addition, the vessel features a considerably naturalistic rendering of the heads, necks, chests, and front legs of two rams, embellished with hooked flanges that represent the rams' beards and the fur on their underbellies. Although they are quite symmetrical and the surfaces of their faces are again covered with the cloud-pattern spirals, the curling of the horns around the heads, the shapes of their snouts, and the curvature of the chests suggest an approach to representation based in part on observation of nature.

Some of the most unusual finds in bronze from the Shang era came from the site of Sanxingdui, in what is now Sichuan province. This site may have been associated with the southwestern Shu culture located in that region. Two sacrificial pits found in Sanxingdui have yielded a trove of artifacts in bronze, ivory, **hardstone**, and gold, including an unusual standing figure in bronze that is larger than life-size (**FIG. 6–10**). The attenuated

6–8 • OWL-SHAPED WINE VESSEL (*ZUN*)
Shang dynasty, ca. 1200 BCE. Bronze, height 18¼″ (46.3 cm). Tomb 5, Xiaotun Locus North, Yinxu, Anyang, Henan province; Institute of Archaeology, CASS, Beijing.

6–9 • WINE VESSEL (*ZUN*)
Shang dynasty, ca. 1300–1100 BCE. Bronze, height 17″ (43.2 cm). Jiangxi or Hunan province; British Museum, London.

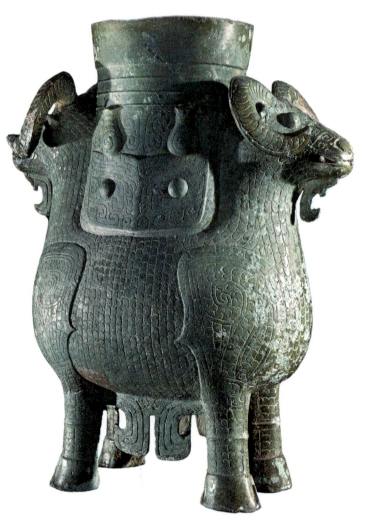

tail in the back is a depiction of an owl's face. The surface is detailed: Some elements are carved in higher relief in order to project above the background, which is carved with hundreds of spiraling cloud-pattern motifs in low relief. The vessel represents an impressive attention to design and an incredible amount of labor.

The medium of bronze was used in regions of China beyond the northern-central area, and these make the development of distinctive regional styles apparent, as in the example of a wine vessel (**FIG. 6–9**), likely from either Jiangxi or Hunan province, in the southern region known as Chu. The use of the piece-mold casting process suggests some commonalities between the Chu state and the Shang kingdom, although the Chu artisans would eventually develop bronze casting in interesting ways that were not explored further north (see **FIG. 6–14**). Both the *taotie*

The Shang and Zhou eras belong to China's Bronze Age, and both periods oversaw the development and refinement of one of the world's greatest bronze **casting** technologies. Bronze is an alloy of copper and other metals; in China, tin and lead were the usual additives, resulting in a metal that was harder and more fluid (when heated) than pure copper and had a lower melting temperature. The specialized process used to smelt metal ore, the difficulty of the casting process, and the durability of objects made from bronze all increased its value. Various kinds of bronze object, including vessels, bells, mirrors, ornaments, chariot fittings, and weaponry, became markers of status. In many cases, ancient bronzes developed a green coloring from exposure to air (**oxidation**) and a crusty surface, or **patina**. Dating a bronze object often relies on stylistic analysis of its ornamentation. Bronze vessels came in a repertoire of standardized shapes associated with particular functions,

mostly related to the presentation of food and drink; their forms often resemble those of ceramic or lacquerware vessels.

The ancient Chinese developed a technique known as **piece-mold casting** to create the earliest bronze vessels. The two illustrations here show the piece-molds used to make a square cauldron, and how the completed vessel would look. The first step in the process was to make a model of a vessel in clay—an appropriate **medium** because of its malleability. Once the model had dried to a **leather-hard** state (stiff, yet still damp), a mold of it was made, in pieces, by pressing slabs of clay against it. Artisans created any exterior decoration desired on the finished vessel at this stage: perhaps by creating it on the model's exterior, then transferring it onto the mold's interior surface; or, more simply, by carving, stamping, or even piping lines of slip directly onto the mold's interior surfaces to create the design. Once they

had completed the mold, the next step was to create a smaller clay core to fit inside: some scholars suggest that artisans would trim down the surface of the model to create the core, but others believe that cores were completely independent creations. Regardless of which theory is correct, any embellishment intended for the interior of the finished piece, such as an inscription, would be applied directly to the core's surface. After firing the core and the pieces of the mold, the artisans would fit all the elements together, locking them into place using keys or mortises, then pour molten bronze into the spaces between the mold and the core to create the vessel. In the final stages, they carefully chiseled out any clay fragments trapped in the cast and smoothed the bronze surface. Molds and cores could not be reused, but a series of molds could be made from the same model.

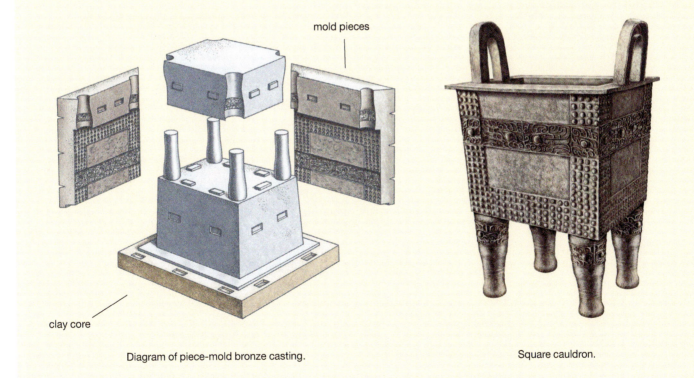

mold pieces

clay core

Diagram of piece-mold bronze casting.

Square cauldron.

figure has a small head, outsized hands that end in circles (possibly intended to hold an elephant's tusk), and an impossibly long body, and it stands elevated on a plinth. The geometry of the face and body conveys a severity that might be appropriate for a guardian figure, although the figure's function is unresolved.

Its shoulders are decorated in low relief, and both the headdress and the plinth have lightly incised, spiraling lines; these features resemble the decoration on the bronzes of the Shang kingdom. The Sanxingdui craftsmen were familiar with both the casting technology and the design motifs used in the Central Plains,

6-10 • STANDING FIGURE
Shang era, ca. 1300–1100 BCE. Bronze, height 8′7″ (2.62 m). Pit 2, Sanxingdui; Sanxingdui Museum, Guanghan, Sichuan province.

but the figure conveys a strong sense of a local style that is confirmed in another bronze artifact from the site, a large mask with a hooked-cloud ornament (**FIG. 6-11**). This mask combines the geometric facial features—here accentuated by oddly bulging eyes—with a familiar representation of a cloud spiral rendered on a much grander scale. These two artifacts attest to this culture's limited interaction with the Shang kingdom.

ZHOU DYNASTY RITUAL AND POLITICAL ARTS

Although many of the artifacts dating to the Western and Eastern Zhou dynasties show some continuity with those of the Shang kingdom, there were also significant changes in both design and

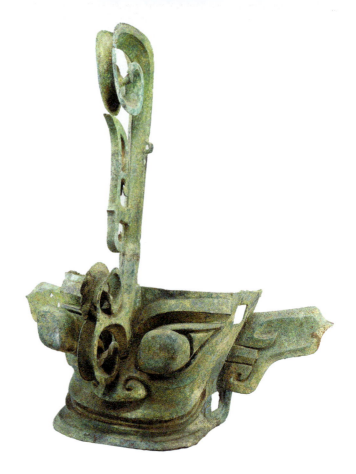

6-11 • MASK WITH HOOKED-CLOUD ORNAMENT
Shang era, ca. 1300–1100 BCE. Bronze, height 16″ (40.5 cm). Pit 2, Sanxingdui; Sanxingdui Museum, Guanghan, Sichuan province.

technology. Where there is continuity, it is often a matter of function, and this can be attributed to the funerary context in which many surviving Zhou artifacts were found. Judging from surviving objects, ancestor worship remained the most significant religious practice in this period, and this resulted again in the production of sets of ritual vessels.

A bell cast by an aristocratic man named Lai (**FIG. 6-12**) and dating to the ninth century BCE is especially notable for the inscription on its exterior, which explains the circumstances behind its creation. Lai had been honored by his ruler with greater political responsibility, and his inscription praises the ruler—to whom he refers as the Son of Heaven—and promises his loyal service. Lai seizes the occasion as an opportunity to cast a set of bells in honor of his deceased father, who had also distinguished himself in service to his ruler. A set of bells typically included different sizes that each produced distinct notes when struck with mallets; this bell came from a set of eight, all decorated similarly and sharing the same inscription. Lai writes that he would use the bells to gladden his ancestors and to pray for good fortune, expressing the hope that his descendants would continue in the same path. The connection between ancestor worship and political practice is evident in this inscription. In theory, a king was chosen because he had an unusually beneficial relationship with his ancestors, and the royal ancestors were

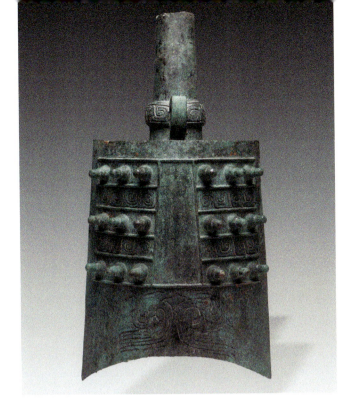

6-12 • MASTER LAI'S BELL
Western Zhou dynasty, ca. 900–800 BCE. Bronze, 27⅝ × 14⁹/₁₆ × 10⁷/₁₆″ (70.3 × 37.0 × 26.6 cm). Meixian, Shaanxi province; Cleveland Museum of Art. Leonard C. Hanna, Jr. Fund 1989.3.

best able to intercede with Shangdi, meaning that a king was uniquely situated to ask for favors on behalf of his people. A king thus received the **mandate of heaven**. Lai's inscription implicitly compares his filial duty toward his father with his duty as a subject toward his sovereign.

A lidded bronze tripod cauldron (**FIG. 6-13**) from the late sixth century BCE shows how an updated design was applied to

6-13 • TRIPOD CAULDRON (*DING*) WITH COVER
Eastern Zhou dynasty, ca. 525–500 BCE. Bronze, 16⅞ × 19¾″ (43 × 50.2 cm). Metropolitan Museum of Art, New York. Charlotte C. and John C. Weber Collection, Gift of Charlotte C. and John C. Weber through the Live Oak Foundation, 1988, 1988.20.6a, b.

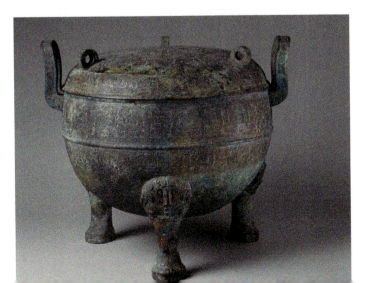

a standard form. The shape of the cauldron has undergone minimal changes since the Shang era. Based on a form designed to cook meat, the deep vessel stands on three legs, each decorated with an animal's head, and the bowl has looped handles attached just below the rim. The lid has three small rings that at first seem purely decorative, but when inverted, the lid itself becomes a footed dish. The cauldron is decorated with an interlaced dragon motif rendered in low relief in registers covering both the bowl and the lid. Dragons were considered auspicious: thought to move easily between air, water, and earth, they made ideal messengers between the earthly and celestial realms. As they were believed to live in the clouds and possess the ability to bring rain, they would eventually become associated with rulers. The tripod form also brings to mind a set of nine tripods said to have been cast for the sage emperor Yu, founder of the Xia dynasty, which became an emblem of kingship. Kings communicated with their ancestors through sacrificial rituals, and the ritual vessels kept in the royal ancestral temple were thus invested with the source of the king's authority.

The pairing of an intricate wine vessel and water basin (**FIG. 6-14**), produced in the early fifth century BCE, reveals the different directions in bronze casting being explored in southern China. In the Chu region, metalworkers had developed a **lost-wax casting** process for bronze; this involved creating a wax model of the finished piece that served as the basis for a

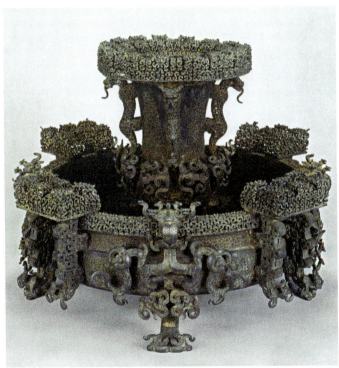

6-14 • WINE VESSEL (*ZUN*) AND WATER BASIN (*PAN*)
Warring States period, ca. 500–450 BCE. Bronze, *zun* height 11⅞″ (30.1 cm), *pan* height 9¼″ (23.5 cm). Leigudun, Hubei province; Hubei Provincial Museum, Wuhan.

birds. The repeated use of diagonals makes the pattern dynamic, and the hooks that appear throughout the design are typical of the late Zhou era.

An example of a *bi* disc (**FIG. 6–16**) from the Warring States period represents some of the finest surviving jade work. It is a more elaborate and elegant version of the basic round disc with a hole in the middle that had been produced since the Neolithic era. This disc shows a great deal of intricate carving. Two serpentine dragons adorn the outer rim of the disc, their curling bodies suggesting the clouds that they were believed to inhabit. They are echoed by two more dragons twined around the interior of the disc, surrounding an inner ring. Painstaking carving has created a pattern of circular bosses in rows on the surface of the disc. This *bi* disc comes from what is likely a royal tomb at Jincun, Henan province, judging from the quality of the artifacts from that site, and would thus be an example of the luxurious objects that were created for a funerary context. The association of the *bi* disc with burials continues in this period; the belief at the time was that the roundness of the disc evoked heaven, and thus the disc's allusions to dragons and clouds appear very appropriate.

6-15 • FLAT WINE VESSEL (*HU*)
Warring States period, ca. 325–200 BCE. Bronze with silver inlay, 12⅜ × 12″ (31.3 × 30.5 cm). Freer Gallery of Art, Smithsonian Institution, Washington, D.C. Gift of Charles Lang Freer F1915.103a-b.

6-16 • DISC (*BI*)
Warring States period, ca. 400–200 BCE. Jade, diameter 6½″ (16.5 cm). Jincun, Henan province; Nelson-Atkins Museum of Art, Kansas City. Purchase: William Rockhill Nelson Trust, 33-81.

clay mold, firing mold and model together, and pouring molten bronze into the openings left by the melted wax. In this example, the vessels and their appendages were cast using the piece-mold process (see Techniques, p. 133), while the rims of the vessels were cast separately with the lost-wax process to create unusually articulated interlace patterns. The final step was to connect all the pieces by soldering. This piece, found in the tomb of the Marquis Yi of Zeng (d. 433–425 BCE) in Hubei province, was likely made for one of his ancestors and passed down to him, judging from the traces of an inscription found on the bottom of the basin. It features a number of mythical creatures, including dragons perched on the sides of the wine vessel.

Another new direction in the Eastern Zhou dynasty was the development of the technique of inlaying precious materials into cast bronze, as seen in a wine vessel from the Warring States period made of bronze with inlaid silver (**FIG. 6–15**). The process involved creating shallow recesses in the surface of the bronze that could be filled after the initial casting with materials that included sheets or strips of copper, silver, or gold; glass; or even turquoise. In this vessel, the gleaming silver contrasts beautifully with the burnished bronze, and the clean lines and simplicity of the vessel's form ensure that the viewer focuses entirely on the design. The roughly symmetrical abstract pattern combines bold and delicate lines that begin to suggest crested and long-tailed

These two rare animal-shaped bronze vessels date from about a thousand years apart. The Shang dynasty wine vessel in the form of a composite animal (**FIG. 6–17**), from Anyang, dates to the thirteenth century BCE. The rhinoceros (**FIG. 6–18**) is also a wine vessel, though a different type; it may date to either the Eastern Zhou or Western Han dynasty. In addition to bronze, it has traces of inlaid gold and black glass eyes. The composite animal includes depictions of a tiger on one end, a duck-billed bird on the other,

coiled snakes on the sides, and an owl's face on the back; it has a lid, spout, and handle and is designed for pouring wine. The rhinoceros has the same function: What looks like a saddle on the rhinoceros's back is actually a lid through which the vessel can be filled. The rhinoceros also has a spout concealed in its left jaw. It does not have a handle; presumably, someone serving wine from this vessel would have to hold it under its belly.

6–17 • WINE VESSEL (*GUANG*) IN FORM OF COMPOSITE ANIMAL
Shang dynasty, 1300–1200 BCE. Bronze, 9¼ × 12¼″ (23.5 × 31 cm). Anyang, Henan province; Freer Gallery of Art, Smithsonian Institution, Washington, D.C. Purchase F1938.5a-b.

6–18 • RHINOCEROS-SHAPED WINE VESSEL (*ZUN*)
Eastern Zhou or Western Han dynasty. Bronze with traces of gold inlay and black glass eyes, height 13⅜″ (34 cm). Shaanxi province; National Museum, Beijing.

THINK ABOUT IT

1. How do the differences in media reflect developments in design and bronze-casting technology from the Shang to the Eastern Zhou dynasties?

2. The maker of the rhinoceros appears to have deliberately hidden its function as a wine vessel, whereas the maker of the composite animal has not. How do the different approaches affect the viewer's experience of each piece?

3. While the rhinoceros is quite naturalistic, the composite animal is essentially abstract. What do you think the composite animal represents or conveys, and why?

4. How appropriate are these objects for use in a ritual context? Explain your reasoning.

LACQUERWARE

One of the specialties of the southern Chu region was its lacquerware, represented here by a wooden bowl painted with red and black **lacquer** (**FIG. 6–19**). Items such as this were commonly preserved in tombs. Lacquer was made from the heated sap of the lacquer tree, native to southern and central China. Used as paint,

it rendered wooden objects impervious to decay. Most objects coated with lacquer received several coats of it, applied with a brush and sanded between coats. Carbon or cinnabar was added to lacquer to create its black or red coloring, and designs were typically rendered in red on a black ground. This bowl, from Changsha, Hunan province, features alternate bands of red and black ground,

6-19 • BOWL
Warring States period, 300–200 BCE. Wood with lacquer, diameter 10″ (25.4 cm). Changsha, Hunan province; Seattle Art Museum. Eugene Fuller Memorial Collection, 51.118.

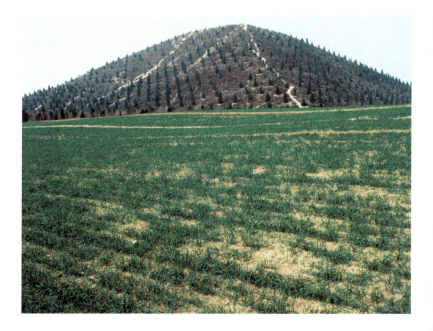

6-20 • TUMULUS
Warring States–Qin dynasty, ca. 247–208 BCE. Earth, height 249 ft (76 m) (formerly 377 ft/115 m). Tomb complex of Qin Shihuangdi, Lintong, Shaanxi province.

on which ethereal long-tailed birds, twisting dragons, and other creatures are painted, all in fine lines that showcase the consummate skill of the craftsman.

THE TOMB OF THE FIRST EMPEROR OF THE QIN DYNASTY

The Qin dynasty is known for the simultaneous farsightedness and brutality of its first emperor, Qin Shihuangdi, and for his tomb complex. As the ruler of the Qin kingdom, he conquered the other Warring States, then worked to unify the Chinese empire, standardizing written language, currency, and weights and measures. He sought to build a Great Wall that would define the Chinese territory as a single state. He also established the central bureaucracy that served as a crucial component of Chinese government into the twentieth century. Still, his cruel treatment of scholar-officials, the excessive punishments meted out to convicts, and his liberal use of both the draft and forced labor made him an unpopular ruler.

Almost as soon as he ascended the throne as the Qin king, he turned his attention to the matter of his tomb. The location of Lintong (near present-day Xi'an, Shaanxi province), was chosen for its good *fengshui*, or geomancy (the art of choosing an auspicious site for new construction): Lintong was naturally protected by a river to the north and mountains to the south. An earthen mound, or **tumulus**, over 300 feet (100 meters) tall (**FIG. 6-20**) constructed there signals the status of this ruler, and several of the important tomb structures are located underground in its vicinity (**FIG. 6-21**). These included a resting hall for Qin

Shihuangdi, partially described in the quotation at the beginning of this chapter.

One of the most impressive elements of the tomb complex is the **terra-cotta** army buried in four pits about a mile (1.5 km) east of the burial mound, presumably to ameliorate the problem of the lack of protection in that direction. Excavation continues on these pits, which were rediscovered in 1974 by a farmer digging a well. They had brick floors, walls made of rammed earth,

6-21 • PLAN OF TOMB COMPLEX OF QIN SHIHUANGDI, INCLUDING WARRIOR PITS
Warring States–Qin dynasty, ca. 247–208 BCE. Lintong, Shaanxi province.

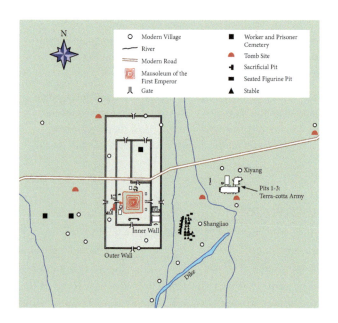

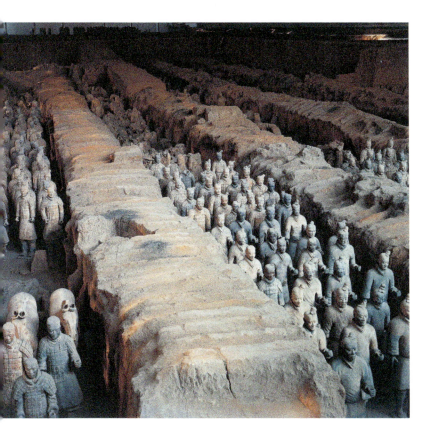

6-22 • INFANTRY PIT
Qin dynasty, ca. 210 BCE. Earthenware, life-size. Warrior Pit 1, tomb complex of Qin Shihuangdi, Lintong, Shaanxi province.

and a wooden framework defining both walls and ceiling. They are estimated to contain over 7,000 life-size sculptures of soldiers in painted earthenware, buried in military formation with real weapons, and representing the different ranks found within the Qin army. The first pit, extending 153,490 square feet (14,260 square meters), may contain over 6,000 soldiers, representing the division referred to as the "right army" of Qin Shihuangdi. At the front of the formation, three rows of archers make up the vanguard; behind them are 30 chariots, each drawn by four life-size terra-cotta horses. The infantry stands behind them, divided into columns by partition walls (**FIG. 6-22**). A surrounding ring of archers with crossbows makes up the flank. The second pit, which is L-shaped and measures 64,580 square feet (6,000 square meters), is believed to contain the so-called "left army," consisting of 1,300 figures representing specialized forces, including archers, chariot drivers, and the cavalry (**FIG. 6-23**). The third pit is the smallest, measuring 5,600 square feet (520 square meters); U-shaped in plan, it is believed to serve as the headquarters and contained 68 soldiers. The fourth pit may contain the "middle army."

The terra-cotta soldiers, sculpted in the round, are remarkably detailed, even to the representation of individual strands of hair and the texture on the soles of their boots. The figures were created using a module system, though the sculptors have taken pains to individualize the faces. The faces represent a range of types, perhaps corresponding to the peoples of different regions that had recently been unified under Qin Shihuangdi, and, as such, an assertion of his power. The perception, however mistaken, that the figures are unique increases the sense of naturalism and attests to the labor required to create them. The artisans who made the soldiers may have been makers of drainage pipes, organized into workshops; some of the figures are signed in unobtrusive places, not to assert the maker's identity but to ensure accountability. The soldiers sustained significant damage even before excavation, possibly under the orders of General Xiang Yu (232–202 BCE), a leader of the rebellion that installed the subsequent Han dynasty.

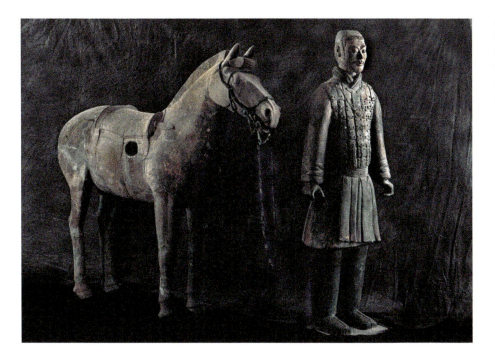

6-23 • CAVALRYMAN AND SADDLED HORSE
Qin dynasty, ca. 210 BCE. Earthenware, height of cavalryman 5′9″ (1.76 m). Warrior Pit 2, tomb complex of Qin Shihuangdi, Lintong, Shaanxi province; Shaanxi Provincial Museum.

HAN DYNASTY FUNERARY ARTS, DAOISM, AND CONFUCIANISM

Although the surviving artifacts from the Western and Eastern Han dynasties attest to the continuing importance of ancestor worship, many simultaneously reveal the antecedents of Daoist religious practice or the significance of Confucian philosophy among the Chinese elite. Daoism (also spelled Taoism) and Confucianism were schools of thought that both began to coalesce in the Eastern Zhou dynasty. Both would have significant ramifications for Chinese culture and society in subsequent eras.

DAOISM

Daoism encompasses beliefs that could be described as either philosophical or religious. Philosophical Daoism can be associated with two principal texts, the *Dao de jing* (sometimes translated as "The Classic of the Way and Its Virtue"), said to be authored by Laozi around the sixth century BCE, and the *Zhuangzi*, the collected wisdom of Zhuang Zhou (369–286 BCE). These texts describe a philosophy that values nature and naturalness, teaches that the world does not revolve around people, and promotes independent, unconventional thinking and behavior. The origins of religious Daoism are harder to locate, as this practice drew together many disparate ideas, including (but not limited to) the worship of deities who inhabited sacred mountains, deities who populated the heavens, and local deities; the pursuit of immortality; notions of complementarity or dualism, as in the opposition of *yin* (elements that might be characterized as female, dark, passive, etc.) and *yang* (elements that might be characterized as male, light, active, etc.); and practices of divination set out in the classic text *The Book of Changes* (the *Yijing* or, in an earlier romanization, the *I Ching*). These religious beliefs and practices would not be referred to as Daoist until the fifth century, but many of the different strands are evident in the funerary artifacts of the Han dynasty. Some scholars refer to them as proto-Daoist. (See also Chapter 7, Context, p. 148.)

THE MAWANGDUI TOMBS Tomb 1 at Mawangdui, Hunan province, dating to about 180 BCE, includes elements that anticipate Daoist religious practice. It was excavated in 1971 and its contents found to be almost perfectly preserved. Recent scholarship suggests that Mawangdui Tomb 1 marks a transition in Chinese religious practice and suggests that beliefs about the afterlife were not unified, even as it embodies the rituals performed for the deceased. Mawangdui was located in the Chu region, and artifacts in Tomb 1 combine elements of this southern culture with elements from the Central Plains, reflecting the different traditions contained within the Chinese empire. The tomb's female occupant was the aristocratic Lady of Dai; she was buried with a wealth of **material culture** (objects suggestive of the culture of a particular group), including beautifully worked textiles and 184 examples

of lacquerware, to sustain her in the afterlife. Her body rested in a wooden coffin covered in embroidered fabric and feathers, with a painted banner laid on its surface; the banner represents different deities and examples of paired *yin* and *yang* imagery that seem to anticipate Daoist religious beliefs (**FIG. 6-24** and Closer Look, opposite). The banner's T-shaped form, the tassels hanging from four of its corners, and the silken cord attached to its top edge suggest that it was once hung vertically. A history of the Han dynasty described mourning banners carried in funerary processions; the Tomb 1 banner might be an example. More likely, it is the Lady's "name banner," which according to the Confucian *Book of Rites* would represent the existence of her soul in the afterlife. Significantly, name banners would typically be hung outside the mourning hall during funerary rites. The banner's ultimate placement on the Lady's coffin recalls similar practices in tombs of the Chu region; placing a name banner in that spot might be an appropriate adaptation of the Chu custom.

6-24 • LINE DRAWING OF FUNERARY BANNER
Western Han dynasty, ca. 180 BCE. Ink and color on silk, 80¾ × 36¼″ (205 × 92 cm). Tomb 1, Mawangdui, Hunan province; Hunan Provincial Museum, Changsha.

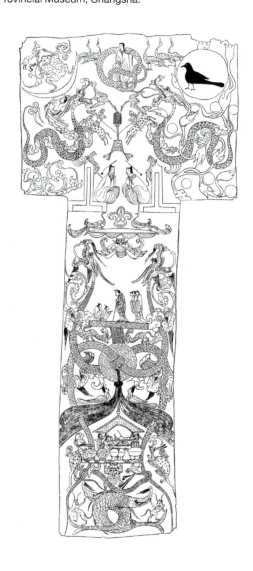

This painted silk banner lay over the innermost coffin of the Lady of Dai and likely represents otherworldly realms. Its complex imagery has generated multiple interpretations. It may be the Lady's name banner, representing her soul in the afterlife. Alternatively, the painting may have been intended to revitalize her: such practices date back to the Warring States period. Paired *yin* and *yang* images may work to unite the two realms inhabited by the two halves of the soul following death; they also suggest regeneration, as do the divine figure Taiyi, spring deities, and copulating fish. The representation of a jade *bi* disc suggests the preservation of the Lady's breath.

FUNERARY BANNER

Western Han dynasty, ca. 180 BCE. Ink and color on silk, 80¾ × 36¼″ (205 × 92 cm). Tomb 1, Mawangdui, Hunan province; Hunan Provincial Museum, Changsha.

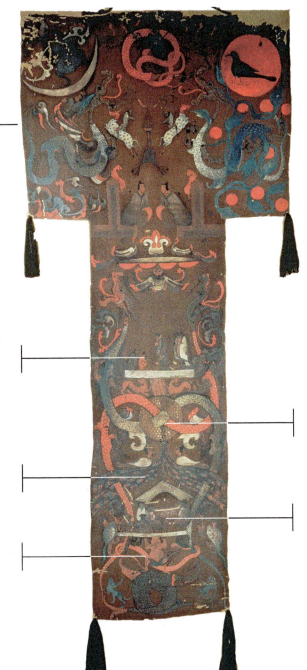

The heavens include gates, a crescent moon (with a toad and a hare), a red sun (with a crow), two dragons, and a figure with a serpentine tail, possibly the primordial deity Nüwa. A female figure rides toward the moon on the wing of the left dragon: an interesting confluence of *yin* imagery that may befit a woman's tomb.

An elaborately dressed woman, leaning on a cane, stands on a platform with two men before her and three more behind her. She is commonly identified as the Lady of Dai.

Two dragons run along the edges of the banner's lower section, unifying this space.

A powerful male figure supports the lower platform, bracing his feet against the backs of a pair of intertwined, copulating fish. He may be Taiyi, identified in the Chu region as a water deity who generates the dualisms of *yin* and *yang*, which in turn produces the seasonal cycles.

The dragons' bodies intertwine and pass through the hole of a *bi* disc. Below it is a pair of hybrid bird–human creatures, possibly wind deities associated with springtime.

In a scene of ritual offering, several figures sit around an altar bearing small bronze vessels; larger vessels are arrayed in front. A cloth-covered object in the background may depict the Lady's body, wrapped in an embroidered shroud.

6-25 • COFFIN WITH CLOUD PATTERNS
Western Han dynasty, ca. 180 BCE. Wood and lacquer, 3'8⅞" ×
8'4¾" (1.14 × 2.56 m). Tomb 1, Mawangdui, Hunan province;
Hunan Provincial Museum, Changsha.

The innermost coffin and painting were placed within three
larger nested lacquered coffins, likely to reflect the Lady's rank.
Although the outermost coffin was painted black, the next two
coffins were decorated more elaborately, perhaps to signify dif-
ferent realms of the afterlife, including the underworld and the
land of the immortals. The second largest coffin (**FIG. 6-25**) fea-
tures side panels that depict protective and auspicious figures and
swirling cloud patterns against a black ground. The third coffin
includes representations of dragons, deer, many more mythical
creatures, and a *bi* disc against a red ground; it may also depict
the mountain Kunlun, which would become sacred in Daoist
religious practice, inhabited by immortals and divine creatures.

The tomb furnishings of the Lady of Dai included many
examples of very fine workmanship. Sets of dishes were painted
in red and black lacquer, a luxurious medium associated with
Chu; the forms of other lacquerware vessels in the tomb recall
the ritual vessels used for ancestor worship in the Shang and
Zhou kingdoms. The cloud pattern is suggested on a pair of
mittens found within Tomb 1 (**FIG. 6-26**); these were made of
plain-weave silk, some of which has been dyed maroon. The
geometric form of the mittens contrasts with the curvilinear
designs embroidered on their central panels, representing not
only clouds but also abstract images of birds. Silk was one of the
most valuable commodities produced by the Chinese, as they
developed the process of raising silkworms and spinning fiber
from the long filaments emitted as they made their cocoons;
woven silk fabric was not only beautiful but also warm in win-
ter, cool in summer, strong, and naturally flame-resistant. The
placement of grave goods in the tomb reflects the belief that this
site would house the earthbound half of the Lady's soul, the *po*; it
was accordingly outfitted with everything she might require in
the afterlife, including food, utilitarian objects, and luxuries.

THE MANCHENG TOMBS A pair of mountainside tombs in
Mancheng, Hebei province, belonging to Prince Liu Sheng and
his consort Dou Wan, dating to around 113 BCE and excavated in
1968, also yielded artifacts that seem to prefigure Daoist religious
belief. Hill-shaped incense burners were found in both tombs;
combined with the fact of the mountainside burials, they suggest
the Daoist concept of sacred mountains inhabited by the immor-
tals. An example from the prince's tomb (**FIG. 6-27**) is a footed
bowl with a conical lid; jagged vertical elements, found on the lid
and at intervals around the rim of the bowl, represent mountain
peaks. Small figures also appear on the lid, suggesting wandering
immortals. The bowl was designed to hold burning incense; when
the lid was replaced, the fragrant smoke would escape through
openings in the lid that were hidden among the vertical elements,
artfully creating the impression of mist rising off the mountains.
This incense burner stands as one of the earliest representations
of **landscape** (Ch. *shanshui*, meaning mountains and water, and
typically including those elements) in Chinese art; in later periods,
landscape would be the most important genre of Chinese painting,
due in part to its association with the Daoist emphasis on natural
phenomena. Made of bronze with elegant abstract patterns inlaid
in gold, the incense burner also indicates the wealth of Prince Liu
Sheng through its use of expensive media and advanced casting
technology.

Both Prince Liu Sheng and his consort were buried in elab-
orate jade funeral suits. The prince's suit (**FIG. 6-28**) is made of
2,498 plaques of jade, sewn together (through holes drilled in

6-26 • MITTENS
Western Han dynasty, ca. 180 BCE. Silk with embroidery, length 9¾"
(24.8 cm). Tomb 1, Mawangdui, Hunan province; Hunan Provincial
Museum, Changsha.

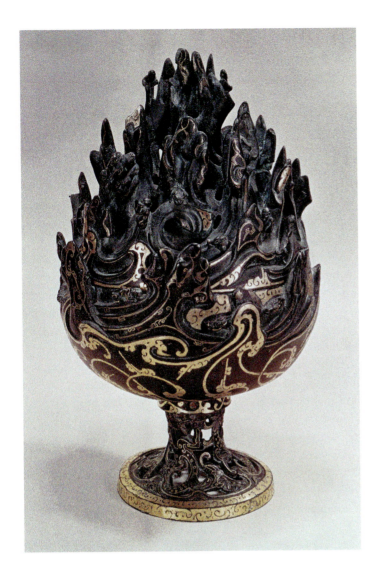

6-27 • HILL-SHAPED INCENSE BURNER
Western Han dynasty, ca. 113 BCE. Bronze and gold, height 10¼″
(26 cm). Tomb 1, Mancheng; Hebei Provincial Museum, Shijiazhuang.

the plaques) with gold wire, and assembled in 12 sections that correspond to the prince's head, face, front torso, back torso, limbs, hands, and feet. These jade suits may reflect the Daoist belief in alchemy (the process through which flesh might transform into precious minerals, thereby rendering a person immortal) or may be protective. Jade plugs were inserted into the prince's various bodily orifices, likely in an attempt to preserve his breath, and a Neolithic *cong* encased his genitalia. Within the prince's suit, two sets of *bi* discs connected with silk were found on his chest and under his back. The rich media and the high quality of the craftsmanship attest to the prince's elite status and to the importance of preparing him appropriately for the afterlife.

CONFUCIANISM

The inclusion of Confucian elements in Han dynasty funerary art complicates our understanding of the art's function. Confucianism, best described as a political philosophy, derives from the teachings

6-28 • FUNERAL SUIT
Western Han dynasty, ca. 113 BCE. Jade and gold,
length 6′2″ (1.88 m). Tomb 1, Mancheng; Hebei
Provincial Museum, Shijiazhuang.

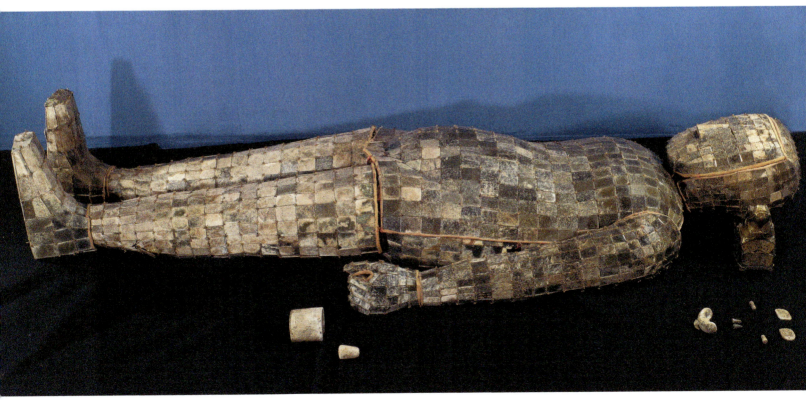

of Confucius (551–479 BCE), a political advisor who left the Eastern Zhou vassal state of Lu in order to search for a ruler more receptive to his ideas. His teachings eventually circulated in the classic *Analects of Confucius*. In the simplest terms, Confucian and Daoist philosophy can be understood in opposition to each other, as Confucianism focuses on people whereas Daoism focuses on nature. Confucian teachings promote benevolence, chastity, loyalty, and filial piety (referring to the deference that individuals show to their parents and that married women show to parents-in-law), encouraging people to respect not only their own positions within a social hierarchy but also those of others. The hierarchy, which is meant to promote harmonious order and considers both age and gender, can be summed up in the Five Relationships: these privilege father over son, ruler over subject, husband over wife, and older brother over younger brother, yet insist on the equality of friends. While the inferior figure in the first four relationships is supposed to submit to the superior figure, the latter is encouraged to treat the former benevolently and to take responsibility for him or her. The father–son relationship is considered analogous to the ruler–subject relationship, laying a foundation for a patriarchal political system in which society is compared to a family. These two relationships, moreover, indicate a connection to the practice of ancestor worship, although in this philosophy an individual's treatment of other people seems more important than religious practice.

THE WU FAMILY SHRINES Because Confucianism lacks an overtly religious component, examples of Han dynasty funerary art that incorporate elements of this philosophy might be regarded as essentially political. One example is the pictorial reliefs from the Wu Family Shrines in Jiaxiang county, Shandong province, begun ca. 147–151 CE. The shrines, located in the Wu family cemetery, were stone chambers that functioned as offering halls, constructed in front of individual tombs. As such, they were somewhat public spaces. Despite falling into ruins centuries ago, the layouts of three of the shrines have been reconstructed: they are known as Offering Hall no. 1, or the Front Shrine; Offering Hall no. 2, or the Left Shrine; and Offering Hall no. 3, or the Wu Liang Shrine. Save for Offering Hall no. 3, they have not been definitively associated with a particular individual, although memorial tablets found at the site provide names, death dates, and other information for members of the Wu family buried in the cemetery. The family belonged to the elite class of scholars and officials; some of its members held minor positions in the Han imperial Confucian bureaucracy, and some studied Confucian philosophy.

Similar in form and decoration, the interiors of the shrines include pictures carved in low relief on the surfaces of the stone slabs that constitute walls, gables, and ceiling. In Offering Hall no. 3, dedicated to Wu Liang (d. 151), the ceiling reliefs present mythical animals and auspicious images, and the gable reliefs feature the Daoist deities Xiwangmu (Queen Mother of the West) and Dongwanggong (King Father of the East). Many of the remaining reliefs, however, reinforce the social strata promoted in Confucian teachings. The wall reliefs are organized in horizontal registers and can be divided into groups that include sage rulers and emperors; virtuous women; filial sons and other virtuous men; and loyal assassins and retainers. A larger image, centrally located on the rear wall, presents a pavilion scene. Most of these images can be connected to Confucian values in that they emphasize the relationships of father and son, ruler and subject, or husband and wife. The reliefs indicate that the leaders of the Wu family not only wished to align themselves with Confucian teachings but also could benefit politically by gaining a reputation for loyalty and filial piety.

Many of the reliefs in the shrines refer to well-known narratives that convey moral lessons. One from the Wu Liang Shrine (FIG. 6-29) depicts an assassin's attempt on the life of the king of the Qin state—who went on to become Qin Shihuangdi. The prince of a rival state sought the assassination of the Qin king, entrusting Jing Ke with the job; it is his loyalty to the prince that is honored here. Jing Ke traveled to the court of Qin with an assistant named Qin Wuyang, a concealed poisoned dagger, and the head of the general Fan Yuqi, who had been a refugee from the Qin state. (Fan had volunteered his head so that Jing Ke might gain the king's trust: another example of loyalty to one's ruler.) The Qin king granted his would-be assassin an audience in which the latter tried valiantly to kill him but failed. The relief in the Wu Liang Shrine includes cartouches that identify the figures: Jing Ke is shown at right, restrained by one of the king's men; Qin Wuyang appears near the top of the composition, kneeling in submission; Fan Yuqi's head lies in an opened box at the bottom; and to the left, the Qin king retreats. The assassin has just thrown his poisoned dagger so forcefully that

6-29 • JING KE'S ASSASSINATION ATTEMPT
Eastern Han dynasty, ca. 151 CE. Ink rubbing of a bas-relief in stone. West wall, Offering Hall no. 3 (Wu Liang Shrine), Wu Family Shrines, Jiaxiang county, Shandong province; Princeton (NJ), Princeton University Art. Far Eastern Seminar Collection. 2002-307.36.

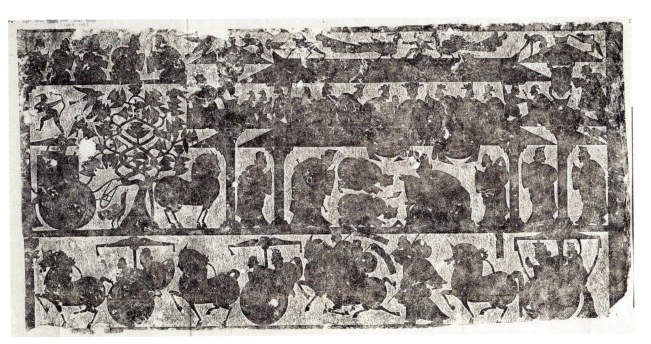

even though it misses the king, it penetrates a column. The column subdivides the space and signals the king's successful escape.

An image that may be the centerpiece of each of the shrines, based on its size and its placement on the bottom register of the rear wall, is the pavilion scene. The example from Offering Hall no. 2, the Left Shrine (**FIG. 6-30**), is in relatively good condition. The focus of the relief is a two-story pavilion that appears at the right. On the pavilion's ground floor is a massive figure that must represent someone of high rank, perhaps a king, raising his hand benevolently. An attendant stands behind him; before him, two men prostrate themselves, and a third bows his head deferentially. On the upper story, female figures sit, most shown in profile except for a central figure that is slightly larger and seen from the front; some have identified this as a banquet scene. Long-tailed, crested birds perch on the pavilion's roof. To the left of the pavilion grows a tree with many birds roosting in it; a distant archer shoots at them. A chariot and a horse have halted beneath the tree, and they are echoed by a line of horses and chariots at the bottom of the composition. The style of the composition is formal, with the different figures arrayed in what appears to be, again, a series of horizontal registers. The smaller size of the figures at the top of the composition suggests that the registers actually may convey recession into depth. The sculptor clearly uses a compass and a square—a combination that would literally convey order—to create his strikingly geometric forms. The style is well suited to the content of this relief, which seems to reiterate the notion of political hierarchy and the ideals of social harmony.

The joining of the different threads of the regional cultures of ancient China made for a civilization that was incredibly rich and complex, and many elements of ancient Chinese society survived into subsequent eras. The belief systems, both religious and philosophical, that developed in the ancient era continued to be driving forces of culture. Chinese rulers continued to govern via the bureaucratic structure established in the Han dynasty. The elite classes naturally continued to serve as **patrons** of the arts. From the third through the tenth centuries, however, foreign cultural practices would have a great impact on Chinese society and shape Chinese culture in new ways.

CROSS-CULTURAL EXPLORATIONS

6.1 What is the difference between material culture and art? Use examples from at least two distinct historical periods in your argument.

6.2 Discuss how ancient artifacts associated with ancestor worship, Confucianism, or proto-Daoism reveal the differences in these belief systems.

6.3 Compare and contrast bronze objects from ancient China and medieval India. What were they used for in each culture? Do artifacts made of bronze tell us anything about Chinese or Indian society in these periods?

6.4 Tombs of rulers, such as Qin Shihuangdi in China or Ibrahim Adil Shah of Bijapur in India, often represent their status. What are the different strategies that convey power at these sites? How do the tombs reflect different religious beliefs?

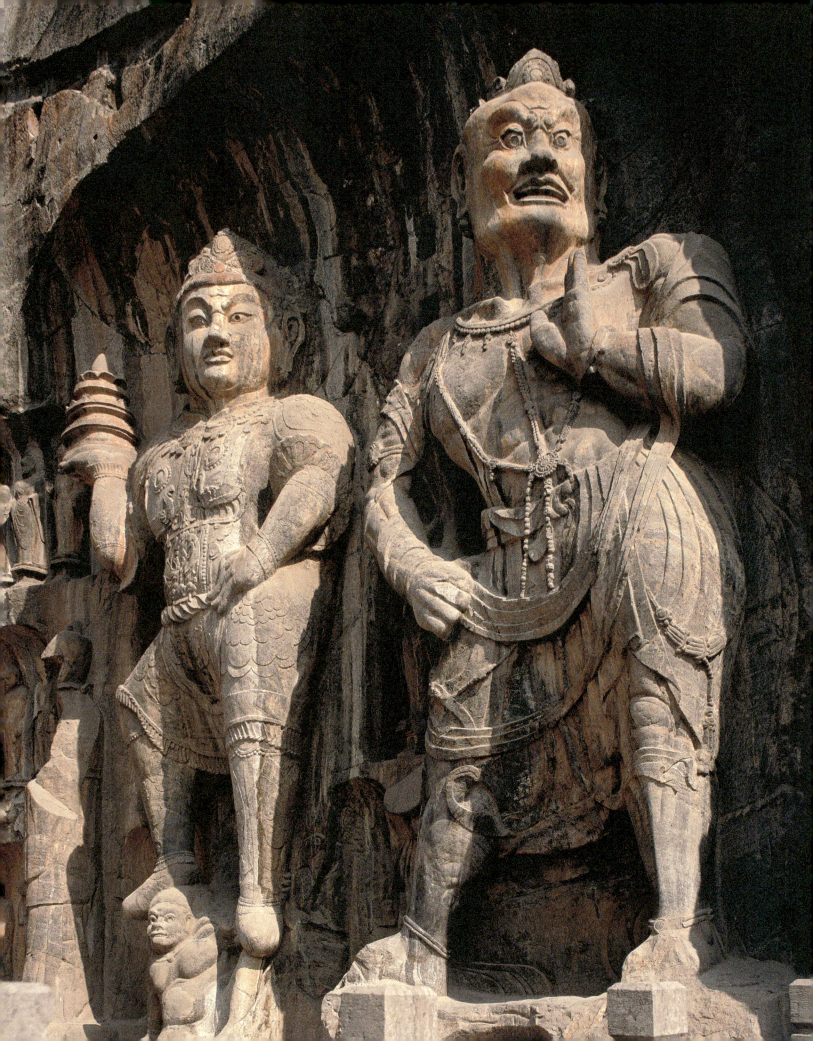

Looking Outward: The Six Dynasties and Sui and Tang Dynasties

In ancient times there were only four classes of people, but now there are six. There was only one teaching, where now there are three.

Han Yu (786–824)

Perhaps the defining characteristic of Chinese culture from the third through tenth centuries is its expansiveness. Beginning in the Han dynasty, the Chinese increasingly interacted with the peoples beyond their borders. Some saw this as a drawback: For example, the official Han Yu included the above lines in a statement supporting Confucianism, which he considered the correct teaching, and critiquing the rival traditions of Daoism and Buddhism (**FIG. 7-1**). He identifies the social classes of the ancient period in descending order of importance as officials, farmers, artisans, and merchants; the new classes were Daoist and Buddhist monks, and their position in the hierarchy varied depending on the ruler's attitude. His criticism reveals that Chinese culture was developing in multiple directions: Indigenous elements continued to evolve and coalesce, while foreign elements introduced new patterns of thought.

The opening of the Silk Road in the Western Han dynasty facilitated the changes taking place in China. This network of

7-1 • COLOSSAL ATTENDANTS OF THE BUDDHA
Tang dynasty, 660–676. Limestone, height 57 ft (17 m).
Fengxian Temple, Cave 19, Longmen Grottoes, Luoyang,
Henan province.

trading routes extended from present-day Xi'an in the east to Constantinople and Rome in the west: The routes skirted the northern and southern perimeters of the Gobi and Taklamakan Deserts and negotiated the Hindu Kush mountains of Central and West Asia, connecting to roads that led west through the Middle East and south to India. The commodities traded along these routes included Chinese silk; lapis lazuli from Ferghana and rock crystal from Samarkand (both located in present-day Uzbekistan); peach trees, wool carpets, and tapestries from Sasanian Iran; Indian sandalwood; and Roman glassware and jewelry. The Silk Road also encouraged travel, resulting in the increasingly cosmopolitan nature of Chinese society.

The political divisions of the era further reflect interaction between the different ethnicities living in China. The Six Dynasties and Sixteen Kingdoms (220–589), Sui dynasty (581–618), and Tang dynasty (618–907) represent periods of rupture and reunification. From the third through sixth centuries, also called the Northern and Southern Dynasties, numerous states controlled different regions. After the Three Kingdoms (220–280) and the consecutive Western Jin (265–316) and Eastern Jin (317–420) dynasties, there was a succession of dynasties with elites of Xianbei ethnicity (people of Turkic and Mongolian background) that nevertheless took steps toward sinicization. These include the relatively long-lived Northern Wei dynasty (386–534) of the Tabgatch people and the much briefer dynasties that followed it: the Eastern Wei (534–550), the Northern Qi (550–577) in the northeast, and the Northern Zhou (557–581) in the northwest. In the south, notable dynasties include the Former Song (420–479) and the Chen (557–589). A Northern Zhou general founded the Sui dynasty and reunified most of China, but a cousin of the second Sui emperor soon seized the throne, inaugurating the Tang dynasty. The links between

Different elements of Chinese cosmology provide a foundation for Daoist religious thought. These include the opposing principles of *yin* and *yang*, the animal symbolism of the cardinal directions, and the Chinese zodiac. In later periods, Daoist religious practice came to incorporate the worship of deities and immortals.

Yin and yang represent complementary forces: Natural phenomena described as *yin* are dark, passive, yielding, and/or feminine, whereas those described as *yang* are light, active, forceful, and/or masculine (see Chapter 6, Closer Look, p. 141). It was considered important to keep these elements balanced. Through the Tang dynasty, the symbols for *yin* and *yang* were the tiger and the dragon.

Each of the four cardinal directions has its own animal symbol and color: The blue dragon represents the east, the vermilion bird represents the south, the white tiger represents the west, and the dark warrior

(an intertwined turtle and snake) represents the north. Collectively these animals were known as the Four Divinities. They appear in Chinese tombs as early as the Warring States period and continued to be important in later periods, decorating the backs of mirrors, stamped on the tiles of official buildings, or even inspiring street names in East Asian capitals. They were also found painted on the walls of both Korean and Japanese pit-shaft tombs.

The Chinese zodiac included 28 lunar mansions, or constellations, each serving as the residence of an associated deity. A celestial equator intersected the mansions, and the 12 animals of the zodiac symbolize divisions of it, referred to as the earthly branches. They are used to designate years in the Chinese calendar and are, in order, the rat, ox, tiger, rabbit, dragon, snake, horse, sheep, monkey, rooster, dog, and pig. Each of these also correlates to a specific direction, with the rat at the north, the rabbit

at the east, the horse at the south, and the rooster at the west, and all the animals in between standing for intervening directions (the tiger in this instance signifying east-northeast, for example).

By the Tang dynasty, and continuing in later periods, references to the many deities of the Daoist pantheon became more common in religious art and architecture. The most highly ranked are the Three Pure Ones (see Chapter 8, FIG. 8–22)—sometimes also referred to as the Three Purities or the Daoist trinity—which included the deified sage Laozi. There were many other deities beyond these, however, some of whom had been deities in popular religions that predated Daoist practice. The Eight Immortals (see again FIG. 8–22) were not deities per se but human beings who had undergone a spiritual transformation; they served as liaisons between people and Daoist deities and provided role models for Daoist practitioners.

Northern Zhou, Sui, and Tang meant that their ruling families were related to people of Xianbei ethnicity, although they regarded themselves as Chinese. The Tang dynasty lasted close to 300 years and is considered a golden age, with significant advances in the literary and visual arts. This chapter focuses on developments in art and architecture that demonstrate how important the cross-fertilization of ideas was for Chinese visual and material culture.

SIX DYNASTIES PICTORIAL ARTS

In the Six Dynasties, painting emerged as a high art, reflected in the esteem accorded to individual artists—whose works were collected and biographies recorded—and the beginnings of critical commentary on painting. Painters, such as Gu Kaizhi (ca. 334–406), wrote about their experience as artists. Portrait painter Xie He (ca. 500–ca. 535) set out to rank other artists, articulating six guidelines that connoisseurs could use to assess painting: "spirit resonance," or a sense of vitality; the use of brushwork to articulate structure; **naturalistic** form; naturalistic color; attention to composition; and copying elements of earlier paintings as appropriate, in order to "transmit the experience of the past." Later connoisseurs, such as Zhang Yanyuan (fl. 874–879), collated the early commentary on painting, considered today as the beginning of Chinese art history.

HANDSCROLLS

Gu Kaizhi was an Eastern Jin figure painter, and an intriguing early composition, *Admonitions of the Court Instructress to the Palace Ladies*, has been associated with him since the eleventh century. However, it is currently believed that *Admonitions* is a fifth- or sixth-century painting, possibly reproducing elements of a composition by Gu Kaizhi. The format of the painting is a **handscroll**: a horizontally organized composition on paper or silk, designed to be gradually unrolled and viewed from right to left. Numerous **seals** (marks stamped on it in **vermilion** paste, made from the mineral cinnabar) identify its collectors over the centuries, several of whom were imperial. The scroll is a visualization of Zhang Hua's (232–300) poem of the same title. The images, with snippets of the poem's text interspersed, teach the proper behavior of imperial consorts and concubines. *Admonitions* represents images of historical figures and several idealized scenes that demonstrate the importance of virtue, cultivation of character, trust, and family. Zhang Hua wrote in a female voice, possibly that of Ban Zhao (ca. 45–ca. 115), the female author of a didactic text titled *Instructions for Women*. The painting's final scene (**FIG. 7-2**) depicts the lecturing lady of the poem writing out her recommendations for two waiting court women. The painter expertly translated the poem into a visual format, selecting key passages for illustration. He represents the sparely rendered yet dynamic figures in even, controlled lines, with little or no sense of the setting in order to emphasize their interaction. Their tranquil postures suggest

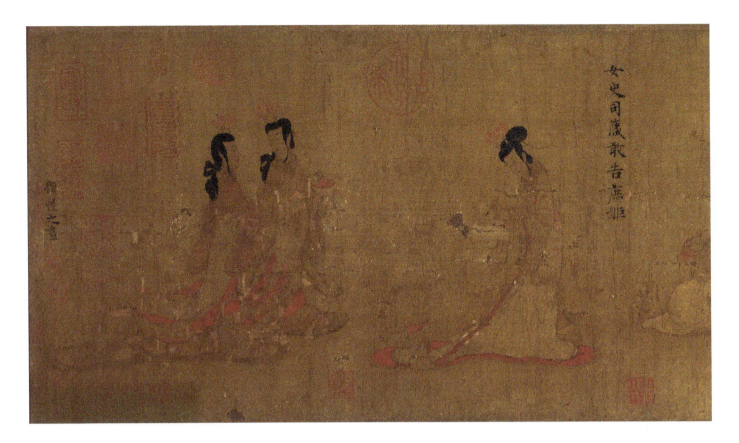

7-2 • Possibly a copy after Gu Kaizhi **ADMONITIONS OF THE COURT INSTRUCTRESS TO THE PALACE LADIES (DETAIL)**

Six Dynasties, ca. 500–600. Handscroll, ink and color on silk, 9⅝ × 135⅜″ (24.3 × 343.7 cm). British Museum, London.

qualities of reflection and forbearance even as their fluttering scarves create a sense of animation.

ENGRAVINGS AND MURALS

Because scroll paintings were fragile, the surviving examples of Six Dynasties pictorial arts tend to be images engraved in stone and **murals** (wall paintings), usually produced for funerary contexts. A Former Song tomb from Xishanqiao in Nanjing, Jiangsu province, includes representations of eight figures stamped into the bricks that form the walls: the Seven Sages of the Bamboo Grove, plus Rong Qiqi (for a detail, see **FIG. 7-3**). The Seven Sages were historical figures of the third century and members of the **literati** (highly educated scholars of some distinction who are sometimes described as scholar-officials, as they typically belonged to the official class of men who served in the government bureaucracy). The Seven Sages practiced Daoism, embodying individualistic and spontaneous behavior. As recluses, they withdrew from the political chaos of the Three Kingdoms and the Western Jin dynasty; their refusal of political office in troubled times ennobles them, as it attests to their sterling judgment. (The much earlier Rong Qiqi, fl. fifth century BCE, was also a recluse.) Reclusion became an important social mechanism in China, figuring prominently in determining literati cultural pursuits, and as such a recurring theme in art and literature. As pictured here, the figures sit among trees (to indicate a natural setting); some play musical instruments, while others succumb to drunkenness. Their relaxed, indecorous

7-3 • SEVEN SAGES OF THE BAMBOO GROVE AND RONG QIQI (DETAIL)

Former Song dynasty, ca. 400–500. Rubbing of stamped bricks, height 31½″ (80 cm). Tomb at Xishanqiao, Nanjing; Nanjing Museum.

7-4 • FILIAL GRANDSON YUAN GU

From a sarcophagus, Northern Wei dynasty, ca. 525. Engraved limestone, 24½ × 88″ (62.2 × 223.5 cm). Nelson-Atkins Museum of Art, Kansas City. Purchase: William Rockhill Nelson Trust, 33-1543/1.

attitudes and exceedingly casual dress (often with exposed flesh) emphasize their departure from convention. Those who constructed the tomb may have shared their political outlook.

An intricately engraved Northern Wei limestone sarcophagus presents more conventional funerary imagery. The sarcophagus's long sides depict Confucian paragons of filial piety (individuals renowned for dedication to parents, parents-in-law, or grandparents), conveying the **patrons'** reverence for their ancestors. One scene shows the Filial Grandson Yuan Gu (**FIG. 7–4**). As the story goes, Yuan Gu's father, concluding that his impoverished household cannot support a grandfather, resolves to abandon the old man in the forest; after he and Yuan Gu carry the grandfather there on a stretcher, the boy picks it up to bring it home again,

disingenuously telling his father that one day they will need it for him. This causes his father to rethink his decision, and they bring the grandfather back home. Yuan Gu is a paragon of filial piety not only because his actions indirectly save his grandfather, but also because he guides his father toward filial behavior without directly criticizing him. This scene reduces the story to two moments, with Yuan Gu, his father, and the grandfather on the stretcher at right, and, to the left, the grandfather sitting on the ground, Yuan Gu picking up the stretcher, and his father turning back. The forest setting, with dense thickets of trees, craggy rocks, and a swiftly flowing stream in the foreground, is a fully realized landscape. Though the artist depends entirely on line to render his forms, he succeeds in creating a complex composition.

The Northern Qi tomb of Lou Rui from Taiyuan is multi-chambered, painted on its walls and ceilings, and filled with 600 tomb figurines: **burial substitutes** meant to serve him in the afterlife. Lou Rui's noble status is reflected in the size and layout, as well as in the quality of the tomb's decoration. Murals painted on plaster on the brick surface depict an entourage of attendants, officials, heralds, and mounted riders. A fragmented mural from the vaulted ceiling, a procession of animals with an ox at the center, represents the twenty-eight constellations of the Chinese zodiac (**FIG. 7-5**; and see Context, p. 148); the flames that rise from their backs suggest starlight. The animals are rendered in outline, with visible underdrawing, and their faces are remarkably expressive. The style of the murals suggests that they may have been done by, or under the supervision of, a court painter.

SIX DYNASTIES BUDDHIST CAVE SITES

During the Six Dynasties, Mahayana Buddhism (Ch. *Dasheng fojia*), probably introduced during the Eastern Han dynasty via the Silk Road, slowly gained a foothold in China. Chinese Buddhists

7-5 • TWENTY-EIGHT CONSTELLATIONS

Northern Qi dynasty, 570. Ceiling mural, 5′3″ × 6′7½″ (1.6 × 2.02 m). Tomb of Lou Rui, Taiyuan, Shanxi province; Shanxi Provincial Institute of Archaeology.

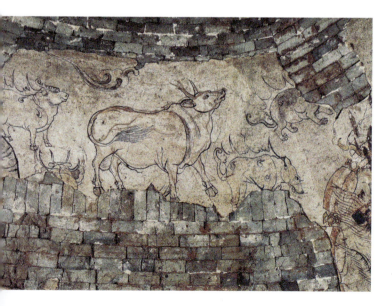

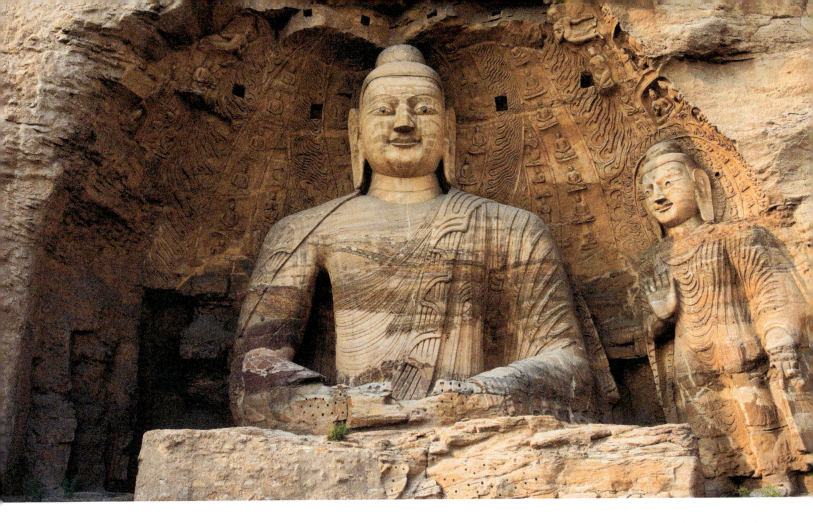

7-6 • COLOSSAL SHAKYAMUNI AND SMALLER BUDDHA
Northern Wei dynasty, ca. 460–465. Sandstone, height 44′11″ (13.7 m).
Cave 20, Yungang Grottoes, Datong, Shanxi province.

worshipped multiple Buddhas (Ch. *fo*)—who preside over different realms—and multiple **bodhisattvas** (enlightened beings; Ch. *pusa*). In this period, Buddhist laypeople and monks from Central Asia settled in China, and the Chinese monk Faxian (337–ca. 424) traveled on foot to Central Asia, India, Sri Lanka, and Nepal in order to retrieve Buddhist **sutras** (sacred scriptures), visiting sacred sites along the way. Of necessity, Chinese Buddhist practice evolved to accommodate certain elements of native belief systems. For example, some Buddhist teachings, such as the principle of nonattachment and the recommendation of monastic livelihood (leading individuals to give up their family names and practice celibacy), contradicted the emphasis on family espoused by both ancestor worship and Confucianism: this could be resolved by the practice of dedicating Buddhist images in honor of one's deceased parents. Other elements within Buddhism correlated well with Chinese beliefs: for instance, entering monastic life and the Daoist notion of reclusion both involved withdrawing from society. Similarly, Daoist immortals had approximate counterparts in Buddhist **arhats** (Ch. *luohan*), said to be enlightened disciples of Shakyamuni (Ch. *Shijia*), the historic Buddha; they vowed

to remain in the world until the appearance of Maitreya (Ch. Miluofo), the Buddha of the Future.

Most Six Dynasties rulers came to support the new religion, although others vehemently opposed it. The Tabgatch rulers of the Northern Wei present a case in point: Emperor Taiwu (r. 424–452) attempted to abolish Buddhism, while some of his successors, such as Emperors Xiaowen (r. 471–499) and Xuanwu (r. 499–515), sponsored the construction of Buddhist chapels.

THE YUNGANG GROTTOES

A persecution of Buddhists (446–452) set the stage for some important Northern Wei monuments: The monk Tanyao from Dunhuang, Gansu province (a Silk Road oasis city), proposed the construction of cave temples at a site in the sandstone cliffs of the Wuzhou Mountains, close to the first Northern Wei capital of Pingcheng (present-day Datong, Shanxi province), in order to expiate any lingering bad karma from Taiwu's persecutions. The site came to be known as the Yungang (Cloud Ridge) Grottoes, and over the next 60 years 53 caves were excavated, 45 of which survive, containing approximately 1,000 niches and 51,000 sculptures. The scale of Tanyao's initial caves (now numbered 16 to 20) indicates imperial sponsorship. Cave 20 features a colossal sculpture of Shakyamuni measuring almost 45 feet (13.7 meters) high, and a smaller, unidentified Buddha (**FIG. 7-6**). An exterior wall and the domed cave roof once sheltered these sculptures, which

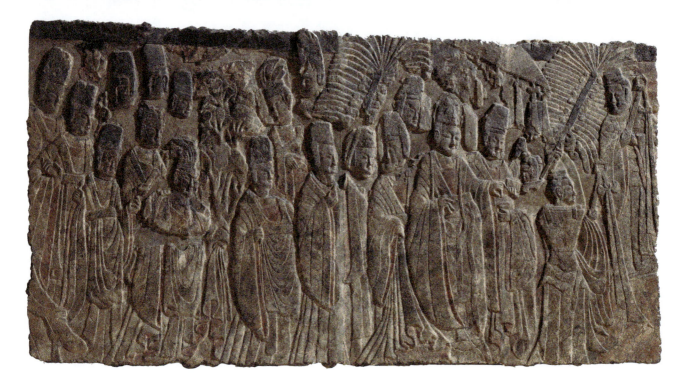

7-7 • EMPEROR XIAOWEN AS DONOR
Northern Wei dynasty, ca. 522–523. Limestone with traces of paint, height 6'10" × 12'11" (2.11 × 3.93 m). Binyang Chapel, Longmen Grottoes, Luoyang, Henan province; Metropolitan Museum of Art, New York. Fletcher Fund, 1935, 35.146.

have sustained erosion over the centuries. The larger Buddha sits cross-legged and makes the gesture, or **mudra**, of meditation (Skt. *dhyana mudra*; Ch. *dingyin*). A halo and a **mandorla** (an almond-shaped halo extending around his body), carved in low relief on the back wall of the semicircular cave, indicate his divinity; they contain flames—meant to suggest the Buddha's radiating energy—and tiny images of Buddhas that recall the miracle at Shravasti, in which Shakyamuni appeared to replicate his body 1,000 times in order to illustrate the principle that existence is only an illusion. The smaller figure standing at the right is recognizable as a Buddha through his **urna** (tuft of hair or third eye, located in the middle of the forehead; Ch. *baihao*), **ushnisha** (fleshy lump on top of the head; Ch. *ruoji*), elongated earlobes, halo, and simple drapery. (For a discussion of the **iconography** of a Buddha, see Chapter 1, Context, p. 16.) Traces of a third figure, similar in size to the smaller Buddha and almost entirely eroded, appear at the left; this suggests that the grouping may represent three Buddhas: Prabhutaratna (Ch. Duobao), the Buddha of the Distant Past; the historic Buddha; and the Buddha of the Future.

THE LONGMEN GROTTOES

The limestone cliffs of the Longmen (Dragon Gate) Grottoes near the second Northern Wei capital at Luoyang also enjoyed imperial patronage. Work on the site, which ultimately included 2,345 caves and niches with over 100,000 images, continued over a period of four centuries into the succeeding Tang and

Song (960–1279) dynasties. Emperor Xuanwu commissioned the Binyang Chapel on behalf of his late parents, Emperor Xiaowen and the dowager empress Wenzhou (d. 494): Matching **relief** carvings from the front wall of the chapel cast Xiaowen (**FIG. 7-7**) and his wife in the role of donors, allowing them to accrue merit even after death. Xiaowen's image is carved in low relief; most of his attendants turn toward him. He stands in front with his left arm outstretched, making him appear slightly bigger than the other figures. Some attendants hold fans to frame his head, or a parasol to shade it—devices that reveal the emperor's status. The entire

7-8 • SHAKYAMUNI AND ATTENDANTS
Northern Wei dynasty, completed 523. Limestone, height 21'2" (6.45 m). Binyang Chapel, Longmen Grottoes, Luoyang, Henan province.

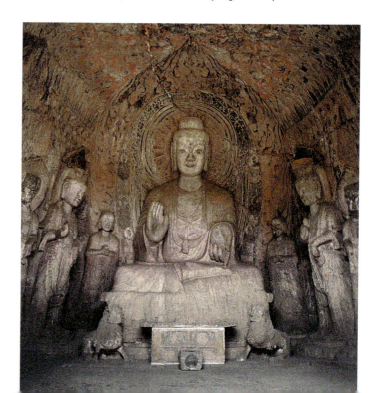

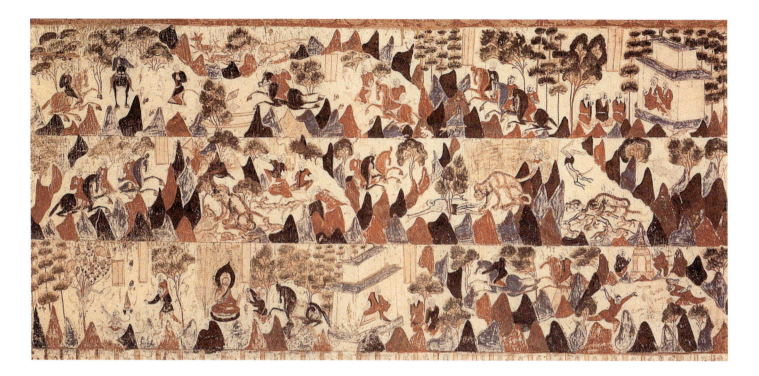

group makes offerings to the chapel's main image, a large sculptural group of Shakyamuni and attendants (**FIG. 7-8**). The historic Buddha appears at the center, wearing an archaic smile (a half-smile that first appears in ancient Greek sculpture, here possibly reflecting the connections between the Mediterranean world, India, and China). He raises his proper right hand (the hand on the right from the figure's own perspective, as opposed to the viewer's), palm facing out, in the gesture known as "fear not" (Skt. *abhaya mudra*; Ch. *shiwuweiyin*). His proper left hand makes the gesture of giving and receiving (Skt. *varada mudra*; Ch. *shiyuanyin*). His robes cover his body, exemplifying the modesty associated with Chinese Buddha images. A painted, low-relief halo and mandorla appear on the wall of the cave behind him. On either side of the Buddha, a pair of monks and a pair of bodhisattvas stand. Their shaven heads distinguish the monks, one of whom may be Shakyamuni's disciple, Ananda (Ch. Anan). Princely attire, including crowns, reveals the bodhisattvas, probably Samantabhadra (Ch. Puxian), the Bodhisattva of Universal Good, and Manjushri (Ch. Wenju), the Bodhisattva of Wisdom. Their elaborate dress is a form of iconography that dates back to the earliest Buddhist teachings, which consider Shakyamuni a bodhisattva before he withdrew from society and attained enlightenment, including the period of time when he lived as a prince in his father's palace; for Mahayana Buddhists, the bodhisattvas' princely garb signifies that, although considered deities, they remain in the world in accordance with their vows to help others attain enlightenment. **Hieratic scale** (depicting elements as large or small depending on their relative importance) clearly signals the status of these various enlightened beings.

THE MOGAO GROTTOES

The Mogao (Peerless) Grottoes in Dunhuang were a key staging point on the Silk Road. Wealthy donors, including officials,

7-9 • MAHASATTVA JATAKA (PREVIOUS LIFE OF THE BUDDHA AS PRINCE MAHASATTVA)
Northern Zhou dynasty, ca. 557–581. Mural. Cave 428, Mogao Grottoes, Dunhuang, Gansu province.

governors, and merchants, sponsored over 400 caves chiseled from a cliff; a single cave's lead patron might receive assistance and donations from others. Monks supervised the sumptuous decoration of the caves, richly painted on every surface (over layers of clay, straw, and plaster) and often containing painted sculptural groups. Prince Jianping (fl. 565–576), who for a decade in the Northern Zhou dynasty governed the Dunhuang region, served as the patron for Cave 428, which includes several images of Shakyamuni as well as thousands of donor images representing monks, nuns, and officials. One mural represents the historic Buddha in his previous life as Prince Mahasattva (Ch. Mohesa): the famous *jataka* tale (Ch. *benshengjing*) in which he sacrifices himself for a hungry tigress and her cubs (**FIG. 7-9**; see also Chapter 12, Closer Look, p. 294). Three **registers** relate the story. In the top register, read from right to left, Mahasattva leaves his parents' house and goes riding with his two brothers. In the central register, read from left to right, they come across the starving animals. The brothers depart to seek help, leaving Mahasattva behind; he proffers himself as food but finds the tigers too weak to eat him. He then throws himself from a cliff, enabling the tigers to lap blood from his broken body. In the bottom register, read from right to left, the brothers discover Mahasattva's scattered bones; they dedicate a **stupa** (shrine) before returning to their father. At the end of the composition, an enthroned Buddha appears. The tale promotes the virtues of selfless compassion and charity while elucidating the extreme choices of previous incarnations that allowed Shakyamuni ultimately to attain enlightenment.

A Buddhist devotional society commissioned this Eastern Wei **stele** (a decorated upright stone slab) to commemorate the construction of a temple complex; its front includes low-relief carvings and an inscription. (The back, not shown, has carved figures at the top and base, as well as 432 identical donor figures arranged in a grid with inscriptions engraved in the surrounding matrix.) Portions of the front show evidence of recarving following damage. A central scene depicts a passage from the *Vimalakirti Sutra* (Ch. *Weimojing*), which relates the theological debate between Vimalakirti (Ch. *Weimo*), a wise layman, and Manjushri, the Bodhisattva of Wisdom. The scripture concerns the concept of nonduality, especially relevant in China because philosophers conceived of phenomena in dualisms (for example, *yin* and *yang*).

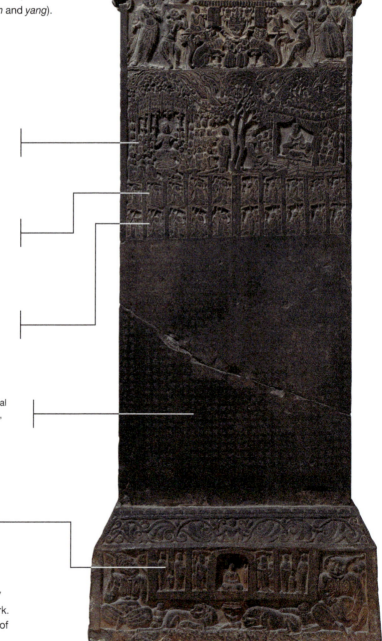

In the broken top register, (badly damaged) bodhisattvas standing on lotuses flank a large Buddha figure. Below them, monks and lions sit beside a central incense burner. Indian ascetics hold a skull and a bird, and guardian figures stand at the bottom corners.

The debate scene shows Vimalakirti on the right in a curtained alcove, with 14 attendants, and Manjushri at the left on a lotus pedestal, with 30 attendants. The *arhat* Shariputra (Ch. Shelizi) is between them on the left side of a tree; he also assumes the form of a female figure (seen on the right side of the tree) and transforms back again to demonstrate the meaninglessness of the male/female dualism.

The stele takes the distinctly Chinese form of a commemorative funerary tablet.

Twenty donor figures arranged in two rows appear below the debate scene.

The inscription names the leader of the devotional society, explains the purpose of the commission, and provides the date of 543.

More figures, including a small central Buddha in a niche with attendants, appear on the stele's base.

STELE DEPICTING THE VISIT OF MANJUSHRI TO VIMALAKIRTI

Eastern Wei dynasty, 543. Limestone, 10′1¼″ × 3′8¼″ (3.08 × 1.12 m). Metropolitan Museum of Art, New York. Rogers Fund, 1929 (stele 29.72, base 30.76.302); Gift of Kochukyo Co. Ltd. 1982 (figure 1982.200).

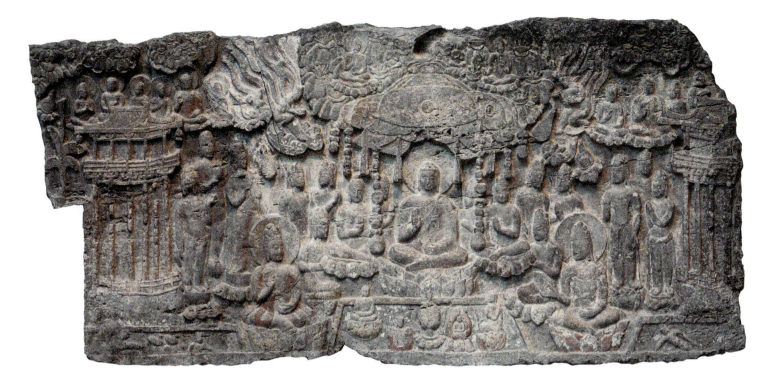

7–10 • WESTERN PURE LAND
Northern Qi dynasty, ca. 550–577. Limestone, 5′2¾″ × 12′11⅝″ (1.59 × 3.34 m). Xiangtangshan Caves, Fengfeng, Hebei province. Freer Gallery of Art, Smithsonian Institution, Washington, D.C. Purchase F1921.2.

THE XIANGTANGSHAN CAVES

The three Northern Qi cave sites at the limestone cliffs of Xiangtangshan in Fengfeng, Hebei province, comprise 30 caves. All are conceived as representing stupas, as evident from their exteriors, carved in the form of architecture with a domed roof. A relief from the site stands as the earliest representation of the Western Pure Land of Amitabha (Ch. Amituofo), the Buddha of the West (**FIG. 7-10**). Practitioners of Pure Land Buddhism, a sect that prospered and developed in China, believed the world too corrupt to allow anyone to attain enlightenment; they accordingly aspired to rebirth in the Western Pure Land, a peaceful and luxuriant realm where enlightenment was certain. Although the accumulation of merit—through chanting or copying sutras, sponsoring rituals or images, giving alms, or other selfless behavior—helped with rebirth in this realm, worshippers believed that chanting Amitabha's name guaranteed it. A believer would pass a lifetime in the Pure Land and, following enlightenment, would presumably be reborn as a Buddha. The Xiangtangshan relief includes the typical elements of the Western Pure Land. Amitabha sits beneath a central canopy, making the gesture of "fear not." Around him are various enlightened beings, including bodhisattvas and flying **apsaras** (female celestial beings). Palatial architecture and jeweled trees appear in the background. In front of the Buddha, a rectangular lotus pond represents the avenue of rebirth: Newly reborn souls sit on some of the blossoms as if they were pedestals, while others emerge from the opening petals or wait, contained within a bud.

SIX DYNASTIES AND TANG CALLIGRAPHY

Although there were renowned calligraphers from earlier periods of Chinese history, the earliest masters of **calligraphy** with surviving works date to the Six Dynasties and Tang period.

WANG XIZHI

The foremost master of this art was Wang Xizhi (303–361) of the Eastern Jin. Legend states that the movements of swimming geese inspired his calligraphy (see Chapter 8, **FIG. 8-25**). Examples of his calligraphy survive only as traced copies and engravings in stone of his original writing; collectors through the centuries made rubbings of the engravings and further tracings of the copies. Wang's most famous composition is the *Preface to the Gathering at the Orchid Pavilion*, written in 353 (**FIG. 7-11**). The example here is a rubbing taken from a stone engraving probably created in the Tang dynasty, which was possibly after a traced copy of the original made by seventh-century court calligraphers. This complicated chain of reproduction attests to the continuing appreciation of Wang's calligraphy. Wang wrote the *Preface* for a collection of poems composed by 42 literati of the period at a gathering at the Orchid Pavilion at Lanting, Zhejiang province. They participated in a poetry contest while drinking wine from cups floated down a stream, with penalty cups for those who did not complete their poems in a timely manner. This appealing back story suggests the gathering of like-minded scholars to indulge in the literary arts, a practice associated with removing oneself from the affairs of the world. The calligraphy is an example of running script: The characters are distinct but certain elements flow together, showing the movement of Wang's hand. The writing is legible, with

7–11 • Attributed to Wang Xizhi
PREFACE TO THE GATHERING AT THE ORCHID PAVILION
Original calligraphy dates to Eastern Jin dynasty, 353; engraving dates to Tang dynasty; rubbing dates to 17th century. Album leaf, ink on paper, 9⅞ × 3¹³⁄₁₆″ (25.1 × 9.7 cm). Metropolitan Museum of Art, New York. Purchase, The Dillon Fund Gift, 1989, 1989.141.2.

7–12 • Huaisu
AUTOBIOGRAPHICAL ESSAY (DETAIL)
Tang dynasty, 777. Handscroll, ink on paper, 11¼ × 297¼″ (28.3 × 755 cm). National Palace Museum, Taipei.

Connoisseurs regard calligraphy (the art of writing) as the premier art form, surpassing painting, but it is important to remember that the two are also considered sister arts, developing in parallel and inspiring each other. They use similar **media**, often ink and paper or silk, and the same tools: inkstones and brushes. Artists or collectors mount examples of calligraphy and painting in similar formats: handscrolls, **hanging scrolls** (vertically oriented compositions meant to be displayed on a wall), screens, **album leaves** (individual pages compiled into an album), or fans. Significantly, some Chinese characters are pictographs, meaning that they derive from pictures (others are better described as ideographs: representing ideas). From the Han dynasty forward, the literati explicitly stated that both calligraphy and painting could reveal an individual's internal life, including thoughts and feelings, or an individual's character: In short, an idea could be expressed outwardly in the form of words or pictures, using the medium of brush and ink.

Various types of calligraphic script appropriate for use in artists' or collectors' seals, in official documents, or for personal writing developed over the course of Chinese history: These include seal script (*zhuanshu*), clerical script (*lishu*), standard script (*kaishu*), running script (*xingshu*), and cursive or "grass" script (*caoshu*). The illustration here shows the differences between script forms, including early scripts not typically used by calligraphers. By the Six Dynasties, calligraphers could utilize any of these as a text or situation required.

HISTORICAL CHINESE SCRIPTS

	Horse	Cart	Fish	See
Oracle Bone script (*jiaguwen*)				
Bronze script (*jinwen*)				
Large Seal script (*dazhuan*)				
Small Seal script (*xiaozhuan*)				
Clerical script (*lishu*)				
Standard script (*kaishu*)				
Running script (*xingshu*)				
Grass script (*caoshu*)				

characters allocated to vertical columns in a balanced manner, but expressive qualities appear in the elegant brushstrokes, which are written more freely than what would be found in standard script. Considering that this reproduction is at best several steps removed from Wang Xizhi's original manuscript, it is difficult to assess how genuine an example of his writing it is: What is important is that collectors believed it to be authentic and used it as the basis for their own calligraphic practice.

HUAISU

The Buddhist monk Huaisu's (737–798) *Autobiographical Essay*, written in wild cursive script, reveals a completely different style (**FIG. 7-12**). While his characters align in vertical columns (read from right to left), they frequently run together. Huaisu's characters vary in size, becoming larger as he approaches the end of his essay and possibly indicating his increasing abandonment: For example, the character for "play" (not shown) takes up a column all on its own. Because many of Huaisu's brushstrokes are exuberantly messy, shorthand squiggles, the essay is difficult to read. Its content concerns his artistic career: Following mentions of

his native place and entry into monastic life, Huaisu describes a period of studying calligraphic history in the Tang capital Chang'an, then relates his acquaintances' comments on his calligraphy. The critiques address Huaisu's place in artistic lineages; the merits of his writing; and his habit of writing while drunk, a state of mind regarded as enabling greater authenticity of emotion in the work. Overall, Huaisu's calligraphy gives the impression of spontaneity, but considering that he was in part copying out others' commentary, what the viewer sees is not extemporaneous composition, but the spontaneous feelings that arose as Huaisu set down a retrospective of his career. Numerous seals indicate the essay's passage through both private and imperial collections since Huaisu's lifetime.

SUI AND TANG IMPERIAL CITY PLANNING AND TOMBS

Following Chinese reunification under the Sui dynasty, Emperor Wen (r. 581–604) ordered the construction of a new capital that

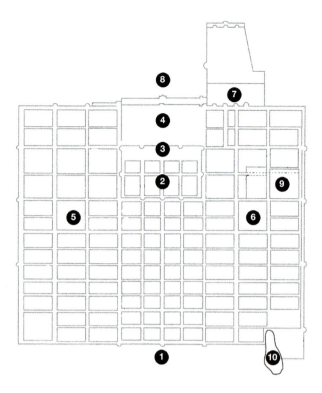

7-13 • PLAN OF CHANG'AN
ca. 700–800.

1. Mingde gate
2. Imperial city
3. Palace city
4. Taiji palace
5. West market
6. East market
7. Daming palace
8. Imperial park
9. Xingqing palace
10. Serpentine lake

was surrounded by mountains and rivers and had auspicious *feng-shui*. He chose a site in Shaanxi province 6 miles (10 km) southeast of the Western Han capital Chang'an. Now known as Xi'an, the Sui capital was called Daxing, but in the Tang it resumed the name of Chang'an.

CHANG'AN

The plan of the capital (**FIG. 7-13**) is remarkably orderly, clearly conveying the administrative abilities of the Chinese ruler and inspired in part by Zhou dynasty concepts of the proper geomantic layout of a city. For this reason, and because Chang'an served as the Tang capital for close to three centuries, it is strongly associated with the Tang era, despite the Sui emperor's involvement with the site. In the seventh century, Chang'an's population was one million, the largest city in the world; as the terminus of the Silk Road, it was strikingly cosmopolitan. The city has a square plan oriented to the cardinal directions; pounded earth walls surrounded it, with gates that controlled access to the city. Thoroughfares and avenues proceed north–south or east–west from the gates, dividing the city into a grid. The main entrance to Chang'an is the Mingde Gate at the south, and the road leading from it was named for the vermilion bird, the animal associated with the south in Daoist cosmology. The southern wards of Chang'an were residential and largely symmetrical (except for the Serpentine Lake found in the southeast

corner of the city), with market areas designated at both east and west. The imperial city compound was located farther north along the central north–south axis; it contained government offices, the Ancestral Temple, and the Altars of Grain and Soil. Beyond this was the palace city, which included three palace complexes. The extreme northern end of the city was perceived as the innermost sector, and the main north–south road terminated at the palace gate. An imperial park and the Daming palace were built north of the palace city in the Tang dynasty. Chang'an's city plan proved so well conceived that it was the urban plan of choice for capitals in both Korea and Japan.

TOMB COMPLEXES

In a way, the imperial tomb complexes of the Tang dynasty were also designed as cities. Two examples are Zhaoling, built for Emperor Taizong (r. 627–649), and Qianling, the resting place of Emperor Gaozong (r. 650–683), Empress Wu Zetian (r. 684–705), and several of their relatives. The emperors chose the mountains located northwest of Chang'an as sites for their tomb complexes.

The Zhaoling tomb complex, like Chang'an, was oriented to the cardinal directions and enclosed by a gated wall. Nearly 200 tombs of officials, their relatives, and attendants were found outside the walls, to the southwest. The tomb of Taizong and his empress was located in the center of the complex, beneath the principal peak of Jiuzong Mountain (which served as the tomb's **tumulus**), and resembled an underground palace. The complex also contained an offering hall, near the south gate, and a broad avenue known as a "spirit path," lined with sculptures, led from the north gate to a large sacrificial **altar**. The altar displayed

7-14 • QUANMAOGUA ("CURLY")
Tang dynasty, ca. 636–649. Stone, height 5′5½″ (1.66 m). Tomb of Emperor Taizong, Zhaoling, Shaanxi province; University of Pennsylvania Museum of Archaeology and Anthropology, Philadelphia. Purchased from C. T. Loo; Subscription of Eldridge R. Johnson.

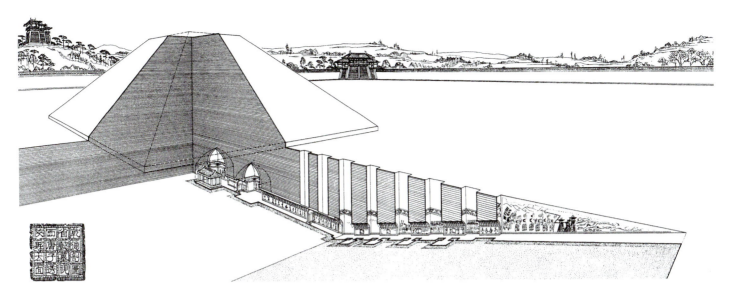

7-15 • DIAGRAM OF TOMB OF PRINCE YIDE
Qianling, Shaanxi province. Tang dynasty, 706.

relief sculptures of six of Taizong's favorite horses, including one named Quanmaogua, or "Curly" (**FIG. 7-14**). The relief has sustained some damage, but its meaning remains clear. Horses signified the military power of the state: Fittingly, Quanmaogua is depicted saddled and bridled, and despite the arrows piercing his body (from his service in an uprising of 622), he moves forward, indicating his endurance. All in all, the Zhaoling complex appears designed to convey Taizong's power.

The Qianling tomb complex was located at Mount Liang. Archaeologists have excavated three tombs there: those of Prince Zhanghuai (Li Xian, 654–684), Prince Yide (Li Zhongrun,

7-16 • *PLAYING POLO* (DETAIL)
Tang dynasty, 706–711. Pigment on plaster. Tomb of Prince Zhanghuai, Qianling, Shaanxi province.
Qianling Mausoleum, Xi'an.

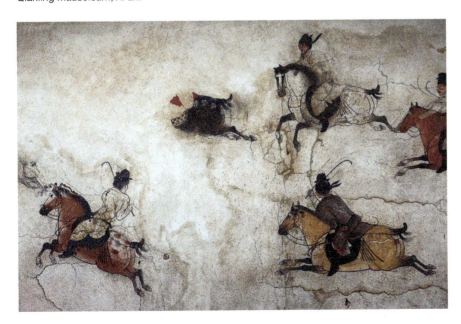

682–701), and Princess Yongtai (Li Xianhui, 684–701). As secondary burials, these tombs provide a glimpse into the political intrigues that attended Empress Wu Zetian's seizure of power following Emperor Gaozong's stroke. Accusing her son and heir apparent, Prince Zhanghuai, of treason, she first exiled him and then compelled him to commit suicide after Gaozong died. A few years later, she declared herself a female emperor and founded the Great Zhou dynasty (690–705). In this era, she commanded the executions of Prince Yide and Princess Yongtai, her grandchildren. Following the empress's death, her son, the newly ascended Emperor Zhongzong (r. 705–710), sought to have his relatives reinterred at Qianling, beginning construction on all three tombs in 706; his brother, Emperor Ruizong (r. 710–712), reopened Prince Zhanghuai's tomb in 710 in order to resume work on its paintings and record the circumstances of the prince's death on his memorial stele.

All three tombs constructed by Zhongzong are similar in form (**FIG. 7-15**). A long, sloping passageway leads underground to an antechamber and burial chamber located underneath the tumulus and connected by a barrel-vaulted corridor. Artists prepared the brick walls with layers of plaster and whitewash, then painted them. Two directional animals—the white tiger of the west and the blue dragon of the east—appear near the entrance as an orienting device. The ramp showcases pictorial imagery with imperial connotations: processions with warriors on horseback and palace guards, set against an urban backdrop of city walls and palaces, or hunting scenes in a landscape setting. Prince Zhanghuai's tomb, somewhat unusually, features a game of polo on the west wall of the ramp (**FIG. 7-16**)—a game of Sasanian origin, in this case possibly representing a real game played in 710 or 711 between Tibetan

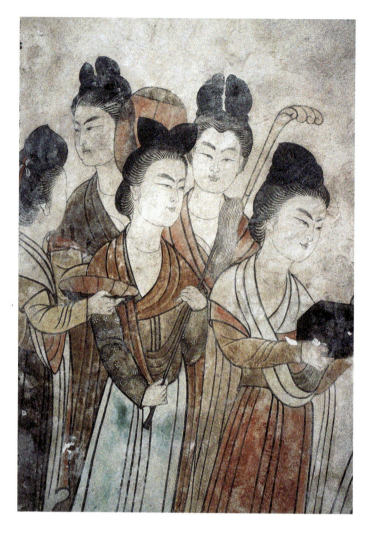

7-17 • COURT LADIES (DETAIL)
Tang dynasty, 706. Pigment on plaster, 5'9⅝" × 6'6" (1.77 × 1.98 m). Burial chamber, Tomb of Princess Yongtai, Qianling, Shaanxi province. Qianling Mausoleum, Xi'an.

envoys and a Chinese team that included the future emperor Xuanzong (r. 712–756). (The Chinese won.) Prince Zhanghuai's tomb also depicts images of foreign envoys, near the bottom of the ramp. The lower corridors of all three tombs depict attendants and symbols of official status, while the tomb chambers are decorated with images of court ladies and attendants; those represented in Princess Yongtai's tomb are slender with full faces, and fashionably attired (**FIG. 7-17**). The elaborate pictorial decoration in these tombs was not merely for the benefit of their occupants; the tombs remained open for some time following the funeral, and the emperor visited them, accompanied by members of the court and foreign emissaries.

SUI AND TANG DYNASTY HANDSCROLL PAINTINGS

Sui and Tang painters continued to take advantage of the handscroll format, which lent itself to the depiction of narrative, landscape, or any subject with a temporal or spatial element. Painting connoisseurs appreciated the format because it allowed them to add their commentary to the scroll, usually mounted after the painting; such inscriptions are referred to as **colophons**. A handscroll was intended for occasional viewing: A collector would lay it on a table, unrolling it with the left hand and rolling up the previously viewed sections with the right, sometimes with interested guests looking on. This enabled close perusal of each section of the painting and any commentary that came after it. Professionals remounted handscrolls as necessary, taking care to preserve each section of the painting and all its colophons; sometimes, however, they trimmed tattered areas and they could rearrange a painting's sections or colophons or even remove them altogether.

SPRING OUTING

A landscape scroll attributed to the Sui painter Zhan Ziqian (fl. 581–609) is *Spring Outing* (**FIG. 7-18**). Like all handscroll paintings assigned very early dates, it is probably a copy rather than Zhan Ziqian's authentic work. *Spring Outing* depicts elegantly dressed figures taking in spring scenery, moving on foot, mounted on horseback, or out on the water. Mountains appear at the top right and low hills at the bottom left, and a large body of water, rendered through a brush pattern called fish-scale waves, appears at the center of the composition and recedes diagonally, creating a sense of depth. Blossoming trees dot the landscape, indicating the season. The painting depicts aristocratic figures at leisure, a political subject that suggests the court's prosperity. The painting is a **blue-green landscape**, so called because of the use of **mineral pigments** derived from (blue) **azurite** and (green) **malachite**. Although malachite was mined domestically, the source for azurite was present-day Tashkent (in Uzbekistan), and it was traded on the Silk Road. In this case, the painter has used malachite to create verdant hues reminiscent of the green of new leaves in spring. The painter highlights the architectural elements with vermilion pigment and the figures' dress and horses with lead-white pigment. Blue-green landscapes are strongly associated with Tang court painters, particularly Li Sixun (fl. ca. 705–720) and Li Zhaodao (fl. mid-eighth century), and when artists use this style of painting after the ninth century, it is often as a deliberate reference to the Tang dynasty.

THE THIRTEEN EMPERORS

The handscroll known as *The Thirteen Emperors*, attributed to Yan Liben (ca. 600–674), presents a sequence of emperors of different dynasties, identified in captions. The emperors appear flanked by attendants, with each emperor the largest figure in his group. Hieratic scale works across the groups as well, however, with the largest emperors in the scroll the most powerful among the 13, and the smallest the most ineffectual. The painter pays close attention to faces and historical costume. The beginning and end of the scroll appear somewhat repetitive, with emperors—some quite imposing—positioned similarly and primarily differentiated

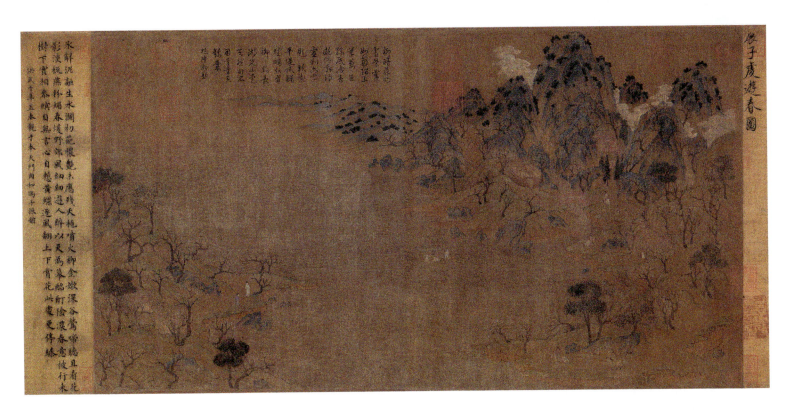

7-18 • Attributed to Zhan Ziqian **SPRING OUTING,
OR _TRAVELING IN SPRING_**
Probably a Song dynasty copy of a Tang dynasty original.
Handscroll, ink and color on silk, 16⅞ × 31¾″ (43 × 80.5 cm).
Palace Museum, Beijing.

by dress. However, the painter depicts the seventh through tenth emperors, all from the short-lived Chen dynasty, rather differently (**FIG. 7–19**). At the right, Emperor Xuan (r. 569–582) sits flanked by eight attendants, two of whom frame his head with ceremonial fans; he usurped the throne from his nephew, and the state lost territory under his reign. The next person depicted, Emperor Wen (r. 559–566), sits on a couch in front of two women, and Emperor Fei (r. 566–568) faces and essentially mirrors him; depicting both

of these emperors with women suggests that they were easily distracted from governance. The next emperor to the left (not shown here) is Houzhu, or the Last Ruler (r. 582–589), who has only one attendant; at the end of his reign, his state fell to the Sui dynasty. The painter, by focusing on four emperors from such a weak state, appears to emphasize the lessons that their biographies offer, suggesting a court commission for didactic purposes.

7-19 • Attributed to Yan Liben **THE THIRTEEN EMPERORS,
OR _SCROLL OF THE EMPERORS_ (DETAIL)**
Probably a copy of an original dated to the Tang dynasty. Handscroll, ink and color on silk, 20³⁄₁₆ × 209¹⁄₁₆″ (51.3 × 531 cm). Museum of Fine Arts, Boston. Denman Waldo Ross Collection, 31.643.

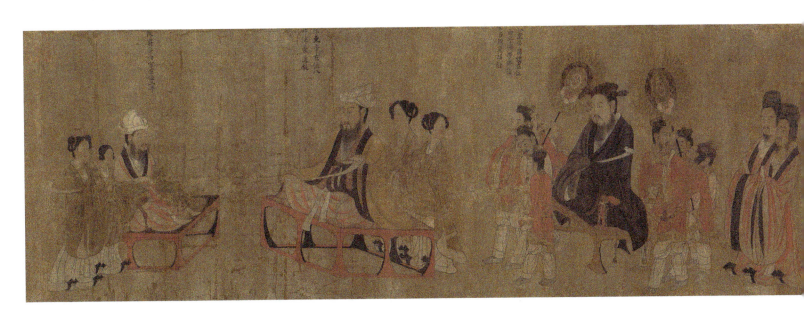

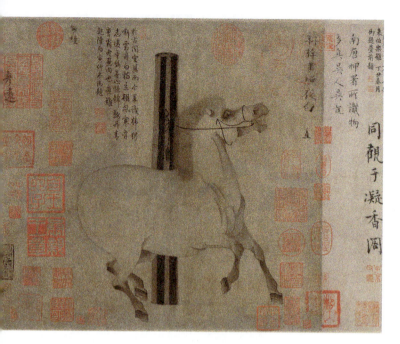

7-20 • Attributed to Han Gan ***NIGHT-SHINING WHITE***
Tang dynasty, 700–800. Handscroll, ink on paper, 12⅛ ×
13⅜″ (30.8 × 34 cm). Metropolitan Museum of Art, New York.
Purchase, The Dillon Fund Gift, 1977, 1977.78.

NIGHT-SHINING WHITE

Another painting mounted as a handscroll is *Night-Shining White*
(**FIG. 7-20**), attributed to the court painter Han Gan (ca. 715–
after 781). Han Gan specialized in painting horses; this particular
specimen is one of Emperor Xuanzong's favorites. *Night-Shining
White* represents a type of horse that began to be imported from
Ferghana in the Han dynasty, via the Silk Road. Tied to a pole, the
horse strains against its bridle and attempts to rear. Horse paintings
became an important **genre** (a subject category in art), and the
restraint of such a spirited animal indicates the emperor's control.
Numerous seals and inscriptions appear on the original sheet of
paper and on another sheet mounted to its right, meaning that the
handscroll's viewers encounter the painting's **provenance** (history

of ownership) and critical commentary before the painting itself.
The seals date from the tenth through twentieth centuries and
belong to various collectors and connoisseurs, including emperors,
members of imperial families, high-ranking officials, and artists;
most are placed along the margins of the sheets of paper, or else
after inscriptions. The inscriptions, also by connoisseurs and col-
lectors, mostly appear on the leading sheet of paper; a few that
intrude on the composition are invariably written by emperors.
Though the seals and inscriptions may seem distracting, a viewer
literate in classical Chinese and cognizant of art history finds that
these additions testify to the painting's importance and increase
appreciation of the work.

WANGCHUAN VILLA

A well-known composition whose original has not survived
is *Wangchuan Villa* by the poet-painter Wang Wei (699–759).
Reportedly, Wang Wei executed this painting as a temple mural,
but its landscape subject adapted well to the handscroll format. A
rubbing taken from a stone engraving of a tenth-century hand-
scroll (**FIG. 7-21**) is believed to preserve the essence of Wang Wei's
composition. Wangchuan Villa was Wang Wei's country estate and
a place that he visited on retreat, commemorating it in his paint-
ing and a related series of 20 poems. One of the scenic spots of
Wangchuan Villa is the Deer Enclosure, which Wang Wei described
in this poem:

> On the empty mountain I cannot see anyone,
> but I hear the sounds of people talking.
> Reflected light enters the depths of the forest,
> once again shining on the green moss.

7-21 • Attributed to Guo Zhongshu after Wang Wei
WANGCHUAN VILLA (DETAIL)
Original painting dates to tenth century; rubbing dates to 1617.
Rubbing, ink on paper, 12½ × 325″ (31.8 × 826 cm). East Asian
Library, University of Chicago.

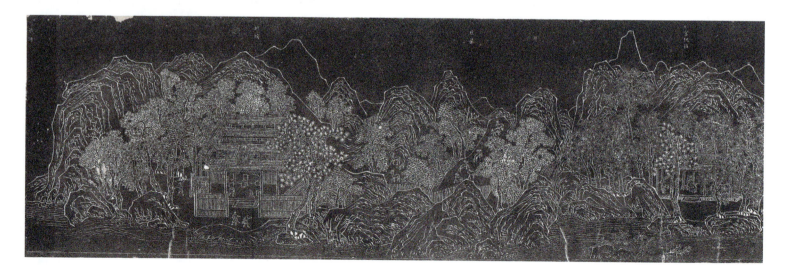

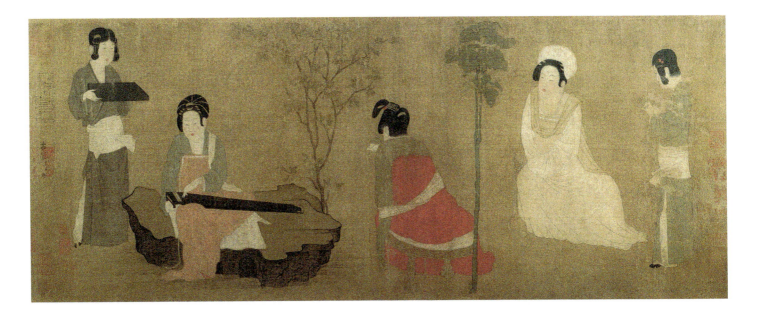

7-22 • Copy after Zhou Fang *PALACE LADIES TUNING THE LUTE*

Handscroll, ink and color on silk, 11 × 29⅝" (27.9 × 75.2 cm). Nelson-Atkins Museum of Art, Kansas City. Purchase: William Rockhill Nelson Trust, 32-159/1

The corresponding scene in the ink rubbing, accompanied by a caption, visualizes the title in a straightforward manner, with deer roaming the hilltops above an enclosing fence. The tenth-century reinterpretation includes elements that were archaic by that period, including the use of the **space-cell** (a cell-shaped enclosure containing pictorial elements apparently set on a different plane of recession from the surrounding elements), a Tang method of depicting depth.

PALACE LADIES TUNING THE LUTE

A relatively short handscroll that exemplifies the genre of paintings of elite women—including court ladies, courtesans, or educated women—is *Palace Ladies Tuning the Lute* (**FIG. 7-22**), a copy after the court painter Zhou Fang (ca. 730–ca. 800). An eighteenth-century art historical source describes a remarkably similar painting attributed to his predecessor Zhang Xuan (fl. ca. 713–742); both painters specialized in this genre. This painting may be a copy after a similar composition by Zhang Xuan, but paintings of women in the Tang style could be attributed to either master, as they were considered to have similar styles. *Palace Ladies Tuning the Lute*, set in a garden, shows two simply dressed maids—one carrying a teacup, the second a tray of lute strings—at the periphery of the composition, flanking three palace ladies at the center. The beautifully attired ladies wear ornaments in their topknots, signaling their elite status. They are also fashionably plump, a beauty standard set in the Tang by the imperial concubine Yang Guifei (712–756), a favorite of Emperor Xuanzong. One gazes off into space, another seen from behind sips tea, and a third sits on a rock and tunes the strings of her zither, as evident from

her hand positions. The theme of tuning the lute (a term applied to many types of stringed instrument) derives from love poetry: It suggests that the performer tunes the strings as she waits to play a song for her beloved. A fourteenth-century connoisseur assessed both Zhou Fang and Zhang Xuan as experts in representing the emotional life of women, and this painting conveys the patient longings of the imperial concubines.

TANG BUDDHIST ART AND ARCHITECTURE

Buddhism continued in the Tang period, thriving in some eras and waning in others. New Buddhist construction in the capital or at nearby sites reflects the sometime support of rulers and the flourishing of certain Buddhist communities. However, some Han Chinese continued to oppose Buddhism on the grounds of its foreignness. Han Yu, the official quoted at the beginning of this chapter, submitted a memorial to the Xianzong emperor (r. 805–820) in 819, objecting to the lavish expense on the public procession of **relics** of the historic Buddha's finger bone, enshrined in the Famen temple in Fufeng, Shaanxi province, and periodically brought to Chang'an; he was exiled for his trouble. Two decades later, though, Emperor Wuzong (r. 841–846) issued an edict proscribing Buddhism, remonstrating that monks and nuns relied on charity and did not pay taxes. This swiftly led to the closure and destruction of many temples and monasteries and the enforced return of the Buddhist clergy to lay status.

THE GREAT GOOSE PAGODA

Until 845, however, the religion did enjoy increasing prominence in Chinese society, as reflected in the construction of the Great Goose Pagoda (**FIG. 7-23**) in Chang'an in 652. Emperor Gaozong sponsored its construction at the suggestion of the Chinese monk Xuanzang (ca. 602–664). A **pagoda** is the East Asian form of

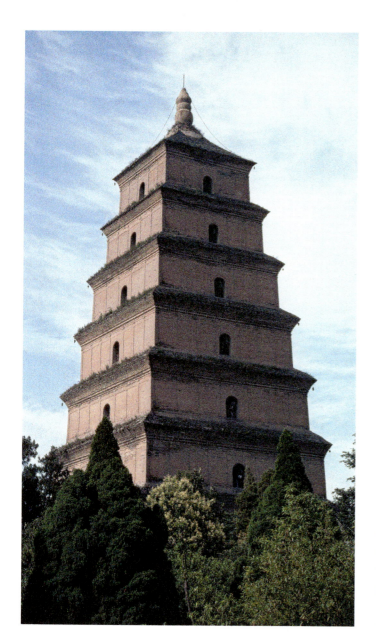

7-23 • GREAT GOOSE PAGODA
Tang dynasty, 652. Masonry, 207 × 82 × 82′ (63 × 25 × 25 m).
Ci'en Monastery, Xi'an, Shaanxi province.

the stupa and functions as a large-scale reliquary: In the case of the Great Goose Pagoda, the "relics" were the Buddha's sacred words, set down in sutras that Xuanzang spent 16 years (629–645) journeying to India and back to obtain. Like Faxian before him, Xuanzang traveled via the Silk Road, visiting (and writing about) several of the important Buddhist sites of Central and South Asia, including Bamiyan, Sarnath, Mathura, and Bodhgaya. In some respects the Great Goose Pagoda recalls the Mahabodhi temple at Bodhgaya: Both are tall, truncated pyramids, square at their bases and tapering in form. However, the seven-story Chinese pagoda could be entered, enabling **circumambulation** on the exterior and interior. Gaozong dedicated the pagoda to his late mother; it was later rebuilt by his consort, Empress Wu.

THE FENGXIAN TEMPLE

Emperor Gaozong and Empress Wu also sponsored Cave 19 at the Longmen Grottoes, known as the Fengxian (Ancestor-Worshipping) Temple and completed in 676. This cave is the site for a colossal sculptural group of the Buddha Vairochana (Ch. Dari Rulai) and his attendants (**FIG. 7-24**), carved out of the limestone cliff. The loss of the cave's roof resulted in significant erosion to several of the figures. Vairochana was known as the cosmic Buddha: the one from whom the entire cosmos emanates. He transcends both time and space, and all other Buddhas are emanations of him. The figure may be intended as a comparison to the Chinese ruler; Empress Wu was intrigued by and subsequently propagated a sutra that predicted the emergence of a Chinese *chakravartin* (universal ruler; Ch. *tianlun wang*)—the secular, earthly equivalent of Vairochana. The naturalistic, 56-foot (17-meter) tall

7-24 • COLOSSAL VAIROCHANA AND ATTENDANTS
Tang dynasty, 660–676. Limestone, height 56′ (17 m). Fengxian Temple, Cave 19, Longmen Grottoes, Luoyang, Henan province.

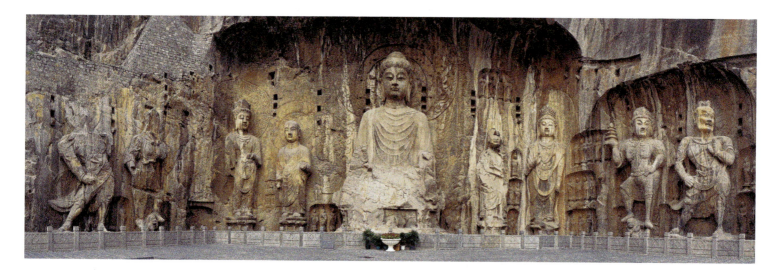

These two images represent different schools of Buddhism as well as different approaches to Buddhist worship. The *Stele with Shakyamuni and Bodhisattvas* (**FIG. 7–25**), a somewhat damaged limestone relief, is associated with Mahayana Buddhism; an inscription on the back provides the date of 537 and suggests that it was made on commission. The eighth-century mural of the *Western Pure Land* (**FIG. 7–26**), from Cave 45 of the Mogao Grottoes at Dunhuang, reflects the beliefs of Pure Land Buddhism. The two works of art have significant differences of scale: The stele is only 30 inches (77 centimeters) high, while the mural covers a wall

and is probably several feet wide. The stele shows the historic Buddha with a halo and flame mandorla, an archaic smile, and elegant waterfall drapery, flanked by two bodhisattvas. The central section of the mural shows the Buddha of the West enthroned and surrounded by a multitude of enlightened beings. Flanking the mural are scenes (not shown) relating the origin story for Pure Land Buddhism: the evil deeds of Prince Ajatashatru (Ch. Adushi; r. 491–461 BCE) that drive his mother, Queen Vaidehi (Ch. Weidi), to seek deliverance through rebirth in the Western Pure Land, learning to envision its 16 distinct elements.

7-25 • STELE WITH SHAKYAMUNI AND BODHISATTVAS
Eastern Wei dynasty, 537. Limestone, 30½ × 17⁷⁄₁₆″ (77.5 × 44.4 cm). Cleveland Museum of Art. Gift of the John Huntington Art and Polytechnic Trust, 1914.567.

7-26 • WESTERN PURE LAND
Tang dynasty, ca. 705–781. Mural. Cave 45, Mogao Grottoes, Dunhuang, Gansu province.

THINK ABOUT IT

1. What do the subjects of these two works of art indicate about the development of Buddhist belief in China?

2. What similarities and differences of style are apparent in these two works of art?

3. The composition of the Western Pure Land mural is much more complex than that of the Stele with Shakyamuni and Bodhisattvas. Do you think that the subject of

the Western Pure Land was completely accessible to viewers? If not, how do you think an audience could come to understand what it represented?

4. What do the different scales of these works of art suggest about the environment in which they were viewed? Explain your reasoning.

Vairochana sits cross-legged; his finely carved halo and flame mandorla appear on the back wall of the cave. Several standing figures arranged symmetrically flank him, although two on the left have eroded: Progressing outward from Vairochana, they are a pair of *arhats* with haloes (likely Ananda and Kashyapa [Ch. Jiaye]), a pair

of bodhisattvas with haloes and flame mandorlas, a *lokapala* (world guardian; Ch. *tianwang*) holding a stupa and trampling a demon underfoot, and an armored *dvarapala* (gate guardian; Ch. *henghaerjiang*). The 48 life-size figures and apertures on the back wall are much later additions to the shrine.

THE NANCHAN TEMPLE

The Main Hall of the Nanchan Temple at Wutaishan (**FIG. 7-27**) dates to 782, according to an inscription on one of the hall's roof beams. In many ways the exterior is typical of post-and-beam architecture. This particular hall is small, measuring three bays wide and three bays deep, and did not require interior columns to support the roof. Painted sculptures stood on a central altar; the main image was the historic Buddha, although the Bodhisattva of Wisdom, Manjushri, riding a lion appeared at one end of the hall, corresponding to an image of the bodhisattva Samantabhadra riding an elephant at the other end. Open space around the altar permitted circumambulation, which was somewhat atypical; it was more usual to have the altar against the back wall in order to allow meditation in front of it. This hall's survival can be attributed to its remote location at Wutaishan (Mount Wutai), considered one of the most sacred mountains in China and the earthly residence of Manjushri; most other wooden temples of the Tang period and earlier were destroyed in the Buddhist persecution of 845.

THE LIBRARY CAVE

The so-called Library Cave (17) at the Mogao Grottoes (see p. 153) preserved a variety of materials, including Buddhist texts, poetry, and paintings, deposited there before the cave was sealed sometime in the eleventh century. Several are scrolls depicting Pure Land Buddhist subjects, reflecting the growing popularity of this sect; an example is *Bodhisattva Guide of Souls* (**FIG. 7-28**). The focus of the painting is a large, elaborately dressed figure who is unmistakably a bodhisattva, judging from his flame mandorla, headdress, jewelry, and multilayered clothing in colorful, intricately patterned fabric evocative of that of an Indian prince. He may represent Avalokiteshvara (Ch. Guanyin), the Bodhisattva of Compassion and one of two bodhisattvas commonly associated with Amitabha's

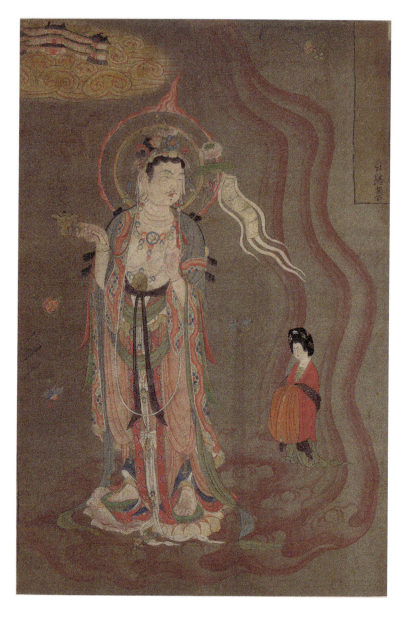

7-28 • BODHISATTVA GUIDE OF SOULS
Tang dynasty, ca. 875–900. Hanging scroll, ink and color on silk, 31⅝ × 21¼″ (80.5 × 54 cm). Cave 17 ("Library Cave"), Mogao Grottoes, Dunhuang, Gansu province; British Museum, London.

7-27 • MAIN HALL
Tang dynasty, ca. 782. Wood, masonry, plaster, and ceramic tiles. Nanchan Temple, Wutaishan, Shanxi province.

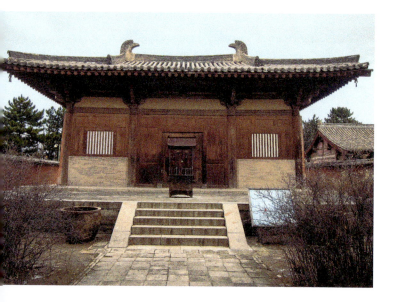

Western Pure Land. He holds an incense burner, a lotus, and a temple banner, and he stands on twinned lotus pedestals. He has just descended from the Pure Land—the golden architecture of which is visible in the composition at the top left—leaving a trail of rosy smoke in his wake. Next to him, and much smaller, is a wealthy woman: she wears makeup, a stylish cloud coiffure (a manner of arranging the hair so that it appears to float around the head) with many different hair ornaments, and voluminous garments in red, orange, and pale green. She is also fashionably plump in the manner of Yang Guifei. Practitioners of Pure Land Buddhism believed that they would be escorted to their rebirth by a bodhisattva or by Amitabha himself. The representation of a female believer emphasizes that this school of Buddhism taught that both men and women could attain enlightenment.

Chinese architects used the **post-and-beam** technique, usually executed in wood, plaster, stone, and ceramic tile, for palace buildings and Buddhist and Daoist temples, and it inspired similar buildings in both Korea and Japan. However, surviving examples from the Tang are rare, because buildings made of wood burn too easily. The earliest surviving post-and-beam building in China is the Main Hall of the Nanchan Temple (**FIG. 7–27**) at Wutaishan, Shanxi province, but a second example from the same location, the East Main Hall of the Foguang Temple, gives a better idea of the intricate structure of this type of architecture.

Buildings made using the post-and-beam method have a three-part structure. First, a stone foundation protects the wooden elements from ground moisture. Secondly, a wooden framework of vertical columns and horizontal beams rests on the foundation, forming the walls and defining the interior spaces of the building. Either plaster or wood can fill the spaces between posts and beams on the building's exterior. The space between columns, called a **bay**, provides a convenient unit of measurement: The diagram shows a building four bays wide and three bays deep. (The actual East Main Hall is seven bays wide and four bays deep.) Post-and-beam architecture does not typically have windows, but the central bays of the **façade** (the front of the building) make a good location for multiple doors. Interior columns divide the space into a **nave** (a central area extending the length of the building) and flanking **aisles**.

In a temple building, the nave can be an ideal location for an altar. The interior columns help to support the roof, the third element of the structure. A roof constructed from semicircular ceramic tiles, laid in interlocking columns, often surmounted a Chinese wooden building, and the weight of a tile roof required the support of a complicated bracketing system. Builders placed wooden **brackets** at the tops of columns, where they intersect with a horizontal tie-beam; the brackets appear stacked one atop another, in a complex interplay of elements referred to as blocks and arms, cantilevering out from the building, supporting the roof, and balancing the weight of the overhanging eaves. In very long buildings, bracket clusters could also appear in the middle of a bay. The brackets channel the weight of the roof down through the columns to the foundation.

A tile roof could take several forms: **hipped**, **gabled**, or **hipped-and-gabled**. Both the Main Hall of the Nanchan Temple and the East Main Hall of the Foguang Temple have hipped roofs: Four trapezoidal sections slope down from a ridgepole at the top. A gabled roof has two rectangular sections extending down from the ridgepole, creating gables (triangular areas of wall) on either end of the building. A hipped-and-gabled roof conjoins the two, with a gabled roof on top and hipping extending below it on all four sides, creating a distinctive profile. A tile roof could have a double set of eaves: The Hall of Supreme Harmony in the Forbidden City, Beijing (see **FIG.** 9–3) has a double hipped roof.

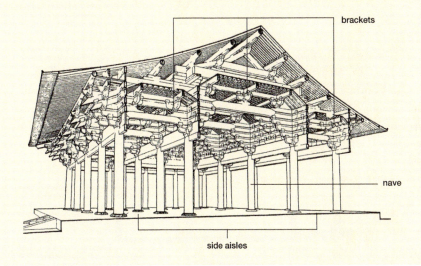

brackets

nave

side aisles

Diagram of structure of East Main Hall, Tang dynasty, ca. 857. Wood, masonry, plaster, and ceramic tiles, 110 × 57′ (34 m × 17.6 m). Foguang Temple, Wutaishan, Shanxi province.

DECORATIVE ARTS FOR THE TANG ELITE

Beginning in the seventh century, many examples of decorative arts produced for the elites of the Tang dynasty reflect diplomatic interchange with Sasanian Iran and trading with Sogdian merchants. Following the Arab conquest of the Sasanian empire, the heir apparent, Peroz II, fled to Chang'an in 670 with his court, bringing craftsmen with him. At the same time, Tang artisans were developing distinctly Chinese forms that would continue to be cited in later periods.

METALWORK

Important advances can be seen in Tang metalwork, particularly in the appropriation of a Sasanian **repoussé** technique developed for working with such metals as gold and silver. It involves hammering a sheet of metal to create a raised design on its opposite side. An eight-lobed mirror in bronze and gold (**FIG. 7–29**) shows how this technique could combine with indigenous Chinese techniques. Certain details correspond to ancient mirrors: Typically, a mirror has one side that is flat and polished and one that is ornamented. In this case, the smooth side of the mirror (not pictured) is cast in bronze using a **piece-mold**, while the decorated back of

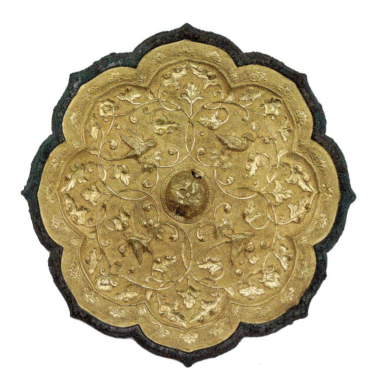

7-29 • EIGHT-LOBED MIRROR
Tang dynasty. Bronze and gold, diameter 8⅞" (22 cm). Freer Gallery of Art, Smithsonian Institution, Washington, D.C. Purchase F1930.45

the mirror is worked in a sheet of gold using repoussé; gold and bronze were then soldered together. The relief decoration, which is not symmetrical but has four clear segments, features ducks pictured among artfully placed blossoming lotuses and vines. Floral motifs around the edge accentuate the mirror's elegant lobed shape, and the motifs surrounding the central boss are outlined by a ring-punched design. The refinement of the representation, which shows the birds' individual feathers, the veins and curling shapes of the leaves, and even the seeds of the lotuses, attests to the confidence of the artisan. In earlier times mirrors, especially when decorated with cosmological symbols, had been regarded as sacred objects that could represent the universe, possibly in part because of their round shape; they were often included in tombs to provide a source of light and a map of the cosmos. By the Tang dynasty, they were also luxury objects that could represent happiness. This mirror may have been a wedding gift, as ducks connote mating for life, while the word for lotuses (*lian*) is pronounced the same as one word for love.

A stem cup (**FIG. 7-30**) made out of silver with slight traces of gilding is also decorated using the repoussé technique, with chased motifs appearing on the exterior. The approach to the design is similar to that of the mirror: The design is again segmented but not symmetrical, divided into eight lobes extending

7-30 • STEM CUP
Tang dynasty, ca. 675–725. Silver with gilding, height 1⅞" (4.8 cm). Courtesy of Asia Society, New York. Mr. and Mrs. John D. Rockefeller 3rd Collection of Asian Art 1979.118.

around the exterior of the cup's body, with certain motifs repeated. Within the embossed parameters of the lobes, birds and flowering plants in relief are set against a minutely engraved background. Vine motifs embellish the stem of the cup. Stem cups also appeared in Sasanian and Sogdian culture and would be reinterpreted in other Chinese media, while images of birds and flowers in later periods became an important Chinese painting genre.

CERAMICS

A vessel that embodies the cross-cultural inspirations of the Tang is a glazed **earthenware** ewer (**FIG. 7-31**). A ewer is a form of pitcher; this example has a fluted rim, long neck, long handle, globular body, and raised foot—a form recognizable from examples of Sasanian metalwork. The medium, however, is distinctly Chinese. Earthenware had long been used to create **pottery** vessels; this example is finished with the signature three-color (*sancai*) **glaze** of the Tang dynasty. Glaze imparts a smooth and often glossy finish to a ceramic piece and, in the case of vessels, typically helps to make them watertight. Formulated as a liquid suspension of minerals, glaze was applied to objects that had already undergone an initial bisque-firing; the object would be fired again to allow the glaze to melt and bond to the object's surface. The foundation of three-color glaze is lead, which fires to off-white; the addition of copper and iron produces green and amber hues. Lead glaze tends to flow in the firing process, often making it difficult to control the final distribution of colors, but here the colors enhance the different elements of the ewer, with the neck appearing primarily amber, the handle and foot predominantly green, and the body showcasing the beautiful mottling of all three colors.

A second ceramic vessel from the Tang dynasty represents the development of a distinctly Chinese style: a two-handled jar in **stoneware** with tea-dust glaze (**FIG. 7-32**). Stoneware, a clay

7-31 • EWER
Tang dynasty, ca. 675–750. Earthenware with three-color (*sancai*) glaze, height 11⅛″ (28.3 cm). Metropolitan Museum of Art, New York. Gift of Stanley Herzman, in memory of Gladys Herzman, 1997, 1997.1.2

7-32 • JAR WITH HANDLES
Tang dynasty, ca. 800–900. Stoneware with tea-dust glaze, height 5¼″ (13.3 cm). Museum of Fine Arts, Boston. Anonymous gift, 1990.107

body that could be fired to a higher temperature than earthenware, was also harder and nonporous, and began to be used more frequently in this period. The tea-dust glaze developed in the kilns of Yaozhou, Shanxi province, in the ninth century, but surviving examples from the period are quite rare. The glaze is rich in iron, resulting in a dark brown color; by deliberately under-firing this vessel, the potter attained a matte finish that approximated the appearance of powdered tea. In many respects, this jar anticipates Song dynasty tea ceramics, in not only the dark color of the glaze but also the exposure of the raw clay in the unglazed foot of the vessel. The shape of this gently rounded vessel is simple and elegant, as are the round loops appearing on the vessel's shoulder; the placement of the handles in some ways recalls those seen on certain bronze vessels of the ancient era.

The changes wrought in Chinese society and culture from the Six Dynasties to the Tang had lasting ramifications for the arts, with the interplay of cross-cultural elements inspiring intense creative innovation. Several of the trends seen in this era—the upsurge of courtly and Buddhist patronage, the elevation of calligraphy and painting to the status of fine arts, and the nascent interest in art history—all continued in subsequent eras. At the same time, the succeeding periods witnessed increased introspection as the peoples of China grappled with notions of identity.

CROSS-CULTURAL EXPLORATIONS

7.1 A recent technological study reveals that the Colossal Buddha at Bamiyan actually postdates the one at Yungang, though it was long thought to be the other way around. What do these two sculptures have in common? Why would it be desirable to create an image on such a massive scale?

7.2 The Great Goose Pagoda represents a variation on the reliquary form of the Indian stupa. What do the pagoda and the stupa have in common? What is different? Is it evident that the pagoda form derives from a stupa?

7.3 Compare and contrast painting from a Chinese cave site, such as Dunhuang, to painting from an Indian site, such as Ajanta. What do the sites have in common?

7.4 Discuss what representations of Chinese women from the Six Dynasties through the Tang era suggest about the ways that women were regarded in different contexts.

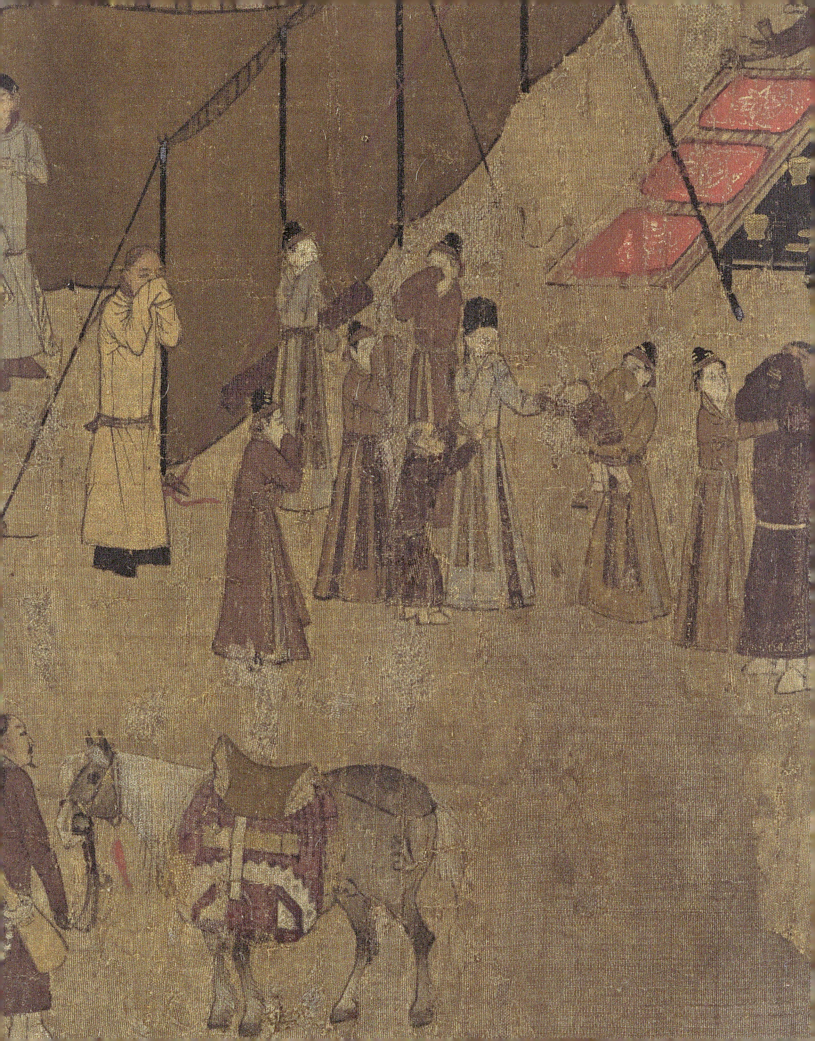

Art, Conquest, and Identity: The Five Dynasties Period and Song and Yuan Dynasties

The Han house is declining, barbarians from all four corners invade; They raise arms, and wars are incessant.

Liu Shang (fl. ca. 766–780)

The period after the fall of the Tang dynasty in 907 was one of great turmoil. For the first several decades, a number of rulers controlled small regions of China—a period known as the Five Dynasties and Ten Kingdoms. In 960, much of China was reunified under the Song dynasty, a period in which it was arguably the most advanced civilization in the world, with important technological developments, a flourishing economy (due in part to interregional and international trade and the development of industry), a burgeoning population, and expanding urban centers. Still, the conflicts with neighboring peoples helped to define this age. In the eleventh century, the government began paying tribute to the Khitans of the Liao state (907–1125) to the northeast and the Tanguts of the Western Xia state (1038–1227) to the northwest. By the early twelfth century, the Jurchens of the Jin state (1125–1234) had conquered all of northern China, and the Chinese court relocated from the fallen northern capital of Bianliang (present-day Kaifeng), establishing a new southern capital at Lin'an (present-day Hangzhou). For this reason, the Song

8–1 • "PARTING FROM NOMAD HUSBAND AND CHILDREN" FROM *LADY WENJI'S RETURN TO CHINA* (DETAIL)

Northern Song dynasty, ca. 1100–1127. Fragment of a handscroll mounted as an album leaf, ink, color, and gold on silk, 9¾ × 26½″ (24.8 × 67.2 cm). Museum of Fine Arts, Boston. Denman Waldo Ross Collection, 28.64.

dynasty is divided into two parts: the Northern Song (960–1127) and the Southern Song (1127–1279). The fact that an eighth-century poet wrote the above lines in a retelling of the story of Lady Wenji (b. ca. 178), and that the story was famously painted in the Song dynasty (see **FIG. 8-1** and Closer Look, p. 180), demonstrates that the concept of China surrounded on all sides by "barbarians" is a persistent theme in Chinese art and history, reflecting also a fascination with the often nomadic lifestyles of these invaders. But these invaders fequently were as fascinated with Chinese culture (see Chapter 7). The resulting mix of cultures and traditions would shape and mold Chinese identity.

In the thirteenth century, the Mongols became a new threat to China as they were to the rest of Asia and even eastern Europe, beginning with the rise of Chinggis Khan (r. 1206–1227) as overlord of the Mongol empire. The horsemen of his army subjugated much of northern Asia, including the Tanguts' Western Xia state. His son and successor, Ögedei (r. 1229–1241), conquered the Jurchens, seizing control of northern China. Khubilai Khan (r. 1260–1294), Chinggis's grandson, finally conquered the Southern Song dynasty, reuniting China under his reign. He moved the capital to Dadu (present-day Beijing) and named his dynasty Yuan, or "origin," adopting certain aspects of Chinese governance and culture. The Yuan dynasty was short-lived, falling in 1368.

The conflicts between the Chinese and the peoples beyond their borders made identity a concern for both artists and **patrons**. Chinese artists and patrons were compelled to consider themselves in relation to not only these other cultures but also their own history. The Mongol rulers in the Yuan similarly emphasized aspects of their own distinctive identity and de-emphasized others. This chapter focuses on arts associated with three sometimes overlapping social groups: court patrons,

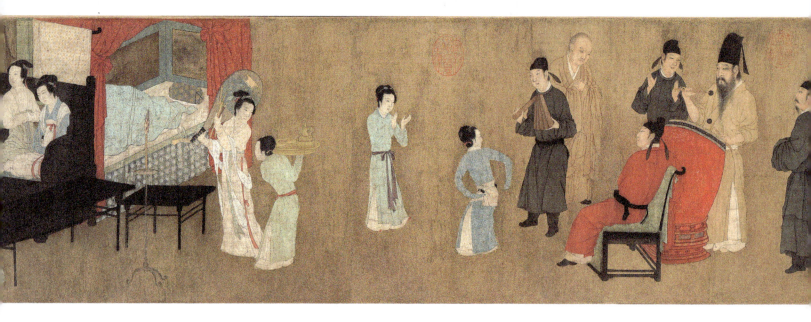

8-2 • Copy after Gu Hongzhong
***NIGHT REVELS OF HAN XIZAI* (DETAIL)**
Southern Song dynasty, ca. 1125–1200. (Original dates to Southern
Tang dynasty, ca. 960.) Handscroll, ink and color on silk, 11⅝ ×
131⅞″ (29 × 335 cm). Palace Museum, Beijing.

religious patrons, and the **literati**, each of which articulates a distinct set of concerns. As in earlier periods, artistic practice could indicate an individual's status or alignment with a particular group, but artists and patrons increasingly employed art as a form of expression.

SOUTHERN TANG COURT PAINTING

In the Five Dynasties period, the Southern Tang court, located in the city of Nanjing, sponsored court painters; the best known of these served under the last ruler, Li Yu (r. 958–975). A painting he commissioned from court painter Gu Hongzhong (fl. 961–975), *Night Revels of Han Xizai*, gained the most notoriety. Although the original version of this painting has not survived, a copy of it probably preserves much of the original composition (read from left to right, the first and second scenes and beginning of the third appear in **FIG. 8-2**). The copy, likely produced at the Southern Song court in the twelfth century, reflects the motivations of both the original artist and the unknown copyist.

The painting shows the interaction of men and women in a richly appointed interior setting. Its back story is the stuff of scandal: Li Yu discovered that his political advisor Han Xizai (d. 970) was inviting his fellow officials and students to his home every evening, where courtesans would provide musical and sexual entertainment for the guests. Although such interaction between scholars and courtesans was expected, it was normally confined to the entertainment district of the capital; here it improperly occurred in the administrative district where Han Xizai lived.

The curious ruler directed Gu Hongzhong to infiltrate the gatherings and record what he saw, and the painter subsequently submitted his rendition of the *Night Revels of Han Xizai*. The story was later told in multiple sources, including dynastic histories, **colophons** to paintings, and painting catalogues; unlike most other pictorial narratives, where the written text serves as a basis for an illustration, Gu Hongzhong's painting apparently preceded the textual accounts of Han Xizai's peculiar behavior.

The **handscroll** works as a **continuous narrative**; figural groupings and the repetition of the figure of Han Xizai, shown with the longest beard and wearing a tall, tasseled black hat, suggest five different scenes. It begins in an alcove, with the representation of rumpled blankets and a suggestion of figures beneath; most of the nearby figures direct their attention to a seated courtesan playing a lute. Throughout the scroll, scenes of the courtesans' musical performance (including dancing and flute-playing) alternate with scenes showing their flirtations with guests. The copyist updated the depicted furnishings, such as painted screens and wine vessels, to represent twelfth-century styles. The figures conform to recognizable types: Most of the men wear robes and hats that identify them as scholars (the exception is a Buddhist monk appearing in the dancing scene), and the women are courtesans and servants, differentiated by dress (the courtesans wear ornaments and multiple layers of garments). Still, the painter takes steps to individualize the figures.

Outraged reactions to the original painting raise the question of why the twelfth-century copy was made. In fact, it may have attempted to recoup Han Xizai's damaged reputation by suggesting that his behavior—which violated Confucian ideals—was intended to register political dissent. The copy contains references to reclusion: a fisherman painting in the first alcove (as fishermen were idealized as leading idyllic lives outside society), the men's uninhibited behavior (as if in retirement and following their inclinations), and even the appearance, in one scene, of Han Xizai in his underwear (see also Chapter 7, FIG.

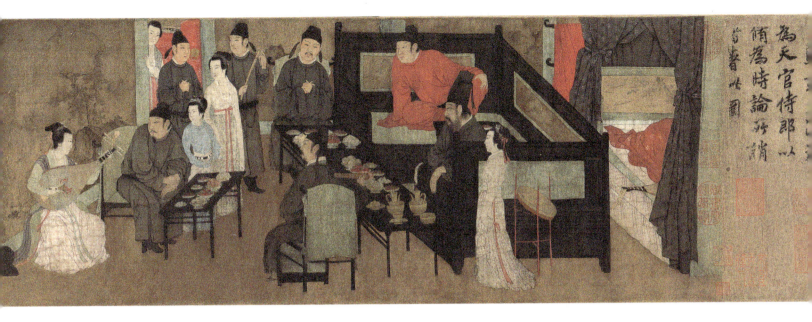

7–3). By portraying Han Xizai in the guise of the court hermit, someone with the mindset of a recluse who nevertheless continues in government service, this painting suggests him as a man of integrity through his unconventional behavior. The **media** of the painting—**mineral pigments** on silk—suggest court production, and the Southern Song court sometimes commissioned copies of earlier works. The chief councillor Shi Miyuan (fl. 1195–1220), whose **seal** appears on the painting, may have been the recipient of the copy.

SOUTHERN TANG AND NORTHERN SONG LANDSCAPE PAINTERS

Landscape emerged as a dominant **genre** in Chinese painting, and the painters of the Southern Tang and Northern Song dynasties that specialized in it would retrospectively be heralded as the originators of pictorial styles that later artists would continue to employ. Landscape painters of this era typically relied on both observation and exaggeration to create their compositions. As a representation of nature, landscape lent itself to Daoist or Confucian interpretations (providing commentary on the place of people in the world), and thus presented a compelling alternative to figure painting, which had been a dominant genre in earlier eras as it tended to encode the social superiority of the aristocracy. The rise of landscape and the decline of figure painting can thus be linked to the social changes taking place in this era, such as the rise of the meritocracy.

THE DONG-JU TRADITION

The **Dong-Ju tradition** was named for the painters Dong Yuan (d. 962) and Juran (fl. 960–985). Dong Yuan held an official position at the Southern Tang court; one work attributed to him is *Wintry Groves and Layered Banks* (**FIG. 8–3**). Painters of this period

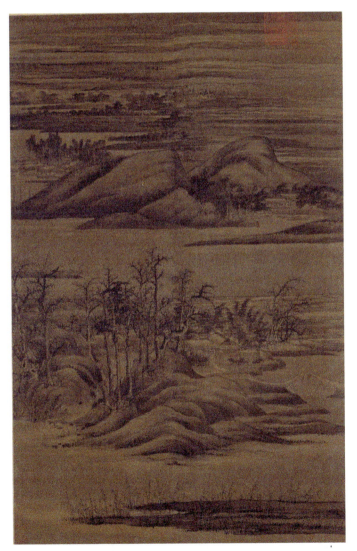

8–3 • Attributed to Dong Yuan
WINTRY GROVES AND LAYERED BANKS
Southern Tang dynasty, ca. 950. Hanging scroll, ink and color on silk, 59′6⅝″ × 3′9⅞″ (1.81 × 1.16 m). Kurokawa Institute of Ancient Cultures, Hyogo, Japan.

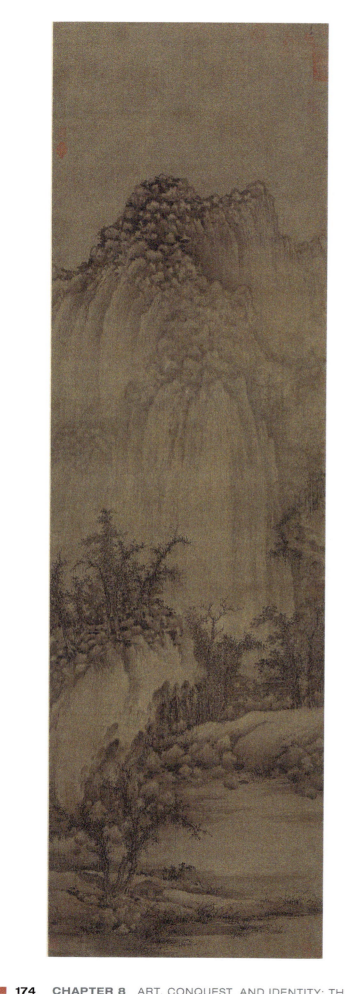

were often concerned with temporality, and Dong Yuan includes seasonal elements: Tree branches are bare, the monochromatic brushwork suggests overcast conditions, and the luminous quality of the forms in the foreground and middle ground suggests a dusting of snow. The painting represents low hills and broad rivers—possibly intended to evoke the landscape of Jiangnan, the region of China south of the Yangzi River that formed the domain of the Southern Tang state—punctuated with modest buildings. The recession into depth is exaggerated: The believable angle of recession seen at the bottom of the composition becomes a tipped-up picture plane at the top, creating the impression that distant plains blend seamlessly into lowering clouds. Certain elements associated with the Dong-Ju tradition appear throughout the composition: These include long, ropy brushstrokes layered one atop another, known as **hemp-fiber strokes** and apparent at the bases of the hills; and the liberal use of dotting to indicate vegetation, on the hills and tree trunks.

Juran was a Buddhist monk. His works, unlike Dong Yuan's, tend to depict precipitous mountain formations associated with the topography of northern China; for this reason, paintings attributed to him, such as *Buddhist Retreat by Stream and Mountain* (**FIG. 8–4**), were likely made following the surrender of the Southern Tang kingdom to the Song in 975. In this painting, two pairs of buildings are seen, nestled in the shade of tall trees and near the banks of a stream, and at the base of the tall mountain that dominates the composition, secreted in a grove of trees. Their relative isolation suggests a Buddhist's intention of retreating from society in order to focus on religious practice. The primary elements of the Dong-Ju tradition found in this painting are the rock formations known as **alum lumps** (named after lumps of potassium aluminum sulphate, which they resembled), most prominent on the mountain peaks. Other elements of this painting—the crab-claw branches of the trees and the serpentine mountain ridge—suggest the work of a different painter altogether, Li Cheng (919–967), whose work Juran may have seen after his move north.

THE LI-GUO TRADITION

The **Li-Guo tradition**, also originating in this era, pairs Li Cheng, a hermit born to an aristocratic family, and the court painter Guo Xi (ca. 1001–1090). Li Cheng's work was widely admired, although no existing painting can be securely attributed to him. One of the better examples of his style is the painting *A Solitary Temple amid Clearing Peaks* (**FIG. 8–5**). The focus is a Buddhist temple located at the top of a hill, before a steep mountain rendered with vertical texture strokes; in the foreground, a traveling scholar and attendant approach a village. The

8–4 • Attributed to Juran BUDDHIST RETREAT BY STREAM AND MOUNTAIN
Northern Song dynasty, ca. 980. Hanging scroll, ink on silk, 72¹⁵/₁₆ × 22⅝" (185.4 × 57.5 cm). Cleveland Museum of Art. Gift of Katharine Holden Thayer 1959.348.

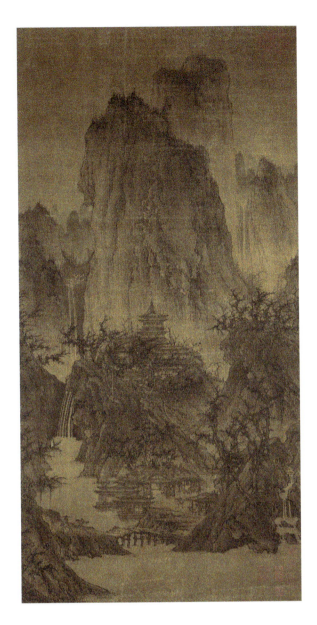

8-5 • Attributed to Li Cheng *A SOLITARY TEMPLE AMID CLEARING PEAKS*

Five Dynasties/Northern Song dynasty, ca. 960. Hanging scroll, ink and color on silk, 44 × 22″ (111.8 × 56 cm). Nelson-Atkins Museum of Art, Kansas City. Purchase: William Rockhill Nelson Trust, 47-71

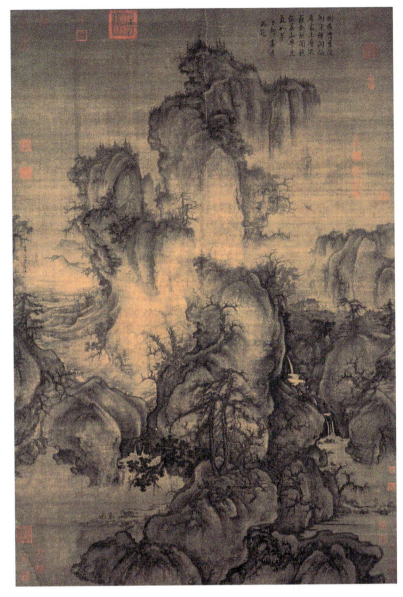

8-6 • Guo Xi *EARLY SPRING*

Northern Song dynasty, 1072. Hanging scroll, ink and color on silk, 5′2¼″ × 3′6½″ (1.58 × 1.08 m). National Palace Museum, Taipei.

artist uses the **ruled-line style** (with the aid of a straight-edge) for the architecture, and while the bracketing system beneath the roof is fully described, the tiles on the roof are not: another element that points to Li Cheng's style, as he received criticism from the scholar-official Shen Gua (1031–1095) for representing only elements visible from his subjective vantage point. The natural elements betray a sense of movement, what a connoisseur might refer to as "spirit resonance": The mountain ridge wends in a reverse S-shape, and the tree branches contort. The man riding on the donkey, wearing a broad-brimmed hat, is recognizable as a scholar through his attire, mode of travel, and his attendant, who carries his wrapped musical instrument. He is probably intended as a surrogate for the viewer, a figure through which one can

imagine entering the landscape. The temple may represent one near Kaifeng built in the late tenth century; if so, this painting may have both political and religious significance.

Guo Xi was a favorite painter at the court of Emperor Shenzong (r. 1067–1085) of the Northern Song; *Early Spring* (**FIG. 8-6**) demonstrates why. The painting is titled, dated, and signed by the artist at the left margin, and the imperial seal is impressed over it, suggesting that Shenzong commissioned the work. It is another example of monumental landscape, with a tall mountain in the background, lower hills in the foreground, and tiny figures appearing throughout the composition: two fishermen at the bottom right; two more fishermen and a child at the bottom left; multiple travelers clambering up a steep path at the center left; and a donkey rider and two attendants crossing a rickety bridge at the center, possibly approaching the temple

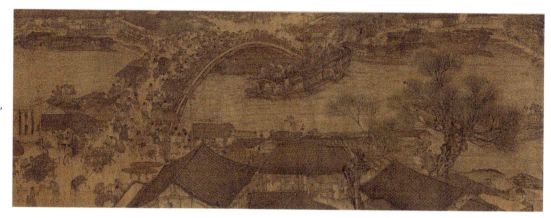

8-7 • Zhang Zeduan
PEACE REIGNS ALONG THE RIVER (QINGMING SHANGHE TU) (DETAIL)
Northern Song dynasty, late 11th to early 12th century. Handscroll, ink and color on silk, 9⅞ × 208¼" (25 × 529 cm). Palace Museum, Beijing.

complex situated halfway up the mountain. The artist reveals a concern with temporality, evident in the representation of the eroded landscape and his precise rendering of the season, especially the bare trees with their crab-claw branches. What the painter wrote about the significance of landscape encourages the reading of the painting as a Confucian hierarchy. Guo Xi and his son wrote a landscape text, *The Lofty Message of Forests and Streams*, and in one passage they assert that a dominating mountain should represent the emperor, and the foothills his advisors. In *Early Spring*, Guo Xi makes a case for the absolute political authority of the emperor, presiding over humble citizens (the fishermen, travelers, and scholar) and religious institutions.

NORTHERN SONG COURTLY ARTS

As already demonstrated by Guo Xi's painting, the arts produced at the Northern Song court often have political significance, in keeping with the agendas of the patrons—typically the emperor, members of the imperial family, or court officials. At the very least, courtly arts tend to reveal the superior skills of artists and the high status of patrons. This is evident in two very different forms of artistic production for the court: painting and ceramics.

PAINTING

One painting that presents a detailed vision of an idealized Chinese city is *Peace Reigns along the River*, attributed to the court painter Zhang Zeduan (fl. ca. 1100), probably dating to the late eleventh or early twelfth century. Because there are several theories on how the painting should be interpreted, art historians disagree about how best to render its title in English; *Peace Reigns along the River* is one of the more neutral translations. The scroll begins with travelers on the outskirts of a city, which may be the capital, and the activities and traffic along a busy river. Humble farmhouses give way to modest restaurants, pavilions under construction, crowded storefronts, and the city gate (rendered in the ruled-line style). One highlight is a "rainbow bridge," so named for its shape, crowded with vendors and sightseers; a sailboat with a stepped mast passes beneath it, guided by men on a towpath (**FIG. 8-7**). The painting

concludes with a view of people from all walks of life—although remarkably few women—moving through the city streets. The places they frequent include wine shops, a silk merchant, a barbershop, a barrel-maker's workshop, and a doctor's clinic. The artist suggests the robust economy of the Northern Song dynasty, reflecting well on the emperor's governance.

In the early twelfth century, Emperor Huizong (1082–1135, r. 1101–1126) emerged as a major patron of the arts. A Bureau of Painting (often colloquially known as the Academy of Painting) had first been established in the Northern Song in 984; Huizong founded a new Institute of Painting that was intended to educate artists, ultimately integrating it with the Bureau of Painting. The emperor closely supervised his court painters, not only challenging them to illustrate lines of poetry but also rewarding those who were keen observers of nature. By the end of his reign, the paintings in the imperial collection numbered over 6,000 and were described in an ambitious catalogue. Huizong himself painted, and many of the paintings attributed to him have

8-8 • Attributed to Emperor Huizong *FIVE-COLORED PARAKEET ON BLOSSOMING APRICOT TREE*
Northern Song dynasty, ca. 1110. Handscroll, ink and color on silk, 21 × 49¼" (53.3 × 125.1 cm). Museum of Fine Arts, Boston. Maria Antoinette Evans Fund, 33.364.

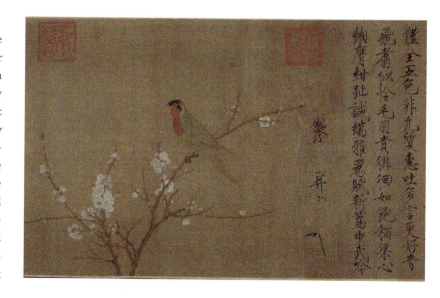

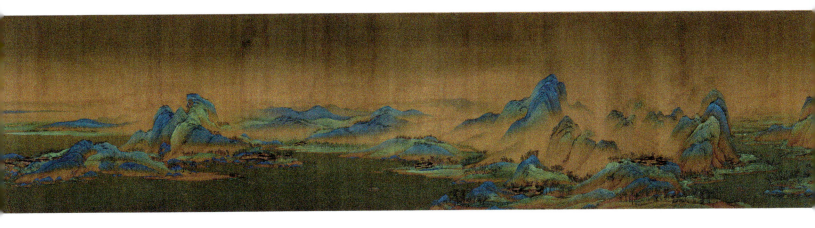

8-9 • Wang Ximeng *A THOUSAND MILES OF RIVERS AND MOUNTAINS* **(DETAIL)**
Northern Song dynasty, 1113. Handscroll, ink and color on silk, 17¾ × 390½″ (45 × 992 cm). Palace Museum, Beijing.

political import. *Five-Colored Parakeet on a Blossoming Apricot Tree* (**FIG. 8-8**) pairs a painting in the bird-and-flower genre with an inscription important in both content and form: a poem and preface celebrating the parakeet and fine **calligraphy** executed in an angular style known as "slender gold." The scroll commemorates the gift of the parakeet, and although it bears Huizong's cipher and seal, the painting may have actually been executed by unnamed court artists. Because five-colored birds had been considered auspicious omens since Han times, the scroll is a visual document confirming that Huizong retained the **mandate of heaven**, crucial given that natural disasters troubled his reign. His inscription calls attention to the parakeet's cultured speech, dignity, and yellow and purple colors—all attributes of the nobility. The bird is shown in profile and appears unmoving, creating a sense of formality befitting art that functions as a political instrument. Huizong ended up kidnapped by the Jurchens, and later generations judged his preoccupation with art as a factor in the fall of the Northern Song dynasty.

Wang Ximeng's (1096–1119) *A Thousand Miles of Rivers and Mountains*, dating to 1113, is another painting that supports Huizong's reign (**FIG. 8-9**). It is a long handscroll painting representing an idealized landscape, rendered in the **blue-green style** of the Tang dynasty (see Chapter 7, **FIG. 7-18**). Wang Ximeng layers the mineral pigments thickly on the mountain peaks and, unusually, dilutes them to color the water. The scale and media of this work immediately identify it as a court production. The surreal beauty of the intensely blue-green mountains suggests a Daoist land of the immortals—appropriate given Huizong's devotion to this religion—and the panorama suggests the extent of the emperor's domain. Figures move through the landscape and among many luxurious buildings, apparently taking in spring scenery. One section includes a water mill, an important technological advance. All in all, this painting supports the notion that Huizong was a capable ruler who commanded a large territory and whose subjects prospered under him.

CERAMICS

The ceramic wares produced for the Northern Song court also benefit from the finest craftsmanship and attracted the appreciation of those with the highest status. Numerous kilns produced distinctive wares in the Northern Song, including many made in **porcelain**, a white clay body more refined than **earthenware** or **stoneware**, owing to the addition of kaolin (a fine white clay; Ch. *gaoling*) and petuntse (kaolinized granite; Ch. *baidunzi*). Porcelain is fired to the highest temperature, between 2,300 and 2,550 degrees Fahrenheit (1,250 and 1,400 degrees Celsius); it is extraordinarily plastic, or easily shaped, and finished objects made from it are hard, nonporous, durable, resonant when struck, and, if sufficiently thin, translucent.

A porcelain bowl with a carved decoration of lotus flowers and leaves (**FIG. 8-10**) is a prototypical example of Ding ware, produced at kilns in Dingzhou, Hebei province. Ding ware is known for its thin forms, refined shapes, and carved or molded decoration. These elements showed up well on a porcelain body covered with a thin transparent **glaze**; white Ding ware is the most common, but there are rare examples of black-glazed and

8-10 • BOWL WITH CARVED DECORATION OF LOTUS FLOWERS AND LEAVES
Song dynasty, ca. 1000–1125. Ding ware; porcelain with clear glaze and copper, diameter 8¾″ (22.2 cm). Courtesy of Asia Society, New York. Mr. and Mrs. John D. Rockefeller 3rd Collection of Asian Art 1979.139.

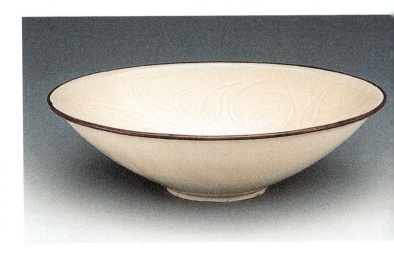

iron-pigment painted Ding wares. An artisan applied copper over the rough, unglazed rim, which increased the impression of refinement; they sometimes used gold or silver instead. The subtle pictorial decoration appears only on the inside of the bowl and is thus visible only to the person using it. Potters typically placed bowls like this on stacked saggars in the kiln and fired them on their rims rather than on their foot rings. Here, the diameter of the foot ring is small in comparison with the rim, creating a sense of delicacy. The Northern Song court commissioned Ding ware, and scholar-officials favored it as well.

Another category of ceramic ware was **celadon**, a term used to describe a wide variety of stoneware or porcelain wares with glazes that have some green in them—ranging from the olive green of Yaozhou ware to the palest blue-green of Guan and Longquan wares. Celadon wares were produced in Korea as well (see Chapter 11, FIGS. 11-14 and 11-15). The rarest of Chinese celadons was Ru ware, produced expressly for imperial use at kilns in Baofeng county and Ruzhou, Henan province, between 1086 and 1125. Agate, rendered to the court as taxes, also came from Ruzhou; it is possible that monochromatic Ru ware was intended to resemble agate or perhaps jade, as the glaze is usually a pale bluish-gray or bluish-green with a subtle crackle pattern. A cup stand (**FIG. 8-11**) from the Qingliangsi kiln in Baofeng county with a lobed shape reminiscent of floral motifs exemplifies the elegance of this ware.

Very different from either Ding ware or celadon wares were the humble tea ceramics produced at kilns in Jian'an, Fujian province, known as Jian ware or tenmoku ware (the Japanese appellation), and made from stoneware or porcelain. They recall the dark wares with tea-dust glaze (see Chapter 7, FIG. 7-32) that began to be produced in the late Tang dynasty. The Jian'an potters could control the kiln atmosphere to create a variety of effects: In a **reducing atmosphere** (with reduced oxygen, created by introducing smoke into the kiln), the iron oxide glaze used for Jian ware typically fires blue-black and sometimes develops iridescent spots, as in the famous oil-spot glaze. In an **oxidizing atmosphere** (with an excess of oxygen), the glaze fires black and breaks, where thinnest, to reddish-brown, and can produce the streaked hare's fur effect (**FIG. 8-12**). The dark glazes of Jian ware contrast beautifully with the light-colored froth of whipped powdered tea. Though Huizong himself wrote about his appreciation of examples of Jian ware with hare's fur glaze, Jian ware was also valued by the literati and Chan Buddhist monks and eventually became much prized in Japan, where many of the surviving examples can be found.

SONG LITERATI PAINTING AND CALLIGRAPHY

In the Song dynasty, for the first time, a major means of advancement in status was through a classical education and strong performance in the civil service examinations. As scholar-officials rose in status, they began to collect art and to write about it. Su Shi (1037–1101) and his colleagues, including Li Gonglin (ca. 1041–1106), Mi Fu (1051–1107), and Huang Tingjian (1045–1105), were especially prolific in this regard. In addition to making paintings and calligraphic works, they wrote inscriptions or **colophons**

8-11 • CUP STAND
Northern Song dynasty, ca. 1086–1125. Ru ware, stoneware with light blue crackled glaze, height 3″ (7.6 cm). Qingliangsi kiln, Baofeng county, Henan province; British Museum, London.

8-12 • TEA BOWL WITH HARE'S-FUR GLAZE
Song dynasty, 1100–1200. Jian ware, stoneware with iron oxide glaze, height 2½ × 4⅝″ (6.4 × 11.7 cm). Metropolitan Museum of Art, New York. H. O. Havemeyer Collection, Bequest of Mrs. H. O. Havemeyer, 1929, 29.100.227.

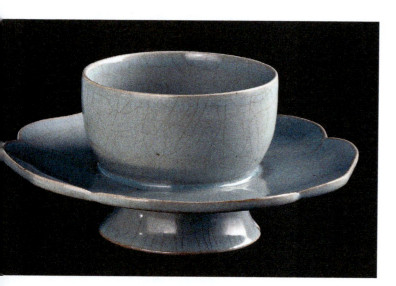

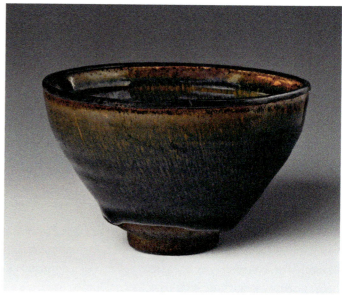

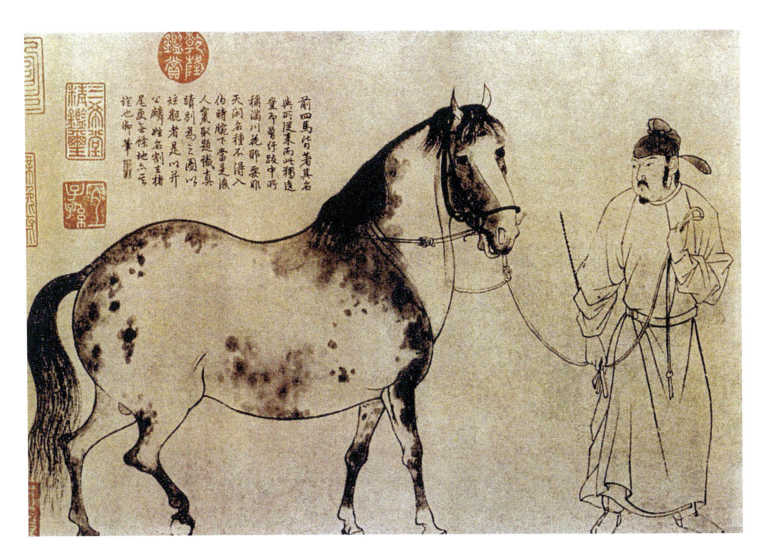

8–13 • Li Gonglin *FIVE TRIBUTE HORSES* (DETAIL)
Northern Song dynasty, ca. 1090. Handscroll, ink on paper.
Formerly Kikuchi Collection, Tokyo; reported destroyed in WWII.

for works of art, they wrote poetry about painting, and they published catalogues of their painting, calligraphy, and antiquity collections. Those who held positions in the bureaucracy—predicated on their performance in the examinations—developed connections to the court. Emperor Huizong's interest in the relationship between poetry and painting may reflect his awareness of their ideas. Several of the literati declared that poems were painting without shape and paintings poetry without words. Unlike court or professional painters, the literati often made recognizably personal art. They frequently painted for themselves or their associates, and some examples of their calligraphy are their personal letters or jottings. They commonly used inexpensive materials: ink instead of mineral pigments, or paper instead of silk. Because their education did not include the same artistic training as court or professional painters, they approached art differently, often valuing qualities of sketchiness and awkwardness that divide them from painters who worked on commission. Threading through their writing is the concept that, for them, art is the outward expression of their own ideas or understanding.

LI GONGLIN

Li Gonglin, who did well in the national civil service examinations and whose interests were wide-ranging, had such deep knowledge of painting history that he worked in multiple pictorial styles. The paintings attributed to him range across a number of genres, as well. *Five Tribute Horses* represents the genre of horse painting and reveals Li's familiarity with Han Gan's paintings (see Chapter 7, FIG. 7-20). Rendered in ink on paper, it shows five horses given as tribute to the young emperor Zhezong (r. 1085–1100) between 1086 and 1088, accompanied by their grooms; inscriptions by his friend Huang Tingjian give more information about each. The sympathy between man and animal is evident, and although the fifth groom appears to be of Han Chinese ethnicity (FIG. 8-13), the first four are not, judging from their dress. As the horse remained a potent symbol of the military power of China, the painting encapsulates the Northern Song consciousness of China's relationship with the peoples beyond its borders. While Li dapples the coat of the horse and thus makes some minimal suggestion of its mass, he renders the figure of the groom in the **plain-outline style**, which originated with him; the painting seems sketchy and the viewer is conscious that this is the artist's interpretation of his subject—a mode of painting in opposition to the more **naturalistic** work of skilled court painters.

Representations of nomads became an important subgenre of figure painting in the Song period. *Lady Wenji's Return to China*, a handscroll that survives only in fragments, relates a narrative about a young Chinese woman, Cai Yan, whose **courtesy name** —adopted in adulthood and used in place of her given name— was Wenji, or "Literary Concubine." She was an official's daughter kidnapped by the Xiongnu in 196. They took Wenji to the Central Asian steppes and compelled her to marry one of their leaders and bear his children; she was ransomed in 208. The painting is based on 18 poems written by Liu Shang (fl. ca. 766–780), and probably had 18 scenes. The painter updates the story by depicting the nomads as the Khitans of the powerful Liao state to the northeast, probably in an effort to promote peaceful relations

between the Liao and the Northern Song. "Parting from Nomad Husband and Children" represents Wenji's mixed feelings, wishing to return to China but heartbroken at leaving her sons behind. The final section, "Wenji Arriving Home," shows her Chinese courtyard house.

"PARTING FROM NOMAD HUSBAND AND CHILDREN" AND "WENJI ARRIVING HOME" FROM *LADY WENJI'S RETURN TO CHINA* (DETAILS)

Northern Song dynasty, ca. 1100–1127. Fragment of a handscroll mounted as album leaves, ink, color, and gold on silk, 9¾ × 26⁷⁄₁₆″ (24.8 × 67.2 cm) and 9¹³⁄₁₆ × 21¹⁵⁄₁₆″ (25 × 55.8 cm). Museum of Fine Arts, Boston. Denman Waldo Ross Collection, 28.64 & 28.65.

The vehicle that will convey Wenji on her journey and the Chinese banners wait at the left of the parting scene. In the final scene, Wenji's carriage stands next to the gate of her home.

Wenji, her husband, and the surrounding figures all cover their faces with their sleeves, concealing their tears. The older boy clings to her skirt and the younger reaches for her from another woman's arms (also see FIG. 8–1).

In this group of people, some must be Chinese captives and others must be nomads, but all are dressed in the Khitan style and equally affected by Wenji's tragedy. The unknown painter emphasizes their commonalities rather than their differences.

The order of the household contrasts with the intermingling of figures on the street, emphasizing that Wenji has finally reached not only a place where all the social customs are familiar, but also the stability of her own family home.

Wenji's house is unmistakably Chinese, with **post-and-beam** construction, halls opening onto courtyards, and a screen wall just beyond the gate for privacy.

Wenji, standing in an interior hall, wears a bright red headdress that distinguishes her from her peers. All the women around her suggest that this is an elite household that practiced female segregation.

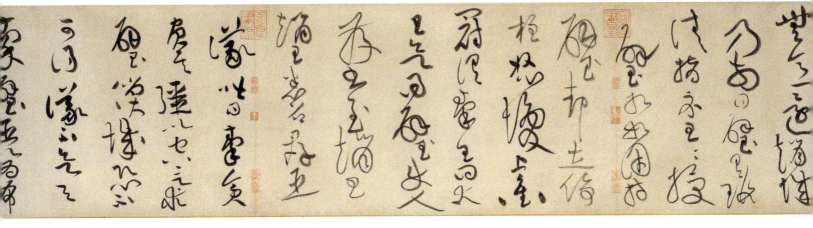

8-14 • Huang Tingjian BIOGRAPHIES OF LIAN PO AND LIN XIANGRU (DETAIL)
Northern Song dynasty, ca. 1095. Handscroll, ink on paper, 13¼ × 724½" (33.7 cm × 18.4 m). Metropolitan Museum of Art, New York. Bequest of John M. Crawford Jr., 1988, 1989.363.4.

HUANG TINGJIAN

Huang Tingjian was a scholar admired for his distinctive calligraphy, which continued to be regarded as the most important of all arts. His *Biographies of Lian Po and Lin Xiangru* (**FIG. 8-14**) copies out excerpts from Sima Qian's (145–ca. 85 BCE) *Records of the Grand Historian*. Huang served in the Palace Library in the Yuanyou reign era (1086–1093), charged with compiling a history of Shenzong's reign; following the death of the dowager empress Xuanren in 1093, however, he and most of the members of Su Shi's circle fell into disfavor and were exiled. These texts may thus have personal meaning for him: The biographies relate a political rivalry, and their author, Sima Qian, was castrated after displeasing his emperor by defending a general who had lost a battle. Huang's choice of the wild cursive style suggests spontaneity, speed, and an accompanying lack of inhibition. The writing reveals the writer's rhythm; some characters flow together, and one can see where

Huang has added ink to his brush and where he has pushed to finish a phrase before the ink completely dries. Some characters are noticeably large, as if felt more emphatically; others are compressed. Throughout the text there is a real sense of the movement of Huang's hand.

MI YOUREN

Mi Youren (1074–1151) was the son of the painter, calligrapher, and collector Mi Fu, and he moved south after the fall of the Northern Song. He often painted landscapes, rendering conical mountains in fat daubs or dots of wet ink, and suggesting mist through a combination of negative space and fluid ink washes; because his technique was similar to his father's, these elements were components of what became known as the **Mi family style**. *Cloudy Mountains*, from 1130 (**FIG. 8-15**), proves that the literati did not paint only in ink on paper. The mountains here are luxuriantly green, and lead-white is used for the mist; trees grow by a riverbank, and we see a fisherman and a bridge—all imagery that can suggest transitions and withdrawal from society. Significantly, this painting bears Mi Youren's own inscription at the top left. He alludes to two important literati motivations for painting: First, he describes his painting as a form of ink-play—a complicated concept, in part indicating that painting was not work as it was for professional artists—and second, he reveals that the painting was a gift to his host. The inscription clarifies the personal nature of the painting.

8-15 • Mi Youren CLOUDY MOUNTAINS
Southern Song dynasty, 1130. Handscroll, ink, lead-white, and color on silk, 17³⁄₁₆ × 75¹⁵⁄₁₆" (43.4 × 194.3 cm). Cleveland Museum of Art. Purchase from the J. H. Wade Fund 1933.220.

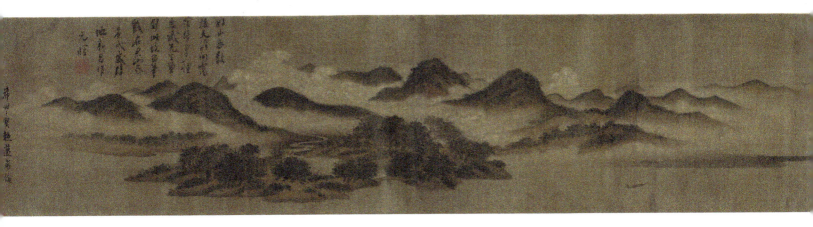

SOUTHERN SONG COURT PAINTING, CALLIGRAPHY, AND PATRONAGE

After the Chinese court moved to Lin'an in 1138, following the kidnapping of Emperor Huizong and the collapse of the Northern Song, court painters continued to work closely with imperial patrons. Although the works they produced often reflected political concerns, the patrons commissioned paintings for other reasons as well. In this period, it became more common for members of the court to inscribe text on paintings, just as Huizong had done. The continuation of forms of courtly artistic practice that had existed in earlier periods asserted the legitimacy of the Southern Song. In fact, the southern regions of China would remain an important cultural center throughout the ensuing centuries.

One purpose of court patronage in this period was to support imperial authority, as seen in a handscroll depicting the *Odes of the State of Bin*, attributed to court painter Ma Hezhi (fl. ca. 1130–1180). The Odes were a section of a Zhou dynasty anthology of poetry, the *Book of Songs*, counted as one of the Confucian classics. The handscroll includes excerpts from the illustrated poetry, written in the style of Emperor Gaozong (r. 1127–1162) and suggesting a connection with his court. One section of the handscroll depicts the ode known as "The Seventh Month" (**FIG. 8-16**), which concerns the workings of the feudal society that existed in the Zhou era, with peasants laboring in support of their aristocratic lords. A grove of mulberry trees appears at the right, with women harvesting the leaves; This is a reference to the feminine work of sericulture, or the

various processes involved in the production of silk textiles. Its masculine counterpart, agriculture, also appears here, with men plowing the furrowed fields at the center of the composition. The scene culminates with a feast, shown at the left, which takes place in the home of the feudal lord. The painting affirms Gaozong's political authority in two ways: in illustrating a well-known poem from a Confucian classic, thereby making a case for the legitimacy of the Southern Song dynasty, and in a comparison of the emperor to the lord of the poem, to whom the people pay fealty.

THE MA-XIA SCHOOL

Court painter Ma Yuan (fl. ca. 1190–1230) originated the **Ma-Xia School** of landscape painting, along with his contemporary Xia Gui (fl. ca. 1180–1224). Ma Yuan left an impressive body of work; he also painted figures, flowers, and architecture, and many of his paintings have inscriptions or seals that attest to his interaction with Emperor Ningzong (r. 1194–1224), Empress Yang Meizi (1162–1233), and other wealthy patrons. *Viewing Plum Blossoms by Moonlight* (**FIG. 8-17**) is a round fan, now mounted as an album leaf, which depicts a scholar and his servant in a mountainous landscape. The seated scholar holds a staff and gazes in the direction of the full moon. The servant waits respectfully a few steps behind him, holding the scholar's wrapped zither. The painting displays several hallmarks of Ma Yuan's style. First, it is a **one-corner composition**, heavily weighted toward the bottom left. Second, it shows some facility with ink wash, particularly noticeable in the silhouette of the distant mountain. Third, the painter suggests mist through a combination of diluted ink wash and negative space. Fourth, Ma Yuan uses a distinctive brushstroke to render the eroded landscape: the **ax-cut stroke**, triangular in shape, and so named for suggesting the texture of wood chopped by an ax. Fifth, the painter emphasizes the gnarled, angular branches of the blossoming plum trees that dominate the foreground. The one-corner composition creates an area of negative

8-16 • Attributed to Ma Hezhi "THE SEVENTH MONTH," FROM THE *ODES OF THE STATE OF BIN* (DETAIL)
Southern Song dynasty (1127–1279). Handscroll, ink, color, gold, and silver on silk, 10¹⁵⁄₁₆ × 261¼″ (27.8 × 663.6 cm). Metropolitan Museum of Art, New York. Ex coll.: C. C. Wang Family, Purchase, Gift of J. Pierpont Morgan, by exchange, 1973, 1973.121.3.

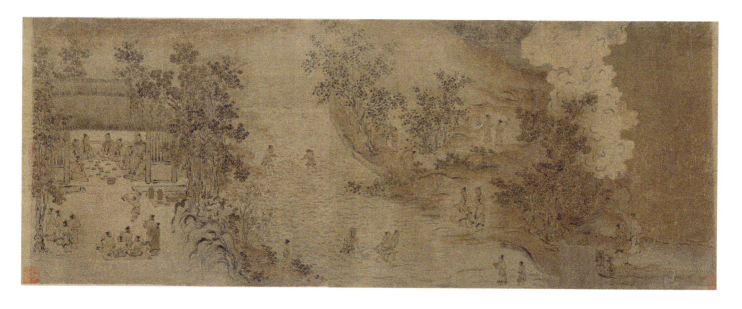

8-17 • Ma Yuan ***VIEWING PLUM BLOSSOMS BY MOONLIGHT***
Southern Song dynasty. Fan mounted as an album leaf, ink and color on silk, 9⅞ × 10½" (25.1 × 26.7 cm). Metropolitan Museum of Art, New York. Gift of John M. Crawford Jr., in honor of Alfreda Murck, 1986, 1986.493.2.

space that is ideal for an inscription, although this fan does not include one.

Xia Gui, by comparison, has relatively few extant works. Although he was expert at painting both figures and landscapes, only the landscapes survive, suggesting how much collectors privileged this genre. *Twelve Views of Landscape* once included 12 scenes, annotated with titles; unfortunately, only the last four survive on Xia Gui's original scroll. (**FIG. 8-18** shows half of the second scene.) An empress's single-dragon seal appears below each of the titles, suggesting that the calligrapher could be Empress Yang Meizi, who also collaborated with Ma Yuan and his son Ma Lin (fl. ca. 1215–1256). The empress, orphaned when young, was the daughter of a court entertainer and rose in status with the support of Ningzong's mother. Earlier commissions helped her to fortify her position by appealing to her intimate relationship with the emperor and claiming a (possibly spurious) connection to a respectable family, and she may have given this painting to her successor, Empress Xie Daoqing (1208–1282), as a means of cementing their relationship and asserting her status as dowager empress. The evocative titles, which read "Distant Mountains, Writing Geese," "Misty Village, Returning Ferry," "Fisherman's Flute, Pure Solitude," and "Misty Bank, Evening Mooring," capture each scene's essence. They allude to poetry on the *Eight Views of the Xiao and Xiang Rivers*, a theme concerning withdrawal from society that originated with the Northern Song literati. The painting includes motifs familiar from the associated pictorial tradition. Xia Gui's deft handling of ink wash creates the illusion of a landscape suffused with mist, and he uses ax-cut strokes in his representation of eroded bluffs.

SOUTHERN SONG AND YUAN RELIGIOUS ART AND ARCHITECTURE

Religious practice provided a refuge from the political and social turbulence of the Southern Song and Yuan periods. This era saw the continuation of familiar forms of religious patronage, with

8-18 • Xia Gui with calligraphy by Empress Yang Meizi
TWELVE VIEWS OF LANDSCAPE **(DETAIL)**
Southern Song dynasty, ca. 1210. Handscroll, ink on silk, 11 × 90½" (28 × 230 cm). Nelson-Atkins Museum of Art, Kansas City. Purchase: William Rockhill Nelson Trust, 32-159/2.

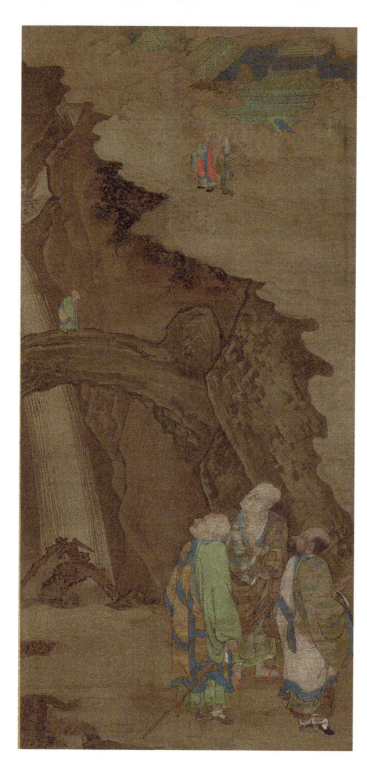

8-19 • Zhou Jichang THE ROCK BRIDGE AT MT. TIANTAI
From the series *Five Hundred Luohans*, Southern Song dynasty, 1178. Hanging scroll mounted on panel, ink and color on silk, 43¼ × 20¾″ (109.9 × 52.7 cm). Freer Gallery of Art, Smithsonian Institution, Washington, D.C. Gift of Charles Lang Freer F1907.139.

rulers sponsoring construction or reconstruction of Buddhist and Daoist temples that would then be richly decorated. Still, the importance of the individual worshipper becomes evident in both patronage and artistic practice.

Over the years between 1178 and 1188, the Huianyuan temple, a Tiantai Buddhist monastery in Ningbo, Zhejiang province, received the donation of 100 hanging scrolls now known by the collective title *Five Hundred Luohans*. A priest, Yishao, who inscribed 48 paintings in the set, probably took charge of the project, seeking participation from individual donors, and the artists Zhou Jichang and Lin Tinggui both worked to create the paintings. Each painting depicts five *luohans* (Skt. **arhats**), recognizable by their shaven heads. The worship of *luohans* was popular in China: These figures, thought to be enlightened disciples of the historic Buddha, remain in the world in anticipation of the appearance of the Buddha of the Future, and thus have life spans that approach immortality. The subject was especially relevant to the temple, built to commemorate the site's "visitation" by 16 *luohans* in 904, and the images, intended for display, have obvious visual appeal. *The Rock Bridge at Mt. Tiantai* (**FIG. 8-19**) is attributed to Zhou Jichang; according to Yishao's inscription, a married woman surnamed Sun donated the scroll in the hope that her action might protect her family. The painting depicts a natural rock bridge, located in the Tiantai Mountains near Ningbo, which was believed to lead to a heavenly realm where the 500 *luohans* resided, the entrance to which was blocked by an enormous boulder at the end of the bridge. According to legend, the *luohans* briefly granted a monk named Tanyou (d. 396) access to their realm because of his piety; he is seen crossing the bridge. Three *luohans* stand on clouds in the foreground, watching his progress, and two more stand among clouds in the background, near their blue-green palaces. Zhou Jichang depicts the figures sensitively, attending to facial expression, gesture, and costume, and Tanyou closely resembles the *luohans*, who often appear in the guise of monks.

CHAN BUDDHISM

Another Southern Song painting, by the monk Fachang Muqi (ca. 1200–after 1279), shows how a new form of Buddhism, Chan, incorporated paintings into religious devotion. Chan is a school of Mahayana practice that approaches the original teachings of the historic Buddha yet also incorporates Daoist concepts. The word represents the Chinese pronunciation of the Sanskrit *dhyana*, which means "meditation"—the primary practice in Chan, thought to lead to spontaneous enlightenment. A painting could be a focal point for meditation, and sometimes the act of making a painting was understood as meditative. Fachang Muqi lived in a Chan monastery near Hangzhou, and *Evening Bell from Mist-Shrouded Temple* (**FIG. 8-20**) is from his series on the theme of the *Eight Views of the Xiao and Xiang Rivers*, which appealed to Buddhists as a representation of the journey toward enlightenment. In this painting, Fachang Muqi uses gradations of ink wash over almost the entire surface to indicate mist; a band of light cuts across the center of the painting. In one area, the dark but still indistinct forms of trees and roof lines emerge: This must be the location of the mostly hidden temple of the title. Because

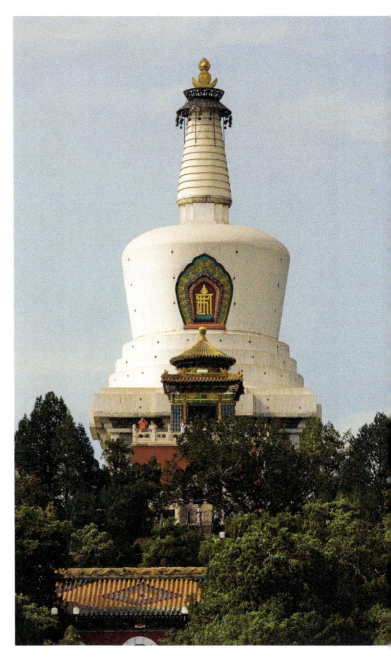

8-20 • Fachang Muqi *EVENING BELL FROM MIST-SHROUDED TEMPLE*
From *Eight Views of the Xiao and Xiang Rivers*, Southern Song dynasty. Handscroll, ink on paper, 13 × 41″ (33 × 104 cm). Hatakeyama Memorial Museum of Fine Art, Tokyo.

mist obscures light, in a Buddhist context it refers to obstacles to enlightenment. The evening bell of the title is meant to evoke sound; here, we should imagine its clear tone piercing the mist and signaling the temple's role in enlightenment.

ESOTERIC BUDDHISM

Tibetan forms of Esoteric Buddhism became more prominent in China with the ascent of the first Mongol emperor, Khubilai Khan (Emperor Shizu), and his empress Chabi (1227–1281). They were followers of the Tibetan Sa skya sect, as was their leading court art-ist, Anige (1245–1306), born in Nepal. The emperor and empress commissioned Anige to oversee the construction of the monu-mental White Stupa (**FIG. 8-21**) in the capital, Dadu. This reliquary, named for the layer of white stucco on its exterior, was intended to house **relics** of the Buddha that had previously been housed in a ruined Liao dynasty **pagoda** on the same site. Fittingly, given the diverse backgrounds of the architect and patrons, it is an example of hybrid architecture: Its plan and two-tiered podium resemble Nepalese *chortens* (**stupas**); its flat dome and conical spire with 13 rings resemble later forms of South Asian stupas; yet it includes corner shrines in the Chinese style. According to reports from the time of construction, the sealed interior of the White Stupa con-tains representations of an immense number of Esoteric Buddhist deities, set in a mandala formation to show their interrelationship, and hundreds of thousands of smaller stupas.

8-21 • Anige **WHITE STUPA**
Yuan dynasty, 1279. Stone with stucco and bronze, height 167 ft (51 m). Miaoying Temple, Beijing.

8-22 • HALL OF THE THREE PURE ONES (SANQING DIAN)
Southern Song and Yuan dynasties, 1247–1294. Wood, plaster, ceramic tile, and marble. Everlasting Happiness Palace (Yongle Gong), Ruicheng (relocated from Yongji), Shanxi province.

8-23 • Liu Guandao
KHUBILAI KHAN HUNTING
Yuan dynasty, 1280. Hanging scroll, ink and color on silk, 6′ × 3′5″ (1.83 × 1.04 m). National Palace Museum, Taipei.

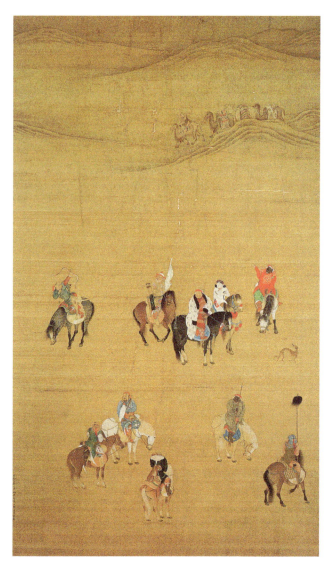

DAOISM

The Yuan state also sponsored the reconstruction of the Everlasting Happiness Palace (Yongle Gong), a Daoist temple. Built in the Song, it had been destroyed under the Jurchens. The layout of the temple is palatial, with three main halls and a gate located on a central axis oriented north–south. A highlight of the temple is the Hall of the Three Pure Ones (**FIG. 8-22**), dedicated to the deities of the Daoist trinity. Its appearance is also palatial: seven bays wide, it is elevated on a marble platform, its wooden elements are painted **vermilion**, its doors have intricate carving, the **hipped roof** has dramatically curving eaves and dragon ornaments on its ridgepole, and its tiles are painted green and yellow. At one time the interior of this hall, which boasts an elaborately **coffered** ceiling, included an **altar** with icons of the trinity. Still preserved are striking large-scale **murals** of the Daoist pantheon, emphasizing the Three Pure Ones and Eight Immortals but including hundreds of deities, lined up so as to suggest the hierarchy among them. (See also Chapter 7, Context, p. 148.) They are boldly outlined with flowing brushstrokes but also finely patterned, and the painters use **malachite** green, vermilion, and gold pigments. In 1959, the temple was moved from its original site at Yongji, Shanxi province, in order to make way for a dam.

YUAN COURT PAINTING

An aspect of the Song dynasty court that some Mongol rulers emulated was the use of paintings as cultural capital. Beginning with the reign of Khubilai Khan, certain members of the Yuan court both commissioned and collected paintings. Although many

of these works have apparent political significance, the paintings a collector acquired also reveal his or her personal interests.

LIU GUANDAO

Liu Guandao (fl. ca. 1275–1300) served as a court painter under the Mongols; from his surviving works, he appears to have been primarily a figure painter. His painting *Khubilai Khan Hunting* (**FIG. 8-23**) shows an imperial hunting party out in the desert. The emperor, wearing an ermine-trimmed robe, sits on horseback beside Empress Chabi. They are surrounded by several mounted hunters, including archers and falconers; one of them even rides with a cheetah sitting behind him. Their dress reveals them as Mongols: they wear garments with slits under the sleeves, to allow them to slip an arm out for greater mobility, and boots with decorated covers. Camels laden with supplies wait in the background. Unlike more formal imperial portraits, this painting reminds the viewer that one of the great advantages the Mongols possessed was their superior horsemanship, while at the same time signaling the political status of the ruler and indicating his nomadic ancestry.

WANG ZHENPENG

Wang Zhenpeng (fl. ca. 1280–ca. 1329) received several commissions from members of the Yuan court in the early fourteenth century. One popular composition was a painting representing a dragon-boat regatta. Such races are traditionally staged on the fifth day of the fifth lunar month, the time of a festival commemorating the death of the poet Qu Yuan (339–278 BCE) of the state of Chu. Wang Zhenpeng's painting, perhaps made first for the Mongol ruler Ayurbarwada (Emperor Renzong, r. 1311–1320), represented a particular regatta organized sometime before 1106 by Emperor Huizong in the Northern Song capital. Ayurbarwada's

sister, Princess Sengge Ragi (ca. 1283–1331), liked Wang's painting and asked him to make one for her as well; she was in the process of amassing a collection of paintings and calligraphy that included many examples from the Song era and a few Yuan dynasty works. Several versions of Wang Zhenpeng's painting have therefore survived to the present day; one example is *Dragon Boat Festival* in the Palace Museum, Beijing. A detail of this painting (**FIG. 8-24**) shows a lake with nine dragon boats vying to pass beneath a rainbow bridge. The nearby palace pavilions identify the courtly context of the race. Possibly the representation of the Northern Song emperor who was so involved with the arts was what intrigued both Ayurbarwada and his sister.

YUAN LITERATI PAINTING

The works of art long considered to be the most important to emerge from the Yuan dynasty are literati paintings. Many scholars of this period were disinclined to serve the rulers who had conquered China. Others found themselves unable to advance via the civil service examinations, which were suspended until 1315 and when reinstituted tended to discriminate against Han Chinese. As a result, some scholars ended up in other professions, including that of painter. Many literati paintings focus on themes of withdrawal from society or returning to the past; the political ramifications of both themes are easy to identify.

8-24 • Attributed to Wang Zhenpeng
DRAGON BOAT FESTIVAL (DETAIL)
Yuan dynasty. Handscroll, ink on silk, 9⅞ × 45⅛″ (25 × 114.6 cm). Palace Museum, Beijing.

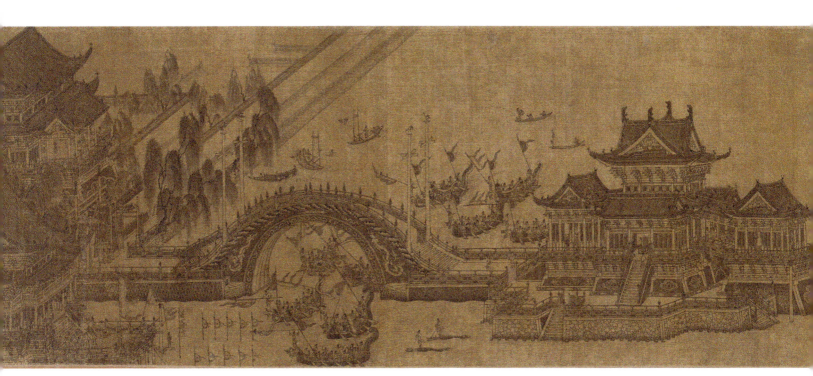

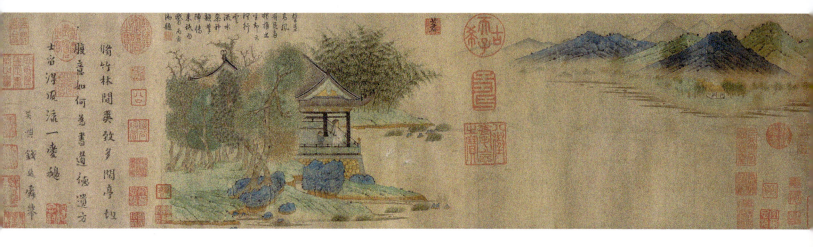

8-25 • Qian Xuan WANG XIZHI WATCHING GEESE
Yuan dynasty, ca. 1295. Handscroll, ink and color on paper, 9⅛ × 36½″ (23.2 × 92.7 cm). Metropolitan Museum of Art, New York. Ex coll.: C. C. Wang Family, Gift of The Dillon Fund, 1973, 1973.120.6.

QIAN XUAN

One scholar who became a professional painter was Qian Xuan (ca. 1235–before 1307), one of the Eight Talents of Wuxing, Zhejiang province. Connoisseurs regarded him as a "leftover subject," loyal to the Song but outliving it. He worked in a number of genres, including figures, birds-and-flowers, and landscape, and his painting was popular enough to have been forged during his lifetime. *Wang Xizhi Watching Geese* (**FIG. 8-25**) focuses on the figure of the famous calligrapher (see FIG. 7-11), standing in a pavilion and looking down on geese swimming in the water, their movements

the inspiration for his calligraphy. The choice of Wang Xizhi for the subject is telling: he had also lived in a chaotic period in Chinese history, and Qian Xuan shows him here as an uninhibited recluse at leisure. The artist's poem indicates that Wang Xizhi is supposed to be copying out the primary Daoist text, the *Dao de jing*, for a friend. This and the brilliant blue and green pigments suggest that Qian Xuan deliberately evokes a Daoist land of the immortals and the withdrawal from the world that that implies. Qian Xuan also references the past through his painting style: the blue-green style recalls the Tang dynasty, and he depicts the distant

8-26 • Zhao Mengfu SHEEP AND GOAT
Yuan dynasty, ca. 1300–1305. Handscroll, ink on paper, 9⅞ × 19″ (25.2 × 48.4 cm). Freer Gallery of Art, Smithsonian Institution, Washington, D.C. Purchase F1931.4.

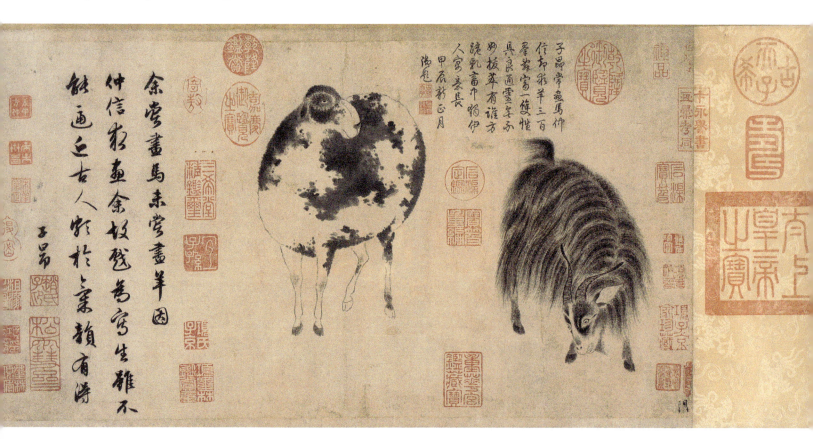

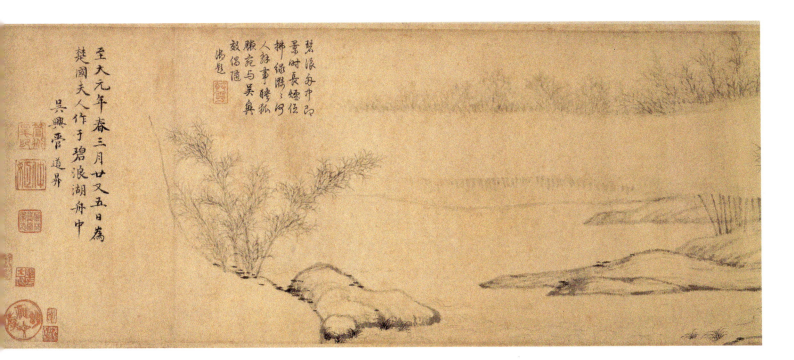

8-27 • Guan Daosheng
BAMBOO GROVES IN MIST AND RAIN (DETAIL)
Yuan dynasty, 1308. Handscroll, ink on paper, 9 × 44⅞″ (23 × 114 cm).
National Palace Museum, Taipei.

mountains in layered geometric planes, an archaic method also identified with that style.

ZHAO MENGFU

Another of the Eight Talents of Wuxing was Zhao Mengfu (1254–1322), a descendant of the first Song emperor, who accepted Khubilai Khan's invitation of an official position at the Yuan court. Ming dynasty connoisseurs briefly counted him among the Four Great Masters of the Yuan, along with Huang Gongwang (1269–1354), Ni Zan (1306–1374), and Wang Meng (ca. 1309–1385); later critics, however, accused Zhao Mengfu of disloyalty to China and added the hermit Wu Zhen (1280–1354) to this group in his place. Zhao was best known for painting landscapes and horses, and many of his paintings suggest that he saw himself as a court hermit. His *Sheep and Goat* (**FIG. 8-26**), done in ink on paper, is made playfully (according to the artist's inscription) and demonstrates how he was able to manipulate meaning. He depicts the long-haired goat, at the right, quite naturalistically; his depiction of the sheep on the left, however, is extraordinarily awkward—a difference that was purposeful. The strangely inflated sheep, standing with its head raised, seems proud; the goat, with its head down, appears deferential. One could read into this a story of two groups of people, with one submitting to the other, except that a goat lowering its horns could also be preparing to attack. Such contradictory interpretations reveal the painting's subtlety: Zhao Mengfu could have intended it to signal either his acceptance of or his resistance to Mongol rule, depending on his audience. The fact that the Chinese word for both animals is the same adds another

layer of meaning, suggesting that the Mongols and the Chinese were less different than they seemed.

GUAN DAOSHENG

Zhao Mengfu's wife, Guan Daosheng (1262–1319), was a famous painter in her own right. Although she was not the first female painter in Chinese history, her paintings are the earliest by any Chinese woman to survive—possibly because of her connection to her highly regarded husband. Certain connoisseurs suggested that women were inferior painters and cast Guan Daosheng's work as essentially feminine, but others acknowledged her considerable talent, and catalogues indicate that she painted the same subjects as men: bamboo, plum blossoms, orchids, landscapes, and Buddhist figures. *Bamboo Groves in Mist and Rain* (**FIG. 8-27**) shows thickets of bamboo growing by a river, with a band of mist cutting through them, a subject that may represent a typical Zhejiang provincial landscape. Interestingly, the genre of bamboo painting is supposed to have originated with a female artist (although this may be apocryphal). The painting bears Guan Daosheng's inscription, which reveals that she painted this work in a boat and dedicated it to Lady Chuguo.

HUANG GONGWANG

Huang Gongwang was another Yuan literati painter born before the fall of the Southern Song. He briefly served the government in a minor post but ended up supporting himself as a diviner and a teacher of Daoist religion before retiring in the Hangzhou area. As a painter, he specialized in landscapes and wrote an essay on the topic. *Dwelling in the Fuchun Mountains* (a detail appears in **FIG. 8-28**) is a long handscroll in ink on paper that represents his mountain residence and was largely executed there. His long inscription tells that, although he laid out the composition in one day, it took him over three years to finish, and then only at the

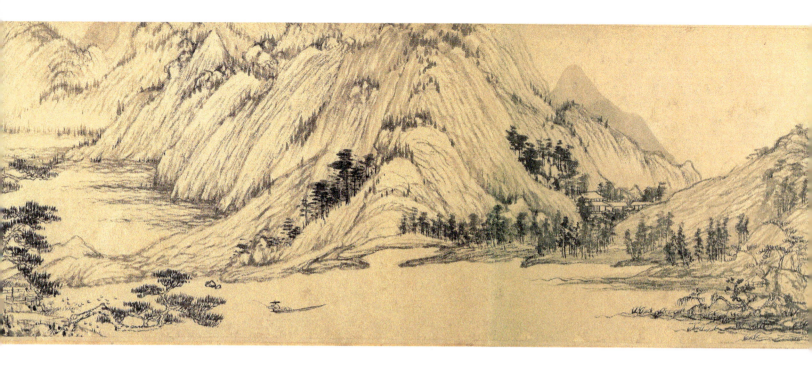

8-28 • Huang Gongwang **DWELLING
IN THE FUCHUN MOUNTAINS (DETAIL)**
Yuan dynasty, ca. 1347–50. Handscroll, ink on paper, 13 ×
250¾″ (33 × 636.9 cm). National Palace Museum, Taipei.

8-29 • Wu Zhen
POETIC FEELING IN A THATCHED PAVILION
Yuan dynasty, 1347. Handscroll, ink on paper, 9⅜ × 39⅛″
(23.8 × 99.4 cm). Cleveland Museum of Art. Leonard C. Hanna,
Jr. Fund 1963.259.

urging of its intended recipient, a friend who was present when
he began the painting. The scroll shows low hills and a broad river
giving way to mountain peaks with clusters of houses, then returns
to the river and a fisherman. A grove of pine trees shades a pavil-
ion; a man stands in it, watching swimming geese (undoubtedly
another representation of Wang Xizhi). Eroded bluffs yield again
to tall mountains. Throughout, Huang Gongwang uses the hemp-
fiber strokes, the vegetative dotting, and the alum lumps of the

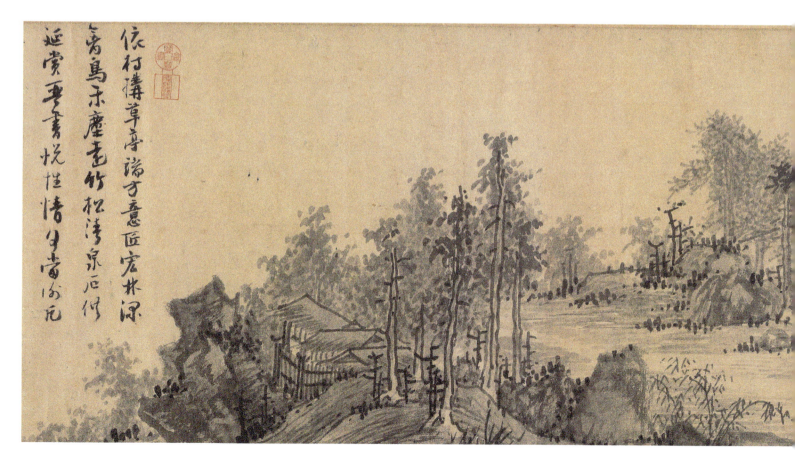

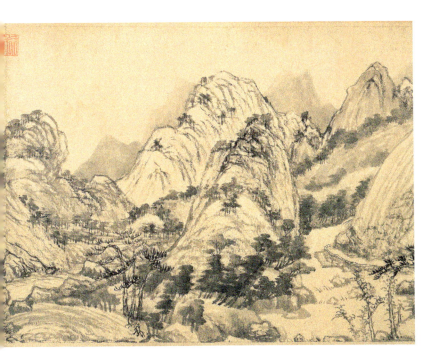

WU ZHEN

The artist Wu Zhen specialized in paintings of landscapes and bamboo—possibly the subjects that he most frequently saw as a hermit. He supported himself through his painting practice but seems to have created *Poetic Feeling in a Thatched Pavilion* (**FIG. 8-29**) for a friend. Wu Zhen wrote an inscription at the left that gives the title, dates the painting to 1347, explains that he made the painting playfully, and provides one of his nicknames: Novice of the Plum Blossoms. The inscription describes how he built the humble pavilion himself in a tranquil site graced with deep woods, bamboo, pines, streams, and rocks, finding it a place where he could enjoy music and reading. In the painting, buildings at the far left are nestled among trees that give a sense of remoteness. In a clearing, two friends face each other inside a rustic structure; a garden rock set nearby suggests that the setting is actually an artful arrangement of natural elements rather than wilderness. The painting's style falls within the Dong-Ju tradition, with alum-lump rocks, vegetative dots, hemp-fiber strokes, and tree trunks exposed from root to tip. In many places, Wu Zhen outlines forms with wet ink and a rounded brushstroke—hiding the tip of the brush to produce an even line—that was characteristic of his style.

NI ZAN

Ni Zan came from a wealthy family, which permitted him sufficient leisure time to pursue the arts and the means to amass a collection of calligraphy, paintings, and antiquities. He had some interaction with Huang Gongwang, who was a couple of

Dong-Ju landscape tradition. The painting had a colorful history after the Yuan dynasty. In 1650, a dying collector tried to burn it in a stove in order to take it to the afterworld; a nephew rescued it, and the damaged first section was cut off and preserved separately. In the late eighteenth century, the painting entered the imperial collection shortly after the Qianlong emperor (r. 1736–1795) acquired a copy of it; the emperor was besotted with the copy and inscribed it dozens of times, leaving the authentic scroll relatively unscathed.

A landscape master active in the early Northern Song was Fan Kuan (ca. 960–1030), a hermit who lived in the mountains. He studied the work of earlier painters, including Li Cheng, and nature, as seen in *Travelers among Mountains and Streams* (**FIG. 8–30**), done in ink and color on silk. Fan used a variety of techniques to depict this scene, from the "raindrop texture strokes" that convey the ruggedness of the vertical cliffs to the dilute ink wash that renders the mist separating foreground from background. The Yuan scholar-official Wang Meng was Zhao Mengfu's grandson and may have received lessons in painting from him. After retirement, Wang lived as a recluse near Hangzhou, then moved to the Suzhou area, where he interacted with other literati. *Dwelling in Reclusion in the Qingbian Mountains* (**FIG. 8–31**), done in ink on paper, is extraordinarily detailed, and the twisting mountains take up much of the composition. Wang Meng reportedly had Guo Xi's painting in mind when he made this, although elements of the Dong-Ju tradition are visible.

8–30 • Fan Kuan *TRAVELERS AMONG MOUNTAINS AND STREAMS*
Northern Song dynasty, ca. 1000. Hanging scroll, ink and color on silk, 6′9⅛″ × 3′4⅝″ (2.06 × 1.03 m). National Palace Museum, Taipei.

8–31 • Wang Meng *DWELLING IN RECLUSION IN THE QINGBIAN MOUNTAINS*
Yuan dynasty, 1366. Hanging scroll, ink on paper, 55½ × 16⅝″ (141 × 42.2 cm). Shanghai Museum.

THINK ABOUT IT

1. Do the media of the two paintings hint at the social status of the painters? Why or why not?

2. Do elements of either painting recall works by earlier artists? List any that you can identify.

3. Daoist teachings hold humankind insignificant in comparison to nature. What signs of human presence are visible in these paintings? Why might the painters allude to Daoist ideas?

4. Fan Kuan hid his signature among the trees at the bottom right. Wang Meng, conversely, signed and dated his work prominently at the top right. What do these different approaches to the signature suggest about the relative importance of the artist's identity?

5. Seals on Wang Meng's painting indicate that he made it for his cousin as a reminiscence of the Zhao family's mountain retreat, but the circumstances behind Fan Kuan's work are unknown. What does this suggest about the literati's approach to painting practice?

8-32 • Ni Zan SIX GENTLEMEN
Yuan dynasty, 1345. Hanging scroll, ink on paper,
24⅜ × 13⅛″ (61.9 × 33.3 cm). Shanghai Museum.

inscriptions; the artist's is found at the center left and reveals how he had traveled by boat to a friend's house only to be met with the demand for a painting as he disembarked. Ni Zan complied despite his exhaustion, dashing off *Six Gentlemen* by lamplight on the paper that his host provided. Huang Gongwang's poetic inscription at the top right provides the painting's title, referring to the six trees in the composition as metaphors for recluses. The addition of these highly personal inscriptions reveals the connections among the literati and attest to their sometimes spontaneous approach to painting.

The political upheavals of the tenth to fourteenth centuries helped to define Chinese identity. After the re-establishment of Chinese rule in 1368, many trends of the Five Dynasties, Song, and Yuan periods persisted. Artists often looked back to the developments of the Song and Yuan, using them as a basis for their artistic practice. Court patronage continued as a significant force in artistic and architectural production even as literati artists developed in new directions. In the fourteenth through twentieth centuries, landscape maintained its status as a dominant genre of painting, and the paintings of women came to be increasingly valued by collectors. Still, growing commercialization in the early modern era led to important changes in Chinese society that had significant ramifications for the arts.

CROSS-CULTURAL EXPLORATIONS

8.1 The original version of *Night Revels of Han Xizai* dates to the tenth century. Look carefully at the details of material culture depicted in the first scene of the copy (FIG. 8-2), such as the clothing, the wine vessels, and the paintings on display. Do they resemble things depicted in examples of eleventh- and twelfth-century Chinese art? If so, how can that be explained?

8.2 How does the art of the literati and the court in the Song dynasty represent distinctive points of view? What do they have in common, if anything?

8.3 Consider the representation of the city in *Peace Reigns along the River* (FIG. 8-7) in light of what we know about the design of the ideal Chinese city.

8.4 Exposure to foreign ideas in the Six Dynasties and Tang eras led to an expansion of Chinese culture. Did the advent of Mongol rule create a similar phenomenon in thirteenth- and fourteenth-century China? Why or why not?

generations older, but he likely learned to paint by studying the works in his own collection. To avoid paying additional taxes after the government raised them, he sold his land and became itinerant, living on a houseboat or relying on others' hospitality. He sometimes gave paintings to his hosts to show his appreciation. *Six Gentlemen* (FIG. 8-32) in many ways is typical of his body of work. He frequently used a vertically oriented composition with some variation on hills in the background, negative space in the middle ground—meant to indicate an expanse of water—and rocks with a cluster of trees in the foreground. (Sometimes, but not here, he added a small pavilion to the foreground.) He often used very dry, pale ink, and his compositions are static, resulting in a quality of plainness and blandness (*pingdan*) that was highly valued in his work. *Six Gentlemen* shows that he draws elements from the Dong-Ju landscape tradition. The painting includes multiple

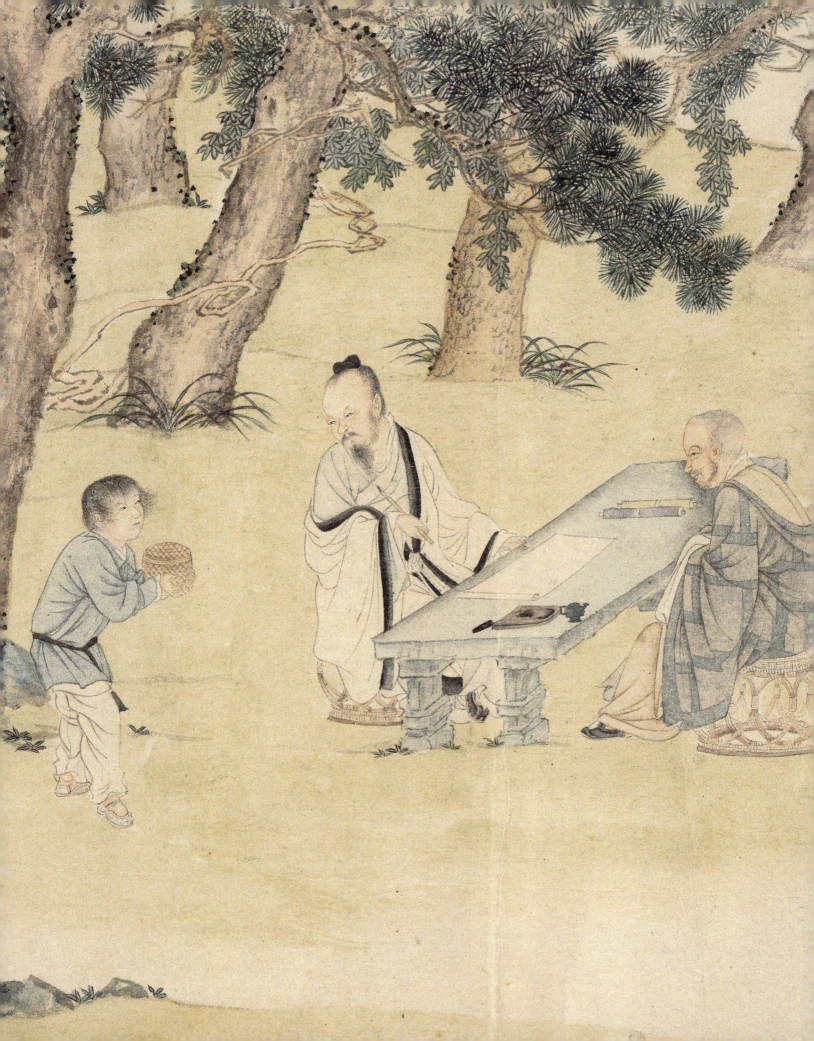

The City and the Market in Chinese Art: The Ming and Qing Dynasties

Yishao [Wang Xizhi] wrote in exchange for a flock of geese. Su Dongpo [Su Shi] wrote in exchange for meat. Both episodes have become legends of a thousand years.

Wen Peng (1498–1573)

The city and the market define Chinese arts from the fourteenth through nineteenth centuries, even for artists who sought to escape them. Although the **literati** artistic tradition and court **patronage** continue, professional artists emerge as a significant force in these periods. Evidence exists for the appearance of art markets in the Song era, and the concept of art as goods to be exchanged dates back to at least the Six Dynasties, as clarified by the above lines. Wen Peng, a member of the literati, wrote them for a Ming professional painter's depiction of the Yuan artist Zhao Mengfu copying out a Buddhist scripture in exchange for tea: The painting is thus a multifaceted example of all the ways that art could be perceived as a commodity (**FIG. 9–1**). Several phenomena led to the increasing commercialization of art in the Ming and Qing: the flourishing export market for Chinese ceramics, the growth of the printing industry, expanding artistic patronage of courtesans and women of the gentry (land-owning families), and the rise of new urban artistic centers. Beijing remained an important site for art and architecture, but southern cities such as Nanjing, Yangzhou, Suzhou (all in Jiangsu province), Hangzhou, and Shanghai saw not only the proliferation of professional painters' studios but also the development of literati artistic circles and the flourishing of garden culture.

All this took place against a historical backdrop that, at least superficially, recalls the Song and Yuan dynasties. Chinese rebels overthrew the Mongols in 1368 and established a new dynasty, the Ming, meaning "bright," installing their leader as the first emperor. In this period, the economy strengthened as trade increased and a new mercantile class emerged. The Ming dynasty lasted nearly three centuries, beginning to decline in the mid-sixteenth century as eunuchs (who served as trusted officials) gained power at court. After internal rebellions weakened the dynasty, a northeastern Asian people, the Manchus (who were descended from the Jurchens), conquered China, founding the Qing dynasty in 1644. Like the Mongols and Xianbei before them, the Manchu rulers worked to assimilate certain aspects of Chinese culture. The Qing witnessed a period of prosperity and population growth through the end of the eighteenth century. However, some Chinese chafed under this renewed foreign rule, and that feeling became accentuated as the dynasty began to wane in the nineteenth century.

MING AND QING POLITICS AND ARCHITECTURE

The surviving architecture of the Ming and Qing dynasties includes spaces that were central to politics and political identity. In China, as elsewhere, access to zones of privilege, such as powerful government offices or intimate gardens, required certain social

9–1 • Qiu Ying *ZHAO MENGFU WRITING THE HEART SUTRA IN EXCHANGE FOR TEA* (DETAIL)
Ming dynasty, ca. 1542–1543. Handscroll, ink and light color on paper, 8¼ × 30⅜" (21.1 × 77.2 cm). Cleveland Museum of Art. John L. Severance Fund 1963.102.

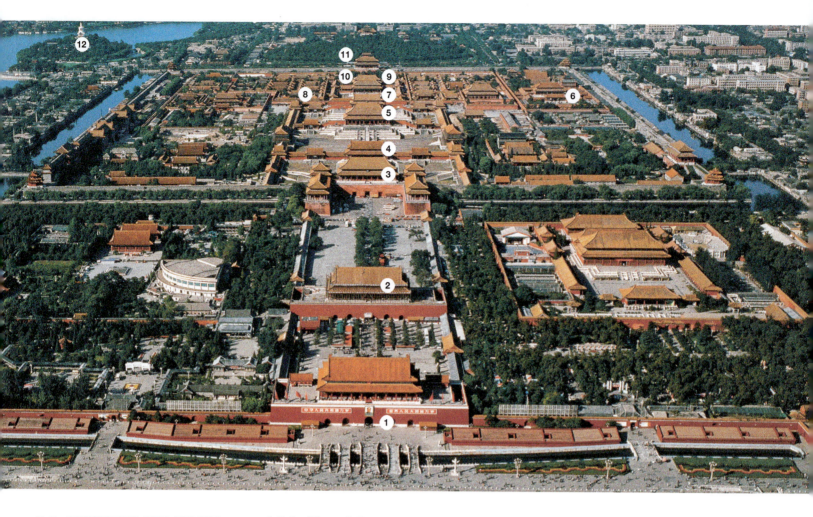

9-2 • FORBIDDEN CITY, BEIJING
Founded Ming dynasty, 1407. 3,150 × 2,460 ft (960 × 750 m).

1. Gate of Heavenly Peace
2. Gate of Correct Deportment
3. Noon Gate
4. Gate of Supreme Harmony
5. Hall of Supreme Harmony
6. The Repose and Longevity Palace Complex
7. Hall of Central Harmony

8. Hall of the Cultivating Mind
9. Hall of Preserving Harmony
10. Palace of Earthly Repose
11. Gate of Martial Spirit
12. Dagoba

connections. Although the imperial government funded much of the architecture under discussion here, some is associated with other social classes, including literati and merchants. Most was built in urban areas, such as the capital or important commercial centers.

BEIJING

The Ming capital, initially established in Nanjing, moved north to Beijing during the reign of the Yongle emperor (r. 1403–1424). Located at the site of the Yuan capital of Dadu, the capital remained there through the end of the Qing. Fifteenth-century Beijing shared some features with Tang Chang'an: Walls surrounded both capitals, and both stood in relation to the cardinal directions, with palace complexes situated on the central north–south axis. In Beijing, however, planners situated the palace complex at the center of the city, surrounded by the imperial city that housed the administrative district, with residential wards located farther out. The capital's later expansion south in the mid-sixteenth century established a walled outer city that accommodated the commercial district, and the older parts of Beijing became known as the inner city.

Construction began on the Forbidden City palace complex (**FIG. 9-2**) in the Yongle reign and was largely complete by 1420, although many fires throughout the Ming and destruction at the turn of dynasties led to significant rebuilding. The Forbidden City, which measures 3,150 by 2,460 feet (960 by 750 meters), was surrounded by walls and a moat that strictly controlled access and acted as boundaries separating it from the public space of Beijing. The southern part of the Forbidden City accommodated the functions of the imperial court, while members of the imperial family resided in the halls of the northern part. The **vermilion** walls of the buildings and the yellow-**glazed** roof tiles make the palace architecture stand out; yellow signified the emperor, as the Mandarin words for "yellow" and "emperor" have identical pronunciations. The Forbidden City's

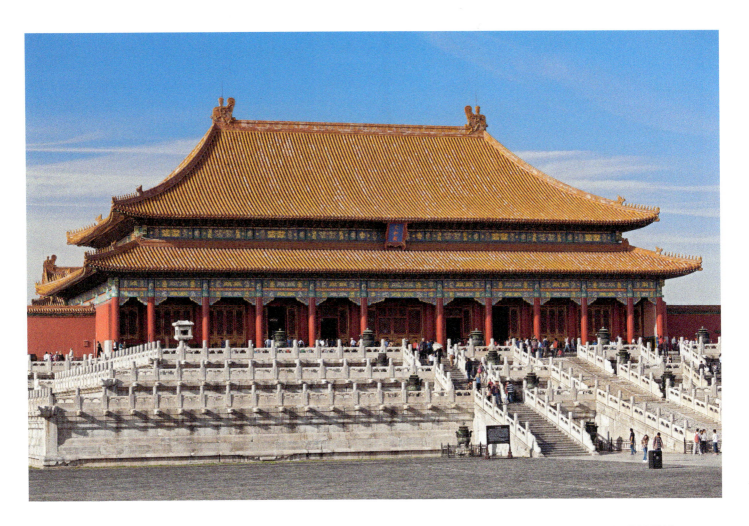

9-3 • HALL OF SUPREME HARMONY
Ming dynasty, 1406; rebuilt Qing dynasty, 1697. Wood, paint, plaster, and ceramic tiles, height 115 ft (35 m). Forbidden City, Beijing.

9-4 • PLAN OF THE TEMPLE OF HEAVEN, BEIJING
Founded Ming dynasty, 1420.

1. Western gate to altars
2. Western Heavenly Gate
3. Ritual Instruments Office
4. Sacrificial Animals Stable
5. Abstinence Palace
6. Circular Mound
7. Imperial Vault of Heaven
8. Complete Virtue Gate
9. Imperial kitchen and storage
10. Slaughter Pavilion
11. Precious Clothing Platform
12. Gate of Prayer for a Prosperous Year
13. Hall of Prayer for a Prosperous Year
14. Hall of the Imperial Heavens
15. Yuelu Bridge

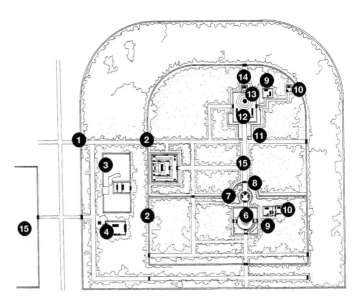

most important buildings lie along the central north–south axis, aligning with the gates of the imperial city to the south. The most prominent is the elevated building now known as the Hall of Supreme Harmony (**FIG. 9-3**), standing at the back of an expansive open courtyard. In the Ming, this building, known then as the Fengtian Hall, hosted state banquets and ceremonies marking the lunar new year, the winter solstice, and the emperor's birthday. It became an audience hall housing a throne room in the Qing dynasty. Built using the **post-and-beam** technique, it measures 11 bays across its façade and boasts a double-**hipped** roof, with mythical animals adorning each end of the ridgepole. Its three-tiered marble platform extends in front of the building, approached by a long ramp; one can easily imagine people gathered here to listen to an emperor's address.

The Jiajing emperor (r. 1521–1567) reconfigured a site that had also been founded by the Yongle emperor: the Temple of Heaven complex (**FIG. 9-4**), located in the southern suburbs of Beijing, which had earlier included a hall designed for sacrifices to both heaven and earth. The three main structures lie on an axis: These are the Circular Mound or the Altar of Heaven, a set

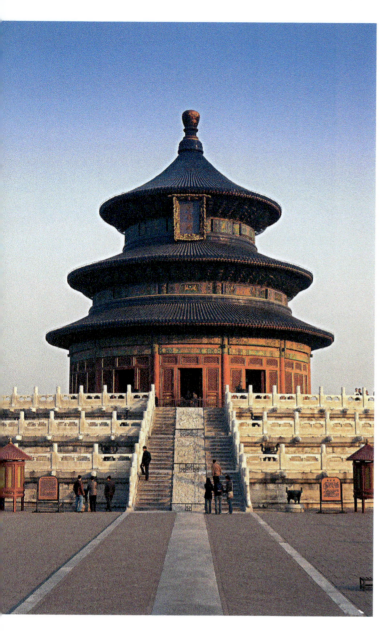

9-5 • HALL OF PRAYER FOR A PROSPEROUS YEAR
Ming dynasty, 1420; rebuilt Qing dynasty, after 1889. Wood, paint, and ceramic tiles, height 125 ft (38 m), diameter 98 ft (30 m). Temple of Heaven, Beijing.

of marble platforms designed for sacrifices; the Imperial Vault of Heaven, a hall containing the tablet of Shangdi as well as those of lesser deities; and the Hall of Prayer for a Prosperous Year, also known as the Hall of Prayer for Good Harvests (**FIG. 9-5**). All are round, and the two post-and-beam halls have blue-glazed tile roofs, signifying heaven's form and color. At this site, the emperor conducted the annual ceremonies that constituted his practice of ancestor worship.

THE GREAT WALL

What we now refer to as the Great Wall of China is a set of Ming dynasty walls, some interconnected, dating not to the early years of the dynasty as one might suspect, but to the sixteenth century, when the Chinese faced increasing conflict with the Mongols. The name refers to the original series of walls—including new construction that linked older structures—erected by order of Qin Shihuangdi, using forced labor, back in the third century BCE. Ming emperors viewed the walls as fortifications of the northern border, which had shifted a number of times since the Qin dynasty. Recent surveys suggest that the Ming walls originally measured almost 5,600 miles (9,000 km) in length and extended through critical mountain passes. Most sections have since fallen into ruin or disappeared in sandstorms; the few surviving sections, built of brick or stone, stand up to 26 feet (8 meters) high and consist of a double wall with a broad walkway in the center, with watchtowers appearing at regular intervals (**FIG. 9-6**). Although some have postulated that the Great Wall might be visible from the moon, no evidence supports this claim.

GARDEN DESIGN

A type of architecture that evokes retreat from politics (in itself a political stance) as well as elite status is the urban garden. Many Ming and Qing examples stand in Suzhou, a small but important commercial center located at the intersection of the Yangzi River and the Grand Canal (a transport route built in the early

9-6 • GREAT WALL
Ming dynasty, ca. 1500–1600. Masonry.

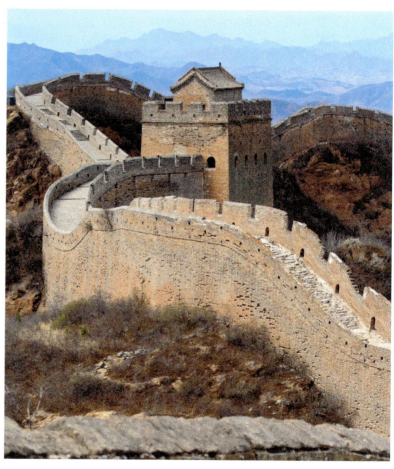

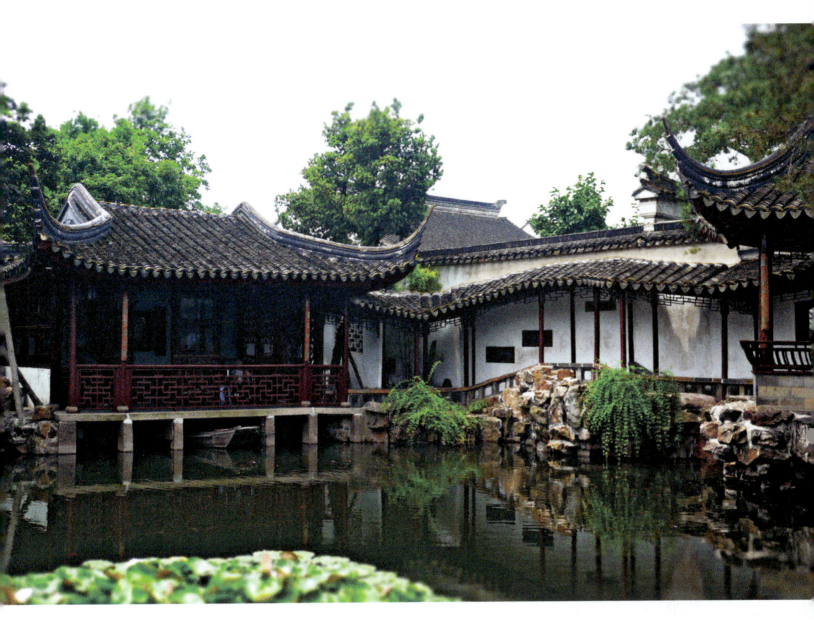

9-7 • SOUTHWESTERN CORNER OF POND, GARDEN OF THE MASTER OF THE FISHING NETS (WANGSHIYUAN)
Qing dynasty, ca. 1765 and ca. 1795, with additions ca. 1916 and 1958; restored in 1940s and 1950s. Wood-and-tile structures, lime-plaster-and-brick walls, rocks, plantings, paving stones, and pond. Suzhou, Jiangsu province.

seventh century that linked the Beijing area, Luoyang, Yangzhou, and Hangzhou). Suzhou is sometimes described as the Venice of China because of the many canals that crisscross the city. In the Qing dynasty, the official Song Zonghuan (fl. ca. 1765) decided to restore and enlarge a twelfth-century Suzhou garden known as the Fisherman's Retreat. His **literary name**, or the name he adopted for literary endeavors, was Wangshi ("Master of the Fishing Nets"), and he renamed the site the Garden of the Master of the Fishing Nets. A later owner, the merchant Qu Yuancun (fl. ca. 1795), redesigned the garden, and its current form preserves many aspects of its late eighteenth-century appearance. Classical Chinese gardens generally feature both rocks and water and represent microcosmic

landscapes: The Garden of the Master of the Fishing Nets has a pond as its centerpiece, as well as many curiously shaped limestone rocks dredged at great expense from the bottom of nearby Lake Tai, and these elements together suggest the complementary opposites of *yin* and *yang*. The garden's designer arranged these and other elements—including plantings, walled courtyards, and buildings—as a series of picturesque vistas, giving many of the features poetic names that reveal the owners' literary inspirations. For example, the southwestern corner of the pond features the Washing Capstrings Pavilion (**FIG. 9-7**, at left), which was named after a passage written by the fourth-century BCE Confucian philosopher Mencius. The dramatically swooping eaves of its roof and its ornate woodwork typify garden architecture. A covered walkway leads to the Moon-Comes-with-the-Breeze Pavilion, the name of which was inspired by a line from a poem by Han Yu (768–824). Both pavilions are built out over the pond, allowing them to stay cool in the summer and provide good views over the water to the rest of the garden. The designer took care to make every element of this small garden visually appealing.

MING AND QING CERAMICS

Ming and Qing dynasty ceramics reflect the distinct tastes of the market. There had already been a strong domestic market for certain ceramic wares, such as **celadons**, and the imperial court had already emerged as an important patron of ceramics; this continued in the Ming dynasty. The Chinese had also already begun exporting ceramics in earlier periods, primarily to Persia and the Middle East, first via the Silk Road and later via sea routes. Ming and Qing potters continued to produce ceramics for Middle Eastern markets, but also began to export to Southeast Asia and Europe.

A major center for **porcelain** production from the Song through the Qing dynasties was the Jingdezhen kilns in Jiangxi province. Potters added local kaolin, noted for translucence, to Jingdezhen porcelain, producing wares of exceptionally high quality. In every era the Jingdezhen potters sent porcelain to the imperial court, and the Ming and Qing courts chose the Jingdezhen kilns as the location of imperial porcelain workshops. A technique of creating designs in **underglaze** blue (**cobalt slip** applied beneath a transparent glaze) resulted in the blue-and-white ware produced in large quantities at Jingdezhen beginning in the Yuan dynasty and continuing in the Ming. Cobalt was mined in western Asia and traded via the Silk Road, and cobalt oxide added to slip made a remarkably indelible pigment. Blue-and-white ware responded to the intensely blue hues of Islamic ceramics and served as a model for some Vietnamese ceramics, and much of it was made for export; some examples had inscriptions in foreign languages incorporated into their designs. An arrow vase (**FIG. 9–8**)—an unusual form, with seven apertures and squared-off elements—can be precisely dated to the Zhengde reign (1505–1521) based on the inscription in underglaze blue appearing on the base. It bears Persian inscriptions set in roundels on both the neck and body, suggesting it was produced for that market or for Muslim eunuchs at Zhengde's court. They read, "O beautiful! O powerful!" and "None knows the extent and limits of Thy power and majesty." The potter painted scrolling motifs and abstract flowers, laid out symmetrically, in underglaze blue around the inscriptions.

The use of **overglaze** enamel to create polychrome wares was a technique developed in the Ming. The chicken cup (**FIG. 9–9**) is an example of a type referred to in Chinese as "joined colors" (*doucai*). An artisan first outlined a design in underglaze blue. After coating the cup with transparent glaze and high-firing it—in essence, creating an example of blue-and-white ware—workers then filled in the design with colored enamels laid on the glazed surface, refiring the piece at a lower temperature to melt the enamel. In the finished product, the subtle blue outline remains visible beside the enamel's vibrant colors. (The related

9-8 • ARROW VASE WITH PERSIAN INSCRIPTIONS AND FLORAL SCROLLS

Ming dynasty, ca. 1505–1521. Porcelain with underglaze blue slip, height 10¼" (26 cm), width 3⅞" (10 cm). Jingdezhen kilns, Jiangxi province; Cleveland Museum of Art. Severance and Greta Millikin Collection 1964.170.

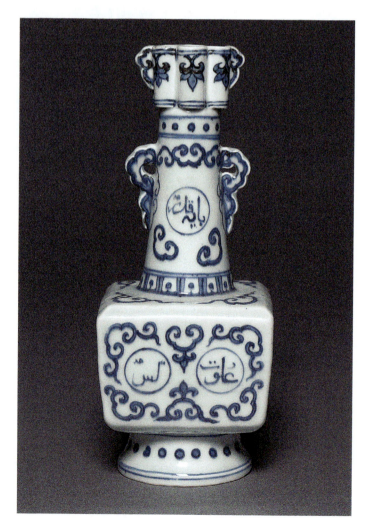

9-9 • CHICKEN CUP

Ming dynasty, 1465–1487. Porcelain with underglaze blue and overglaze enamels, diameter 3¼" (8.3 cm). Metropolitan Museum of Art, New York. Purchase, Mrs. Richard E. Linburn Gift, 1987, 1987.85.

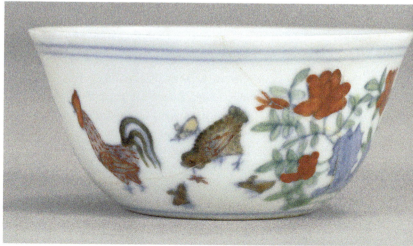

Woodblock printing, which originates in China, is the world's oldest form of printing, already well established in the Tang dynasty. The process created many items related to Chinese visual culture: catalogues of paintings and **calligraphy**, published jottings of artists and connoisseurs, prints that functioned as greeting cards, and so forth. In the Ming dynasty, the market for the illustrated book expanded. An illustration for the Yuan dynasty drama *Story of the Western Wing* (also known as *Romance of the Western Chamber*), still popular in the late Ming when it was published by Min Qiji (1580–after 1661), demonstrates the **medium**'s appeal. The story concerns the love affair of Oriole (Ch. Yingying) and Scholar Zhang, and attracted a female audience. Min Qiji's set of 20 prints stands out for depicting

the examples of visual and material culture in which the narrative appeared at the time, including fans, scrolls, screens, framed pictures, stationery, ceramic wares, lanterns, and even puppetry.

"ORIOLE WRITES A LETTER TO SCHOLAR ZHANG" (ACT 18), *STORY OF THE WESTERN WING*, PRINTED BY MIN QIJI (1580–AFTER 1661)

Ming dynasty, 1640. One of a set of 20 polychrome woodblock prints, $10\frac{7}{8} \times 12\frac{3}{4}''$ (27.5 × 32.3 cm). Museum für Ostasiatische Kunst, Cologne. R 62,1.

The unknown artist presents the scene as if it were painted on a **hanging scroll**. Rolled-up sections of the scroll-within-the-print appear at top and bottom, and its brocade mounting at left and right. A printed inscription identifies this as the play's eighteenth act.

In a garden pavilion that functions as a studio, Oriole writes a letter to Scholar Zhang, spreading out paper with one hand and holding a brush in the other. Scrolls, a book, and several writing implements lie on the table. The presence of a maid, standing off to the side, signals Oriole's high status.

A limestone rock, willow tree, and ornate architecture, including a carved vermilion railing and the pavilion's round window, make the setting recognizable as a garden.

A messenger waits for the letter outside the pavilion, his horse grazing nearby.

The print's reduced color palette reflects in part the limitations of woodblock printing at this period.

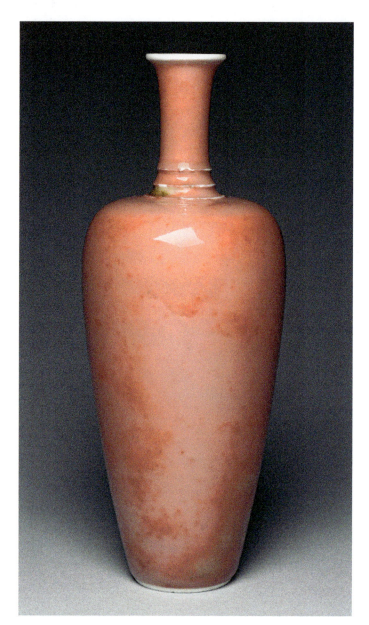

9-10 • "THREE-STRING" VASE
Qing dynasty, 1710–1722. Porcelain with peach-bloom glaze, height 8″
(20.2 cm), diameter 3¼″ (8.1 cm). Walters Art Museum, Baltimore. 49.155.

wucai or "five-color" ware featured bolder applications of stronger colors.) The domestic market especially prized chicken cups, said to be worth their weight in gold. The fine details included in this example reveal the sureness of the artisan's hand.

A "three-string" vase (so called for the three raised rings appearing where the neck meets the body) with peach-bloom glaze (**FIG. 9-10**) represents Qing imperial taste. Reportedly, it belonged to the thirteenth son of the Kangxi emperor (r. 1662–1722), Prince Yi (1686–1730). "Peach-bloom glaze" is a Western appellation; in Chinese the color is referred to as "bean-green and apple-red." Unusually glossy in appearance, the vase probably has three layers of glaze: a clear glaze, a copper-red glaze, and a second layer of clear glaze. Copper glazes fire red in a **reducing atmosphere** and green in an **oxidizing atmosphere**; this

vase has beautifully nuanced colors ranging from pink to rose, and one spot of olive green on the neck. Potters had worked since the Song dynasty to develop glazes that produce subtle variations in color depending on manipulation of conditions in the kiln. Meant to hold flowers, the vase belongs to a set of eight vessels designed for a scholar's study—to enhance the intellectual pursuits of its owner.

MING PROFESSIONAL PAINTERS

The growing market for art in the Ming dynasty led to a rise in the number of professional painters. Professional painters earned a living by selling their paintings, whether they received commissions from patrons or sold them from their workshops. Most worked in cities, and the best sometimes received appointments

9-11 • Dai Jin *THE HERMIT XU YOU RESTING BY A STREAM*
Ming dynasty. Hanging scroll, ink and color on silk, height 4′6⅜″ (1.38 m).
Cleveland Museum of Art. John L. Severance Fund 1974.45.

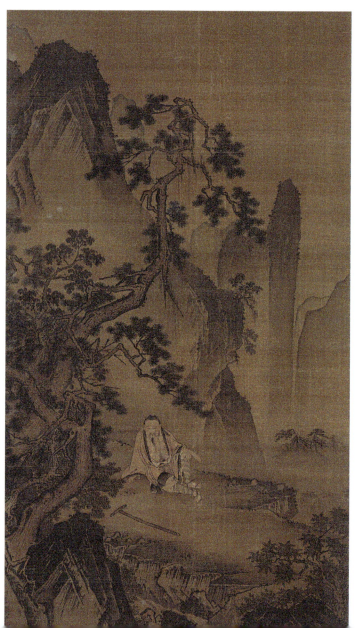

as court painters. They generally studied painting formally, sometimes learning their trade by working as apprentices, and their paintings often (but not always) demonstrate superior draftsmanship and the use of more expensive media, such as **mineral pigments** and silk. In these respects, they tend to differ from literati painters, although the lines between these two groups are not as clear as one might expect.

DAI JIN

Dai Jin (1368–1462) was a versatile painter, able to work in three **genres**: figure, landscape, and bird-and-flower painting. A possibly apocryphal story relates that a eunuch recommended him as a painter at the Ming court. After he accepted the appointment, however, another painter accused him of concealing insults to the emperor in his work, causing him to flee the capital. A native of Hangzhou, Zhejiang province, he returned there, working as a professional painter. He receives credit as the founder of the **Zhe School** of painting—not an actual school but a loosely affiliated group of professional painters working in Zhejiang who saw Dai as their leader. His painting *The Hermit Xu You Resting by a Stream* (**FIG. 9–11**) is typical of the Zhe School style. It clearly derives from the academic painting of the Southern Song, when the Chinese capital was also located in Hangzhou: Dai Jin's painting includes the **ax-cut strokes** and ink wash associated with Ma Yuan and Xia Gui (see Chapter 8, **FIGS. 8–17** and **8–18**). The painting depicts a Confucian recluse famous for his refusal of high office, merging the genres of landscape and figure painting.

WU WEI

Wu Wei (1459–1509), who specialized in figures and landscapes, alternated between serving as a painter-in-attendance under several Ming emperors—he was a favorite at the Beijing court but developed a reputation for arrogance—and working as a professional painter in the former capital, Nanjing. His training was unusual: He received an education appropriate to an official career (plans that derailed when he was orphaned) and learned to paint by studying his father's art collection. In Nanjing, he gained notoriety for drinking and dalliances with courtesans. *Lady Carrying a Pipa* (**FIG. 9–12**) focuses on a beautifully dressed female figure, shown in profile, with bowed head and downcast eyes; Wu Wei renders his subject minimally, in ink on paper, but with virtuosity, particularly visible in the flowing, modulated brushwork that evokes the woman's movements. The musical instrument—shown wrapped, on the woman's shoulder, with only its tuning pegs visible—strongly evokes courtesans (as already seen in *Night Revels of Han Xizai*, Chapter 8, **FIG. 8–2**), and this painting may depict a courtesan that Wu Wei knew personally. Another theory suggests that the painting refers to a moving literary narrative about a courtesan, possibly the original poem of 816 by Bai Juyi (772–846), "Song of the Pipa," or a mid-fourteenth-century play based on it. Wu Wei signed his painting at the top left and impressed his artist's **seal**; other inscriptions include one by a contemporary. The

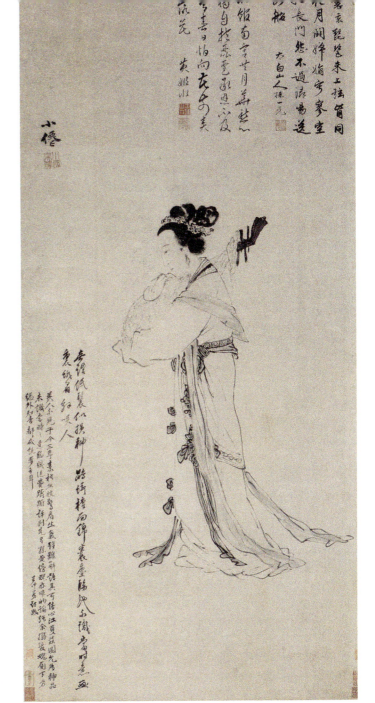

9–12 • Wu Wei *LADY CARRYING A PIPA*
Ming dynasty. Hanging scroll, ink on paper, 49¼ × 24⅛" (125.1 × 61.3 cm). Indianapolis Museum of Art. Gift of Mr. and Mrs. Eli Lilly 60.36.

painting's media, its correspondence to literary themes, and the inscriptions all reveal how much the work of professional painters could have in common with that of the literati.

ZHOU CHEN

An unusual composition by a professional painter—as it is difficult to imagine its market—is *Beggars and Street Characters* by Zhou Chen (ca. 1455–after 1536). This artist took a more typical route toward his trade, learning to paint both figures and landscapes as an apprentice, and specialized in scholarly themes. Zhou Chen's own

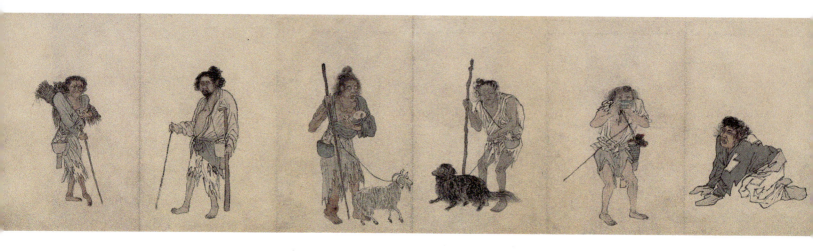

9–13 • Zhou Chen
BEGGARS AND STREET CHARACTERS (DETAIL)
Ming dynasty, 1516. Album remounted as handscroll. Ink and color on paper, 12½ × 96¼″ (31.9 × 244.5 cm). Cleveland Museum of Art. John L. Severance Fund 1964.94.

colophon for *Beggars and Street Characters*, now divided into two **handscrolls**, claims that he spontaneously depicted two dozen of the people whom he saw daily in the streets and markets as a warning to society. A detail of six figures (**FIG. 9-13**) shows them all dressed in rags, barefoot, with unkempt hair and terrible expressions, clearly in desperate straits. At the right, a vegetable seller devours watermelon; two other figures lead goats. One of these, a woman afflicted with a goiter and a sore on her swollen leg, attempts to nurse an emaciated infant. Other figures in the painting include animal trainers, entertainers, and wood gatherers. It was extraordinary to record the suffering of the urban underclass,

9–14 • Qiu Ying ZHAO MENGFU WRITING THE HEART SUTRA IN EXCHANGE FOR TEA
Ming dynasty, ca. 1542–1543. Handscroll, ink and light color on paper, 8¼ × 30⅜″ (21.1 × 77.2 cm). Cleveland Museum of Art. John L. Severance Fund 1963.102.

and Zhou Chen's contemporaries believed that he intended it as a critique of the harsh reign of the Zhengde emperor, known for the influence of corrupt eunuchs and an unconscionable increase in taxes. The absence of connoisseurs' seals may reflect the uncomfortable nature of the painting's content.

QIU YING

The professional painter Qiu Ying (ca. 1494–ca. 1552) spent some time as Zhou Chen's apprentice and also studied by copying paintings from earlier eras. He was well connected in the art scene of Suzhou, enjoying stints as a painter-in-residence at the homes of collectors and collaborating with literati artists. He developed a reputation as a specialist in both figure painting and **blue-green landscape**, the latter so popular that Suzhou painting workshops began to produce forgeries of them. A painting that demonstrates the connections among Qiu Ying and his contemporaries, as well as the importance accorded to past artists, is *Zhao Mengfu Writing the Heart Sutra in Exchange for Tea* (**FIG. 9-14**). The handscroll depicts the respected calligrapher writing out the Buddhist scripture for a priest, accepting tea in return. (For more on the *Heart* or *Prajnaparamita Sutra*, see Chapter 2, pp. 44–45 and Chapter 14, p. 326.) The collector Zhou Fenglai, who had obtained a poem that Zhao Mengfu had written about the episode, commissioned

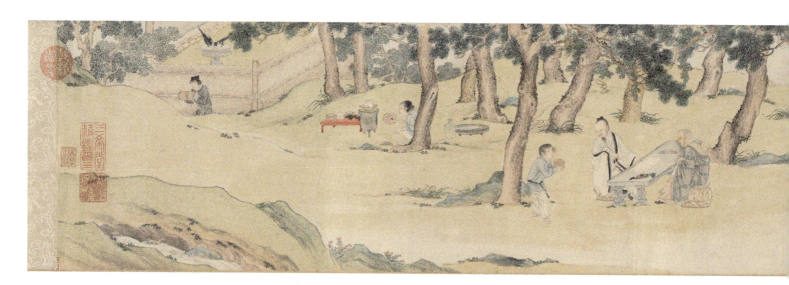

the painting. He then solicited a transcription of the Heart Sutra from the literati painter Wen Zhengming (1470–1559), mounting Qiu's painting, Zhao's poem, and Wen's calligraphy together in the same scroll. A series of colophons, by two of Wen Zhengming's sons and a later owner, Wang Shimou (1536–1588), relate the complicated history of the handscroll; Wang Shimou ended up removing Zhao Mengfu's poem, which has since disappeared. Zhou Fenglai specified that Qiu Ying use the **plain-outline style** associated with Li Gonglin (see Chapter 8, FIG. 8-13) for the figures, a request with which he complied, although—unusually—he colored their garments with subdued shades of blue. He used muted hues of mineral pigments for the setting, which represents a scholar's garden. A servant some distance away fans a brazier to heat water for tea. The painting includes only collectors' seals and bears no signature.

CHEN HONGSHOU

Chen Hongshou (1598–1652) worked in the late Ming dynasty as a professional painter (specializing in figures) and received an invitation to serve as painter-in-attendance at the Beijing court, yet his education led him at times to approach art with a literati sensibility. He made the hanging scroll *Lady Xuanwenjun Giving Instructions on the Classics* (**FIG. 9-15**) as a gift commemorating his own aunt's sixtieth birthday in 1638, as he explains in a long inscription at the top of the composition. Lady Xuanwenjun belonged to a Six Dynasties official family that specialized in the study of a classic text concerning the rituals of the Zhou dynasty. At the age of 80, as the foremost expert on the text, she single-handedly revived its study, instructing 120 scholars in its nuances. Chen Hongshou intended his depiction of this venerable woman as a compliment to his aunt. He depicts her seated in front of a landscape screen—her advanced age indicated by her impressively wrinkled face. Several female attendants, including one carrying a book, wait on her. Her male students sit at a respectful distance. The exaggerated elements in Chen's composition convey an antique air that seems appropriate for this historic subject.

9-15 • Chen Hongshou
LADY XUANWENJUN GIVING INSTRUCTIONS ON THE CLASSICS
Ming dynasty, 1638. Hanging scroll, ink and color on silk, 68⅜ × 21¾" (173.7 × 55.4 cm). Cleveland Museum of Art. Mr. and Mrs. William H. Marlatt Fund 1961.89.

MING LITERATI PAINTERS

The Ming literati shared a classical education that informed their art. Some studied painting, usually with other members of the literati. Some, like Wen Zhengming, painted on request if not on commission. Many created correspondences between poetry, calligraphy, and painting, drawing on literary themes for their subjects, inscribing their own works with poems, or writing for the paintings of others. Most of the Ming literati demonstrate some degree of art historical knowledge, and some were theorists or connoisseurs who wrote about painting. As in earlier periods, some entered into official service, while others avoided it, adopting the stance of a recluse.

SHEN ZHOU

Shen Zhou (1427–1509) belonged to a wealthy literati family, and in his youth he studied painting with literati teachers. Because he did not serve in the bureaucracy (offering his obligations to his aging mother as an excuse for fifty years), he had ample time to paint, leaving behind a number of landscapes and bird-and-flower paintings. He is regarded as the leader of the **Wu School**, a group of literati artists working in the Suzhou region, which was known as Wu. He painted "Poet on a Mountaintop" (**FIG. 9-16**) for the

collector Wu Kuan (1435–1504), who presented him with a blank album; later, Shen Zhou's student Wen Zhengming would add his own paintings to some of the empty pages. "Poet on a Mountaintop" depicts mountains rising out of mist, with a grove of trees partly obscuring a temple building. Isolated against the negative space at the top of the composition is a figure holding a staff, standing on a prominent peak; the staff and the remote setting suggest that he is a recluse. The figure appears to read the artist's quatrain written in the sky; composed in the first person, it reveals that the figure of the poet wishes for a friend's company. Poem and painting play off each other well, and it is likely that they were conceived together. Shen Zhou draws the figure in an abbreviated manner typical of literati painting since the Song and Yuan dynasties (see Chapter 8, FIGS. 8-18, 8-28, and 8-29), and he chooses the **Dong-Ju** style for the landscape, with **hemp-fiber strokes**, vegetative dots, and trees with exposed trunks. The relatively wet ink and the use of a round brushstroke (with a hidden brush tip) for the outline, which recall the style of one of the Four Great Masters of the Yuan, Wu Zhen (see Chapter 8, FIG. 8-29), became hallmarks of Shen Zhou's style.

WEN ZHENGMING

Wen Zhengming, a native of Suzhou, began studying painting with Shen Zhou at age 20 and collaborated with Qiu Ying on more than one occasion, serving in office only briefly and beginning quite late, at age 54. He most commonly painted landscapes and garden scenes. He made *Living Aloft* (**FIG. 9-17**) for a contemporary, Liu Lin (1474–1561), on the occasion of Liu's retirement from government service. Wen's long inscription at the top, followed by two of

9-16 • Shen Zhou "POET ON A MOUNTAINTOP"
From the *Landscape Album*, Ming dynasty, ca. 1490–1500. Album leaves, ink and color on paper, 15¼ × 23¾″ (38.7 × 60.33 cm). The Nelson-Atkins Museum of Art, Kansas City, Mo. Purchase: William Rockhill Nelson Trust, 46-51/2.

9-17 • Wen Zhengming *LIVING ALOFT*
Ming dynasty, 1543. Hanging scroll, ink and color on paper, 37½ × 18″
(95.3 × 45.7 cm). Metropolitan Museum of Art, New York. Promised Gift
of Marie-Hélène and Guy Weill, (L.2001.85.2).

his seals, names the recipient, describes his plans, and provides the painting's title and date. Liu Lin intended to reside thenceforth in the second story of his house, in order to be farther removed from the troubles of the world. Accordingly, Wen Zhengming painted a residence in a remote location, with a stream in front of it, mountains standing behind it, and a dense thicket of trees overtaking its garden. The house's second story, open to the air on three sides, rises above the trees. Three figures occupy the large upstairs room: Liu Lin, facing outward; a visiting friend, sitting opposite him; and a servant with a tray, off to the right. The foreground includes the **alum lumps** and vegetative dotting of the Dong-Ju painting tradition, but the crystalline brushwork visible in the foliage is a feature of Wen Zhengming's mature style.

LU ZHI

Lu Zhi (1496–1576), born into the gentry in Suzhou, was Wen Zhengming's student. Like Shen Zhou, he never embarked on an official career; he may have received gifts in exchange for paintings, although he did not paint on commission. He painted both bird-and-flower paintings and landscapes. *The Jade Field* is not a typical literati painting: It is a blue-green landscape, and Lu Zhi fills the entire composition with dense rock formations, leaving no negative space. He painted the work for the Suzhou physician Wang Laibin (1509–after 1550), possibly as payment for medical services. It begins with two figures disappearing into a grotto; between mountain peaks the viewer glimpses plowed fields (**FIG. 9-18**), and, near the end of the painting, brightly painted pavilions. The content of the painting evokes a famous early poem

9-18 • Lu Zhi *THE JADE FIELD* (DETAIL)
Ming dynasty, 1549. Handscroll, ink and color on paper, 9½ × 53⅝″
(24.1 × 136.1 cm). Nelson-Atkins Museum of Art, Kansas City.
Purchase: William Rockhill Nelson Trust, 50-68.

by Tao Qian (literary name Yuanming, 365–427), "The Peach Blossom Spring," in which a fisherman passes through a cave and emerges at the other side to find a valley and people wholly cut off from the outside world—a theme with overtones of reclusion. The painting includes a forged colophon that imitates the artist's hand, signature, and seals; his genuine colophon would have had value on its own, and was probably removed from this scroll. Still, the colophon probably replicates the artist's original inscription: a poem that refers to Daoist medicine, alchemy, and concepts of the cosmos, connections that clarify why this painting made an appropriate gift for a doctor.

CHEN CHUN

Another Suzhou scholar who studied with Wen Zhengming, and possibly Shen Zhou as well, was the painter Chen Chun (also known as Chen Shun, 1483–1544). He too chose to work as a professional calligrapher and painter, specializing in bird-and-flower paintings and landscapes. Some of his work was **unorthodox** in style—meaning that it did not belong to any established tradition of painting—but he occasionally referenced the styles of painters from the past. One painting of this type was *Hills and Streams after Rain*, created in the **Mi family style** of the Song dynasty; the center of the composition appears in **FIG. 9-19**. The Mi-style elements of the composition include conical mountains created from layered daubs of ink, dotting that suggests

vegetation, and negative space that conveys bands of mist cutting through the landscape. Chen's use of white pigment to highlight the clouds recalls Mi Youren's similar technique in *Cloudy Mountains* (FIG. 8-15). Unusually, Chen Chun renders the landscape in vibrant hues of green, painting the foliage of the trees with quick applications of colored wash; this technique of laying down areas of wet ink or pigment without outlining them first is referred to as **boneless**, and he used it in other paintings as well. Although many of the Wu School painters attempted paintings in the Mi family style, Chen Chun's inspiration was more direct. His village, Dayaocun, had been the home of Mi Youren's sister after her marriage, and Mi Youren had painted the place; centuries later, Chen Chun's grandfather owned Mi Youren's painting of Dayaocun, and Chen Chun was undoubtedly familiar with it.

XU WEI

Xu Wei (1521–1593), from Shaoxing, Zhejiang province, had an extraordinarily difficult life. While it is often possible to see some aspect of an artist's background reflected in his or her work, Xu Wei's paintings present a conundrum. Orphaned in childhood, he had been a prodigy excelling in many arts, including calligraphy and painting. He served in the government for a time but seems to have suffered from bouts of madness. Two events from his life are especially lurid: his suicide attempt (in which he used various sharp objects to do violence to his eardrum, skull, and testicles)

9-19 • Chen Chun (a.k.a. Chen Shun) *HILLS AND STREAMS AFTER RAIN* (DETAIL)
Ming dynasty. Handscroll, ink and color on paper, 10⅜ × 65¾″ (26.3 × 167.1 cm). Nelson-Atkins Museum of Art, Kansas City. Purchase: William Rockhill Nelson Trust, 46-42.

兰亭舊種越王蘭碧浪紅

青天六傳近日幾青成束束一籃

不值亚文錢

天作奇書畫畫雲中思本掌

儀羲獻之羽勤

墨点嬌姿小緣句蕖中亦之

賞青青長安醉客辞蔫为崇去

踏沉青青亭上塵

9-20 • Xu Wei TWELVE PLANTS AND TWELVE CALLIGRAPHIES (DETAIL)
Ming dynasty. Handscroll, ink on paper, 13½ × 396⅜″ (34.2 × 1014 cm). Honolulu Museum of Art. Gift of the Martha Cooke Steadman Fund, 1960, 2710.1.

and the murder of his third wife (for which he was imprisoned; an intercessor eventually won his unwilling release). He began painting around the age of 50, and judging from his surviving works, he mostly painted sublime images of flowers and plants. *Twelve Plants and Twelve Calligraphies* pairs sequential images of plants with Xu Wei's writing in running script; the first two images are a peony and a magnolia (**FIG. 9-20**). Xu Wei created some of the most painterly art of the Ming dynasty: He relies on different gradations of ink wash, laid one on top of another in a wet-on-wet technique, to convey translucence. He paints the plants using the boneless method. His technique has antecedents in the **splashed-ink** work of Chan Buddhist artists and in the paintings of Chen Chun.

Dong Qichang's discussion of social groups of painters, which echoed the ideas of two contemporaries, is known as the theory of the Northern and Southern Schools. It shaped views about painting for centuries to come, leading to the literati being regarded as truer artists than court and professional painters. Dong Qichang used the context of art patronage to separate the so-called scholar-amateur painters from those who received monetary compensation for painting, designating the former group as the Southern School and the latter group as the Northern School. The names derive from Chan Buddhist notions of differences between gradual and sudden enlightenment. The Northern Schools of Chan practice promoted the long commitment to Buddhist teachings that lead over several lifetimes to enlightenment; Dong Qichang compared this to the formal training of court or professional painters and their

work for a particular patron or the market. The Southern School of Chan practice believed in sudden enlightenment; Dong Qichang likened this to the situation of literati painters, who, as amateurs, supposedly painted based on spontaneous inspiration and did not typically develop their painting skills through extensive training. He later applied these theories to Ming painting, praising the literati painters of the Wu School and disdaining the academic and professional painters of the Zhe School.

The following translations of Dong Qichang's writing appeared in Xie Zhiliu's and Wen C. Fong's essays for *The Century of Tung Ch'i-ch'ang* (1992). These sources and others that take a critical look at Chinese art patronage have begun to debunk the idea that literati, court, and professional painters can always be easily distinguished, and judgments made of the respective value of their work.

In Chan Buddhism there is a Southern and a Northern school, which first separated in the Tang period; in painting, a similar division into a Southern and a Northern school also appeared in the Tang period. But those involved were not divided between southerners and northerners. The Northern School followed Li Sixun [fl. ca. 705–720] and his son [Li Zhaodao, fl. mid-eighth century], who painted landscapes with color; their manner was transmitted in the Song period by, among others, Zhao Gan [fl. mid-tenth century], Zhao Boju [ca. 1120–ca. 1170], and [Zhao] Bosu [1123–1182] down to Ma [Yuan, fl. ca. 1190–ca. 1225] and Xia [Gui, fl. ca. 1220–ca. 1250]. The Southern School began with Wang Mojie [Wang Wei], who first used a light ink wash technique, transforming the outline method; it was transmitted by Zhang Zao [fl. late eighth–early ninth century], Jing [Hao, ca. 870–80–ca. 935–40], Guan [Tong, fl. 907–923], Dong [Yuan], Ju[ran, fl. ca. 960–ca. 986], Guo Zhongshu [d. 977], and the Mis father and son [Mi Fu; Mi Youren, 1074–1151] down to the Four Great Masters of the Yuan.

When a scholar turns to painting, he applies to it the methods of writing unusual characters in the grass or clerical script, making his trees resemble curved iron bars and his mountains look as if they were drawn in the sand. The narrow path of sweetness and vulgarity should be avoided altogether. His painting will then have a scholarly breath (qi). Otherwise, even if a work shows high technical competence, it already falls into the pernicious ways of the professional artisans.

Although Qiu [Ying, ca. 1494–ca. 1552] and Zhao [Mengfu, 1254–1322] are different in their style, they both belong to the school of the professional, unlike those who take painting as a form of self-expression or a source of sheer joy.

When painting, he [Qiu Ying] was so concentrated that he would hear the sound of the sonorous marching band as if it were merely the clank of women's hairpins or bangles from the other side of the wall. His art is almost a painstaking task. Not until I reached the age of fifty did I realize that the painting of this school should not be practiced.

DONG QICHANG

The literati painter Dong Qichang (1555–1636), a native of the Shanghai area who held a prominent official position at court, was an important art theorist. He helped to disseminate an enduring viewpoint: that literati painting fundamentally differed from that of court artists and professionals (see Point of View, above). In his own painting, he aspired to follow the Dong-Ju tradition and the Four Great Masters of the Yuan. His inscription at the top right for the painting *Qingbian Mountains* (**FIG. 9-21**) declares that the painting follows the manner of Dong Yuan, one of the painters who established the Dong-Ju tradition. However, as the title clarifies, this painting is also a re-imagining of an earlier painting by Wang Meng, entitled *Dwelling in Reclusion in the Qingbian Mountains* (see **FIG. 8-31**). A striking aspect of Dong Qichang's composition is its deliberately illogical passages. He plays with scale throughout; he

pushes the twisting forms of the mountain beyond anything seen in nature, in order to convey their energy; he undercuts his own depiction of mist through negative space by omitting the light ink wash that would allow the viewer to envision the transition from one element to another. Dong Qichang's landscape moves decidedly away from **naturalism** and toward the realm of ideas: In essence, his is a painting about painting.

MING AND QING FEMALE PAINTERS

Female painters seemed to increase in number during the Ming and Qing dynasties—or, perhaps, connoisseurs began to appreciate their work, leading them to collect more of it and write about it

青年圖像此義葉
丁巳夏五明日寫
陳慎其此文
董其昌
積漢千靈互紫雲
雲瑞雅大見邢瑞
秋岑戶雲坊清日
源泗亭申起毛志

9-21 • Dong Qichang QINGBIAN MOUNTAINS
Ming dynasty, 1617. Hanging scroll, ink on paper, 88⅜ × 26½″ (224.5 × 67.2 cm). Cleveland Museum of Art. Leonard C. Hanna, Jr. Fund 1980.10.

more frequently. A comprehensive history of female painters compiled in the early nineteenth century lists 216 in total, with close to half of these living during the Ming dynasty and a significant number dating from the early and middle Qing. Recorded female painters in these eras were court ladies, wives and daughters of scholarly families or the gentry, concubines or maids, or courtesans. Those whose works have survived emerged from environments that fostered female painters: They belonged to families with strong

traditions of painting practice, or they began as courtesans with significant training in the arts.

QIU ZHU

The daughter of the professional painter Qiu Ying, possibly named Qiu Zhu (fl. ca. 1563–ca. 1580), was also a highly skilled painter, working in multiple genres, including landscapes and figure paintings. One of her specialties was the figure of the Bodhisattva of Compassion, Guanyin (Skt. Avalokiteshvara), as seen in a detail from an album of 24 images of this deity accompanied by text, painted in gold on ink-dyed paper. By the late Ming dynasty, Guanyin had come to be perceived as female and held special relevance to women: Women commonly appealed to her, particularly in matters involving children. This suggests that the album's patron may also have been a woman. Two seals of a wife of the collector Xiang Yuanbian (1525–1590) appear in this album, which may be significant; Qiu Ying had served as his artist-in-residence. The last leaf (**FIG. 9–22**), which Miss Qiu signed, depicts the **bodhisattva** seated on the rocks of Mount Potalaka—believed to be Guanyin's

9-22 • Miss Qiu (possibly named Zhu)
PORTRAITS OF GUANYIN (DETAIL)
Album of 26 leaves, Ming dynasty, ca. 1580. Gold on ink-dyed paper, 11¾ × 8⅝″ (29.9 × 22 cm). Herbert F. Johnson Museum of Art, Cornell University, Ithaca, NY.

9-23 • Xue Wu (courtesy names Susu and Sujun)
CHRYSANTHEMUMS AND BAMBOO
Folding fan, Ming dynasty, 1633. Ink on gold
paper, 7⅜ × 22½″ (18.7 × 57.2 cm). Honolulu
Museum of Art. Gift of Jean-Pierre Dubosc,
1957, 2312.1.

abode—next to the sea. An attendant beside her holds a vase, which is one of Guanyin's attributes, and the bodhisattva wears a crown that is partly concealed by fabric draped over her head. Miss Qiu renders the figures primarily in bold, flowing outlines that are quite even in width, suggests the billowing waves with fine lines, and uses subtly modulated lines and smudges of gold to indicate the texture of the rocks on which the bodhisattva sits. The album's images appear to derive from a series of works that ultimately trace back to the Northern Song painter Li Gonglin's handscroll of 32 manifestations of Guanyin (now lost), although another Ming dynasty professional painter is also credited with images of Guanyin in gold on dark paper.

XUE WU

The paintings of courtesans typically present literati themes, reflecting the affinity between the two groups. Courtesans received educations strong in poetry and music, and appealed to the literati partly because of their artistic inclinations; a

courtesan's paintings helped her to construct a public image that revealed facets of her character. The surviving paintings of Xue Wu (ca. 1564–ca. 1637), also known by the **courtesy names** Susu and Sujun, predominantly depict plants that have poetic associations with scholars, such as orchids, bamboo, narcissus, and chrysanthemums. Xue Wu spent time in Suzhou, Beijing, and—in her youth—the famous Qinhuai courtesan district of Nanjing; she reportedly made multiple marriages and began to practice Buddhism near the end of her life, styling herself as a hermit. *Chrysanthemums and Bamboo* (**FIG. 9-23**) is a late work, painted in monochrome ink on gold-flecked paper, in the format of a folding fan (which originated in Japan and became a popular format in China in the Ming). The two plants and a garden

9-24 • Chen Shu ***FLOWERS*** (DETAIL)
Qing dynasty. Handscroll, ink on paper, 12¼ × 217″ (31.1 × 551.2 cm). Asian Art Museum, San Francisco. Gift of the Connoisseurs' Council. 1991.225.

rock constitute the majority of the composition. Off to the right, Xue Wu inscribed a signed quatrain that refers back to a poem by the recluse Tao Qian titled "Drinking Wine," alluding to his chrysanthemum hedge, his view of the southern mountains, and his wine cup, and clearly connecting the fan's imagery with notions of withdrawal from the world.

CHEN SHU

A highly successful female painter of the Qing dynasty was Chen Shu (1660–1736), a native of Jiaxing, Zhejiang province—an area that boasted many female painters. Chen Shu married a calligrapher who supported her artistic inclinations and often inscribed her works with poetry. She was most productive after her children grew up, and sometimes sold her paintings for household money; later, her son served at the court of the Qianlong emperor (r. 1736–1795) and presented examples of her paintings to him. Chen Shu inspired several of her descendants to take up painting themselves. She specialized in the depiction of birds and flowers, and a handscroll focusing on the latter subject opens with a blossoming plum tree (**FIG. 9-24**). Her rendering of plants here follows the tradition of Chen Chun (who was unrelated to her) and recalls that of another of his followers, Xu Wei. Unusually, she executes the plum tree in the boneless style (see p. 208), with an emphasis on tonal ink washes rather than brushwork.

QING COURT PAINTERS

The Manchu court continued to support artists, regarding this practice as a means of demonstrating affinity with Chinese culture, and the Qing emperors amassed a collection that included many of the finest specimens of Chinese painting and calligraphy. The Kangxi and Qianlong emperors were particularly active in this regard; the latter often asserted his connoisseurship by writing inscriptions directly on his paintings (see Chapter 8, p. 191). The emperors asked literati to advise them on art acquisitions, and painters working at the court had access to examples of various Chinese painting traditions.

Several of the earliest Qing dynasty artists worked in **orthodox** styles that strongly evoked the past. These include the painters known as the Four Wangs: Wang Shimin (1592–1680), an amateur artist and follower of Dong Qichang; his friend Wang Jian (1598–1677); his student Wang Hui (1632–1717); and his grandson Wang Yuanqi (1642–1715). The last two both ended up serving under the Kangxi emperor. Wang Yuanqi, a scholar, arrived at court via the civil service examinations, holding office in the Imperial Secretariat and serving as an art expert. He produced many paintings in the literati mode for the court, such as *Wangchuan Villa* (**FIG. 9-25**): These demonstrate the Manchu patron's desire to lay claim to the Chinese literati heritage. *Wangchuan Villa*, a vibrantly colored composition, obviously derives from a later recension of poet-painter Wang Wei's earlier composition of the same title (see also Chapter 7, **FIG. 7-21**), most likely a stone engraving dating to 1617. Wang Yuanqi's choice of Wang Wei for inspiration clearly demonstrates his own alignment with Dong Qichang's Southern School. His colophon indicates his attempt to capture one of Wang Wei's best-known ideas—that there is painting in poetry and poetry in painting. The references to the golden age of the Tang suggest also the Manchus' desire to **appropriate** Chinese tradition.

In the late sixteenth century, Jesuits first entered China, and by the eighteenth, they had become valued advisors at the Qing court. They brought in examples of European art, which

9-25 • Wang Yuanqi *WANGCHUAN VILLA* (DETAIL)
Qing dynasty, 1711. Handscroll, ink and color on paper, 14 × 214¾" (35.6 × 545.5 cm). Metropolitan Museum of Art, New York. Ex coll.: C. C. Wang Family, Purchase, Douglas Dillon Gift, 1977, 1977.80.

9-26 • Lang Shining (Giuseppe Castiglione) and Chinese court painters *INAUGURATION PORTRAITS OF THE QIANLONG EMPEROR, HIS EMPRESS, AND THE ELEVEN IMPERIAL CONSORTS, OR MIND PICTURE OF A WELL-GOVERNED AND TRANQUIL REIGN* (DETAIL)
Qing dynasty, 1736. Handscroll, ink and color on silk, 20⅞ × 271″ (52.9 × 688.3 cm). Cleveland Museum of Art. John L. Severance Fund 1969.31.

exposed Chinese artists to a different approach to the representation of nature. One Jesuit, Giuseppe Castiglione (1688–1768), arrived in Beijing in the Kangxi reign and adopted the Chinese name Lang Shining. A native of Milan, he had trained as a figure painter in the late Baroque style; in China, he painted for three different emperors—Kangxi, Yongzheng (r. 1723–1735), and Qianlong. Lang Shining is best known for his paintings of horses, which remained a metaphor for imperial power, but he also painted the first three bust portraits in *Inauguration Portraits of the Qianlong Emperor, His Empress, and the Eleven Imperial Consorts* (**FIG. 9-26**); Chinese painters completed the final ten. In many respects, Lang Shining's painting combines elements of European and Chinese styles. His composition has a formality common to portraits of emperors and empresses: The static and symmetrical figures are positioned frontally, in dress that reveals their status. The bust portrait recalls a form used by Nepalese artist Anige for Yuan imperial portraiture. The hint of modeling evident in the faces is unusual: Lang Shining, by necessity, eschewed the Baroque convention of the half-lit face, which the Qianlong emperor rejected on the grounds that it made faces

look dirty, so instead the artist conveyed three-dimensionality through subtle gradations of ink wash. The emperor acknowledged the work with the impression of nine of his seals.

QING INDIVIDUALIST AND ECCENTRIC PAINTERS

With the increasing pressure of the market, artists who did not enjoy the benefits and stability of political alignment with the Qing court were often compelled to embrace the emerging artistic criterion "originality" as a means to survive in the patronage system. Some artists fervently opposed to Manchu rule affirmed their commitment to Chinese tradition and history through the medium of painting. Others developed in new directions, and alternative paths in image-making also became a means to register resistance and a sense of loyalty to the erstwhile Ming government. The latter artists are often labeled "individualist" or "eccentric," and include both amateur and professional painters.

GONG XIAN

With questions of loyalties again coming to the fore, many Chinese identified themselves as leftover subjects of the Ming. Some have interpreted the landscapes of the educated professional painter Gong Xian (ca. 1617–1689), who worked in the cities of Nanjing and Yangzhou, as embodying loyalist sentiments. His market may have consisted primarily of other leftover subjects, many of whom gathered in Nanjing, the seat of the brief Southern Ming dynasty (a last stand of the Ming imperial line), after 1644.

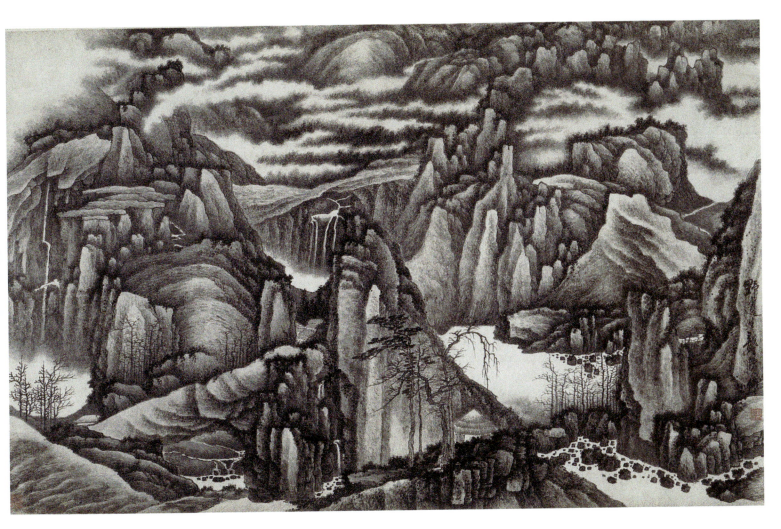

9-27 • Gong Xian A THOUSAND PEAKS AND MYRIAD RAVINES
Qing dynasty, ca. 1679. Hanging scroll, ink on paper, 24⅜ × 40⅛″ (62 × 102 cm). Museum Rietberg, Zurich. Gift of Charles A. Drenowatz.

The strong contrast between light and dark evident in his work distinguishes it from that of his peers; he achieved this unusual effect by applying ink in layers, and the dark landscapes suggest the artist's somber mood following the change of dynasty. Gong Xian also sought to convey a quality of strangeness that may reflect his mindset in the early Qing, and he valued observation of nature over the study of historical painting traditions. His best known work is *A Thousand Peaks and Myriad Ravines* (**FIG. 9-27**), a painting that has another source altogether: The craggy rock formations, wisps of cloud, and the stark contrast between light and dark all echo an engraving of 1579 by the Flemish artist Anton Wierix (ca. 1559–1604). Titled *View of Thessaly and the Vale of Tempe*, it appeared in an illustrated book that Jesuits brought into China. Gong Xian takes elements familiar from earlier Chinese landscapes—mountain peaks, mist, waterfalls, streams, rocks, vegetation, and a rustic hut—and crams them together, overlapping the different forms. With minimal use of negative space or atmospheric perspective, there is little sense of depth; instead, the picture plane appears tipped up.

ZHU DA AND SHITAO

Loyalist themes are strong in the work of the individualist Zhu Da (also known as Bada Shanren, 1626–1705), who was related to the Ming imperial family—a connection that may have been politically dangerous for him. A native of Nanchang, Jiangxi province, he entered Chan monastic life just after the establishment of the new dynasty and remained a monk until 1680, probably as the best means of withdrawing from society. He further isolated himself by feigning madness and refusing to speak for a number of years, communicating primarily through gestures and writing. He inscribed his paintings with cryptic poems that, upon careful study, often reveal political themes. One example is *Moon and Melon* (**FIG. 9-28**), painted after his return to his hometown. Working in ink on paper, Zhu Da painted a watermelon in the foreground and a large, circular outline behind it that represents the moon. At the top of the painting, he scrawled a quatrain, using obscure variations for some of the characters: "A Ming cake seen from one side, / The moon, so round when the melons rise. / Everyone points to the mooncakes, / But hope that the melons will ripen is a fool's dream." The allusion to round mooncakes, eaten at the Mid-Autumn Festival, is one key to the painting's meaning. Zhu Da painted this on the evening of the 1689 festival, which also marked the anniversary of an unsuccessful revolt against the Manchus in Nanchang that culminated in the execution of its two Chinese

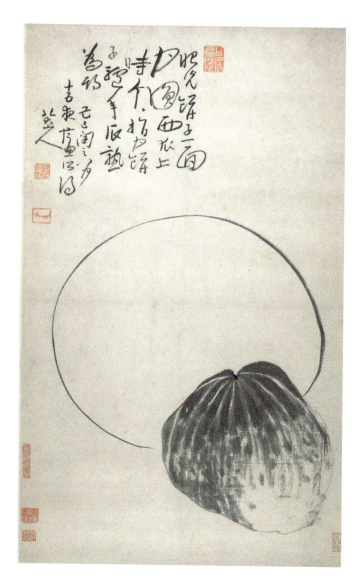

9-28 • Zhu Da (a.k.a Bada Shanren) MOON AND MELON
Qing dynasty, 1689. Hanging scroll, ink on paper, 29 × 17¾″ (73.6 × 45.1 cm). Harvard Art Museums/Arthur M. Sackler Museum, Cambridge, MA. Gift of Earl Morse, Harvard Law School, Class of 1930, 1964.94.

life first in Nanjing and then in Yangzhou, where he supported himself as a professional painter. He approached painting in a completely unorthodox manner, writing, for example, that if his work bore any resemblance to that of the ancients, it was because they were copying him. His landscape album titled *Reminiscences of Qinhuai River* demonstrates his individualist mindset. The final leaf (**FIG. 9-29**) shows a man standing in a boat, looking up at a mountain looming over the river. Shitao uses dots to indicate vegetation and hemp-fiber strokes (unusually depicted as vertical) that derive from the Dong-Ju tradition, but the trees that appear to grow upside down halfway up the mountain are quite unusual, and the bold, insistent brushwork delineating the mountain peaks may embody the painter's original theory of the primordial brushstroke. The inscription filling the negative space of this leaf reveals that Shitao made the album for a friend who sent him some paper and requested a painting. Shitao chose to paint his reminiscences of their time together in the 1680s searching for plum blossoms on the Qinhuai River near Nanjing, and indeed the figure on the

9-29 • Shitao (Zhu Ruoji, a.k.a. Daoji or Yuanji)
REMINISCENCES OF QINHUAI RIVER (DETAIL)
Qing dynasty, ca. 1695–1700. Album of eight leaves, ink and color on paper, 10 × 8″ (25.5 × 20.2 cm). Cleveland Museum of Art. John L. Severance Fund 1966.31.8.

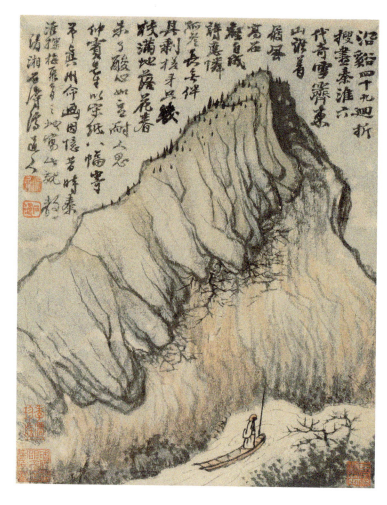

leaders. Mooncakes further evoke the Chinese rebels who overthrew the Yuan and carried the cakes as proof of affiliation with the insurgents. The moon stands for the Ming emperors; the character *ming* consists of the radicals, or components, for sun and moon. As for the melon, it has two political meanings. It alludes to the fall in status of the loyal Marquis of Dongling, a Qin aristocrat who became a melon farmer under the Han. Its seeds (implied in the poem by the notion of ripening) refer to multiple imperial descendants, as the Chinese words for "seed" and "son" are identical. This seemingly simple painting therefore expresses the impossibility of reinstating the Ming.

Zhu Da had a distant imperial cousin, Shitao (1642–1707—born Zhu Ruoji, also known by the nickname Daoji), who followed a similar path. He was a native of Guilin, Guangxi province, and became a Chan monk for a time, teaching himself to paint during this period of his life, before returning to secular

boat, who could be taken as a recluse, appears to be enjoying the spring scenery. Much of the inscription consists of Shitao's poem describing recluses moving through the landscape, looking for plum trees and composing poetry.

JIN NONG

Jin Nong (1687–1764), born into the gentry in Hangzhou, was a member of the literati and a student of poetry who retired to Yangzhou for its literary culture. He began to paint on commission and was numbered among the Eight Eccentrics of Yangzhou, a group of painters (not all contemporaneous) who developed individual styles and refused to follow established conventions. Jin Nong specialized in paintings of plum blossoms; one of the most unusual is a hanging scroll from 1760 (**FIG. 9-30**). It represents a cropped view of the intertwining, upward-growing branches of a blossoming tree. Jin Nong often painted this subject in monochrome, but here he brushed many of the flowers with pale pink hues. He wrote an inscription at the top left, in distinctive calligraphy based on Han dynasty clerical script, and impressed his artist's seal. The inscription reveals that Jin Nong created the painting for a prominent Yangzhou salt merchant (Jiang Chun), demonstrates the artist's serious study of poetry, and suggests that he meant his imagery to refer to a woman. Jin Nong begins with lines from a poem he had written for an earlier painting presented to a friend on the occasion of his acquisition of a new concubine. In poetry, plum blossoms can represent a scholar: Blooming in winter, according to the Chinese lunar calendar, they suggest a scholar's arrival at greatest intellectual prowess in later life. Alternatively, they can represent a beautiful woman: Flowers are reproductive organs, and the texture and hue of plum-blossom petals compare to an ideal woman's skin. In citing his own poem, Jin Nong foregrounds the feminine associations of the plum blossom. Then, he declares that he used red and black pigments from a woman's cosmetic box for this composition—a practice that must be considered radical. Finally, he suggests that the painting might make an appropriate gift for someone in possession of ten bushels of pearls—a reference to a tune used for song lyrics, a genre of poetry closely associated with courtesans. The educated recipient often hosted literary gatherings; it is possible that the poetic associations outlined in the inscription made the painting more appealing to him, and that Jin Nong may have been commenting on some aspect of his relationships with women.

REN XIONG

Ren Xiong (1820–1857), an educated professional painter, worked in Shanghai. Several members of his family became painters, and he took lessons in portraiture in his youth. He painted his

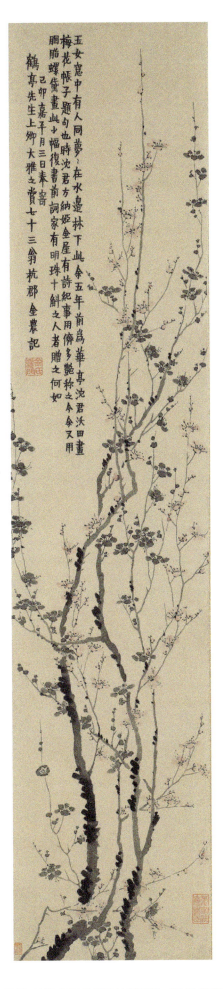

9-30 • Jin Nong BLOSSOMING PLUM
Qing dynasty, 1760. Hanging scroll, ink on paper, 51¼ × 11⅛ (130.2 × 28.2 cm). Freer Gallery of Art, Smithsonian Institution, Washington, D.C. Purchase F1965.10.

The painters of both of these compositions were Buddhist monks. Wu Bin (fl. 1591–1626), who painted *The Sixteen Luohans*, worked in Nanjing on commissions from the Beijing court; Buddhist figures were one of his specialties, and he was a Chan monk. His 16 *luohans*, or **arhats**, represent the original disciples of the historic Buddha; in this detail **(FIG. 9-31)**, several gather around the Bodhisattva of Wisdom, Manjushri. Luo Ping (also known as Luo Pin, 1733–1799), who painted *Hanshan and Shide* **(FIG. 9-32)** was Jin Nong's student, and counted alongside him as one of the Eight Eccentrics of Yangzhou. His painting represents two poets: Hanshan lived in a cave outside a Chan monastery, and Shide, a monk of low status and a laborer, brought him food. Luo Ping's long inscription appears at the top of the composition: Most of it transcribes a poem jointly written by Hanshan and Shide, which takes up the question of happiness and begins and ends with the line "Ha! Ha! Ha!"

THINK ABOUT IT

1. Wu Bin is described as a court painter, and Luo Ping as an eccentric. Does Luo Ping's work seem more eccentric than Wu Bin's? Why or why not?

2. The subjects of both paintings are revered figures within Buddhist traditions: arhats and bodhisattvas are enlightened, whereas Hanshan and Shide, if not actually enlightened, at least approach a deep understanding of the dharma (teachings of the Buddha). Do the painters make that evident? If so, how? If not, why not?

3. Both of these compositions deal to a greater or lesser extent with ideas of play and amusement. What are some of the visual signs of these ideas? Would you have suspected that this would be a value within Buddhism? Explain your reasoning.

9-32 • Luo Ping (a.k.a. Luo Pin) *HANSHAN AND SHIDE*
Qing dynasty. Hanging scroll, ink and slight color on paper, 31 × 20⅜″ (78.7 × 51.8 cm). Nelson-Atkins Museum of Art, Kansas City. Purchase: William Rockhill Nelson Trust, 72-5.

9-31 • Wu Bin
***THE SIXTEEN LUOHANS* (DETAIL)**
Ming dynasty, 1591. Handscroll, ink and color on paper, 12⅝ × 163⁹⁄₁₆″ (32.1 × 415.4 cm). Metropolitan Museum of Art, New York. Edward Elliott Family Collection, Gift of Douglas Dillon, 1986, 1986.266.4.

Self-Portrait (**FIG. 9-33**) near the end of his short life. *Self-Portrait* is a study in contradictions, reflecting Ren Xiong's refusal to adhere to convention. Roughly life-size, it depicts the artist's head and shoulders, sensitively and naturalistically rendered, emerging from voluminous, boldly outlined garments that seem cartoonish in their execution. Along the left margin, Ren Xiong's inscription fills most of the available negative space, demanding attention. Though parts are difficult to understand, the inscription clearly refers to his sense of disconnection from a tumultuous world. The figure is shown frontally, with his hands clasped in an aggressive pose, mouth set, and eyes lifted to meet those of the viewer.

With the inscription in mind, it becomes tempting to read this as another contradiction: The artist confronts his audience, seeking to forge a connection where he feels none.

The new developments in arts and architecture of the Ming and Qing dynasties demonstrate the impact of increasing urbanization and commercialization. At the same time, certain trends—such as increasing interaction with Europeans—would become much more important as China moved into the twentieth century. With the overthrow of empire in 1911, the Chinese struggled to define the role of their traditional culture in their push toward modernization.

9-33 • Ren Xiong *SELF-PORTRAIT*
Qing dynasty, ca. 1856–1857. Hanging scroll, ink and color on paper, 46¼ × 30¾″ (177.5 × 78 cm). Palace Museum, Beijing.

CROSS-CULTURAL EXPLORATIONS

9.1 Consider how landscape paintings, bird-and-flower paintings, and gardens present different views of nature. What qualities of nature are these works of art attempting to convey? How are the Chinese views of nature in the Ming and Qing periods distinct from those of other cultures?

9.2 A hallmark of Chinese painting, particularly (but not limited to) that of the literati, is the incorporation of calligraphy into the composition. How does this affect the viewer's experience of the art? Is this a common feature in other artistic traditions? Why was it done so frequently in China?

9.3 European art was an important element at the Qing dynasty court and at the Mughal court in India. How did the introduction of European art affect Chinese and Indian artistic practice?

9.4 Patronage helped to shape the art of the Ming and Qing dynasties. How is art that is produced on commission different from art that expresses something about the artist's personality? Is it truly possible to produce art in a context entirely separate from market forces?

The Push for Modernization: 1912 to the Present

When society changes, thinking changes, and naturally art changes as well.

Xu Bing (b. 1955)

Under pressure from revolutionaries—including Chinese who objected to Manchu rule and intellectuals (such as the Western-trained Sun Yat-sen, 1866–1925) convinced that a republic would be a better form of government—the last Qing emperor abdicated in early 1912. In the turbulent years since, the Chinese have sought to rethink their society as it becomes more deeply integrated into the world at large. The last century—a period of increasingly nationalistic ideology—has witnessed the negotiation of the relentless push for modernization against the desire to retain certain aspects of traditional Chinese culture. Some artists reject the ingrained tendency to exalt the past, others reject the unreserved embrace of new elements, and still others seek a balance between historical and contemporary ideas. The artist Xu Bing, quoted above, has made thought-provoking work that grapples with these problems (**FIG. 10-1**). Although many artists continue to work in traditional **media** or with traditional content, rapid change within China itself and artists' increasing participation in the international art scene have helped shape twentieth- and twenty-first-century Chinese art.

10-1 • Xu Bing A BOOK FROM THE SKY
1987–1991. Carved woodblocks, bound hand-printed books, and ink on paper, dimensions variable. Installation view at the Elvehjem Museum of Art, Madison, Wisconsin, 1991. Courtesy Xu Bing Studio.

The Republic of China was established in 1912. In its early years, warlords fought over Chinese territory, but in 1928 the Nationalist party (Guomindang)—also known as the Kuomintang or KMT—gained control of the government. The other major political party was the Communist party (Gongchandang). After China entered fully into war with Japan in 1937, the two parties briefly joined forces to oppose the Japanese, but conflict between them escalated in the 1940s and a civil war broke out in 1945. In 1949, the Communists declared victory and founded the People's Republic of China. The Nationalist government moved the seat of the Republic of China to the island province of Taiwan; the split between the two governments continues to be a source of conflict. In both the Republican and Communist eras, the government endorsed substantive reforms, including changes in the written language and new ideas about the societal role of women. The Communist government made further changes with the aim of improving the standard of living for the general populace, in particular the creation of agricultural collectives, the promotion of industrialization, and policies that have led to an economic boom.

REPUBLICAN-ERA PICTORIAL ARTS, 1912–1949

The establishment of the Republic of China in 1912 led to changes in the art world, modeled on facets of artistic practice in America and Europe. Chinese artists began going abroad to study. Art schools, museums, and galleries opened, and a broader range of people had access to art than in the past, when collectors and connoisseurs hailed from the elite classes. Still, certain elements of traditional artistic practice persisted.

CHEN HENGKE

One painter from the early republic, Chen Hengke (**courtesy name** Shizeng, 1876–1924), drew inspiration from Ming and Qing painters—including Shen Zhou, Gong Xian, and Shitao (see Chapter 9, FIGS. 9-16, 9-27, 9-29)—as well as from a period of study of Western-style art (*yoga*) in Japan, which was also rapidly modernizing. Known for his **landscape**, figure, and bird-and-flower paintings in a traditional mode, he eventually became a painting professor in Beijing. His *Viewing Paintings at an Exhibition* (**FIG.** 10-2), a **hanging scroll** in ink and color on paper, depicts an event held in a hall in Beijing's Central Park, with proceeds benefiting victims of flooding, and attracting over 600 visitors per day—a subject that reflects the growing democratization of art at that time. In the foreground, a group of people cluster around a table, perusing a **handscroll** and albums on display. Men and women mix together; their hats and coats reflect both Western and Chinese fashions. A male figure in the foreground, seen in profile, is clearly of European descent, while others in the group seem to be of Chinese ethnicity. In the background, landscape paintings mounted as hanging scrolls attract the attention of another group of people. At the top left, what appears at first glance to represent a **calligraphy** scroll is actually Chen Hengke's inscription, giving the title, date, and circumstances of the work. In addition to providing insight into Beijing's art scene, this painting suggests the cosmopolitan nature of Beijing society in the 1910s.

GUAN ZILAN

Shanghai also had a robust international population, and its artists often pursued modernist approaches to art. One was Guan Zilan (also known as Violet Kwan, 1903–1986), active in the 1920s and 1930s and a teacher in an academy of fine arts. She received

10-2 • Chen Hengke (courtesy name Shizeng)
VIEWING PAINTINGS AT AN EXHIBITION
1917. Hanging scroll, ink and color on paper, 34½ × 18⅜″ (87.7 × 46.6 cm). Palace Museum, Beijing.

10-3 • Guan Zilan (a.k.a. Violet Kwan) ***PORTRAIT OF MISS L***
1929. Oil on canvas, 35½ × 29½″ (90 × 75 cm). National Art Museum of China, Beijing.

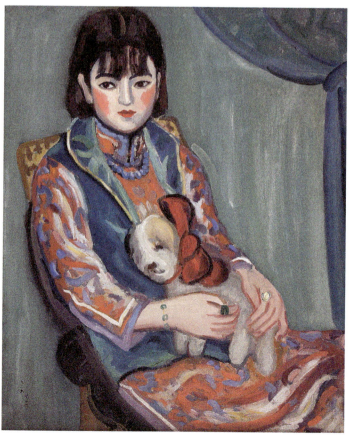

painting instruction in Shanghai, under a professor who had studied in Japan with a painter trained in Paris; in 1928, she too traveled to Japan, enrolling at the Tokyo Institute of Culture. A year later, she painted *Portrait of Miss L* (**FIG. 10-3**). This work, executed in oil on canvas, recalls the art of the Japanese painter Yasui Sotaro (1888–1955), as well as the French painter Henri Matisse (1865–1953), who like many artists of his time developed an interest in the style of the Japanese **woodblock prints** that began to appear in France in the late nineteenth century. The painting focuses on the figure of a young woman with bobbed hair and bangs sitting in a chair and cradling a lap dog, dressed in a modern Chinese dress called a *qipao* and a vest, and adorned with jewelry that advertises her high status. Guan Zilan juxtaposes areas of flat, vibrant color with areas of abstract pattern, using bold outlines and gestural brushstrokes. In many ways, the painting reflects fashionable elements within Shanghai society.

WOODBLOCK PRINTS

In the 1920s and 1930s, the writer Lu Xun (1881–1936), a major figure in Chinese literature, began to promote the modern woodcut as a means of educating and organizing the people. He believed that literature, art, science, and medicine could all contribute to China's modernization and help to alleviate the people's suffering, an idea that would become associated with the Communist party. Despite the medium's origins in China, printmakers of the 1930s looked to early twentieth-century European examples for inspiration. Hu Yichuan's (1910–2000) woodcut

To the Front! (**FIG. 10-4**) from 1932 was designed to mobilize the Chinese following the Japanese invasion of Manchuria in 1931. (According to some accounts, the Second Sino-Japanese War begins with this incident; others date the beginning of the war, which ended in 1945, to the invasion of China proper in 1937.) The printmaker, who had studied oil painting at a Hangzhou academy, became involved with the modern woodcut movement in 1931, and *To the Front!* recalls the work of German printmaker Käthe Kollwitz (1867–1945) in its stark presentation of its subject matter. The print appeared in a mid-1932 Shanghai art exhibition intended to disseminate the political message of the leftist Spring Earth Painting Research Center: that art should educate, inform, and organize the masses.

HUANG BINHONG

Other artists continued to work in established modes of painting. For example, Huang Binhong (1865–1955) painted landscapes that drew on his study of nature and his familiarity with Chinese painting history. Born to a scholarly family, he received a classical education and studied historical paintings in private collections, including works by Dong Qichang (see Chapter 9, **FIG. 9-21**). After failing his civil service examinations (taken during the Qing era), Huang began to collect painting and calligraphy and to edit art historical writings for publication, and he later became an art professor. Although he spent much of his career in Shanghai, Beijing, and Hangzhou, from the early to mid-1930s he traveled through the mountainous landscapes of southern China, recording them

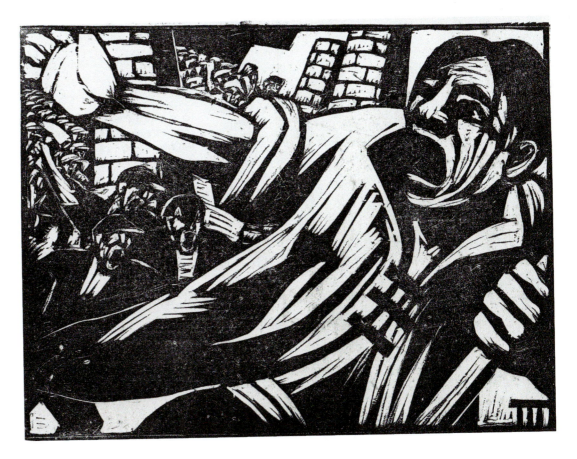

10-4 • Hu Yichuan
TO THE FRONT!
1932. Woodblock print, 9⅛ × 12″ (23.2 × 30.5 cm). Lu Xun Memorial Museum, Shanghai.

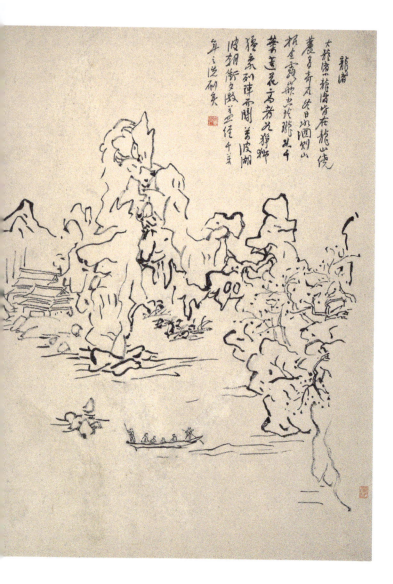

10-5 • Huang Binhong "DRAGON ISLET"
From the album *Sketches of Twelve Strange Mountain Peaks*, ca. 1935. Album leaf, ink on paper, 22 × 16½" (55.9 × 41.9 cm). Metropolitan Museum of Art, New York. Gift of Robert Hatfield Ellsworth, in memory of La Ferne Hatfield Ellsworth, 1986, 1986.267.203.

left. He implies a body of water in the foreground through a rendering of a boat and longer brushstrokes that suggest ripples. At the top right, Huang's inscription names the place depicted and describes the erosion of the mountains over millennia. In many ways, this is a painting in the **literati** mode.

XU BEIHONG

The artist Xu Beihong's (1895–1953) interest in infusing modernism into traditional modes of painting is evident in his oeuvre. He came from a family of painters and initially learned to paint by copying not only paintings but also images from **material culture**. An early mentor advised him to study both Chinese and Western sources: His study of Western-style painting began in Japan in 1917 and continued, with government support, in Paris, London, and Berlin. After returning to China in 1927, he became an art professor. He specialized in both horses and figure paintings, working in traditional Chinese media as well as in oil on canvas. His *Yu Gong Removes the Mountain* (**FIG. 10–6**) is inspired by a story in a classical Chinese text: An old man, Yu Gong had worked his whole life, with the aid of sons and grandsons, to remove a mountain that blocked his view; in the end, divine intervention accomplished the feat. A handscroll in traditional media, it nevertheless reveals Xu Beihong's choice of classical and Renaissance modes of representation: He focuses on the labor of several partially clothed or nude male figures. It was unusual for Chinese artists to paint nudes, unless they were making erotic art. At left,

in quickly executed pencil sketches done on site. He used some of these as the basis for an album titled *Sketches of Twelve Strange Mountain Peaks*; one leaf depicts "Dragon Islet" (**FIG. 10–5**). Huang Binhong renders the contorted silhouettes of the mountains in swiftly executed, modulated outlines, with no use of texture strokes other than some dotting; he adds temple buildings at the

10-6 • Xu Beihong *YU GONG (FOOLISH OLD MAN) REMOVES THE MOUNTAIN*
1940. Handscroll, ink and color on paper, 4'8¾" × 13'9¾" (1.44 × 4.21 m). Xu Beihong Memorial Museum, Beijing.

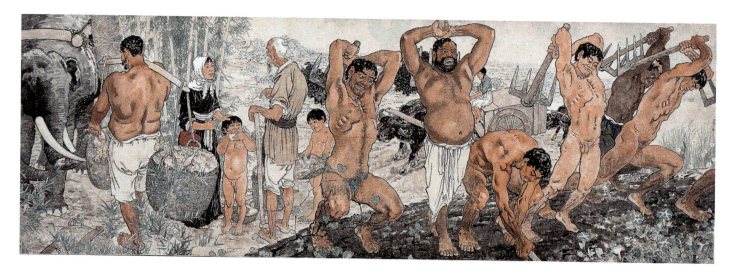

10-7 • Qi Baishi "COCKROACH AND BOWL"
From the album *Insects and Plants*, 1943. Album leaf, 10⅛ × 13½″
(25.7 × 34.3 cm). Metropolitan Museum of Art, New York. Gift of
Robert Hatfield Ellsworth, in memory of La Ferne Hatfield Ellsworth,
1986, 1986.267.237

the old man speaks to a woman accompanied by two nude boys,
and a man carries two baskets filled with earth on a shoulder pole.
A woman drives a cart in the background and an elephant stands
at far left. Xu Beihong made this painting in India in 1940, during
the war, using Indian art students as his models. He intended it as a
representation of the importance of determined resistance against
Japan, and the Communist government later acclaimed the paint-
ing for its championing of communal effort.

QI BAISHI

The artist Qi Baishi (1864–1957), from an impoverished farming
family, worked as a carpenter before learning to paint at age 27.
He became well versed in figure, landscape, and other **genres** of
painting. Though he studied the individualist and eccentric works

10-8 • Ding Cong IMAGES OF PRESENT TIMES
1944. Handscroll, gouache on paper, 11⅜ × 58⅝″ (29 × 149 cm).
Spencer Museum of Art, University of Kansas. Lawrence, Ks. Gift
of Dr. William P. Fenn. © Ms. Shen Jun.

of Ming and Qing painters—such as Xu Wei, Zhu Da, and Jin
Nong (see Chapter 9, FIGS. 9-20, 9-28, and 9-30)—Chen Hengke
advised him to develop his own style. His works commonly rely
on a bold outline and vibrant colors to describe his subjects; his
minimalist approach is the element that most strongly suggests a
modernist take on tradition. "Cockroach and Bowl" (FIG. 10-7),
from the album *Insects and Plants* of 1943, belongs to the traditional
grasses-and-insects genre. It shows a simply rendered blue-and-
white porcelain bowl, with a traditional cloud-collar pattern
on the rim of the interior, delineated in freehand. Next to it, Qi
Baishi depicts the cockroach in black ink, conveying the flatness
and luster of its carapace, as well as the delicacy of its legs.

DING CONG

A return to the use of painting as political critique is seen in *Images
of Present Times* (FIG. 10-8), by Ding Cong (1916–2009), the son of
a Shanghai cartoonist. He painted it in 1944, during World War II,
which he spent working first in Hong Kong and then in Sichuan.
The caricatures of people that he represents here indicate that he
viewed China's Nationalist government as corrupt. The paint-
ing uses the Western medium of gouache (opaque watercolor).
Organized as a handscroll, it includes a banner with the title and
the date. Perhaps the most telling image of the first half of the
scroll is the blindfolded painter wearing a Western-style suit, who
displays a hanging scroll depicting a tiger sitting on a rock. Ding
Cong seems to suggest through this figure that painters depicting
popular subjects in traditional media remain oblivious to the suf-
fering around them. Other figures in the painting include scholars,
women and children, war profiteers, writers, censors, injured sol-
diers, wealthy figures unmoved by the plight of others, refugees,
beggars, officials leaving grain to be devoured by rats, and a sup-
pressed journalist.

COMMUNIST-ERA POLITICAL ARTS, 1949–1976

In many ways, the current layout of Tiananmen Square (FIG.
10-9) in Beijing is a visual representation of the ideals of the
Communist government. Its open area had first been created in
the early twentieth century by removing the battlements that

In 1942, the future Communist party chairman, Mao Zedong (1893–1976), gave a speech in Yan'an, Shaanxi province—the location of the Communist base—on how art and literature must serve political causes. Mao proclaimed that creative works should manifest both political and artistic integrity, insisting that art and literature be evaluated based on their effect on social practice. This speech provides context for the art produced from the founding of the People's Republic in 1949 through Mao's death in 1976. It advocates that art serve the people's struggle and helped to determine various aspects of artistic production.

The following translated excerpts of Mao's speech appeared in *Sources of Chinese Tradition* (1960).

Though man's social life constitutes the only source for art and literature, and is incomparably more vivid and richer than art and literature as such, the people are not satisfied with the former alone and demand the latter. Why? Because, although both are beautiful, life as reflected in artistic and literary works can and ought to be on a higher level and of a greater power and better focused, more typical, nearer the ideal, and therefore more universal than actual everyday life. Revolutionary art and literature should create all kinds of characters on the basis of actual life and help the masses to push history forward. For example, on the one hand there are people suffering from hunger, cold, and oppression, and on the other hand there are men exploiting and oppressing men—a contrast that exists everywhere and seems quite commonplace to people; artists and writers, however, can create art and literature out of such daily occurrences by organizing them, bringing them to a focal point, and making the contradictions and struggles in them typical—create art and literature that can awaken and arouse the masses and impel them to unite and struggle to change their environment. If there were no such art and literature, this task could not be fulfilled or at least not effectively and speedily fulfilled.

There are two criteria in art and literary criticism: political and artistic. According to the political criterion, all works are good that facilitate unity and resistance to Japan, that encourage the masses to be of one heart and one mind, and that oppose retrogression and promote progress; on the other hand, all works are bad that undermine unity and resistance to Japan, that sow dissension and discord among the masses, and that oppose progress and drag the people back. And how can we tell the good from the bad here—by the motive (subjective intention) or by the effect (social practice)? Idealists stress motive and ignore effect, while mechanical materialists stress effect and ignore motive; in contradistinction from either, we dialectical materialists insist on the unity of motive and effect. The motive of serving the masses is inseparable from the effect of winning their approval, and we must unite the two.

Politics is not the equivalent of art, nor is a general world outlook equivalent to the method of artistic creation and criticism. We believe there is neither an abstract and absolutely unchangeable political criterion, nor an abstract and absolutely unchangeable artistic criterion, for every class in a class society has its own political and artistic criteria. But all classes in all class societies place the political criterion first and the artistic criterion second. The bourgeoisie always rejects proletarian artistic and literary works, no matter how great their artistic achievement. As for the proletariat, they must treat the art and literature of the past according to their attitude towards the people and whether they are progressive in the light of history. Some things which are basically reactionary from the political point of view may yet be artistically good. But the more artistic such a work may be, the greater harm it will do to the people, and the more reason for us to reject it. The contradiction between reactionary political content and artistic form is a common characteristic of the art and literature of all exploiting classes in their decline. What we may demand is unity of politics and art, of content and form, and of the revolutionary political content and the highest possible degree of perfection in artistic form. Works of art, however politically progressive, are powerless if they lack artistic quality. Therefore we are equally opposed to works with wrong political approaches and to the tendency towards so-called "poster and slogan style" which is correct only in political approach but lacks artistic power. We must carry on a two-front struggle in art and literature.

once stood in front of Tiananmen, the Gate of Heavenly Peace, at the south of the Forbidden City (see Chapter 9, FIG. 9–2). Various movements and protests in the Republican era took place here. In 1949, Chairman Mao Zedong announced the establishment of the People's Republic of China by raising its flag over Tiananmen. The subsequent years witnessed new construction in Tiananmen Square, beginning with the Monument to the People's Heroes. Completed in 1958, this massive granite obelisk, embellished with **relief** carvings, is elevated on a marble platform and stands 125 feet (38 meters) tall. Its form recalls both Western-style monuments (as interpreted by Soviet architects) and Chinese memorial **steles**, and it aligns with Tiananmen and the central axis of the Forbidden City. Another major project was the Great Hall of the People, completed in 1959, which stands on the west side of the square. Built in a Western style and over 148 feet (45 meters) tall, it houses meetings of the National People's Congress as well as state banquets. The Museum of the Chinese Revolution and the Museum of Chinese History stand on the east side of the square, and the government constructed Mao's Mausoleum at the south of Tiananmen Square following his death in 1976. The open space of

10-9 • TIANANMEN SQUARE, BEIJING.

the square, which can accommodate gatherings of 600,000 people, has served as the site of rallies and parades in the Communist era, but has also witnessed protests—most notably a pro-democracy demonstration in 1989.

PAINTING

Tiananmen itself still stands at the north of the square, now bearing an iconic portrait of Chairman Mao and slogans reading "Long live the People's Republic of China! Long live the great unity of the people of the world!" It is represented in the background of a painting of 1964 by Sun Zixi (b. 1929), *In Front of Tiananmen* (**FIG. 10-10**)—painted **vermilion**, with a double roof in golden tile and festive red lanterns hung in the side bays of the **façade**. Different

groups within modern Chinese society appear in the foreground, emphasizing how China's imperial past has been superseded. At the center, a beaming group of workers—men, women, and children—poses for a commemorative photograph in front of Mao's portrait on the gate; Mao is depicted larger than them and appears to look benevolently upon them. At the right is a group of sailors in uniform; at the left, a group of people in ethnic dress, representing China's minority populations. Sun Zixi, a member of the People's Liberation Army who studied oil painting after the revolution, conveys harmonious unity and order.

10-10 • Sun Zixi *IN FRONT OF TIANANMEN*
1964. Oil on canvas, 5'1" × 9'4¼" (1.55 × 2.85 m). Chinese National Art Museum of China, Beijing. Courtesy Hadrien de Montferrand gallery and the artist.

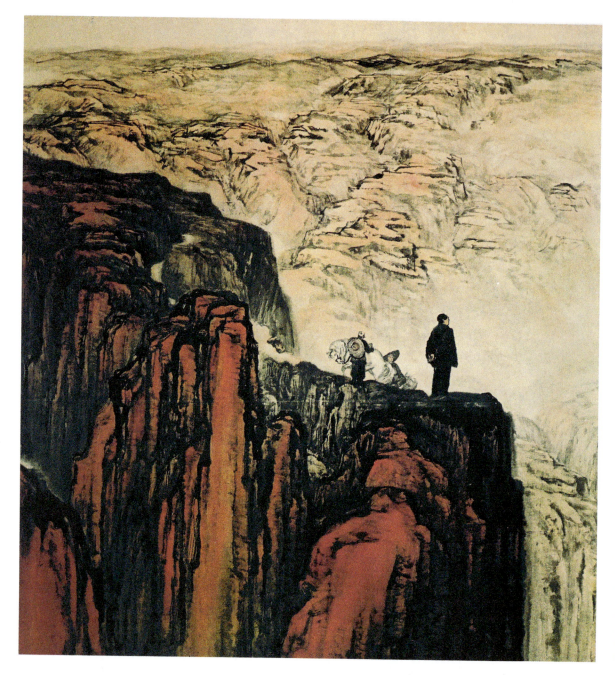

10–11 • Shi Lu
FIGHTING IN NORTHERN SHAANXI
1959. Ink and color on paper, 7'9¾" × 7'5⅝" (2.38 × 2.15 m). Museum of the Chinese Revolution, Beijing.

The Museum of the Chinese Revolution in some cases commissioned paintings: One is Shi Lu's (1919–1982) *Fighting in Northern Shaanxi* (**FIG. 10–11**), which dates to 1959, the tenth anniversary of the People's Republic. Shi Lu, who was both a painter and a printmaker, devoted himself to the Communist cause and spent the war years in Yan'an creating propaganda supporting the movement. He intended this example of national-style painting (*guohua*)—executed in ink and color on paper, and using some brush techniques from painters of the imperial period—to convey a sense of Chairman Mao's leadership in times of strife. Mao stands on a mountain ridge, surveying the landscape before him; although the small figure is shown from the side, his profile and hairline are unmistakable. The red tinge of the mountains is a deliberate association with Communism. Unfortunately, a member of the People's Liberation Army called the political content

of the painting into question, misinterpreting it as showing Mao distanced from the people (the troops he leads are not visible) and in a precarious position, with no path showing a way forward. Shi Lu was judged a counter-revolutionary and suffered greatly under the Cultural Revolution (1966–1976).

The artist Li Keran (1907–1989) also made many examples of national-style painting (and he too ended up in a re-education camp in the Cultural Revolution). Having received training in the landscape style of the **orthodox** masters of the Qing dynasty, he became critical of their reliance on past traditions, believing that it was important to look to everyday life for subject matter. He later studied oil painting and sketching from life under a European artist in Hangzhou, and he benefited from the mentorship of Qi Baishi, who helped him to gain a teaching position in Beijing. These experiences led him to support a modernist

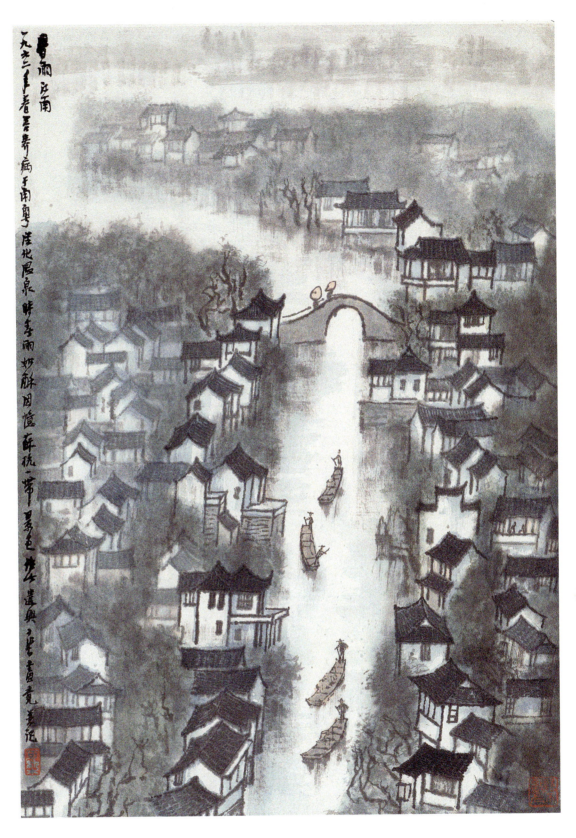

10–12 • Li Keran
SPRING IN JIANGNAN
1962. Ink and color on paper, 27⅛ × 19¼" (69 × 49 cm). National Art Museum of China, Beijing.

synthesis of Western and Chinese elements. He promoted a style described as Revolutionary Realism, meant to convey the beauty of the landscape and to present heroic images of workers, peasants, and soldiers. Beginning in the 1950s, the government provided opportunities for artists to travel throughout China, and Li Keran visited several scenic areas in the south, sketching and making landscape paintings. His painting of 1962 *Spring in*

Jiangnan (**FIG. 10–12**) undoubtedly draws on these trips. It depicts a river, lined with tiled-roof houses, as it passes through a city. Two peasants with broad-brimmed hats stand on a high-arched bridge, and small fishing boats make their way down the river. The entire landscape is suffused with mist. Based on what Li Keran viewed himself, it conveys the reality of life under the Communist government.

POSTERS

The Cultural Revolution sought to annihilate vestiges of "old" Chinese culture and foreign elements and to re-educate enemies of the people (such as intellectuals). Red Guards, who were students from correct class backgrounds (workers, peasants, or military), carried out much of the destruction. While they attacked historical Chinese art and architecture, artists produced propaganda posters. A Red Guard studying at the Central Academy of Industrial Arts, Liu Chunhua (b. 1944), is generally credited with a famous image of Mao Zedong, *Chairman Mao Goes to Anyuan*, although it was collectively designed by a group of students in Beijing. Mao's wife, Jiang Qing (1914–1991), approved of the 1967 original in oil on canvas so heartily that she declared it a model painting; this led to its reproduction in the millions as a poster in 1968 (**FIG. 10-13**). The image depicts a youthful Mao as a Communist organizer, on his way to lead a coal-miner's strike in 1921. He is again shown on a mountain peak, but from a vantage point that indicates his superiority over the viewer. His robes billow, suggesting both forward movement and—curiously—older representations of Buddhist and Daoist divinities. The blue skies overhead suggest a good outlook for Mao, and the folded

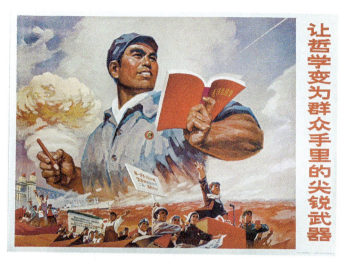

10-14 • *LET PHILOSOPHY BE TRANSFORMED INTO A SHARP WEAPON IN THE HANDS OF THE MASSES*
1971. Poster, 29⅞ × 41⅜″ (76 × 105 cm). University of Westminster, London. Chinese Poster Collection, The Paul Crook Collection.

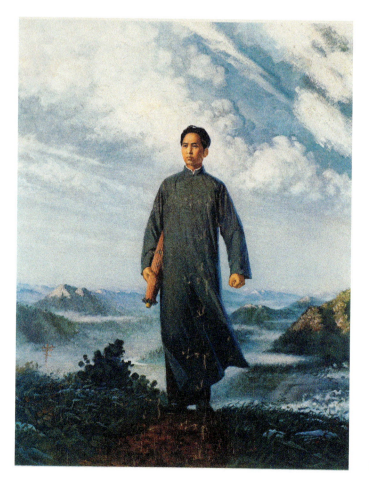

10-13 • Liu Chunhua *CHAIRMAN MAO GOES TO ANYUAN*
1968. Poster, color lithograph on paper, 37½ × 29⅞″ (95.2 × 76 cm). Victoria & Albert Museum, London.

umbrella tucked under his arm represents his preparation for inclement weather.

Another poster produced during the Cultural Revolution, *Let Philosophy Be Transformed into a Sharp Weapon in the Hands of the Masses* from 1971 (**FIG. 10-14**), conveys again the centrality of Chairman Mao to this movement even as it glorifies the Chinese people. An idealized male figure, armed with a copy of the *Quotations of Chairman Mao* (also known as the *Little Red Book*) and a red pencil for annotation, rises up in the sky; he wears a pin decorated with Chairman Mao's profile, and the title of his book is easily legible. He looms over a landscape that features workers demonstrating with signs and a red sea. All the figures have a red cast to their skin, and they are depicted in the heroic mode of Soviet Socialist Realism—a style intended to glorify the working-class struggle—with proud stances, beaming faces, and bulging muscles. This inspirational poster exhorts viewers to consider carefully Chairman Mao's teachings and to use them in the ongoing struggle to remake Chinese society.

POST-CULTURAL REVOLUTION PAINTING, 1976 TO THE PRESENT

After the Cultural Revolution, painters found increasing freedom to make works that did not reflect the Communist party's view of China or its political agenda. As time passed, some painters openly criticized the government and its policies. Others re-engaged with elements associated with China's imperial era or with other cultures altogether.

LUO ZHONGLI

Luo Zhongli (b. 1948) made the painting *Father* (**FIG. 10-15**), a large work in oil on canvas, in 1980, before he graduated from the

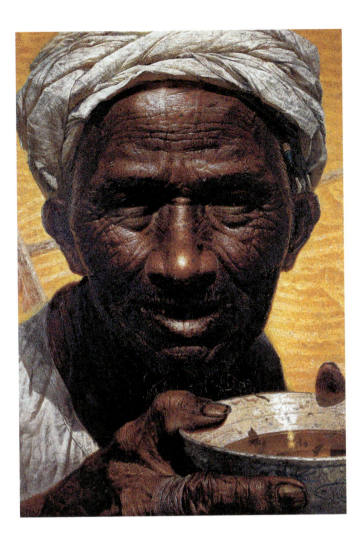

10-15 • Luo Zhongli FATHER
1980. Oil on canvas, 7'5⅜" × 5'5⅝" (2.27 × 1.54 m). National Art Museum of China, Beijing. Courtesy the artist.

Sichuan Academy of Fine Arts. It is an unstinting close-up of the wrinkled, chapped, and sun-blackened face of a peasant holding a bowl, a pen tucked behind his ear. The artist saw this man outside a public lavatory on New Year's Eve and was moved to record his suffering. The title of his painting is ironic, reminding viewers of the ways that parents and the elderly in general were venerated in earlier eras and positioning this figure in sharp contrast. Luo Zhongli painted his subject in a photorealist style that he had seen in American portraits: This choice gives rhetorical force to the painting, belying the idealized Chinese peasants pictured in earlier eras and emphasizing the desperation of those living in poverty. The scale of the painting is jarring for a representation of a downtrodden member of society; it would be much more appropriate for an icon of a Communist leader. For these reasons, *Father* registers as a work of subtle social criticism.

WU GUANZHONG

The intellectual painter Wu Guanzhong (1919–2010) suffered in the early years of the Communist era and throughout the Cultural Revolution. Having trained in both Chinese and Western styles of painting at art schools in Hangzhou and Beijing, he received government funding to study modern art in Paris in 1946. He returned to China in the early years of Communist governance and began to teach at Beijing's Central Academy of Fine Arts, only to find his interest in formalism vilified as bourgeois: It conflicted with the then-dominant practice of **Socialist Realism**. He refused to compromise the way he painted, and when the Cultural Revolution began, he was forbidden to paint, write, or teach. In 1970 he entered a labor camp. After the Cultural Revolution ended, however, Wu Guanzhong enjoyed greater freedom as an artist, and he published an essay arguing that artists should pursue beauty of form and move away from making didactic art. His lasting attraction to **abstraction** is evident in *Lion Grove Garden* of 1983 (**FIG. 10-16**), named after an extravagant Suzhou garden first built in the Yuan dynasty and rebuilt in the Ming and Qing. His painting depicts one of the best-known sections of the garden: an extensive rockery, created from Lake Tai rocks (see also Chapter 9, FIG. 9-7), located adjacent to the garden's pond, and full of winding paths and passageways. Garden architecture and trees are visible just beyond the rockery. Wu Guanzhong paints these features with a variety of different texture strokes: long, curving brushstrokes and dotting for the rocks, modulated lines for tree trunks, finer strokes for foliage, and flat applications of ink wash for water. The Lion Grove Garden, as a relic of the past that has survived into the present, makes an interesting choice of subject. In other ways, the painter seems to synthesize old and new elements: Some aspects of his brushwork distinctly recall the unorthodox work of the Qing dynasty painter Shitao (see Chapter 9, FIG. 9-29), but Wu Guanzhong's affinity for formalism is also apparent.

FANG LIJUN

The artist Fang Lijun (b. 1963), who studied printmaking at the Central Academy of Fine Arts, painted from a sense of displacement in the years following the Tiananmen Square protests of 1989. His grandfather had been a landlord, meaning that Fang Lijun belonged to a suspect class, and he and his family faced

10-16 • Wu Guanzhong LION GROVE GARDEN
1983. Ink and color on rice paper, 5'8⅛" × 9'6⅛" (1.73 × 2.90 m). Courtesy of the artist's estate.

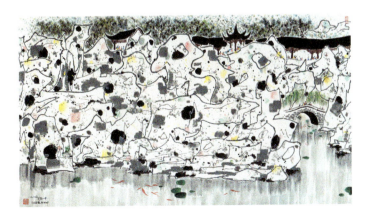

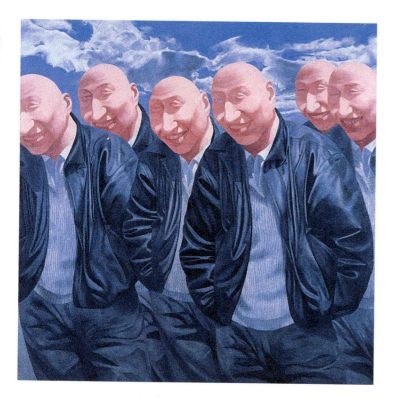

focused on vaguely menacing figures with shaved heads. *No. 3* in the series (**FIG. 10-17**) presents six virtually identical men. All have the same distorted and exaggerated facial features and wear the same clothing. They slouch with their hands in their pockets and incline their heads at the same angle. All grin in an unsettling way. Fang Lijun based the figures on photographs of himself and his friends, but homogenizes them. The reduplication of the figure suggests a loss of individuality: The six men function as a threatening collective. They evoke the rootlessness of the Chinese urban population in the early 1990s, a time when laborers left their homes and traveled to cities in search of work—a phenomenon that represented a threat to the social order.

YU YOUHAN

The first satirical images of Chairman Mao began to appear in the 1980s. After the founding of the People's Republic, his image was ubiquitous and instantly recognizable; artists who painted him ironically or in parody after his death did so as a way of underscoring the legacy of the Mao cult. Yu Youhan (b. 1943), who also studied at the Beijing Central Academy of Fine Arts and subsequently became an art professor in Shanghai, continually returns to Mao's image. One of his recent paintings (**FIG. 10-18**) seamlessly blends the Chairman's features and Marilyn Monroe: Yu gives the head Mao's hairstyle and receding hairline, with Marilyn's bleached hair color. The face has Marilyn's features enhanced with colorful eye shadow, dark brow pencil, and red lipstick. The artist uses a vibrant palette to create blocks of color, but the effect is lurid and unsettling. The painting responds to American artist Andy Warhol's (1928–1987) Pop Art series of portraits of famous figures, which included images of both figures and took photographic renditions of heads with softened outlines as a foundation for flat applications of bright colors. Yu Youhan's composite of Mao and Marilyn inherently compares the ways that both subjects manipulated their images in order to inspire adulation from viewers, while simultaneously encouraging a contrast of Mao's ruthless qualities against Marilyn's projection of innocence and weariness.

PAINTERS WORKING OUTSIDE MAINLAND CHINA

The conflicts that preceded the 1949 revolution caused some artists to leave China. Some of them had already studied abroad and were thus prepared to begin a new life in a different culture. Many Chinese relocated to Taiwan, and when the Nationalists established a new seat of government there, they managed to bring most of the surviving imperial collection of art with them.

10-17 • Fang Lijun *SERIES 2, NO. 3*
1992. Oil on canvas, 6'6" × 6'6" (2 × 2 m). Fukuoka Asian Art Museum. Courtesy the artist and HanartTZ Gallery Hong Kong.

struggle and oppression when he was growing up. He began shaving his head in high school to signify his resistance to school authorities. By 1992, he was working out of an independent studio in Beijing and creating a disturbing series of paintings that conveyed hopelessness; they belonged to a movement that Chinese critics described as Cynical Realism. His *Series 2* from that year

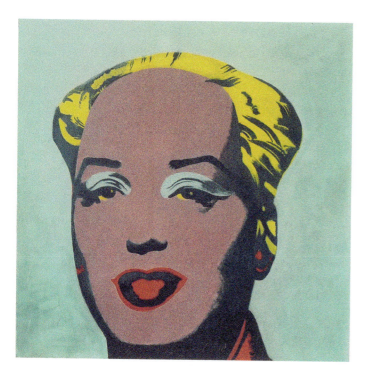

10-18 • Yu Youhan *A POCKET WESTERN ART HISTORY ABOUT MAO—"FOREIGN MAO," MAO/MARILYN*
2005. Acrylic on canvas, 4'11" × 4'11" (1.48 × 1.48 m). Courtesy of Yu Youhan and ShanghART Gallery, Shanghai and Beijing.

These two works of art both convey political messages. A group of unnamed artists, many affiliated with the Sichuan Academy of Fine Arts, created *Rent Collection Courtyard* in 1965. In multiple scenes, it enacts a story about a greedy and uncaring landlord profiting from the misery of peasants; the detail here shows the landlord waiting impassively for payment (**FIG. 10–19**). *Silence* (**FIG. 10–20**), by Wang Keping (b. 1949), dates to 1978 and seems to take up the theme of censorship, showing an abstract figure apparently gagged and blindfolded. Wang Keping, a former Red Guard, was a self-taught outsider artist—someone whose state-designated line of work had nothing to do with art—and this piece was selected for the controversial *Stars Art Exhibition* of 1979, organized by people working outside the art world at a time when the government controlled the content of most art exhibitions.

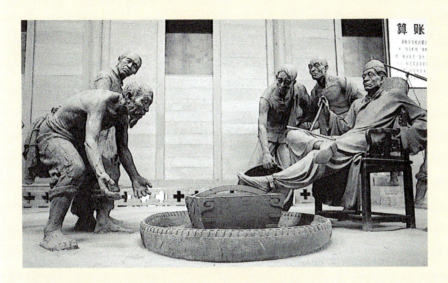

10–19 • *RENT COLLECTION COURTYARD* (DETAIL)
1965. Clay, life-size. Dayi, Sichuan province, China.

10–20 • Wang Keping *SILENCE*
1978. Wood, height 18⅞″ (48 cm).
Courtesy galerie Magda Danysz.

THINK ABOUT IT

1. *Rent Collection Courtyard* consists of figures sculpted naturalistically in clay and installed within a former landlord's mansion in Dayi, Sichuan province. Wang Keping, by contrast, explicitly rejected naturalism when he was making *Silence*, choosing to leave the natural qualities of the tree stump as intact as possible. What is the difference between naturalism and naturalness? Do *Rent Collection Courtyard* and *Silence* represent different approaches to art? Explain your reasoning.

2. These two works of art are very different in scale. The figures in *Rent Collection Courtyard* are life-size, while *Silence* is 15¾ inches (40 cm) high. How does that affect the viewer's experience of each piece?

3. *Rent Collection Courtyard* and *Silence* date fewer than 15 years apart, yet indicate a fundamental change in the ideas expressed by artists: The Communist party commissioned the former and it advances the Communist cause, whereas an unaffiliated artist created the latter as an image of protest. Discuss what these differences suggest about Chinese society before and after the Cultural Revolution and the role of the state in the production of art.

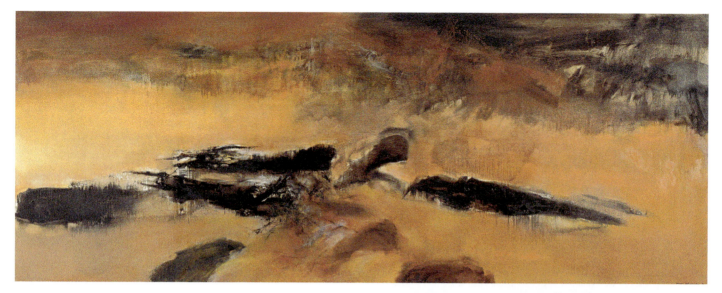

10–21 • Zao Wou-ki [Zhao Wuji] *EN MÉMOIRE DE MAI*
1972. Oil on canvas, 6′6″ × 17′3″ (2 × 5.25 m). Musée national d'Art moderne—Centre Georges Pompidou, Paris. Gift of the artist, 1973.

ZAO WOU-KI

The painter Zao Wou-ki (Zhao Wuji, 1921–2013) moved to Paris in 1948. He had studied and taught art in Hangzhou, and was interested in such late eighteenth- and early nineteenth-century French painters as Paul Cézanne (1839–1906). Later, he was drawn to the gestural painting associated with **Abstract Expressionism** and Jackson Pollock (1912–1956) with its spontaneous dribbles, smears, or splashes of paint—a mode of painting that is undoubtedly modernist yet also, according to Pollock, inspired by East Asian painting. (Perhaps Pollock was thinking of the **splashed-ink** styles used by Chan and **Zen** painters.) Zao created *En Mémoire de Mai* (**FIG. 10-21**) in 1972, and its forms demonstrate his interest in gesture. Painted shortly after returning from his first visit to China since leaving almost a quarter-century earlier, the painting in some ways is reminiscent of a landscape. It commemorates his wife, a Chinese actress who had committed suicide that year; Mai is a French version of her given name.

TSENG YUHO

Tseng Yuho (Zeng Youhe, 1925–2017), also known as Betty Ecke, showed talent at painting even as a young girl in Beijing. Both her parents were from scholarly families and supported her education. Tseng began studying art with a **Manchu** prince, Pu Jin, who was a painter in the orthodox style; later she received a university degree, with coursework in Chinese painting, Chinese literature, and Western art history. She counted Xu Beihong (see **FIG. 10-6**).among her teachers. Tseng studied brush techniques

10–22 • Tseng Yuho [Zeng Youhe] (a.k.a. Betty Ecke)
SEAGULLS
1965. Paper collage, 72 × 36½″ (182.9 × 92.7 cm). Honolulu Museum of Art. Gift of Sister Kay Thompson and Philip Thompson in memory of their mother Marie Sara Garvey Thompson, 1992 (7049.1)

from the Song through Qing dynasties but sought to develop her own style. She began exhibiting her art in one-woman shows outside of China in 1946 and moved to Hawai'i in 1949. She earned a doctorate in art history from New York University, achieving professional success as both an art historian and an artist. In the 1950s, Tseng developed a form that she called *zhuihua* ("assembled paintings"), drawing upon her experience with traditional scroll-mounting practices in 1940s Beijing. For these works, she tore into scraps handmade paper from China, Japan, and Polynesia, and assembled them as collages, then painted over them in ink and colors, sometimes applying metallic foil (such as gold, silver, palladium, or aluminum). One example, *Seagulls* (**FIG. 10-22**), seems to incorporate gold foil into an abstract composition. Tseng has written of the media and technique as reflecting East Asian art history: paper was invented in China, paper collages appeared in Heian Japan (see Chapter 13, FIGS. 13-23 and 13-25), and gold leaf was used to embellish Japanese Buddhist sculptures (see Chapter 12, FIGS. 12-26 and 12-28; and Chapter 13, FIGS. 13-11 and 13-21) and screens (see Chapter 14, FIGS. 14-31, 14-32, 14-34, and 14-35; and Chapter 15, FIGS. 15-7, 15-8, 15-11 and 15-12). In titling this work *Seagulls*, Tseng may have been alluding to a passage in the Daoist text *Zhuangzi*, in which gulls are metaphors for freedom, or to a Tang poem by Du Fu (712–70) that describes a gull drifting between heaven and earth.

INSTALLATIONS, PERFORMANCES, AND NEW MEDIA, 1980S TO THE PRESENT

Beginning in the 1980s, Chinese artists increasingly experimented with **installations**, performance art, and new media (photography and film). As practiced in recent decades, these categories overlap a great deal: Installations frequently comprise multiple media, and

10-23 • Xu Bing A BOOK FROM THE SKY (DETAIL)
1987–1991. Detail of bound hand-printed books (see FIG. 10-1).
Courtesy Xu Bing Studio.

artists often document their performances in photography and video. The works discussed here present a modernist response to aspects of historical Chinese culture.

XU BING
The artist Xu Bing (b. 1955), who studied graphic reproduction at Beijing's Central Academy of Fine Arts, has created a series of projects that play upon language and meaning. An early installation that considered these issues is *A Book from the Sky* (FIGS. 10-1 and **10-23**) from 1988. The installation revolves around Xu Bing's invented "language" of approximately 4,000 characters: He recombined elements commonly used in Chinese characters to create meaningless forms that nevertheless seem, at first glance, as if they should be comprehensible. Using the style of script preferred in Song printing, he carved his made-up characters on individual blocks and set them in frames in order to hand-print 3,230 square feet (300 square meters) of paper in the format of the accordion-folded pages of a traditional Chinese book. Xu Bing bound most of the resulting pages into 120 editions of a four-volume book, laying the volumes on the floor to create one element of the installation; in addition, he suspended banners of printed pages from the ceiling of the exhibition space and made panels of text for the walls. He states that all audiences experience a loss of meaning when confronting this work: Chinese readers because they discover that Xu Bing's characters are actually nonsensical, and others because they assume that they cannot read the language. Scholars have proposed different interpretations of *A Book from the Sky*, including a comment on the impossibility of communication with the divine, a protest against political abuse of language, or a critique of the meaninglessness of cultural production. In creating this installation, Xu Bing draws upon the centrality of writing in Chinese culture, refers to historical forms of writing, and duplicates the authentic woodcut bookmaking process. Following more than a decade working outside China, Xu Bing returned to Beijing and assumed the vice-presidency of the Central Academy of Fine Arts.

CAI GUO-QIANG
The pyrotechnic events of Cai Guo-Qiang (b. 1957) are examples of performance art that happen to be documented in photographs. Fittingly, the artist trained in stage design in Shanghai. He works in nontraditional media and is particularly known for his use of fireworks and gunpowder, both invented by the Chinese. *Project for Extraterrestrials No. 10: Project to Extend the Great Wall by 10,000 Meters* (FIG. **10-24**) is from a series that attempts to make contact with life elsewhere in the universe: Its events are only fully visible from space. For this piece, Cai Guo-Qiang conceived of a fuse, requiring 1,320 pounds (600 kilograms) of gunpowder, extending for 10,000 meters (32,800 feet) from the famous Jiayuguan pass of the Great Wall (see Chapter 9, FIG. 9-6) out into the adjacent Gobi Desert. After igniting the fuse at night, the resulting explosion, which burned for 15 minutes, did appear visually to extend the

10-24 • Cai Guo-Qiang *PROJECT TO EXTEND THE GREAT WALL BY 10,000 METERS: PROJECT FOR EXTRATERRESTRIALS NO. 10*
Realised at the Gobi desert, west of the Great Wall, Jiayuguan, Guansu Province, February 27, 1993, 7.35pm, 15 minutes. Explosion length: 10,000m. Gunpowder (600kg) and two fuse lines (10,000 m each). Commissioned by P3 art and environment, Tokyo.

Great Wall, zigzagging across the landscape in a way reminiscent of a dragon's form. The project took the Chinese landscape as a canvas, and choosing the old frontier as the site echoed the liminality of Cai Guo-Qiang's work, poised between references to traditional culture and modernism.

AI WEIWEI

The Beijing artist Ai Weiwei (b. 1957) is best known for his installations, photographs, and videos. He spent a decade working in New York and became familiar with the work of several twentieth-century avant-garde artists. After returning to China in 1993,

10-25 • Ai Weiwei *DROPPING A HAN DYNASTY URN*
1995. Triptych of gelatin silver prints, each 4′10¼″ × 3′11⅝″ (1.48 × 1.21 m).

he began to make art that considered how to reconcile the weight of tradition with the desire for modernization. In a 1995 triptych of photographs titled *Dropping a Han Dynasty Urn* (**FIG. 10-25**), he suggests that there is no point in valorizing the past for its own sake. In the first photograph, he holds up a **glazed stoneware** urn—an actual Han dynasty object—for consideration. In the second, the camera captures Ai Weiwei with open hands, the vase in mid-air. In the third, the artist holds the same position, but now the urn lies shattered at his feet. Ai Weiwei chooses an example of material culture that might not be valued were it not for its great age, but destroying an ancient **artifact** for the sake of making contemporary art sends a clear message about the obliteration of the old by the new. At the same time, his triptych may present a critical stance on the destruction wrought during the Cultural Revolution. Ai Weiwei's recent art has become increasingly critical of the Chinese government, earning him the reputation of a dissident. His detention for three months in 2011 led to an international outcry.

PHOEBE CHING-YING MAN

Phoebe Ching-ying Man (b. 1969), an art professor in Hong Kong, takes on late twentieth-century responses to Communist governance in her installation *97 Reunification, I Am Very Happy...* (**FIG. 10-26**). This installation commemorates the political reversion of Hong Kong to China after having held the status of British Crown Colony for 99 years—a move that caused consternation among some Hong Kong residents. The artist's installation consists of red characters covering the walls and ceiling of the exhibition space. Upon closer examination, the viewer discovers that it is an eight-character sentence repeated over and over again: *jiu-qi huigui, wo hen gaoxing* (translated in the English title of the installation). At the time, residents of Hong Kong posted signs displaying these words in large characters everywhere, and the artist echoes them in her installation, choosing red for its associations with festivity in the imperial era and with Communism in the twentieth century,

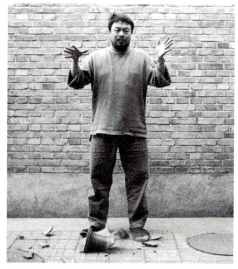

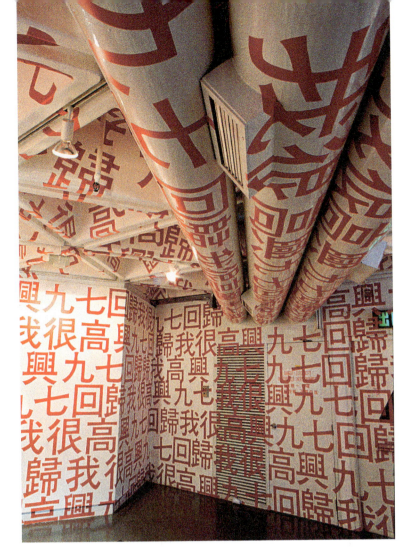

his head fills the frame. Only his progressively darkening face and the quality of the light seem to change from one photograph to the next. Zhang Huan dictated what should be written, including the names of his ancestors, and much of the writing refers to stories about family and divination texts that consider specific aspects of human physiognomy. In the first photograph, the middle of his forehead bears the four-character phrase meaning "foolish old man removes the mountain" (see FIG. 10-6). *Family Tree* finds a compelling tension between individual identity and texts that relate to family and the course of a human life—all aspects integral to the human experience—and uses elements from historical Chinese culture to create something new.

LIN TIANMIAO

The artist Lin Tianmiao (b. 1961) worked as a textile designer in New York for eight years before settling in Beijing and beginning her artistic career in the mid-1990s. She often uses thread as a medium, and through it she connects back to the gendered division of labor in feudal and imperial China: the idea of sericulture as women's work (see Chapter 8, FIG. 8-16). As a child, the artist assisted her mother in unraveling and rewinding cotton thread from uniforms and gloves, another experience that informs her

10-27 • Zhang Huan FAMILY TREE
2000. Set of nine chromogenic prints, each 23⅞ × 19⅞″ (60.8 × 50.6 cm). M+ Sigg Collection, Hong Kong. Courtesy Zhang Huan Studio.

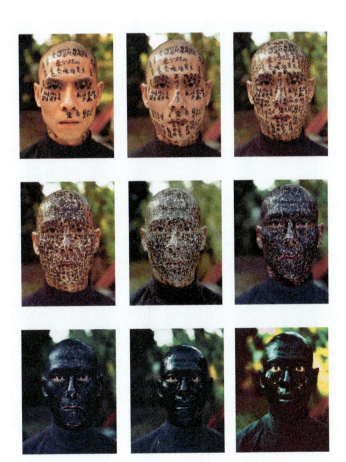

10-26 • Phoebe Ching-Ying Man 97 REUNIFICATION, I AM VERY HAPPY...
1997. Installation, plastic. Hong Kong Arts Centre, Hong Kong.

and using large characters appropriate for signage. Still, the artist introduces a sense of ambivalence into her installation. The replication of the sentence can be interpreted as a groundswell of happiness at the prospect of Communist governance. However, it can also be read as a rote repetition of the only sanctioned response, and the way that the characters insistently fill the space suggests that there is literally no room for an alternative reaction.

ZHANG HUAN

Zhang Huan (b. 1965), who studied at the Central Academy of Fine Arts, works in Shanghai and New York, making performance art as well as photographs that focus on the body. He often uses himself as a subject. *Family Tree* (**FIG. 10-27**) is a set of nine chromogenic prints that he has described as a serial self-portrait. He invited three calligraphers to write characters directly on his face over the course of a day: The nine photographs document how the words gradually envelop him and seem to eradicate his individuality. The photographs show Zhang Huan in the same place, with the same implacable expression, and in most of the photographs

The artist Wenda Gu (in Chinese name order, Gu Wenda, b. 1955), trained in landscape painting and calligraphy, began a series of installations titled *United Nations* in 1993. The series evokes the U.N.'s goal of unifying different cultures, which the artist suspects will not be achieved within his lifetime. His concept was to create renditions of national monuments, primarily using human hair as his medium. Reasoning that hair encodes genetic identity, he collected a diverse range of specimens from hundreds of barbershops in China, Hong Kong, Russia, Poland, Israel, South Africa, and the United States. *China Monument: Temple of Heaven* refers in name to the famous temple in Beijing (see Chapter 9,

FIGS. 9–4 and 9–5), but rather than making a straightforward model, Wenda Gu uses different elements to suggest both explicit and tenuous connections to Chinese history. The installation uses seal script and Chinese furniture in nontraditional ways and seeks to create surprising juxtapositions. The artist intended Chinese viewers to recognize some elements and for others to experience the installation as exotic.

Wenda Gu UNITED NATIONS CHINA MONUMENT: TEMPLE OF HEAVEN

1998. Mixed-media installation, hair, television, film, and furniture. Hong Kong Museum of Art. Courtesy the artist.

Visitors can walk through the installation, experiencing it in a way that evokes movement through an architectural site.

Wenda Gu weaves light and dark hair together to make translucent panels of bold calligraphic forms against a pale background. These are probably meant to recall the inscribed tablets housed at the Beijing Temple of Heaven.

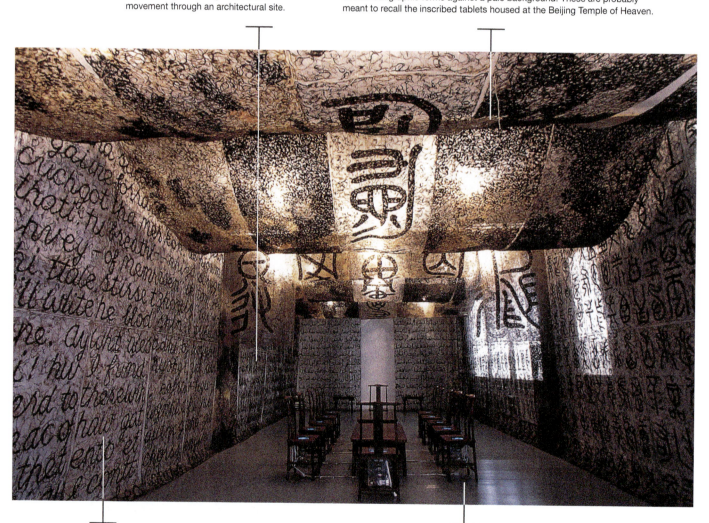

The artist invented the "script," which imitates the written forms of Chinese (specifically seal script), English, Hindi, and Arabic—four of the world's most commonly spoken languages. None of it is actually legible, which conveys the limits of human understanding and suggests the empty signification of language.

The chairs and table resemble furniture made for the meditative context of Ming dynasty tea ceremonies. Wenda Gu installed television monitors in the seats of all the chairs, using them to display film of passing clouds. These elements help to create a tranquil atmosphere suggestive of prayer.

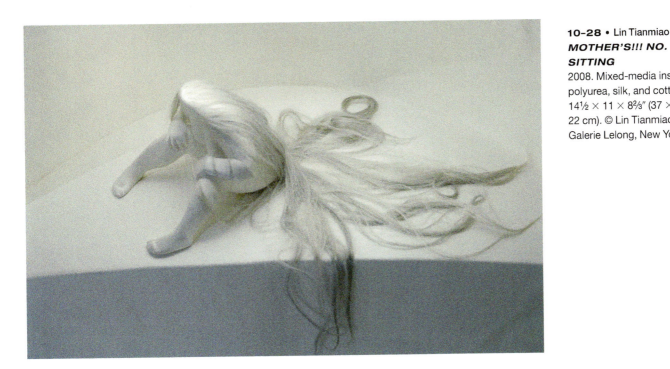

10-28 • Lin Tianmiao
***MOTHER'S!!! NO. 6,
SITTING***
2008. Mixed-media installation of
polyurea, silk, and cotton thread,
14½ × 11 × 8⅔" (37 × 28 ×
22 cm). © Lin Tianmiao, Courtesy
Galerie Lelong, New York.

current work. A 2008 installation of 18 related abstract sculptural forms is titled *Mother's!!!* and plays on a variety of contradictions. For example, Lin Tianmiao intended the installation title to be multivalent, referring not only to things maternal but also to one of the most potent swear words in modern Mandarin. The pieces in the installation are entirely white and displayed in an exhibition space wrapped from floor to ceiling in white silk—suggestive of a silkworm cocoon and stages of life, perhaps, but also, because of the traditional associations of the color white, redolent of death. (It may be significant that the silk-making process demanded the boiling of silkworms in their cocoons.) *Mother's!!! No. 6, Sitting* (**FIG. 10-28**) is a figural piece in mixed media, using polyurea (a resin blend), silk, and cotton thread. It depicts a rounded, womanly figure, headless but with long hair, sitting crouched with her legs splayed and her hands gripping her knees—an attitude suggestive of imminent childbirth. In an environment that strongly evokes stillness and death, the sculpture represents the beginning of life.

Chinese art and architecture over the course of millennia have developed such diversity that it is impossible to sum them up briefly. The distinct social, religious, philosophical, and political practices of multiple regions within China form the amalgam that is Chinese culture, further inflected by the cultures outside China with which its people have interacted. Yet throughout different historical eras, Chinese artists have responded to threads of continuity—whether to take them in or to reject them. Even in the twentieth and twenty-first centuries, as artists have increasingly engaged with concepts of modernity, much of their art still finds roots in some aspect of Chinese history.

CROSS-CULTURAL EXPLORATIONS

10.1 Chairman Mao and the Mughal Emperor Jahangir both articulated their ideas about art at some length. How do these two authority figures espouse different ideologies about art and artists? What led them to address this subject?

10.2 Discuss the use of art as political propaganda in different historical periods or cultures—for example, imperially sponsored art in earlier periods of Chinese history against the pro-Communist art of the mid-twentieth century, or posters in twentieth-century China and India. What elements do successful examples of propaganda include?

10.3 Do the women artists of the Ming and Qing dynasties reveal different concerns from those expressed by women artists of the modern era? Is the female identity of the artist important? Can women's art ever be said to be distinctly feminine, and if so, in what ways? If not, why not?

10.4 Discuss how the installations and works in new media of the contemporary era sometimes take a radical approach to the representation of the past. Is this significantly different from artistic practice in earlier periods of Chinese history?

PART THREE
Korea
and Japan

Maruyama Okyo **CRACKED ICE** (DETAIL)
Edo period, ca. 1780. Two-panel screen, ink on paper
sprinkled with mica, 23⅘ × 71⅔" (60.5 × 182 cm).
British Museum, London.

In comparison to India and China, Korea and the island nation of Japan are small countries. However, despite their size, Korea and Japan have influenced both Asia's and the West's historical, economic and cultural development, and continue to make waves on the international contemporary art scene.

The shortest distance between South Korea and mainland Japan is about 120 miles (193 kilometers), via the Korea Strait, a narrow sea passage separating South Korea and southwest Japan. For centuries the Korea Strait served as a passageway between Korea and Japan for the exchange of goods, culture, technology, and religion. In the sixth century, Korean priests crossed the Korea Strait to introduce Buddhism into Japan.

By the time Buddhism reached Japan from its Indian source, having meandered along the Silk Road through Central Asia, China and Korea, it was a well-formulated religion accompanied by a potent mix of cultural influences. Both Korea and Japan absorbed numerous influences from the Chinese civilization in particular, but managed to retain and develop their own distinctive belief systems and traditions, which in turn were transmitted back to other parts of Asia and the West.

This Japanese two-fold screen painting (*furosaki byobu*) dated ca. 1780, depicting cracked ice by Maruyama Okyo, is a wonderful example of how Japanese artists integrated foreign ideas and techniques into their artwork but at the same time developed a unique style, which in the case of this screen is breathtakingly modern. Screens like this one were part of the subdued décor of the teahouse. Placed on the floor, they functioned as a backdrop to complement the tea ceremony utensils displayed on the tearoom's tatami mats. Such screens also protected the hearth from draughts. Guests participating in the tea ceremony knelt on the floor at the same level as the screen. How refreshing for guests to see a vista of cracked ice inside the tearoom on a hot, humid day. Maruyama Okyo incorporated Western-style perspective into this painting to suggest a sense of distance. Carefully orchestrated lines of ink disappearing towards a low horizon convey a large expanse of ice, cracking into fissures, as warmer weather or perhaps a person approaches. The absence of detail, in keeping with Zen Buddhist sensibilities, suggests the unseen and the vastness of the cosmos, while allowing the viewer to meditate on nature's astonishing beauty.

In particular, this painting highlights nature's important position within the Japanese worldview, and how appreciation for the natural world shaped religious beliefs and inspired artists to explore nature's mysteries in a wide range of artistic expressions.

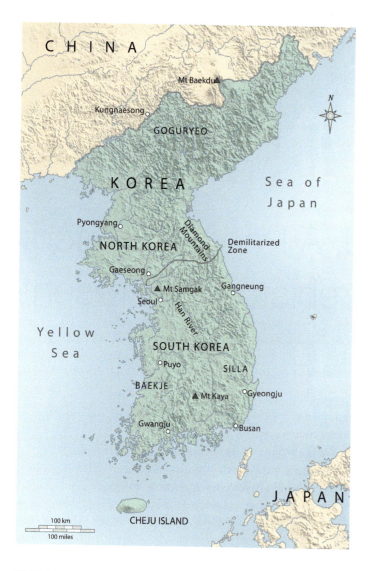

MAP 11–1 • KOREA

from approximately 7000 BCE. Striking earthenware ceramics, known as comb-patterned pottery (*jeulmun*), were excavated at the Neolithic site of Amsa-dong near the Han River, Seoul. Common throughout the Korean Peninsula, comb-patterned pottery is characterized by geometric designs impressed or incised into the moist clay surface before firing (**FIG. 11-2**). This reddish-brown unpainted container with pointed base, possibly used to store grain, was constructed by hand from coils of clay. Slanted lines incised into the clay create a flurry of enigmatic patterns. Archaeological discoveries further suggest that trade contacts between the Korean Peninsula and Japan existed during Neolithic times. For example, fragments of Japanese **Jomon** pottery have been excavated at the Neolithic site of Dongsam-dong in Korea.

Korea's Bronze Age began around 1000 BCE, with bronze technology introduced from northeast China. Connections between China and Korea intensified around 100 BCE during China's Han dynasty, when the Chinese established a series of outposts in Korea. Lelang (located near today's Pyongyang in North Korea) became an important Chinese colony and commercial hub. Until its demise in 313 CE, Lelang provided a "gateway" into Korea for foreign goods and ideas, including the Chinese written language. This potent combination of outside influences mingling with local traditions contributed to the blossoming of a distinctive Korean identity during the era known as the Three Kingdoms period.

11-2 • COMB-PATTERNED VESSEL
Neolithic period, ca. 3000 BCE. Earthenware with incised decoration, height 16" (40.5 cm). Hanyang University Museum, Seoul.

Confucianism, and Christianity, and more recently the relentless forces of modernization.

Archaeology is a relatively new discipline in Korea, ironically advanced by Japanese colonial archaeologists during Japan's occupation of Korea from 1910 to 1945. Since the 1950s, however, Korea has asserted control over its own cultural legacy, breaking free from imperialist and colonial interpretations that denied or minimized its contribution to the history of Asian art. In particular, from the 1970s onward Korean archaeology flourished with the participation of skilled Korean scholars.

NEOLITHIC AND BRONZE AGE

Hundreds of Neolithic settlements located near rivers and along the coast have been discovered, with important find such as pottery, stone tools, and bone fish hooks shedding light on the societies of these ancient communities. The earliest known examples of Neolithic ceramics in Korea, handmade clay vessels, date

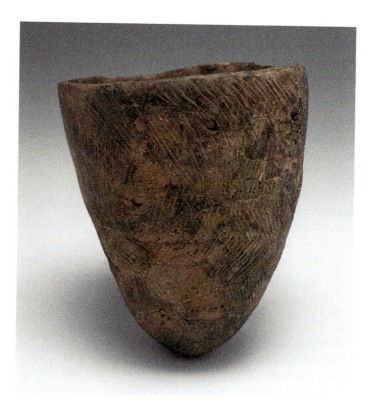

THREE KINGDOMS PERIOD

Between ca. 57 BCE and 668 CE, Korea's political and cultural landscape was dominated by three independent and rival states known as Goguryeo (Koguryo), Baekje (Paekche), and Silla (see MAP 11–1). All three kingdoms benefited from trade relations with China. Material goods were not the only imports from Korea's neighbor: Confucianism, Daoism, and Buddhism, powerful forces in the evolution of Korean society, arrived from China during this era and established roots within the bedrock of shamanic beliefs. Commencing around the sixth century, the Chinese script was adapted to fit the Korean spoken language—a development in communication that facilitated the recording of ideas and the expansion of scholarship.

GOGURYEO

Goguryeo, located in the north, was the largest of the three kingdoms, with territory that reached from the Han River Valley into parts of what today is northeast China. One of the great Goguryeo kings was King Gwanggaeto (r. 391–413 CE), whose name means "broad expander of domains." His military triumphs, which included repelling Japanese forces that attacked Silla (at this time under Gwanggaeto's protection), were recorded on a huge stone memorial **stele** erected in 414 at his tomb in the old Goguryeo capital of Kungnaesong (present-day Jian, northeast China). Commissioned as a memorial by Gwanggaeto's son, King Jansu, the stele was inscribed with 1,802 classical Chinese characters. The image shown here (**FIG. 11–3**) is a replica on display in the grounds of the Independence Hall of Korea, Cheonan.

Valuable information about life and death in ancient Goguryeo has been gathered from the study of vividly painted **murals** (wall paintings) decorating the tombs of the kingdom's elite. Over 10,000 tombs, some of them elaborate stepped pyramids constructed from stone, have been identified. About 90 of these tombs contain painted murals featuring an astonishing range of subject matter, reflecting Goguryeo's cosmopolitan outlook. The lives of royalty are lavishly displayed in court events and hunting scenes. However, the daily life of commoners is also recorded in everyday scenes that revolve around such domestic settings as the kitchen, stables, and granary.

Societal beliefs in the spiritual realm find concrete expression in numerous images of guardian deities, mythical figures, and celestial beings that inhabit the colorful paintings for the deceased's benefit. Traditionally, death was not considered a final demise but a continuation of life, complete with material comforts. Burial goods accompanied the deceased, but most of the tombs were looted centuries before any official excavations of the last 100 years. As Buddha's teachings became more widespread, beliefs regarding the afterlife shifted gradually toward the Buddhist perspective. The tomb paintings' varied iconography was inspired by diverse sources, including Chinese mythology, Daoism, and Buddhism. Using ink and pigments, the interior burial chamber walls were covered with paintings executed on lime-plastered surfaces, although in some cases, murals were painted directly onto untreated stone slabs. Fine examples of tombs with murals are found in the vicinity of present-day Jian (in northeast China) and in the ancient Korean capital of Pyongyang.

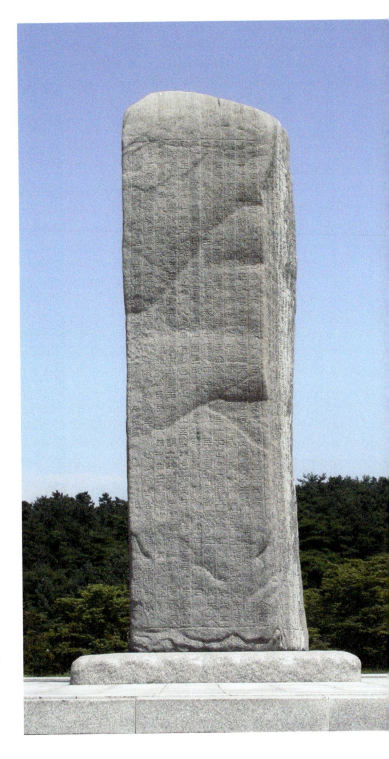

11–3 • STELE OF KING GWANGGAETO OF GOGURYEO
Replica of 414 CE orginal. Granite, height 23' (7 m). Independence Hall of Korea, Cheonan.

Muyongchong Tomb (fifth century CE) near Jian, poetically called the Tomb of the Dancers, is famous for the well-preserved murals that decorate its stone chambers, which lie buried beneath an earthen **tumulus** 164 feet (50 meters) in diameter. On the tomb's eastern wall, a man on horseback, likely the tomb's occupant, is entertained by a troupe of musicians, singers, and dancers (**FIG. 11–4**). Five dancers perform a coordinated dance in spotted outfits with long, flowing sleeves. The men are dressed in billowing pants and jackets, while the women wear long gowns tied at the waist over loose-fitting pants. This distinctive Goguryeo clothing resembles the traditional Korean dress of today. On the western chamber wall, hunters on horseback armed with bows and arrows chase deer and tigers through a mountainous landscape (**FIG. 11–5**). One agile hunter astride a galloping horse swivels around in his saddle to shoot an arrow at fleeing prey from behind. The tomb's ceiling is filled with cosmological and religious imagery, such as lotus flowers floating in the heavens, reminders of the occupant's ultimate spiritual destination—perhaps the Buddhist Pure Land (*Jeongto*).

BAEKJE

Baekje is sometimes described as "the lost kingdom," since little of its cultural legacy has survived. Located in southwestern Korea, Baekje cultivated close relations with south China and Japan—indeed, shades of Baekje's golden past can be glimpsed in the architecture and contents of Horyu-ji temple and Chugu-ji convent, Japan (see Chapter 12, pp. 290–297). Similar to neighboring

11–5 • HUNTING SCENE
Three Kingdoms period, Goguryeo kingdom, 5th century.
Wall painting. Muyongchong Tomb, Tonggou, near Jian.

Goguryeo and Silla, Baekje absorbed the advances of Buddhism and Daoism. A remarkable gilt-bronze incense burner excavated at a temple site near Puyo in 1993 reveals the eclectic mix of influences circulating within Baekje (**FIG. 11–6**). Daoist and Buddhist elements rub shoulders in this elaborate piece, composed of a dragon stand, lotus petal bowl, and mountain-shaped lid. Mountain-shaped incense burners illuminating Daoist concepts of

11–4 • DANCING SCENE
Three Kingdoms period, Goguryeo kingdom, 5th century.
Wall painting. Muyongchong Tomb, Tonggou, near Jian.

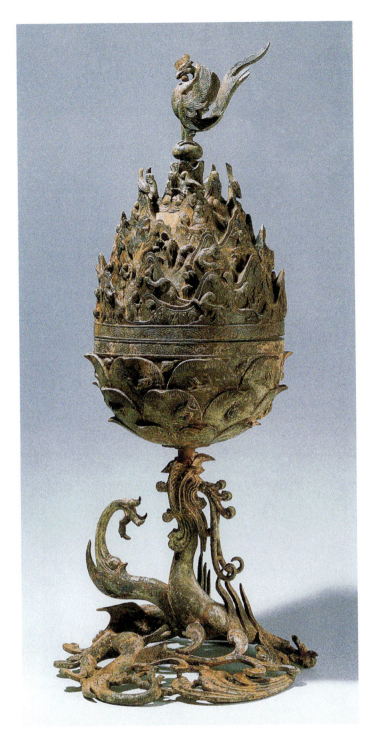

11-6 • INCENSE BURNER
Three Kingdoms period, Baekje kingdom, 6th century. Gilt bronze, height 24⅓″ (61.8 cm). Buyeo National Museum.

the afterlife were common in China (see Chapter 6, FIG. 6-27). In the Korean incense burner, heavenly beings and immortals inhabit mountain peaks crowned with a phoenix, while a dragon writhes below. According to ancient Chinese lore, the divine phoenix appears during periods of peace and prosperity—doubtless a fond wish of the Baekje people, plagued with battles against Goguryeo and Silla. The dragon is an ancient symbol of the "ancestor of all created beings," who has the power to ascend into heaven.

Fragrant incense smoke wafted out of holes in the lid to complete the spiritually charged imagery.

SILLA

The kingdom of Silla, situated on Korea's southeastern coast facing Japan, is well known for its artistic accomplishments. Silla was a wealthy kingdom, rich in gold mines and iron ore. Such commodities as gold, iron, and horses were exported to China and, in turn, Silla imported such goods as silks, books, and tea from China. Silla's capital, Gyeongju (Kyongju), was known as Kumsong, or "City of Gold." This title was apt as the city was a prosperous, cosmopolitan metropolis modeled on the Chinese Tang capital of Chang'an. Powerful kings and queens ruled Silla society with the assistance of a council of aristocrats (*hwabaek*). Magnificent royal tombs buried within Gyeongju's environs attest to the authority of Silla royalty and provide a tantalizing glimpse of the splendor of court life. Large earthen tumuli mark the sites of Silla tombs. They cover wooden chambers sheathed in stone. The deceased were buried in wooden coffins, their dusty remains contrasting sharply with their well-preserved, dazzling possessions: golden crowns, belts, shoes, and jewelry.

Tomb 98, the Great Tomb at Hwangnam, Gyeongju, is one of Silla's famous tombs. Scholars debate its age, but it likely dates from the fifth to sixth century. The tomb, comprising twin mounds over 70 feet (21 meters) in height, occupies a site that measures 262 feet (80 meters) by 393 feet (120 meters). One of Tomb 98's most precious **artifacts** (man-made objects) is a shimmering gold and jade crown, unearthed in 1974 from the northern tumulus (see FIG. 11-1). This ornate, elegant crown was fashioned from thin sheets of embossed gold, fastened together with gold wires and rivets. A circular headband supports three treelike vertical forms and two antlerlike prongs. A collection of long, dangling ornaments hang from the crown. Gold spangles and comma-shaped pieces of jade decorate the crown's surface and, if worn, one can imagine it glinting and tinkling with the slightest movement.

The crown's unusual design, with its vertical projections resembling trees and antlers, is reminiscent of headgear found in Russian tumuli, and may indicate Korea's connection to Siberian shamanism. According to early myths and written records, ancient Silla rulers functioned as shaman-rulers whose political authority overlapped with their role as shaman. The treelike shape has been interpreted as a cosmic tree, a form of spiritual highway that links the earthly realm with the celestial realm, an instrument by which shamans and deities moved freely between worlds. Antlers have long been associated with the fertility of the earth, an appropriate symbol for a royal ruler responsible for the prosperity of their subjects. A female probably owned this crown, because a gold belt found in the same tomb belonged to a woman.

In the southern mound, the remains of a man, accompanied by **grave goods** to assist him in the afterlife, including a

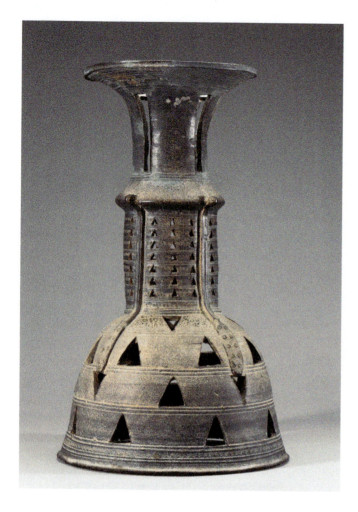

11–7 • VESSEL STAND WITH SNAKE DECORATION
Three Kingdoms period, Silla kingdom, 5th–6th century. Gray stoneware with traces of natural ash glaze, height 23″ (58.7 cm). Arthur M. Sackler Museum/Arthur M. Sackler Museum, Partial gift of Maria C. Henderson and partial purchase through the Ernest B. and Helen Pratt Dane Fund for the Acquisition of Oriental Art, 1991.501.

rows. Snake imagery may provide a clue to the contents of the container that once rested on the stand. Arguably, snakes carry many meanings, although it is worth noting that drinking snake wine was believed to enhance virility. Scholars suggest that this ceremonial stand supported a small container filled with wine or water as a ritual offering to the deceased. Although it is technically unglazed, ash from the kiln has formed an accidental yet subtle **patina** on the stand's surface.

BUDDHISM AND KOREA

Buddhism officially reached Korea in the fourth century, transmitted by Chinese Buddhist monks. As it spread throughout the Three Kingdoms and became the faith of the ruling aristocracy, temples were built, religious images created, and rituals held for the protection of the state. Shamanism was gradually displaced but did not vanish despite the integration of various native gods into the Buddhist pantheon; indigenous folk practices continued alongside

11–8 • *BODHISATTVA SEATED IN MEDITATION*
(Likely the Bodhisattva Maitreya.) Three Kingdoms period, Silla kingdom, 6th–7th century. Gilt bronze, height 36⅘″ (93.5 cm). National Museum of Korea, Seoul.

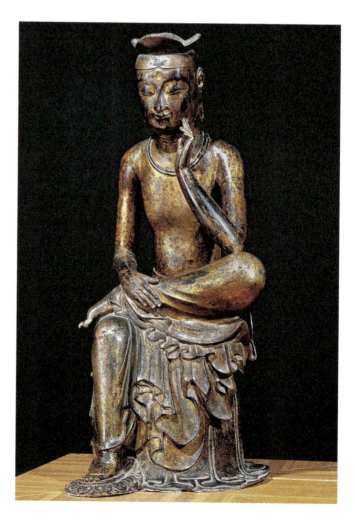

gilt-bronze crown and a large arsenal of weapons, have been discovered. The identity of the occupants of the twin burials is not known. Most likely the deceased are husband and wife, king and queen.

Silla's capital, Gyeongju, eagerly soaked up influences from China, the Middle East, and as far away as the Mediterranean. In addition to finding exquisitely crafted gold objects in Silla tombs, archaeologists have also unearthed glass beads and vessels, perhaps inspired by Middle Eastern sources, or imported from the Middle East and beyond via the Silk Road. Silla royalty were well prepared for the afterlife. Aside from the requisite luxury grave goods, large collections of ceramics containing food and other provisions for the deceased filled the tombs. Many of the ceramics, including stands designed to support round-bottomed vessels, are unglazed **stoneware**, a high-fired gray ware fashioned on the potter's wheel (**FIG. 11-7**). Four stylized snakes slithering up the sides decorate this ceremonial stand with distinctive triangular apertures arranged in **registers**, or vertical

Buddhist ceremonies. One of the most enchanting Buddhist sculptures from the Three Kingdoms period is the gilt-bronze image of a **bodhisattva** (likely the Bodhisattva Maitreya) seated in the pensive pose (**FIG. 11-8**). With his slight smile, elegant fingers that lightly brush his cheek, and right foot resting effortlessly on his left knee, the bodhisattva radiates serenity and stability. The entire figure, from gently bowed head to serpentine toes, is suffused with an inner vitality (*yeonggi*). His contemplative pose and the treatment of the drapery, indicative of advanced metal **casting** practices, evoke Chinese Northern Wei and Northern Qi sculptures from the sixth century (see Chapter 7, FIG. 7-25), although a distinctive Korean identity is evident in the bodhisattva's slender form, stylized facial features, and lotus crown. He also wears a disc attached to a sash on his left side that is associated with Korean court attire.

QUEEN SEONDEOK

Women in the Silla kingdom enjoyed a moderately high status, as evidenced in the respected positions they occupied as queens and female shamans. Silla society was based on a hierarchical ranking system; however, within this rigid structure women were allowed to inherit wealth and position, especially in the absence of male heirs.

In the middle of the seventh century, two queens ruled Silla: Queen Seondeok (r. 632–647), followed in quick succession

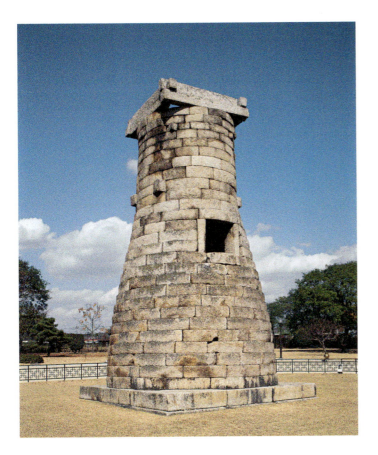

by Queen Jindeok (r. 647–654). Queen Seondeok was a bright and capable ruler. A story in the thirteenth-century *Samguk Yusa* (*Memorabilia of the Three Kingdoms*) describes how the seventh-century Chinese emperor Taizong gave Queen Seondeok a gift of peony seeds, along with a painting to demonstrate what the flowers would look like. Seondeok looked at the painting and determined that the peonies would have no fragrance, which proved to be correct. She based her observation on the absence of butterflies in the painting. Under Queen Seondeok's leadership, alliances were forged with Tang dynasty China, allowing Korean scholars to study in China. She also strengthened Silla's absorption of Buddhism by building Buddhist temples. Seondeok's other interests included astronomy; she commissioned the Cheomseongdae astronomical observatory, one of the oldest extant observatories in Asia (**FIG. 11-9**). Dating from 634, the weathered stone tower is about 30 feet in height (9 meters). It can still be seen in Gyeongju, defiantly standing against a backdrop of distant high-rises. Cheomseongdae is translated as "platform for observing the stars," although exactly how this structure was used is not known. The bottle-shaped tower consists of 27 circular layers on a square base surmounted by a square platform. The 27 layers possibly allude to Queen Seondeok as the 27th ruler of Silla. In general terms the round forms coupled with square shapes likely reflect the Chinese theory of round-heaven, square-earth. Halfway up the tower, an opening faces south. Like the Chinese, the Koreans kept astronomical records and documented celestial occurrences such as solar eclipses, comets, and meteor showers, all of which were considered intricately linked to the destiny of humankind.

Queen Seondeok valued celestial guidance during a reign dogged by uneasy alliances and bursts of violence with rival kingdoms Goguryeo and Baekje. Under her shrewd stewardship, Silla survived and prospered. Several decades after Seondeok's death, Silla, assisted by the Chinese Tang army, conquered Goguryeo and Baekje. The Korean Peninsula was then united in 668 under one hereditary ruler.

UNIFIED SILLA KINGDOM

Unified Silla (668–935) experienced a "golden age" of peace, prosperity, and cultural excellence, corresponding approximately with China's Tang dynasty. Trade networks with northeast Asia flourished, bringing great wealth to the Korean Peninsula. Unified Silla's maritime contacts included Persia, adding another dimension to the kingdom's influential sphere. The kingdom also looked carefully at Chinese technological innovations and closely

11-9 • CHEOMSEONGDAE ASTRONOMICAL OBSERVATORY
Three Kingdoms period, Silla kingdom, 634. Stone, height 30′9″ (9.4 m). Gyeongju.

observed the Tang court's socio-political policies for ways to advance their society. Confucian scholarship and Buddhist philosophy became tightly woven into the fabric of Korean government institutions. Members of the *Hwarang*, an elite group of aristocratic warriors, well versed in Confucian and Buddhist matters, were recruited as state administrators. Meanwhile, Gyeongju, Silla's vibrant capital, grew more splendid after unification. According to historical records the city had a population of about 1 million at its height. Judging by glowing reports in the *Samguk Yusa*, Gyeongju was an urban utopia with sumptuous mansions and pleasure gardens for the aristocracy, rows of tiled-roof houses, and not a single thatched roof in sight.

After unification, Buddhism became firmly entrenched as the state religion. Its appeal reached beyond the cloistered elite to touch the masses. Under the patronage of the imperial family and fellow aristocrats, majestic temples sprang up in and around Gyeongju, their glinting beauty constructed with the help of slave labor. Unfortunately, few structures from the Unified Silla period survived the ravages of Korea's tempestuous history. One great monument that has endured through the centuries, however, is the Buddhist cave temple Seokguram, perched like a giant sentinel on the slopes of Mount Toham, near Gyeongju. Constructed during the eighth century, Seokguram is traditionally associated with Kim Daeseong (701–774), a royal patron and prime minister who wished to honor his royal ancestors. Although fashioned after earlier Chinese Buddhist cave temples (see Chapter 7, FIG. 7-6), which in turn drew inspiration from ancient Indian prototypes (see Chapter 1, FIG. 1-23), the Korean temple deviates from its predecessors in construction. Rather than taking shape within the rock through excavation, the surfaces of Seokguram's interior walls are built with mathematical precision from blocks of granite attached together with stone rivets. Inside the artificially constructed grotto, a circular sanctuary with a domed ceiling houses an imposing granite statue of the seated Buddha, over 11 feet (3.4 meters) in height (FIG. 11-10). In an unusual twist, Buddha's halo was carved separately on the back wall. Artistic precedents for Seokguram's fleshy, broad-shouldered Buddha in clinging robes can be traced back to early Indian sculptures of the Buddha (see Chapter 2, FIG. 2-16) and their more recent stylistic incarnations found in eighth-century Tang China (see Chapter 7, FIG. 7-26). Buddha's majestic form is surrounded by a host of bodhisattvas and other spiritual beings delicately carved in relief on the temple's walls. Their circular arrangement infuses the chamber with a swirling cosmic energy, at the centre of which is Buddha, the essence of stillness anchored firmly on his lotus pedestal. The Seokguram Buddha's identity is contested, however the earth-touching gesture (*bhumisparsha mudra*) of his right hand suggests that this Buddha represents either the historical Shakyamuni Buddha at the moment of enlightenment, or Shakyamuni Vairochana, a transcendent manifestation of the Buddha. At sunrise, rays of light seep through the temple's entrance (when opened) to bathe the Buddha in a soft glow. In turn the Buddha appears to radiate light, especially from his crystal **urna** (third eye). An ethereal yet powerful presence, the Seokguram Buddha, facing east across the sea toward Japan, protects the kingdom from overseas invasion.

Unified Silla's control of the region weakened during the ninth century, undermined by warring factions within the royal family, withdrawal of support from China following the Tang dynasty's collapse, and the resurgence of old kingdoms such as Goguryeo. Indeed, by 935 the Goryeo dynasty (derived from

11–10 • SEATED BUDDHA AT SEOKGURAM CAVE TEMPLE Unified Silla period, ca. 751. Granite, height (Buddha only) 11'2" (3.42 m). Near Gyeongju.

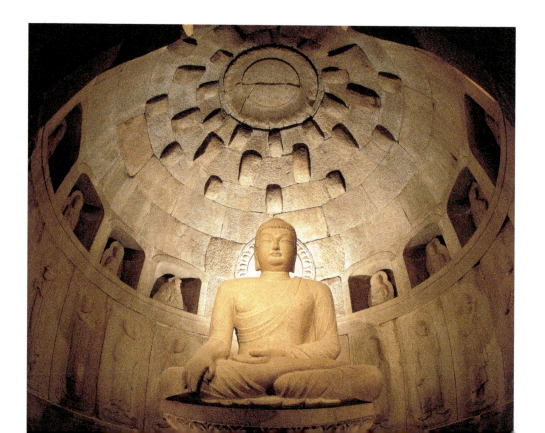

Goguryeo) dominated the Korean Peninsula, and it would do so for several centuries.

Sustained contact between Korea and Japan during the Three Kingdoms and Unified Silla periods allowed Korea to leave a distinctive imprint on the evolution of Japanese society and culture. Various burial objects, such as gold crowns, **Sueki ware** (gray-green pottery), jade ornaments, weapons, and horse-riding accoutrements, excavated from Japan's Kofun era tombs (see Chapter 12, p. 285) are strikingly similar to their counterparts in ancient Korea. Future archaeological discoveries will shed more light on the extent of Korea's early influence on neighboring Japan and, conversely, Japan's influence on Korea.

GORYEO DYNASTY

As the Unified Silla kingdom started to disintegrate in the ninth century, the Goryeo (918–1392) gradually took control of the peninsula and, under the leadership of Taejo Wang Geon (r. 918–943), completed the consolidation of Goryeo in 936. Songdo (present-day Gaeseong in North Korea), strategically positioned in the middle of the peninsula and recommended by Buddhist geomancers as an auspicious location for a long-lasting kingdom, became Wang Geon's political and cultural capital. A bronze statue of Wang Geon—probably clothed in royal robes originally—was unearthed near the ruler's tomb in Gaeseong in 1993 (**FIG. 11-11**). Wang Geon also rebuilt and fortified the old Goguryeo capital of Pyongyang—likely a shrewd political maneuver to link the Goryeo (also known as Koryo) dynasty to the glories of the ancient Goguryeo kingdom. Korea, a Western/European name, is derived from Goryeo.

China, especially during the early years of the Goryeo dynasty, exerted a strong influence on Korea's political, social, and cultural development. Gaeseong's layout was modeled on that of Chang'an, China's historic Tang dynasty capital. An extensive building program, including numerous palaces and Buddhist temples, transformed Gaeseong into a wealthy, cultivated capital that was admired by visiting Chinese envoys. Confucianism, introduced to Korea during the Three Kingdoms period, became a principal ideology of the state, contributing to the standardization of government operations. Commencing in 958, potential administrators had to pass civil service examinations steeped in Confucian content, with a view to encouraging a wider range of talented individuals to advance through the bureaucratic ranks. In reality, most candidates were aristocrats, and important official positions were awarded to the aristocratic elite.

Trade with Song China flourished during the Goryeo dynasty. Korea exported gold, silver, copper, paper, fans, ink, brushes, and ginseng to China, and in turn such goods as silks, porcelain, musical instruments, books, medicine, and spices were imported into Korea from China. Korean scholars studied

11-11 • WANG GEON
Goryeo period, 10th century. Bronze, height 56″ (143.5 cm). Gaeseong, Central History Museum, Pyongyang.

Chinese classical literature and wrote poetry in Chinese. Korean Buddhist monks traveled to China and India to further their religious studies, returning to Korea well versed in various branches of Buddhist thought. During the early Goryeo period two Buddhist schools, **Gyo** (Doctrine) and **Seon** (Meditation) gained prominence. Goryeo Buddhist monasteries became vital centers of scholarship and art. It was an exciting time for Korean artists, who benefited from the influx of new ideas, technology, and cultural innovations, not only from China but also from the Middle East as foreign merchants arrived by sea to trade with the Koreans.

GORYEO SOCIETY AND BUDDHISM

Goryeo society was highly stratified, consisting of three distinctive classes: aristocrats, commoners, and "low-born" (mostly servants and slaves), organized according to kinship groups. Although the nobility and general population lived separate lives, the importance accorded to education permeated many levels of society. Even children from the lower ranks had access to learning in village schools and Buddhist temples, a factor that contributed to the kingdom's high literacy levels. Polygamy was an accepted custom; indeed, Wang Geon had 29 queens who produced 25 sons and 9 daughters. Within this system, Goryeo daughters were given equal rights with their brothers when it came to inheritance.

In addition to adopting Confucian practices for government operations, Wang Geon declared Buddhism to be the state religion. Buddhism was able to penetrate all sectors of society. Throughout the year, numerous grand Buddhist festivals, complete with processions and feasts, drew excited crowds. Several of these festivals—for example, *Paekchung*, the feast for the

The luminous hanging scroll shown here, featuring a Seated Willow-Branch Gwanse'eum Bosal, the Bodhisattva of Compassion (Skt. Avalokiteshvara; Ch. Guanyin), was painted during the fourteenth century, when Korea was subject to Mongol control (FIG. 11–12). Commissioned for a temple, the image provided a welcome aid for meditation and worship. Using ink, rich colors, and gold pigment on silk, the artist painted an exquisitely attired Gwanse'eum Bosal who gazes down from his rocky perch on Mount Potalaka at a tiny seeker of wisdom, the young **Sudhana**. Sudhana was an Indian youth who searched for enlightenment, and during his quest learned from 53 spiritual masters, including the Gwanse'eum Bosal. The Bodhisattva's fine silk robes, enhanced with jewelry, reflect the luxurious tastes of the sophisticated aristocracy. Gold pigment is generously applied to the composition as seen in the glimmering auras surrounding his form, patterns in the weathered rock, and even such small details as the veins of lotus petals. Cloaked in a diaphanous garment, the Bodhisattva transmits a lightness of being as he appears to float rather than sit in the dreamy-looking landscape, featuring both bamboo fronds and coral branches. His identity as the Willow-Branch Gwanse'eum Bosal is confirmed by the vase containing a willow sprig near his right hand. In Buddhist texts, willow has purifying and restorative properties, an appropriate attribute for the Gwanse'eum Bosal, who vows to cure sickness. Paintings of the Willow-Branch deity were popular in Song dynasty China, although images of this bodhisattva as an iconographic type first emerged in China during the Tang dynasty. This Korean painting of Gwanse'eum Bosal possesses distinctive Korean touches, such as the depiction of the vase as a **celadon**-glazed vessel (see FIG. 11–16) for holy water (*kundika*). Thanks to religious exchanges that took place between Korea and Japan, paintings of this quality were exported to Japan, where surviving examples are preserved today.

11-12 • SEATED WILLOW-BRANCH GWANSE'EUM BOSAL (THE BODHISATTVA OF COMPASSION)
Goryeo dynasty, late 14th century. Hanging scroll, ink, colors, and gold pigment on silk, height 62″ (159.6 cm). Arthur M. Sackler Museum/Arthur M. Sackler Museum, Bequest of Grenville L. Winthrop, 1943.57.12.

GORYEO CERAMICS

Before Wang Geon died he left "The Ten Injunctions," a set of directives for his descendants to follow to ensure a prosperous kingdom. In his fourth injunction he acknowledged the dynasty's cultural and political debt to Tang China, but he also emphasized Korea's individuality and the importance of the country's unique identity: "In the past we have always had a deep adoration for Tang-style culture, and we have modeled their institutions. But our country is a separate land, and our people's character is different. Therefore, there is no reason to copy it."

Innovations in Korean culture are particularly evident in the evolution of ceramics. Goryeo dynasty celadon or green-glazed wares are world-renowned for their technical artistry, subtle beauty, and originality. Chinese potters invented celadon glazes—the Longquan workshops in Zhejiang province, in particular, had established a reputation for producing fine celadon ware. Scholars debate the date of arrival of celadon technology in Korea but generally concur that celadons were first

souls of the dead—combined Buddhist and ancient shamanistic practices, which added to their popular appeal. Under the lavish patronage of the royal court, aristocracy, and Buddhist elite, the arts thrived in the service of Buddhism. Sumptuous temples with elegant stone **pagodas** (tiered towers) and glowing wall paintings housed impressive collections of Buddhist statuary in marble, bronze, and wood. As with such treasures from earlier periods, few remain today as invading forces both during and after the Goryeo dynasty destroyed or looted much of Korea's artistic heritage. In particular, the Goryeo suffered waves of Mongol assaults from the north, beginning with an invasion in 1231.

Goryeo's first ruler, Wang Geon, placed the dynasty under the protection of the Buddha. Successive rulers who faced incursions from tenacious invaders north of Korea also invoked the protective forces of Buddhism to ward off attacks. During King Hyonjong's reign (1009–1031), a monumental project began to carve a complete edition of the Buddhist texts (*Tripitaka*) onto **woodblocks**, to preserve the Buddha's teachings and summon spiritual protection for the peninsula. The woodblocks were finally completed in 1087. Regrettably, Mongol invaders managed to destroy these blocks in the thirteenth century, although remnants of the prints still exist. Another set of woodblocks consisting of over 80,000 blocks was completed in 1251. This second set, known as the *Tripitaka Koreana*, is currently preserved at Haeinsa Monastery on Mount Kaya in South

Korea (**FIG. 11–13**). Created from birch wood, these blocks are masterfully carved in classical Chinese script. Haeinsa Monastery used the blocks to print copies of the *Tripitaka* in ink for Buddhist educational purposes.

A discussion of the Goryeo dynasty would not be complete without introducing the remarkable invention of metal movable type in the first half of the thirteenth century (wooden movable type had been developed in China around 1045 by Bi Sheng). Invented by Goryeo artisans in response to increasing demand for books, both religious and secular, the world's first metal movable type preceded Gutenberg's printing press in Europe by about 200 years. Naturally, this invention was a huge boost for the efficient production and dissemination of information. Books on a wide selection of subjects, including Buddhism, Confucianism, and literature, could now be mass-produced. The oldest existing book printed using metal movable type is the Korean Buddhist text *Buljo Jikji Simche Yojeol* (known as *Jikji*), printed by Hungdok Temple in 1377.

11–13 • MONK WITH ORIGINAL WOODBLOCK FROM THE *TRIPITAKA KOREANA*
Goryeo dynasty, 1251. Haeinsa Monastery, Mount Kaya.

made there during the ninth century. Early Korean celadons closely follow Chinese models, but by the twelfth century, once Korean potters had perfected the art of glaze chemistry and the wizardry of kiln temperature and atmosphere, they produced some of Asia's most original ceramics. Even the Chinese, with their rich tradition in ceramics, took note. Chinese Song writer Taiping Laoren (twelfth–thirteenth century), when discussing treasured items, such as the brocades of Sichuan and the porcelain of Dingzhou, included Korean celadons in his list of "first under Heaven." Further evidence of China's admiration for Goryeo celadon ware is found in the discovery of such ceramics at Chinese archaeological sites.

During the Goryeo dynasty, celadons were used by people from a variety of socio-economic backgrounds; however, the finest ceramics were reserved for members of the royal family, aristocracy, and Buddhist clergy. Centers of Goryeo celadon production were concentrated in southwest Korea, with ships transporting the ceramics up the west coast to the capital at Gaeseong. Goryeo potters made celadons for both utilitarian and ritual purposes out of clay and glaze containing small amounts of iron. During the firing process, in an oxygen-deprived kiln at a temperature of 2,100 to 2,190 degrees Fahrenheit (1,150 to 1,200 degrees Celsius), the iron transforms

to create the translucent bluish-green glaze that characterizes celadon ware. Early Goryeo celadons, dating from the eleventh to early twelfth centuries, tend to be plain, or decorated in a minimal fashion with incised designs. A perfect example of a celadon with these traits is a ewer, or pitcher, in the shape of a bamboo shoot (**FIG. 11–14**). Designed to contain either wine or water, all parts of the lustrous blue-green ewer are eloquently integrated to suggest the vitality of a bamboo shoot. The main body of the vessel is decorated with leaves in relief, their veins are incised with fine lines. Neatly crowning the vessel, the lid, in the shape of a sprouting shoot, has a hole for a cord to connect it to the handle. In turn, the handle and spout also resemble bamboo segments.

Around 1150, Korean potters expanded their repertoire of decorative techniques to include innovative methods of

11–15 • *MAEBYEONG* BOTTLE
Goryeo dynasty, late 12th–early 13th century. Celadon-glazed stoneware with incised and inlaid decoration, height 13″ (33.7 cm). Tokyo National Museum.

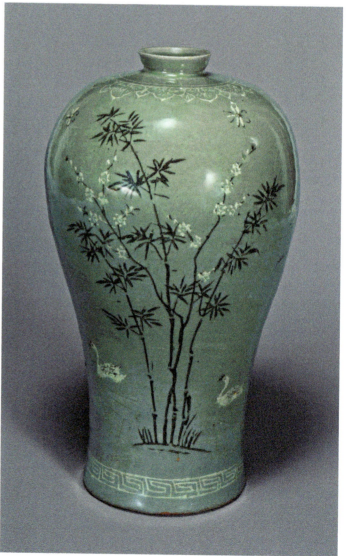

11–14 • EWER IN THE SHAPE OF BAMBOO SHOOT
Goryeo dynasty, 1100–1150. Celadon-glazed stoneware with incised decoration, height 10″ (25.4 cm). Victoria and Albert Museum, London.

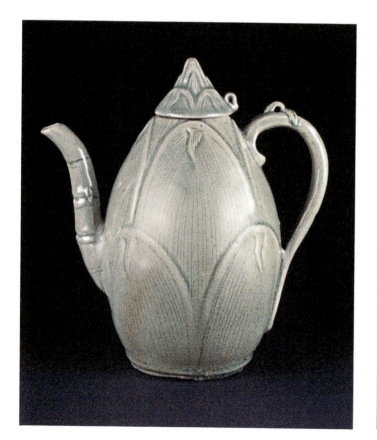

ornamentation, such as **inlay** and **underglaze** painting. A *mae-byeong* bottle—a small-mouthed vessel with broad shoulders and a narrow base—decorated with images of a plum tree in blossom, bamboo, water birds, and butterflies is a product of these new techniques (**FIG. 11–15**). The designs were first incised onto

11–16 • WINE POT WITH BOWL
Goryeo dynasty, 1150–1200. Celadon-glazed stoneware with incised, inlaid, and underglaze copper decoration, height 13″ (34.2 cm). National Museum of Korea, Seoul.

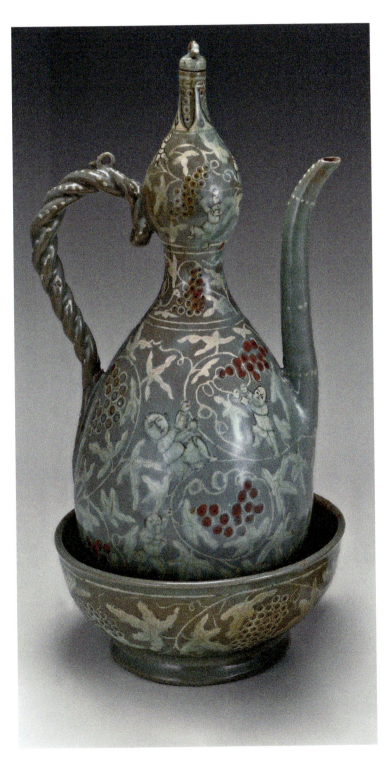

the clay vessel. Next, the incised imagery was inlaid with either black or white **slips** (a combination of clay and water) before a celadon glaze was applied and the vessel fired. Careful attention was paid to the arrangement of the motifs in relation to the vessel's rounded forms to ensure a harmonious composition. Originally, this storage jar for such liquids as wine and vinegar was covered with a bell-shaped lid.

The golden era of celadon production is said to stretch from the mid-twelfth century to the Mongol invasion of 1231. During this period, Korean potters conducted bold experiments that combined inlaying with underglaze copper oxide decoration. A gourd-shaped wine pot with bowl showcases the creative results of these technical innovations (**FIG. 11–16**). Compared to the bamboo-shoot ewer, this wine pot is very ornate, with decoration symbolizing material wealth and an abundance of male offspring. Images of energetic children pulling on grapevines are inlaid in the surface. Bunches of grapes, highlighted with underglaze copper oxide, provide accents of reddish color. The handle resembles a twisted vine while the spout suggests a bamboo stalk. Both handle and spout are decorated with tiny white spots. The decoration on the bowl's exterior echoes the grapevine motif, and lotus leaves incised on the bowl's interior complete the design.

Beautifully crafted celadon wares of all types and shapes streamed out of the workshops for use in elegant palaces, stately mansions, and Buddhist temples. In addition to ewers and wine pots, Goryeo potters also produced celadon flower vases, incense burners and containers, cosmetic sets, tea bowls, *kundika* (water sprinklers), pillows, and roof tiles. According to historical records, in 1157 the pleasure-seeking King Uijong (r. 1146–1170) ordered the roof of a summer pavilion at Gaeseong to be covered with celadon tiles. Decorated with molded patterns of leaves and flowers, these roof tiles were criticized by officials as excessively extravagant. King Uijong's luxurious pavilion, overlooking an ornamental lake in the palace garden, shimmered like a blue-green kingfisher in the changing light.

Despite the high level of skill required to make these luxury items for the elite, Korean potters had little status. They were not considered artists, and there are no names on individual celadons. Over time, Goryeo ceramics became synonymous with celadons, although unglazed stonewares, black wares, and white porcelains were also manufactured during this dynasty.

DECLINE OF THE GORYEO DYNASTY
Toward the end of the dynasty, Korea was not only under Mongol control but also suffering attacks on its coastline from marauding Japanese pirates. During these troubled times, Korea's weakened political and religious structures, increasingly undermined by internal disorder and corruption, were matched by deteriorating standards in the arts. Despite its inevitable decline, the once-powerful Goryeo dynasty is known as "Korea's Age of Enlightenment."

JOSEON DYNASTY

Leaving white-haired Mother in Gangneung,
With my forlorn heart I head to Seoul.
Turning back awhile to the village in north, I see
White clouds drift over green mountains in sunset.

Lady Saimdang (sixteenth century poet and artist)

The Joseon period (1392–1910) began when General Yi Seonggye (1335–1408; later King Taejo) overthrew the Goryeo and established his own dynasty. The dynasty was named Joseon after an earlier legendary Korean kingdom, but it was also called the Yi dynasty, from its founder's surname. One of the most remarkable factors of this dynasty is that it endured until 1910.

General Yi Seonggye established his capital at Hanseong (modern-day Seoul) in 1394 and instituted a series of reforms that laid the groundwork for the new dynasty's formation. He dismantled the political and economic power of the Buddhist clergy by rejecting Buddhism as Korea's state religion in favor of Chinese Neo-Confucianism (a revitalization of Confucian philosophy that combined elements of Daoist and Buddhist philosophy within an overall controlling framework of Confucian logic). Without state support, some Buddhist temples were demolished and their lands confiscated, forcing monks to relocate to distant mountain retreats. Although Buddhism was removed from the public sphere, on a private level it was tolerated, along with shamanistic practices. Neo-Confucianism also became the philosophical foundation of the new government, which modeled its bureaucracy on that of Ming dynasty China (1368–1644). Following China's example, entry into the state bureaucracy was governed by rigorous government examinations. However, unlike China's more inclusive policy of attracting a wide pool of prospective candidates, eligible Korean exam-takers were limited to the scholarly upper class (*yangban*). Members of this class, which included high-ranking citizens and military men, were enthusiastic practitioners of Chinese painting, poetry, and music, and generous art patrons.

Joseon dynasty scholars produced numerous cultural and scientific advances, such as the invention of the rain gauge, the bowl-shaped sundial, and *hangul* (the Korean alphabet), an elegant and efficient phonetic writing system. Developed under the leadership of King Sejong (r. 1418–1450), *hangul* allowed Koreans to write in their own language rather than in Chinese, stimulating a surge in creative development. The complex Chinese script, however, remained the preferred writing system of Korean scholars until the twentieth century.

The steady Confucianization of Joseon society slowly undermined the social and economic privileges women had enjoyed in the Goryeo period. Women's participation in the outside world, especially those belonging to the *yangban* class, gradually receded to a life of domesticity as "inside people." Confucian teachings conceptualize the perfect woman as a "good wife and wise mother." The subordination of women, which included limited educational opportunities and the erosion of legal and inheritance rights, reached its lowest point in the late Joseon period, when Neo-Confucianism's strong patriarchal system became fully entrenched.

Although the Joseon era was marked by periods of suffering—most notably caused by Japanese invasions under Toyotomi Hideyoshi in 1592 and 1597 (see Chapter 14, p. 353) and the **Manchu** invasion of 1636–1637—periods of stability, enhanced by a mid-seventeenth-century government policy of seclusion from neighboring countries (resulting in Korea's nickname "Hermit Kingdom"), allowed Korea to prosper. Many of Korea's outstanding cultural landmarks, such as Seoul's Sungnyemun (Gate of Exalted Ceremonies), Gyeongbok Palace, Changdeok Palace, and Jongmyo royal ancestral shrine, date from the Joseon dynasty, an era peppered with accomplished rulers and silenced only in 1910 with Japan's annexation of Korea.

11–17 • SUNGNYEMUN (GATE OF EXALTED CEREMONIES)
Seoul. Joseon dynasty, originally built in 1398.

JOSEON ARCHITECTURE

Traditionally, Seoul was the center of government and the official residence of the royal family. Palaces and ancestral shrines dominated the capital, protected by a great wall. Entry into Seoul through the Sungnyemun (Gate of Exalted Ceremonies) provides the visitor with a glimpse of Joseon culture—sophisticated, stately, and authoritarian (**FIG. 11–17**). Originally completed in 1398, this imposing gateway consists of a stone foundation topped by a Chinese-style, two-tiered, tiled and bracketed wooden structure. It operated as the main entrance into the city and starting point of a wide road leading to Gyeongbok Palace, Joseon's oldest palace compound. Sadly, the palace was burned down in 1592 during the Japanese invasion and not rebuilt until the late 1860s.

CHANGDEOK PALACE Changdeok Palace, commissioned as a secondary palace by King Taejong (r. 1400–1418) and completed in 1412, was also ravaged during the Japanese attacks, but was rebuilt in 1609 by King Seonjo. It subsequently functioned as the principal residence of Joseon monarchs and the seat of government until the rebuilding of Gyeongbok Palace.

Located on hilly land east of Gyeongbok Palace, Changdeok's elegant buildings and gardens are integrated into the natural topography of the site, imbuing the palace with a special beauty. Mount Ungbongsan, revered as a guardian mountain, casts a protective shadow over a complex of royal residences, spacious gardens, and official buildings, such as Injeongjeon (Throne Hall) (**FIG. 11–18**). Originally constructed in 1405, this colorful yet dignified throne hall, inspired by Chinese architectural traditions, was used for important state affairs, including the coronation of new monarchs and the reception of foreign dignitaries. Set on a stone platform, Injeongjeon's two-tier structure, with an array of guardian creatures keeping watch along the eaves, is painted in a traditional Korean style called *dancheong*—"cinnabar and blue-green." Although red and blue-green are favored colors, yellow, black, and white are also used to correspond to the Five Elements (fire, wood, earth, water, and metal). Dark red pillars boldly define the main entrance, while blue-green upper walls and eaves complement the shadowy areas. This powerful interplay of warm and cool colors adds dramatic interest to the building. A closer look at the colorful patterns decorating the eaves reveals floral designs of peonies and chrysanthemums, symbols of prosperity and longevity. *Dancheong* not only enriches the exterior but also protects the wood from weathering and insects.

Inside the hall, a single space with a high ceiling, an elaborate throne beneath a carved wooden canopy dominates (**FIG. 11–19**). Behind the royal seat an eye-catching painted screen displaying the Sun, Moon, and Five Peaks, a subject with Daoist roots, punctuates the background. This stylized, formal landscape,

11–18 • DETAIL OF PAINTING ON EAVES, INJEONGJEON (THRONE HALL), SEOUL.
Joseon dynasty, originally built in 1405. Periodically destroyed and restored. Current structure dates from 1804.

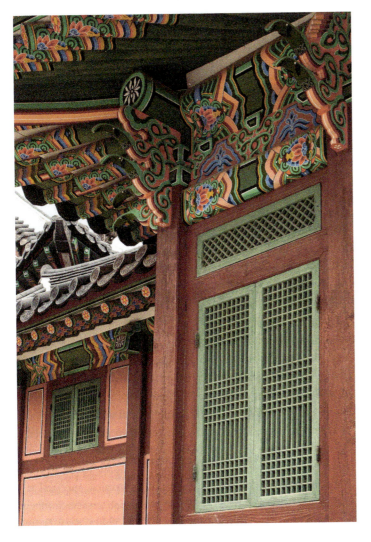

11–19 • DETAIL OF THRONE AND SCREEN PAINTING OF THE SUN, MOON AND FIVE PEAKS
Injeongjeon (Throne Hall), Seoul. Joseon dynasty, 1405.

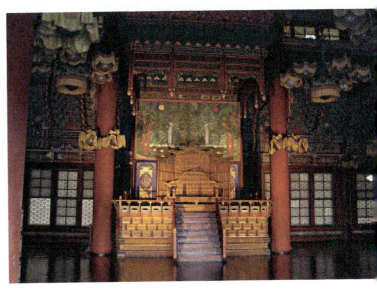

PORCELAIN Purity. Beauty. Austerity. Elegance. These words are frequently associated with Korean **porcelain**. Fashioned from refined white clay and covered with a translucent glaze before being fired at high temperatures of between 2,300 and 2,550 degrees Fahrenheit (1,250 and 1,400 degrees Celsius), porcelain emits a ring when struck. Long imported from China as a luxury item for society's elite, porcelain began to be made in Korea during the Goryeo dynasty, possibly as early as the eleventh or twelfth centuries. By the fifteenth century, demand for porcelain had increased, leading to its widespread production. Inspired by Chinese imported wares and firing technology, official government-controlled kilns were established in the late 1460s and the finest porcelains, reserved for the royal court, were manufactured at official kilns in Gwangju, near Seoul. At first, Joseon potters emulated Chinese porcelains, but gradually a distinctive Korean style emerged, characterized by innovative vessel shapes and unique ornamentation.

Plain white porcelain was especially popular in Joseon Korea, in part a reflection of Neo-Confucian tastes, which valued austerity rather than opulence. A wine cup made in the fifteenth century for use in Confucian ancestral rituals is an excellent example of the snowy-white porcelain produced at Gwangju's kilns (**FIG. 11–24**). Its unadorned beauty embodies Neo-Confucian ideals of order and restraint.

Although undecorated or minimally ornamented white porcelain remained popular throughout the Joseon era, Joseon consumers also appreciated colorful porcelain. Blue-and-white porcelains were imported from China, followed later by polychrome porcelains. In turn, Korean potters mastered the art of decorating white porcelain ware with designs painted in **cobalt** blue, iron-brown, and copper-red under the glaze. Dating from the seventeenth century, a large porcelain jar, created for court use, features a lifelike grapevine painted in underglaze iron-brown slip (**FIG. 11–25**). Leaves, tendrils, and grapes captured in subtle gradations of color from light to dark brown flow over its bulbous shoulders. This deftly painted design was executed

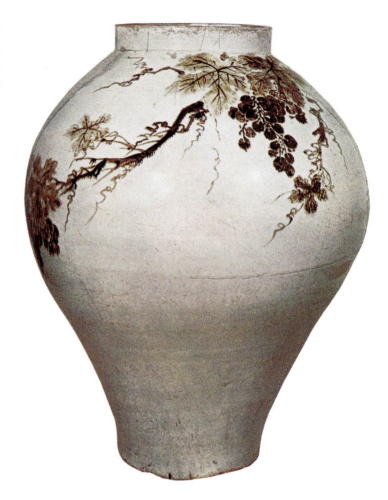

11–25 • JAR WITH GRAPEVINE DECORATION
Joseon dynasty, 17th century. Porcelain with decoration painted in underglaze iron-brown slip, height 22⅛″ (53.8 cm). Ewha Women's University Museum, Seoul.

by a court artist, not a potter. The bottom section of the vessel remains plain, in keeping with Neo-Confucian preferences for restrained ornamentation. The crack in the middle of the jar exposes how it was made in two parts that were joined together.

11–24 • WINE CUP
Joseon dynasty, 15th century. Porcelain, height 1⅝″ (4.1 cm), diameter 4½″ (15.5 cm). Metropolitan Museum of Art, New York. Rogers Fund, 1917 (17.175.1).

Unlike *buncheong* ware, porcelain was produced throughout the Joseon period.

JOSEON PAINTING

Although Buddhism no longer enjoyed the official patronage of Korea's ruling elite, it remained popular with monarchs, upper-class women, and the masses. Buddhist paintings and sculptures were created for both private devotion and temple complexes. Queen Dowager Munjeong (1501–1565), a devout Buddhist and art patron, played an active role in revitalizing Buddhism in the mid-sixteenth century. The widow of King Jungjong (r. 1506–1544), she ruled between 1545 and 1565 as regent on behalf of her son, King Myeongjong. Queen Munjeong's embrace of Buddhism's more egalitarian philosophy granted her political power denied to women by Confucian dictates. In 1549, Munjeong scrapped the state's anti-Buddhist code and in 1551, some 2,600 new priests were ordained. The queen also commissioned numerous Buddhist paintings, including the hanging scroll of a wizened **arhat** (*nahan*) named Deoksewi reading a sutra in a natural setting (**FIG. 11-26**). An *arhat* is a disciple of the Buddha who has attained spiritual enlightenment. Executed in 1562, the accompanying gold inscription informs the viewer that this image was one of a set of 200 paintings ordered by Queen Munjeong. Originally all 200 paintings were enshrined by Munjeong at Hyanglim Temple, Mount Samgak, as an act of piety to bring peace to the land. She also sought health and prosperity for her sickly son, King Myeongjong. The *arhat*'s colorful red-and-green robe, embellished with swirling gold patterns, contrasts with the somber ink landscape of rocks and pine branches, showing the influence of earlier Chinese ink paintings.

PORTRAIT PAINTING Portraiture flourished during the Joseon era, largely due to the importance Confucianism placed on ancestor worship and family lineage. Court painters executed portraits of kings and their queens, which were enshrined in royal ancestral portrait halls following their subject's death. Interestingly, formal portraits of women dwindled as the dynasty wore on, a casualty of Confucian morals regarding gender segregation that forbade women to sit for a male painter.

Other types of portrait commonly painted at this time were those of Buddhist monks for use in temples, and famous scholars and government officials commissioned by proud relatives for enshrinement and veneration in family ancestral halls. Portraits of meritorious subjects (*gongsin*) were also popular: Bureaucrats who made distinguished contributions to the state were awarded

11-26 • *THE ARHAT DEOKSEWI*
Joseon dynasty, 1562. Hanging scroll, ink and color on silk, 18 × 11⅜″ (45.72 × 28.89 cm). Los Angeles County Museum of Art. Murray Smith Fund M.84.112.

the title of *gongsin*, and an elaborate portrait invariably accompanied this award. Such paintings—for example, the full-length *Portrait of Oh Jaesun*, dated 1791 and attributed to renowned artist Yi Myeong-gi—combine stylized formality with an individual's physical likeness and personality (**FIG. 11-27**). Oh Jaesun

11–27 • Attributed to Yi Myeong-gi **PORTRAIT OF OH JAESUN**
Joseon dynasty, 1791. Hanging scroll, color on silk, 59⅞ × 35¼″
(152 × 89.6 cm). Leeum, Samsung Museum of Art, Seoul.

individuality. Eyes, in particular, were believed to transmit the soul. Oh Jaesun's eyes are fully alert, despite the onset of old age indicated by his mottled skin and wispy beard, both meticulously painted.

LANDSCAPE PAINTING Innovative developments occurred in landscape painting during the late Joseon period. Early Joseon artists relied heavily on various Chinese traditions for their vision of the landscape, as illustrated in court painter An Gyeon's (active ca. 1440–1470) painting of 1447 entitled *Dream Journey to the Peach Blossom Land* (**FIG. 11-28**). Based on an imaginary tale by the Chinese poet Tao Qian (365–427), this painting illustrates a dream of encountering a lost paradise, the Peach Blossom Land. The towering mountain peaks and expansive vistas surrounding this magical land (visible in the right-hand section of the scroll) recall landscapes featured in Chinese Northern Song paintings. At the same time, An Gyeon leaves his personal mark on the landscape in the form of dynamic brushstrokes and expressive interplay between solids and voids. However, by the eighteenth century, Korean landscapists transformed Chinese influences into a distinctive Korean style. Part of this search for a stronger Korean identity coincided with the collapse of the Ming dynasty in China. Released from China's pervasive influence, Korean intellectuals, while immersed in the Chinese classics, began to focus on Korea and Korean society. As the scholar Pak Chiwon

served King Jeongjo (r. 1776–1800) as a high-ranking officer, a fact attested to by his dignified pose, formal green robe, and black silk winged hat. The embroidered image of two cranes decorating his chest signifies that Oh Jaesun attained the court's highest rank, *il pum*. The stateliness of this portrait is offset by the artist's detailed treatment of the official's face to convey his

11–28 • An Gyeon **DREAM JOURNEY TO THE PEACH BLOSSOM LAND**
Joseon dynasty, 1447. Handscroll, ink and light colors on silk,
15 × 41¾″ (38.7 × 106.1 cm). Central Library, Tenri University,
Tenri (near Nara), Japan.

(1737–1805) remarked, "We are different from China, why try to emulate China?" Chiwon was a proponent of the *Silhak* ("practical learning") school of thought, a late Joseon Korean social reform movement noted also for its promotion of Korean studies. In the visual arts, Korean landscapes and the lifestyles of Korean people became popular subjects.

Jeong Seon (1676–1759), a scholar-official, was a pioneer in painting famous scenic locations in Korea. Although artists had painted Korean vistas before the eighteenth century, Seon is credited with initiating and developing "true-view landscape painting" (*chin'gyong sansu*), a practice that championed the portrayal of Korean scenery as an alternative to Chinese-inspired landscapes. Seon traveled around Korea in search of remarkable natural sites to paint. In particular, the Diamond Mountains (Geumgang-san), now in North Korea, fascinated him. He painted numerous representations of this craggy mountain range, an example of which is the hanging scroll *Panoramic View of the Diamond Mountains (Geumgang-san)*, dated 1734 (**FIG. 11-29**).

Using a bird's-eye perspective and energetic, dark brushstrokes, Jeong Seon captures not only the crystalline appearance of the innumerable mountain peaks but also the "aura" of Geumgang-san, referred to in the accompanying inscription, via soft blue washes and misty valleys. Although Jeong Seon never completely abandoned Chinese pictorial methods, by executing Korean landscapes in such a vibrant, original manner he contributed to a distinctively Korean style of landscape painting.

GENRE PAINTING Late Joseon **genre painting**, highlighting everyday life in Korea, reflected this growing interest in all things Korean. Kim Hongdo (1745–1806) and Sin Yunbok (1758–?) are two important artists who vividly captured ordinary Koreans from various social classes going about their daily lives. Both men were professional painters employed by the court's Bureau of Painting.

In a series of 25 album leaves, now in the collection of National Museum of Korea, Kim Hongdo painted commoners immersed in everyday activities such as washing clothes in a stream, threshing rice, or tiling a roof. In a detailed painting of roof tiling (**FIG. 11-30**), Kim Hongdo demonstrates his powers of observation and playful humor. Numerous workers in white outfits are absorbed in a variety of tasks. Two people are crouched on the roof: One pulls a string attached to a clay ball while the other is about to catch a tile tossed from below. Under the roof, a man checks the pillar's alignment, while close by a carpenter is busy smoothing a plank of wood with a plane. The spectator on the right appears to be supervising the scene, judging by his clothing and posture. Using a limited palette of blues

11-29 • Jeong Seon **PANORAMIC VIEW OF THE DIAMOND MOUNTAINS (GEUMGANG-SAN)**
Joseon dynasty, 1734. Hanging scroll, ink and colors on paper, 40⅝ × 37″ (130.1 × 94 cm). Lee'um, Samsung Museum of Art, Seoul.

11-30 • Kim Hongdo **"ROOF TILING"**
Late Joseon dynasty, 18th century. Album leaf, ink and light color on paper, 11 × 9″ (28 × 24 cm). National Museum of Korea, Seoul.

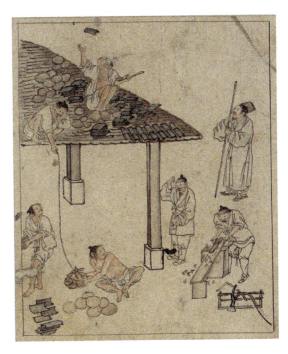

Tano Day, an important Korean festival with ancient Chinese roots, is celebrated on the fifth day of the fifth month according to the lunar calendar. Originally, the festival was associated with agricultural rites to ensure a bountiful harvest. In Joseon times it became a day of outdoor entertainment. Men participated in wrestling matches and women played on swings or bathed in streams.

Sin Yunbok "WOMEN ON TANO DAY"
Joseon dynasty, late 18th–early 19th century. Album leaf, ink and colors on paper, 11⅛ × 13⅞″ (28.3 × 35.2 cm). Gansong Museum of Art, Seoul.

Two young monks gleefully spy on the bathing *gisaeng* (female entertainers) from behind a rock. This element of voyeurism heightens the erotic overtones of the painting.

This brightly dressed *gisaeng* reveals her undergarments as she plays on the swing, a provocative image for the period.

Gisaeng in traditional Korean dress (*hanbok*) relax on the hillside. The woman in blue releases her long braided wig.

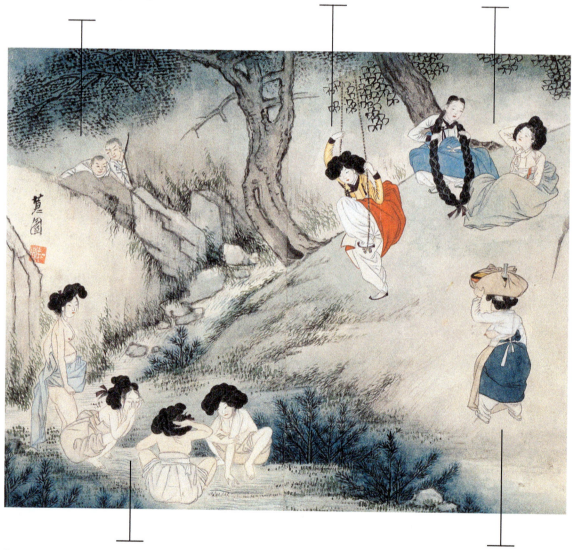

Four semi-nude *gisaeng* bathe in a flowing stream. Sin Yunbok captures the individuality of these women through their varied actions and distinctive facial expressions. The standing *gisaeng* directs her gaze toward the viewer. This bold presentation of female nudity in a Korean landscape is remarkable for the time. In Western art, the female nude in a modern context, free from classical or biblical references, does not appear until the mid-nineteenth century. Sin Yunbok's taste for erotica resulted in his expulsion from the court's Bureau of Painting.

A matronly washerwoman with exposed breasts carries a load of laundry on her head.

and browns, Kim Hongdo created a composition that appears deceptively simple. The figures are cleverly arranged in a circular format to animate the scene, which is further energized by his masterful use of line, conveying a wide range of gestures and facial expressions.

Unlike Kim Hongdo, who enjoyed illustrating the lives of commoners, Sin Yunbok focused on the activities of the *yangban* class, often in the company of female entertainers (*gisaeng*). His painting "An Amusing Day in a Field in Spring," part of an album of genre scenes, presents a group of gentlemen accompanied by two *gisaeng* enjoying a fall outing in the countryside (**FIG. 11-31**). The seated gentleman lower right plays a Korean zither (*gayageum*). Members of the group are fashionably dressed. The men wear white garments with distinctive lacquer-coated horsehair hats, while the elaborately coiffed women are clothed in billowing blue skirts paired with short fitted jackets.

Although upper-class women were generally confined to their private, domestic world, lower-class women—for example, servants, shamans, and *gisaeng*—were allowed into the public realm. *Gisaeng* occupied an ambiguous place in Joseon society. Although they came from low-class backgrounds, their beauty and accomplishments in the arts, such as singing and dancing, allowed them to mingle with powerful gentlemen from the upper classes. Most *gisaeng* were denied marriage and motherhood. When viewed within the context of Joseon society, which officially favored gender segregation, this picnic is charged with sexual desire. By placing the gentlemen in the company of *gisaeng*, is the artist indirectly hinting at the men's dissipation?

JOSEON WOMEN ARTISTS

Within the confines of Joseon society, which was regulated according to Confucian propriety, there was little room for women to thrive as writers and artists. Scholars and government officials believed that an educated woman would neglect her domestic responsibilities. This prevailing attitude is summarized in the following quotation taken from a text entitled *Trivial Discourses of Seongho* (*Seongho saseol*), written by scholar Yi Ik (1681–1763): "Reading and lecturing are men's work. Women should serve their families, hold ancestral rites, and entertain guests. Given these roles, how can women spare time for reading books?"

The invention of *hangul* in the early Joseon period, much like the development of *kana* in Heian Japan, provided females with access to learning. Women eagerly devoured Chinese texts and novels now available in Korean. Although they were denied a formal education until the last years of the Joseon era, a number of elite Joseon women, largely self-taught at home with the assistance of male family members, left behind a significant body of poetry, prose, calligraphy, embroidery, and paintings. One woman, Sin Saimdang (1504–1551), is well known for her contributions to Korean culture.

Taught to read and write by her scholarly father, Sin Myeonghwa, Lady Saimdang learned to paint as a young child by

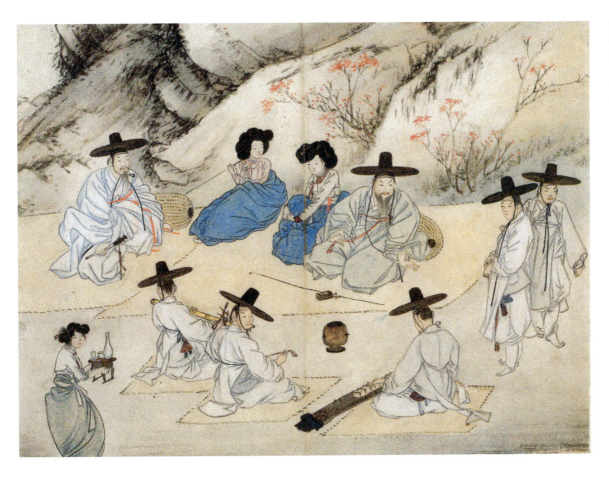

11-31 • Sin Yunbok "AN AMUSING DAY IN A FIELD IN SPRING" Late Joseon dynasty, 18th century. Album leaf, ink and color on paper, 11⅛ × 13⅞" (28.3 × 35.2 cm). Gansong Museum of Art, Seoul.

emulating the works of earlier Joseon artist An Gyeon. Married at 19, Lady Saimdang was the example of the dutiful daughter, "good wife and wise mother," while developing her painterly talents. She took her inspiration from nature and excelled at painting landscapes and exquisitely detailed works filled with grapevines, grasses, flowers, fruits, insects, birds, and animals, as seen in a sixteenth-century painting attributed to her, entitled *Mice Nibbling at a Watermelon* (**FIG. 11-32**). Part of a multipaneled screen, this bucolic image is not only pleasing to the eye but also rich in symbolism. Watermelons are associated with fertility, a concept reinforced by the inclusion of two mice, two large, ripe watermelons, and two butterflies. This emphasis on duality also refers to the harmonious interplay of *yin* and *yang* elements.

During her lifetime, Lady Saimdang's artworks attracted the admiration of Joseon scholars and even King Sukjong. The respected scholar Eo Suk-gwon enthusiastically declared in his book *Miscellany from a Storyteller* (*Paegwan japgi*) that Saimdang's "still lifes of grapes and her landscapes excel those of her contemporaries."

11-33 • BANKNOTE (50,000 WON) FEATURING SIN SAIMDANG
2009. Bank of Korea.

In 2009, the Bank of Korea placed an image of Sin Saimdang, the first woman to grace Korean currency, on their new 50,000 won bill (**FIG. 11-33**). According to bank officials, Sin Saimdang was selected for her ability—notice her portrait (inspired by historical accounts) is accompanied by details of the grapevines she was famous for painting—and "to promote gender equality and women's participation in society." However, she is also mythologized as a perfect model of the "good wife and wise mother" and raised seven children, one of whom, Yi I, became a famous Neo-Confucian philosopher. Controversy accompanied the bank's decision. While some applauded the attempt to address gender inequality in public life, others—especially feminist groups—criticized the choice of Sin Saimdang as reinforcing sexist stereotypes that still lurk within contemporary Korean society. Kwon Hee-jung, a leading women's rights advocate, commented: "Although women nowadays are highly capable and educated, the idea of 'wise mother and good wife' holds them down." Ultimately, when Sin Saimdang's artistic legacy is examined on its own terms, unclouded by external narratives accumulated over time, an extraordinary talent shines through.

11-32 • Attributed to Lady Sin Saimdang
MICE NIBBLING AT A WATERMELON
Joseon dynasty, 16th century. A panel from a screen painting, ink and color on silk, 13⅜ × 11⅛″ (34 × 28.3 cm). National Museum of Korea, Seoul.

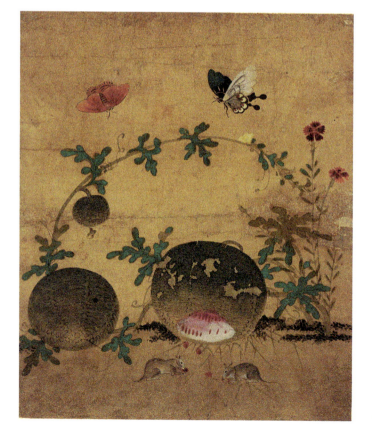

FALL OF THE JOSEON DYNASTY

Korea experienced periods of great turmoil during the late nineteenth century. Court rivalries intensified, and civil uprisings flared up in various parts of the country as the political situation deteriorated and the economy faltered. In its weakened state, the Joseon government succumbed to the expansionist ambitions of the Japanese, who colonized Korea in 1910.

COLONIZATION AND WAR

Korea endured great suffering during the first part of the twentieth century, creating an inhospitable climate for artistic development. Japan's oppressive colonization of Korea

(1910–1945), which included the suppression of Korea's language and culture, was compounded by the misery of World War II (1939–1945). Korean men were forced to fight in the Japanese army or labor in Japanese factories, while thousands of young Korean women were forcibly recruited as "comfort women," sex slaves for the Japanese soldiers. The Korean War (1950–1953) and division of the country into two brought further hardship.

THE KOREAN WAR

After Japan was defeated in World War II, peace still eluded Korea. The American army took control of southern Korea, and Soviet forces occupied northern Korea. In 1948 both northern and southern Korea became independent states, with Kim Il-sung instituting a Communist regime in the north supported by the Soviet Union, and Syngman Rhee establishing a US-backed capitalist government in the south. The Korean War, which devastated much of the country, killing around 3 million soldiers and civilians, broke out in 1950 when Kim Il-sung attacked South Korea (**FIG. 11–34**). The United States and 16 United Nations member states assisted South Korea, while the Soviet Union and China aided North Korea. Although fighting ended with a ceasefire in 1953, the absence of a signed peace treaty means that the two Koreas are technically still at war, facing each other across the demilitarized zone.

One Korean artist who captured the mood of Korea in turmoil is Lee Joong-sup (1916–1956). In the 1930s Lee studied in Tokyo, where he was exposed to trends current in Western art

11–34 • THE AFTERMATH OF FIGHTING IN SEOUL
Koreans suffer on the street. Photo, 1950.

11–35 • Lee Joong-sup *THE BULL*
1953. Oil on paper, 12 × 16¼″ (30.5 × 41.3 cm). Ho-Am Museum, Yongin, South Korea.

at the time. During the Korean War, Lee became so impoverished that his wife, the daughter of a Japanese businessman, and children returned to Japan. While separated from his family, he painted emotionally charged paintings expressing his personal feelings of loss and frustration with Korea's plight. In his painting, *The Bull*, dated 1953, a contorted creature—recalling the expressively painted images of twentieth-century French artist Chaim Soutine—confronts the viewer with a tortured, angry look (**FIG. 11–35**). The bull, a symbol of labor and perseverance in Korea, encapsulates the long-suffering condition of the artist and his country. Following a period of poor physical and mental health, Lee Joong-sup died at the age of 40.

WOMEN AND ART

Toward the end of the nineteenth century, traditional views of women were challenged as societal forces questioned the institutional discrimination against women. In particular, Catholicism and Eastern Learning (Donghak), a Korean religious movement, were advocates of greater equality for women. Modern schools for females opened, providing women with an education and employment options outside the home, and this fueled a growing women's movement. In 1894, the landmark Gabo Reform abolished laws regarding gender segregation and prohibition of re-marriage for women. By the 1920s, a significant number of women were active professionals in a variety of disciplines, such as education, medicine, and the arts.

Under the yoke of Japanese colonial rule, the Korean women's movement persisted, often intersecting with nationalist campaigns to address the dual problems of gender and racial discrimination. These early struggles paved the way for future advances in women's rights in South Korea, with accompanying opportunities for female artists, after Korea's liberation in 1945.

ART IN NORTH KOREA

The Korean War ravaged much of North Korea, leaving cities in ruins and industrial production crippled. Against this troubled backdrop, Kim Il-sung (1912–1994), admired for his earlier resistance activities against the Japanese, rose to power. He established a secretive, repressive Communist state modeled on political systems forged in the Soviet Union and the People's Republic of China. Calling himself "Great Leader" or *suryong*, Kim Il-sung emphasized industrial growth while propagating the "cult of Kim." Similar to other self-aggrandizing Communist leaders such as Joseph Stalin (Soviet Union) and Mao Zedong (China), who manufactured a beyond-mortal status, Kim Il-sung patronized **Socialist Realist** art to convey his idealized persona. This style of art, designed to glorify the state, is steeped in propaganda and often grand in scale. Standing 65 feet in height (20 meters), the bronze statue of Kim Il-sung on Mansudae Hill, overlooking Pyongyang, is a perfect example of Socialist Realist art (**FIG. 11–36**). Originally gilded, it was created by the artists of Mansudae Studio in 1972 and placed outside the Museum of the Revolution to mark Kim Il-sung's sixtieth birthday. Crisply dressed and with his right arm raised over Pyongyang, Kim Il-sung looks supremely confident and in control. Statues of the "Great Leader" are found in front of every public building and in most villages, while state-produced photographs of him hang in every house. His image is inescapable.

11–36 • Mansudae Studio KIM IL-SUNG
1972. Bronze originally gilded but gilding later removed, height 65 ft (20 m). Mansudae Hill, overlooking Pyongyang.

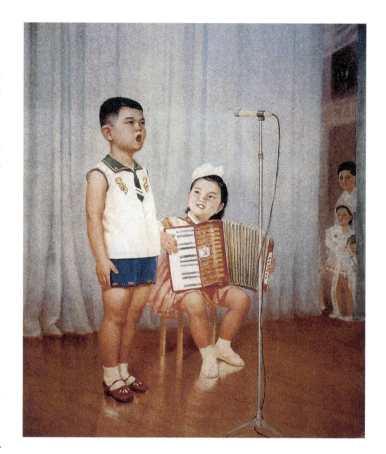

11–37 • Han Jun-bin WE'RE THE HAPPIEST IN THE WORLD
1975. Ink on paper, 4'4⅖ × 3'8⅞" (1.3 × 1 m). National Gallery, Pyongyang.

Kim Il-sung also promoted the idea of North Korea as a wonderful paradise on earth. North Koreans, with little or no exposure to the outside world, are presented with such cheerful images as *We're the Happiest in the World* (1975), painted by Han Jun-bin (**FIG. 11–37**). The focus of this painting is two robust-looking children performing on stage. The boy, wearing a military-style outfit, sings heartily, accompanied by a smiling girl on an accordion. In the wings, stage left, other rosy-cheeked children await their turn in the limelight. In reality, North Koreans are not the happiest in the world, working long hours for what is arguably the lowest standard of living in East Asia. Only a privileged elite experience a more comfortable life, and those who question state policies face imprisonment or death.

KIM IL-SUNG'S LEGACY

By the 1990s North Korea was floundering. Years of isolation from other nations, except for limited contact with China, Russia, Vietnam, and Cuba, perpetuated by Kim Il-sung's philosophy of *Juche* (self-reliance) had taken its toll. The North Korean economy was in shambles, drained by huge expenses on armaments, including the development of nuclear weapons, and the agricultural collectives failed to meet the population's needs, leaving thousands to starve. Undeterred, North Korea's media continued to project a glowing image of a thriving nation, and showered

praise on the "Great Leader." After his death in 1994, the title of "Eternal President" was bestowed on Kim Il-sung. The Kim dynasty continued, first under Kim Il-sung's son Kim Jong-il (1941–2011), known as "Dear Leader," followed by his son Kim Jong-un (b. 1984), the "Great Successor." Like his father, Kim Jong-il ensured that the arts, including dance, opera, film, and theater, continued to serve the regime. In addition, politicized messages glorifying North Korea and its leaders were delivered via regimented mass performances held in stadiums. In the illustrated scene from a mass performance of 2007, an enormous mosaic-like image of former leader Kim Il-sung is composed of thousands of "human pixels"—individuals holding up coordinated pages of a book (**FIG. 11-38**). Thousands of performers, including children, participated in spectacular displays of synchronized gymnastics and dances accompanied by music. In the spirit of the collective, group dynamics are emphasized, rather than an individual's talent.

It remains to be seen what the future holds for North Korea and the role of the artist. Meanwhile, it is illuminating to explore artistic developments in South Korea to see what happens when artists are largely free of external constraints.

ART IN SOUTH KOREA

Unlike its northern neighbor, South Korea gradually evolved into a modern democratic state with a well-developed industrialized economy. However, its phoenix-like ascent was not without

turbulence. The early decades following the Korean War were unsettled years as the country, scarred by its recent history, grappled with political instability and a rapidly changing economic and social landscape. Postwar artists such as Park Seo-bo (b. 1931) and Lee Ufan (b. 1936) responded to these societal tectonic shifts with a variety of artistic styles, while addressing underlying tension between tradition and modernism.

POSTWAR PERIOD PAINTING: PARK SEO-BO AND LEE UFAN

The end of the Korean War marked a period of questioning for Park Seo-bo, prompting the artist to explore new artistic avenues. As he commented: "There was no food, no job opportunity, everything had gone back to ashes; all conventional values and ideas were laid naked and bare. I had to raise questions." Park, after graduating from the painting department of Hong-ik University, Seoul, in 1954, became a driving force behind the Korean avant-garde *Informel* movement, an abstract art movement influenced by contemporary approaches in Western art, such as American **Abstract Expressionism**. Rebelling against conservative Korean art circles, *Informel* artists explored their emotional responses to the pathos of human existence in large-scale paintings dripping with thickly applied paint. Many of their paintings, often somber in color, also included mixed-media elements. In his moody image *Work No. 18–59*, painted in 1959, Park Seo-bo combined oil paint with cement and hempen cloth, demonstrating his dexterous handling of materials (**FIG. 11-39**). Viewed overall, the scratched and

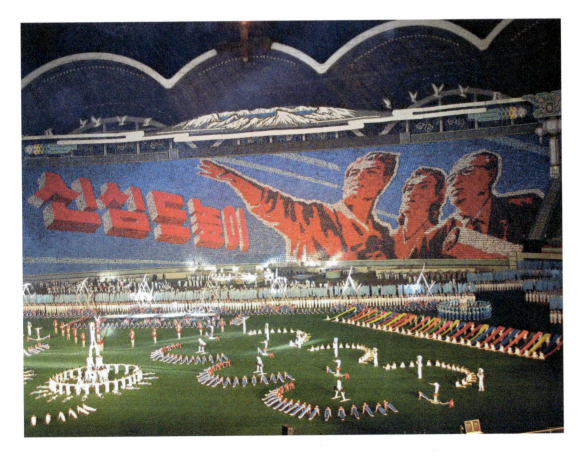

11-38 • A SCENE FROM THE MASS GAMES (ARIRANG FESTIVAL) 2007. May Day Stadium, Pyongyang.

pockmarked surfaces, dotted with bandage-like scraps of hemp, evoke a war-torn city reduced to rubble, or a dirty, scabby wound.

In the 1970s, Park also participated in the growth of another nonrepresentational Korean art movement, known as *Tansaekhwa* (Monochrome or single-color painting). Monochrome artists focused on fusing the traditional Korean spirit and modern art by emphasizing the flatness of the picture surface, seeking harmony with nature and using only one color—usually a subdued neutral color or white. Artist-philosopher Lee Ufan, a pivotal figure in the Korean Monochrome movement, believes that "all things in the universe emerge from a point and return to a point." His unframed painting *From Point* (1978) consists of a white surface activated by a series of blue brushstrokes ranging in density from dark to barely visible (**FIG. 11–40**). With each sweep of the paint-loaded brush, moving from left to right, paint wears off, leaving a physical record of time passing. Lee's use of pigment mixed with crushed stone and animal-skin glue contributes to the composition's mysterious appearance by producing a gritty residue on the canvas's surface. The work's elegant simplicity, echoing the restraint of Joseon white porcelain or a fine calligraphic brushstroke, offers a soothing antidote to the complexity of a rapidly evolving consumer culture.

11–40 • Lee Ufan FROM POINT
1978. Stone pigment and glue on canvas, 5′11½″ × 7′5⅖″ (1.82 × 2.27 m). Studio Lee Ufan.

11–39 • Park Seo-bo WORK NO. 18–59
1959. Cement, hemp cloth, and oil on canvas, 24 × 19⁷⁄₁₀″ (61 × 50 cm). Collection of Mr. and Mrs. Lee Ku-yeul, Seoul.

Lee, who was born in South Korea but moved to Japan as a young man, is an example of a new wave of Korean artists who have become increasingly influential in international art circles. From the 1960s on, the numbers of Korean artists studying and living abroad multiplied, as did those participating in international art exhibitions.

PAINTING IN THE 1980s

South Korea's economic policy established in the 1960s produced remarkable results during the 1980s and 1990s as the country's program of modernization and industrialization gained momentum. At the same time, political protests marked the 1980s as South Koreans demonstrated against the military government and pushed for democratic reform. Two distinct styles of painting emerged at this time: the *Sumukhwa*, or Oriental Ink movement, and the *Minjung Misul*, or People's Art. Despite their striking differences in style and philosophy, artists from both groups, although familiar with contemporary Western art, imbued their work with a unique Korean cultural identity.

ORIENTAL INK MOVEMENT Ink painting—traditionally the art of scholars and Buddhist monks—has an illustrious history in Asia. Participants in the Oriental Ink movement, led by Song Su-nam (b. 1938) and Hong Sok-chang (b. 1941), both professors at Seoul's Hongik University, breathed new life into the ink painting tradition as part of a general trend to reclaim a national identity. In *Summer Trees* (1983) by Song Su-nam, the artist used such traditional materials as paper and ink, but his exploration of the tonal variations of ink in an abstract composition produced a contemporary twist (**FIG. 11–41**). Light, pale washes contrast with dark,

dense marks, implying both spatial depth and sunlight dancing on the trees. Song Su-nam viewed the act of painting as closely intertwined with the rhythms of nature, and harmonized his breathing with the movements of the brush. The artist's lyrical abstractions express an inner spirituality, which he felt was missing in the modern technological era.

MINJUNG ART The political art movement *Minjung Misul* (People's Art) emerged in the early 1980s as a critical response to Korean modernist art, which some artists felt was out of touch with the realities of Korean society. *Minjung* artists rejected the Monochrome art movement as elitist, charging that their abstract paintings and philosophical musings had little meaning for the people. *Minjung* artists advocated that art should reflect the current state of society and the realities of people's lives. In their efforts to create a type of art that the masses could easily understand, these artists created images of everyday people, such as hungry peasants and exhausted factory workers, in a realistic style. They also criticized corrupt officials, the military government, the gap between rich and poor, and the division between North and South Korea in their art. *Minjung* artists spurned Western culture for its associations with capitalism and imperialism. Instead, they valued Buddhist art, shamanistic paintings, and folk art, all associated with Korea's traditional culture, which permeates *Minjung* art in innovative ways.

One influential artist associated with the *Minjung* movement was Oh Youn (1946–1985). In particular, he became known for his woodblock prints of ordinary people engaged in traditional activities such as making *kimchi* (a spicy pickled cabbage dish), or more dramatically, the suffering of the masses, as captured in his woodblock print *Grandmother* (**FIG. 11-42**). The old woman radiates distress through her bony, bent form, lined face, and anguished cry. Oh Youn spent a great deal of time observing and sketching his subjects before distilling his findings to their raw essence. In a note to himself, he urged: "Be more simple, more succinct." Opponents of the movement criticized *Minjung* artwork for being too idealistic or for degenerating into left-wing propaganda, while the South Korean government censored and even imprisoned radical *Minjung* artists for challenging its authority.

ART AND TECHNOLOGY: PAIK NAM JUNE

It is perhaps fitting that South Korea, known for its technological advances, especially in the electronics industry, was the birthplace of Paik Nam June (1932–2006), a pioneer in the fusion of art and modern technology. More commonly known outside Korea as Nam June Paik, he fled with his family to Hong Kong during the Korean War, later settling in Japan. He incorporated television and

11-42 • Oh Youn GRANDMOTHER
1983. Woodblock print, ink and colors on paper, 20 × 14⅖" (51 × 36.6 cm). British Museum, London. Courtesy Gana Art Center, Seoul.

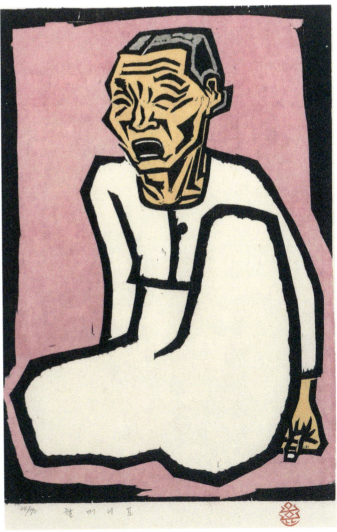

11-41 • Song Su-nam SUMMER TREES
1983. Ink on paper, height 25⅝" (65 cm). British Museum, London. Courtesy Seoshin Gallery.

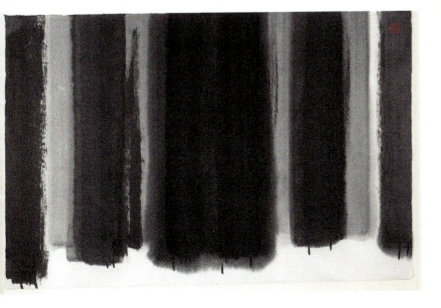

video into his thought-provoking sculptures and installations. An important avant-garde international artist from the 1950s until his death, Paik once stated that just "as collage technique replaced oil paint, the cathode ray [television] tube will replace the canvas."

As a young man, Paik studied music, art history, and philosophy in Japan and Germany. In 1958, during his stay in Germany, Paik met the American avant-garde musician and performance artist John Cage (1912–1992), who inspired him to explore the artistic possibilities of television and, later, video. Paik is often acclaimed as the first video artist. In the 1960s, he was an active member of the international group Fluxus, founded by architect/artist George Maciunas (1931–1978). A goal of Fluxus (Greek for "flowing") was to counteract "the separation of art and life" and promote "living art."

Art and life, tradition and technology are seamlessly integrated in Paik's *TV Buddha* (1974), an intriguing installation with multiple meanings (**FIG. 11–43**). An antique bronze statue of Buddha sits in front of a video camera and meditates on its own image on a television monitor. According to Buddhist teachings, the historical Buddha withdrew from the material world and sought enlightenment within. In Paik's work the Buddha appears trapped in time and space. He is an icon on television, an elusive figure, much like the flesh-and-blood celebrities of contemporary culture. The Buddha's motionless image on a television screen bewilders spectators used to rapidly changing, entertaining television shows. In Paik's hands technology becomes a playful trickster, challenging our notions of reality.

In 1964, Paik moved to New York, where he continued to experiment with electronic media. His later projects, such as the 1995 video installation *Electronic Superhighway: Continental U.S., Alaska, Hawaii*, often dwarf the viewer while commenting on technology's powerful presence in contemporary society (**FIG. 11–44**). In *Electronic Superhighway,* a map of the United States filled with 336 computer-controlled video monitors is outlined in neon lights, bringing to mind colorful road maps or the flashing motel or restaurant signs that entice drivers off the highway. The video monitors form a wall of constantly changing soundtracked images that reflect the diversity of America's states. Paik is credited with inventing the term "electronic superhighway," and embedded in this captivating installation is the idea that today's electronic media allow us to travel the world without physically leaving our homes. The question remains, however, as to the integrity of information transmitted on our screens, and how it is disseminated.

Paik Nam June's innovative use of new technology as an art medium stretched the boundaries of art, and his profound influence on later generations of artists around the world is widely acknowledged. As former Fluxus member Yoko Ono (b. 1933) succinctly put it: "Let's not be modest about it. I think he created a revolution in art."

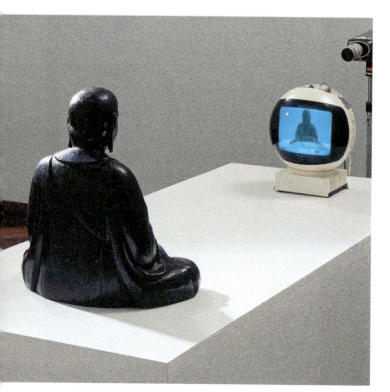

11–43 • Paik Nam June *TV BUDDHA*
1974. Video installation with bronze Buddha statue, 63 × 84⅗ × 31½" (160 × 215 × 80 cm). Stedelijk Museum, Amsterdam.

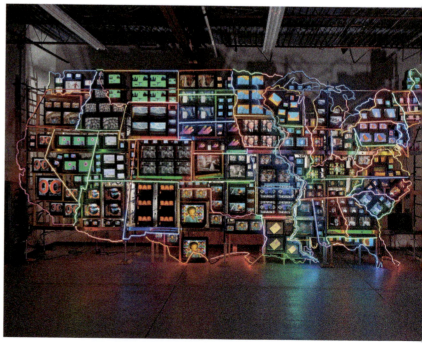

11–44 • Paik Nam June *ELECTRONIC SUPERHIGHWAY: CONTINENTAL U.S., ALASKA, HAWAII*
1995. 49-channel closed-circuit video installation with 336 monitors, neon, steel, and electronic components, approx. 15 × 40 × 4 ft (4.57 × 12.19 × 1.2 m). Smithsonian American Art Museum, Washington, D.C.

ARTISTIC DEVELOPMENTS IN THE 1990s

As the pro-democracy movement of the 1980s triumphed, political repression was replaced by a more democratized, liberal society in the 1990s. Women's movements blossomed in the changing socio-political atmosphere. Women artists, such as Yun Suk Nam (b. 1939) and Kimsooja (b. 1957), took advantage of South Korea's more open society by producing multifaceted, experimental artworks that attracted the attention of the Korean art scene and international art world.

YUN SUK NAM In 1996, Yun Suk Nam became the first woman artist to win the prestigious Joong-sup Lee Award, a remarkable achievement given that she became a professional artist only at age 40. She is a founding member of South Korea's feminist art movement, and many of her artworks critically examine the lives of women and their status in society. In her provocative *Pink Room* series (1996–2000), Yun Suk Nam constructed various rooms traditionally associated with women, such as the bedroom, living room, and kitchen. Her vision of these domestic spaces is chillingly unsentimental. Take, for example, *The Kitchen* of 1999 (**FIG. 11–45**). The gleaming, modern kitchen, suffused in pink, with pretty pink upholstery and glittery pink marbles, also includes an iron spike poking out of the Western-style chair. On closer inspection, the viewer sees the chair is fitted with pointed steel legs resembling the small knives (*eunjangdo*) that Korean women once carried for protection. A dejected-looking female figure in wood wears a silk garment suggestive of Korea's traditional dress (*hanbok*). In this work, Yun Suk Nam explores tensions between the past and present. She also reminds us of how gender inequality, rooted in Confucian patriarchal values, is still a problem. She challenges the traditional definition of Korean women as self-sacrificing beings always serving others, and communicates the importance of cultivating self-identity. Without a true sense of self, emptiness prevails and no quantity of material goods can fill the void.

KIMSOOJA Similar to Paik Nam June, Korean-born Kimsooja can be described as a global artist. Although based in New York, she frequently spends time in Seoul and Paris. Kimsooja's artistic practice, which includes performance, video, and installation, reflects her global outlook while drawing on culturally specific aspects of traditional Korea. As a child she experienced a nomadic existence, moving from place to place with her family because of her father's job in the military. Before every move, unbreakable household possessions, such as clothes, linens, and books, were packed up into colorful cloth bundles known as *bottari*. *Bottari* are used as containers, for the storage and transportation of goods. Traditional Korean bedcovers sewn by women serve as the wrapping material. Kimsooja describes the bedcover as a "symbolic site," the place where "we are born, where we rest and love, where we dream and suffer and finally die. It keeps memories of the body alive, which result in another dimension." Bulging, brightly patterned *bottari* feature in many of Kimsooja's artworks, including

11–45 • Yun Suk Nam
THE KITCHEN
1999. Mixed media installation,
9'10¹/₁₀" × 9'10¹/₁₀" × 7'2³/₅"
(3 × 3 × 2.2 m). Artist's collection.

the performance piece of 1997 entitled *Cities on the Move, 2,727 km Bottari Truck* (**FIG. 11–46**).

In this work Kimsooja packed numerous *bottari* bags, piled them on a truck, and set off from Seoul on an 11-day journey around South Korea. She traveled through cities associated with her past. The performance was filmed and images of the artist perched on a mountain of *bottari* summon the collective memory of refugees fleeing their homeland. *Cities on the Move* operates on many levels. In addition to Kimsooja's exploration of mobility, whether forced or voluntary, her focus on textiles draws attention to the hidden history of women as seamstresses. Kimsooja characterizes *Cities on the Move* as "a social sculpture, loaded with memory and history, which locates and then equalizes physical and mental space."

Despite greater visibility for women artists in Korea in the 1990s, opportunities for exhibiting and selling their work, or professorships in universities, were still limited, as the Korean contemporary art scene was largely controlled by male-dominated networks. In the twenty-first century the door of opportunity blew wide open, with increasing numbers of women participating in the arts, not only as artists but also as academics and curators.

ART IN THE TWENTY-FIRST CENTURY

Recent South Korean art is characterized by its diversity. Traditional arts and crafts exist alongside the latest developments in contemporary culture. Established art galleries and artist-run alternative spaces exhibit artworks that are wide-ranging in style, media, and subject matter (popular topics include tradition, identity, politics, society, and nature), attracting local and foreign art

11–47 • Lee Bul THE SECRET SHARER
2011. Stainless-steel frame, acrylic, urethane foam, PVC panel, PVC sheet, PET, glass and acrylic, beads, dimensions variable. Installation view of "Lee Bul: From Me, Belongs to You Only," Mori Art Museum, Tokyo. Collection: Amore Pacific Museum of Art, Yongin, Korea.

collectors. Lee Bul (b. 1964) and Suh Do-ho (b. 1962) are two of many prominent South Korean artists who contribute to today's multifaceted, constantly changing international art scene. They reach out to audiences across cultures with conceptually brilliant, beautifully crafted artworks.

LEE BUL After graduating from Seoul's Hongik University in 1987 with a degree in sculpture, Lee Bul acquired a reputation for creating provocative artworks, such as outlandish public performances, installations of ornamented rotting fish, and silicone cyborg sculptures. Lee grew up in a politically active family. As the daughter of political dissidents she remembers the South Korean military government harassing her parents. Although she rejects "isms" of any kind and distances herself from Korea's feminist movement, Lee often challenges social, cultural, and ideological constructs through her art. *The Secret Sharer* of 2011 veers toward greater self-reflection (**FIG. 11–47**). The large, carefully constructed dog-shaped sculpture, modeled on Lee's dog, sits on top of a table. The ethereal beauty of the materials used—glass and mirrors—clashes with the visceral image of the dog's wide-open mouth as it vomits. The title implies something hidden, a puzzle for the viewer to mull over while becoming part of the piece, as the mirrors reflect our fragmented, imperfect forms. The shimmering, fragile appearance of *The Secret Sharer* underscores the notion that nothing is constant and everything

11–46 • Kimsooja CITIES ON THE MOVE, 2,727 KM BOTTARI TRUCK
1997. Single channel video, 7:33 min. loop, silent. Eleven-day performance in South Korea. Commissioned by Korean Arts & Culture Foundation, Courtesy of Kimsooja Studio.

changes. Inequalities can be addressed and corrected, but dreams of an ideal society, always within arm's reach, remain dreams.

SUH DO-HO As a young man, Suh Do-ho studied art in both Korea and the United States. Today, he maintains studios in Seoul and New York. In an interview for *designboom*, he discussed how his artworks are physically created in the studio but the conceptualization process "happens in in-between places, when in transit, like in an airport, on the airplane, or on the train—those in-between places." Traveling to and from Korea heightened Suh's awareness of a rapidly changing country. In *Reflection,* a large-scale fabric installation exhibited in 2004 at the Maison Hermès Gallery, Tokyo, the artist ruminated on the past through the gauzy lens of memory (**FIG. 11–48**). *Reflection,* exquisitely fashioned from steel tubing and sheer blue nylon, was an ethereal replica of the traditional brick gateway from Suh's childhood home in Seoul. The installation consisted of two fabric gates separated by a translucent floor, which provided the effect of a reflection. Its ghostly form was a reminder of the insubstantial quality of memory, and our inability to recall accurately places from our past. The gate was

a transitional space rather than a destination. Gates functioned as borders between public and private areas or acted as connecting elements between two distinct environments, such as outside and inside. Pivotal events in a person's life—birth, marriage, acute illness, and death—can also be viewed as portals to another state of being. Ultimately in *Reflection,* Suh Do-ho, a Buddhist, created a reminder of the insubstantial nature of our world, both real and imagined.

11–48 • Suh Do-ho REFLECTION
2004. Large-scale fabric installation (polyester fabric, metal armature), dimensions variable. On exhibition at the Maison Hermès Gallery, Tokyo. © Do Ho Suh.

CROSS-CULTURAL EXPLORATIONS

11.1 The scholar Daniel Kane, in his article "Enigma in Stone" (*Archaeology*, March/April 2002), states the following about the stele of King Gwanggaeto of Goguryeo: "Depending on who you talk to, the 20-foot-high inscribed monument, erected 15 centuries ago in what is today China, provides evidence for early Japanese control of the Korean peninsula, a Korean invasion of Japan, or a multi-ethnic legacy celebrated by modern China's Communists." What are these various opinions based on?

11.2 The Mongol emperor Khubilai Khan (1215?–1294) ruled over a vast empire, which stretched from China to Iraq and from Siberia to Afghanistan. He also subjugated Korea. Discuss the impact of Mongol rule on the culture of two countries during the thirteenth century.

11.3 Discuss the influence of Socialist Realist art from China and the Soviet Union on the development of North Korean painting after 1953.

11.4 Dictators understand the power of art to sway opinion, which is why repressive regimes support the arts that trumpet their ideology and stifle creative expression, which promotes criticism and debate. Discuss three images commissioned by Asian autocratic rulers in their quest for power. What messages are conveyed in these works and how do these messages contradict what is happening in the society at the time?

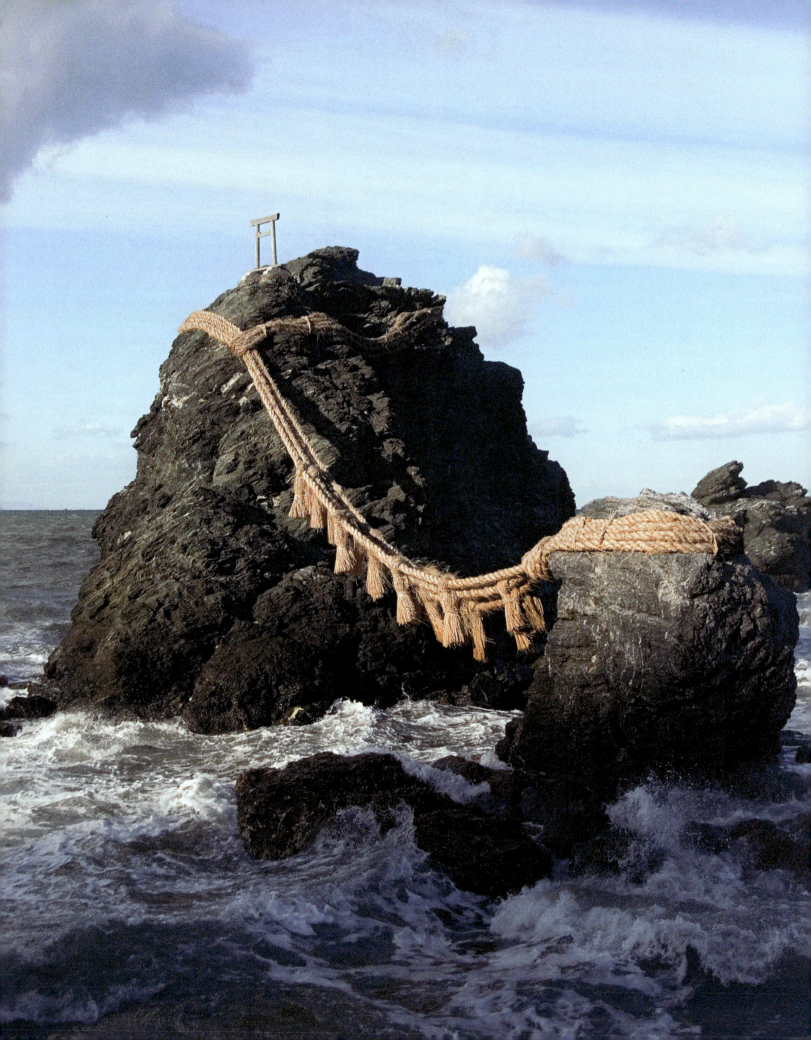

The Way of the Gods and the Path of the Buddha: Japanese Art from Prehistory to the Asuka Period

Regard Heaven as your father, Earth as your mother, and all things as your brothers and sisters.

Shinto belief (Oracle of the Kami of Atsuta)

Contemporary Japan presents the visitor with a welter of disconnected images of space and time: modern cramped apartment buildings; ancient wide-roomed castles; fast, efficient trains jammed with commuters; serene unadorned **Shinto** shrines; wide-eyed cartoon characters on television; and timeless Buddhist temples filled with incense. This country of contrasts consists of four main islands: Hokkaido, Honshu, Shikoku, and Kyushu, and approximately 3,000 small islands (**MAP 12-1**). According to an ancient Japanese creation myth, the Japanese islands were brought into being by two primordial deities, Izanagi (male) and Izanami (female). The gods stood on the floating bridge of heaven and thrust a jeweled spear into the primeval void to see if any land lay below. The spear touched the ocean and they used this instrument to stir the waters. When they lifted up the spear, brine dripped from its tip to form the first Japanese island. Other islands and a multitude of deities later materialized from the couple's sexual union. Surrounded by water, two rocks have been "wedded" together with heavy rice-straw ropes, symbolizing the relationship between these two legendary creators of Japan (**FIG. 12-1**). At dawn the sun rises between the two rocks. The larger "husband" rock is crowned with a *torii*, a gate marking the entrance to a Shinto

12-1 • WEDDED ROCKS
Futamigaura, Ise-Shima National Park.

shrine. Every year the ropes are replaced in special ceremonies performed by Shinto priests.

Japan is a country of hills and mountains, with these features occupying approximately 80 percent of the terrain. It is also a land prone to volcanic eruption and earthquakes, forces of nature that encouraged the historic preference for building in wood. Wood is more forgiving than stone in the event of a disaster, and it was readily available and easier to work with than the local volcanic stone.

At the time of the last Ice Age, around 30,000 BCE, when the sea level dropped, the Japanese islands were connected to the Asian mainland by land bridges, allowing peoples from mainland Asia to settle Japan. About 10,000 years ago, with the melting of ice caps, the sea level rose and the Japanese islands became separated from the continent. Owing in part to its island status, Japan has experienced periods of relative isolation during which a distinct Japanese culture has thrived. At other times, particularly with the arrival of Buddhism from Korea in the sixth century CE, Japan has been exposed to foreign influences that have further enriched the country's art and society.

SHAMANISM AND THE DEVELOPMENT OF SHINTO

Long before the arrival of Buddhism in Japan, the Japanese had developed an indigenous belief system rooted in **shamanism** but later known as Shinto (Way of the Gods). Shinto, which evolved out of the needs of an early agrarian culture, initially functioned without scriptures, dogmas, devotional images, famous teachers, or elaborate structures. Indeed, the earliest Shinto places of worship were sacred sites in nature encircled by stone markers or

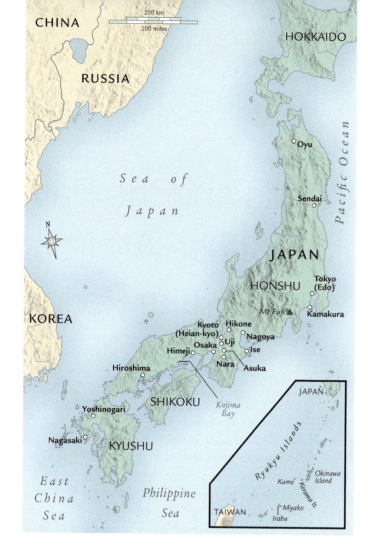

MAP 12–1 • JAPAN

12-2 • MAIN HALL, INNER SHRINE
Ise-jingu, Mie prefecture. Last rebuilt 2013.

through a gateway, or *torii*. One of Japan's great Shinto shrines is nestled deep in a forest of ancient trees at Ise, on the island of Honshu (**FIG. 12-2**). The Ise shrine is the residence of the most revered *kami* of all, Amaterasu (see pp. 287–288).

Shinto's reverence for nature informs an aesthetic that has permeated Japanese art throughout the centuries (**FIG. 12-3**). This aesthetic is characterized by an appreciation for the intrinsic beauty of natural materials such as clay and wood; asymmetry, as found in a tree knotted with age; and a respect for timeworn rustic objects fashioned by hand.

JOMON PERIOD

One of the earliest cultures to surface in Japan has been named by archaeologists as the **Jomon** ("cord markings") culture (ca. 14,000–300 BCE), because of the ceramic vessels of the period that feature distinctive cord patterns. The Jomon people who

12-3 • SACRED GROVE
Miyako Island, Okinawa prefecture.

demarcated by structures such as rock piles crowned with stones. Male and female shamans, functioning as intermediaries between the human and spirit worlds, presided over communal ceremonies. Shamans ensured the well-being of the community by conducting rituals such as those to bring the rains or promote a bountiful harvest. Over time, and especially in response to Buddhism, which arrived with its own sophisticated theological framework and attendant trappings, Shinto developed a clergy, images, and architectural forms.

Shinto, which is still practiced today, emphasizes a harmonious relationship with nature and respect for the divine authority of the imperial family, who are believed to be direct descendants of the sun goddess, Amaterasu. Ancient lore reveals that the sun goddess was miraculously born from the left eye of the legendary deity Izanagi. Shinto helps one to live in harmony with the **kami** (supernatural beings) that exist in the natural world and are embodied in such phenomena as trees, rocks, and water.

Shintoists venerate not only the *kami* but also the natural site (**iwakura**) where the spirit resides. The *iwakura* usually features a wooden shrine surrounded by a wooden fence to separate the sacred space from the mundane world. Access to the shrine is

Remarkably, ancient shamanic practices flourish today in parts of Japan, such as Okinawa prefecture in the south, and Hokkaido, the northernmost island.

Once an independent kingdom, the Ryukyu Islands, located southwest of mainland Japan, collectively comprise Okinawa prefecture (see **MAP 12–1**). Okinawa Island, the largest in the Ryukyu archipelago, evokes images of either a tropical paradise or scenes of horrific fighting between the Japanese and Americans during World War II. Less well known is Okinawa's long history as a place of shamans and sacred groves. Ancient shamanic rituals persist today as part of the indigenous Kami-sama religion. Remarkably, this belief system has survived battling feudal chiefs, the encroachment of such outside religions as Buddhism and Christianity, and the occupation of foreign forces. In 1879, the Japanese officially annexed Okinawa. Today, Kami-sama is Okinawa's official and publicly funded religion. One fascinating aspect of Kami-sama is the importance of women within its leadership. The majority of spiritual leaders are women, as are the participants in Kami-sama's myriad ritual practices. In leafy sacred groves (*utaki*) and village squares throughout Okinawa prefecture, priestesses (*kaminchu*) perform sacred rites for the welfare of the community (see **FIG. 12–3**).

The following passage is from *The Japan We Never Knew: A Journey of Discovery* (1997) by David Suzuki and Keibo Oiwa. This extract describes how the two authors and photographer Yasuo Higa visited Irabu Island, Okinawa prefecture, to witness the shamanic women's festival called Hidagan-Nigai.

We spent the night in Hirara, then took the 7.30 a.m. ferry to nearby Irabu Island to see the women's festival, called Hidagan-Nigai, similar to Uyagan. From the boat we could see a group of women sitting in a semicircle in a small park facing the water. Not far away was another group of about sixty women sitting in the parking lot surrounded by stores and houses. They were facing the slip where boats were launched into the sea. The people in this fishing village believed the sea was a god. Women prayed to the god to give them a prosperous life and to protect their family members at sea.

Half the parking lot was filled with small trays, all placed neatly in straight lines. The size of the offerings reflected the size of the family's boat. The trays carried rice, two bottles and cups for sake, salt, and dried fish. Some had a pack of cigarettes. The women faced the lines of trays. Most were middle-aged or older. They were dressed in kimonos except for a few who wore western clothes. At the front were two women. One, around fifty years old, wore a white gown over her kimono. Her face struck us with its intensity and exotic beauty. Sitting beside her was a woman known as a leading shaman. Her look was less intense and more relaxed. In front of the women was a pile of sand in which massive amounts of incense burned. Behind the curtain of smoke a pig's head sat on the ground. The ritual had begun before we arrived with the sacrifice of the pig on the beach. To the left a group of men and women surrounded a huge wok-like pan in which pork was being cooked. Here the men cooked and remained in the background while the women took center stage.

Something bothered us about the setting. The sacred ceremony was taking place in the midst of concrete. On the ground were lines showing cars where to park. There was even a car parked right in front of a sign asking people not to park there for the ceremony. Higa's pictures of this place, taken fifteen years ago, show the women facing a sloped runway to the beach for the boats. Now the beach was not visible. A road and wall had been built between it and the parking lot. Sensing our discomfort, Higa explained that the women deal with the invisible world of spirits, the nonphysical world, and these changes in the material world were of no concern to them. The shaman began to sing a hauntingly slow and beautiful song, a recitation of the gods through the ages…

Later, Higa told us more about the meaning of the rituals. The way of thinking represented by the rituals is indigenous to the island, but the form was imposed by the fifteenth-century rulers of the Ryukyu Kingdom. The forms look different in each village, but there is a commonality to all native people.

What is common? A belief in souls and eternity.

first settled along Japan's coastal plains and river valleys were hunter-gatherers who lived in rudimentary huts and used stone implements such as arrowheads, knives, and axes. Food was plentiful. Fish, shellfish, deer, wild boar, berries, and nuts were all part of their diet. The cultivation of domestic plants such as beans and gourds and the development of populous structured village communities emerged around 5000 BCE. Even before the establishment of a settled agricultural economy, Jomon artisans had created some of the earliest examples of ceramics in the world, such as a clay vessel dating from around 12,000 BCE (**FIG. 12–4**).

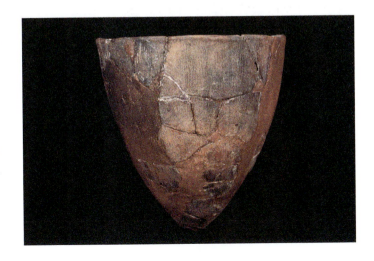

12-4 • VESSEL
Jomon culture, 12,000 BCE. Low-fired clay.

Without the aid of the potter's wheel, Jomon ceramic ware was fashioned by hand using the coiling technique. Damp clay was rolled into long, thin cylinders and then wound coil upon coil in successive loops, starting at the base, to form the body of the vessel. Once constructed, additional ropes of clay were attached to the vessel's moist exterior walls, and patterns resembling basket weaving or matting were pressed onto the surfaces using coarse ropes. After completion, the vessel was left to dry and then fired in an outdoor bonfire. Although the majority of Jomon ceramic wares have a utilitarian function as cooking or storage vessels, some of the more elaborate examples, especially from the Middle Jomon period (ca. 2500–1500 BCE), may have been used for making offerings in ritual ceremonies (**FIG. 12-5**). This ornate vessel features an elongated body impressed with cord pattern markings and a flamboyant rim comprised of undulating coils. The top half of the pot is blackened with soot, suggesting that it was used to boil food.

The large quantities of ceramic vessels excavated at Middle Jomon sites indicate an increase in population and a more sedentary lifestyle. Larger settlements made up of pit dwellings—so called because their floors were constructed 1½ feet (0.5 meter) below the ground—were established in mountain regions as warmer temperatures encouraged the population to shift from the coastal zones. A typical pit house was constructed from

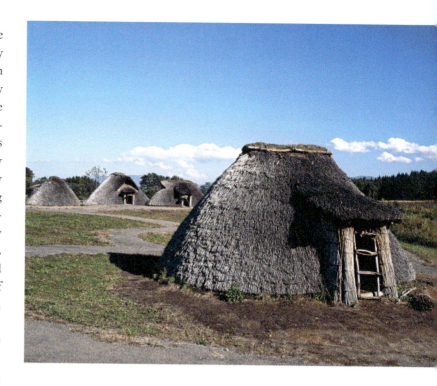

12-6 • RECONSTRUCTED JOMON PIT DWELLING
Sannai Maruyama, Aomori City. Jomon period.

wood and covered with a thatched roof of reeds or bark (**FIG. 12-6**). It was circular in plan and as large as 20 feet (6 meters) in diameter. Approximately five people could gather comfortably around the central cooking area.

In some communities, dwellings contained stone platforms on the northwest side, displaying stone phalli and female pottery figurines. Such images were produced throughout the Jomon eras, however the prevalence of female figurines and phallic symbols during the Middle and Late Jomon periods (ca. 1500–1000 BCE) indicates a rise in shamanic activity and fertility cults. Clay female figures vary in appearance from simple images with little decoration to more complex ones like the example shown here from the Late Jomon period (**FIG. 12-7**). Wearing elaborate headgear, the squat, hollow figure is an interesting combination of simplicity and intricacy. The hands and feet are mere knobs but the body is decorated with raised coils of clay and patterns impressed with cords that may represent tattoos or painted designs. Another distinctive feature is the large insectlike eyes, bisected in the middle with slits. While its true meaning remains unknown, it is generally described as a fertility figurine because of its pointed breasts and curved hips.

As temperatures began to cool during the Late Jomon period, the population migrated away from the mountains and back toward the coast, settling in particular along the eastern shores of Honshu. Seafood became an important part of their diet, and advances were made in fishing technology, such as the development of the toggle harpoon. Other findings from the Jomon culture include evidence of bark baskets, jewelry fashioned from jade, and woven fabrics from plant fibers such as hemp.

12-5 • VESSEL
Middle Jomon period, ca. 2500–1500 BCE. Low-fired clay, height 16½″ (42 cm). Kimbell Art Museum, Fort Worth.

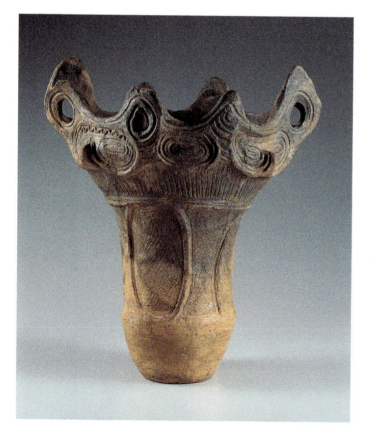

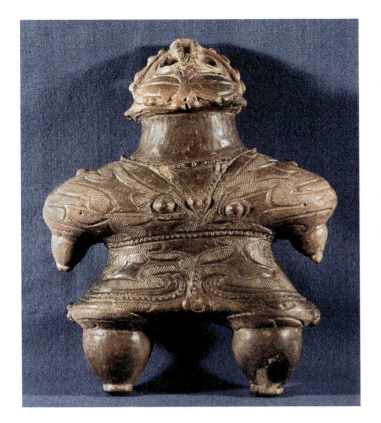

12-7 • FIGURINE
Late Jomon period, ca. 1500–1000 BCE. Low-fired clay, height 10¼″ (26.2 cm). Tokyo National Museum.

The Jomon people buried their dead. Human remains have been found entombed within shell mounds and also in burial pits beneath the center of stone circles as large as 138 feet (42 meters) in diameter. The Nonakado stone circle at Oyu in Akita prefecture is typical, with an upright vertical stone in the center surrounded by long, narrow stones laid flat on the ground, radiating like rays of the sun to an outer enclosure of

stones (**FIG. 12-8**). In addition to functioning as a cemetery, the Oyu site, whose soil has yielded numerous **artifacts** (man-made objects)—including urns, bowls, and "charms" from a variety of eras—likely played a role in ritual ceremonies.

YAYOI PERIOD

According to an ancient legend, the Shinto sun goddess Amaterasu gave the Japanese people a handful of rice to cultivate and, in turn, prosper from. Scholars generally agree that rice was initially introduced into Japan from China, although precisely when and how rice farming reached Japan is subject to debate. Evidence of rice has been found in sites in Kyushu, southern Japan, dating from the late Jomon period. However, it was during the Yayoi era (ca. 300 BCE–300 CE) that rice cultivation became widespread, with the use of sophisticated irrigation systems to control water flow into the rice paddies.

The shift away from a hunter-gatherer society to a settled agricultural one centered on rice farming coincided with the arrival of newcomers from the mainland. Numerous hypotheses exist to explain this influx of peoples from Korea and China into Japan. Popular theories range from traders seeking wider markets, to refugees escaping the turmoil of China during the Warring States period (481–221 BCE).

The Yayoi culture, named after the district in Tokyo where artifacts from this era were first excavated, was obviously stimulated by innovations from the continent. In addition to introducing wet rice cultivation practices to the Japanese, the foreigners brought with them the potter's wheel, cloth-making techniques, metalworking skills, and numerous metal objects, including iron tools, weapons, and ceremonial mirrors made of bronze. The immigrants also introduced more elaborate

12-8 • NONAKADO STONE CIRCLE
Oyu, Akita prefecture.
Late Jomon period,
ca. 1500–1000 BCE.

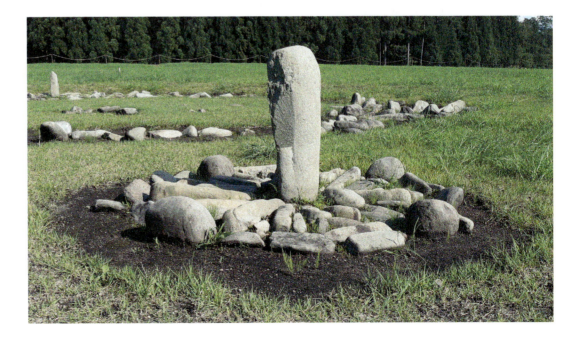

forms of government, which contributed to the formation of a stratified society based on class and hierarchy. The indigenous population gradually assimilated these outside influences for their own purposes. Yayoi artisans were skilled at replicating bronze objects, such as mirrors, spears, and daggers, from Chinese originals, but they also produced artifacts with their own distinctive style—for example, bronze *dotaku*, bell-shaped objects with circular "handles." Great care went into crafting these vessels, initially using stone molds and later clay ones. In an example excavated in Hyogo prefecture (**FIG. 12-9**), a finlike border with projecting spiral knobs runs around the body of the vessel. Spiral patterns also decorate the main surfaces, and these swirling forms are enclosed within a gridlike pattern of geometric designs. On another *dotaku* from Kagawa prefecture, animals and sticklike figures are visible in hunting or agricultural scenes (**FIG. 12-10**).

12-9 • *DOTAKU*
Late Yayoi period, 2nd–3rd century CE. Bronze, height 18¾″ (47.5 cm). Hyogo prefecture; Tokyo National Museum.

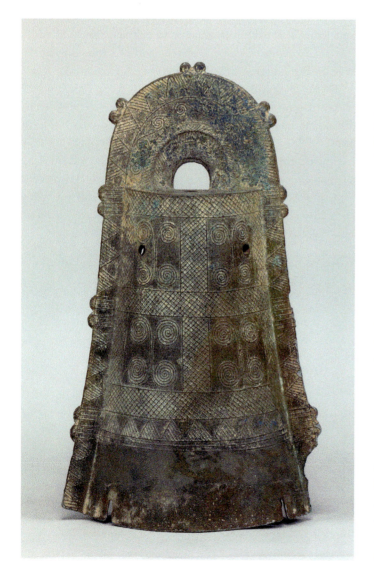

12-10 • *DOTAKU* WITH IMAGES OF ANIMALS AND PEOPLE (DETAIL)
MIddle–Late Yayoi period, ca. 100 BCE–300 CE. Bronze, height 16⅞″ (42.8 cm). Kagawa prefecture; Tokyo National Museum.

Dotaku most likely originated as a type of Chinese musical instrument (*zhong*) or a small Korean bell worn by horses and other domesticated animals. Over time, in the hands of Japanese craftsmen, *dotaku* lost their function as bells and evolved into objects valued for ceremonial importance. Approximately 400 *dotaku* have been recovered to date, the majority unearthed in the Kyoto-Nara area on the island of Honshu. The vessels vary in height from 4 to 50 inches (10 to 127 centimeters). Some have clappers inside that produce a muffled tone when rung. If the vessel is struck with a stick, it makes a rattling sound. However, their role as a musical instrument has been demonstrated to be limited. Interestingly, *dotaku* were buried either singly, in pairs, or in groups at isolated locations away from settlements. Hilltops were favored places. *Dotaku* are sometimes found buried with bronze mirrors and weapons in caches unrelated to grave sites. It is not known why these ornate bronze vessels were buried and

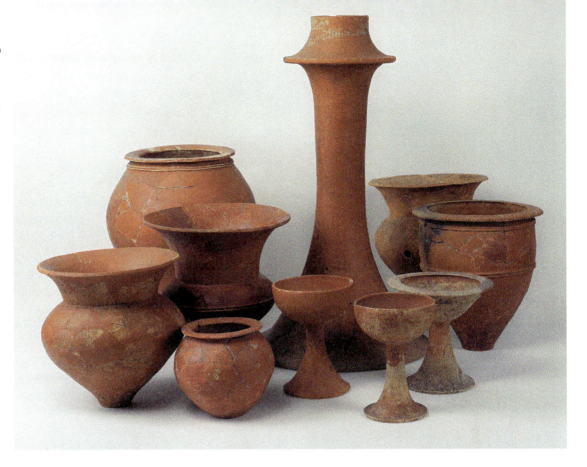

12-11 • PEDESTAL AND ASSORTED VESSELS
Middle Yayoi period, ca. 100 BCE–100 CE. Painted earthenware. Property of the Culture Agency Japan.

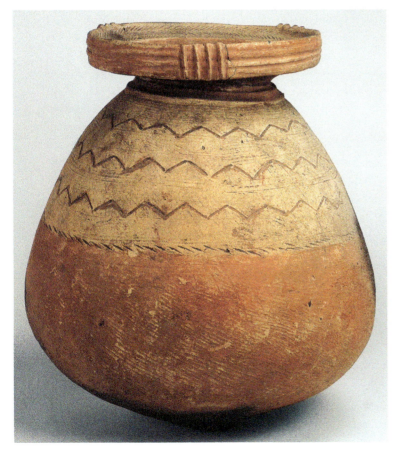

12-12 • VESSEL
Late Yayoi period, 1st–3rd century CE. Terra-cotta, height 13″ (32.6 cm). Tokyo National Museum.

what their function was within the animistic beliefs of the population, although it is often suggested that they were used in rites to promote the fertility of the soil and to ensure a harmonious relationship between the human realm and the cosmos.

As the Yayoi culture flourished, a wide variety of ceramics were produced to serve the complex ceremonial and everyday needs of the people (**FIG. 12-11**). Bowls, bottles, goblets, cups with handles, cooking pots, storage jars, and burial urns were finely crafted using both the existing coil technique and the potter's wheel. Yayoi ceramics made from fine alluvial clays tend to emphasize simplicity and smooth, thinner walls rather than the flamboyant designs and tactile surfaces of Jomon ware. Yayoi stylistic preferences are evident in what is most likely a storage jar for grains and liquids (**FIG. 12-12**). The round body of the vessel gives way to a short, narrow neck and coiled lip, decorated with strips of clay in sets of four. Although many Yayoi ceramics were treated simply with a coat of red paint, some were ornamented with incised geometric patterns and lines.

One of the most interesting finds regarding the development of the Yayoi culture was the discovery in 1986 of the Yoshinogari settlement in Saga prefecture, Kyushu. Yoshinogari was first established in the third century BCE and reached its zenith around the first century CE. From the archaeological findings a picture emerges of a fortified agricultural community of considerable size. The moat-encircled village housed a variety of structures, including over 300 pit dwellings, high-floored houses for the elite, storehouses, watch towers, and a large wood-and-thatch structure on stilts, presumed to be

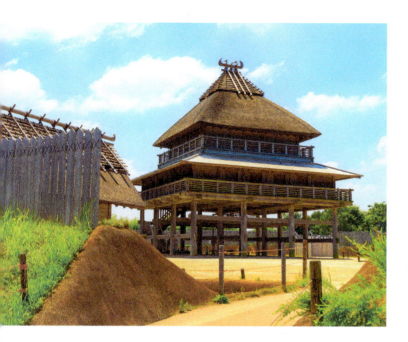

12-13 • RECONSTRUCTION, CEREMONIAL HALL
Yoshinogari Historic Site, Saga prefecture. Original structure: Late Yayoi period, 1st–3rd century CE.

a ceremonial hall (**FIG. 12-13**). The concept of a raised dwelling constructed from wood and thatch may have its roots in the architectural traditions of southern Asia, and it is this style of architecture that permeates the designs of later Shinto shrines.

On the periphery of the residential area at Yoshinogari, over 2,000 burial sites and numerous burial jars have been discovered. Yoshinogari demonstrates the complete shift from a simple culture of farmers living in small villages and gathering food from the surrounding area to a sophisticated society with grain surpluses and notions of hierarchy. By the end of the Yayoi period, village communities had evolved into chiefdoms, and fighting between confederations of chiefdoms became more common.

QUEEN HIMIKO AND EMPRESS JINGU

Periodically, powerful men, and sometimes women, took control of these warring factions. Chinese sources mention a Queen Himiko who in about 180 CE united various dissenting groups to create the powerful state of Yamatai. Japanese sources do not mention Himiko, but they do mention a charismatic female ruler with shamanic powers who lived at more or less the same time. Empress Jingu (169–269 CE) is credited with conquering kingdoms in southern Korea while pregnant with the future emperor Ojin. Who were Queen Himiko and Empress Jingu? To date, archaeologists have not excavated any tombs that correspond to the burial sites of either. Nevertheless one can assume that certain historical truths lie within their recorded mentions and that women did occupy powerful positions in Yayoi society. Much later, during the Meiji period (1868–1912), a portrait of Empress Jingu by the Italian artist Edoardo Chiossone appeared on a 10-yen note, one of few Japanese women to appear on Japanese currency (**FIG. 12-14**). Chiossone, who worked for the Paper Currency Bureau in Japan, concocted a portrait of a Westernized Empress Jingu, further distancing her from her Yayoi origins.

KOFUN PERIOD

Yayoi culture was gradually eclipsed by that of the **Kofun** period (ca. 300–552), so called for the many large tombs (*ko* = old, *fun* = grave mound) that were built during this era. Yamato, located in present-day Osaka-Nara area, became the dominant state. Yamato, which gained control over surrounding chiefdoms through intermarriage, military prowess, and political maneuvers, has been tentatively identified with the state of Yamatai. According to fourth-century Korean records, fighting took place between the Korean kingdoms and Japan during the Kofun period. Fifth-century Chinese sources speak of regular visits to China by

12-14 • GOVERNMENT BANKNOTE FEATURING EMPRESS JINGU
Meiji period, 1878. British Museum, London.

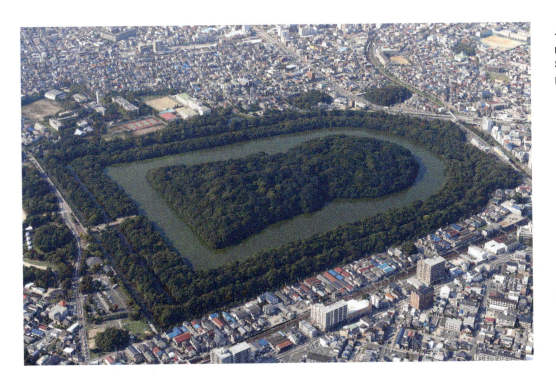

12-16 • SUEKI VESSEL
Kofun period, ca. 6th century. High-fired pottery with ash glaze, height 21⅜″ (55 cm). Tokyo National Museum.

emissaries from the Japanese court, and close links between Japan and the continent are evident in the hierarchical structure of the Kofun court and in their artistic accomplishments.

The Yamato government was a coalition of powerful clans presided over by an emperor who acquired the status of divine ruler as a descendant of the Shinto sun goddess Amaterasu. The supremacy of the emperor and his imperial household can be seen in the enormous Kofun tombs that rise from the flat plains of Osaka prefecture.

One of the most impressive Kofun tombs is the resting place of Emperor Nintoku, who likely reigned from the late fourth to early fifth century CE (**FIG. 12-15**). From an aerial perspective, one is struck by the tomb's bell-shape design, which resembles a *dotaku*. At the heart of the tomb complex is an earthen mound, often described as keyhole-shaped, which rises 90 feet (27 meters) above the plain. The keyhole-shaped tomb is protected by three moats, and the entire mausoleum occupies an area of about 460 acres (185 hectares). Owing to excavation restrictions imposed on grave sites of emperors by Japan's Imperial Household Agency, Emperor Nintoku's burial chamber has not been unearthed. However, from the evidence provided by numerous, smaller keyhole-shaped tombs for which excavation was permitted, Nintoku's burial place is most likely a square or round stone room positioned close to the top of the mound. Within the chamber it was customary to inter the body in a wooden or stone coffin, surrounded by numerous **grave goods** to assist them in the spiritual realm.

The various funerary goods unearthed from Kofun **tumuli** (burial mounds) include Chinese bronze mirrors, iron weapons, openwork gold crowns, jade personal ornaments, and **Sueki ware**, a new type of elegant gray-green pottery. The piece shown here has four small mouths and models of animals

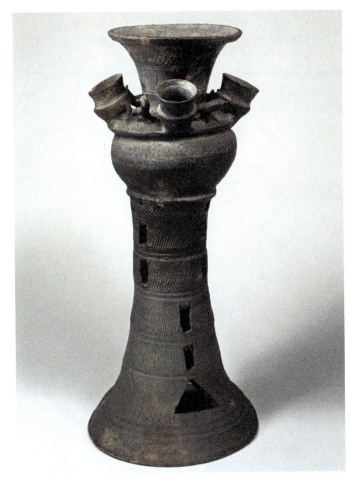

embellishing its top section. The attached stand is pierced with openings that both are decorative and were intended to minimize cracking during the firing process (**FIG. 12-16**). Popular with the ruling classes, Sueki ware was introduced into Japan by

Korean craftsmen during the fifth century. This high-quality pottery, often used for ceremonial purposes, was turned on the wheel and fired at very high temperatures (over 1,800 degrees Fahrenheit/1,000 degrees Celsius). As a result, Sueki ware acquires an ash glaze from the vitrification of matter from the kiln walls. Equestrian objects such as bridles, stirrups, and saddles, often of gilded bronze, have also been found in the tombs, indicating the emergence of a horse-riding culture. Three items in particular surface regularly from the grave mounds: the sword, the bronze mirror, and the curved jewel **magatama**, often fashioned from highly polished jade (**FIG. 12–17**). These objects are symbols of divine authority and have great ritual significance. *Magatama* also decorate Korean gold crowns and jewelry from the same period, emphasizing close relations between Japan and the Korean peninsula.

Today, Emperor Nintoku's tomb is besieged by the suburbs of Sakai city and appears as a grassy, tree-covered hump to those who take the 40-minute walking path around the perimeter of the site. During the Kofun era, the slopes of Nintoku's burial mound and the tumuli of other powerful leaders were clearly accented with pottery figurines called **haniwa** (*hani* = clay, *wa* = circle). *Haniwa* are hollow **terra-cotta** cylinders topped with an array of images such as creatures (fish, birds, and monkeys), objects (furniture, boats, and houses), and figures (stylish women, warriors in armor, and falconers). The number of *haniwa* marking a tomb varied from a few to thousands. It is estimated that Emperor Nintoku's tomb bristled with approximately 20,000 *haniwa*. Likely sources of inspiration for *haniwa*

figures are the countless terra-cotta figurines and animals buried in such ancient Chinese tombs as the sumptuous tomb of the despotic third-century BCE emperor Qin Shihuangdi, located near Xi'an (see Chapter 6, pp. 138–139). Detailed studies have been made of the placement of *haniwa* on the sloped tombs. A typical pattern featured a house-shaped *haniwa* positioned directly over the deceased, with other *haniwa* outlining the keyhole shape in one, two, or three tiers. Human *haniwa* and those of creatures faced outward, with their backs to the mound, to address the realm of the living. The earliest *haniwa* were simple clay cylinders that may have held vessels containing ceremonial offerings; however, in time *haniwa* evolved into an eclectic array of objects, animals, and humans.

12–18 • *HANIWA* FIGURE OF FALCONER
Kofun period, 6th century. Terra-cotta, height 29⅘″ (75.8 cm). Yamato Bunkakan, Nara.

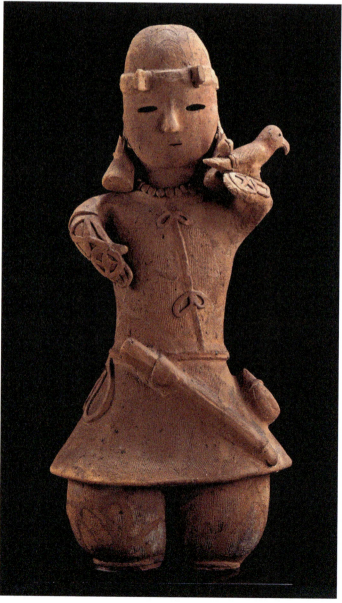

12–17 • MAGATAMA
Kofun period, 5th–6th century. Jadeite. Eta Funayama tumulus, Nagomi Town, Kumamoto prefecture; Tokyo National Museum.

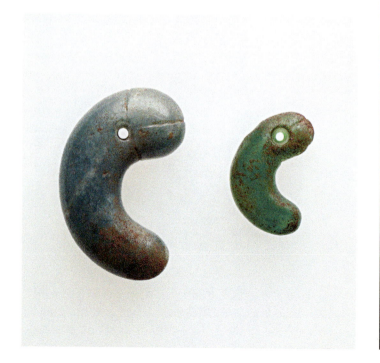

The figure of the falconer is one of the more elaborate *haniwa* (**FIG. 12–18**). Fashioned from slabs and rolls of clay and over two feet (60 centimeters) in height, the falconer is an imposing figure. He is a study in simplicity and subtle detail, with mere holes for the eyes and mouth, yet the body is etched with fine lines and decorated with pellets of clay for the necklace and strips of clay for the bows on his costume. He carries a sword at his waist and a round wrist-protector used in archery. Perched on his left arm is a falcon with a bell attached to its tail to frighten its prey. Not all *haniwa* are as easily identified as the falconer. Speculation swirls around a female *haniwa* excavated from a tomb in the Kanto region (**FIG. 12-19**). She is often described as a seated female shaman. Her elaborate hairstyle, robes, and jewelry

12-19 • *HANIWA* FIGURE OF SEATED FEMALE SHAMAN
Kofun period, 6th century. Terra-cotta, height 27″ (68.5 cm). Tokyo National Museum.

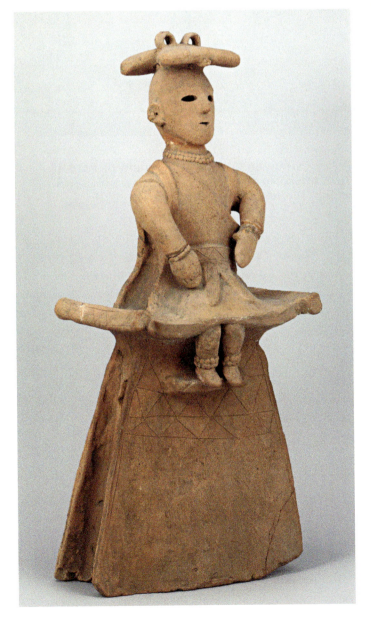

denote high-ranking status but most importantly a small bag and a mirror with five bells are attached to her left hip. During the sixth century, mirrors with metal bells were made in large quantities in the Kanto area and functioned as objects of spiritual importance. Even today, female shrine attendants (*miko*) entertain *kami* with a circular dance while shaking bell-wands (*suzu*) at carefully timed intervals. The bell-wand is reputed to have powers to bless and protect.

What was the purpose and meaning of *haniwa*? This question has not been definitively answered, but the various theories range from the practical (*haniwa* prevent slopes from collapsing) to the supernatural (they contain spirits or protect the sacred site from evil spirits). Indeed, with the *haniwa's* characteristic **anthropomorphic** and asymmetrical forms—notice the irregular placement of the falconer's facial features—*haniwa* do seem to breathe and appear strangely animate. In general terms, these figures can be seen as a bridge between the realm of the dead, over which they presided, and the world of the living, whose domain they faced from a sloped vantage point.

THE SUN GODDESS AMATERASU AND THE SHINTO SHRINE AT ISE

The Japanese ability to incorporate sophistication in to seemingly unpretentious forms finds an early manifestation in the Shinto shrine complex at Ise, home of the sun goddess Amaterasu. Legend has it that the sun goddess herself chose this beautiful wooded site by the Isuzu River. Shinto pilgrims and visitors to the inner shrine (Naiku) are first greeted by a *torii*, a sacred gateway marking the entranceway to hallowed ground. After passing through the *torii*, the visitor crosses the river to the Shinto compound via the Uji Bridge, and in doing so is purified in heart and mind. Purification, both spiritual and physical, is an important component of the Shinto belief system. After crossing the Uji Bridge, pilgrims walk down to a stepped site by the river to cleanse themselves ritually while visitors are expected to wash their hands and rinse their mouths before moving toward the main shrine. To reach the sanctuary's perimeter, visitors follow a picturesque meandering path through the trees. The main hall (see **FIG. 12-2**), constructed from cypress wood with a thatched roof, stands on a white-pebbled ground, and a series of wooden fences enclose the sacred space. Access to the building is reserved for members of the imperial family and high-ranking priests. Shinto worshippers and visitors are able to say their prayers only from beyond the outermost fence. Emphasis is therefore on venerating the sacred shrine from the exterior.

The initial construction of the Ise shrine is said to date from the first century CE, and according to legend it was built to house the sacred mirror of Amaterasu. The current main hall is a reconstruction of the ancient shrine and dates from 2013. Every 20 years, with few exceptions since the seventh century, a new shrine has been built next to the existing main hall and the earlier shrine dismantled. This elaborate rebuilding program,

called *Sengu*, symbolizes renewal and continuity. Priests who participate believe they are revitalizing the soul of Japan and transmitting Japanese traditions to the next generation.

Despite its rustic appearance, the main hall is a remarkable study in understated elegance. Subtle details catch the eye—for example, forked **finials** have gold leaf ornamentation and cylindrical roof weights are tipped with metal to catch the sunlight. Built without nails, the shrine's timbers are fitted together using a traditional **mortise-and-tenon** technique, whereby a projecting pin (tenon) on one element fits into a hole (mortise) on another. Three sacred Shinto symbols—mirror, sword, and *magatama*—are housed inside the sanctuary. A popular story recounts how the mirror came to embody Amaterasu's spirit. At one point, the sun goddess was very angry with her brother Susanoo no Mikoto (the god of storms). Among other offenses, he had ransacked her rice fields, wrecked her looms, and defecated in her palace, causing her to retreat into a cave. Naturally, the sun's departure was of great concern to the other gods, and they devised a plan to lure her from the cave. They hung a mirror from a tree and made a loud commotion to attract her attention. Ame no Uzume (goddess of dawn and revelry) performed a topless erotic dance that made the deities burst out laughing. Ame no Uzume informed the sun goddess that there was a superior deity outside, and when Amaterasu ventured outside the cave to investigate, she saw her reflection in the mirror. Unaware of the trick being played on her, the sun goddess was prevented from returning to the cave by a sacred rope placed across the entrance. Once the new shrine is completed after each 20-year hiatus, the mirror is covered in silk to avoid defilement by being seen during its ritual move to the adjacent location.

More than 20 important ceremonies are held every year at the Ise shrine. One of the most important is the Kanname-sai, a thanksgiving ceremony held in mid-October, during which the first fruits of the annual rice harvest are dedicated to Amaterasu. Shinto worshippers come to the shrine every day to pray and seek guidance from the spiritual realm. Offerings made to *kami* include fruit, rice, incense, money, and *fuda*, or strips of paper symbolizing purity (**FIG. 12-20**). Another important way of honoring the deities is to entertain them with dances. Shrine attendants (*miko*) perform ritual dances, or **kagura**, a symbolic manifestation of the sexually provocative dance of Ame no Uzume.

The Ise shrine's current appearance owes much to its ancient prototypes from the Kofun period. However, as the centuries passed, the design of the building became more refined and inclusive of outside influences. With the arrival of Buddhism from Korea in the sixth century, smooth flat planks replaced logs for the shrine walls and, following the style of Buddhist temples, some Shinto shrines were painted red. Shinto gracefully weathered and survived the advent and dominance of the Buddhist religion in part because both religions share a fundamental reverence for nature; Shinto shrines continued to be built in tranquil locations and some were integrated into Buddhist complexes.

12-20 • SHEAVES OF RICE AND STRIPS OF PAPER (SYMBOLIZING PURITY) offered to the *kami* by the Emperor Ise-jingu, Mie prefecture.

Today, Shinto is an integral part of Japanese society, especially in rural Japan. Shinto permeates everyday life—for example, the national sport of sumo wrestling has its origins in an ancient Shinto practice honoring the *kami*. The canopy hanging over the ring evokes a Shinto shrine, the referee's attire resembles the robes of a Shinto priest, and before wrestling commences, salt is thrown to purify the ring. Currently, as in the past, a Shinto parishioner can also be a follower of Buddhism, although, according to the anthropologist C. Scott Littleton, "in a great many respects to be Japanese is to be Shinto, no matter what other religions one espouses."

EARLY BUDDHIST ART

Teach this triple truth to all: A generous heart, kind speech, and a life of service and compassion are the things that renew humanity.
Buddhist belief

Mahayana Buddhism, the initial branch of Buddhism to reach Japan, was officially introduced to the Japanese imperial court at

the start of the Asuka period (552–645). Around 552, emissaries from the king of Baekje in Korea presented the Japanese emperor Kimmei (r. 540–571) with a gilded bronze statue of the Buddha together with Buddhist **sutras** (sacred scripts) and a letter containing the following persuasive message: "This doctrine can create religious merit and retribution without measure and without bounds, and so lead on to a full appreciation of the highest wisdom." By the time Buddhism reached Japan from India, having meandered along the Silk Road through Central Asia, China, and Korea, it was a well-formulated religion accompanied by a potent mix of cultural influences. Emperor Kimmei was impressed with the new religion but acted with caution; he did not want to offend the indigenous nature and ancestor spirits, and so initially he permitted only the influential Soga family to practice Buddhism. Remarkably, by 623 there were 46 Buddhist temples, 816 monks, and 569 nuns. How did this happen?

Prior to the Korean Buddhist delegation's arrival in about 552, numerous members of Japan's immigrant community were in fact Buddhists. Craftsmen from China and Korea, specializing in such vocations as painting and weaving, had settled in the Yamato area during the fifth century. Sustained by foreign immigrants, wealthy aristocratic families, and renowned Buddhist visitors, Buddhism gained strength. Shinto's archaic worship of nature spirits and its accompanying plain aesthetic tastes could not compete with the complexity of the Buddhist pantheon and its attendant rich continental culture. Members of Japan's elite gravitated toward the spiritual solace and intellectual stimulation that Buddhism offered. The prospect of gaining merit and rewards through worship was also attractive. Aristocrats and commoners alike were in awe of the magnificent temples filled with imposing sculptures and luminous paintings. Dimly lit temple interiors appealed to the senses. Flickering candles, the smell of incense, chanting monks, and the sound of bells, gongs, and drums entranced the devotee.

Initial military and political conflicts between supporters of Shinto and advocates of Buddhism dwindled, and a peaceful coexistence between the two belief systems prevailed. Buddhism won the imperial family's approval, and from Emperor Yomei's reign onward (r. 585–587), almost all emperors were practicing Buddhists, although the imperial family maintained its descent from the Shinto sun goddess, Amaterasu, and also took part in traditional Shinto rituals.

Buddhism's arrival in Japan had a profound influence on Japanese art and society. Following the first Buddhist statue presented to Emperor Kimmei, Korean- and Chinese-inspired Buddhist art flowed into Japan along with other cultural forms, such as philosophy, music, dance, and Chinese writing. Japan had not yet developed a written language. Other imports from the continent that transformed Japanese society included medicine, government, city planning, and technology. An unprecedented program of building temples and religious complexes ensued, with the aid of foreign, especially Korean,

architects, sculptors, and painters, who arrived with the new religion to teach the necessary skills for constructing and furnishing temples. Buddha and his entourage of **bodhisattvas** (Jap. *bosatsu*) were worshipped in temples, unlike Shinto deities, who inhabited nature or modest shrines. At this stage in Japanese Buddhist history, construction of temples, monasteries, and convents took place under the patronage of the imperial family, powerful clan leaders, or important individuals.

Asuka near Nara was the era's first imperial capital. The Asuka period is also known as the Suiko period, a reference to the accomplished Empress Suiko, who ruled from 593–628. Prior to the eighth century, it was not uncommon for an empress to occupy the imperial throne; Japan had six female rulers between 593 and 770.

During the early years of the Asuka period, Japan consisted of the Yamato state and numerous separate regions ruled over by powerful clans. Under the leadership of Empress Suiko and her nephew Prince Shotoku, the imperial family truncated the influence of clan chiefs by subjecting all regional leaders to supreme imperial authority. Moreover, taking a cue from the Chinese centralized system of government, the imperial family moved Japan toward unification. The advance of Buddhism increased the atmosphere of unity. Astute rulers campaigned to make Buddhism the official national religion, in part to undermine links between warring clan leaders and local deities.

EMPRESS SUIKO AND PRINCE SHOTOKU

Empress Suiko (554–628), the beautiful daughter of Emperor Kimmei, ascended the throne in 593 after an exhaustive power struggle. According to the *Nihon Shoki* ("Chronicle of Japan"), Suiko was respected by the high councilors for her intelligence, and it was hoped she would unite various dissenting factions. Shortly after her ascension to the throne, her nephew, Prince Shotoku (572–622), with the support of the powerful Soga family, was appointed Suiko's regent and heir apparent. Most of the literature on Japanese art and history suggests that political power during Empress Suiko's reign was in the hands of Prince Shotoku and minister Soga no Umako. However, closer analysis of her reign reveals that Suiko wielded more authority than previously acknowledged. Indeed, her title, "Suiko Tenno," is testimony to her exalted position: *Tenno* is generally translated as "Empress" or "Emperor," signifying the supreme ruler, regardless of gender.

Empress Suiko did not sit quietly on the sidelines of Japanese history. According to the *Nihon Shoki*, she organized military expeditions to Korea. In 600, for example, she dispatched over 10,000 soldiers to Korea to punish the King of Silla for invading Japan's ally, Mimana (Imna), in Southern Korea. Also in 600, the empress opened up diplomatic relations with the Chinese court of the Sui dynasty. Her many other accomplishments include the adoption of a series of moral injunctions known as the "Seventeen Article Constitution." Inspired by Confucian principles, the Constitution provided the shapeless government

bureaucracy with an administrative structure that placed the *Tenno* at its zenith. Under Empress Suiko's leadership, Buddhism acquired official recognition with the "Flourishing Three Treasures Edict" in 594.

Suiko was also an active patron of Buddhist art. Historical records describe how, in 605, she commanded members of the imperial court to support the creation of two (no longer in existence) 16-foot (4.8-meter)-high images of Buddha, one in copper and gold and the other in embroidery. Upon completion, these works were housed in Gango-ji temple. In spite of Empress Suiko's newly minted alliance with Buddhism, she did not discard her Shinto beliefs and, when an earthquake wreaked havoc during the summer of 509, imperial orders were given to make sacrifices to the god of earthquakes, Nai no Kami.

Prince Shotoku shared his aunt's enthusiasm for Buddhism. Shotoku, if the stories are true, was an ardent Buddhist scholar who gave lectures at court on the Buddhist sutras, wrote the "Seventeen Article Constitution," and founded many Buddhist temples. When Prince Shotoku died, in 622, the Japanese chronicles poetically declared that everyone in the land cried, the farmers stopped plowing, and the women laid down their pestles and ceased pounding. After his death, Prince Shotoku became the focus of the Shotoku Taishi cult, and his contribution to Buddhism was raised to mythical proportions. Contemporary Japanese historians such as Oyama Seiichi debate the historicity of claims associated with Prince Shotoku. However, his establishment of Horyu-ji in partnership with Empress Suiko is undisputed.

HORYU-JI

Sadly, many of Japan's cities were demolished in bombing raids during the final months of World War II, but the ancient imperial capitals of Kyoto and Nara escaped the conflagration. Horyu-ji, a 40-minute bus ride from Nara's bustling center, is the oldest surviving temple in Japan, and the monastic complex contains the world's oldest existing wooden structures (**FIG. 12-21**). Empress Suiko and Prince Shotoku founded Horyu-ji in 607. The exact age of the temple is still debated in academic circles, since a fire ravaged the premises in 670, but it is generally believed that the current building is a reconstruction from the end of the seventh century.

The overall appearance of Horyu-ji, with its clay-tiled roofs, elaborate wooden brackets, upturned eaves, and highly visible pagoda, evokes Buddhist temples from China's Six Dynasties era (220–589) or Korea's Three Kingdoms period

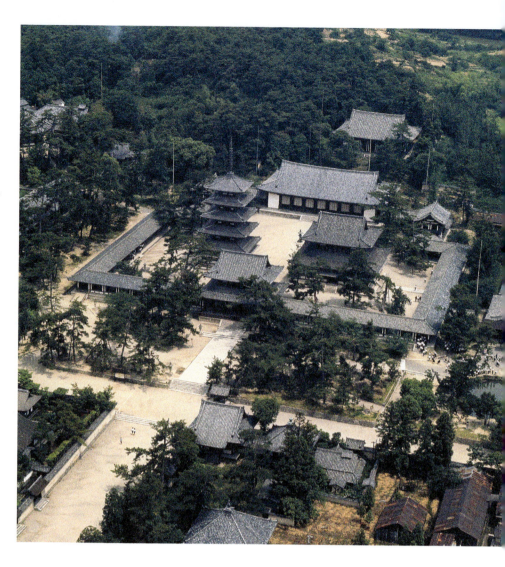

12-21 • GENERAL VIEW OF HORYU-JI
Nara prefecture. Asuka period, 7th century.

(ca. 57 BCE–668 CE). This is not surprising, since many of Japan's accomplished architects and artists at this time were of Chinese or Korean descent. Horyu-ji is divided into two main sections: the western precinct, which contains the **pagoda** (tiered tower)

12-22 • PLAN OF THE WESTERN PRECINCT OF HORYU-JI.

1. Pagoda
2. *Kondo* (main hall)
3. Lecture hall
4. *Chumon* (central gate)
5. Roofed corridor
6. Sutra repository

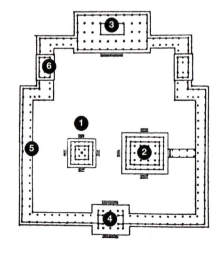

and *kondo* (main hall), and the eastern precinct, which includes the smaller Chugu-ji, a nunnery. Access to the western precinct is via the *chumon* (central gate) (**FIG. 12-22**).

After crossing the threshold of the ancient gate, one enters the calm of an inner sanctum. A large open courtyard covered in yellowish-white pebbles and featuring the occasional weather-beaten pine tree is enclosed on all sides by cloistered walkways. Breaking up the space are the five-story pagoda and the *kondo* containing Buddhist images. What is fascinating about the placement of these two structures is the emphasis on asymmetry and lateral movement, deviating from the Chinese model, which stressed symmetry and linear penetration through a succession of important structures. At Horyu-ji, after walking through the *chumon*, which itself is slightly off-center, the visitor moves either left to contemplate the pagoda or right to enter the *kondo*. Asymmetry becomes a hallmark of Japanese art.

Rising elegantly out of the pebbled courtyard, the five-story pagoda, at one time strikingly adorned with red paint and gold leaf, is 110 feet (33 meters) in height (**FIG. 12-23**). In early Buddhist thought, the number 5 usually symbolizes the cosmos, comprising four cardinal points and a zenith. As the pagoda soars toward the sky, the five separate stories decrease in size, further reinforcing its attenuated form. At the core of the pagoda is a single pillar of wood, which extends upward from the stone base and culminates in a copper shaft tipped with a "jewel," symbolic of Buddhist wisdom (**FIG. 12-24**). The wooden pillar supports the storied eaves, which are attached to the column by a system of elaborate brackets. These brackets take the form of stylized clouds, further evoking the atmosphere of spiritual awakening. At the base of the wooden pillar, religious **relics** are secreted in a stone vessel.

Although the precious relics are not on view, the pagoda provides a focus for Buddha's divine energy within the temple complex. Devout followers of Buddhism can **circumambulate** clockwise around the pagoda to absorb the sacred blessings of Buddha. Walking slowly, one is reminded of Buddha's Four

12-23 • FIVE-STORY PAGODA, HORYU-JI
Nara prefecture. Asuka period, 7th century.

12-24 • CROSS-SECTION OF FIVE-STORY PAGODA, HORYU-JI.

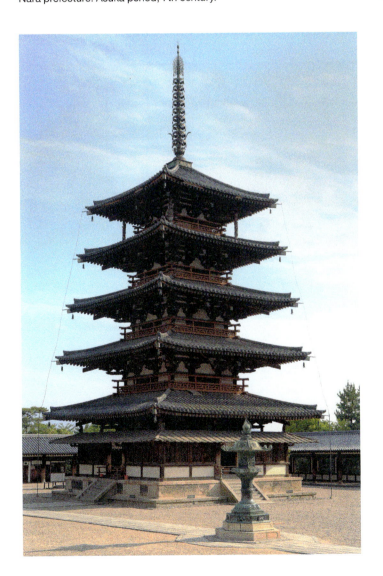

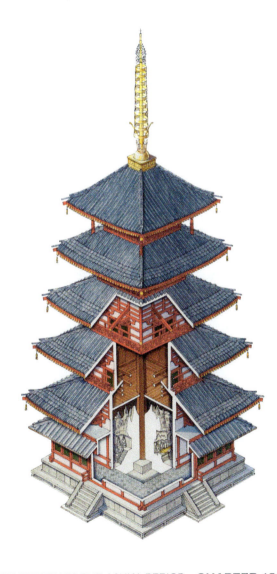

Noble Truths and their dissemination north, south, east, and west, by four equidistant stairways leading to four entrances. Apart from the ground floor, there is no access to the pagoda's upper levels. Instead, one is invited to gaze at the gradually rising tiers and contemplate the transition from the mundane world to the spiritual realm. Meanwhile, the divine forces of the universe are transmitted downwards through the pagoda's vertical "antenna" to illuminate our gray, unenlightened existence.

The *kondo* to the right of the pagoda also offers the practitioner solace from the world of suffering (**FIG. 12-25**). Unlike the pagoda, the *kondo* is used for worship and ceremony, and the devotee can circumambulate within the building around a raised platform filled with Buddhist statuary. From the outside, the main features of the *kondo* are its stone base, four entrances, and **hipped-and-gabled** upper roof (sloped, with a gable—triangular section of wall—on top). Despite the appearance of several stories, the *kondo* consists of only two stories. The "third" story is floorless, but its elevated form adds to the overall impression of monumentality. Further interest is added by dramatic contrasts forged between the *kondo* and its immediate environment. The natural bright light of the courtyard gives way to the main hall's dimly illuminated interior, and the stark appearance of the open courtyard is countered by the wealth of painted and gilded Buddhist statuary on view within.

12-25 • *KONDO* (MAIN HALL), HORYU-JI
Nara prefecture. Asuka period, 7th century.

One of the most famous gilt-bronze statues housed in the *kondo* is a sculpture known as the *Shaka Triad* (**FIG. 12-26**). Shaka is the Japanese abbreviation for Shakyamuni, the historical Buddha. Shaka is seated cross-legged on a throne accompanied by two bodhisattvas. Behind Shaka, a flaming body halo swirls with undulating patterns. According to an inscription on the back of the halo, this triad was commissioned by Empress Suiko and several palace members in memory of two prominent court ladies who died in 621. It was also commissioned in an attempt to improve the health of Prince Shotoku and his consort at the time. Unfortunately, both died shortly after, and when the sculpture was completed in 623 it was dedicated to their spiritual repose.

Shaka and his attendant bodhisattvas appear simultaneously imposing, with their rigidly frontal positions, and soothing, with their heavily lidded eyes and slightly smiling expressions. To comfort the onlooker, Shaka performs the "fear not" (Skt. *abhaya*) **mudra** (gesture) with his raised right hand while his open left hand communicates charity. The sculptor responsible for this work is Tori Busshi, a descendant of Chinese or Korean craftsmen and a member of the acclaimed Tori family, who offered their services as "masters of Buddhist images" (*busshi*) to Empress Suiko. Tori's *Shaka Triad* was partly inspired by continental models from the Chinese Northern Wei period (386–534) (see Chapter 7, **FIG. 7–8**). This is apparent in the stylized "waterfall" drapery of Shaka's robes, the figure's elongated proportions, and the halo's decorative patterns. However, Tori's

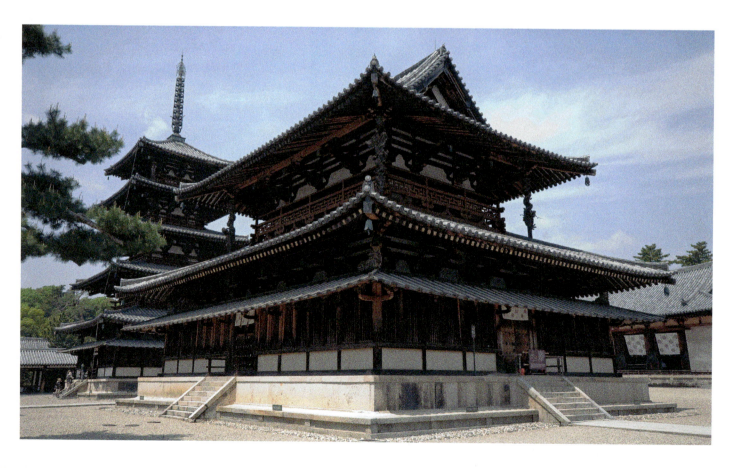

unique style is revealed in his creative abstractions of the drapery patterns and exuberant exploration of curvilinear forms. Even though Shaka's halo appears to be a seething mass of flames and lotus vines, seven small seated Buddhas of the Past, who preceded Shaka, calmly occupy the dynamic environment. Stillness and movement, a persistent refrain in the *Shaka Triad*, remind the devotee to cultivate tranquility amid inevitable change. In addition to the sophisticated aesthetic appearance of the work, the finely cast bronze sculpture also indicates that Tori and his assistants were accomplished technicians. Bronze sculptures such as this were made using the **lost-wax casting** method, a complex and lengthy process requiring advanced technical skills. This involved covering a wax model of a piece in clay, then firing it to melt away the wax, producing a clay mold for the molten metal.

Although the *kondo* is unquestionably ancient, like most historic Japanese buildings subject to fires and earthquakes it has been augmented and restored over the centuries. For example, a covered porch was added in the eighth century, and in the seventeenth century, dragon corner posts were installed (**FIG. 12-27**). These ascending and descending dragons guard the building and are protectors of Buddha's Law. More recently, old interior frescoes of a Buddhist Paradise, damaged by fire in 1949, have been vividly reconstructed.

A large selection of Horyu-ji's exquisite treasures are now housed in Tokyo's National Museum; however, approximately 1,000 works remain in Horyu-ji's Gallery of Temple Treasures (Daihozoin). Two of the remarkable Daihozoin treasures on display from the Asuka period are the *Kannon*, the Bodhisattva of

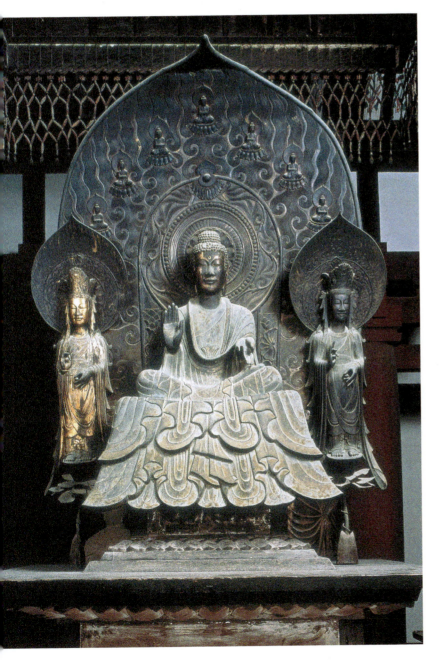

12-26 • Tori Busshi *SHAKA TRIAD*
Kondo (main hall), Horyu-ji, Asuka period, 623. Gilt bronze, height 46" (116.8 cm). Nara prefecture.

12-27 • **DETAIL OF DRAGON POSTS**
17th century, *kondo*, Horyu-ji. Nara prefecture.

Nature in all its fleeting beauty is found in the Tamamushi Shrine, a portable tabernacle said to have belonged to Empress Suiko. The shrine was named after the thousands of iridescent tamamushi beetle wings placed beneath the openwork gilt-bronze bands framing the panels and decorating the pedestal. At one time, glittering blue-green wings shone through the intricate metal-work, highlighting the colorful paintings executed in reds, yellows, greens, and browns against a black lacquered background.

Inside the shrine's miniature *kondo*, an image of the Bodhisattva of Compassion is found, a replacement for an earlier work.

Themes of compassion and self-sacrifice are displayed in the shrine's paintings. In this illustration, inspired by the *jataka* stories (tales of Shaka's previous lives before he attained enlightenment), Prince Mahasattva, one of Shaka's earlier incarnations, sacrifices himself to feed a starving tigress and her seven cubs in a bamboo grove (see also Chapter 7, p. 153).

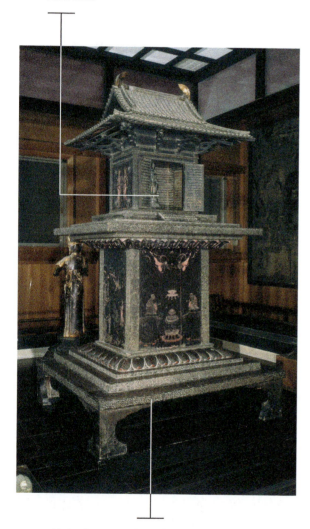

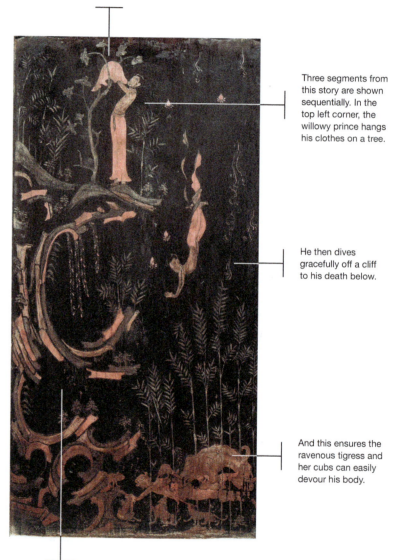

Three segments from this story are shown sequentially. In the top left corner, the willowy prince hangs his clothes on a tree.

He then dives gracefully off a cliff to his death below.

And this ensures the ravenous tigress and her cubs can easily devour his body.

Made of cypress and camphor wood, the shrine consists of three main sections: the pedestal, a rectangular plinth, and the miniature *kondo*.

TAMAMUSHI SHRINE AND DETAIL OF "HUNGRY TIGRESS" PANEL
Asuka period, ca. 650. Cypress and camphor wood, with lacquer, height 7'7½" (2.33 m). Gallery of Temple Treasures, Horyu-ji, Nara prefecture.

Despite the heroic yet horrific nature of the scene, the artist has created an image of great beauty through the use of sinuously flowing lines, landscape details reduced to their essence, and a quiet sense of detachment regarding death. Death is not to be feared. It is merely another step in the cycle of life and rebirth.

Compassion (**FIG. 12-28**), and the Tamamushi Shrine (see Closer Look, opposite).

Bodhisattvas appear as attendants of the Buddha, as seen in the *Shaka Triad*, but they also function independently of the Buddha as deities in their own right. Endowed with great benevolence, **Kannon**, the Bodhisattva of Compassion, is one of the most popular and frequently depicted deities in Japanese art. Kannon initially appears as a male, often sporting a mustache, but by the late medieval period, he metamorphoses into a more obviously female form. This shift toward feminizing Kannon may be because society ascribed feminine characteristics to deities who exhibited behavior culturally associated with women, such as compassion, gentleness, and, of course, maternity. The Asuka period gilt-bronze Kannon on display in Horyu-ji's Daihozoin is an early representation of the Bodhisattva of Compassion in Japan; however, a whiff of femininity already clings to the sculpture. Kannon stands serenely on an inverted lotus pedestal, clasping the wish-granting jewel. The bodhisattva's hands and feet appear large in proportion to the rest of the body. At one time, the head was framed with a halo, now lost. Kannon's fleshy body is swathed in princely robes that are tied in the center with a butterfly-shaped bow and scarves that flare out at the sides with a "fish tail" pattern. The deity's three-pronged coronet is incised with images from nature, such as the sun, moon, and birds—a reminder that all phenomena are ephemeral and as illusory as moonlight on water.

CHUGU-JI

Horyu-ji's important buildings are not confined to the sacred enclosure. As a functioning monastery, it has many structures outside the main complex that support the day-to-day running of monastic life, such as the lecture hall, library, and accommodation for monks. One building frequently overlooked by the casual visitor is Chugu-ji, the oldest remaining imperial convent in Japan, located close to Horyu-ji. Official documentation on Chugu-ji's origins is scant. Reputed to be more than 1,300 years old, it was initially the palace of Empress Anahobe no Hashihito, Prince Shotoku's mother. Little remains from the Asuka period, although two remarkable treasures have survived: a wooden sculpture regarded by the convent as **Nyoirin Kannon** but usually identified by art historians as **Miroku Bosatsu** (Skt. Maitreya), Buddha of the Future, and the Tenjukoku Embroidery. Both the sculpture and the embroidery (only a replica is on display) are exhibited in Chugu-ji's Treasure Hall.

Chugu-ji's *Miroku Bosatsu*, carved out of camphor wood, is seated in a meditative pose with the right foot resting on the left

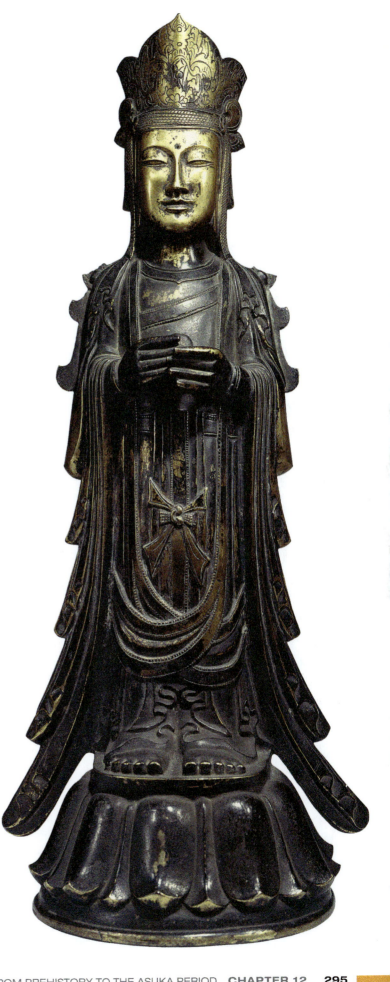

12-28 • *KANNON* (BODHISATTVA OF COMPASSION)
Asuka period, 7th century. Gilt bronze, height 26⅛″ (67 cm).
Gallery of Temple Treasures, Horyu-ji, Nara prefecture.

knee and the right hand touching the right cheek (**FIG. 12-29**). Originally, this sculpture was painted, however, all the pigments have peeled off, leaving a **lacquer** surface darkened by incense smoke (lacquer was a heated tree sap, applied to wood to preserve it). One is drawn to Miroku's serene expression as he absorbs the suffering of humanity with calm acceptance. His hair is pulled off his brow into two round chignons, except

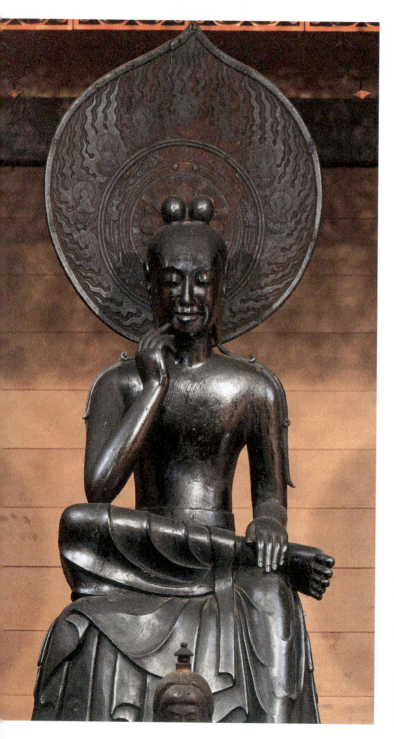

12-29 • *MIROKU BOSATSU*
Asuka period, 7th century. Camphor wood, height 34½″ (87.5 cm). Chugu-ji, Nara prefecture.

for delicate strands of hair that spill over his shoulders. Miroku appears vulnerable in his gentle elegance but also impenetrable, a spiritual force impervious to worldly distractions. Parallels can easily be spotted between the Chugu-ji *Miroku Bosatsu* and a Korean counterpart in the National Museum of Korea (see Chapter 11, **FIG. 11-8**). Profound similarities between the two images vividly underscore the close relations shared by Japan and Korea in the seventh century.

One of Japan's National Treasures, the Tenjukoku Embroidery was hand-sewn by court ladies and is the oldest surviving example of Japanese embroidery (**FIG. 12-30**). When Prince Shotoku died in 622, one his consorts, Lady Tachibana, was overcome with grief. A sympathetic Empress Suiko ordered the court ladies to make two embroidered curtains featuring the Prince in **Tenjukoku**, "Land of Celestial Immortality," as a memorial to the deceased and to comfort the bereaved. Artisans of Korean lineage created the original designs for the embroidery.

Unfortunately, the embroidered silk curtains suffered periods of neglect, and only fragments of the original textiles exist

12-30 • TENJUKOKU EMBROIDERY
Asuka period, 7th century. Fragments of the original, embroidered silk. Chugu-ji, Nara prefecture.

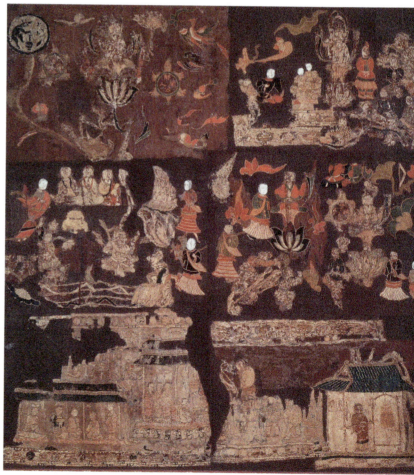

today. At one time, the embroidery languished, forgotten, in Horyu-ji's sealed treasury; it was rediscovered only in 1274 by the charismatic Buddhist nun Shinnyo. In addition to rescuing the panel from obscurity, Shinnyo is also credited with raising funds to create a replica of the damaged embroidery. To complicate matters, the surviving Tenjukoku Embroidery is a composite of original fragments and sections of the replica. Astonishingly, the original pieces with their well-preserved threads are much brighter than the replicated sections, attesting to the technical excellence of dyeing and weaving during the Asuka period. Judging by the delicate beauty of the few remaining fragments, one can only imagine the richness of the embroidery in its original form as a pair of embroidered silk curtains. In ancient Japan, such curtains were placed in Buddhist shrines and also used to enclose four-pillared beds.

A distinctive Korean influence can be detected in the red-and-green costumes worn by the men and women who inhabit the heavenly land. Men are attired in round-necked jackets, skirts, and baggy pants, while women sport long jackets, pleated or striped skirts, and a sashlike garment across their chests. In Korea's Goguryeo kingdom similar fashions were worn at court. With only fragments of the embroidery left to contemplate, Tenjukoku emerges as a mysterious realm composed of fashionably attired men and women, temples, such creatures as tortoises and exotic birds, otherworldly beings emerging from lotus blooms, and celestial elements, such as the moon. The imagery is not fully understood by scholars. In the upper left-hand corner, a symbolic depiction of the moon features a rabbit, a medicine vessel, and a branch of a katsura tree, possibly alluding to an ancient Chinese mystical belief that a rabbit in the moon prepares the potion of immortality.

Despite the fragmentary nature of the textile, four turtles with four Chinese characters on their shells can be spotted. Originally, there were 400 turtles and a total of 400 Chinese characters. The characters document who made the embroidery and why. One of the visible turtles bears the name of Empress Anahobe no Hashihito, celebrated as a deified founder-patron of Chugu-ji.

THE RELATIONSHIP BETWEEN BUDDHISM AND SHINTO

It is often suggested that Shinto and Buddhism coexisted over the centuries because they complemented each other. Shinto, in general terms, emphasizes issues relating to the earthly realm, such as the promotion of fertility and the harmony of the natural world, whereas Buddhism, although it addresses the suffering of existence, explores the concepts of salvation and transcending earthly existence after death. It is no coincidence that in Japan today, birth and marriage ceremonies are rooted in Shinto, while funerals and matters relating to the deceased are within the Buddhist domain. The balance, however, was not always equitable. Over the centuries to come, Buddhism incorporated important Shinto gods into the Buddhist pantheon as deities, and Shinto shrines were absorbed into Buddhist complexes. Conversely, the abundance of Buddhist images provided Shinto with an incentive for capturing its own deities in the visual arts.

CROSS-CULTURAL EXPLORATIONS

12.1 In ancient Korea and Japan, shamanism predated Buddhism and was an integral part of society. Compare the status and roles of shamanism in contemporary Korea and Japan. Select two images from both countries that express shamanistic beliefs.

12.2 How was Buddhism transmitted from India to Japan? What factors allowed Buddhism to take root in China, Korea, and Japan? What aspects of Buddhism do you find most relevant to your life and why? Select and discuss an image of the Buddha on display in either your local museum or a nearby Buddhist temple.

12.3 Compare and contrast three images of the historical Buddha. Select one example from India, one from China, and one from either Korea or Japan. Discuss these images within the context of their societies.

12.4 Discuss the accomplishments of three women in early Asian societies and their contributions to the arts. What barriers did they face? What do these three women have in common?

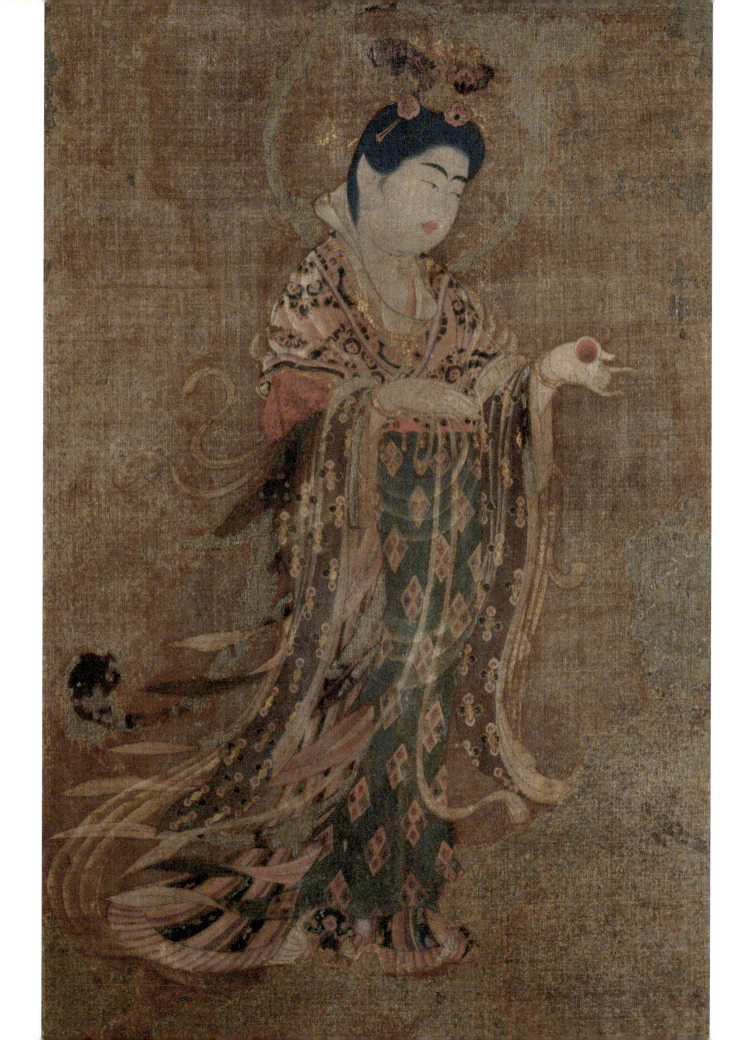

External Influences and Internal Explorations: The Nara and Heian Periods

The clouds,
the blue clouds
trailing on the northern mountain
tear away from the stars,
tear from the moon.

Empress Jito (645–702)

After the Asuka period, Japan continued to absorb Chinese philosophy, politics, and institutional systems. With the Taika Reforms of 645–646, Emperor Kotoku (r. 645–654) implemented land-use changes based on Confucian principles, which abolished private ownership of land. He also established a centralized government under the authority of the emperor. Coupled with this shift toward centralization of authority, Buddhism became increasingly important; the court used it to advance state interests, and the arts associated with it were infused with Chinese, Korean, and even Indian influences (**FIG. 13-1**). The Taika Reforms also championed the notion of a permanent imperial capital city. Prior to the Nara period (645–794), it was customary to move the capital after the emperor died, to avoid contamination associated with a place of death. In 710, the court relocated to Nara, which is often described as Japan's first permanent imperial capital, and the city after which the period is named.

13-1 • KICHIJOTEN
Nara period, 8th century. Color and gold on hemp, 20⅞ × 12½″ (52.9 × 32 cm). *Kondo*, Yakushi-ji, Nara.

NARA PERIOD

Modeled on China's Tang dynasty capital of Chang'an, Nara at its height was a bustling city with an estimated population of 200,000. Laid out in a grid pattern, the city was dominated by the Imperial Palace, which in accordance with Chinese geomantic principles occupied the heart of Nara's northern end (**FIG. 13-2**). Historical accounts describe a prosperous city filled with

13-2 • MAP OF NARA

1. Saidaiji	9. Rashomon
2. Toshodaiji	10. Shomu's grave
3. Yakushiji	11. Todaiji
4. Imperial Palace	12. Kasuga Shrine
5. Hokkeji	13. Shin Yakushiji
6. Kofukuji	14. Mt. Mikasa
7. Gangoji	15. Mt. Kasuga
8. Daianji	16. Mt. Takamado

mansions, temples, marketplaces, tree-lined boulevards, and canals. Nara's architecture borrowed heavily from Chinese sources; palaces featuring tiled roofs, crimson pillars, and slate floors would not have looked out of place in Tang China.

CHINESE INFLUENCES

It is easy to understand Japan's enthusiasm for Chinese culture at this time. During the Nara period, Tang dynasty China (618–907) became one of the world's most powerful empires, with over a million people inhabiting the cosmopolitan capital of Chang'an. Many of the city's inhabitants arrived from distant parts of Asia as Chinese armies marched across central Asia, opening up trade routes with access to foreign goods and ideas. Japanese merchants imported exotic wares from China, acquired via the Silk Road. Many of these foreign treasures, including musical instruments, jewelry, and textiles, originated in China, Central Asia, India, Greece, and Rome. The beautifully crafted instrument shown here—believed to have originated in China—is decorated with a man from Central Asia, seated on a camel and playing a *biwa* (lute). A tropical tree is also featured (**FIG. 13-3**).

Japanese envoys were dispatched to the Tang imperial court and Japanese Buddhist monks furthered their studies in Chang'an. In turn, the Nara court welcomed visitors from India, embraced Chinese fashions, and adopted Chinese written characters (Jap. **kanji**). The two great chronicles of Japan, the *Kojiki* (712) and *Nihon Shoki* (720), were written in the Chinese script. This eager emulation and assimilation of foreign influences permeated Nara culture, as is evident in city planning, architecture, sculpture, and painting. The statue of Yakushi Buddha, often identified as the Medicine Buddha (Skt. Bhaishajyaguru, Ch. Yaoshi), and the painting of Kichijoten (Skt. Lakshmi), the deity of wealth and good fortune, both preserved at Yakushi-ji temple, Nara, are two examples of this trend in Japanese art.

YAKUSHI-JI AND THE *YAKUSHI BUDDHA* Plagued by fires, wars, and natural disasters, the origins and timeline of Yakushi-ji are confusing. Emperor Temmu (r. 673–686) commissioned the temple in 680, hoping to cure his wife, Empress Jito (r. 690–697), of a serious eye disease. Ironically, Temmu died while Jito recovered and Yakushi-ji was completed around 698 under her direction. Today, the only structure remaining from the Nara period is the east **pagoda**.

A bronze sculpture of Yakushi Buddha is housed within the *kondo* (main hall) (**FIG. 13-4**). His lustrous form, darkened over time, is framed by a more recent gleaming gold halo, replicated from the original. Sitting serenely in the lotus position and attended by two **bodhisattvas**, *Yakushi Buddha* is believed to cure the sick and keep illness away. He reaches out with his left hand, which once held a medicine jar, to those who suffer from physical and mental afflictions. Numerous trans-continental influences shaped this statue. The *Yakushi Buddha*'s fleshy form can be traced back to Chinese Tang sources, in turn inspired by ancient Indian depictions of Buddha. The top horizontal band of his rectangular throne, evoking a medicine box, is decorated with undulating grape leaves, motifs that appear in Greek and Persian monuments. On each side of the throne, animals sacred to the Chinese—dragon, phoenix, tortoise, and tiger—mark the four directions as they stave off evil (see Chapter 7, Context, p. 148).

KICHIJOTEN In China, concepts of feminine beauty changed during the eighth century. A slender, willowy form was no longer the ideal; instead, a round, more voluptuous body was celebrated. This shift in taste infiltrated the visual arts. Buddhas and bodhisattvas from this time swell in size, and depictions of women reflect a preference for plump forms swathed in flowing robes. Japanese courtly tastes followed the latest Chinese aesthetic.

At Yakushi-ji, an image of Kichijoten, painted on hemp by an unknown artist, captures eighth-century notions of the feminine ideal (see **FIG. 13-1**). Derived from Lakshmi, the early Indian

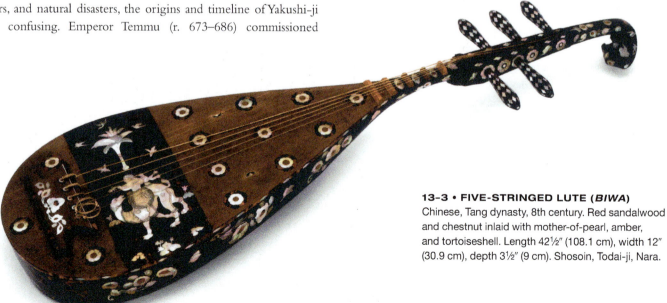

13-3 • FIVE-STRINGED LUTE (*BIWA*)
Chinese, Tang dynasty, 8th century. Red sandalwood and chestnut inlaid with mother-of-pearl, amber, and tortoiseshell. Length 42½" (108.1 cm), width 12" (30.9 cm), depth 3½" (9 cm). Shosoin, Todai-ji, Nara.

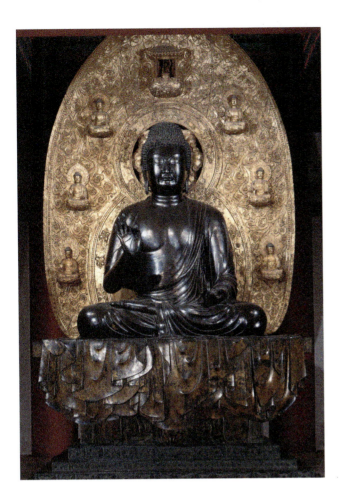

13-4 • YAKUSHI BUDDHA (MEDICINE BUDDHA)
Nara period, late 7th–early 8th century. Bronze, height 8′ 4″
(254 cm). *Kondo*, Yakushi-ji, Nara.

goddess of fortune who was absorbed into the Buddhist pantheon in India, Kichijoten became popular in Japan as a deity associated with the harvest, fertility, and good fortune. At first glance, *Kichijoten* appears to be a beautiful, stylish court lady rather than a religious icon. She glides forward wearing a richly patterned, Tang-style gown over her fashionably fleshy body, and an ornate headdress. Diaphanous scarves float behind her and gold jewelry accents her pale skin. With her round face, crescent-shaped eyebrows, long, narrow eyes, and **vermilion** (red) lips, she is the epitome of beauty during the Nara era, popularized in Chinese paintings of court beauties by Tang artist Zhou Fang (ca. 730–ca. 800; see Chapter 7, FIG. 7–22). Clues to her identity as Kichijoten lie in her halo, the "wish-granting jewel" in her left hand, and her right hand, which communicates the *mudra* of charity, characterized by an open palm facing downward. Unfortunately, more than half of Kichijoten's headdress in the Yakushi-ji painting

is missing; even sections of the hemp cloth disintegrated, to be later replaced. Originally, her headdress may have featured a Buddhist wheel and phoenix, symbolic of the empress in courtly traditions. Such details decorate Kichijoten's crown in some later images of the deity.

BUDDHISM UNDER EMPEROR SHOMU AND EMPRESS KOMYO

Buddhism's influence intensified during the reign of Emperor Shomu (701–756; r. 724–749) and his queen-consort, Empress Komyo (701–760). Emperor Shomu continued the practice of fusing Buddhist doctrine with government policies, and actively promoted Buddhism as protector of the state. In 741, following Empress Komyo's wishes, he ordered temples, monasteries, and convents to be built in Japan's 66 provinces. Emperor Shomu also commissioned the Great Eastern temple at Nara, Todai-ji. There were many political advantages to be gained from establishing a national system of religious institutions. As provincial temples came under the jurisdiction of the central imperial temple, Todai-ji, government policies could be effectively disseminated throughout the provinces.

TODAI-JI Todai-ji, first constructed in 752, was designed to impress, literally from the ground up—a large tract of sloping land was leveled to accommodate the temple complex. Although most of the original buildings have disappeared, the Great Buddha Hall (Daibutsuden) (FIG. 13-5), with its **hipped** roof and wide, overhanging eaves, has clung tenaciously to the style of its original

13-5 • THE GREAT BUDDHA HALL (DAIBUTSUDEN)
Todai-ji, Nara. Original structure completed during the Nara period in 752. Destroyed in 1180. Current building completed in 1707; extensively restored 1906–1913.

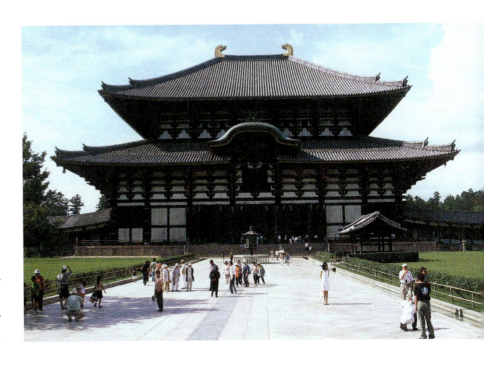

buidling. Unfortunately, the original Daibutsuden was destroyed by fire in 1180, and its current incarnation dates from the early eighteenth century. Todai-ji is still ranked as one of the largest wooden buildings in the world, and, astonishingly, the current structure is only two-thirds the size of the original eighth-century temple, which measured 285 feet (87 meters) in length and 154 feet (47 meters) in height. Despite its diminished size, Todai-ji still dwarfs the visitor and overwhelms the believer and nonbeliever alike with its monstrous beauty. Gleaming *shibi*—crescent-shaped roof ornaments covered in gold leaf—catch the eye even on an overcast day. *Shibi*, inspired by a mythical sea creature, are believed to protect the building from fire.

Todai-ji represents the celebratory, public face of Nara Buddhism. Members of the nobility and influential laity gathered inside its porches to listen to monks performing arcane rituals and to gaze up at the gigantic bronze Buddha housed

within (**FIG. 13-6**). Buddha's left hand, lying open in his lap, performs the gesture of welcome (Skt. *varada mudra*), while his right hand with palm facing outwards expresses the wish to end suffering (Skt. *abhaya mudra*).

Commissioned by Emperor Shomu in 743, the 53-foot (16-meter)-high gilded bronze statue of the Buddha Roshana (Skt. Buddha Vairochana), viewed as the generative force of the cosmos, was inspired by enormous statues of Buddha created in China (see Chapter 7, FIG. 7-24). Unfortunately, the monumental sculpture was ravaged by fire. All that remains of the original statue are a few patches of drapery and the odd lotus petal. The current Buddha filling the Daibutsuden is a reconstruction from the seventeenth century. Even the original temple likely had difficulty accommodating its giant tenant. Today, as the writer Arthur Drexler eloquently observed, "the statue seems to be wearing its building like a tight-fitting overcoat, leaving only

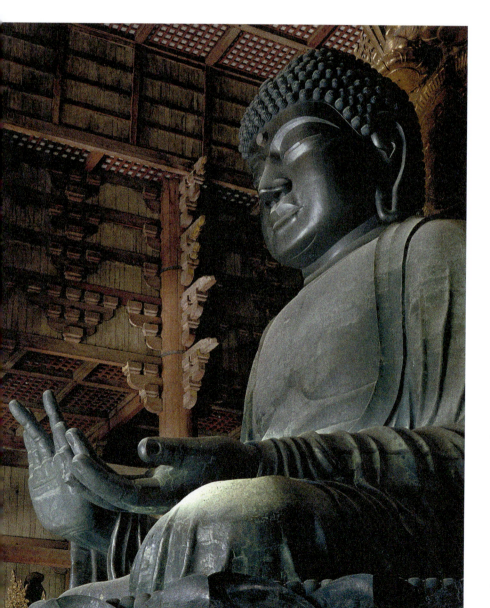

13-6 • BUDDHA ROSHANA
Nara period, 8th century, reconstructed 17th century. Bronze, height 53′ (16 m). Daibutsuden, Todai-ji, Nara.

13-7 • BUDDHIST MONKS CLEANING THE BUDDHA ROSHANA
Todai-ji, Nara.

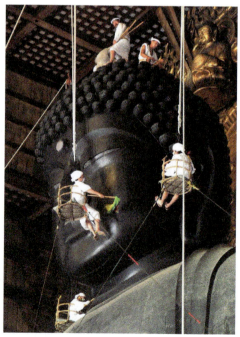

cramped folds of space in which visitors struggle for a distorted view of the blackened, imperfect colossus."

The creation of *Buddha Roshana* from his lotus-petal throne to his snail-shell curls was a difficult undertaking. Large amounts of metal were accumulated for the task and a team of skilled metalworkers and carpenters assembled. An expert of Korean descent, Kuninaka no Muraji Kimimaro, directed the project. Conscripted peasants performed most of the general labor. Emperor Shomu's intentions were both politically motivated and altruistic: He wanted to bring unity, spiritual comfort, and wealth to his people. Ironically, the construction of Todai-ji and the Buddha caused economic problems and was not the panacea that Shomu hoped for. An entry dated 757 of the court record *Shoku Nihon-gi* reported that "the people are made to suffer by the construction of Todai-ji, and the clans worry over their sufferings." Undeterred, the emperor demanded completion of Todai-ji and its enormous statue. The statue is still maintained today, with an annual cleaning rite that takes place on August 7 (**FIG. 13-7**).

No expense was spared at the *Buddha Roshana*'s dedication ceremony in the spring of 752. Multicolored banners decorated the Daibutsuden and arrangements of flowers and strewn petals added color and scent to the occasion. Court and government officials, thousands of monks, and important visitors from China and India attended the event. Bodhisena, an Indian monk, performed the eye-opening ceremony, during which the Buddha statue's pupils were painted in, symbolically imbuing it with life. Traditional music, singing, and dancing followed the eye-opening ceremony. The entire event was presided over by Empress Koken (r. 749–758), the daughter of Emperor Shomu and Empress Komyo; they had abdicated in favor of their daughter, but were also in attendance.

EMPRESS KOMYO Empress Komyo's full name, Komyoshi, means "luminous brightness." In her role as empress she was instrumental in setting up provincial temples (*kokubun-ji*) and convents (*kokubunni-ji*) modeled on the Chinese system, and establishing centers for the poor and infirm. A section in the *Shoku Nihon-gi* discusses the empress's achievements, including her part in the creation of Todai-ji.

> The building of Todai-ji temple and the establishment of official state temples throughout the land were initiated by the empress. She also founded both the Hiden'in to feed the starving and the Seyaku'in to care for the sick.

As a devout Buddhist, Komyo spread the faith by sponsoring **sutra** copying. Considered a form of worship and an act of faith,

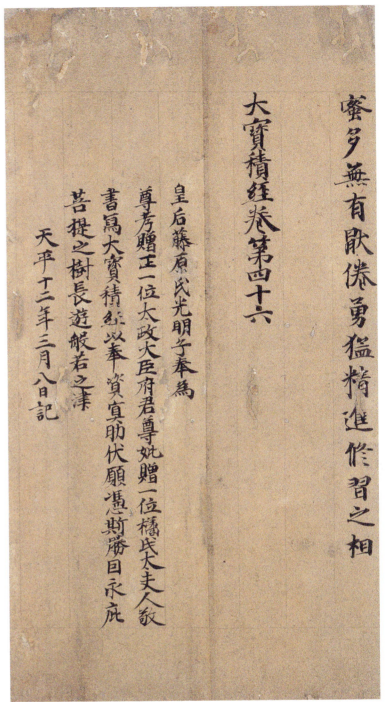

13-8 • Attributed to Empress Komyo **IZUMO EDITION OF *DAIHOSHAKKYO SUTRA* (DETAIL)**
Nara period. Ink on paper, 10½ × 5¾" (27 × 14.6 cm). Kyoto National Museum.

copying Buddhist texts was also an effective way to master the Chinese script (**FIG. 13-8**). Sutras were imbued with spiritual powers, and, on occasion, individual words were cut out of texts and made into amulets. For example, a person suffering from an eye disorder might wear an amulet for "eye." Sutra copying continues to be an important Buddhist practice today, as a method of honoring Buddha and Buddhist teachings and accruing merit for oneself or others.

Komyo commissioned various additions to temples such as Kofuku-ji, and converted sections of her palace into the convent-temple Hokke-ji, which became the administrative headquarters for provincial convents. An important wooden statue at Hokke-ji with mystical ties to the empress is *Juichimen Kannon* (*Eleven-headed Avalokiteshvara*) (**FIG. 13-9**). Radiating lotus plants, this deity is a manifestation of Kannon, the Bodhisattva of Compassion, and the 11 heads carved on his crown symbolize 11 virtues used to defeat 11 desires blocking the path to Awakening. His elongated arms, one of which holds a lotus in a vase, are evidence of the bodhisattva's superhuman powers.

13-9 • *JUICHIMEN KANNON (ELEVEN-HEADED AVALOKITESHVARA)*
Late Nara/early Heian period, late 8th–early 9th century. Painted wood, height 3'3⁹⁄₁₀" (1 m). Hokke-ji, Nara.

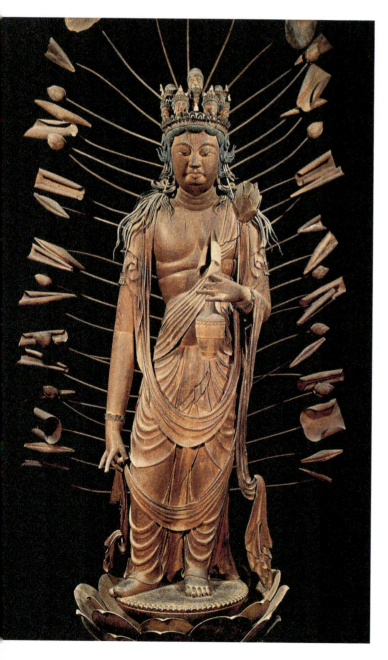

Stories of Komyo's charitable activities have entered legend. One account describes how she built a bathhouse at Hokke-ji, where she personally cleansed a leper covered in stench-filled boils (actually a divine being in disguise). Over the centuries Empress Komyo was deified as a compassionate bodhisattva and, according to popular narratives, Hokke-ji's *Juichimen Kannon* is a reflection of her image and radiant spirit.

When Emperor Shomu died in 756, Empress Komyo donated hundreds of his possessions to Todai-ji, in memory of her husband. An eclectic array of objects, including weapons, paintings, medicines, ceramics, furniture, musical instruments, jewelry, Buddhist ritual implements, and textiles, many of them originating in Korea, China, and beyond, were stored in Todai-ji's wooden treasure house, the Shosoin. This collection offers the modern viewer a fragmentary glimpse of an historic era shaped by a heady mix of internationalism, opulence, strife, and religiosity.

CORRUPT CLERGY AND REFORMS UNDER PRIEST GANJIN Monastic life requires self-discipline and self-sacrifice; however, some Buddhist clergy did not follow the required code of conduct. From time to time, unruly monks and nuns were charged with drunkenness, sexual misconduct, and acts of violence. Reforms were implemented and searches made for spiritual leaders to prevent such behavior. One such spiritual mentor was the Chinese

13-10 • *PRIEST GANJIN*
Nara period, 8th century. Dry lacquer, painted, height 32¹⁄₁₀" (81.7 cm). Toshodai-ji, Nara.

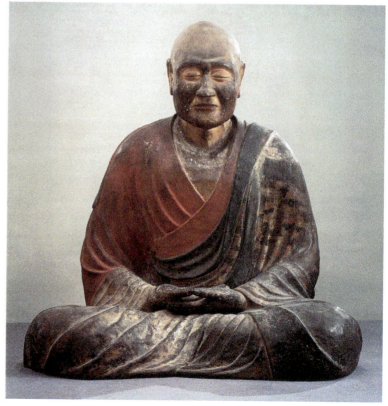

monk Jianzhen, known in Japan as Ganjin (688–763). The Japanese court invited Ganjin to Japan to uphold monastic principles and establish authentic ordination practices.

When Ganjin arrived in Nara in 754, he was 66 years old and blind from an infection that he caught during his perilous journey from China, which included shipwrecks and several failed attempts to reach Japan. Unfazed, Ganjin presided over Todai-ji and is credited with instituting the correct ordination of Buddhist clergy. Ganjin also founded Toshodai-ji at Nara, and a hollow dry-lacquer statue of the priest, created around the time of his death, is still housed in this temple (**FIG. 13-10**). Astonishingly lifelike, Ganjin's portrait captures the blind monk meditating in flowing, colored robes, his cross-legged pose defying the creeping infirmities of old age. Ganjin's indomitable will is communicated through his tightly closed lips and erect posture. The realism evident in this statue is owed partly to the artist's expert manipulation of the hollow dry-lacquer method (*dakkatsu kanshitsu*). This technique was exported to Japan from China and became popular during the Nara period. To create Ganjin's statue, the artist applied layers of **lacquer**-soaked hemp cloth over a clay core. After the lacquer hardened, the clay core was removed to leave a hollow, durable, lightweight statue. Surface details were fashioned from a mix of ingredients, such as lacquer, wood powder, and flour. Paint was added to provide a vibrant finishing touch. Notice how Ganjin's red robe, dark eyebrows, and facial stubble animate the portrait. A description of Ganjin's death in the *Shoku Nihon-gi* suggests the monk faced death with the same discipline he applied to life: "Up to that time he was sitting erect, and then he passed away quietly and calmly."

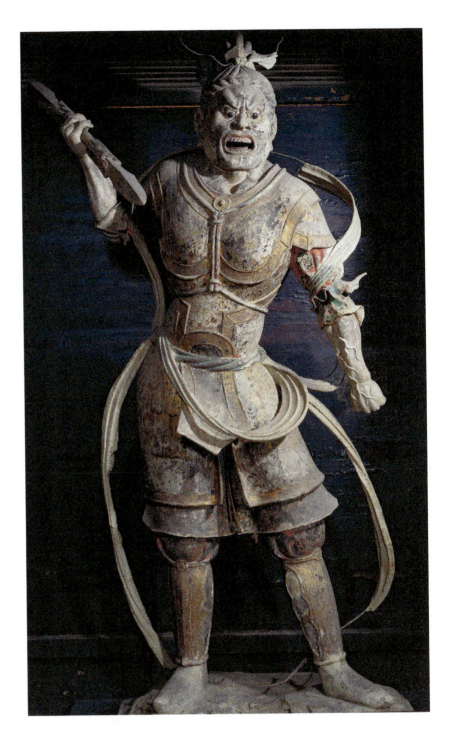

13-11 • SHUKONGO-JIN
Nara period, 8th century. Clay with polychromy and gold leaf, height 5'8⅝" (1.739 m). Hokke-do, Todai-ji, Nara.

BUDDHIST GUARDIAN DEITIES Buddhism, over time, accumulated a kaleidoscopic cast of Buddhas, bodhisattvas, and guardian deities. The latter, ever vigilant, protect the Buddha and his Law from evil forces. An especially ferocious guardian figure within the Buddhist pantheon is Shukongo-jin, who terrifies Buddha's enemies with his wrathful appearance. A well-preserved, life-size, polychrome clay image of Shukongo-jin is housed at Hokke-do, one of the many smaller buildings that occupy Todai-ji's sacred precinct (**FIG. 13-11**). Howling with rage, Shukongo-jin—destroyer of the faithless, comforter of the faithful—glares down at unseen opponents. Scarves swirl around his body as he stabs at the air with his weapon and tightens his fist. His horrific appearance, complete with bulging veins, contrasts oddly with his elegant battle dress. Paintings of lotus flowers can still be seen on his left arm against a background of red, green, and gold leaf.

NARA COURT: LATER YEARS

EMPRESS KOKEN-SHOTOKU Empress daughter of Emperor Shomu and Empress Komyo, Koken-Shotoku (718–770) served as the last female ruler of early Japan. This fascinating woman, who

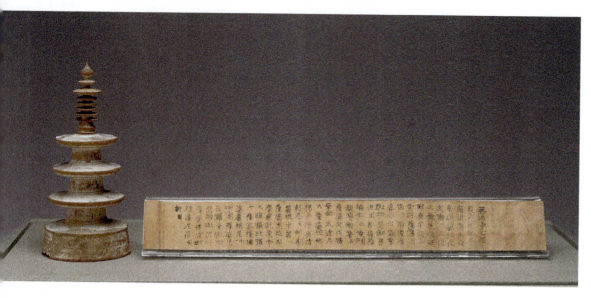

13-12 • ONE OF THE "ONE MILLION PAGODAS" (HYAKUMANTO) AND PRINTED BUDDHIST TEXTS (DHARANI)
Nara period, ca. 770. Wood covered with lead white covering; printed paper charm: ink on paper, height 8⅗″ (22 cm). Middlebury College Museum of Art, Middlebury, Vermont. Purchased with funds provided by the Christian A. Johnson Memorial Fund and the Barbara P. and Robert P. '64 Youngman Acquisition Fund for Asian Art, 2004.025.

reigned twice—first as Empress Koken (749–758) and then as Empress Shotoku (764–770)—is the subject of scholarly debate and speculation, much of it negative. Historians, especially before World War II, often portrayed her as a weak woman who endangered the dynasty by relinquishing control to the controversial Buddhist monk Dokyo. The empress's close relationship with the handsome monk fueled gossipy rumors that the two were romantically involved, all the more scandalous since she had shaved her head and taken the vows of a nun. Recent scholars have revised this tarnished image of the empress by focusing on her accomplishments and the strength of her imperial edicts.

Empress Shotoku, with Dokyo's assistance, embarked on an ambitious building program. She ordered the construction of a Buddhist temple within the **Shinto** shrine complex at Ise and established the Great Western temple, Saidai-ji, at Nara.

Another significant, though less visible, project commissioned by Empress Shotoku was the printing of one million (*hyakuman*) tiny prayer scrolls (*dharani*) encased in miniature wooden pagodas (**FIG. 13-12**). Dating from around 770, the paper scrolls, featuring Buddhist texts printed from either metal plates or **woodblocks**, are among the earliest extant examples of printed works in the world. Sealed inside the pagodas' dark cavities, the scrolls' unread prayers cleanse sins and bestow peace, prosperity, and spiritual protection on the realm of a Buddhist ruler. Copying sutras by hand accrues religious merit. All that merit swells exponentially when you mass-produce a million texts to be housed in spiritual receptacles. Ten important temples in and around Nara reportedly received 100,000 of these prayer charms. Even today, hundreds still exist. Horyu-ji near Nara houses a sizable collection. Empress Shotoku's *hyakumanto dharani* project can be seen as an act of pious devotion, atonement, or shrewd political gesture—perhaps all three. When one is surrounded by strife and disgruntled rivals, it cannot hurt to declare one's importance as a Buddhist monarch, protector of the realm a million times.

Despite the empress's concentrated efforts to secure peace and prosperity for all, her hold on power was tenuous. Simmering hostilities were inflamed in 769 when an oracle at the Usa Shrine issued a divine proclamation naming Dokyo as the next emperor. It is unclear whether Dokyo was the victim of an elaborate scheme to discredit him or the perpetrator of a plot that backfired. Resentful factions took offense at Dokyo's involvement in affairs of state, and with the death of Empress Shotoku in 770 the audacious priest was demoted and banished.

WANING STATUS OF WOMEN Suiko, Jito, Komyo, Shotoku—the impressive roll call of empresses falls silent after Empress Shotoku's reign. Centuries passed before the next female ruler, Empress Meisho, ascended the throne in the seventeenth century. Women's exclusion from imperial succession in the late Nara period reflected the growing appreciation of the Chinese classics and adoption of Chinese legal and political systems that favored patriarchy and patrilineality. Confucian philosophy taught that it was against the "natural order" for a woman to be monarch, as women were subordinate to men. Empress Koken-Shotoku's idiosyncratic performance as ruler further convinced the court that a woman was unfit for government. Female sovereigns were not the only casualties of Chinese ideals regarding gender hierarchy. Royal consorts, female officials, and women clerics also experienced a decline in authority and status. Women's subordination at court and within religious circles inevitably stifled their ability to sponsor and influence cultural and religious projects on the scale that their forebears had done.

CHANGES IN IMPERIAL CAPITAL As Buddhism teaches, permanence is an illusion. Nara's era as the "permanent capital" ended in 784 when Emperor Kammu (r. 781–806) moved the imperial capital to Nagaoka, and then in 794 to Heian-kyo, "capital of peace and tranquility." Kammu's move to Heian-kyo, known today as Kyoto, marked a shift in imperial line and was likely spurred by

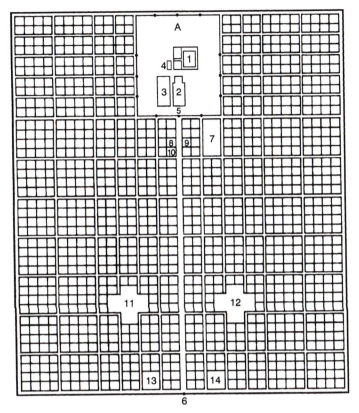

13-13 • LAYOUT OF HEIAN-KYO (KYOTO)
Heian period.

A. Daidairi (Greater Imperial
 Palace)
1. Dairi (Imperial Residence)
2. Chodoin
3. Barakuin
4. Shingonin
5. Suzakumon
6. Rashomon
7. Shinsenen
8. Ukyo-tsukasa (office of
 the right side of the capital)
9. Sakyo-tsukasa (office of
 the left side of the capital)
10. Nishi Shunjodono
11. Western Market
12. Eastern Market
13. Saiji (Western Temple)
14. Kyoogokokuji (Toji, Eastern
 Temple)

imperial concern over the growing interference of Buddhist clergy in political matters. Heian-kyo also offered the strategic advantage of river access to the sea. Kyoto was to remain the imperial capital for the next 1,000 years.

HEIAN PERIOD

Art is what reveals to us the state of perfection.
Kukai (Buddhist monk)

Similar to Nara, Kyoto's original layout was based on the grid plan of Chang'an, China's old Tang capital. The emperor's palace was located in the northern section of the city and the elegant residences (*shinden*) of the aristocracy, complete with gardens and water features, occupied the eastern sector (**FIG. 13–13**). As China's Tang dynasty disintegrated, weakened by religious strife and civil

unrest, Japan's imperial government officially terminated relations with China in 894. Japan then experienced a period of relative isolation, and after centuries of absorbing influences from China and Korea, Japan during the Heian period (794–1185) gazed inward to fashion a unique cultural identity. Japanese art and literature flowered, buoyed by an era of moderately stable political conditions that lasted for more than 300 years.

Between the tenth and twelfth centuries, the Fujiwara family dominated the political landscape. This powerful, aristocratic clan monopolized senior government positions, occupied prime lands, and created tax-exempt estates. The Fujiwara attained power in part through matrimonial alliances. Fujiwara daughters were married into the imperial family, and a succession of male Fujiwara relatives assumed political control as imperial regents. Drained of political power, the emperor's role was reduced to that of ceremonial figurehead presiding over court rituals. In addition to dictating matters of state, the Fujiwara also became great patrons of the arts. A sophisticated secular court culture evolved while Buddhism and religious art continued to flourish under the umbrella of two major Buddhist schools, Esoteric Buddhism and Pure Land Buddhism.

ESOTERIC BUDDHISM, THE ARTS, AND SOCIETY

Esoteric Buddhism (*Mikkyo*—secret teachings) is, as its name suggests, a mysterious, complex form of Buddhism with roots that stretch back to ancient Indian and Chinese sources. Esoteric Buddhism emphasizes the mystical abilities of priests who conduct arcane rituals, perform *mudras*, recite mantras, and meditate on **mandalas** (pictorial representations of the cosmos) to ensure the spiritual and material well-being of the laity. Esoteric Buddhist practices often took place in remote mountain temples, far from the distractions of city life. Teachers secretly transmitted Esoteric Buddhist doctrines to disciples.

During the early Heian period, two reform-minded monks—Saicho (767–822) and Kukai (774–835)—introduced two Buddhist sects, Tendai and Shingon, into Japan from China. Rejecting the worldly concerns that plagued Nara temples, Saicho and Kukai traveled to China, where they learned the secrets of Esoteric Buddhism from Chinese masters. On their return and equipped with sacred texts and religious artworks, Saicho established the Tendai headquarters at Enryaku-ji temple on Mount Hiei, northeast of Kyoto, and Kukai founded the Shingon monastic complex on Mount Koya, near Osaka. Mount Koya remains an important center of Shingon scholarship and practice today, although the original Heian-era structures have not survived. Esoteric Buddhism's early focus on spiritual rather than temporal matters appealed to the Heian court, and Esoteric Buddhist temples received court patronage as centers of prayer for the nation's welfare.

In both Tendai and Shingon, the historical Buddha Shakyamuni ceases to be of supreme importance. Instead,

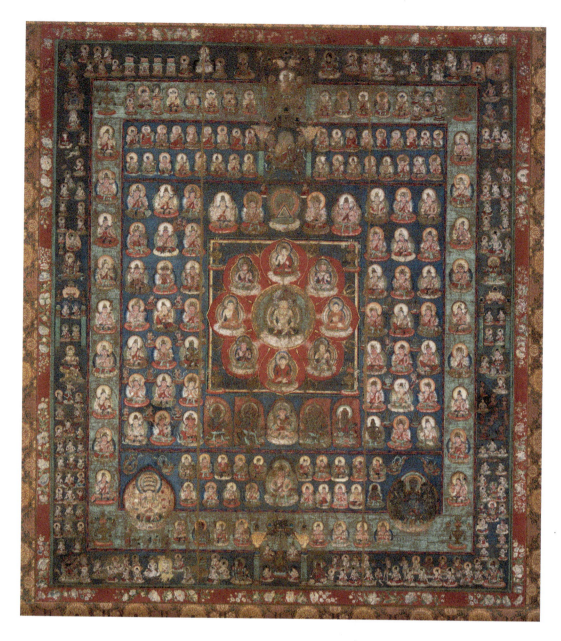

13–14A • WOMB WORLD MANDALA (TAIZOKAI) OF THE RYOKAI MANDALA
Heian period, late 9th century. Hanging scroll, color on silk, 6′ × 5′1½″ (1.83 × 1.54 m). To-ji, Kyoto.

13–14B • DETAIL OF THE WOMB WORLD MANDALA (TAIZOKAI) OF THE RYOKAI MANDALA

Esoteric Buddhists revere Buddha Vairochana (Jap. Buddha Roshana) as the source of all existence and the cosmic entity who governs the universe. Vairochana is the Universal Buddha; the historical Buddha Shakyamuni is the form he manifested on earth. According to Esoteric Buddhist doctrine, Buddha Vairochana is accompanied by a vast pantheon of Buddhas, bodhisattvas, and guardian deities, all of whom are considered manifestations of Vairochana. Keeping track of this spiritual cast of thousands and their various interconnecting relationships is a daunting task. Artworks such as the mandala were created to map the hierarchical nature of Buddha Vairochana's intricate universe and to provide a focus for teaching and meditation.

One of the oldest extant painted mandalas in Japan is the *Ryokai Mandala* belonging to Kyoto's To-ji temple of the Shingon sect (**FIGS. 13–14A**, **13–14B**, **FIGS. 13–15A**, and **13–15B**). Dating from the late ninth century, the *Ryokai Mandala* consists of a pair of hanging mandalas painted with mineral

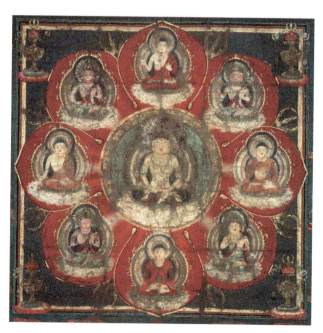

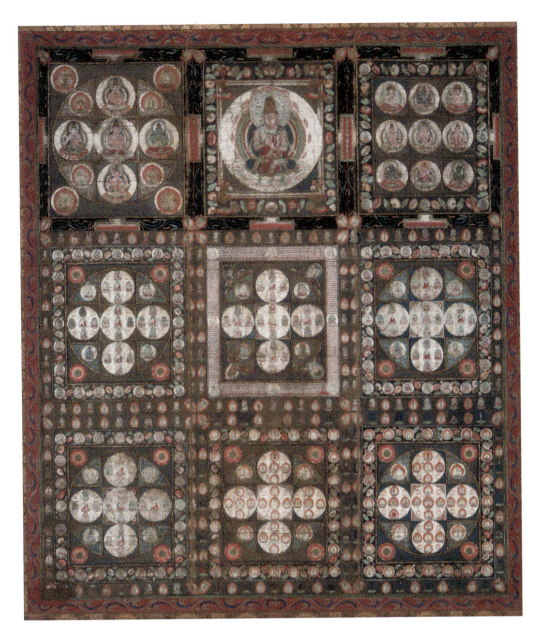

13–15A • DIAMOND WORLD MANDALA (KONGOKAI) OF THE RYOKAI MANDALA
Heian period, late 9th century. Hanging scroll, color on silk, 6′ × 5′1½″ (1.83 × 1.54 m). To-ji, Kyoto.

13–15B • DETAIL OF THE DIAMOND WORLD MANDALA (KONGOKAI) OF THE RYOKAI MANDALA

colors on silk. The two mandalas are known as the *Womb World Mandala (Taizokai)* and the *Diamond World Mandala (Kongokai)*. Traditionally, the paired mandalas are hung on either side of the altar or displayed flat in special ritual halls and used in various Esoteric Buddhist practices, such as initiation rites. In one initiation ritual, the devotee throws a flower onto the mandala to determine which buddha or bodhisattva will become their personal deity and focus of devotion.

In both the *Womb World* and *Diamond World Mandalas*, Buddha Roshana occupies a central position (**FIGS. 13–15A, 13–15B**). His multiple manifestations in the form of Buddhas, bodhisattvas, and deities cluster around his seated form in groups referred to as courts. In each court individual figures function both as separate icons and as embodiments of Buddha Roshana's authority. When studied separately, the *Womb World Mandala* symbolizes the physical world and the *Diamond World Mandala* signifies the spiritual realm. Esoteric Buddhist doctrine stresses

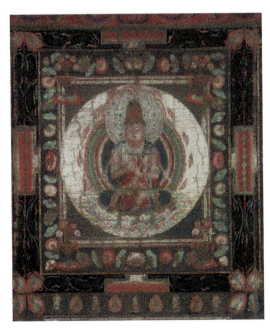

the unity of the Buddhist cosmos, and for a person to achieve enlightenment in this life, matter and spirit must be united. Therefore, the two panels comprising the *Ryokai Mandala* are visual evocations of the Esoteric Buddhist ideal.

Shingon acolytes in their quest for enlightenment contemplated the *Ryokai Mandala* and performed mysterious rituals guided by the mandala's rich iconography and philosophical tenets. Sustained contemplation of the *Ryokai Mandala* is a challenging exercise. The dizzying array of figures (1,875 in total!)

13-16 • RED FUDO (FUDO MYOO) AND ATTENDANTS
Heian period, 9th century. Color on silk, 65 × 37¾" (165 × 95.8 cm).
Myo-o-in, Mount Koya, Wakayama prefecture.

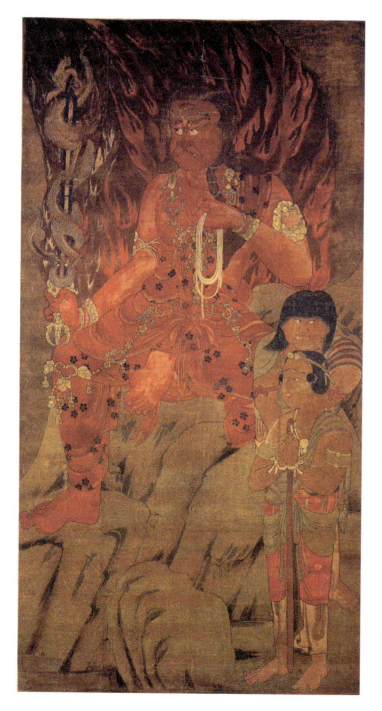

painted in blues, greens, and reds each radiate energy from within their assigned courts. Hands are constantly in motion as different *mudras* are struck, and heads tilted at various angles display a range of facial expressions. A set of wrathful deities, Godai Myoo (guardians of the Buddhist Law), encircled with flames, such as those inhabiting the Court of Wisdom located immediately beneath the central square in the *Womb Mandala*, grimace and twitch as they frighten the nonbeliever and destroy illusions (see FIG. 13-14A).

An important function of Esoteric Buddhist art was to teach and admonish, not to delight. Fierce-looking Godai Myoo—especially Fudo Myoo, the King of Light—frequently appear in Esoteric Buddhist paintings and sculptures as manifestations of the wrathful aspect of Buddha Roshana (FIG. 13-16). Popular Shingon deity Fudo Myoo may look ferocious in this painting, with his bulging eyes, fangs, and weapons, but as a fully enlightened being he brings light and wisdom into the world. His anger is aimed at the wicked. With his dragon sword of wisdom and coils of rope he defeats evil. As the "Immovable One," Fudo sits on bare rocks against a fiery background. Flames signifying wisdom burn up hindrances and evils. His red, fleshy body

13-17 • NYOIRIN KANNON
Heian period, ca. 840. Painted wood, height 3'6¾" (1.088 m).
Kanshin-ji, Osaka.

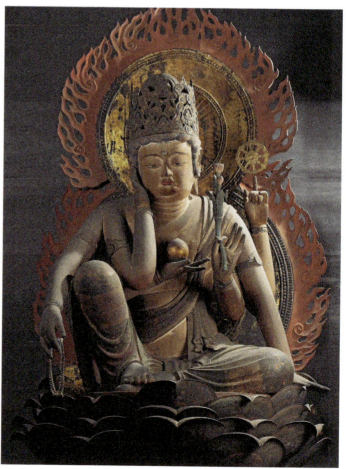

contrasts with the pale forms of his attendants. According to legend, Fudo's red appearance originated with the deity materializing before priest Chisho Daishi during meditation. In order to capture this fleeting image, Daishi sketched Fudo in blood extracted from rubbing his forehead on the ground. Devotional practices associated with Fudo are demanding. Devotees stand under cascading waterfalls to cleanse the body and spirit and then perform rites focused on a blazing altar fire.

Another deity associated with Shingon worship is Nyoirin Kannon (Skt. Avalokiteshvara), the multilimbed bodhisattva who grants wishes (**FIG. 13-17**). Wearing a crown, this feminine-looking *Nyoirin Kannon* sits regally in the position of royal ease, with his right leg bent and the soles of his feet pressed together. His six arms hold various attributes such as the wish-granting jewel, the lotus flower, and the wheel of Buddha's Law. One of his right hands rests on his cheek, symbolizing the state of contemplation. *Nyoirin Kannon* was carved out of a single block of wood, although his arms were created separately and then attached. His plump face, with clearly defined rolls of flesh and heavy proportions, is characteristic of the early Heian aesthetic.

13-18 • *KONDO* (MAIN HALL)
Muro-ji, Nara prefecture. Early Heian period, 9th century; modified in the early 13th century.

Images of Fudo Myoo and Nyoirin Kannon have survived the centuries, but the works are left unsigned, their creators unknown. Most likely the artists were monks affiliated with the various temples, their knowledge of the myriad deities deepened by years of study.

Esoteric Buddhist sects established their temples in secluded mountain settings resulting in the reassertion of native traditions in architecture. The symmetrical temple plan adopted from China gave way to an asymmetrical layout of buildings that fitted naturally into the rugged landscape. Small-scale, austere-looking buildings—for example, the *kondo* (main hall) at Muro-ji, a mountain temple associated with the Shingon sect—were constructed with wooden plank floors instead of stone, and cypress-bark shingle roofs instead of tiles (**FIG. 13-18**). Nestled among cypress trees, the wooden *kondo*, with its bark shingle roof, blends into its mountainous location.

Saicho, the leader of the Tendai sect, advocated the policy of seclusion, and women, seen as sexual temptations to the sequestered monks, were banned from Mount Hiei. This practice of prohibiting women from Buddhist sites gained momentum during the early Heian era, and by the end of the period many important monasteries were closed to women. The lives of Buddhist nuns were naturally affected by these developments. Lacking imperial or state support many nunneries

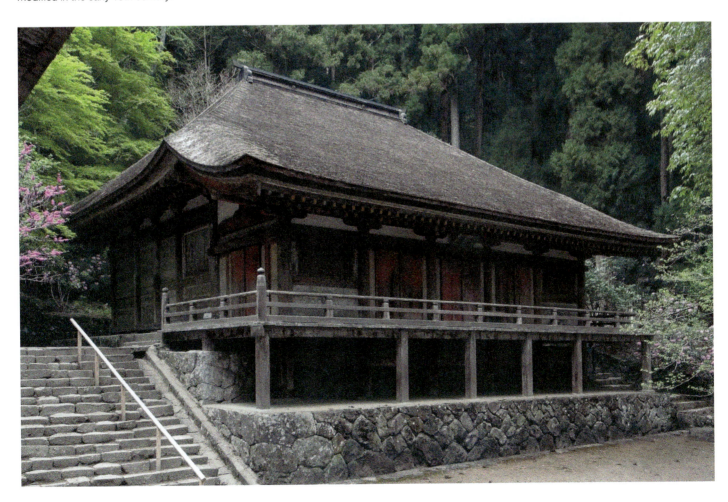

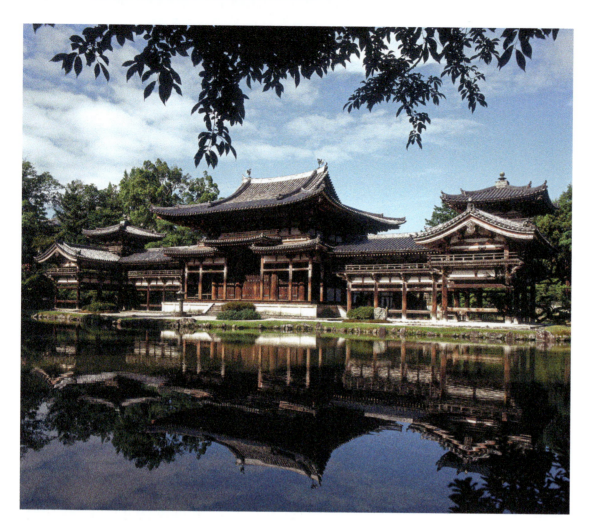

were abandoned or converted into temples for monks. Esoteric
Buddhism, with its complex doctrines, arcane rituals, and
hierarchical organization of gods, appealed primarily to the aris-
tocracy and not the masses. Indeed, Esoteric Buddhism thrived
under the patronage of the imperial family and Heian elite.

PURE LAND BUDDHISM, THE ARTS, AND SOCIETY

According to Buddhist doctrine, *Mappo* was the period when
Buddha's once flourishing Law would decline and disappear, to be
replaced by widespread corruption, conflict, and vice. The age of
Mappo was predicted to commence in 1052, plunging the world
into chaos. In the years leading up to 1052, a sense of unease set-
tled over the Heian court. The Heian nobility could already point
to signs of disorder, with a growing military class threatening their
privileged existence. Hope was at hand, however, in the form of
Pure Land Buddhism.

Pure Land Buddhism focused on Amida Buddha (Buddha
of the Western Paradise) and offered salvation not in this world
but after death. Again with ancient Indian roots but developed
in China, Pure Land Buddhism became an official Japanese sect
(Jodo) under the leadership of the monk Honen (1133–1212).
Pure Land Buddhism dispensed with the complexity of Esoteric

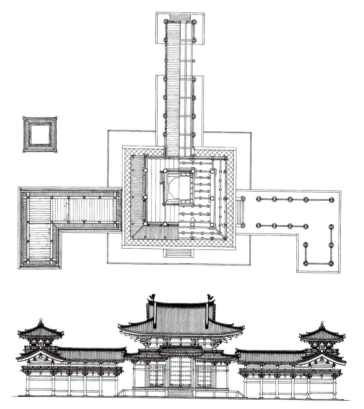

13-20 • PLAN AND ELEVATION OF THE PHOENIX HALL.

Buddhism and the struggle to attain enlightenment in a world earmarked for misery, and offered a simpler approach, sometimes described as the "easy route" to salvation. The only prerequisite for salvation was faith in Amida Buddha (Skt. Amitabha) and the diligence to recite his name. Recitation of the mantra *Namu Amida Butsu* ("Praise to Amida Buddha") would lead to rebirth in Amida Buddha's Western Paradise, a peaceful realm featuring glittering palaces and ponds. From his Paradise, people could comfortably work toward enlightenment without the burden of earthly troubles. Pure Land Buddhism taught that at the time of a believer's death, Amida Buddha himself, accompanied by celestial beings, would descend from the heavens to escort the departing soul into Paradise. This event would also include flowers raining down from the sky, fragrant incense, and enchanting music, all very appealing to the refined aesthetic tastes of the aristocracy. Alternatively, sinners faced various hellish tortures and eventual rebirth lower down on the chain of existence. Pure Land Buddhism, with its powerful message of salvation for all, spread quickly throughout Japan to reach all levels of society. Traveling monks, such as Honen, were instrumental in disseminating the faith to the masses. Even today, Pure Land Buddhism retains its popularity within Buddhist traditions of modern Japan. The arts flourished in support of Pure Land teachings. In particular, the Heian elite constructed temples and commissioned statuary in honor of Amida Buddha.

BYODO-IN Not far from Kyoto on the banks of the Uji River stands Byodo-in, an elegant temple whose airy structure overlooking a lotus-filled pond conjures up an earthly vision of Amida Buddha's Western Paradise (FIG. 13-19). Byodo-in was originally built by a famous statesman of the Heian period, Fujiwara no Michinaga, as a country home. This rural residence offered a respite from the turbulence of city life and stifling summer heat. After many years as a country retreat, the estate was transformed by Michinaga's son, Fujiwara no Yorimichi, into a Buddhist temple in 1052, the first year of *Mappo*. Following a long political career as regent to a series of emperors, Yorimichi spent his retirement years at Byodo-in and died there, aged 82.

The main building of Byodo-in, called the Phoenix Hall, was constructed on a small island in the center of an artificial pond shaped like a Sanskrit "A" for Amida Buddha. A statue of Amida Buddha is housed in the central hall (FIG. 13-20). Facing east over the pond, the Phoenix Hall, with its stone base, red wooden pillars, upturned eaves, and tiled roofs, is only one story in height, despite its layered appearance. On either side of the main hall, covered walkways on stilts branch out to turreted structures, which in turn sweep out at right angles toward the water. Viewed from the air, the building's unusual plan

resembles a bird with outstretched wings preparing to land. The bird theme continues with a pair of gilt-bronze phoenixes gracing the ridgepole. Phoenixes were traditionally believed to alight on well-governed lands. They were also associated with imperial authority, and in particular the empress. Positioned overlooking the pond, the Phoenix Hall's structure, porous in appearance with its slender columns and raised walkways, dissolves in its watery reflection; it is a perfect place to contemplate the pleasures of Amida Buddha's Western Paradise. When the doors of the Phoenix Hall are open, a gilt wooden statue of Amida Buddha carved by the renowned artist Jocho (d. 1057) is visible from across the pond (FIG. 13-21).

Close up, the seated deity—over 9 feet (2.75 meters) in height—appears powerful yet approachable, a demeanor well

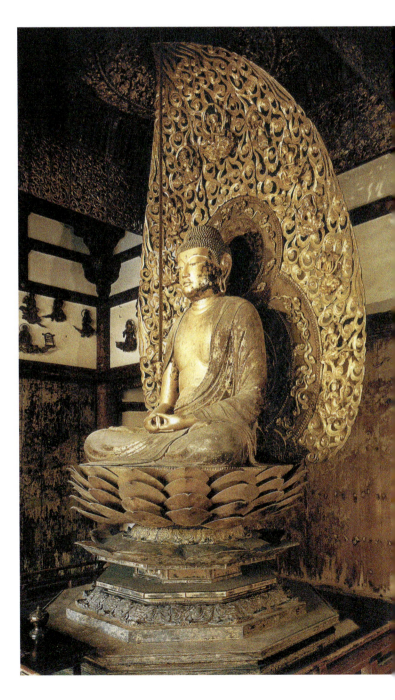

13–21 • Jocho *AMIDA BUDDHA*
Phoenix Hall, Byodo-in, Heian period, ca. 1053. Gold leaf and lacquer on wood, height 9′8″ (2.95 m). Uji, Kyoto prefecture.

Developed in Japan, the joined-block wood sculpture technique (*yosegi zukuri*) is a method of constructing large-scale wooden sculpture. The entire work is constructed from individually carved blocks of wood that are joined together. The carving is then completed and the assembled sculpture finished with lacquer and gold leaf or paint. The joined-wood technique allowed the production of larger sculpture, as the multiple joints reduce the problems of drying and cracking found with sculpture carved from a single solid block. Another advantage of this method was that it facilitated the mass production of sculptures with the aid of apprentices in workshops—very useful as the demand for Buddhist statuary increased.

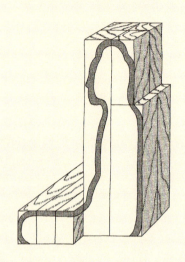
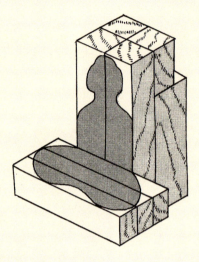

Diagrams showing the blocks of wood used by Jocho to create the *Amida Buddha* statue in the Phoenix Hall, Byodo-in (see FIG. 13–21).

suited to the sculptural program of the Phoenix Hall, which focuses on the "Welcoming Descent" (**raigo**): Devotees believe that when a follower dies, Amida Buddha will descend from his Western Paradise to welcome the soul into Paradise. In an age troubled by frequent fires, floods, earthquakes, and disease, where death closely shadowed the population, the concept of *raigo* proved a popular source of comfort. A *raigo* painting with attached golden cords was often placed opposite a dying devotee. The believer grasped the cords to ensure that their soul would directly ascend into Buddha's Western Paradise.

On entering the Phoenix Hall, the worshipper feels privately welcomed by the downward gaze of *Amida Buddha* (see FIG. 13–21). Sitting cross-legged in the meditative position, his solid form is framed by an intricately carved **mandorla** (flamelike halo) teeming with small divinities playing music. The musical theme continues on the walls surrounding *Amida Buddha*, where carved images of **apsaras** (celestial beings) on floating clouds play musical instruments or dance.

Wooden images were commonly carved out of a single block of wood (*ichiboku zukuri*) with a few appendages attached separately. Jocho and his assistants created the highly regarded *Amida Buddha* statue using the **joined-block technique** (see Techniques, above). Jocho was recognized for his talents and awarded the prestigious title "Master of the Dharma Eye" (*Hogen*), an honor that was rarely given to artists.

Richly colored paintings, now muted with age, also decorate the walls and interior door panels, further enlivening the festive atmosphere. These paintings, depicting scenes of Amida Buddha's Western Paradise and the *raigo,* are tinged with familiar elements, such as the green, rolling hills of the local landscape. This combination of Buddhist imagery with recognizable scenery reflects a growing interest in Japanese-style painting, or **yamato-e**. Byodo-in embodies the aristocrat's desire for rebirth in Amida Buddha's luxurious Paradise while also enjoying the delights on offer in the earthly life, at the Heian court.

HEIAN COURT LIFE

Amida-oriented Buddhism, with its promises of an exquisite afterlife, captured the imaginations of courtier and commoner alike. During the Middle Heian period (951–1086), often referred to as the Fujiwara period after the dominant aristocratic family, the preoccupation with beauty captured in artistic representations of Amida Buddha's Western Paradise also permeated secular court life. Life at the Heian court reached an extraordinary level of sophistication structured around the aesthetics of beauty and pleasure. Ideals of beauty for women and men became firmly established. A beautiful woman had a round face with small features, a plump body, chalky white skin, red lips, and lustrous, long black hair (see FIG. 13–27). She plucked out her eyebrows and then painted them in above their original location. Teeth were blackened with a black dye, as white teeth were considered ugly, "like peeled caterpillars." This practice of blackening the teeth (*haguro*) continued well into the nineteenth century. Makeup, such as tooth black, white face powder, and rouge, was stored in elegant lacquer

cosmetic boxes. One of Japan's designated National Treasures, this black lacquer cosmetic box shown here is decorated with wheels in gold lacquer and mother-of-pearl inlay (**FIG. 13-22**). The wheels are partly submerged in flowing water. Heian nobility traveled around in well-appointed ox-drawn carriages, and ox-cart wheels soaking in water to prevent drying and cracking were a common sight in Kyoto at the time. However, the design may also allude to Buddha's Wheel of Law. The wheel pattern is also repeated in the box's silver handles. Secular and sacred images intertwine in the service of beauty.

The ideal for a handsome man was, again, the round powdered face with small features, plump body, and high eyebrows, although men were not required to pluck their eyebrows. A thin mustache, coupled with a tuft of hair on the chin, was also fashionable. Both men and women dressed in multiple layers of silk robes, artfully chosen to communicate the rank of the wearer and to complement the social occasion and season. Special attention was paid to the arrangement of colors to emphasize one's refinement and excellent taste. If one garment forming the outfit appeared to be slightly wrong in color, even at the opening of a sleeve, the wearer would suffer embarrassment. Lady Murasaki Shikibu (ca. 970–ca. 1015), author of *The Tale of Genji*, discusses such a social blunder in her diary following a court event:

> The Empress was wearing the usual scarlet robe, under which she had kimonos of light plum, light green and yellow rose. His Majesty's outer robe was made of grape-coloured brocade; underneath he had a willow-green kimono and, below that, one of pure white—all most unusual and up-to-date in both design and colour … Lady Nakazukasa's robe, which was also of grape-coloured brocade, hung loosely over a plain jacket of green and cherry.

On that day all the ladies in attendance on His Majesty had taken particular care with their dress. One of them, however, had made a small error in matching the colours at the openings of her sleeves. When she approached His Majesty to put something in order, the High Court Nobles and Senior Courtiers who were standing nearby noticed the mistake and stared at her. This was a source of lively regret to Lady Saisho and the others. It was not really such a serious lapse of taste; only the colour of one of her robes was a shade too pale at the opening.

Standards of beauty were also applied to members of the priesthood. In *The Pillow Book*, written by the irreverent lady-in-waiting Sei Shonagon (ca. 965–ca. 1025), the moral importance of an attractive preacher is discussed:

> A preacher ought to be good-looking. For, if we are properly to understand his worthy sentiments, we must keep our eyes on him while he speaks; should we look away, we may forget to listen. Accordingly an ugly preacher may well be the source of sin.

In addition to lavishing attention on personal appearance, Heian aristocrats, numbering no more than a thousand individuals, were expected to participate in a refined court culture revolving around music, dance, painting, calligraphy, and the literary arts, especially poetry. Both men and women of the court spent their ample leisure time painting, playing the *koto* (zither) or *biwa* (lute), and writing poetry. Other courtly activities included incense mixing, which developed into a sophisticated art form with celebrated incense makers. In an era when bathing was infrequent and people wore voluminous silk garments that were difficult to clean, perfume was a valued commodity to stifle unpleasant smells.

13-22 • COSMETIC BOX
Heian period, 12th century. Black lacquer with gold lacquer and mother-of-pearl inlay, 5⅛ × 12 × 8⅘″ (13.5 × 30.6 × 22.4 cm). Tokyo National Museum.

Sei Shonagon was another great literary lady-in-waiting, who served at court around the same time as Lady Murasaki. Sei Shonagon also came from an educated family; indeed, her father, Kiyohara no Motosuke, was a respected poet. Comparisons are often made between the more reserved, introspective Lady Murasaki and the gregarious, witty conversationalist, Shonagon. Evidence of Shonagon's sparkling wit can be found in her *Pillow Book* (*Makura no Soshi*), a miscellaneous collection of short essays, poems, lists, and observations about nature, human behavior, and her experiences at the court of Empress Teishi. Written during the 990s and completed about 1002, *The Pillow Book* reads like a private journal, exposing Shonagon's thoughts in an uncensored manner. Some of her opinions, especially regarding what she considers hateful or embarrassing, reveal a woman with a wicked sense of humor. Included in her section on "Hateful Things" are the following examples from a translation by Richard Bowring (1982):

One is in a hurry to leave, but one's visitor keeps chattering away. If it is someone of no importance, one can get rid of him by saying, "You must tell me all about it next time"; but, should it be the sort of visitor whose presence commands one's best behaviour, the situation is hateful indeed.

To envy others and to complain about one's own lot; to speak badly about people; to be inquisitive about the most trivial matters and to resent and abuse people for not telling one, or, if one does manage to worm out some facts, to inform everyone in the most detailed fashion as if one had known all from the beginning—oh, how hateful!

An admirer has come on a clandestine visit, but a dog catches sight of him and starts barking. One feels like killing the beast.

One has been foolish enough to invite a man to spend the night in an unsuitable place—and then he starts snoring.

One has gone to bed and is about to doze off when a mosquito appears, announcing himself in a reedy voice. One can actually feel the wind made by his wings and, slight though it is, one finds it hateful in the extreme.

Fleas, too, are very hateful. When they dance about under someone's clothes, they really seem to be lifting them up.

A lover who is leaving at dawn announces that he has to find his fan and his paper. "I know I put them somewhere last night," he says. Since it is pitch dark, he gropes about the room, bumping into the furniture and muttering, "Strange! Where on earth can they be?" Finally he discovers the objects. He thrusts the paper into the breast of his robe with a great rustling sound; then he snaps open his fan and busily fans away with it. Only now is he ready to take his leave. What charmless behaviour! "Hateful" is an understatement.

Other sections in *The Pillow Book* highlight Shonagon's careful observation of nature, as is evident in the opening passage of the book, where she eloquently describes the optimal time of day for appreciating the four seasons:

In spring it is the dawn that is most beautiful. As the light creeps over the hills, their outlines are dyed a faint red and wisps of purplish cloud trail over them.

In summer the nights. Not only when the moon shines, but on dark nights too, as the fireflies flit to and fro, and even when it rains, how beautiful it is!

In autumn the evenings, when the glittering sun sinks close to the edge of the hills and the crows fly back to their nests in threes and fours and twos; more charming still is a file of wild geese, like specks in the distant sky. When the sun has set, one's heart is moved by the sound of the wind and the hum of insects.

In winter the early mornings. It is beautiful indeed when snow has fallen during the night, but splendid too when the ground is white with frost; or even when there is no snow or frost, but it is simply very cold and the attendants hurry from room to room stirring up the fires and bringing charcoal, how well this fits the season's mood! But as noon approaches and the cold wears off, no one bothers to keep the braziers alight, and soon nothing remains but piles of white ashes.

One of the charms of *The Pillow Book* is how Shonagon's tenth-century world catches up with modern times when she reflects upon the intricacies of human emotions. In a line from her essay "Things That Cannot Be Compared," she writes: "When one has stopped loving somebody, one feels that he has become someone else, even though he is the same person." Such acute awareness of emotional states, people's foibles, and nature's beauty has inspired numerous artists over the centuries to reinterpret the text; a recent example is Peter Greenaway's movie *The Pillow Book* of 1996

Perfume-making competitions were held, and both men and women concocted scents made out of such ingredients as cinnamon, ground conch shell, Indian resin, sandalwood, musk, sweet pine, white gum, cloves, and tropical tulip. The scents worn by an aristocrat were an integral part of their courtly persona.

With their passion for pleasure, the Heian elite devoted considerable time to romance and sexual encounters. Like other courtly pursuits, romance was elevated to an art form, with strict codes of behavior based not on legal or moral factors but on rules of taste. Polygamy was an accepted practice among the Heian aristocracy. Suitable wives were selected according to a clearly defined ranking system within court society. It was beneficial for a nobleman to have several wives because women often died in childbirth and children, especially daughters, provided a method of advancement through the ranks. A carefully arranged marriage between a young daughter and a courtier ranked higher than the father could lead to the nobleman's improved political and social standing. According to law, women were obliged to

remain faithful to their husband. However, in reality married women enjoyed extra-marital affairs, a practice that was tolerated providing the relationships were carried out with discretion and the obligatory good taste. Secret meetings between lovers took place at a remote Buddhist temple or the woman's spacious family estate where she lived, while her husband was away visiting other wives or living in a separate residence. Even when a married couple shared the same mansion, private quarters in different sections facilitated clandestine affairs. Within the exotic yet cloistered world of the Heian elite, the arts blossomed, fueled by a preference for Japanese artistic traditions.

CALLIGRAPHY, LITERATURE, AND PAINTING

Ninth-century innovations included the creation of a phonetic writing system called *kana*, traditionally reputed to be an invention of the Buddhist priest Kukai. Prior to the invention of *kana*, the Japanese had used the Chinese system of writing. The Chinese script, signifying erudition and political power, was adopted by Japan as the official language of scholarship. Legal documents, Buddhist sutras, and poetry were all written in Chinese characters. However, Japanese is very different from Chinese, and the use of Chinese characters to express the Japanese language proved cumbersome. Through a process of simplifying Chinese characters, the Japanese developed a syllabic script, with abbreviated Japanese characters representing syllables instead of ideograms. Japanese men and women now had the freedom to write Japanese exactly as it was spoken. In time, two forms of *kana* developed: *katakana*, a formal, angular script favored for official documents, and *hiragana*, a flowing, cursive script used for personal and literary forms of expression. Despite the introduction of *kana*, Chinese continued to be viewed as the language of scholarship until the 1800s. Therefore, certain texts were still written in Chinese, especially those concerned with legal, literary, or philosophical matters. Chinese characters were also sprinkled throughout the new Japanese script to create masterful displays of calligraphy. Today, the Japanese writing system is a complex combination of *kanji* (Chinese characters), *katakana*, and *hiragana*. Modern Japanese also includes words using the European alphabet.

An early surviving example of *hiragana* can be seen in a page from the *Ishiyama-gire*, an early twelfth-century anthology of poetry known in English as the *Thirty-Six Immortal Poets*, produced in albums (**FIG. 13-23**). The spidery script dances over decorative writing paper embellished with silver and gold plant motifs. As with Chinese text, Japanese characters are written in vertical lines and read from top to bottom and right to left across

the page. This album leaf features two poems by the courtier Ki no Tsurayuki. One of the poems is translated as follows:

> Until yesterday
> I could meet her,
> But today she is gone—
> Like clouds over the mountain
> She has been wafted away.

Strewn among the text, leaves and branches painted in silver with accents of gold appear wind-blown against a background of collaged, colored papers, torn at the edge; a fitting backdrop to a poem about loss.

Although both men and women wrote in *kana*, the native script became known as "women's hand," perhaps because Chinese was associated with male scholars and rarely taught to women. Women embraced the new script as literacy offered not only a creative outlet for Heian court ladies but also a way of advancing one's status through romantic liaisons. Those who could write beautifully were admired for their refinement, and beautiful writing attracted the attention of high-ranking men. The subtle language of poetry became a common form of communication between lovers, friends, and family members. In Kyoto, the streets at dawn were a hive of activity as messengers delivered the expected "morning after" poems between lovers, written on exquisite paper delicately scented with incense and attached to dewy blossoms or a tree sprig redolent with

meaning. For example, a pine tree sprig indicated the strength of a man's love, for just as the resilient pine remains green all year, so his love would thrive.

Poetry competitions were held at court and competitors vied with one another to create the finest **waka**, 31-syllable poems in five lines. The poem featured above by Ki no Tsurayuki is an example of *waka*. Private parties held in mansions featured poetry events in elegantly landscaped gardens (**FIG. 13-24**). A *shinden*, originally constructed from wood with a bark roof, was characterized by a central hall (the *shinden* itself), where the master lived and received guests. It faced south onto a courtyard, the garden, and perhaps a lake. Hallways extended on the other three sides to subsidiary buildings, where wives and other family members and retainers had their apartments. Mansions dating from the Heian era have not survived. During Winding Water banquets, guests sat by the garden's meandering stream as cups of rice wine floated by. Each guest in turn picked up a cup, drank, and recited a poem before returning the cup to float on down the stream. Courtiers with little talent for poetry and calligraphy faced dismal social and career prospects. Closeted inside this literary hothouse, various Heian court women, such as Ono no Komachi, Lady Ise, Lady Murasaki Shikibu, Sei Shonagon, and the author known only as the mother of Fujiwara no Michitsuna, produced some of Japan's finest poetry and prose, including diaries and novels.

HEIAN COURT WOMEN Vivid descriptions of court life found in the writings of these aristocratic women provide a tantalizing glimpse into their privileged lives. They enjoyed contests testing their incense-blending skills. Other courtly amusements, aside from romantic pursuits, included dances, playing music, painting, practicing calligraphy, and needlework. Ceremonies, festivals, and outings to Buddhist temples by ox-drawn carriage also occupied their time. However, if not actively engaged in court service as a lady-in-waiting, a noblewoman's life was generally confined to the shadowy interiors and covered walkways of the *shinden*.

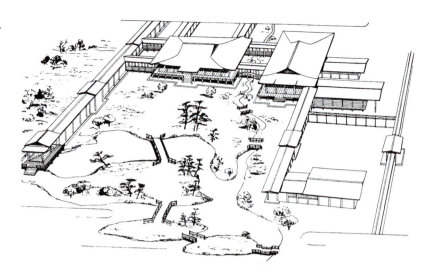

13-24 • DRAWING OF A *SHINDEN*-STYLE MANSION
(After Dr. Mori Osamu)

Surrounded by servants who looked after all domestic matters, including child-care, the courtly woman, cocooned within multilayered silk robes, lived a sheltered, sedentary existence. Many of her days were spent secreted behind screens and curtains as custom dictated (see **FIG. 13-26**). Boredom and loneliness inevitably set in, as is evident from entries in the *Gossamer Diary* by the aforementioned mother of Fujiwara no Michitsuna. An entry dating from 971 captures her sense of inertia:

> This was for me a melancholy period. Life seemed pointless, the monotony was unbroken: a listless rising and going to bed, no variation for twenty days on end. What had brought me to this, I wondered. But there was after all nothing to be done about it.

On the positive side, time for reflection, coupled with economic advantages, allowed Heian women to inherit and retain property, and to make advances in the arts. One of the early Heian female writers to gain acclaim was Lady Ise (ca. 875–ca. 940). She was included in the list of 36 immortal poets. Talented and beautiful,

CONTEXT | The Japanese Writing System

KANJI	HIRAGANA	KATAKANA	RŌMAJI (romanization)	ENGLISH
私	わたし	ワタシ	*watashi*	I, me
金魚	きんぎょ	キンギョ	*kingyo*	goldfish
煙草 or 莨	たばこ	タバコ	*tabako*	tobacco, cigarette
東京	とうきょう	トウキョウ	*tōkyō*	Tokyo, literally meaning "eastern capital"

Lady Ise was a member of the Fujiwara clan and held various court positions, including lady-in-waiting to Onshi, the consort of Emperor Uda. Ise's poetry, like that of her contemporaries, is suffused with romantic longings, an acute sensitivity to the subtle nuances of court life, and a heightened appreciation of beauty made all the more poignant through awareness of the transitory nature of existence. Images from the natural world, such as scattering blossoms or spring rains weaving patterns on water, communicate the sorrows of life's fleeting beauty. Buddhist teachings on impermanence also informed her poetry. Below are two *waka* poems by Lady Ise. The first poem is her lyrical response to a note she received from an admirer who felt she was hiding from him, while the second poem stresses the importance of keeping a love affair secret, a difficult task in a closed society awash with gossip so easily generated from behind flimsy screens.

> How can I vanish
> before meeting someone
> like a water bubble
> ceaselessly flowing
> on a stream of thoughts.

> Speak of this to no one,
> not even in dreams
> and in case the pillow
> should be too wise,
> we'll have no pillow but our arms.

The enjoyment of reading such poems was enhanced by the decorative methods used to record fine poetry. The page shown here, from a collection of poetry dating from about 1112, features a poem by Lady Ise written on a collage of colored papers that form a landscape of gently rising hills (FIG. 13-25). Details such as trees, birds, and clouds in silver and gold ink animate the scene. Lady Ise's poem is written on this elegant surface in black ink using a **running-grass script**. A combination of *kana* and *hiragana* flow across the sheet in waves of spiky, asymmetrical lines, revealing subtle variations in the application of brushstrokes. This eloquent fusion of poetry, calligraphy, and visual arts captures perfectly the refined aesthetic standards of the Heian era.

LADY MURASAKI SHIKIBU AND *THE TALE OF GENJI* A highlight of Japanese literature is the historical novel entitled *The Tale of Genji*, written by Lady Murasaki, a lady-in-waiting in the service of Empress Shoshi at the imperial court. Dating from the early eleventh century, *The Tale of Genji* is considered to be the world's first novel. Set against the backdrop of the Heian court, it weaves a long, intricate tale of the fictional Prince Genji and his relatives. Throughout the 54 chapters the book recounts in great detail the pleasures and challenges of court life, with a colorful cast of over 400 characters spanning three generations. Lady Murasaki based the novel on her observations at court, so the plot focuses on romantic entanglements or court intrigues described in psychological depth. Prince Genji's exploits include impregnating his stepmother, spiriting away a ten-year-old girl to his residence with future romantic intentions, and causing scandals at court with his numerous affairs. Lurking beneath the novel's exploration of worldly pursuits is the Buddhist awareness of impermanence and the futility of chasing after earthly delights that quickly fade.

Lady Murasaki belonged to a literary family of respected scholars and poets. She studied Chinese literature by sitting next to her brother when he was being taught the Chinese classics, lessons considered unsuitable for females. Entries in her diary show that she was a bright student who surpassed her brother in memorizing Chinese characters. Her intellectual abilities did not go unnoticed by her father, who uttered the words "What a pity she was not born a man!"

Widely popular over the centuries, *The Tale of Genji* has inspired numerous artists to illustrate the text. More recently it has been the subject of opera, film, and television shows, such as the television anime series *Genji Monogatari Sennenki* of 2009, directed by Osamu Dezaki.

The earliest extant Genji paintings date from the early twelfth century and were part of a series of handscrolls (*Genji Monogatari emaki*) that combined the text, written in *kana*, with images. It was a huge undertaking, given the length of the novel.

13-25 • PAGE FROM THE *ISE SHU*
Heian period, ca. 1112. Ink, silver, and gold ink on a collage of colored papers, 7⅞ × 6¼″ (20 × 15.8 cm). Yamato Bunkakan, Nara.

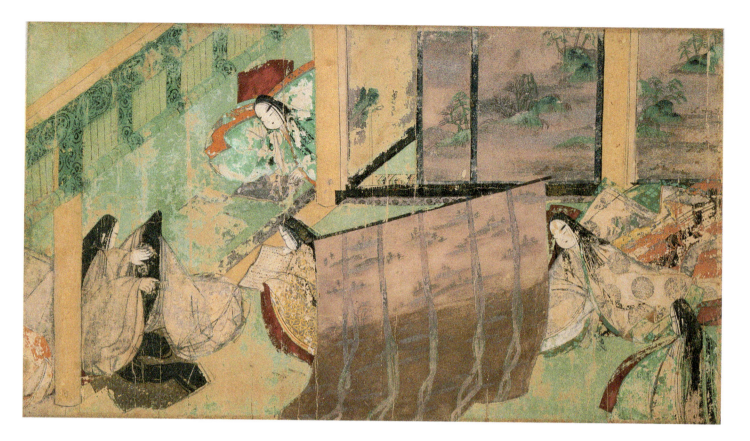

13-26 • SCENE FROM THE "AZUMAYA" ("THE EASTERN COTTAGE") CHAPTER OF *THE TALE OF GENJI*
Late Heian period, 12th century. Handscroll, ink and color on paper, height 8½″ (21.6 cm). Tokugawa Art Museum, Nagoya.

Numerous calligraphers, artists, and assistants created the estimated 10 to 12 scrolls. Each scroll is a powerful work of art. Flowing calligraphy written on paper decorated with gold and silver is interspersed with colorful images oozing psychological drama. Only 20 paintings from this early scroll set survive today. Owing to their fragile condition they have been laid out flat to avoid further deterioration. A close examination of two of these paintings illuminates the complexities of the introspective Fujiwara court (**FIG. 13-26** and Closer Look, opposite). The illustration of an episode from Chapter 50, entitled "Azumaya" (The Eastern Cottage), places the spectator like a bird hovering over a room without a roof, gazing down at what appears to be a peaceful domestic scene inside an elegant residence. *The Tale of Genji* scroll was unrolled a section at a time and read from right to left, similar to a Chinese handscroll, whose format inspired the Japanese version. In the right-hand corner, sandwiched between a hanging screen with ribbons and a sliding screen, ladies-in-waiting sit swathed in billowing garments. Further over to the left, Lady Naka no Kimi is having her long, glossy black hair combed by an attendant. Sitting opposite Naka no Kimi we see her beautiful half-sister, Ukifune, who is examining a picture scroll while a lady-in-waiting reads the corresponding text. To the untrained eye this once brightly painted scene appears merely decorative, a light-hearted presentation of the lives of courtly women. On closer inspection of the left section of the sliding screen, it appears to be slightly open. Prince Niou, a handsome womanizer, has taken advantage of the gap to spy on Ukifune in the intimacy of her room. According to strict court protocol, the act of being seen by Niou in such a private space signifies a violation of Ukifune. Although Niou is not visible in the painting, having scuttled back to the imperial palace, his invasive presence is marked by the open screen.

Ukifune's distress is later amplified when she has to choose between two admirers, Niou and Kaoru. In despair she contemplates drowning herself in the treacherous Uji River. Ukifune's emotional discomfort cannot be transmitted through facial expression because her features, like those of her companions, are painted in a stylized, abbreviated fashion, with dashes for eyes, thicker strokes for eyebrows, a hook for the nose, and tiny rosebud lips. Instead, tension is expressed through the open sliding screen—decorated with gnarled trees in a watery landscape—fluttering curtain, diagonal lines that dissect the scene into claustrophobic compartments, and Ukifune's physical isolation at the end of a steeply rising plane. These understated compositional devices conveying turbulence mirror the Heian courtier's heightened sensitivity to the subtle undercurrents of court life. Avoidance of portraiture by Heian artists stemmed from a belief that it was rude to capture an exact likeness of someone. Scholars also suggest that superstitious Heian courtiers were afraid that a lifelike portrait could be used for casting evil spells.

These brightly painted, jewel-like illustrations, originally executed in vibrant colors such as blue, purple, green, orange,

Prince Genji is pictured visiting his favorite consort, Murasaki (not to be confused with the author), shortly before her death. Beautiful, graceful, and refined, Murasaki was unable to become his primary wife as her family belonged to the lower aristocratic ranks.

SCENE FROM THE "MINORI" ("THE RITES") CHAPTER OF *THE TALE OF GENJI*
Late Heian period, 12th century. Handscroll, ink and color on paper, height 8⅝" (21.9 cm). Gotoh Museum, Tokyo.

Genji, with bowed head, sits at the base of the sloped plane with his back to the garden. He is overcome with sorrow and cannot bear the idea of living without Murasaki.

The roof has been removed and we peer voyeuristically at the suffering below. Murasaki is dying. Leaning against an armrest, she appears locked into place at the top of a steep incline.

Murasaki's adopted daughter is tucked into a corner between the curtain of state and the sharply angled wall.

Genji's sorrowful state of mind and hunched form are reflected in the wind-blown foliage of the neglected garden. The bush clover, one of the seven plants of fall, indicates that Genji's visit takes place during the season associated in aristocratic circles with melancholic feelings of impending loss. Murasaki dies in the fall after a long illness.

Despite their emotional turmoil, the faces of both Genji and Murasaki show little individuality, a pictorial convention that allowed viewers to identify psychologically with the characters portrayed in the paintings.

and red over preparatory ink drawings, are examples of *yamato-e* (Japanese painting). The term derives from the Yamato plain (Nara area) where the ancient Japanese emperors established their court. Paintings in the *yamato-e* style depict Japanese narratives or landscapes in a Japanese fashion, as opposed to images in the **kara-e** (Chinese painting) style, which feature Chinese subjects executed in a Chinese manner. Heian paintings in the classic *yamato-e* tradition are characterized by flat planes of bright color, rich patterns, and codified pictorial elements such as figures with minimal facial features or interiors with "blown-away" roofs, as illustrated in the twelfth-century *Tale of Genji* scrolls.

In addition to tales of courtly romance, Heian handscrolls featured a wide variety of subjects for the literate viewer to pore over, ranging from historical narratives and religious topics to humorous stories and medical issues.

GAKI ZOSHI (*SCROLL OF THE HUNGRY GHOSTS***)** One of the functions of painted handscrolls, apart from providing

entertainment or historical records, was to educate the viewer. The *Hungry Ghosts Scroll*, or *Gaki zoshi* (late twelfth century), with its nightmarish images of desperate ghosts, provides a stark lesson on karmic retribution (**FIGS. 13-27**). According to Buddhist doctrine, six realms of reincarnation await those who fail to escape the repetitious cycle of life, death, and rebirth through enlightenment. These realms, discussed in such texts as the Lotus Sutra, are hells, hungry ghosts, animals, hostile demons, humans, and celestial beings. Entrance to a particular realm is determined by one's behavior, good or bad, in the previous existence. People who become hungry ghosts suffer horribly for their gluttonous ways; in life these were those who ignored the Buddhist dictum to "leave the table when six-tenths full." Such sinners, as graphically depicted in the *Gaki zoshi*, are condemned to endure unbearable thirst and hunger. Invisible to humans, these grotesque, bloated creatures eat corpses in graveyards or the excrement of poor people to appease their cravings, which never cease. As these decrepit beings pick their way through graveyard and street, one is struck by the realistic depiction of their movements, combined with exaggerated facial expressions. The portrayal of these repulsive ghosts was based on the artist's observation of skeletons, dead bodies, and impoverished peasants. In addition to the intrusion of reality into the nightmare realm, the composition also exhibits archaic stylized elements, such as the rounded hummocks sprouting sickly-looking trees.

Although very different in style from the illustrations featured in the *Genji Monogatari emaki*, the *Gaki zoshi* images also fall under the umbrella term of *yamato-e*, emphasizing the diversity of styles and subjects found in Heian painting. An obvious difference between the two handscrolls, apart from expressive faces contrasting with stylized ones, is the limited use of color in the *Gaki zoshi*. Color is sparingly applied in transparent washes, as opposed to the built-up layers of vivid color illuminating the *Genji* scrolls. Also, the Chinese emphasis on line and brushwork to convey form and movement is more prominent in the *Gaki zoshi*.

Viewers of this scroll, with its squalid details of life as a hungry ghost, were encouraged to abandon their sinful ways, if not for virtuous reasons, then through fear.

SHINTO AND THE ARTS

During the Heian period, Shinto fell more deeply under the sway of Buddhism. As Buddhism established temples in remote, rural settings traditionally associated with Shinto deities, Shinto shrines became more ornate, with vermilion-painted woodwork and metal decoration. Images of male and female **kami** (supernatural beings/deities) appeared in human form. The earliest extant Shinto statues of gods and goddesses date from the ninth century. Without a history of Shinto figural prototypes to draw from, artists relied heavily on Buddhist statuary for inspiration, as seen in the wooden sculpture of the seated *Shinto Goddess* in the Matsuo Taisha Shrine (**FIG. 13-28**). Carved from a single block of cypress wood, the statue displays the influence of Buddhist iconography in her cross-legged pose, *mudra*-like hand position, serene expression, and topknot suggestive of Buddha's **ushnisha**. Her matronly form is draped in aristocratic robes of the time. The goddess's courtly appearance stems in part from the practice of nobility claiming descent from *kami*. Although not much remains of the original paint, one can still see remnants of cinnabar red, long associated with magical powers of protection, on her inner robe and lips. Shinto and Buddhist beliefs continued to blend with the development of *honji suijaku*, a **syncretic** fusion of Shinto and Buddhist doctrine based on the notion that Shinto deities are local Japanese manifestations of Buddhist gods. Shinto shrines and Buddhist

13-27 • "HUNGRY GHOSTS IN A GRAVEYARD" AND "HUNGRY GHOSTS EATING FECES," FROM THE *GAKI ZOSHI*
Late Heian period, 12th century. Handscroll, ink and color on paper, height 10¾" (27.3 cm). Tokyo National Museum.

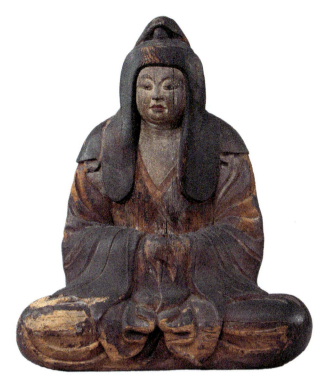

13-28 • SHINTO GODDESS
Heian period, 9th century. Wood, painted, height 34½"
(87.6 cm). Matsuo Taisha Shrine, Kyoto.

temples were built within the same complex and as a unit offered
spiritual services to the populace.

BEHIND THE SCENES

Lady Murasaki also wrote a diary, and it is useful to compare
the idealized version of Heian court life promoted in *The Tale
of Genji* with the realities exposed in her diary. Not all courtiers
behaved like refined gentlemen. Entries in her diary describe
drunk, lecherous men pawing at women and making obscene
jokes. Aristocratic women in particular, because of their subor-
dinate position in a polygamous society, suffered from loneliness,
jealousy, and rejection—emotions they were expected to keep to
themselves. Their problems, however, pale in comparison to the
hardships experienced by heavily taxed, illiterate commoners, the
majority of whom toiled in the rice fields of aristocratic estates,
barely subsisting on meager food supplies. Commoners were
viewed by the upper classes as subhuman, judging by the terms
esemono and *esebito* (doubtful, questionable creatures), frequently
applied to the masses. Sei Shonagon in her *Pillow Book* describes
her distaste for commoners thronging a temple and blocking her
view of a Buddha icon during a pilgrimage:

> They looked like so many basket-worms as they crowded
> together in their hideous clothes, leaving hardly an inch of
> space between themselves and me. I really felt like pushing
> them all over sideways.

Detached from the outside world, the Heian elite sank deeper into
their pleasure palaces, unwisely ignoring developments fermenting

in the provinces. During the late Heian period, Fujiwara political
hegemony was challenged by the rise of warrior clans (**samurai**),
initially employed by the aristocracy to manage their revenue-pro-
ducing provincial properties, but who increasingly controlled
matters outside the capital. Conflicts between rival military and
courtly factions intensified over time, culminating in the Genpei
Civil War (1180–1185), a brutal five-year struggle that led to the
collapse of the legendary Heian era.

CROSS-CULTURAL EXPLORATIONS

13.1 Every culture develops ideals of beauty for
men and women. Discuss ideals of beauty
during the Tang, Heian, and Goryeo periods.
What factors shaped ideals of beauty within
these cultures? Refer to specific images to
illuminate your points.

13.2 During the Heian period (794–1185), various
court women, such as Lady Ise, Lady Murasaki,
and Sei Shonagon, became famous for their
literary works. How do you account for this
flowering of literature by women? Was there
a similar outpouring of literature by women
in other Asian cultures at the time?

13.3 Read *The Pillow Book* (*Makura no Soshi*) by
Sei Shonagon. Create your own "Pillow
Book" based on various topics discussed by
Shonagon, for example "Hateful Things,"
"Embarrassing Things," "Things That Cannot
Be Compared," "Rare Things," "Splendid
Things," "Annoying Things," "Adorable
Things," and "Squalid Things." Maintain
the style and tone used by Shonagon.

13.4 In Japanese art, nature is often used in a
symbolic and metaphorical role to convey
emotion. Examine three paintings executed
around the same time but from different
Asian cultures that employ natural elements
to express emotion. Discuss how the portrayal
of nature in these paintings heightens the
emotional atmosphere of the scene.

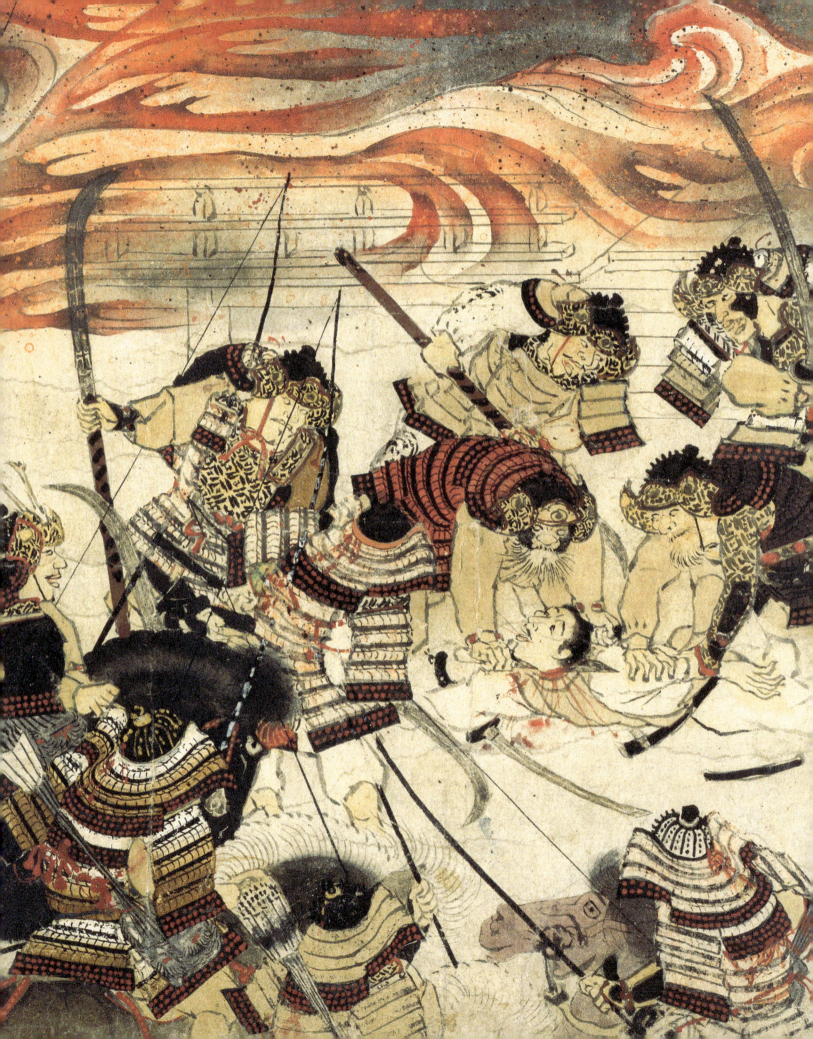

Strife and Serenity: Kamakura, Muromachi, and Momoyama Periods

Those who cling to life die, and those who defy death live.

Uesugi Kenshin (sixteenth-century military lord)

Following the Genpei Civil War (1180–1185), Kyoto was in ruins and the great Nara temples reduced to ashes (**FIG. 14-1**). The imperial court remained in Kyoto, but political power was now in the hands of the Minamoto, a powerful **samurai** family led by Minamoto Yoritomo (1147–1199). After defeating the rival Taira clan in 1185, Yoritomo established a military government (**shogunate**) at Kamakura, today a city near Tokyo, on the rugged east coast. To confirm his authority, Yoritomo ordered the emperor to give him the new title of "shogun" (general-in-chief), opening a fresh chapter in Japanese history based on military dominance.

KAMAKURA PERIOD

The Kamakura period (1185–1333) was only the first in a series of military administrations that lasted until 1848, punctuated by frequent civil wars as various clans competed for the title of shogun. Although stripped of political power, the imperial institution remained intact, with the emperor functioning as a ceremonial

14-1 • HEIJI MONOGATARI EMAKI (TALE OF HEIJI SCROLLS) (DETAIL)

Kamakura period, late 13th century. Handscroll, ink and colors on paper, 16¼ × 275¹¹⁄₁₆″ (41.3 × 700.3 cm). Museum of Fine Arts, Boston. Fenollosa-Weld Collection, 11.4000.

figurehead. Members of the imperial court, finding refuge in what remained of their elegant past, continued to patronize the arts despite dwindling sources of revenue. Their provincial holdings were in large part lost to the samurai who in previous periods had been sent to govern the properties. Paradoxically, many of the great samurai families had aristocratic ancestors.

The new patrons of the arts were the military elite as well as powerful Buddhist priests. The aesthetic culture cultivated by the military class blended with courtly tastes that defined the preceding Heian era, although there were deviations. Kamakura leaders rejected the constrained actions and emotional sensitivity characteristic of Heian art in favor of a robust, dynamic style tinged with realism that complemented their active lives as warriors. This innovative style drew inspiration from the artistic legacy of the Nara period, cultural developments in Song dynasty China (as relations between China and Japan were renewed), and **Zen Buddhism**. It was also shaped by heavy doses of martial spirit.

MILITARY CULTURE

Forged from the clash of metal, the Kamakura period is well known for its military culture, founded on loyalty, obedience, and honor. The shogun ruled Japan with the assistance of powerful lords (**daimyo**) who commanded bands of samurai warriors. Pledging allegiance to the shogun, these military men willingly sacrificed their lives in battle or in ritual suicide (**seppuku**) to avoid dishonor. Fascination with **bushido** (the "way of the warrior") is evident from the many war tales found in Kamakura literature and in the dramatic images decorating screens, hanging scrolls, and narrative handscrolls. One famous illustrated scroll (**emaki**) set, the *Heiji Monogatari emaki* (*Tale of Heiji* scrolls), dating from the thirteenth century, depicts various Minamoto–Taira battles,

fought years before in the twelfth century. Three scrolls survive from the series. Painted in vivid colors, an illustration from one of them provides a panoramic view of Minamoto forces attacking the Kyoto palace of retired emperor Go-Shirakawa in 1160 (see FIG. 14-1). During the fighting, Go-Shirakawa, who sided with the Taira clan, was captured and his palace burned to the ground. To recreate these events, the artist relied on verbal descriptions and a novel about the Heiji war written in 1220. Both sources, rich in embellishment, mixed fact with fiction.

The artist provides a wealth of detail as opposing forces collide in this fiery scene. Minamoto soldiers charge forward, beheading royal guards, and spearing imperial servants or trampling them to death with their horses' hoofs. Ladies-in-waiting fleeing the burning palace jump into the courtyard well, only to drown. Others perish in the flames, captured in stylized forked patterns by the artist. Billowing black smoke spits out glowing cinders, red dots made with the flick of a paintbrush. The appeal of this action-packed scroll to the military class is obvious. One can imagine a shogun poring over the images one section at a time, relishing past military exploits.

Although *The Tale of Heiji's* violent subject matter differs from courtly pursuits featured in earlier Heian scrolls such as *The Tale of Genji* (see Chapter 13, FIG. 13-26, and Closer Look, p. 321), stylistic links between the two scrolls can be detected. In both scrolls the artists use the bird's-eye viewpoint, bright colors, rich patterns, and steep diagonal lines. However, unlike the poetic inertia pervading the *Genji* scroll, the image of Minamoto forces attacking the palace is a swirling mass of energy generated by the chaos of battle. Warriors rendered in lively ink strokes wear ghoulish expressions that match the unfolding carnage. Despite the absence of information on the scroll's artist or patron, the detailed imagery provides valuable insights into the fighting methods of the samurai, their armor, and weaponry.

WEAPONS AND ARMOR Battles between the Minamoto and Taira clans, as illustrated in *The Tale of Heiji* scrolls, were fought by armored warriors on foot and on horseback, using bows and arrows, and razor-sharp swords. Archers galloped full-tilt toward the enemy, releasing their arrows mere seconds before they veered away. Their distinctive curved swords (*tachi*) were worn at the waist. Bearing the signature "Nagamitsu," a steel sword from the Kamakura era exhibits the high level of craftsmanship required to make a perfectly designed yet lethal weapon (FIG. 14-2). Capable of chopping a person in two with one slice, the blade's strength is derived from a complex process of welding, folding, hammering, and tempering several grades of steel. The wavelike markings on the blade emerge from the forging of different metals. Elaborate fittings, such as the handle and sword guard (*tsuba*), missing from this example, completed the sword. Ritual was an integral part of the sword-making process. Before creating a blade, the swordsmith, dressed in white like a **Shinto** priest, performed purification rites. Cherished swords were given names, reflecting the belief that the sword was imbued with a spirit. This sword was named *Dai Hannya* in reference to the *Dai Hannya Sutra* (*Heart Sutra*).

Elaborate suits of armor were constructed to protect warriors—especially those on horseback—from injury and death. Fine examples, such as the well-preserved suit (**yoroi**) originally worn by a military lord and dating from the early fourteenth century, combine opulence with function (FIG. 14-3). The main body of the armor is composed of overlapping lacquered iron and leather scales, fastened together with leather straps and silk cords. A lacquered doeskin featuring a stenciled image of the wrathful Buddhist deity **Fudo** decorates the metal breastplate. In addition to protecting the warrior and enhancing his status, this beautifully crafted suit was also designed to scare the enemy. In the heat of battle, a fierce warrior encased in full armor complete with metal mask and horned helmet appeared frighteningly demonic.

Most people correctly assume that samurai were men. However, during the Kamakura era a woman called Tomoe Gozen (1157?–1247?), an attendant, concubine, or wife of

14-2 • Osafune Nagamitsu *DAI HANNYA NAGAMITSU*
Kamakura period, 13th century. Steel, length 29″ (73.6 cm).
Tokyo National Museum.

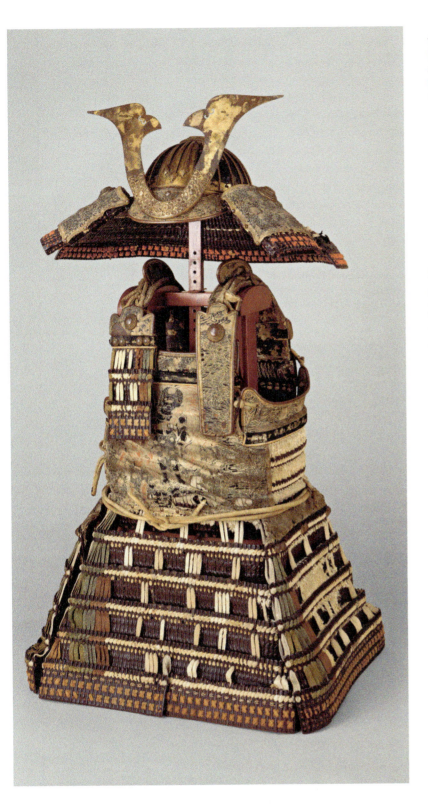

14-3 • SUIT OF ARMOR (YOROI)
Late Kamakura period, early 14th century. Lacquered iron and leather, silk, stenciled doeskin, and gilt copper, height 37½" (95.3 cm). Metropolitan Museum of Art, New York. Gift of Bashford Dean, 1914 (14.100.121 a-e)

on foot. She handled unbroken horses with superb skill; she rode unscathed down perilous descents. Whenever a battle was imminent, Yoshinaka sent her out as his first captain, equipped with strong armor, an oversized sword, and a mighty bow; and she performed more deeds of valor than any of his other warriors.

Scholars debate whether Tomoe was an historical figure or a fictitious literary character. Even if she is a figment of the imagination, her role as a female warrior reflects the reality of some women, who were trained to use weapons and took up arms to protect their households during times of warfare.

Samurai not only excelled in the martial arts but also, as centuries passed, many became accomplished painters and poets. Samurai often drew parallels between their lives and cherry blossoms. Like the cherry blossoms, life was short but glorious, and just as the cherry blossoms fall in the wind, so the samurai bravely accepts his death. Cherry blossoms became the symbol of *kamikaze* suicide pilots during World War II.

RECONSTRUCTION AND RENEWAL

Artists as well as armorers flourished during the Kamakura period. First of all, buildings and artworks destroyed or damaged in the Genpei War required replacement or restoration, stimulating the creation of a new aesthetic. Even important temples, such as Todai-ji (see Chapter 13, pp. 301–303), did not escape destruction as Buddhist clergy took sides in the civil war. Japan's national temple aligned itself with the Minamoto clan only to be torched in 1180 by the Taira. Once fighting subsided, the triumphant Minamoto Yoritomo initiated a reconstruction program, with the rebuilding of Todai-ji an immediate priority. He authorized a public fundraising campaign: Members of the aristocracy and warrior elite contributed funds, as did the emperor and Yoritomo himself, who provided a very generous donation. An important figure in charge of planning and overseeing the reconstruction program was Shunjobo Chogen (1121–1206), a Buddhist priest.

KAMAKURA PERIOD SCULPTURE

Shunjobo Chogen is immortalized in a painted wooden sculpture, likely made just after his death, for use in memorial services honoring the priest (**FIG. 14-4**). It is an excellent example of the interest in realism that pervades Kamakura art. Carved from cypress wood using the **joined-block technique**, this portrait statue of Chogen as an old man is neither flattering nor flashy. He sits cross-legged, wearing a black robe that falls in deeply cut folds over his slightly hunched body. Sagging flesh produces shadowy

Minamoto Yoshinaka, became a renowned samurai. In the fourteenth-century war epic *Tale of the Heike* (*Heike Monogatari*) she is described as follows:

> Tomoe was especially beautiful, with white skin, long hair, and charming features. She was also a remarkably strong archer, and as a swordswoman she was a warrior worth a thousand, ready to confront a demon or a god, mounted or

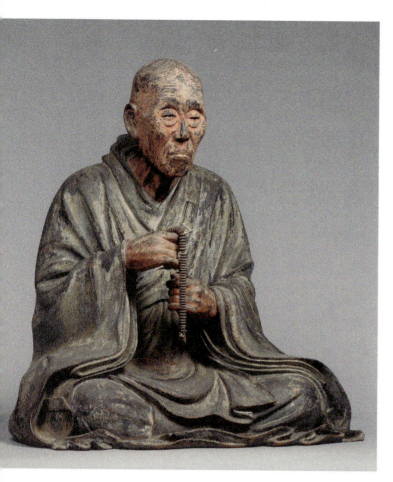

14-4 • *PRIEST SHUNJOBO CHOGEN*
Kamakura period, early 13th century. Painted cypress
wood, height 32⅜″ (82.2 cm). Todai-ji, Nara.

creases around his neck, and there are large bags under his eyes.
Notice how one eye is slightly narrower than the other. Deep
in prayer, he holds a beaded **rosary** used in mantra recitations.
Spiritual intensity shining out of a realistically depicted old man is
also found in the earlier Nara period (645–794) portrait sculpture
of the priest Ganjin (see Chapter 13, FIG. 13-10). This revitalization
of Nara art is not surprising, as Kamakura artists busy restoring
or replacing damaged works naturally looked to surviving Nara
works for inspiration.

The sculptor responsible for Chogen's portrait is unknown.
However, judging by the style and skilled carving techniques
exhibited in this work, he may be associated with the Kei atelier,
a prominent school of sculptors claiming artistic descent from
the famous Heian sculptor Jocho (see Chapter 13, pp. 313–314
and FIG. 13-21). The Kei school prospered during the Kamakura
era, with such gifted sculptors as Unkei (d. 1223) and Kaikei
(fl. 1185–1223) replenishing Todai-ji's collection of icons. Both
masters, with a host of assistants, collaborated on two enormous
wooden guardian figures (**Kongo Rikishi**) placed inside the Great
South Gate at Todai-ji (**FIGS. 14-5** and **14-7**). Standing about
27 feet (8 meters) tall, the deities spring to life in a swirl of drap-
ery and flying scarves. Their aggressive poses, bulging muscles,

and fierce expressions are designed to scare off evil spirits. Such
dynamic figures, created in the early thirteenth century, comple-
ment the militaristic spirit of the Kamakura era and have more
in common with the animated guardian deities from the Nara
period, such as *Shukongo-jin* (see Chapter 13, FIG. 13-11), than with
the more self-contained Heian era (794–1185) guardian figures,
such as an eleventh-century image of Zochoten (see FIG. 14-6 and
Compare, opposite). Remarkably, Todai-ji's *Kongo Rikishi*, cre-
ated using the joined-block technique, were completed in just
over two months, confirmation of the efficient studio practices of
the Kei school.

14-5 • Unkei and Kaikei *KONGO RIKISHI (UNGYO)*
Kamakura period, 1203. Painted wood, height, 27′5″ (8.40 m).
Great South Gate, Todai-ji, Nara. National Museum, Nara.

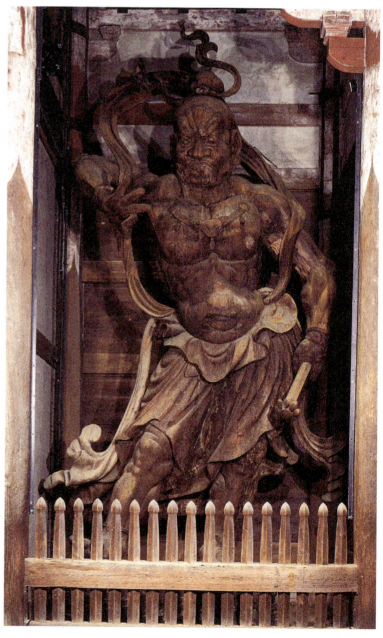

These two guardian figures were created more than a century apart but they share the same function as protectors of Buddhism. *Zochoten* (**FIG. 14–6**), representing the *shitenno* (world guardian; Skt. *lokapala*) who guards the southern quarter of the world, dates to the eleventh century, and *Agyo* (**FIG. 14–7**), one of a pair of *Kongo Rikishi* figures guarding Todai-ji, is dated 1203. *Zochoten* is carved from a single block of wood, whereas *Agyo* is constructed using the joined-block technique. Originally, both statues were brightly painted.

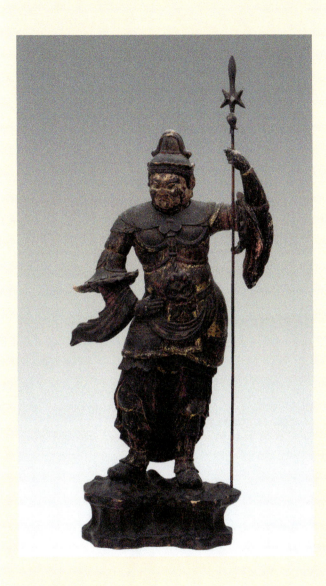

14-6 • *ZOCHOTEN*
Heian period, 11th century. Wood with traces of paint and gilding, height 27⁷⁄₁₆″ (69.7 cm). Harvard Art Museum/Arthur M. Sackler Museum. Promised gift of Walter C. Sedgwick in memory of Elizabeth Sedgwick and Marjorie Sedgwick (124.1979).

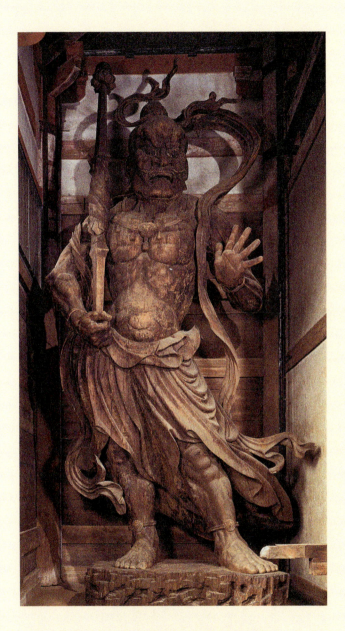

14-7 • Unkei and Kaikei ***KONGO RIKISHI (AGYO)***
Kamakura period, 1203. Painted wood, height 27′4″ (8.36 m). Great South Gate, Todai-ji, Nara. National Museum, Nara.

THINK ABOUT IT

1. What do these two images have in common?

2. How are they different?

3. Art is often described as a reflection of society. How does the statue of *Zochoten* reflect the values of Heian society and the statue of *Agyo* reflect the values of Kamakura society?

Much less terrifying, and closer in style to the decorative Heian era *Zochoten* statue is the early thirteenth-century image of *Jizo Bosatsu* by Kaikei, housed in Todai-ji (**FIG. 14–8**). Jizo, often accompanying Amida Buddha in paintings, is a **bodhisattva** who saves souls languishing in Hell. Omnipresent and accessible, Jizo is also the protector of children before birth,

14–8 • Kaikei *JIZO BOSATSU*
Kamakura period, dated between 1203 and ca. 1210. Painted wood with cut-gold leaf, height 35⅜″ (89.8 cm). Kokeido Hall, Todai-ji, Nara. National Museum, Nara.

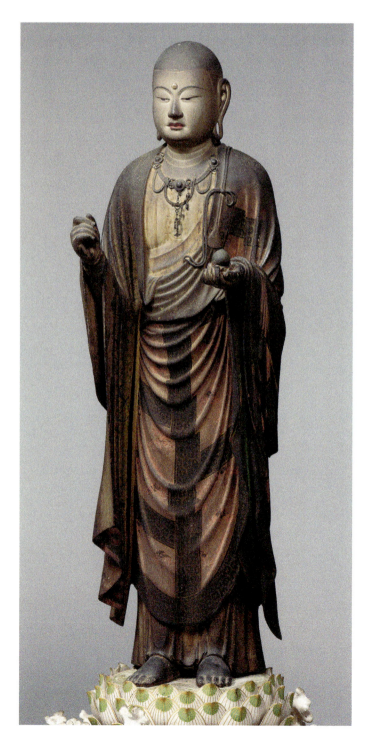

during childhood, and after death. He is characteristically portrayed as a shaven-headed monk carrying a staff (missing from this image) and a jewel to light his way as he descends into murky, hellish realms. In this statue he appears more princelike than monklike, with his elegant flowing robes decorated with cut-gold leaf (**kirikane**) and his conspicuous necklace. Scholars have noted Chinese Song dynasty influences in the elaborate treatment of the drapery. Jizo's continued popularity in Japan is visible in the numerous Jizo shrines marking city streets and the countryside. In many temples, simply carved stone figures dressed in red bibs representing the bodhisattva are poignant memorials to deceased children entrusted to Jizo.

The Kamakura era is also known for portrait sculptures of such secular figures as nobles or military rulers. Minamoto Yoritomo, founder of the Kamakura shogunate, is posthumously depicted as a seasoned shogun in the portrait statue shown here (**FIG. 14–9**). Despite his advancing years he appears as a powerful figure, alert and in control. He is dressed in traditional court attire with ballooning pants and a black pointed hat. He holds a ceremonial board (*shaku*) in one hand, creating a slight deviation from his rigidly symmetrical form. Inlaid crystal eyes with painted pupils animate the shogun's steely gaze. This type of statue was usually housed in ancestral shrines.

KAMAKURA PERIOD PAINTING

Interest in portraiture with a similar roster of subjects is also a hallmark of Kamakura painting. Once again we see the warrior-statesman Minamoto Yoritomo, this time as a younger man

14–9 • *MINAMOTO YORITOMO*
Kamakura period, 13th–14th century. Painted wood, inlaid crystal eyes, height 27¾″ (70.5 cm). Tokyo National Museum.

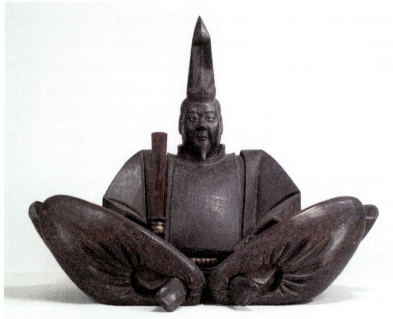

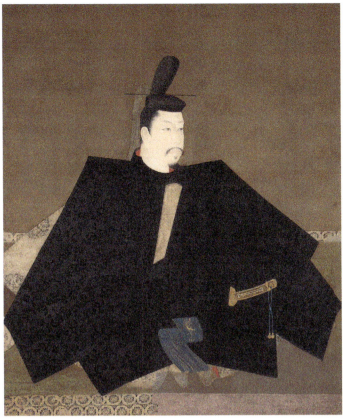

14-10 • PORTRAIT OF MINAMOTO YORITOMO
Believed to be an early 13th-century copy of an earlier painting (1179) attributed to Fujiwara no Takanobu, Kamakura period. Hanging scroll, color on silk, height 4′8⅓″ (1.43 m). Jingo-ji, Kyoto.

(**FIG. 14-10**). Debate swirls around this painting. Traditionally the portrait has long been confidently identified as the young Yoritomo and its painting attributed to the courtier Fujiwara no Takanobu (1142–1205), a well-known portraitist. Recently, however, scholars such as Michio Yonekura have argued that it instead depicts a figure from more than a century later, Ashikaga Tadayoshi (1306–1352), the brother of shogun Ashikaga Takauji. Whether the painting is of Yoritomo or of Tadayoshi—and whether it dates to the twelfth or the fourteenth century—it skillfully combines formality with individuality in stark contrast to the stylized, expressionless facial types popular in the Heian era. Dressed in dark patterned court robes accented with a red inner collar, the subject's crisp form is sharply silhouetted against an austere background. Emblems of authority—the ceremonial *shaku* and hilt of his sword—protrude from his carapacelike garments. He is the embodiment of the disciplined warrior. At the same time he is an individual, a fact communicated through his distinctive, subtly shaded facial features, such as full lips, fleshy nose, wispy facial hair, and lidded eyes.

Famous battles painted on picture scrolls were also in demand during the Kamakura age. We have already examined a section from the famous *Heiji Monogatari* scroll set depicting internal struggles (see pp. 325–326 and FIG. 14-1). Japan also faced external threats from Khubilai Khan's Mongol armies (which included Chinese and Korean soldiers) in 1274 and 1281. According to Mongol and Japanese chronicles, both invasion attempts on Kyushu were thwarted when powerful storms scattered the Mongol ships. Recent scholarship suggests that Japanese warriors were capable of fending off Mongol invaders without meteorological advantage. However, belief in divine-sent winds (*kamikaze*) repelling Mongol attacks fueled sentiments that Japan was a land protected by Shinto gods, not just Buddhist deities. Japanese suicide pilots (*kamikaze*) during World War II revitalized the concept of "divine winds" when they identified with the destructive powers of legendary spiritual forces.

Scenes from the Mongol attacks are captured in handscrolls entitled *Illustrated History of the Mongol Invasions* (*Moko shurai ekotoba*), created in the late thirteenth or early fourteenth century, not long after the enemy's defeat (**FIG. 14-11**). These detailed scrolls were commissioned by the Japanese warrior Takezaki Suenaga to commemorate his actions in the fierce fighting that preceded any intervention of "divine winds." Images of Suenaga engaged in battle are often accompanied by his name to ensure his bravery

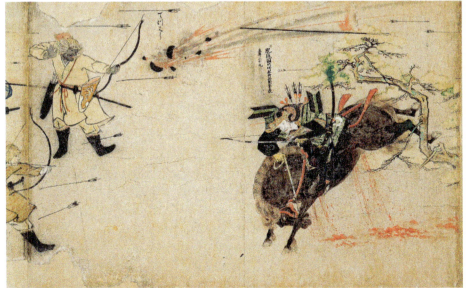

14-11 • SECTION OF ILLUSTRATED HISTORY OF THE MONGOL INVASIONS (MOKO SHURAI EKOTOBA)
Kamakura period, late 13th or early 14th century. Handscroll, ink and color on paper, 15¾″ × 75⅓′ (40 cm × 23 m). Imperial Household Collection, Tokyo.

is well documented. In this detail, a heavily armored Suenaga on horseback gallops toward three Mongol archers (later additions to the scroll) on foot, dressed in long leather coats. A barrage of Mongol weapons, including poison arrows and exploding ceramic projectiles filled with gunpowder and metal shards, an invention of the Chinese, rain down on the Japanese soldiers. Both Suenaga and his horse are wounded. Blood gushes out of the terrified animal. Suenaga escapes a grisly death when other Japanese warriors come to his rescue.

After the Mongols retreated in their ships, Suenaga, unable to claim such traditional spoils of war as land, successfully petitioned the Kamakura shogunate for recognition of his military service using the picture scrolls to bolster his claims. He was awarded a feudal fief. Numerous other samurai also claimed rewards, further straining shogunate resources following the costly war.

Religious subject matter, as in Kamakura sculpture, pervades Kamakura painting. Pure Land Buddhism (see Chapter 13, pp. 312–314) remained popular, with the added boost of proselytizing priests Honen (1133–1212), Shinran (1173–1263), and Ippen (1239–1289) reaching out to all sections of Japanese society with their emphasis on salvation for all. *Raigo* paintings featuring Amida Buddha's heavenly descent to welcome the dying believer's soul into his Western Paradise were frequently

14-13 • "THE HELL OF DISSECTIONS"

From the *Jigoku zoshi* (*Hell Scrolls*), Kamakura period, late 12th century. Handscroll, ink and color on paper, 10¼ × 35½″ (26.1 × 90.3 cm). Miho Museum, Shiga prefecture.

commissioned. In a sumptuous hanging scroll, Amida Buddha and his retinue of 25 bodhisattvas stand on a cascading stream of white clouds that swiftly carry the heavenly delegation to earth (**FIG. 14-12**). Their mission is to transport the soul of a dying monk up to Amida's Paradise. The monk is shown inside a dwelling in the lower right section while Amida's luminous palace, reminiscent of the Byodo-in temple at Uji (see Chapter 13, pp. 313–314 and FIG. 13-19), hovers in the gloom overhead. Amida and his entourage are brilliantly illuminated in gold paint and flakes of gold leaf. Although somber in color, the hilly background, inspired by the Japanese countryside, sparkles with flowering cherry trees and waterfalls. Nature occupies a sizable portion of the painting, attesting to a growing interest in **landscape**.

At the other end of the spectrum from Paradise is Hell, a frightening terminus for sinners who fail to seek salvation before death. In handscrolls such as *Jigoku zoshi* (*Hell Scrolls*), designed to remind one of the penalties of a sinful life, various Buddhist hells are depicted in lurid detail (**FIG. 14-13**). Some of the worst punishments are reserved for monks who have committed murder. In this scene from "The Hell of Dissections" (late twelfth century), five murderous monks cower naked in the left corner as they await dismemberment on bloody dissection tables. A grotesque-looking warden boils human remains in a cauldron. The accompanying text reports that when a warden says "alive," the monk's bodies are reassembled and their torture begins all over again. In an age of natural disasters and brutal wars, Kamakura artists were surrounded by

14-12 • THE DESCENT OF AMIDA BUDDHA AND TWENTY-FIVE BODHISATTVAS

Kamakura period, 13th century. Hanging scroll, colors and gold on silk, 4′9¼″ × 5′1½″ (1.45 × 1.55 m). Chion-in, Kyoto.

real-life images of suffering that doubtless fueled their graphic depictions of Hell.

During this troubled era, withdrawal from life's chaos became an attractive ideal. At age 50, the courtier and poet Kamo no Chomei (1155–1216) turned his back on the secular world to become a Buddhist recluse. He lived with few material possessions in a small thatched-roof hut, which he constructed on Mount Hino outside Kyoto. Kamo no Chomei is best remembered for his classic essay *An Account of a Ten-Foot-Square Hut* (*Hojoki*), which records his reflections on the nature of existence, including the hardships of the world he abandoned (see Point of View, p. 352):

> Ever since I fled the world and became a priest, I have known neither hatred nor fear. I leave my span of days for Heaven to determine, neither clinging to life nor begrudging its end. My body is like a drifting cloud—I ask for nothing, I want nothing. My greatest joy is a quiet nap; my only desire for this life is to see the beauties of the seasons.

The image of a religious recluse meditating in nature is poetically captured in a portrait of scholar-monk Myoe Shonin (1173–1232), abbot of Kozan-ji, a mountain temple northwest of Kyoto (**FIG. 14-14**). It is attributed to the thirteenth-century artist-monk Jonin, also a resident of Kozan-ji, where this painting is still preserved. Myoe, a patron of the arts, was an unusual, somewhat reclusive character. Ordained in both the **Shingon** and **Kegon** schools of Buddhism, he also incorporated Zen meditation (*zazen*) and Shinto beliefs into his practice. In addition, for almost 40 years he kept a journal of his dreams, including his analysis of them. Demonstrating familiarity with his subject, the artist paints a lifelike portrait of Myoe meditating in a pine tree behind the temple. Facial features, such as wrinkles at the corners of his tightly closed eyes and a stubbly chin, are carefully rendered. A rosary and incense burner emitting faint spirals of smoke hang from a spindly branch to his left. Cocooned within branches, he is an integral part of nature.

Much like the eclecticism of Myoe's beliefs, this unusual painting is a fusion of artistic styles. In contrast to the delicate lines and subtle colors defining his face, the tangled mass of pine trees are rendered in dark calligraphic strokes with washes of color. Realistic portraiture fades into a stylized, decorative treatment of the landscape. Atmospheric progression, where forms dissolve into a background haze, prevalent in Chinese Song dynasty landscape paintings, is replaced by an emphasis on the two-dimensionality of the picture surface. In Jonin's painting, foreground and background are treated in a similar fashion, with little change in color, style, or focus. Attenuated trees and delineated banks of mist retain volume rather than disappearing into the background.

Myoe's interest in Zen Buddhism, a school that became entrenched in Japan during the Kamakura period, brought him into contact with Zen master Eisai (1141–1215). Eisai is said to

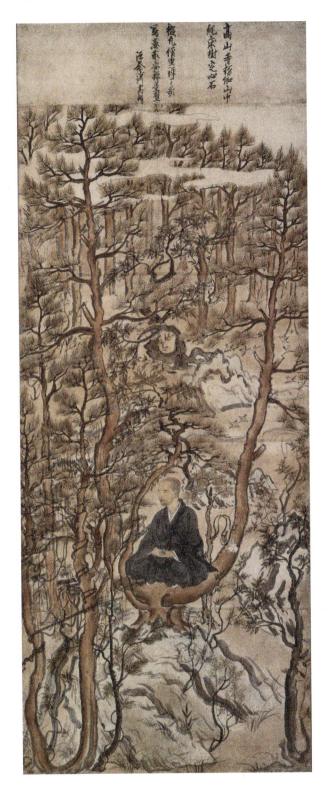

14-14 • Attributed to Jonin
PORTRAIT OF SCHOLAR-MONK MYOE SHONIN
Kamakura period, early 13th century. Hanging scroll, ink and color on paper, 57½ × 23⅛" (146 × 58.8 cm). Kozan-ji, Kyoto.

have given tea plants to Myoe, who planted them on Kozan-ji's grounds. Tea cultivation thrived at the temple, and the area became one of Japan's earliest tea production zones. As well as advancing tea cultivation in Japan, Zen Buddhism influenced the development of the tea ceremony, calligraphy, painting,

architecture, garden design, flower arranging, literature, performance, and the martial arts.

ZEN BUDDHISM

Known as Chan Buddhism in China and Seon in Korea, Zen Buddhism (Zen means "meditation") allegedly originated in India with a monk called Daruma (Skt. Bodhidharma). He taught that intense meditation was the pathway to enlightenment. By the late twelfth century his teachings, transmitted to China in the sixth century, had taken root in Japan. Two Japanese Buddhist masters who studied in China, Eisai and Dogen (1200–1253), are credited with establishing Zen in Japan. A fundamental difference between Zen Buddhism and Pure Land Buddhism is that Zen promotes the idea of Buddhahood in one's present lifetime, whereas in Pure Land Buddhism the goal is rebirth in Paradise after death. In Zen, enlightenment is attained from within, via meditation, self-reliance, and restraint, not through faith in an external being such as Amida Buddha. Meditation, to focus the mind, is of primary importance in Zen practice, not worship of devotional icons, study of religious texts, or observance of complicated rituals that may obscure the truth. Aside from meditation, Zen practice includes manual labor and the study of **koan** (questions or exchanges) with a Zen master as methods of attaining the clarity necessary for enlightenment. These koan—for example, "What is the sound of one hand clapping?" or "Does a dog have Buddha nature?"—cannot be logically answered. Instead the disciple must use intuition, unclouded by rational thought, to transcend the fixed notions of reality that are an impediment to true insight.

Zen's emphasis on rigorous self-discipline appealed to the military elite, and, with generous patronage from shoguns such as Ashikaga Yoshimitsu (1358–1409), an accomplished poet and collector of Chinese paintings, and Ashikaga Yoshimasa (1430–1490), Zen Buddhism flourished throughout Japan. Members of the nobility, including women, were also drawn to Zen, attracted in part by the sophisticated Chinese culture that accompanied the new religion. Numerous Chinese-style Zen monasteries were founded, such as Kennin-ji (1202) in Kyoto and Kencho-ji (1253) in Kamakura, and these monastic institutions became important centers of scholarship and culture. Zen monks with extensive ties to China also became advisers to shoguns on cultural, economic, and political matters, especially during the Muromachi (Ashikaga) period, when Zen Buddhism's pervasive influence reached all levels of society.

MUROMACHI (ASHIKAGA) PERIOD

Often described as Japan's most turbulent era, the Muromachi period (1392–1573) emerged out of conflict. Worn down by financial costs incurred fighting the Mongols, together with internal corruption and civil strife, a struggling Kamakura shogunate was supplanted by another military family, the Ashikaga. The first Ashikaga shogun, Ashikaga Takauji (1305–1358), established his military capital in Kyoto in 1336. After a period of political instability, the third Ashikaga shogun, Ashikaga Yoshimitsu, silenced opposing factions and took control in 1392, a date that formally marks the start of the Muromachi era. The period is known either by the shogunal name Ashikaga, or by the location of their headquarters, the Muromachi district of Kyoto. Maintaining stability was a constant struggle for the Ashikaga shogunate, especially in the provinces, where lords (*daimyo*) became increasingly hungry for power and territory. Between 1467 and 1477 Japan was once again convulsed in civil war (the Onin War). A century of turmoil followed before three warlords, commencing with Oda Nobunaga (1534–1582), took command and restored unity.

Despite this bleak summary of the Muromachi era, most battles were localized and intermittent, allowing life to continue—even flourish—in the face of adversity. Kyoto once again surfaced as the country's political and cultural capital. In addition, with the rise of powerful provincial lords who required armaments for their warriors, furnishings for their castles, and luxury items to define their status, artists and craftsmen also found patrons in the provinces.

New developments in agriculture and mining spurred economic growth, as did trade with Ming dynasty China (1368–1644). The Japanese exported such items as lumber, swords, lacquerware, and folding fans in exchange for silk, porcelain, copper coins, and medicines. A growing merchant class benefited from improved methods of communication and transportation implemented by armies moving frequently around the country. During the sixteenth century, with the arrival of the Portuguese and Spanish, Japan's trade networks expanded beyond Asia into Western Europe. European missionaries also arrived to spread Christianity, with limited success.

During this period of military strife and shifting economic and social patterns, women suffered a decline in status. Under the persistent threat of war, heads of households increasingly left all property to a male heir to preserve their estates. New marriage policies dictated that the bride transfer allegiance from her own family to that of her husband. Confucian principles, which found support among the warrior class, fostered a patriarchal family system where women's designated roles were those of subservient wife and daughter. Deprived of property rights and the protection of their family after marriage, women became economically and socially vulnerable. In this climate of exclusion and constriction, where the dominant masculine military culture left little room for women, opportunities for female artists were limited.

While Pure Land Buddhism remained popular during the Muromachi era, Zen Buddhism's two major sects, **Rinzai**, established by Eisai, and **Soto**, established by Dogen, attracted numerous followers from peasants to emperors. Rinzai, which stressed sudden enlightenment, had particular appeal for the

elite military classes. Soto's emphasis on gradual enlightenment found support amongst the peasants and provincial samurai. Rinzai Zen, with its high-status patrons and influential temples in Kyoto and Kamakura, produced some of the era's greatest artists.

ZEN INK PAINTING

Zen Buddhist teachings, which minimize image worship, had a profound effect on the arts. Unlike Esoteric Buddhism and Pure Land Buddhism, which were responsible for a host of colorful sculptures and paintings depicting deities as aids to salvation, Zen Buddhism fostered artworks reflecting such principles as austerity, self-discipline, respect for nature, and the importance of meditation. In particular, the spirit of Zen is captured in Chinese monochrome ink paintings by such Song dynasty artists as Fachang Muqi (see Chapter 8, p. 184 and FIG. 8–20), which were brought to Japan by Chinese Chan (Zen) monks, many of whom were fleeing the Mongol invasions of China in the thirteenth century, and by Japanese monks returning from studies in China. Japanese Zen monks created their own distinctive ink paintings, with monk-artists like Josetsu (fl. ca. 1405–ca. 1430), Sesshu Toyo (1420–1506), and Sesson Shukei (1504–ca. 1589) becoming masters of the tradition.

JOSETSU Little is known about Josetsu, who lived as a monk at the renowned Zen temple Shokoku-ji in Kyoto. Established by Ashikaga Yoshimitsu, Shokoku-ji, similar to other Zen monasteries, housed its own painting atelier to satisfy the high demand for paintings from military patrons. Over time many Zen temples, being centers of artistic production, developed a "salon culture" where monks steeped in the arts of calligraphy, poetry, and painting became known as **literati** monks (*bunjinso*). Zen follower and Ashikaga shogun Yoshimochi (1380–1428) commissioned Josetsu around 1413 to create a painting for a small standing screen. Shortly after its completion, the image, accompanied by 31 poems, each one written by a different monk, was transformed into a hanging scroll known as *Catching a Catfish with a Gourd* (FIG. 14–15).

At the core of this compelling painting is a Zen riddle: "How do you catch a catfish with a gourd?" Although it is a futile task, the shabby-looking fisherman with his piglike face and rumpled clothing is intent on trying. He stands on the riverbank holding an orange gourd with outstretched hands as if sizing up the slippery creature for capture. Much like the 31 monks who wrote the poems, the viewer is invited to ponder this riddle, presented in visual form. As this absurd activity defies logic one is provoked into fresh ways of "seeing."

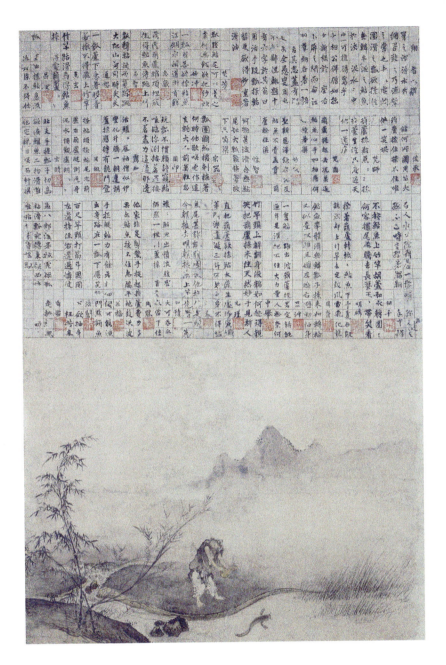

14-15 • Josetsu **CATCHING A CATFISH WITH A GOURD**
Muromachi period, ca. 1413. Hanging scroll, ink and slight color on paper, 43⅞″ × 29⅞″ (111.5 × 75.8 cm). Taizo-in, Myoshin-ji, Kyoto.

From a compositional viewpoint, the observer's conventional expectations are also challenged. Traditionally, the narrative flow of a painting moved from right to left, whereas in Josetsu's work the meandering stream carries the wriggling catfish toward a marshy body of water lower right. The left side is weighed down by such tangible elements as clumps of bamboo, rocks, mountain peaks, and the fisherman, whereas the right side, which dissolves into ambiguous open spaces for the viewer to contemplate. Asymmetry, associated with the beauty of imperfection, is therefore a feature of this scroll, as it is of other Zen paintings. In true Zen fashion, all distracting extraneous details are left out. Color is also minimal, reduced to a few interesting accents, such as the orange gourd. At the same time, there

is nothing impoverished about this image. As a master of ink and brush, Josetsu demonstrates that the ink has "five colors." Tones vary from blacks to delicate washes of gray. Finally, at the top is a collection of cryptic poems by Zen Buddhis monks written in response to the painting. The essence of the message is that answers are not easily provided; The individual must make an effort to "see" the world in a different light.

SESSHU TOYO Sesshu's artistic talents emerged at an early age. A popular story, although impossible to verify, recounts how as a child acolyte he was tied by a Zen priest to a pillar in the temple hall for misbehavior. When the priest returned he was amazed to find that Sesshu had drawn a realistic mouse on the wooden floor using his big toe and tears. As a young monk Sesshu lived at Shokoku-ji, where he studied painting with Tensho Shubun

14–16 • Sesshu Toyo WINTER LANDSCAPE
Muromachi period, ca. 1470s. Hanging scroll, ink on paper, 18¼ × 11½" (46.4 × 29.4 cm). Tokyo National Museum.

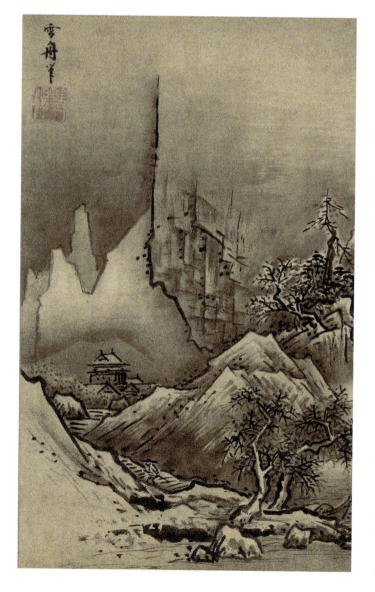

14–17 • Attributed to Sesshu Toyo DARUMA
Signed Sesso. Muromachi period, 15th century. Hanging scroll, ink on paper, 30⅞ × 13⁵⁄₁₆" (78.7 × 33.8 cm). Idemitsu Museum of Arts, Tokyo.

(d. ca. 1460), a highly respected monk-artist of the time who had been a pupil of Josetsu. Sesshu was revered as both a monk and an artist in Japan and Ming dynasty China.

Sesshu traveled to China in 1467 as part of an official trade delegation. He stayed there until 1469, taking the opportunity to visit Zen (Chan) monasteries, examine Chinese art, and sketch the Chinese countryside, all of which inspired his unique ink-and-wash paintings. Two of Sesshu's remarkable hanging scrolls, *Winter Landscape* and *Daruma*, are aids for meditation while possibly also reflecting the artist's own brush with enlightenment, and they illustrate his ability to paint in different styles.

Winter Landscape, originally part of a set of landscapes featuring the four seasons, crackles with energy (**FIG. 14-16**). Powerful calligraphic brushstrokes, scratchy intersecting lines, and soft washes of gray combine in this unusual painting. A solitary figure, lower left, makes his way up the steep path toward the temple. Stripping out all extraneous details, the artist captures winter's chill in the barren, twisted trees and snow-covered terrain. In the distance a jagged line, like a flash of lightning,

bisects the composition, leaving the mountains behind the temple as a blank space while the other side of the jagged line disintegrates into a fractured surface filled with brushstrokes. Is this the result of meditation? Is the agitated "monkey mind" filled with pointless distractions finally calm? Yet behind the beauty of a snow-shrouded mountain, much like the purity of a tranquil mind, is the rock face, the unavoidable hard work behind the serenity of enlightenment.

An imaginary portrait of the Zen patriarch Daruma (Bodhidharma) is signed Sesso, and Sesso Toyo is believed by many scholars to be the young Sesshu (**FIG. 14–17**). The painting exhibits the swift yet controlled manner of applying paint typical of Sesshu. As with enlightenment, which may suddenly strike after rigorous practice, Daruma's robe is painted in bold, sweeping strokes. His bushy eyebrows, beard, bulbous nose, and earring (an appearance associated with foreigners, as Bodhidharma came from India) are more subtly executed.

Daruma's intense expression, conveyed through dilated pupils and clenched mouth, stems from a story that the monk cut off his eyelids in order to meditate permanently and not fall asleep. Daruma was also said to have lost the use of his legs after meditating in a cave for nine years. These legends spawned armless and legless, round Daruma dolls, which spring back when pushed over. Characteristically red, these dolls are regarded today as symbols of perseverance and good luck.

SESSON SHUKEI During his life, Sesshu attracted numerous followers, many of whom studied painting with the master in a studio he established in the countryside of Yamaguchi prefecture (the southeastern tip of the island of Honshu). One admirer of Sesshu's work, although not a pupil, was the Zen Buddhist monk-artist Sesson Shukei. Sesson lived in northern Honshu, far from Kyoto and Yamaguchi prefecture, but he was able to study Sesshu's work in collections belonging to the *daimyo* of his region. He lived to be over 80, and developed a distinctive, idiosyncratic style characterized by dramatic compositions, dynamic brushwork, and subtle nuances in ink tones. A small painting from the mid-sixteenth century entitled *Wind and Waves* highlights Sesson's abilities as an artist (**FIG. 14–18**). What is particularly striking about this composition is the sense of motion unleashed by the gale that threatens the lives of humans and their fragile structures. Notice the building's bent roof and the flimsy sailboat. It is impossible to anchor oneself in this swirling landscape. This painting was executed during the turbulent years of the later Muromachi period, and it is tempting to see it as a reflection of an unstable world buffeted by political chaos and warfare.

THE ZEN DRY GARDEN

Monochrome ink paintings and Zen dry landscape gardens (*karesansui*) have much in common. Skilled ink painters like Sesshu designed gardens that resembled their paintings. In keeping with Zen austerity, color is largely absent from the Zen dry garden, with rocks and gravel replacing ink and water. An early sixteenth-century garden at Daisen-in, Daitoku-ji, Kyoto, attributed to the Zen monastery's founder, Kogaku Soko (1465–1548), in collaboration with the monk-artist Soami (1455–1525), conjures up a landscape

14–18 • Sesson Shukei WIND AND WAVES Muromachi period, ca. mid-16th century. Hanging scroll, ink and slight color on paper, 8¾ × 12⅓″ (22.2 × 31.4 cm). Nomura Art Museum, Kyoto.

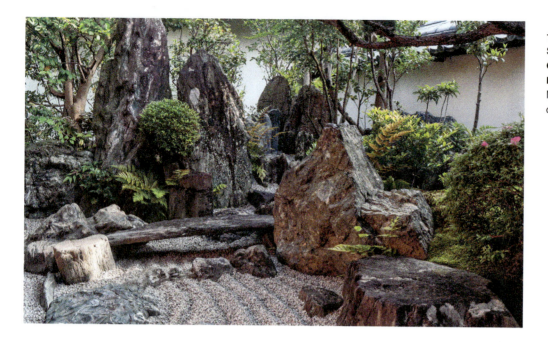

14–19 • Attributed to Kogaku Soko in collaboration with Soami
GARDEN OF THE DAISEN-IN, DAITOKU-JI, KYOTO
Muromachi period, early 16th century. 12 × 47′ (3.65 × 14.3 m).

painting in three dimensions (**FIG. 14–19**). Although the enclosed garden is small, measuring only 12 × 47 feet (3.65 × 14.3 meters), an illusion of a vast landscape unfolds before the viewer. In the background, carefully selected rocks suggest mountains, a flat slab in the middle ground brings to mind a bridge, while underneath a stream of white gravel flows into a broad "river" dotted with "islands." Clipped pines, pruned shrubs, and moss add subtle accents of color. Daisen-in, similar to other dry landscape gardens, is designed for external contemplation, not for walking around in. Viewers meditate on the tranquil scene from perimeter viewpoints. The concept that a rock equals a mountain and raked gravel equals flowing water teases the mind like a Zen riddle, prodding the individual to comprehend the garden intuitively, possibly sparking new insights.

Japan's most famous and stark dry landscape garden is found at Ryoan-ji, a Zen temple in Kyoto founded in 1450 by the warrior Hosokawa Katsumoto (**FIG. 14–20**). Constructed in the late fifteenth century, this restrained yet monumental garden consists of 15 enigmatically arranged rocks set in a 75 × 29-foot (23 × 9-meter) flat rectangle of carefully raked white gravel. Patterns in the gravel are visible; horizontal lines give way to circles around rocks bordered by moss. Earthen walls streaked with subtle hues surround the garden on three sides. Reduced to essentials, the significance of such a bare composition invites

14–20 • ROCK GARDEN, RYOAN-JI, KYOTO
Muromachi period, ca. 1480. Current garden design likely dates from around 1650. 29 × 75′ (9 × 23 m).

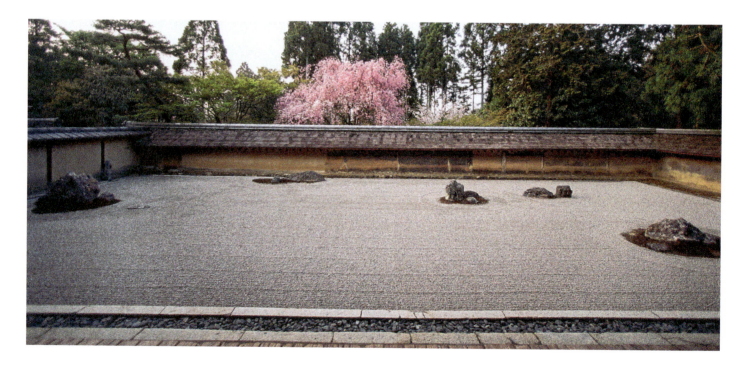

endless speculation. Tourist guidebooks suggest the rocks represent mountain peaks above clouds, islands in a sea, or a tigress and cubs crossing a river. Scholarly texts focus on the symbolism of rocks in gravel. One interpretation proposes that still water (the mind) reflects true reality, but once a stone (thought) creates ripples, reality becomes distorted. Ultimately, the Zen garden cannot be intellectualized, only experienced, by individuals in search of spiritual growth. Enlightenment can strike not only during meditation but also while mindfully performing mundane tasks. Monks at Ryoan-ji cultivate a calm mind as they tend the garden, pulling out weeds, clearing away leaves, and raking the gravel.

It is not known who designed the garden, although most likely a Zen monk collaborated with two gardeners, Kotara and Seijiro, whose names are carved on one of the rocks. These gardeners belonged to Kyoto's underclass, a group of outcasts known pejoratively as *kawaramono* (riverbed people). Traditionally, *kawaramono* performed the city's repulsive jobs, for example skinning and tanning hides, but by the fifteenth century, as societal upheavals wore down established class structures, members of this group became known for placing rocks in gardens, an important role usually performed by Shinto priests and Buddhist monks. The Ashikaga were known for patronizing creative, talented individuals from all sectors of society.

ZEN BUDDHIST CONVENTS

Buddhism prospered during the Kamakura and Muromachi eras, in part because of generous funding from high-ranking female patrons and the active participation of nuns. Convents provided a safe haven for women in distress, such as aristocrats who despaired of life, war widows, the sick, and the impoverished. In addition, as ordination controls loosened and revivalist movements championed the inclusion of nuns in monastic orders, convents attracted women interested in pursuing a religious path. New nunneries were constructed and older, decaying ones were revived. Similar to Zen Buddhist monasteries, although less visible, Zen convents became vibrant centers of spiritual, intellectual, and artistic activity.

A surprising number of portraits of religious women are still housed in Japanese convents and temples. These portraits, such as the sixteenth-century painting of nun Shun'oku-Soei, were commemorative images used in memorial rites honoring the deceased (**FIG. 14-21**). Painted by Tosa Mitsumochi (fl. ca. 1550), shortly before or after she died, Shun'oku-Soei's portrait depicts a disciplined, shaven-headed nun meditating in a bamboo chair. Her shoes are neatly placed on a stool. Although elderly, she meditates steadfastly, impervious to physical discomfort. Above her head is a lengthy inscription written in 1546 by the 98th head priest of Daitoku-ji Zen temple, which states that Shun'oku-Soei studied Zen Buddhism at Daitoku-ji and later became chief nun of Soun-an temple. Inscriptions, written by a priest from an affiliated monastery or a high-ranking person, were usually added to a portrait after the subject's death.

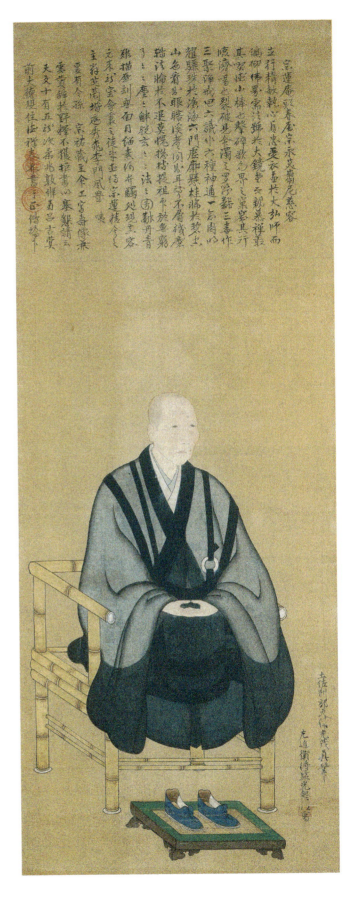

14-21 • Tosa Mitsumochi
PORTRAIT OF THE NUN SHUN'OKU-SOEI
Muromachi period, 16th century. Hanging scroll, colors on silk, 35⁹⁄₁₀ × 13⁴⁄₅″ (91.2 × 35.2 cm). Daiji-in, Kyoto.

14-22 • PORTRAIT SCULPTURE OF A ZEN PRIEST
Muromachi period, 15th century. Lacquer on wood with inlaid crystal eyes, height 40½" (103 cm). Metropolitan Museum of Art, New York. Purchase, John D. Rockefeller 3rd Gift, 1963, 63.65.

ZEN BUDDHIST STATUARY

Although Zen doctrine placed little emphasis on Buddhist statuary, realistic, life-size sculptures (*chinso chokoku*) of important Zen masters were created to transmit the master's essence to disciples after his or her death. This fifteenth-century devotional icon carved from wood and coated with lacquer realistically depicts the Zen priest's face, which is accented with twinkling eyes of crystal that give the sculpture a remarkably lifelike quality (**FIG. 14-22**). Seated in meditation, the stout priest swathed in priestly robes stares through the viewer—no longer attached to the world of delusion.

Although the production of high-quality Buddhist sculpture slowed considerably during the Muromachi

era, one sculptural form that blossomed was the carving of wooden masks for Noh theater by highly skilled craftsmen.

NOH THEATER

Noh performance originally developed during the Muromachi period under the direction of Kan'ami (1333–1384) and his son Zeami (1363–1443). These talented playwrights and actors created Noh (which translates as "ability") out of a fusion of such elements as Shinto dances, popular peasant plays, court music, Chinese drama, and Buddhist teachings. Records dating from the Muromachi period reveal that early Noh groups were comprised of a wide variety of people, including children, women, nobles, warriors, peasants, and social outcasts. By the seventeenth century, Noh had shed its amateurish roots and matured into a refined classic art, performed by professionally trained men for an elite audience. Ashikaga shoguns, in particular Yoshimitsu, became avid patrons of Noh, contributing to its reputation as a sophisticated art form enjoyed by high-status warriors and nobility.

Realism is not a goal of Noh theater. Poetic and hypnotically slow-moving, it is a form of symbolic dance-drama performed on a bare wooden stage with few props. The back wall of a Noh stage always features a painted image of a sacred pine tree, a timeless symbol of Noh. Actors wearing elaborate costumes and otherworldly masks, accompanied by musicians and a chorus, stand out against the subdued setting (**FIG. 14-23**). Reminiscent of a Shinto shrine, this elegantly crafted cypress-wood stage is bordered by a strip of white pebbles. The main actor (*shite*), wearing a mask and holding a fan, stands center stage. Musicians play instruments in front of the rear wall, painted with a sacred pine tree. The chorus sits to one side,

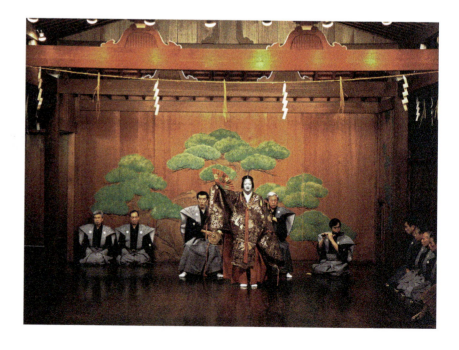

14-23 • NOH STAGE FEATURING A SCENE FROM THE NOH PLAY *YUYA*, **ATTRIBUTED TO ZEAMI.**
Kanazawa City.

stage left. Content is conveyed through chanted speech, haunting sounds of flute and drums, stylized movements filled with meaning, dramatic surprises, silences that speak volumes, and restrained emotions. For example, heartrending weeping is typically expressed with a flat hand partly covering the forehead, and joyous love through a touch of the sleeve. Innuendo, mystery, and elusive beauty are prized components of Noh plays.

In general, Noh plays can be divided into five categories: god plays, warrior plays, women plays, demon plays, and miscellaneous plays. Subjects, often steeped in the supernatural, were inspired by historical events or such classical literary works as *The Tale of Genji*. A popular warrior play entitled *Atsumori*, written by Zeami, captures a common theme in Noh drama: a troubled character addressing past actions to free their soul or that of their victim. Based on an incident in *The Tale of the Heike*, the warrior Kumagai is overcome with grief after beheading Atsumori, a young aristocratic flute player. Kumagai becomes a priest named Rensei and resolves to pray for Atsumori's salvation at Ichinotani, where the execution took place. The play opens with Kumagai uttering the words, "Life is a lying dream, he only wakes who casts the world aside," and concludes with Atsumori's ghost acknowledging that the priest's prayers opened the door to salvation for both him and his murderer: "No, Rensei is not my enemy. Pray for me again, oh pray for me again."

MASKS Traditionally men played all roles, both male and female, with the aid of painted wooden masks. A Noh mask is not merely a face representing another being but a powerful tool to express the emotional state of a character, in particular the main protagonist. Masks display a wide range of facial types, including those of gods, youths, old men, demons, and angry women. Masks depicting young men and women, such as the *Ko-omote* mask (**FIG. 14–24**), are characterized by round, smooth features, blackened teeth, and a calm demeanor, whereas those of demons or angry/jealous women—for example the *Hannya* mask (**FIG. 14–25**)—are frighteningly expressive, with glaring golden eyes, snarling mouths, and horns. Fibers were sometimes attached to suggest facial hair, or metal set into eyes to intensify expression. The *Okina* mask (**FIG. 14–26**), representing a god with the face of a smiling, wrinkled old man, features bushy eyebrows made from rabbit fur and a long, wispy horsehair beard. His lower jaw, loosely attached with hemp cord, stirs when the actor moves, providing an illusion of speech. Various moods are transmitted through the way light touches a mask, or by an actor's slight tilt of the head. For example, if it is tilted upward to absorb more light, the mask appears to smile or laugh. By the sixteenth century, the art of carving Noh masks had developed into a largely hereditary profession, with special techniques passed down from father to son. Beautifully crafted Noh masks, imbued with latent energy that is

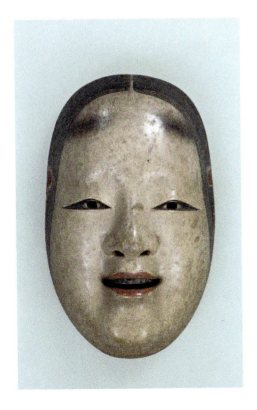

14–24 • NOH MASK (*KO-OMOTE*)
Muromachi period, 15th century. Painted wood, 8⅓ × 5⅓″ (21.2 × 13.6 cm). Tokyo National Museum.

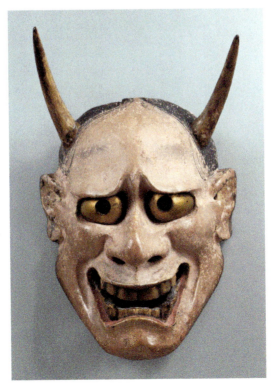

14–25 • Attributed to Hannyabo NOH MASK (*HANNYA*)
Muromachi period, 15th century. Painted wood, 8⅓ × 6⅜″ (21.2 × 17 cm). Eisei Bunko Museum, Tokyo.

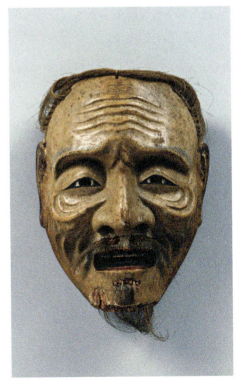

14–26 • Attributed to Fukurai NOH MASK (*OKINA*)
Muromachi period, 15th century. Painted wood, 7⁹⁄₁₀ × 6½″ (20 × 16.4 cm). Tokyo National Museum.

activated by skilled performers, are treated with great respect by the actors.

Dramatic Noh plays, interspersed with short, humorous pieces for comic relief (**kyogen**), continue to captivate audiences in contemporary Japan. However, Noh performance, with its mysterious masks, symbolism, subtle nuances, and slow pace, can be difficult for the modern viewer to understand. Zeami, who wrote treatises on the art of Noh, offers the following Zen-inspired advice to spectators:

> Forget the specifics of a performance and examine the whole. Then forget the performance and examine the actor. Then forget the actor and examine his inner spirit. Then, forget that spirit, and you will grasp the nature of the noh.

THE GOLDEN PAVILION (KINKAKU)

Kyoto resident Ashikaga Yoshimitsu is an excellent example of the warrior as art patron. Having attained military supremacy, he established his own cultural legacy to rival that of the imperial court, the traditional custodian of culture. In addition to his patronage of Noh theatre, he promoted *renga* (linked verse) and amassed an impressive collection of Chinese paintings. As a follower of Zen, it was he who in 1382 founded the Zen monastery Shokoku-ji, which, as we have seen, became a lively center of scholarship and the arts (see p. 335). After Yoshimitsu abdicated the shogunate to his son Yoshimochi in 1395, he built a luxurious retirement villa in northern Kyoto. The villa included a beautifully landscaped garden accented with an elegant pavilion, an architectural gem known later as the Golden Pavilion (Kinkaku) (**FIG. 14–27**). In this idyllic setting, Yoshimitsu spent his time and resources cultivating the arts.

Positioned overlooking a large artificial pond, the Golden Pavilion, an enchanting three-storied structure built to nourish both the senses and the spirit, combines Chinese architectural influences with indigenous preferences. The ground floor, constructed from unpainted wood, functioned as a place of relaxation and point of departure for boat rides in colorful Chinese-style boats. The second level, with its spacious veranda offering fine views of the lake, was used for moon-viewing parties. The top floor, with its bell-shaped windows inspired by Chinese sources, housed statues of Amida Buddha and 25 bodhisattvas, attesting to Ashikaga Yoshimitsu's eclectic tastes. It was not uncommon for members of the warrior class to practice Zen Buddhism while remaining devotees of Amida Buddha. Evocative of a beautifully gilded Buddha statue, the top two stories are covered in gold leaf, and cast brilliant reflections on the waters below. A golden phoenix crowns the wood-shingle roof. Traditionally a symbol of the imperial family, its inclusion trumpets the retired shogun's aspirations to courtly status and cultural authority. When the villa complex was completed in 1408, Yoshimitsu hosted a lavish party that included the emperor as a guest.

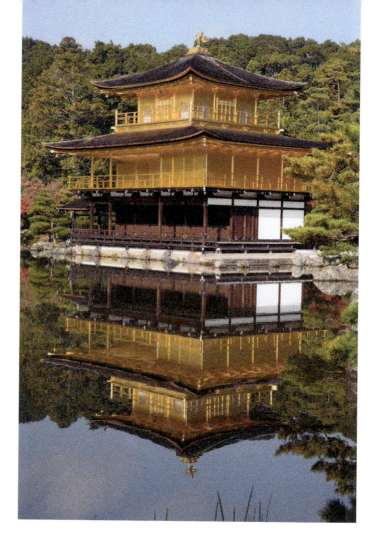

14–27 • GOLDEN PAVILION (KINKAKU), ROKUON-JI
Kyoto. Originally built Muromachi period, 1390s. Destroyed 1950; rebuilt 1955.

The artfully designed garden, including the pond with man-made islands representing cranes and turtles (symbols of longevity), is an integral part of the pavilion's beauty. Unlike the Zen dry landscape garden, which cannot be entered, Kinkaku's garden invites contemplation from a boat drifting across the pond or from paths meandering around the water's edge. Various views of the pavilion are offered from these vantage points. Pines, maples, and cedars, carefully planted for their seasonal color, enrich the parklike setting. This highly choreographed landscape is cleverly designed to appear natural.

After Yoshimitsu's death, the villa was converted into a Zen temple, Rokuon-ji. Most of the original buildings perished over the centuries. The Golden Pavilion survived until 1950, when a mentally unstable monk burned it down, an act that inspired Yukio Mishima's famous novel *The Temple of the Golden Pavilion* (1956). Kinkaku was rebuilt in 1955.

WABI, SABI, SHIBUI

Three important aesthetic concepts, known as *wabi, sabi, shibui,* took shape during the Muromachi period. An understanding of

these concepts, related to Zen ideals, will illuminate key philosophical principles behind Japanese aesthetics—in particular, those governing the tea ceremony. *Wabi* is associated with "cultivated poverty," which in artistic terms translates into an appreciation of simplicity, austerity, and understatement. *Sabi* is linked to the beauty of silence and timeworn objects, a preference for the old over the new. It can also refer to enjoyment of the imperfect and weathered—for example, an irregularly shaped tea bowl or moss-covered rock. *Shibui* is interpreted as that which is bitter but refreshing, like Japanese green tea, and finds artistic expression in interesting accents, such as a touch of red in an otherwise monochromatic painting (see FIG. 14-15).

COLLAPSE OF THE ASHIKAGA SHOGUNATE

By the mid-sixteenth century, the Ashikaga shogunate was in trouble. Decades of succession disputes and warfare had eroded the centralized authority of the military government. Japan became a fractured collection of about 250 domains controlled by rival regional *daimyo*, some of whom ignored their allegiance to the shogun to strengthen their own armies and economic resources. As warring factions struggled for control, the Muromachi age ended much the same way it commenced, in chaos and bloodshed. In 1573, the fifteenth and last Ashikaga shogun, Yoshiaki, was banished from Kyoto by a *daimyo* named Oda Nobunaga (1534–1582), and the Ashikaga shogunate collapsed. Three powerful military leaders in succession—Oda Nobunaga, Toyotomi Hideyoshi (1537–1598), and Tokugawa Ieyasu (1543–1616)—stepped into this power vacuum, and unity was gradually restored to Japan.

MOMOYAMA PERIOD

> On top of the hill in the middle of the city Nobunaga built his palace and castle, which as regards architecture, strength, wealth and grandeur may well be compared with the greatest buildings in Europe.
>
> **Luis Frois** (sixteenth-century Portuguese Jesuit) **describing Oda Nobunaga's Azuchi Castle**

Oda Nobunaga's rise to power was greatly assisted by his shrewd military tactics and use of Western firearms, first brought to Japan by the Portuguese in 1543. He established a new era known later as the Momoyama (Peach Hill) period, after the location south of Kyoto where his general and successor, Toyotomi Hideyoshi, built an opulent castle-palace. As well as adopting Western guns, Nobunaga also tolerated the Europeans, allowing their beliefs and styles to infiltrate Japanese society.

Following Nobunaga's death in 1582, Hideyoshi, notable for his meteoric rise from foot soldier to general, took control and continued the process of reuniting Japan. The peace that resulted from reunification boosted economic growth. Foreign and domestic trade flourished. Luxury goods from Europe and the Asian mainland became popular with the ruling elite and newly affluent townspeople. Hideyoshi also supported the rebuilding of war-battered Kyoto, and the city returned to its former glory. Spurred on by ambition, Hideyoshi was not content with ruling Japan. In 1592 and 1597 he launched two brutal invasions of Korea, which ultimately failed.

After Hideyoshi died in 1598, the third great warrior to assume power was Tokugawa Ieyasu. He eliminated all rivals by 1615 and adopted the title of shogun, ushering in the Tokugawa period (1615–1868). These military men, when not ruthlessly crushing their enemies, were great patrons of the arts, pouring time and resources into an astonishing array of art forms, ranging from rustic teahouses to ornate castles, modest bamboo tea implements to screens embellished with gold leaf. The somewhat brief Momoyama period (1573–1615), sandwiched between two formidable shogunates—Ashikaga and Tokugawa—is sometimes referred to as Japan's "Golden Age."

CASTLES

The introduction of European firearms to Japan in the 1540s influenced castle architecture in the late sixteenth century. Castles became heavily fortified structures on massive stone bases to withstand attacks from the latest weaponry, which included cannon. However, these imposing castles also functioned as the luxurious residences of militaristic rulers, reflecting their authority, wealth, and artistic tastes. Spacious rooms featured fine furnishings, wall paintings, decorated sliding doors (*fusuma*), and portable painted screens (*byobu*), while outside, gardens complemented the building's opulence. Over the centuries most of these early castles were dismantled or destroyed. Himeji is one of the few remaining ones, an elegant castle built on a low hill overlooking today's city of Himeji, near Osaka (FIG. 14-28).

14-28 • HIMEJI CASTLE
Hyogo prefecture. Momoyama period, 1581; enlarged 1601–1609.

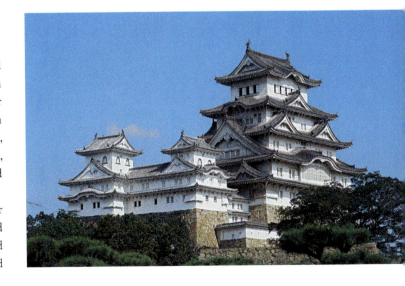

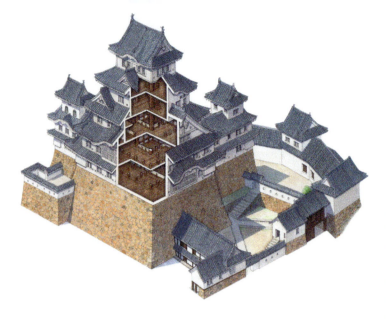

14-29 • ISOMETRIC CUTAWAY OF HIMEJI CASTLE.

HIMEJI Nicknamed "White Heron Castle" because of its white plaster walls and winglike tiled roofs, Himeji was initially constructed by Hideyoshi in 1581 on the site of an earlier fortress. Between 1601 and 1609 the castle complex underwent further expansion. The palatial residences of the owners, their families, and their retinue were protected by a mazelike arrangement of moats, fortified gates, high walls, and towers (**FIG. 14-29**). Attackers also faced weapons fired from openings in walls or falling rocks dropped from stone-drop windows. Watching over the castle complex, a multistoried keep (*donjon*) operated as a residence, storehouse, armory, and final stronghold during times of war. Constructed from wood and plaster on a stone base, the *donjon* combines strength with beauty, expressed in intricate groupings of ornamented **hipped-and-gabled** roofs.

Himeji Castle was also the warlord's administrative center and home to numerous samurai. Those ranked highest lived closer to the central compound. Beyond the castle walls a bustling town developed as peasants, artists, craftsmen, and merchants moved into the area, attracted by economic opportunities and work prospects. Indeed, castle towns during the Momoyama period experienced considerable growth. Aside from Himeji, other prominent castle towns included Hiroshima, Hikone, and Nagoya. As the Momoyama era progressed, a wealthy, educated group of artists, craftsmen, and merchants emerged as a distinct sector within the townspeople class. Talented artists received commissions to decorate the interiors of castles like Himeji, Buddhist temples, and residences of the nobility and wealthy townsmen. Important rooms, such as audience or guest halls, used for reception and entertainment purposes, were often built in the *shoin* style.

SHOIN

The term *shoin* refers to a style of residence that developed during the Muromachi and Momoyama periods. Formal *shoin*-style reception rooms, as featured in an artist's rendering of the Kojoin guest hall (1601) at the Buddhist temple Onjo-ji, near Kyoto, are characterized by several elements—in particular, a writing nook, a decorative alcove (*tokonoma*), staggered shelves, and floors covered with **tatami** mats (**FIG. 14-30**). Other features associated with the *shoin* room are decorated sliding doors (*fusuma*) and white translucent paper screens (**shoji**). Aside from decoration, these partitions are integral components of an architectural interior, creatively dividing and opening up flowing spaces often devoid of permanent furniture. Traditionally, the activities of daily life—eating, sleeping, writing, reading, and playing or listening to music—took place at floor level.

14-30 • THE KOJOIN GUEST HALL
Onjo-ji, Otsu, Shiga prefecture. Momoyama period, 1601.

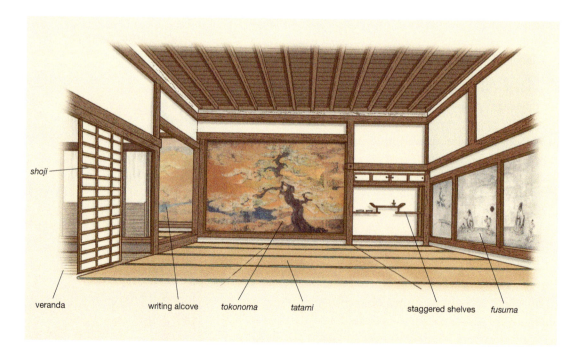

shoji — veranda — writing alcove — tokonoma — tatami — staggered shelves — fusuma

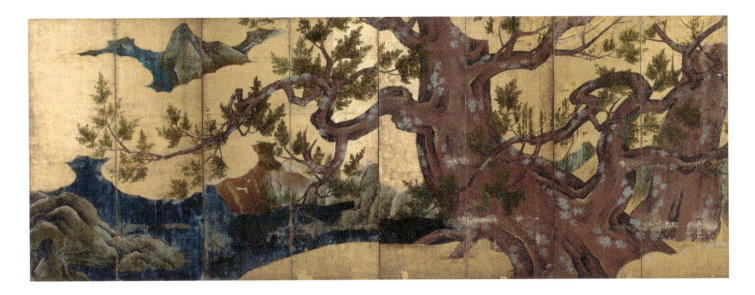

PAINTED SCREENS

Momoyama screens are remarkable for their monumental size (the average screen is approximately 5 feet/1.5 meters tall and 12 feet/3.5 meters long), extravagant use of gold leaf, and diversity of subject matter. Popular subjects include scenes of nature, panoramic views of Kyoto, historic events, seasonal outings to view spring cherry blossoms or fall maples, theatrical performances, and images of Europeans. These themes reflect the varied interests of Momoyama patrons. Three artists in particular excelled at painting large-scale **murals** (wall paintings) and screens: Kano Eitoku (1543–1590), Hasegawa Tohaku (1539–1610), and Kaiho Yusho (1533–1615).

KANO EITOKU As a member of the famous Kano School, patronized by military rulers from the late fifteenth century until 1868, Eitoku was part of a well-established lineage of professional secular artists. Kano School painters perfected a bold style that fused the Chinese monochromatic ink painting tradition (see Chapters 8 and 9) with bright colors and decorative qualities associated with *yamato-e* (Japanese-style) works. They also used gold leaf extensively in their paintings. One theory for the lavish use of gold leaf is that it reflected light and brightened shadowy castle interiors. Shimmering golden artworks depicting secular subjects also transmitted an owner's wealth, marking a shift from gold's earlier associations with the glories of Buddhism.

Eitoku's many patrons included Nobunaga, Hideyoshi, other *daimyo*, and court nobles. In order to satisfy the relentless pace of commissions, Eitoku relied heavily on his atelier of skilled assistants. An eight-panel folding screen attributed to Eitoku is believed to date from 1590, the year of his death (**FIG. 14-31**). The size of the screen is impressive: over 5 feet (1.5 meters) in height and about 15 feet (4.6 meters) in length. Its striking blue and gold composition, dominated by the image of a gnarled cypress

14-31 • Attributed to Kano Eitoku CYPRESS TREE
Momoyama period, 1590. Color, ink, and gold leaf on paper, 5′6⅞″ × 15′1½″ (1.7 × 4.6 m). Tokyo National Museum.

tree, is executed on a series of paper-covered latticework panels joined with hinges.

Eitoku has created a daring design using the sacred cypress tree as a unifying element. The trunk of the lichen-covered cypress, painted in strong brushstrokes, rises up from the foreground plane while its twisted branches reach out toward the dark blue water, greenish rocks, and gold-leaf clouds. The use of gold in both the foreground and the background simultaneously unites and flattens the composition, contributing to the overall decorative effect. Only a section of the tree is visible, alluding to nature as a mighty, eternal force.

Another monumental folding screen by Eitoku, complete with eye-catching **motif**, is entitled *Chinese Lions* (**FIG. 14-32**). In Asia, lions have a long history associated with Buddhism

14-32 • Kano Eitoku CHINESE LIONS
Momoyama period, late 16th century. One of a pair of six-panel screens; color, ink, and gold leaf on paper, 7′4″ × 14′10″ (2.22 × 4.52 m). Imperial Household Collection, Tokyo.

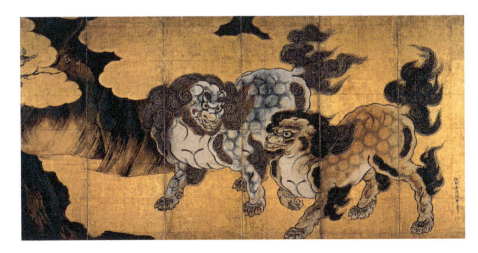

(see Chapter 1, pp. 10–11). The Historical Buddha was known as the "Lion of the Shakya Clan," and images of lions guard Buddhist icons and temples. Inspired by Chinese images of the lion, Eitoku's stylized creatures, boldly outlined in sweeping black brushstrokes, stride toward a rocky landscape. A descendant of Eitoku, Kano Eino (1631–1697), in his *History of Japanese Painting* (1678) described the artist's brushwork as having the "vigor of leaping cranes and fleeing snakes." Once again, gold leaf is lavishly applied throughout the composition, creating spatial ambiguity between the ground and the clouds. Gold spirals in the lions' manes and tails further heighten the screen's decorative appearance. Despite the aesthetic appeal of these lions and veiled references to Buddhist iconography, the muscular strength and fierce expressions of Eitoku's beasts symbolize the warlord's power. According to one tradition, this imposing six-panel screen (originally one of a pair), over 7 feet (2.1 meters) tall and almost 15 feet (4.6 meters) long, decorated Hideyoshi's military headquarters.

HASEGAWA TOHAKU Another dynamic Momoyama artist whose style was shaped by both the Kano School and Chinese monochromatic painting was Hasegawa Tohaku. He was able to work independently of the Kano atelier because of an abundance of wealthy patrons, coupled with his exceptional talent. Although he produced many colorful paintings in the Kano tradition, Tohaku also created large compositions in ink on multipaneled screens—for example, *Pine Forest*, dating from the late sixteenth century (**FIG. 14-33**). In this work, one of a pair of six-panel screens, scattered pine trees emerge from a mist-shrouded landscape only to disappear, affirming the presence of the unseen. Painted solely in ink with subtle tonal gradations, pine trees formed from dark, bold strokes loom out of the void, while those suggested in faint, soft washes recede into the background. Their blurred forms appear to move slightly in the swirling mist. The "empty" spaces awaken the unconscious mind, enhancing the meditative atmosphere of the painting. Many of Tohaku's monochrome paintings, both on screens and on sliding doors, are preserved in Zen temples.

KAIHO YUSHO The son of a samurai and a contemporary of Kano Eitoku and Hasegawa Tohaku, Kaiho Yusho entered Tofuku-ji, a Zen temple in Kyoto, as a child. He left Tofuku-ji at around the age of 40 to pursue a career as an artist. Yusho developed a unique style based on his studies of Chinese ink painting and the Kano tradition, skillfully combining technical mastery with poetic expression. Zen sensibilities also leave their mark on his work, in particular seeing beauty in the mundane, as illustrated in a pair of screens featuring fishing nets drying in the sun (**FIG. 14-34**). Triangular nets draped over tall poles appear like magical tents against a backdrop of gold. Spiky fronds of green marsh grass decorate the right panels while above, broad bands of dark water sweep across the screens. Both the sky and the shore are rendered in gold leaf, enhancing the atmospheric quality of this luminous, yet everyday, scene.

NAMBAN SCREEN PAINTINGS The first Europeans to arrive in Japan were Portuguese traders shipwrecked off the southern coast of Kyushu in 1543, sparking an influx of European traders and missionaries. The Japanese called these foreigners *Nambanjin*, a derogatory term meaning "southern barbarians," as they initially appeared from the south. At first these foreigners, interested mainly in business and in converting people to Christianity, were cordially received. Warlords such as Nobunaga and Hideyoshi,

14-33 • Hasegawa Tohaku PINE FOREST
Momoyama period, late 16th century. One of a pair of six-panel screens; ink on paper, 5'1⅜" × 11'8" (1.56 × 3.56 m). Tokyo National Museum.

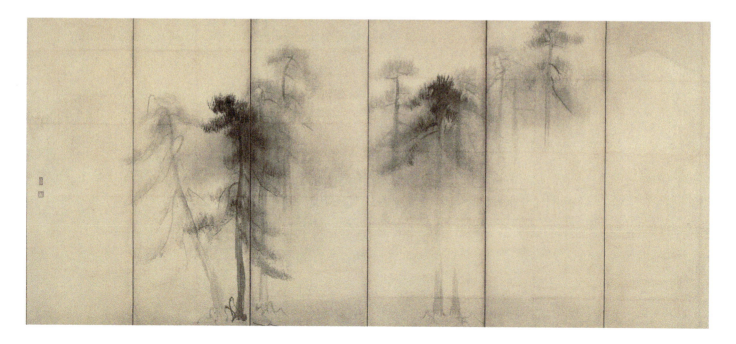

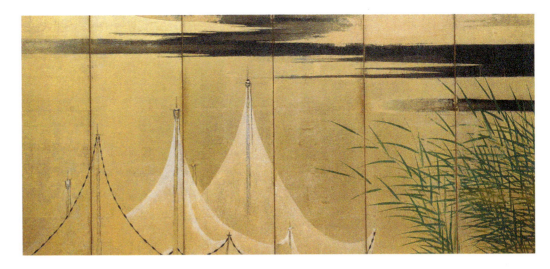

14-34 • Kaiho Yusho
FISHNETS DRYING IN THE SUN
Momoyama period, early 17th century. Pair of six-panel screens; color and gold leaf on paper; each screen 5′3″ × 11′6″ (1.6 × 3.51 m). Imperial Household Collection, Tokyo.

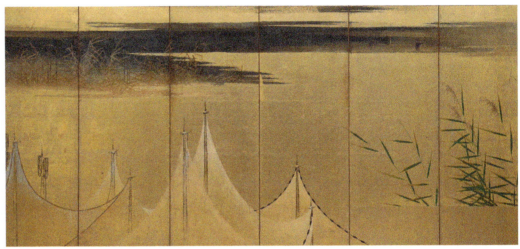

eager to capitalize on trading opportunities and the acquisition of European firearms, tolerated their presence.

The arrival of Europeans by sailing ship became a fashionable subject for screen paintings known as *Namban byobu* (screens of the southern barbarians; **FIG. 14-35**). Artists delighted in painting detailed scenes of the peculiar-looking visitors with their long noses and odd customs, using vivid colors associated with the *yamato-e* tradition. In these two panels from a six-panel screen painted by Kano Naizen (1570–1616) in 1593, a Portuguese galleon, teeming with traders, sailors, African slaves, and Jesuit missionaries clad in black clerical attire, unloads its boisterous human cargo at Nagasaki harbor. This painting was based on sketches made by Naizen at the port. European clothing, with its hats, pantaloons, and capes, as worn by figures in this painting, fascinated the Japanese, and on festive occasions stylish lords dressed up in Western fashions, sometimes adding a rosary or crucifix as a final touch. Even Hideyoshi enjoyed wearing a beaded velvet cape.

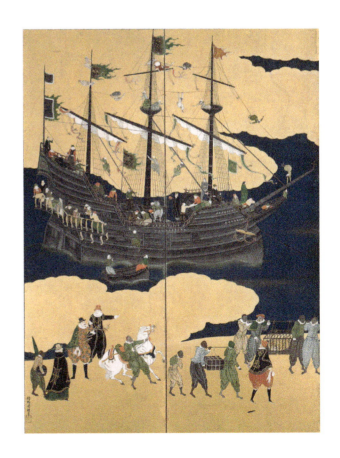

14-35 • Kano Naizen *ARRIVAL OF THE PORTUGUESE*
Momoyama period, 1593. Two panels from a six-panel screen; color and gold leaf on paper, 5′1″ × 11′10⅞″ (1.55 × 3.63 m) overall. Kobe Museum of Namban Art.

Missionary activity steadily increased. By about 1580, over 150,000 Japanese had converted to Catholicism and approximately 100 churches had been built. Christianity's spread was viewed as a threat to governmental authority, and toward the end of the Momoyama era official attitudes towards foreigners changed from tolerance to hostility. Hideyoshi initiated anti-Christian policies, which resulted in the crucifixion of 26 Christians in 1597. Hideyoshi's successor, Tokugawa Ieyasu, delivered the final blow in 1614 by expelling all Christians and banning Christianity in Japan.

TEXTILES: NOH ROBES

Momoyama opulence seeped into a wide range of artistic expressions, including textiles. In particular, fine examples of silk robes worn for Noh performances have survived. Sericulture, or silk production, had reached Japan via Korea around 300 CE. Over the centuries, Japanese weavers developed sericulture techniques introduced by artisans from the Asian continent. During the cosmopolitan Momoyama epoch, Japan's textile industry, responding to extravagant tastes of wealthy patrons, absorbed the latest textile innovations from both China and Europe.

Popular methods of decorating high-quality fabrics during the sixteenth century included such techniques as *surihaku* and *nuihaku*. An elegant Noh robe showcases the *surihaku* technique, in which gold- or silver-leaf designs are applied to fabric with paste (**FIG. 14–36**) to create a design of gold-leaf grapevines laden with fruit and square decorative papers affixed to purple silk. Another example shows how *surihaku* could be combined with embroidery (*nuihaku*) to create a Noh robe ablaze with flowery images and plank bridges on red and white squares (**FIG. 14–37**). Such robes, worn as outergarments by actors in performances, delighted Hideyoshi, an enthusiastic patron of Noh and supporter of Kyoto's silk-weaving industry.

In addition to promoting outward displays of wealth and power, leaders also cultivated the tea ceremony, an antidote to excess with its emphasis on simplicity and spiritual reflection. Warriors, aristocrats, and wealthy merchants found refuge from life's challenges in the sanctuary of a simple teahouse nestled within the tranquil gardens of their residences.

14-37 • NOH ROBE WITH DESIGN OF FLOWERS AND PLANK BRIDGES
Momoyama period, 16th century. Embroidery (*nuihaku*) and gold foil (*surihaku*) on plain-weave silk, height 4′6⅛″ (1.376 m). Tokyo National Museum.

14-36 • NOH ROBE WITH DESIGN OF GRAPEVINES AND DECORATIVE PAPER
Momoyama period, 16th century. Gold foil (*surihaku*) on purple plain-weave silk, 3′5″ × 1′7″ (103.9 × 48.5 cm). Tokyo National Museum.

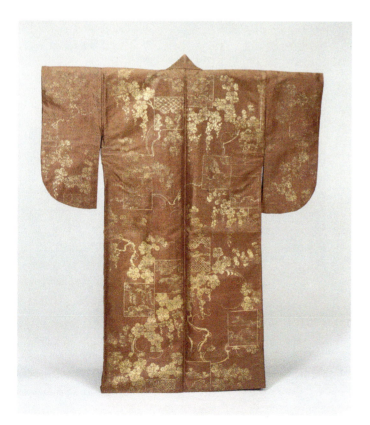

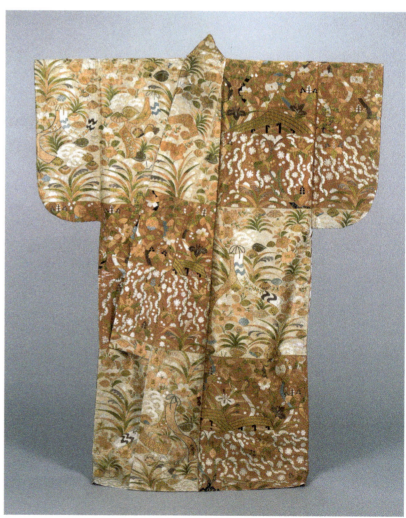

TEA CEREMONY

Tea, valued for its medicinal properties and purported ability to promote longevity, arrived in Japan from China during the eighth or ninth century, brought by Japanese Buddhist monks returning from their studies abroad. Monks used tea as a stimulant to keep awake during meditation. By the sixteenth century tea was a popular drink with people of all classes. Japan's tea ceremony, *chanoyu*, a refined aesthetic experience practiced by society's elite in the Momoyama period, developed during the earlier Muromachi era.

Chanoyu evolved from humble roots—the simple tea-drinking customs of Zen Buddhist monks. In the hands of Murata Shuko (1423–1502), a student of Zen Buddhism who rose from the merchant class to become tea master to the shogun Ashikaga Yoshimasa, the concept of a ceremony evolved combining Zen sensibilities, the beauty of art, and appreciation for the mundane. Shuko instituted a type of tea ceremony known as *wabicha* (*wabi*-style tea). The *wabi* aesthetic values simplicity, austerity, and understatement (see pp. 342–343). In keeping with this aesthetic, Shuko advocated that the tea ceremony take place in a small room and be performed with minimal utensils. One of the greatest tea masters, Sen no Rikyu (1521–1591), took this advice to heart by designing a tiny, rustic teahouse, only two tatami mats in size (approximately 6 feet/1.8 meters square), which accommodated two or three people at a ceremony. Unlike earlier tearooms, which were part of existing buildings, Rikyu's teahouse was built as a separate structure in a garden setting.

SEN NO RIKYU The son of a wealthy Sakai merchant family, Sen no Rikyu became tea master to both Nobunaga and his successor, Hideyoshi. Drawing on his studies of Zen Buddhism at Daitoku-ji and his preference for *wabicha*, Sen no Rikyu is credited with refining and codifying a style of tea ceremony that endures today. In particular, he emphasized the importance of four important principles: harmony, respect, purity, and tranquility, transmitted through the teahouse's austere architecture, integration with nature, contents, and tea rituals.

TAIAN TEAHOUSE, MYOKIAN TEMPLE Partly inspired by the rustic simplicity of a Japanese farmhouse and hermit's hut, Taian teahouse at Myokian, a Zen Buddhist temple near Kyoto, is attributed to Sen no Rikyu (**FIG. 14–38**). Built in 1582, this small teahouse, about nine by nine feet (2.7 × 2.7 meters), includes a one-mat area called the *katte*, where preparations for the ceremony take place, and a two-mat space for guests. Designed in accordance with the *wabi* aesthetic, Taian has a wood-shingle roof, rough earthen walls, exposed wooden posts, and paper-covered windows set at various heights. An important feature of Taian, and indeed teahouses in general, is the alcove (*tokonoma*) where the host displays an artwork and/or seasonal flower arrangement (*ikebana*) for guests to contemplate. Subtle details accent this artfully humble environment. The cedar post supporting the left side of the *tokonoma* is deliberately prized for its unfinished, slightly bent,

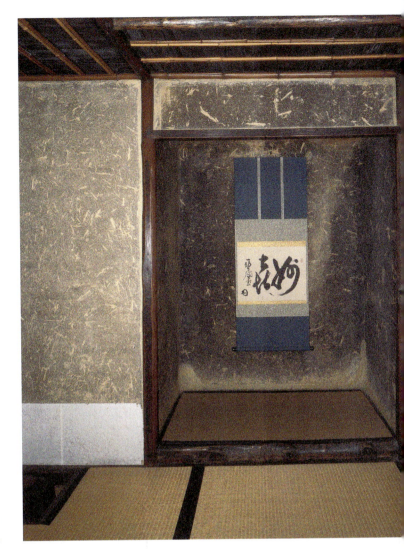

14–38 • Sen no Rikyu TAIAN TEAHOUSE (INTERIOR VIEW)
Myokian temple, Kyoto prefecture. Momoyama period, 1582.

appearance. Known as the "heart post," it symbolizes the relationship between house and earth and, by extension, the bond between humankind and nature. Another understated touch is the asymmetrical arrangement of the tatami mat, which is not aligned with the heart post.

Beauty is found in unexpected places. Ashes sculpted into wavelike shapes may decorate the sunken corner hearth where water is boiled in an iron kettle. As the Japanese philosopher Yanagi Soetsu (1889–1961) once wrote, "The Way of Tea is the religion of beauty."

Entry into Taian teahouse is through a small sliding door, an innovation of Sen no Rikyu, who believed that everyone should be equal in the tearoom (**FIG. 14–39**). Regardless of status, guests must stoop and crawl into the softly illuminated interior, leaving their weapons and worldly concerns behind.

THE WAY OF TEA The tea ceremony is a multifaceted art that requires the participation of both tea master and guests. It takes

The tea garden (*roji*), functions as a transitional space between the busy outside world and the tranquil realm of the teahouse. Guests walk slowly through an artfully arranged landscape featuring gates, fences, stones, water, and vegetation to participate in the meditative practice of the tea ceremony. For many tea masters the tea garden, complete with winding path, symbolizes the journey from town to a hermit's mountain retreat.

THE TEA GARDEN, URASENKE, KYOTO
Designed by Sen no Rikyu's grandson Gempaku Sotan (1578–1658).

The tea garden is largely filled with evergreen trees and shrubs, suggesting the peaceful atmosphere of a remote mountain landscape. Flowering plants are shunned to avoid distraction and to heighten the beauty of a single bloom displayed inside the tearoom in the alcove (*tokonoma*).

Stepping stones (*tobi-ishi*) create attractive patterns on the ground, protect the guests' footwear from mud and moisture, and direct their footsteps. Guests walking slowly on the uneven stones are compelled to focus on the path. Larger stones allow the guest to pause and savor the garden's beauty. Moss-covered stones symbolize the passage of time.

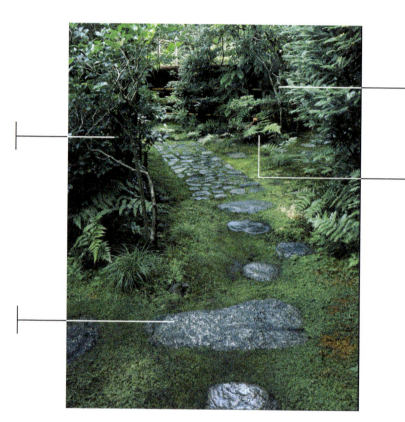

Stone lanterns (*toro*) provide light (the tea ceremony often takes place during the early morning or evening) and atmosphere.

Stone basin filled with water (*tsukubai*) where guests rinse their hands and mouths to purify themselves before entering the teahouse. A bamboo ladle rests on the basin.

years of training to become an accomplished tea master. There are many variations within the tea ceremony regarding levels of formality, presentation styles, types of food served, and duration; a formal ceremony steeped in complex procedures can last for four hours. The following is a brief description of the traditional tea ceremony formulated by Sen no Rikyu. However, it is important to remember that despite the ritual's highly orchestrated character, no two tea ceremonies are alike just as no two teahouses are identical; there is room for creative spontaneity within the ceremony.

A small group of guests walk along a winding garden path toward the teahouse (see Closer Look, above). They pause at a stone water basin to rinse their hands and mouths, an act of physical and spiritual purification. Upon reaching the teahouse,

14-39 • TAIAN TEAHOUSE
Myokian temple, Kyoto prefecture. Momoyama period, 1582.

guests enter through the tiny door to experience the Way of Tea. While waiting for the host's arrival, guests, seated on tatami mats, contemplate the floral arrangement or scroll hanging in the *tokonoma*. Emanating calm, the host appears and carefully prepares the frothy green tea in a prescribed manner. The process of serving and drinking tea also follows precise codes of conduct—for example, the host presents the bowl of tea with its best side facing forward to the guest. After receiving the bowl with both hands, the guest turns it clockwise to avoid sipping from the bowl's finest angle. After tea is served, tea implements—for example, the bamboo tea scoop and whisk, lacquered tea caddy, and ceramic bowls—are put on display for guests to examine. Deceptively simple in appearance, these utensils are carefully crafted with attention to form and texture. Conversations about the implements or artifact in the *tokonoma* contribute to the teahouse's peaceful atmosphere. Discussions about politics or business are avoided. Once the ceremony is over, guests quietly leave the intimate gathering, refreshed in mind, body, and soul.

RAKU TEA BOWLS Raku, which means "enjoyment" or "pleasure," is a famous ceramic ware associated with the tea ceremony. During more opulent manifestations of the ceremony, imported Chinese porcelains were prized tea vessels. Sen no Rikyu rejected the smooth perfection of Chinese porcelain in favor of Chinese and Korean peasant ceramics and rustic, irregular Japanese bowls reflective of the *wabi-sabi* aesthetic. Some of Rikyu's favorite tea bowls included raku ware, developed especially for the tea ceremony by Kyoto tile-maker Chojiro (1516–1592) under the tea master's direction. The son of a Korean artisan, Chojiro created unevenly shaped and glazed tea bowls, known later as Raku after an appreciative Hideyoshi awarded a gold seal inscribed Raku to Chojiro's apprentice, Jokei. This honor was in memory of Chojiro, who had died six years before. Chojiro's legacy lives on in modern-day Kyoto, where his descendants continue to produce Raku ware.

Traditionally Raku, as illustrated in a late sixteenth-century tea bowl named *Yugure* (*Twilight*) by Chojiro, was not made using the potter's wheel but carved and molded by hand from a lump of soft clay (**FIG. 14–40**). A colored glaze was applied to the uniquely crafted bowl before it was fired for a short time at a low temperature, about 1,850 degrees Fahrenheit (1,000 degrees Celsius). Once the glaze formed, the vessel was extracted from the kiln with iron tongs and left to cool. This process resulted in an irregularly shaped and glazed bowl that complemented the tea master's respect for the imperfect. The bowl's undulating rim is pleasing to the lips. Its tall sides and wide, flat bottom are designed to accommodate the movements of the bamboo whisk. Light and porous, Raku bowls contain insulation qualities that simultaneously maintain the tea's heat and protect the user's hands. Names were given to bowls based on a variety of factors, including their physical appearance or literary or historical associations inspired by their designs. *Twilight*, the name given to

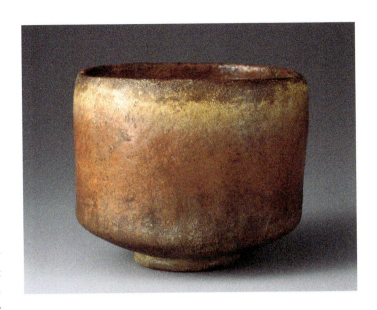

14–40 • Chojiro *YUGURE (TWILIGHT)*
Momoyama period, late 16th century. Red Raku ware; glazed earthenware, height 3⅝″ (9 cm). Gotoh Museum, Tokyo.

Chojiro's bowl, is fitting. The soft reds, smoky grays, and mottled hues conjure up the last rays of light before nightfall.

Twilight is an example of red Raku, one of two main types of Raku ware. The other is black Raku. Both types accentuate the tea's attractive green color. Hon'ami Koetsu (1558–1637), a talented calligrapher, painter, and potter, created an early seventeenth-century black Raku tea bowl named *Shichiri* after one of its owners, Shichiri Hikoemon (**FIG. 14–41**). The bowl's irregular shape, comprising four petals, is covered in a black lustrous glaze formed from a mixture of iron and crushed rock extracted from Kyoto's Kamo River. Patches of glaze were deliberately scraped

14–41 • Hon'ami Koetsu *SHICHIRI*
Momoyama-Edo period, early 17th century. Black Raku ware; glazed earthenware, height 3⅜″ (8.6 cm). Gotoh Museum, Tokyo.

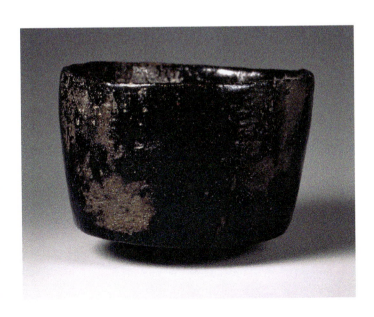

The history of Japan from the Kamakura period through the Momoyama era chronicles its struggles and triumphs as a country moving from a medieval society toward a pre-modern nation. Themes of warfare and serenity mark this period. Where many chose to fight, others fled from the chaos. Warring lords like Oda Nobunaga went on the offensive and built huge castles to intimidate the enemy. For those who despaired of worldly woes, taking Buddhist vows and entering monastic life was an option, although feuding monks and monasteries were not uncommon. Another more unusual choice, as seen in the case of courtier and poet Kamo no Chomei (1155–1216), involved renouncing the world and retreating to a hermit's hut (a precursor of the modest tea hut) in the mountains.

Below is an extract from Kamo no Chomei's *An Account of a Ten-Foot-Square Hut* (Keene, 1960) written in 1212.

Now that I have reached the age of sixty, and my life seems about to evaporate like the dew, I have fashioned a lodging for the last leaves of my years. It is a hut where, perhaps, a traveler might spend a single night; it is like the cocoon spun by an aged silkworm. This hut is not even a hundredth the size of the cottage where I spent my middle years.

...The present hut is of no ordinary appearance. It is a bare ten feet square and less than seven feet high. I did not choose this particular spot rather than another, and I built my house without consulting any diviners. I laid a foundation and roughly thatched a roof. I fastened hinges to the joints of the beams, the easier to move elsewhere should anything displease me... A bare two carts would suffice to carry off the whole house...

...I have built a little shelf on which I keep three or four black leather baskets that contain books of poetry and music and extracts from the sacred writings. Beside them stand a folding koto and a lute.

Along the east wall I have spread long fern fronds and mats of straw which serve as my bed for the night. I have cut open a window in the eastern wall, and beneath it have made a desk. Near my pillow is a square brazier in which I burn brushwood.

To the north of the hut I have staked out a small plot of land which I have enclosed with a rough fence and made into a garden. I grow many species of herbs there.

The following passage is from *They Came to Japan: An Anthology of European Reports on Japan, 1543–1640* (Cooper, 1981), a collection of writings by Europeans who visited Japan during the sixteenth and seventeenth centuries. Compiled by Michael Cooper, this extract, written by the Portuguese Jesuit Luis Frois (1532–1597), describes Oda Nobunaga's luxurious Azuchi Castle (later destroyed).

On top of the hill in the middle of the city Nobunaga built his palace and castle, which as regards architecture, strength, wealth and grandeur may well be compared with the greatest buildings of Europe. Its strong and well constructed surrounding walls of stone are over 60 spans in height and even higher in many places; inside the walls there are many beautiful and exquisite houses, all of them decorated with gold...and in the middle there is a sort of tower which they call tenshu.... It consists of seven floors, all of which, both inside and out, have been fashioned to a wonderful architectural design.... The [interior] walls are decorated with designs richly painted in gold and different colours, while the outside of each of these stories is painted in various colours.... As the castle is situated on high ground and is itself very lofty, it looks as if it reaches to the clouds and it can be seen from afar for many leagues. The fact that the castle is constructed entirely of wood is not at all apparent either from within or from without, for it looks as if it is built of strong stone and mortar.

To one side of the castle Nobunaga built another separate palace, although the buildings are linked by corridors of great perfection and elegance. There are many attractive and fine gardens, which differ from ours in practically every respect. The wealth of the apartments, the artistry and workmanship, the excellent wood, the general neatness, the matchless and distant view commanded by all these places—all this caused great admiration.

away to reveal the brown earthenware underneath, adding visual and textural interest as well as conveying the *sabi* ideal of a time-worn vessel. Treasured bowls, admired for their aesthetic appeal, association with important individuals, and how naturally they fit into the hands, are also valued for their spiritual properties.

Although political discussions are avoided in the tearoom, the political power of an accomplished tea master should not be underestimated. As Sen no Rikyu's star rose as tea master to Hideyoshi, so did his political influence and economic status as the shogun's social and diplomatic intermediary. Rikyu's rise to power may have been his undoing. For reasons that are still debated by scholars, Hideyoshi ordered Rikyu to commit ritual suicide in 1591, a command he later regretted.

WOMEN AND THE TEA CEREMONY Historical records confirm that women participated in tea gatherings as early as the late sixteenth century. However, before to the nineteenth century, women's involvement with the tea ceremony in an official capacity was limited and tea practice remained predominantly a masculine culture until after 1894, when women were permitted to study, teach, and publicly perform the ceremony. By the twentieth century, tea practice was entrenched in the high-school

curriculum and was a popular way for women to learn manners, etiquette, and deportment. In contemporary Japan, tea practice is viewed as a women's activity, although men still dominate the high-level positions in established tea schools. Serious practitioners of *chanoyu*, whether female or male, understand that to become a true tea master, it is not enough to be a proficient host; the Way of Tea comes from the heart. In the words of Sen no Rikyu:

> Many though there be
> Who with words or even hands
> Know the Way of Tea.
> Few there are or none at all,
> Who can serve it from the heart.

JAPAN'S INVASION OF KOREA

Japan's ceramic industry received a boost from Hideyoshi's ruthless yet unsuccessful invasions of Korea between 1592 and 1598. Hideyoshi attacked Korea as a prelude to conquering China, an unfulfilled dream of the Japanese warlord. Before defeat, Japanese troops raped, killed, and looted throughout Korea. Temples and palaces were demolished and fine cultural treasures destroyed or stolen. Thousands of Korean prisoners were brought back to Japan to work as indentured laborers, among them several hundred potters

intentionally abducted to produce ceramics for *daimyo* with commercial interests in ceramic production. At the time of Hideyoshi's Korean campaigns, China and Korea's ceramic industries were technically more advanced than their Japanese counterparts. Porcelain technology, perfected in China during the fourteenth century, had spread to Korea, and by the late sixteenth century Korean porcelains were highly prized by the Japanese. One Korean potter, Ri Sampei (1579–1655), captured by the *daimyo* Nabeshima Naoshige (1538–1618), was taken to the Arita area of Kyushu, where he discovered porcelain clay in 1616. Early Japanese porcelains, fired in multichambered kilns, imitated Korean and Chinese wares; however, fine porcelains with distinctive Japanese designs were produced during the Edo period (1615–1868) (**FIG. 14–42**). This colorful porcelain dish is decorated with maple leaves carried along by a rushing stream. In typical Japanese fashion, the motif combines bold patterns with empty space.

Hideyoshi's imperialist ambitions ceased with his death in 1598, terminating Japan's aggressive foreign policy until the nineteenth century. Tokugawa Ieyasu (1542–1616), the third unifier of Japan, established the powerful Tokugawa shogunate in 1615, inaugurating an epoch of relative peace for more than 250 years. The Tokugawa military government was based in Edo (present-day Tokyo), and so the term Edo period refers to the era of Tokugawa hegemony.

14-42 • DISH WITH MAPLE LEAVES
Edo period, 18th–19th century. Porcelain (Nabeshima ware), diameter 8⅛″ (20.5 cm). British Museum, London.

CROSS-CULTURAL EXPLORATIONS

14.1 Discuss three ink paintings by Sesshu Toyo. To what extent was he influenced by the work of Chinese artists such as Fachang Muqi? How does Sesshu's work deviate from Chinese sources?

14.2 Discuss the fifteenth-century Zen garden at Ryoan-ji. What does it have in common with a Chinese or Korean garden of your choice from the same era? How is Ryoan-ji's garden distinctive?

14.3 Discuss the tea ceremony during the Momoyama period. Is there a place for the traditional tea ceremony in our modern multicultural world? In what ways can the practice of tea enhance our lives? Or is it an elitist pastime available only to the wealthy?

14.4 Why did Hideyoshi invade Korea? Discuss the impact of Japan's invasions of Korea on Korean culture. How was Japanese culture affected by attacking Korea?

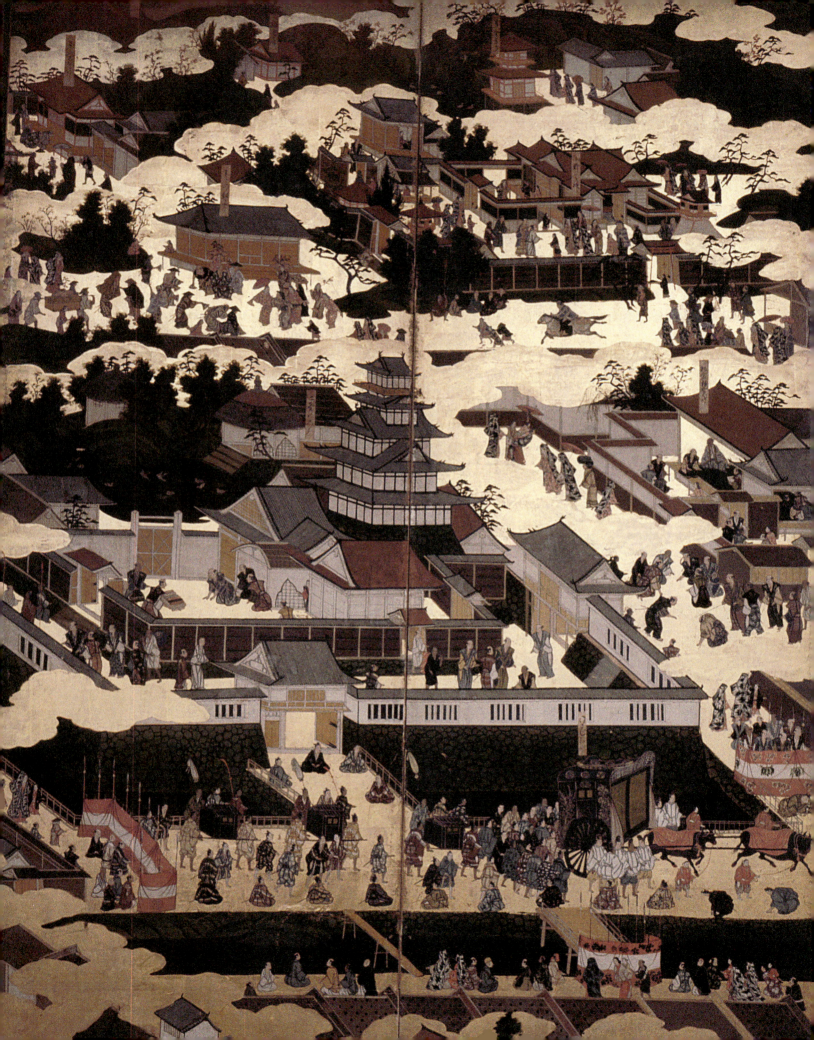

15

CHAPTER

From Isolation to Internationalism: Edo Period to the Present

To come to know your enemy, first you must become his friend, and once you become his friend, all his defenses come down. Then you can choose the most fitting method for his demise.

Tokugawa Ieyasu (1542–1616)

Tokugawa Ieyasu, a ruthless and shrewd military strategist, ended several centuries of bitter civil wars by eliminating all rivals and gaining control of Japan in 1615. As shogun, a title conferred upon him by the emperor in 1603, he established his headquarters at Edo (present-day Tokyo), after which the Edo period (1615–1868) is named. The era is also known as the Tokugawa period after the shogunate that ruled for over 250 years.

Under the Tokugawa shogunate, political stability and economic growth prevailed but at the cost of a harsh and repressive regime. Tokugawa rulers adopted a form of Neo-Confucian ideology that demanded unquestioning loyalty to the shogun and state, and the art and architecture they sponsored served to reinforce this (**FIG. 15-1**). Wary of the destabilizing influence of foreigners, especially Westerners seeking converts to Christianity, the Tokugawa shogunate implemented an isolationist policy through various edicts (1633–1639). Foreigners

were expelled from Japan and Christianity outlawed. In addition to banning foreigners, Japanese citizens were forbidden to leave the country. A few exceptions to the closed-doors policy included a community of strictly controlled Chinese merchants in Nagasaki and a group of Dutch traders confined to a small island in Nagasaki harbor. Trade and diplomatic relations also continued with Korea. Despite this policy of enforced isolation, foreign ideas and influences infiltrated Japan, in particular through books, much to the delight of Japanese scholars, artists, and scientists.

CLOSED DOORS: EDO PERIOD

Edo, the new administrative capital and site of Tokugawa Ieyasu's castle (destroyed in 1657), grew quickly from a sleepy fishing village in the sixteenth century to a bustling city of about 1 million people by the early eighteenth century. **Daimyo** (regional lords), ordered by the **shogunate** to live a portion of every year in Edo, contributed to the surge in population. A principal intention behind this command was to stifle any rebellious behavior by ambitious *daimyo*. When the lord visited his provincial residence, his family had to remain in Edo, virtually as hostages. Also, maintaining a sumptuous mansion in the capital, complete with numerous retainers, was very expensive, leaving little money to finance antigovernment activities. *Daimyo* competed among themselves to build and furnish the finest homes in Edo, drawing on the services of a growing class of artisans and merchants.

Edo society was highly structured, with distinctive class divisions. The shogun, imperial family, courtiers, and *daimyo* occupied the highest levels, followed by the samurai/government administrators. Farmers comprised the next rung on the

15-1 • SHOGUNAL PROCESSION IN FRONT OF NIJO CASTLE AND THE NINONMARU PALACE (DETAIL)
Edo period, early 17th century. From a pair of screens depicting scenes of Kyoto; color and gold leaf on paper; each screen 5'1⅖" × 11'6¾" (156 × 352.5 cm). Burke Collection, New York.

1

social ladder, while artisans and merchants—known as the townspeople (*chonin*)—belonged to the lowest classes. *Chonin* formed the majority of the population in Edo and other growing cities, such as Osaka. In a surprising twist, by the end of the seventeenth century many urban merchants outstripped the samurai in accumulated wealth, which contributed to their unofficial rise in status. Literacy spread throughout all sectors of society. A more educated population, coupled with an expanding national economy based on money, contributed to a rich cultural environment, ripe with patrons from all classes. Artists created works in many different styles to appeal to these consumers' broad range of tastes. Although Buddhism and Shinto remained an integral part of Edo society, the art produced during this era is noticeably more secular in subject matter.

ARCHITECTURE

Recognized by UNESCO as a World Heritage Site, Nijo Castle originated in 1601 when Tokugawa Ieyasu ordered the *daimyo* in Western Japan to contribute funds, materials, and labor to the building of his Kyoto residence (see FIG. 15-1). A palatial structure with beautiful gardens, Nijo Castle was finally completed in 1626. by Ieyasu's grandson, Tokugawa Iemitsu. Although the shogun's primary home was Edo, he stayed at Nijo Castle when he visited Kyoto, the ancient imperial city where the royal court still resided. The Ninomaru palace, set in the castle's gardens, served as the shogun's living quarters, offices, and reception rooms (FIG. 15-2).

The palace, largely constructed from Japanese cedar wood (*hinoki*), consists of five interconnecting buildings laid out along a diagonal axis. As a security measure to alert its residents to intruders, the corridors were designed with "nightingale floors," which chirped like birds when walked upon. One of the most striking rooms is the Ohiroma (Great Hall), where the shogun received important guests, including the emperor. Emphasizing his power and authority, the shogun sat on a raised platform. Walls and sliding doors are beautifully decorated with paintings by Kano Tan'yu (1602–1674), a member of the renowned Kano family (see Chapter 14, pp. 343–346). On the wall behind the shogun's dais, a monumental pine tree set against a backdrop of

shimmering gold leaf symbolizes the shogun's strength, wealth, and right to rule. Overhead, the **coffered** ceiling (featuring decorative recessed panels), accented with gilt metal fittings, is brightly painted in vibrant patterns. Nijo Castle rivaled Kyoto's imperial palace in splendor—a deliberate ploy to showcase the shogun's cultural sophistication and promote his political supremacy over the emperor.

KATSURA IMPERIAL VILLA Although dispossessed of power, the emperor was charged by the shogun with keeping the nation's cultural and spiritual traditions alive through artistic, ceremonial, and religious activities. For the next two centuries the emperor and nobility, with limited funds, fulfilled this role under the watchful eye of the shogun's representatives.

Located on the Katsura River southwest of Kyoto, Katsura Imperial Villa was built in stages between about 1620 and 1663 as a country retreat for Prince Toshihito (1579–1629) and his descendants (FIG. 15-3). It was designed as a place for contemplation and creative pursuits. Even the location had literary associations: In *The Tale of Genji*, the novel dating from the courtly Heian era (794–1185) and one of Prince Toshihito's favorite books, Prince Genji enjoyed moon-viewing parties at his palace overlooking Katsura River (see Chapter 13, pp. 319–321). Toshihito's villa includes a moon-viewing platform with a bamboo floor (visible on the front of the building in FIG. 15-3), where host and guests appreciated the moon's beauty while writing poetry, listening to music, and sampling edible treats.

Nature is an integral part of Katsura Imperial Villa. The rooms of the main building are staggered along a diagonal axis, offering orchestrated views of the gardens. In fine weather the sliding white *shoji* panels were partly opened or completely removed to allow a harmonious fusion between interior and exterior spaces. Slender wooden columns, left unpainted, rest on large stones embedded in the earth. Katsura's close relationship between building and setting, inclusion of raw materials left in their natural state, and lack of ornamentation borrow from tea ceremony architecture but on a large scale. Exhibiting qualities of restraint and refinement, Katsura Imperial Villa typifies a

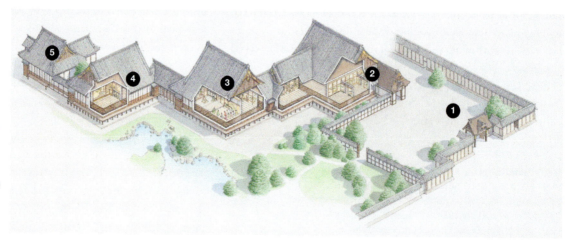

15-2 •
NINOMARU PALACE
Nijo Castle, Kyoto.
1. Entrance to the Ninomaru palace
2. Small reception rooms
3. Ohiroma (Great Hall)
4. Kuroshoin (inner audience chamber)
5. Shiroshoin (shogunal living quarters)

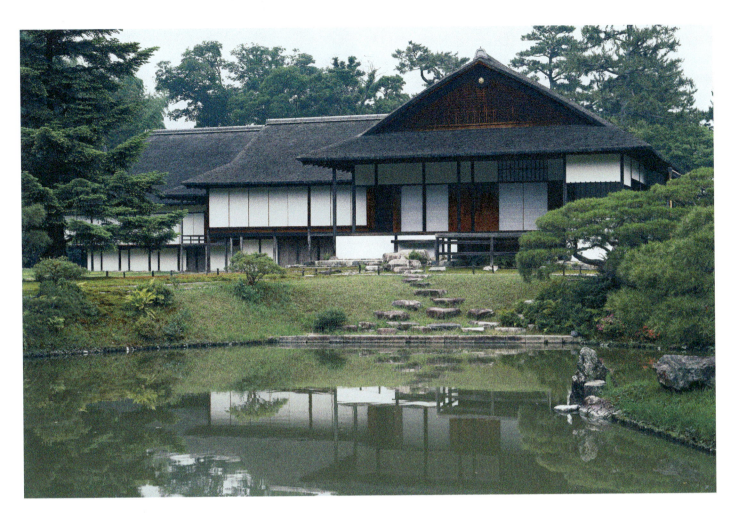

15-3 • KATSURA IMPERIAL VILLA
Kyoto. Edo period, ca. 1620–1663. Imperial Household Agency.

15-4 • INTERIOR, KATSURA IMPERIAL VILLA
Kyoto. Edo period, ca. 1620–1663. Imperial Household Agency

style known as *Sukiya*, or "room or building of taste." The term refers to minimal decoration but not an absence of artfulness. Indeed, the building's apparent simplicity is deceptive. Master craftsmen/artists paid careful attention to proportion, texture, and detail. Inside *tatami*-floored rooms, sliding screens (*fusuma*) decorated with black-and-white or subtly colored paintings by members of the acclaimed Kano family catch the eye, as do door handles shaped like baskets of flowers, and shelves made from 18 exotic woods, including ebony, rosewood, Bombay black wood, Chinese apple, and Japanese hazel (**FIG. 15-4**). Encapsulating the ideals of Japanese residential architecture, this timeless building inspired such Western architects as Walter Gropius and Le Corbusier in the early twentieth century.

PAINTING

In the world of painting, members of the Kano School continued to dominate as official artists to the shoguns. Their numerous studios also provided the imperial court and newly affluent merchants with a steady

supply of high-quality artworks. However, with the changing face of Edo society, other schools emerged, offering different styles of painting. One of the first influential alternative schools to surface was the Rinpa School.

RINPA SCHOOL "Rinpa," a term coined in the modern era, combines the word *rin* in the name of one of its famous artists, Ogata Korin (1658–1716), with *pa*, meaning "school." The Rinpa School was comprised of painters and decorative artists who shared an interest in Japanese literature and revitalizing the aesthetics of courtly art from the late Heian period, rather than an organized school like the Kano, with its emphasis on lineage and training. Two closely connected artists from an earlier century—Hon'ami Koetsu (1558–1637) and Tawaraya Sotatsu (fl. 1600–1630s)—laid the foundations of the Rinpa style. Rinpa works, inspired by Heian-era *yamato-e* paintings and craft ornamentation, are generally characterized by bold colors, complex patterns, and lavish use of silver and gold (see Chapter 13, **FIG. 13–22**). Rinpa-style art, which originated in Kyoto, appealed in particular to the aristocracy, cultured military lords, and the merchant elite. Rinpa artists produced artworks in a variety of media, including lacquer and ceramic, sometimes collaborating on projects together or working closely with craftsmen for unique results.

Born into a wealthy Kyoto family of polishers and appraisers of swords, Hon'ami Koetsu represents the new type of educated, upwardly mobile man from the *chonin* class who enjoyed connections with nobility and military leaders. An accomplished calligrapher, Koetsu also excelled as a lacquerware designer, tea ceremony master, and potter (see Chapter 14, **FIG. 14–41**). Koetsu's *Boat Bridge* writing box, made from lacquered wood, sprinkled gold, and lead, is a wonderful example of Rinpa art forged from a close collaboration between artist and craftsman (**FIG. 15–5**). Koetsu's innovative design of boats supporting a temporary bridge was inspired by Minamoto Hitoshi's tenth-century poem about the boat bridge at Sano, northeast of Kyoto. In his poem, Hitoshi expresses how crossing the bridge triggers thoughts about life's uncertainties. Parts of the poem written in silver characters are scattered over the curved lid. Koetsu deliberately leaves out the words "bridge" and "boat" as they are pictorially represented, heightening the dynamic relationship between image and text. It is an extraordinary composition as the bridge, formed from a band of lead, is viewed from above while golden boats float below in patterned waves.

In 1615, Koetsu established a Buddhist community and artistic hub outside Kyoto at Takagamine, on land given to him by Tokugawa Ieyasu. According to a diagram of Takagamine houses and their owners, the settlement included members of Koetsu's family and colleagues; however, the name of his close collaborator Tawaraya Sotatsu does not appear on the map. Like Koetsu, Sotatsu came from the upper ranks of the merchant class. Records show that he owned a shop in Kyoto that sold paintings, painted fans, and decorated paper. Admired for

15-5 • Hon'ami Koetsu ***BOAT BRIDGE***
Edo period, early 17th century. Writing box, lacquered wood with sprinkled gold and lead, 9½ × 9 × 4⅜″ (24.2 × 22.9 × 11.8 cm). Tokyo National Museum.

his abilities as a painter, Sotatsu joined forces with Koetsu on numerous projects, including the production of beautiful picture scrolls combining poetry, calligraphy, and painting. In the *Deer Scroll*, created around 1610, Koetsu's elegant calligraphy is inscribed on paper exquisitely painted by Sotatsu (**FIG. 15–6**). On a vast length of paper (only a small detail is shown here) Sotatsu depicted deer in a misty setting using gold and silver paint. Koetsu then wrote 28 poems, selected from the thirteenth-century anthology *Shin Kokinshu*, on this decorated surface. Both the imagery and the poems refer to fall. In Japanese art and literature the deer is a symbol of fall. Sotatsu painted the deer in a wide variety of poses, as they stand alone, in pairs, or in a herd. In style, too, there is variation, ranging from fleshy forms composed of subtle gradations of color to mere outlines as deer disappear into the mist.

As his career progressed, Sotatsu distinguished himself as a painter of large, decorative screens. Among his most famous works is a pair of six-panel folding screens called *Waves at Matsushima* because some scholars believe the paintings depict Matsushima (Pine Islands), a famous scenic spot near Sendai in northeastern Japan (**FIG. 15–7**). The screens are signed Sotatsu Hokkyo. "Hokkyo" is a Buddhist honorary title awarded to accomplished artists. Sotatsu captures the essence of the landscape's rugged beauty through an innovative composition, where the main elements of the painting—roaring waves, rocky islands, gnarled pines, and sand banks—sweep across the screens in a symphony of color, pattern, and movement. Pine-clad islands painted in watery shades of blue, green, and brown are battered by foam-flecked waves rendered in swirling lines

15-6 • Hon'ami Koetsu (calligraphy) and Tawaraya Sotatsu (painting) *DEER SCROLL* **(DETAIL)**
Edo period, ca. 1610. Handscroll, ink, gold, and silver on paper, 13⁷⁄₁₆″ × 30′6³⁄₁₆″ (34.1 × 930.1 cm). Seattle Art Museum, Seattle. Gift of Mrs. Donald E. Frederick 51.127

of ink and gold. The rocks' mottled appearance evolved from a technique popularized by Sotatsu known as *tarashikomi*, where ink and colors are dropped onto existing areas of wet ink and pigments, to form their own painterly designs. Like a seabird in flight or a storm-tossed boat, the spectator's viewpoint rises and falls with the scenery's changing perspective. Flat areas of gold leaf on the right screen resemble a cloud formation only to reappear on the left screen as a sand spit with pine trees growing from its glistening surface. Sotatsu's daring explorations of form,

pattern, and surface decoration, amplified by dramatic contrasts in style and technique, influenced later generations of artists.

Although Koetsu and Sotatsu are now regarded as originators of the Rinpa style, it was Ogata Korin (1658–1716) and his younger brother Kenzan (1663–1743) who rejuvenated the artistic practices of these earlier artists and, as mentioned earlier, attracted the title Rinpa School.

Korin and Kenzan were well-educated sons of a rich textile merchant in Kyoto. Their father owned a fashionable shop that

15-7 • Tawaraya Sotatsu *WAVES AT MATSUSHIMA* **(DETAIL OF RIGHT SCREEN)**
Edo period, 17th century. Pair of six-panel folding screens, ink, mineral colors, silver, and gold leaf on paper; each screen 4′9⁷⁄₈″ × 12′1½″ (1.52 × 3.69 m). Freer Gallery of Art, Washington, D.C. Gift of Charles Lang Freer. F1906.232.

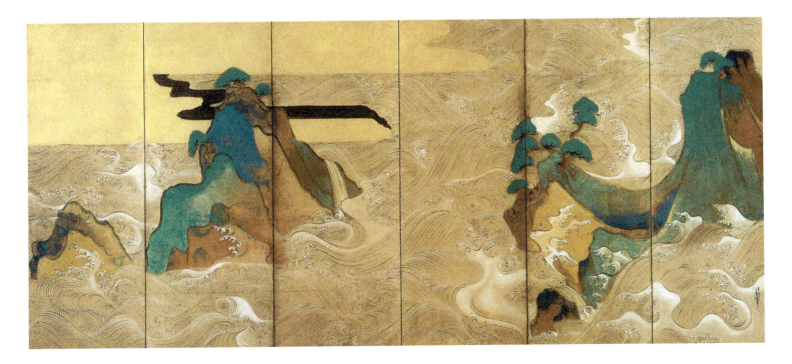

15-8 • Ogata Korin RED AND WHITE PLUM BLOSSOMS
Edo period, ca. 1710–1716. Pair of two-panel folding screens, ink, colors, silver, and gold leaf on paper; each screen 5'1⅝ × 5'7⅞" (1.565 × 1.725 m). MOA Museum of Art, Atami, Shizuoka prefecture.

provided fabrics and clothing to influential customers, including samurai and members of the imperial family. As a young man, Korin lived an extravagant lifestyle, and there are many anecdotes describing his flamboyant display of wealth. On one occasion during a picnic, he brought out leaves covered in gold from his picnic basket and used them to float cups of sake along a nearby stream. When the family business failed, Korin made a living painting scrolls and screens, and designing textiles, lacquers, and ceramics. Kenzan launched a pottery business, and the brothers often collaborated on projects.

Korin developed his artistic abilities by studying under Yamamoto Soken, an artist associated with the Kano School, and by copying Sotatsu's works, several of which belonged to the Ogata family. Korin shared Sotatsu's nostalgia for Heian culture, and the older artist's influence is visible in Korin's work, as illustrated in a pair of two-panel folding screens entitled *Red and White Plum Blossoms* (ca. 1710–1716) (**FIG. 15-8**). Three powerful components dominate the painted surfaces: a thawing, swirling stream executed in ink and silver, gnarled plum trees on either side, and a luxurious background of gold leaf. Korin takes advantage of the subtle effects formed by the *tarashikomi* technique to create mossy, lichen-spotted trees. Building on Sotatsu's and Koetsu's artistic legacy, Korin artfully fuses naturalistic representation with flat abstract patterns in one dramatic composition, a hallmark of the Rinpa style.

Korin's numerous talents included hand-painting clothing. A luxurious silk robe designed and painted by Korin is an example of a **kosode**, meaning "small sleeves" (**FIG. 15-9**). During the Edo period, the *kosode*, a precursor of the **kimono**, was worn as an outergarment by both sexes from all classes. Historians believe that the wealthy Edo wood merchant Fuyuki commissioned Korin to paint this robe. Coordination of the design to fit the garment's folds demanded great skill. Using ink and delicate colors Korin decorated the *kosode* with lifelike images of fall plants: chrysanthemums, bush clover, bellflowers, and pampas grass. Korin's ability to portray the natural world accurately was enhanced by the many drawings he made of flowers and grasses from life. A gap in the floral design appears at the waistline, perhaps to accommodate the more fashionable, wider **obi** (sash). This unique and quietly elegant garment is a reflection of the refined tastes and wealth of high-ranking merchants.

One of the greatest potters of the Edo era, Ogata Kenzan also excelled as a calligrapher and painter. During his childhood, Kenzan spent time at the artistic community of Takagamine studying ceramics with Koho, Koetsu's grandson, and as an adult his mentor was the celebrated Kyoto potter Nonomura Ninsei (fl. ca. 1646–1694). In 1699 Kenzan founded a pottery workshop at Narutaki, Kyoto—one of several that he established during his life as a successful artist-potter in Kyoto and later Edo. As the owner of an atelier with a staff of trained artisans including throwers, glazers, and kiln operators, Kenzan's main role was that of designer, artistic director, and decorator. Many of the earthenware and stoneware works he produced during his career are ornamented with Rinpa-style motifs; however, some of his most original designs, inspired by nature, are groundbreaking in

15-9 • Ogata Korin KOSODE WITH FALL FLOWERS AND GRASSES
Edo period, early 18th century. Hand-painted, ink and color on silk, 4′10″ × 4′3¼″ (1.472 × 1.302 m). Tokyo National Museum.

their expressive patterns, bordering on abstraction (**FIG. 15-10**). In this glazed tea bowl, designs in white slip suggest a tangled web of foliage.

Having risen from the affluent merchant class, Kenzan rejected the potter's anonymity and lowly status and signed his works with his own name. In time, that name became a well-recognized one, with a Kyoto tourist guidebook of his day recommending "Kenzan ware" as an essential souvenir for the visitor.

The art of the Ogata brothers attracted numerous followers, and in the early nineteenth century the Rinpa School experienced another creative revival, this time in Edo.

NATURALISTIC PAINTING Foreigners may not have been welcome in Japan under the Tokugawa shogunate, but their cultures continued to influence Japanese society through the import of foreign goods. Japanese artists were introduced to Western-style art—especially linear perspective and shading techniques—through European paintings, prints, and illustrated books, which entered Japan in increasing numbers after a ban on foreign literature was lifted in 1720. Other Western products of particular interest to artists were optical devices, such as spectacles, magnifying glasses, microscopes, and telescopes, introduced by the Dutch and widely available in Japanese society by the middle of the eighteenth century. In effect, Japanese artists were exposed to new ways of seeing that fostered experimentation with a more naturalistic style of painting. One of the first Edo era artists to incorporate naturalism into his works in a unique way was Kyoto resident Maruyama Okyo (1733–1795).

Okyo mastered Western ideas of spatial recession as a young man when he worked for a Kyoto toy merchant, designing paintings with Western-style perspective and shading for imported European novelty viewing machines. In his mature works Okyo integrated his knowledge of Western techniques with his traditional Kano School training, studies of Chinese painting, and close observation of nature to create stunning wall paintings and

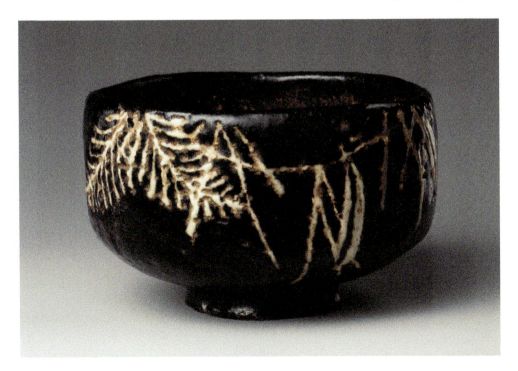

15-10 • Ogata Kenzan TEA BOWL
Edo period, 18th century. Glazed earthenware decorated with designs in white slip, diameter 4¾″ (12.1 cm). Metropolitan Museum of Art, New York. Bequest of Edward C. Moore, 1891, 91.1.361.

15-11 • Maruyama Okyo PINE TREES IN THE SNOW (DETAIL)
Edo period, late 18th century. One of a pair of six-panel folding screens, ink, slight color, and gold leaf on paper; each screen 5′7⅛″ × 11′10½″ (1.55 × 3.62 m). Mitsui Bunko, Tokyo.

screens—for example, the pair of six-panel screens known as *Pine Trees in the Snow* (**FIG. 15-11**). These screens, commissioned by a rich merchant, are filled with naturalistic snow-covered pine trees set against a decorative backdrop of gold leaf. At first glance, *Pine Trees in the Snow* resembles Kano Eitoku's *Cypress Tree* (1590) (see Chapter 14, **FIG. 14-31**). However, Okyo's pine trees more closely echo the natural world. Unlike Kano Eitoku's cypress tree, which spreads across the screen in imaginative contortions, Okyo's pines appear naturally bent in response to the elements. Where Eitoku painted his tree trunk with dark outlines to suggest volume, Okyo delicately modeled his trees using subtle contrasts of light and dark ink. In addition, Okyo, an advocate of sketching from nature (an uncommon practice at the time), painted individual pine needles bristling beneath the snow to complete the radiant winter landscape.

Okyo's paintings, infused with naturalism, attracted prosperous patrons, not only from the merchant class but also from the imperial court in Kyoto and the shogunate in Edo. He became very successful and founded the Maruyama School in Kyoto. One of Okyo's gifted students, Nagasawa Rosetsu (1754–1799), developed an idiosyncratic style, often characterized as "eccentric," possibly reflecting the cross-pollination of techniques and ideas circulating among Edo period artists, regardless of their association with a particular school.

ECCENTRIC PAINTERS As Okyo's pupil, Rosetsu, the son of a samurai family, received instruction in both traditional practices and the new naturalism developed by his teacher. Rosetsu was allegedly expelled from Okyo's studio for poor behavior and for deviating too far from his master's teachings. The painting *Bull and Puppy* from the late eighteenth century perfectly illustrates Rosetsu's creative abilities and unconventional artistic vision (**FIG. 15-12**). An enormous, carefully modeled bull (traditionally used in farming but also considered a vehicle for Buddhist deities) occupies the left screen of a pair of six-panel screens. Its elongated form

15-12 • Nagasawa Rosetsu BULL AND PUPPY (DETAIL)
Edo period, late 18th century. One of a pair of six-panel folding screens, ink and gold wash on paper, 5′7¼″ × 12′3″ (1.70 × 3.75 m). Los Angeles County Museum of Art. Etsuko and Joe Price Collection L.83.45.3a.

stretches beyond the screen's borders. However, it is the whimsical addition of a tiny white puppy nestled against the huge gray bull that catapults this painting into the dream realm. The improbable combination of creatures and the puppy's bright-eyed cuteness anticipate modern images found in Japanese cartoons. Unfortunately, Rosetsu's imaginative contribution to Japanese art ended prematurely with his sudden death at the age of 46.

Other notable eccentric artists from the period, known for their individualism and reinterpretation of tradition, are Ito Jakuchu (1716–1800) and Soga Shohaku (1730–1781).

LITERATI PAINTING Chinese art and culture continued to interest Japanese artists seeking new forms of self-expression. In particular, Chinese **literati** painting became popular in Kyoto art circles in the eighteenth century, spurred on by interest in Chinese literature and philosophy and imported Chinese art and painting manuals. Chinese Buddhist monks had also introduced literati culture at Manpuku-ji, a Zen temple south of Kyoto. Traditionally, the literati, or educated elite (scholars and government officials), in China practiced painting as a form of self-cultivation and a gentlemanly pastime. Chinese literati artists were primarily amateurs, painting for their own enjoyment. In Japan, both amateurs from diverse backgrounds, including monks and merchants, and professional artists who sold their paintings for a living embraced literati painting, also known as **Bunjinga** (literati painting) or Nanga (Southern painting—after the Chinese literati painter Dong Qichang's theory of Northern and Southern schools of painting; see Chapter 9, Point of View, p. 210). Contact with Chinese merchants in the port city of Nagasaki, who painted literati-style landscapes for pleasure, contributed to a growing interest in Japanese Bunjinga. Two of Japan's most original literati painters, Ike Taiga (1723–1776) and Yosa Buson (1716–1783), transformed the ideals and techniques of Chinese literati artists into their own distinctive compositions.

Born into a peasant family, Ike Taiga quickly transcended his humble background through his abilities in calligraphy and painting. At age 14, he started his painting career in Kyoto as a painter of fans. Productive and versatile, he painted throughout his life, eagerly absorbing the various artistic styles prevalent in Edo period Japan. Native Rinpa influences, European techniques, and Chinese methods can all be detected in his work. Taiga learned about literati painting through Chinese painting manuals, the artwork at Manpuku-ji, and connections with other literati artists. His interpretations of Chinese landscape paintings are often infused with elements of the Japanese countryside, inspired by his extensive travels around Japan. In his painting *True View of Kojima Bay* he replaced an imaginary Chinese setting with a personal impression of Kojima Bay, Okayama prefecture (**FIG. 15-13**). Kojima Bay comes alive with his eclectic inventory of brushstrokes, including rhythmical oval dots. At the same time, Taiga's assimilation of Chinese models is evident in the composition of distant mountains viewed

15-13 • Ike Taiga TRUE VIEW OF KOJIMA BAY
Edo period, third quarter of 18th century. Hanging scroll, ink and color on silk, 39¼ × 14¾" (99.7 × 37.6 cm). Hosomi Museum, Kyoto.

over foreground ones and the inclusion of two travelers dressed in Chinese clothes climbing the mountain (lower right). Taiga captures the essence of the landscape, its poetic beauty and atmospheric quality, through his innovative synthesis of styles laced with personal expression.

UKIYO-E: PICTURES OF THE FLOATING WORLD

One result of the growth of cities, such as Kyoto, Osaka, and Edo, was the emergence of a popular urban culture that catered to the tastes and interests of an affluent merchant/townspeople class. Townspeople, with expendable incomes and increased leisure time, flocked to the city entertainment districts, such as Edo's Yoshiwara pleasure quarters, to enjoy the attractions offered: licensed brothels, bathhouses, restaurants, bars, sumo wrestling rings (*dohyo*), and theaters. Samurai also patronized the so-called "floating world"

(*ukiyo*), although officially they were discouraged from entering the Yoshiwara neighborhood by the shogunate.

Ukiyo is an ancient Buddhist term referring to the ephemeral and transitory nature of life. During the Edo period, the entertainment district, with its fleeting pleasures and rapidly changing fashions, acquired this name. Responding to life's brevity, patrons of the floating world indulged in amusements, food, drink, and sex. The seventeenth-century writer Asai Ryoi sums up the *ukiyo* philosophy in the following way:

> Living only for the moment, turning our full attention to the pleasures of the moon, the snow, the cherry blossoms and the maple leaves; singing songs, drinking wine, diverting ourselves in just floating, floating; caring not a whit for the pauperism staring us in the face, refusing to be disheartened, like a gourd floating along with the river current: this is what we call the floating world.

TECHNIQUES | Woodblock Printing

Japanese woodblock prints are made by transferring an image carved into the surface of a wooden block, often of cherry wood, to a sheet of paper.

The artist makes a design on ordinary paper, which is then transferred to a sheet of special thin, semitransparent paper. This sheet of paper is pasted face down onto the wood block (1). The surface of the block is cut and chiseled away to leave a design

formed of raised lines and solid areas (2 and 3). Ink is applied to this surface (4), and a piece of paper placed over it. The reverse of the paper is rubbed with a disc-shaped pad (*baren*) (5), which causes the transfer of ink from the block to the paper (6). Early woodblock prints used only black ink, but by the 1760s, techniques were developed for printing multiple colors. A separate block was carved for each color.

Paintings and **woodblock prints** celebrating the lifestyle of the "floating world" are known as *ukiyo-e*, literally "pictures of the floating world" (see Techniques, opposite). *Ukiyo-e* artists and their patrons favored three main subjects: beautiful women—especially the courtesans (licensed prostitutes) of the pleasure quarters— the **Kabuki theater** (scenes from plays and portraits of popular actors), and erotica (*shunga*). In the nineteenth century, landscape prints also became popular.

UKIYO-E WOODBLOCK PRINTS *Ukiyo-e* prints, unlike paintings, were mass-produced and inexpensive. Available on the streets or in small stores, a standard print was the same price as a bowl of noodles. Commoners, especially townspeople and tourists in search of cheap souvenirs, bought prints of the floating world to decorate their homes or place in album collections. Although aristocratic samurai also purchased *ukiyo-e* prints, they were generally created by and for the lower ranks of society. Woodblock print production was a collaborative effort, involving the publisher, artists, carvers, and printers. The publisher played an important role, commissioning artists to create designs and hiring carvers and printers to manufacture the images. Also responsible for sales, the publisher often suggested subjects to be illustrated. The names of both artist and publisher appear on the prints.

At first woodblock prints were black and white or colored by hand. However, as printmaking technology improved with the use of multiple blocks to print colors, polychrome prints flooded the market. One of the first artists to benefit from such technical advances was Suzuki Harunobu (1725?–1770), who became famous for his colorful depictions of courtesans (**FIG. 15-14**). In this print dated 1769, Motoura, a high-ranking courtesan in Edo, and her young apprentice Yaezakura, are observing the boat-filled bay from an open window. The slender, fashionably dressed courtesan with her *obi* tied at the front, signifying her profession, is smoking a pipe. Meanwhile, the young girl looks through a telescope at some distant point in the bay. Peering through telescopes was a common pastime of prostitutes and their clients, and the sexual connotations of this phallic-shaped instrument were well understood. Harunobu's idealized image of the courtesan focuses on external beauty. Motoura's luxurious clothing and elaborately coiffed hair decorated with ornaments mask the harsh reality of a young woman sold into prostitution as a child by her family. Likened to beautiful flowers, as the title of this print suggests, courtesans of the floating world, once their youthful beauty had faded, would often suffer grinding poverty, disease, and early death.

A master at capturing female beauty, Kitagawa Utamaro (1753–1806) is well known for his portraits of floating-world beauties and images of courtesans in sexually intimate scenes (**FIG. 15-15**). Originally the frontispiece to an album of erotica,

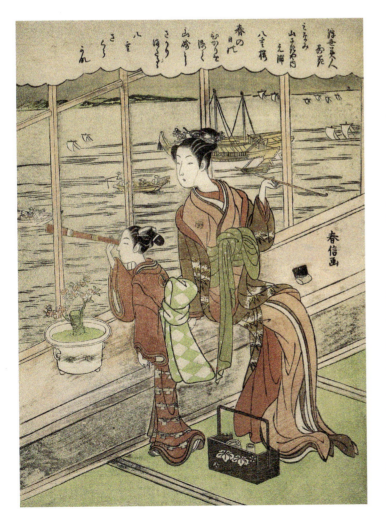

15-14 • Suzuki Harunobu *THE FLOWERS OF BEAUTY IN THE FLOATING WORLD: MOTOURA AND YAEZAKURA OF THE MINAMI YAMASAKIYA*
Edo period, 1769. Polychrome woodblock print on paper, 11½ × 8⅜" (29.3 × 21.3 cm). The Art Institute of Chicago. Clarence Buckingham Collection, 1925.2116.

15-15 • Kitagawa Utamaro *COUPLE IN AN UPSTAIRS ROOM*
From the album *Poem of the Pillow*, Edo period, 1788. Polychrome woodblock print on paper, 10 × 14½" (25.5 × 36.9 cm). British Museum, London.

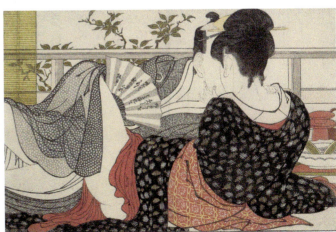

Poem of the Pillow, this print eliminates extraneous details and focuses on a couple embracing in an upstairs room. For a brief period they are united in passion. The man's right eye flows into the woman's hairline and their entwined bodies, defined by sinuous lines, form a luxurious heap of patterned robes. A glimpse of the woman's buttocks and the nape of her neck, considered an erogenous zone, heighten the erotic atmosphere. The poem written on the fan complements the scene:

> Its beak caught firmly
> In the clam shell,
> The snipe cannot
> Fly away
> Of an autumn evening.

Utamaro's parade of beautiful women included not only courtesans but also geisha or "people of the arts" (**FIG. 15–16**).

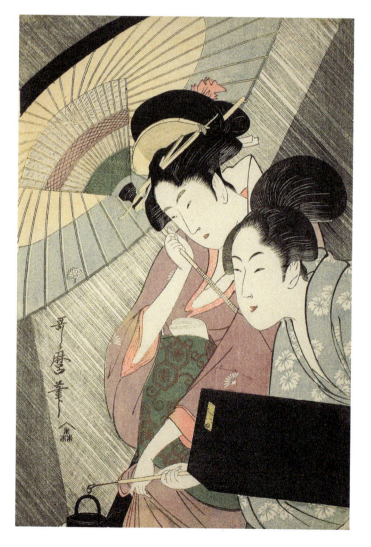

15–16 • Kitagawa Utamaro *NIGHT RAIN*
Edo period, ca. 1797. Polychrome woodblock print on paper, 15⅛ × 10⅛" (38.5 × 25.9 cm). The Art Institute of Chicago. Gift of Mr. and Mrs. Gaylord Donnelley, 1968.158.

Geisha—women who entertain but are not sexually involved with their clients—should not be confused with courtesans. However, geisha sometimes crossed the line between entertainment and sex. Occupying a high social position amongst the ranks of indentured women in the floating world, geisha were trained to play traditional musical instruments like the **shamisen** (lute), dance, and sing. Using their talents and art of conversation they entertained men in the teahouses and at private parties. Celebrated geisha and courtesans influenced the fashions of the day.

In Utamaro's print, a finely dressed geisha and her attendant, who carries a *shamisen* case and lantern, hurry through the night rain. At first glance, their faces illuminated by the lantern appear similar in their stylized beauty, but subtle differences in the women's features and expressions transmit individual nuanced emotions. Utamaro's versatile use of line, displayed in depictions of driving rain, umbrella spokes, and garment folds, provides structure to the composition, showcasing his superb skills as a designer.

Kabuki theater, more popular and action-packed than the refined, stately Noh dramas patronized by the aristocracy and *daimyo*, inspired a wealth of *ukiyo-e* prints. Some of the best-selling prints featured famous Kabuki actors in leading roles or in well-known plays. They functioned much like eye-catching posters, advertising talented stars and Kabuki theater's allure. Fans avidly collected prints of their favorite actors. Between 1794 and 1795 Toshusai Sharaku created about 145 prints of Kabuki actors, and then mysteriously disappeared. He signed his prints "Sharaku," but little is known about this enigmatic artist. One possible explanation for his brief career is that Sharaku's expressive depictions of Kabuki actors, which magnified the actor's personal characteristics beneath the costumes and makeup, were too unflattering for the public's taste. Indeed, the exaggerated facial expressions and gestures of his subjects appear almost caricaturelike. One wonders what the actor Otani Oniji III thought of a print of himself in the role of Yakko (manservant) Edobei from the play *The Two-Colored Reins* (**FIG. 15–17**). Set against a glistening mica background, the villainous Edobei is a study in greed. He leans forward with grasping hands to steal money from an unseen victim, his face distorted with malevolence. The pent-up atmosphere of an impending immoral act is artfully suggested; however, details of the actor's grotesque hands, sagging jowls, and hooked nose may have alienated buyers used to more idealized versions of the stars. The writer Ota Shokusanjin (1749–1823), a contemporary of the artist, said, "[Sharaku] drew portraits of actors, but he ended up drawing them in an undesirable way as he was trying hard to depict them too truthfully."

During the early nineteenth century *ukiyo-e* representations of the landscape became common, in part fueled by the public's increased interest in travel around Japan. Katsushika Hokusai (1760–1849), a successful painter and book illustrator, designed many landscape prints that focused on scenic views

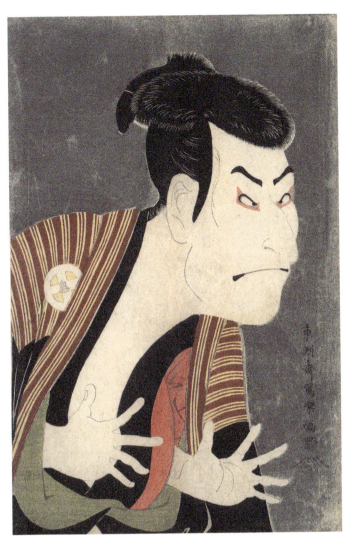

15–17 • Toshusai Sharaku *OTANI ONIJI III AS YAKKO EDOBEI IN THE PLAY THE TWO-COLORED REINS*
Edo period, 1794. Woodblock print, ink, color, and white mica on paper, 15 × 9⅞″ (38.1 × 25.1 cm). Metropolitan Museum of Art, New York. Henry L. Phillips Collection, Bequest of Henry L. Phillips, 1939, JP2822.

of nature in various seasons and weather conditions. Hokusai is arguably best known for his series *Thirty-Six Views of Mount Fuji* (ca. 1826–1833), which includes the memorable *The Great Wave off Kanagawa* (**FIG. 15–18**). Disaster is about to strike three narrow boats with their cargo of fish, caught in the trough of a giant wave. Nothing will save the boatmen from their dangerous plight, not the protective Shinto *torii* on the vessel's stern (top right), nor the Shinto deities inhabiting snowcapped Mount Fuji in the background. Wavelike in appearance, Mount Fuji colludes with the turbulent waters engulfing the boats.

Hokusai described himself as "an old man mad about drawing," and his passion for art encompassed Western techniques and materials. The low horizon line and small-scale Mount Fuji reflect his understanding of Western perspective, while the striking Prussian blue used extensively in this print originated in Europe. In turn Hokusai's work, and indeed the woodblock prints of other *ukiyo-e* artists, inspired nineteenth-century Western artists—for example, Claude Monet, Edgar Degas, Mary Cassatt, Vincent van Gogh, and James Whistler—to experiment with bright colors, bold lines, unusual points of view, asymmetrical designs, and scenes of daily life in their compositions. Today, *ukiyo-e* prints are coveted worldwide by art collectors and fetch high prices in the art market—a far cry from

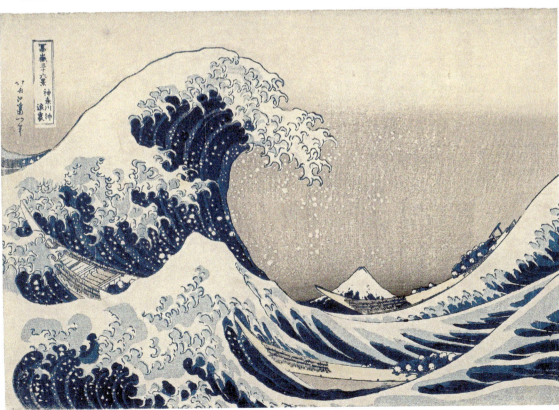

15–18 • Katsushika Hokusai *THE GREAT WAVE OFF KANAGAWA*
Edo period, ca. 1831. Polychrome woodblock print on paper, 10⅜ × 15³⁄₁₆″ (25.9 × 38.5 cm). Honolulu Academy of Arts. Gift of James A. Michener, 1955, 13695.

their origins as inexpensive, expendable amusements, which included use as wrapping paper.

KABUKI A fusion of dance, drama, and music, Kabuki theater became one of the most popular floating-world attractions, especially with townspeople. Actors dressed in sumptuous costumes and often wearing dramatic makeup entertained audiences with melodramatic plays based on ancient legends, historical events, traditional stories, or contemporary tales of ordinary citizens involved in sensational events such as theft, suicide, and murder. Larger-than-life acting and lavish sets contributed to the spectacle (see Closer Look, opposite). Kabuki's founder is believed to be a Shinto shrine priestess named Okuni, who led a female theatrical troupe in Kyoto in the early seventeenth century. The women's innovative, sexually provocative performances blended dance, music, singing, drama, and fashion to captivate audiences. Many of the performers were prostitutes, and their sexual favors were frequently sold along with the theatrical events. The shogunate frowned on these practices and in 1629 banned women from the stage. Teenage boys replaced the female actors, but they too were dismissed in 1652 for licentious behavior. Finally older

men took over all roles, male and female, and their more formalized productions, which borrowed elements from Noh theater and Bunraku (traditional puppet theater), shaped the development of modern-day Kabuki.

TEXTILES

Japan's textile industry flourished during the Edo period. Elaborate costumes were designed for Noh and Kabuki performances, but demand for stunning robes also came from the elite and newly rich merchants. Artisans used a wide variety of techniques, including dyeing, embroidery, appliqué of gold foil, and hand painting (see FIG. 15–9) to decorate textiles with intricate designs that trumpeted the wearer's wealth and cultural sophistication. Clothing ornamented with metallic thread and gold foil shimmered as the wearer moved, and glinted by candlelight (FIG. 15–19). In the woman's silk *kosode* illustrated, tie-dyed fishnet patterns in dark blue are paired with embroidered and stenciled imitation tie-dyed chrysanthemum flowers and Chinese characters. A popular symbol of longevity, the chrysanthemum is associated with the well-known legend of Chrysanthemum Boy, who became immortal after drinking dew from chrysanthemum

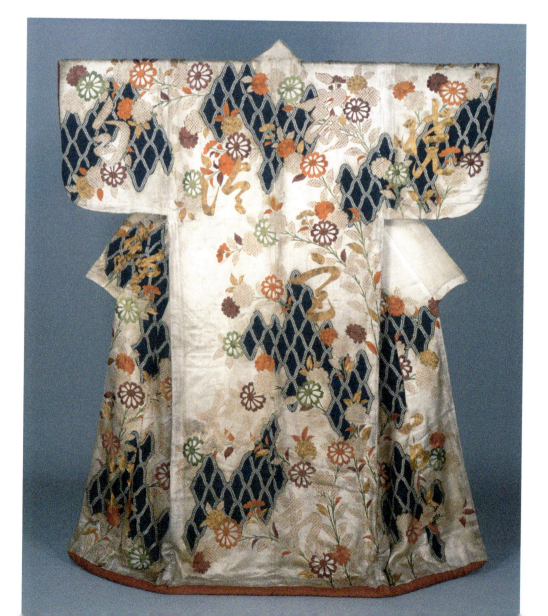

15–19 • *KOSODE* WITH NET PATTERN, CHRYSANTHEMUMS, AND CHINESE CHARACTERS
Edo period, 1668/1704. Tie-dyeing, stenciled imitation tie-dyeing, and silk and metallic thread embroidery on silk satin, 5′2⅜″ × 4′7″ (1.585 × 1.396 m). Tokyo National Museum.

This colored woodblock print provides a panoramic view of a Kabuki performance inside the Nakamura Theater in Edo. As with Noh theater, most Kabuki actors came from families associated with the profession. Training started at an early age and included all aspects of Kabuki, including mastering the art of makeup. The three Chinese characters comprising the word Kabuki are: *ka* (song), *bu* (dance), and *ki* (skill). Kabuki performances sometimes lasted all day. Vendors supplied hungry patrons with food and drinks, which were consumed during the performance.

Numerous shops surrounding the theater sold Kabuki souvenirs, such as woodblock prints.

Utagawa Toyokuni I
INTERIOR OF A KABUKI THEATER
Edo period, ca. 1800. Colored woodblock print, 15 × 29½″ (37.7 × 74.7 cm). British Museum, London.

A small wooden structure equipped with a retractable curtain occupied the main stage. Kabuki theaters often featured a revolving stage that provided impressive set changes and trapdoors to facilitate sudden entries or exits.

Musicians are tucked away behind the black screen.

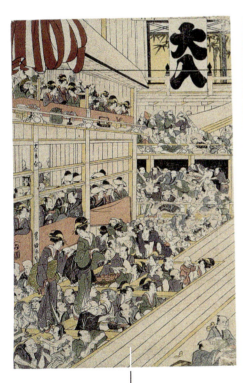 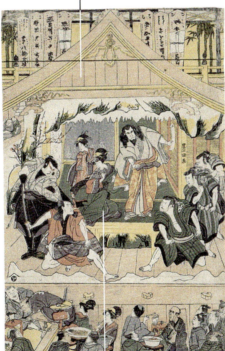 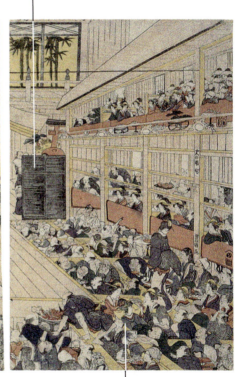

Actors used the runway (*hanamichi*), stretching from the stage to the rear of the theater, for dramatic entrances and exits. The runway also enabled stars to perform some of their most exciting parts in close proximity to the audience.

After 1652, men played the female roles. The female impersonators (*onnagata*) who cultivated idealized notions of femininity became favorites of the audience. Ironically, *onnagata* set trends in fashion and movement that were copied by stylish women.

The audience actively participated in the performance by yelling out the actors' names or comments—for example, "I was looking forward to that!" At times the audience became rowdy and brawls broke out.

petals. Aside from its purpose as clothing, a robe spread out on a lacquer hanger also functioned as a decorative screen.

Not everyone could afford silk clothes or was permitted the luxury of wearing them by the shogunate. Farmers were prohibited from wearing silk, and wore clothes made from cotton or fibers from native trees like wisteria and mulberry. *Chonin*, too, were subject to the sumptuary laws, as they often had the wealth to outshine their samurai overlords.

AINU COSTUME Japan's indigenous people, the Ainu, now live mainly on the northern island of Hokkaido. Traditionally a society of hunter-gatherers with **animist** beliefs, the Ainu developed a distinct language, religion, and culture. During the Edo period, contact between the Japanese and Ainu increased and their unique robes woven from the inner bark of the elm tree were embellished with indigo-dyed cotton pieces acquired from Japanese traders (**FIG. 15-20**). This ceremonial garment (*attush*), created by an Ainu craftswoman and embroidered with cotton thread, was worn by a male officiate conducting one of the numerous Ainu spiritual rituals. The beautiful designs honor the gods and protect the wearer against evil spirits. Waves of Japanese settlers from the south who encroached on Ainu land, followed by discriminatory government policies in the nineteenth and twentieth centuries, eroded Ainu communities and customs. Despite the Ainu's continuing struggles as a marginalized group within Japanese society, however, their culture is undergoing a dynamic resurgence.

WOMEN ARTISTS

The Tokugawa government's promotion of Neo-Confucian teachings, which generally viewed women as subordinate to men, lowered the status of women within Japanese society. Professional artists during the Edo era were primarily men, as women were expected to spend their days fulfilling family and household duties. However, with the increasing affluence of the lower classes, educational opportunities for females increased, and many young girls (except those from the lowest ranks) were taught to read and write and were schooled in the domestic and cultural arts. Women who wished to pursue the arts more seriously did so during their leisure time.

Considering the societal restrictions imposed on females during the Edo period, a surprising number of women artists gained recognition for their artistic talents. Two examples are Tokuyama Gyokuran (1727/8–1784), an accomplished painter, calligrapher, and poet, and Katsushika Oi (1818–1854), who became known for her paintings and woodblock designs.

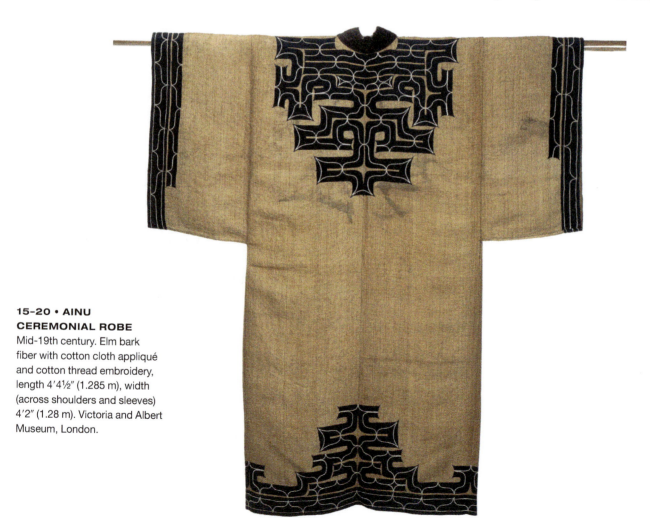

15-20 • AINU CEREMONIAL ROBE
Mid-19th century. Elm bark fiber with cotton cloth appliqué and cotton thread embroidery, length 4′4½″ (1.285 m), width (across shoulders and sleeves) 4′2″ (1.28 m). Victoria and Albert Museum, London.

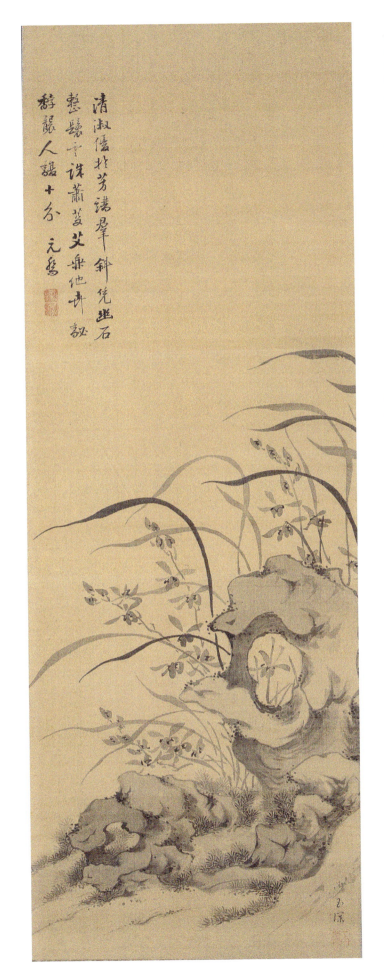

清淑僑於芳講羣斜笑幽石
整襟乎誅蕭艾聚她舟
皺靜龢人龢十分
元燁

15-21 • Tokuyama Gyokuran

ORCHIDS AND ROCK WITH CALLIGRAPHY

Edo period, 1750–1784. Hanging scroll, ink on silk, 35¾ × 13⅛″ (90.8 × 33.3 cm). University of Michigan Museum of Art. Gift of Ellen and Richard Laing, 2006.

TOKUYAMA GYOKURAN Gyokuran came from an artistic family. Both her mother and her grandmother were published poets who operated a successful teahouse in Kyoto. She married Ike Taiga (see pp. 363–364), a poor but gifted artist, who became her teacher and an influential force behind the evolution of her painting style. The unconventional couple, known to swap clothes and play music in the nude, lived a bohemian lifestyle in a small, cluttered house in Kyoto. Gyokuran's mastery of different styles is evident in her work, as is her command of the brush and ink. She also developed her own personal approach to painting, which is illustrated in a hanging scroll featuring orchids and an eroded rock (**FIG. 15-21**). Celebrated for its fragile beauty, the orchid was a favorite subject of Gyokuran. The flowers, one seen through the hole in the weathered rock, are delicately rendered, while the leaves are executed with thick, fluid brushstrokes. Following Taiga's death in 1776, Gyokuran continued to paint while running the family teahouse.

KATSUSHIKA OI As the daughter of the famous *ukiyo-e* artist Katsushika Hokusai (see pp. 366–367), Oi learned to draw and paint at a young age. She also assisted her father in his studio. Indeed, Hokusai was one of several *ukiyo-e* artists who welcomed women into their workshops as apprentices. Like her father, Oi enjoyed experimenting with Western painting techniques, as demonstrated in her dramatic use of light and shadow in the painting entitled *Yoshiwara at Night* (ca. 1850s; **FIG. 15-22**). Unlike the idealized portrayals of courtesans favored by her fellow artists,

15-22 • Katsushika Oi *YOSHIWARA AT NIGHT*

Edo period, ca. 1850s. Hanging scroll, ink and color on paper, 10⅜ × 15¾″ (26.3 × 39.8 cm). Ota Memorial Museum of Art, Tokyo.

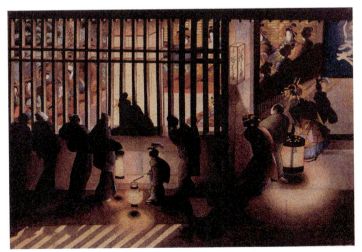

Oi's atmospheric painting of a brothel exposes the grim reality of prostitutes on display behind a window of wooden bars. Shadowy figures peer into the illuminated interior to gawk at the finely dressed women with white powdered faces. The lantern shining at the corner of the bordello greets potential clients with the words "A thousand customers, ten thousand welcomes."

ZEN BUDDHIST ART FOR THE MASSES

Despite the dominant Neo-Confucian ideology, both Buddhism and Shinto continued to thrive in Edo period Japan, influencing developments in literature and the arts. Zen Buddhism, traditionally practiced by the nobility and warrior elite, became more attractive to the masses as provincial and rural temples made efforts to address their needs. A key figure in reaching out to commoners, especially peasant farmers, was the Zen monk Hakuin Ekaku (1685–1768). Born in a village near Mount Fuji, he delivered passionate sermons in the countryside, and some of his writings about Zen Buddhism were easy to understand. As a self-taught painter and calligrapher he also communicated the heart of Zen with visual aids; Hakuin often gave away his bold, sometimes humorous, paintings to people of all social and economic backgrounds as a way of spreading Zen teachings. Hakuin stressed the importance of meditation, and in his ink painting of Hotei, an itinerant monk who became a folkloric deity of good fortune, we see a flabby, unkempt old man seated on his large cloth bag, meditating (**FIG. 15-23**). Using swift, ropy brushstrokes and a range of ink tones, Hakuin expressed the spiritual bliss of Everyman-monk at peace with the world. The inscription floating above his head says, somewhat comically, "Hey monk, what a surprise—you're doing *zazen* today?" "Yup."

EDO PERIOD, FINAL YEARS

The Edo era, marked by 250 years of relative peace and seclusion, ground to a halt in 1868 when domestic and foreign tensions bubbled to the surface, resulting in the abolition of the Tokugawa shogunate by disgruntled samurai and the return of power to the emperor, an historic occasion called the Meiji Restoration. Under Emperor Meiji (1852–1912), the imperial capital moved from Kyoto to Edo, which was renamed Tokyo ("Eastern capital").

15-23 • Hakuin Ekaku **HOTEI MEDITATING**
Edo period. Hanging scroll, ink on paper, 48⅔ × 19⅘" (123.7 × 50.3 cm). Ginshu Collection.

MEIJI PERIOD

Knowledge shall be sought throughout the world so as to strengthen the foundation of imperial rule
Article V, The Charter Oath, 1868

Relations between Japan and the West were kick-started again in 1853, when the American Commodore Matthew Perry arrived in Edo Bay, with four gunboats to demand that Japan establish trade and diplomatic connections with the United States. Japan complied and foreign influences started to swamp the country, especially after the shogunate's dissolution in 1868 and the establishment of the Meiji ("Enlightened Rule") era (1868–1912). Intent on making Japan a wealthy nation with a strong military, the Meiji government embarked on a program of Westernization and modernization. Aspects of Western government, industry, technology, education, and fashion were introduced into Japanese society. Artists and architects also looked to the West for inspiration. Enterprising Japanese artists studied in Europe and America or with foreign teachers, now welcomed in Japan.

PAINTING

YOGA (WESTERN-STYLE PAINTING) Oil painting, a European import, proved to be a popular painting technique with late nineteenth-century Japanese artists. One artist who mastered the medium and became famous for his Western-style painting (*yoga*) was Kuroda Seiki (1866–1924). At 17, Kuroda moved to Paris, where he abandoned his law studies for painting. He remained in France for about ten years, studying art under Raphael Collin (1850–1916) and absorbing the French Impressionist experiments with light, color, and atmosphere. After his return to Japan he became a professor of Western-style painting at Tokyo School of Fine Arts.

Kuroda's triptych *Wisdom, Impression, Sentiment* (ca. 1897), consisting of three separate canvases, celebrates the subject of

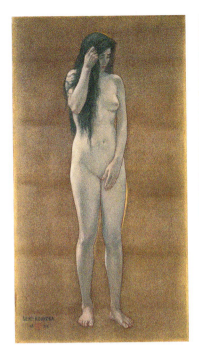
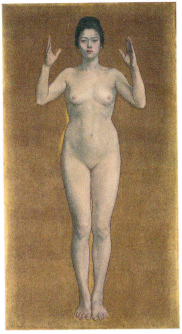
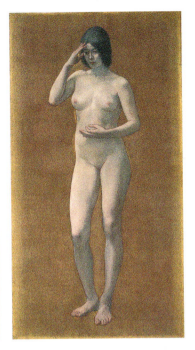

15-24 • Kuroda Seiki
WISDOM, IMPRESSION, SENTIMENT
Meiji period, ca. 1897. Oil on canvas, each 71⅛ × 39⅕″ (180.6 × 99.8 cm). Kuroda Memorial Hall, National Research Institute for Cultural Properties, Tokyo.

the female nude, so prevalent in Western art (**FIG. 15-24**). In all three images, the Japanese model strikes unusual poses to convey abstract concepts. Her carefully modeled figure, inspired by Western artistic practices, is set against a gold background evoking traditional Japanese screens. Also in keeping with Japanese traditions is the dark contour line defining her overall form. *Wisdom, Impression, Sentiment* was exhibited in Tokyo in 1897 where it sparked controversy because it was considered disgraceful and immoral to show an image of a nude woman in public. In 1900, Kuroda submitted the triptych, under the new title *Study of a Nude*, to the International Exposition in Paris, where it received a silver medal.

NIHONGA (JAPANESE-STYLE PAINTING) Not everyone appreciated the headlong rush to embrace Western art if it meant discarding Japanese native traditions. The American scholar Ernest Fenollosa (1853–1908), who taught philosophy and political economy at Tokyo Imperial University, and art critic Okakura Kakuzo (1862–1913) were especially vocal about preserving Japan's past. They advocated the study of traditional arts but also encouraged the development of a new style of Japanese art that became known as *Nihonga* (Japanese-style painting). *Nihonga* artists typically painted on paper or silk with traditional

media, but were comfortable injecting their compositions with a range of stylistic and technical elements borrowed from both Japanese painting traditions and Western art.

Yokoyama Taikan (1868–1958) is known as a *Nihonga* pioneer and his work *Floating Lights* (1909) is an example of Japanese-style painting (**FIG. 15-25**). Using the Asian format of the hanging scroll and such traditional media as ink, mineral pigments, and gold on silk, Yokoyama painted a divination scene that he witnessed during his travels to India. Three ethereal-looking women dressed in pastel-colored saris are assembled beside the River Ganges to discover their fate. The woman standing on the right is about to place her earthenware plate containing flaming vegetable oil onto the water's surface. If it floats and the flame continues to burn she can look forward to good fortune. The other two women have already launched their plates and watch the outcome with rapt attention. *Floating Lights* features an interesting hybrid of influences. The naturalistic depiction of the water is inspired by Western sources but the delicate

15-25 • Yokoyama Taikan
FLOATING LIGHTS
Meiji period, 1909. One of a pair of hanging scrolls, ink, colors, and gold on silk, 56½ × 20½″ (143 × 52 cm). Museum of Modern Art, Ibaraki.

patterning of the leaves overhead is reminiscent of a Rinpa School decorative aesthetic (see pp. 358–361).

SEPARATION OF SHINTO AND BUDDHISM

Restoration of power to the emperor rekindled worship of the emperor as a "living god," a descendant of the Shinto sun goddess, Amaterasu. The Meiji government introduced a policy of "separation of Shinto and Buddhism" and adopted Shinto as the state religion. Buddhism endured a period of suppression, resulting in the destruction of many Buddhist temples and their contents. Further devastation was avoided when Ernest Fenollosa persuaded the Japanese government to protect its cultural heritage. During his time in Japan, Fenollosa and fellow American, physician William Bigelow (1850–1926), acquired a large collection of Buddhist artworks, later donated to the Museum of Fine Arts, Boston.

JAPAN'S GROWING MILITARISM

Once engaged with the outside world, Japan began to flex its dormant muscles and reach out for territory beyond its borders. Isolationism was a thing of the past, and a new "Japanized Asia" loomed on the horizon. Japan annexed Taiwan in 1895 and in 1910 colonized Korea. The Meiji period ended in 1912 with the death of the Meiji emperor. During the succeeding Taisho period (1912–1926) the policies of the Taisho government further solidified Japan's hawkish foreign agenda. Treaties were signed with Western nations that recognized Japan's expanding economic, political, and military interests in Korea, Manchuria, and China.

SHOWA PERIOD

The Showa ("enlightenment and harmony") era (1926–1989) is named for the reign of emperor Hirohito, who lived through tumultuous and periodically horrific times. The year 1945 marked Japan's defeat in World War II and subsequent seven-year Occupation by Allied, mainly American, troops. Under foreign pressure, Japan transformed into a democracy, with the emperor reduced to a ceremonial head of state. One painful memory from the war, indelibly etched on the Japanese psyche, was the dropping of atomic bombs (1945) by American airmen on Hiroshima and Nagasaki (**FIG. 15–26**). Approximately 210,000 people died instantly in the bombings, and thousands more perished over time from their wounds and radiation sickness. Demonstrating resilience, Japan quickly rebuilt after the war and by the 1960s emerged as an economic powerhouse in the modern world. Japanese artists also edged their way into the international spotlight with their progressive contributions to modern art and architecture.

KENZO TANGE

When visitors from around the globe came to Tokyo in 1964 for the summer Olympics, they marveled at the elegant stadiums designed by one of Japan's leading postwar architects, Kenzo Tange (1913–2005) (**FIG. 15–27**). A graduate of Tokyo University, Tange was inspired to become an architect in the 1930s after seeing designs by Swiss architect Le Corbusier (1887–1965) in a

15-26 • HIROSHIMA
1945. View of the flattened city with the dome of the Prefectural Industrial Promotion Hall in the foreground.

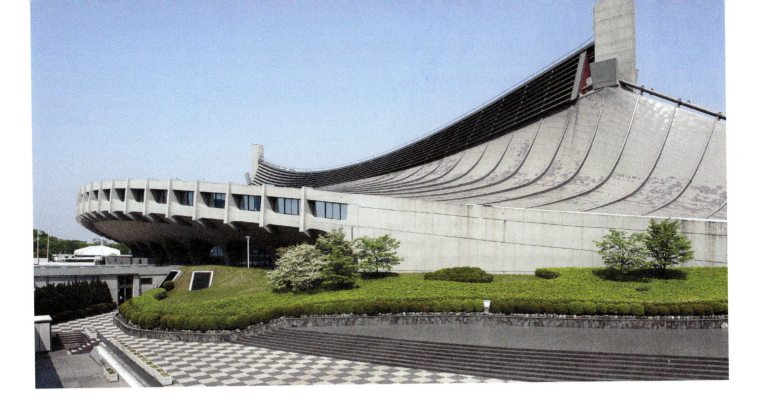

15-27 • Kenzo Tange YOYOGI STADIUM
Showa period, 1961–1964. Concrete and steel cable. Tokyo.

Japanese magazine. Tange's Olympic swimming pool and gymnasium are a daring modernist blend of Japanese architectural forms with what were the latest developments in structural engineering. The roofs of the buildings are suspended from steel cables, eliminating the need for supporting interior pillars that would interfere with the flow of space and block views. Qualities valued in traditional Japanese architecture—flexible interiors plus integration of the building with its environment—are ingeniously incorporated into a modern concrete structure. The sweeping rooflines, almost "tentlike" in appearance, simultaneously reflect Japan's vitality as a modern nation and invoke ancient Shinto shrines with their pointed finials.

THE GUTAI GROUP

Gutai, meaning "embodiment" or "concrete," was the name chosen by a group of postwar artists for their collective, which included founding members Jiro Yoshihara (1905–1972) and Shozo Shimamoto (1928–2013). They challenged preconceptions as to what constitutes art. Formed in 1954, the group produced a range of avant-garde paintings, **installations**, and performances, which pre-dated many experimental developments in European and American art. One aim of Gutai was to "pursue the possibilities of pure and creative activity with great energy." Reflecting this philosophy, Shozo

Shimamoto, at the *Second Gutai Art Exhibition* in 1956, created a work called *Hurling Colors*, by smashing bottles of paint onto canvases placed on the floor (**FIG. 15-28**). The physical act of creating eclipsed the importance of the final material product.

Another Gutai artist, Atsuko Tanaka (1932–2005), who joined the group in 1955, explored the porous boundaries between performance and the visual arts in works such as *Electric*

15-28 • Shozo Shimamoto HURLING COLORS
Showa period, 1956. Performance at the *Second Gutai Art Exhibition*, Tokyo. Courtesy Takashi Shimamoto.

Dress (1956; **FIG. 15–29**). Engulfed in a flashing garment composed of about 200 lightbulbs painted in bright colors, Tanaka appeared as a dynamic entity but also vulnerable, much like postwar Japan. As Japan's economy boomed, so did the culture of advertising. Tanaka's inspiration for the dress came from the blinking neon signs encouraging citizens to become avid consumers. Although her performance can be interpreted as a celebration of Japan's technological progress, *Electric Dress* also highlights technology's destructive potential. The lightbulb dress, with its trailing electrical wires, is a dangerous outfit, threatening the wearer with electrocution.

FROM 1989 TO THE PRESENT

Emperor Hirohito's death in 1989 marked the end of the Showa period. Shortly afterward the Japanese economy spiraled downward. Hirohito's involvement in Japan's militaristic expansion in the first half of the twentieth century came under public scrutiny,

15–29 • Atsuko Tanaka ELECTRIC DRESS
2nd Gutai Art Exhibition, 1956 (modeled by artist). Enamel paint on lightbulbs, electric cords, and control console, 64⁹⁄₁₀ × 31²⁄₅ × 31²⁄₅″ (165 × 80 × 80 cm). Original dress no longer extant, reconstructed in 1986. Photo © The former members of the Gutai Art Association.

as did Japan's legacy of aggressive nationalism. Contemporary Japanese artists, emerging during this time of open debate, rapid change, and global influences, produced a wide range of works, reflecting both political and personal concerns. Artists such as Yanagi Yukinori (b. 1959) and the performance group Dumb Type, formed in 1984, created powerful artworks that frequently exposed flaws in Japanese society.

YANAGI YUKINORI

Yanagi Yukinori, a resident of Hiroshima, addressed the ugliness of blind nationalism in an aesthetically pleasing installation titled *Hinomaru Illumination (Amaterasu and Haniwa)* (1993) (**FIG. 15–30**). Rows of *haniwa* figures inspired by ancient ceramic tomb sculptures (see Chapter 12, pp. 286–287) stand at attention in front of a billboard-size steel panel displaying an hypnotic neon version of Japan's national flag, the *hinomaru* ("circle of the sun"). The sun is closely linked to the imperial family, who, according to Shinto belief, descended from the sun goddess, Amaterasu. After Japan was defeated in World War II, Emperor Hirohito formally renounced his divine status. The *haniwa* symbolize the unthinking masses duped by those in power, whether that is the imperial regime or corporate Japan. The *haniwa's* slavish worship of the flag is also a criticism of ultranationalist groups that discriminate against ethnic minorities within Japan, such as Koreans and the Ainu.

DUMB TYPE

Dumb Type is an interdisciplinary collective of approximately 15 members, ranging from musicians, architects, visual artists, and choreographers to computer programmers. Under the direction of the late Teiji Furuhashi (1960–1995), Dumb Type emerged from Kyoto Art University with a desire to challenge the complacency of the art world. The name Dumb Type alludes to the problems of a society saturated with information but cognizant of nothing. Dumb Type's internationally acclaimed performances such as *pH* (1990–1991), mesmerize audiences with their richly layered multimedia explorations of current issues (**FIG. 15–31**). In *pH*, Dumb Type critically examines contemporary Japanese society, in particular the pressures of living in a high-tech environment and a rampant consumer culture. Furuhashi explained the meaning of *pH* in relation to the performance: "pH is a science term and pH7 is the center, where things are balanced. It's like heaven, limbo, and hell. Japanese society now, especially Tokyo, is like limbo. People think it's heaven but it's not. It's really destructive."

The stage designed for the performance resembled an oblong squash court with seating perched precariously on scaffolding above the set. The spectators looked down on the action below. The floor functioned simultaneously as a stage and as a screen for visual images of urban life projected from above. At one point, a man lying face down on a skateboard swirled onto the stage with arms flailing. The floor featured a projected slide of a gray metropolis seen from the air. One was given the impression of a man in free fall, descending like a fallen angel into

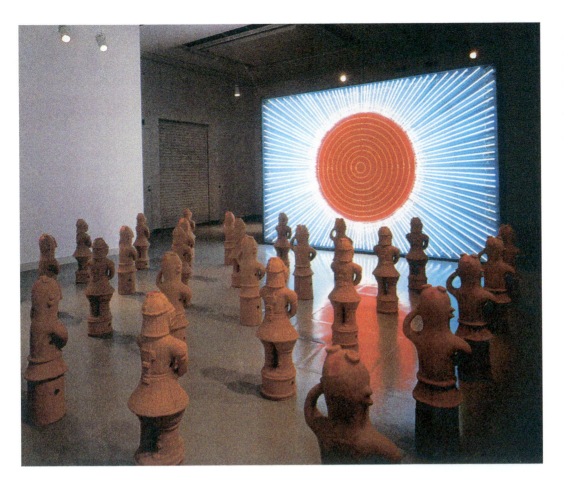

15-30 • Yanagi Yukinori
HINOMARU ILLUMINATION (AMATERASU AND HANIWA)
1993. Neon, neon transformer, programming circuit, painted steel, and *haniwa* figures; each *haniwa* figure approximately 39″ (99 cm) high. Installation at the Museum of Art, Kochi. Courtesy Miyake Fine Art, Tokyo and Yanagi Studio.

the unforgiving landscape below. At carefully timed intervals, a large computer-controlled bar the width of the entire stage swept dangerously close to the audience as it crossed from one side of the space to the other. A second computerized bar moved relentlessly to and fro, only 16 inches (40 centimeters) above the stage floor. Five performers, two men and three mannequinlike women moving within what appeared to be a giant photo-copying machine, were forced to anticipate the movements of the truss or be knocked down. In one "scene," the actors were mindlessly engaged in supermarket shopping. Suddenly, the space was overrun with battery-powered pink fuzzy piglets. The action intensified as the shoppers stuffed as many piglets as possible into their shopping carts before the truss forced their exit.

MORIMURA YASUMASA

A graduate of Kyoto City University of Arts, Morimura Yasumasa (b. 1951) is an **appropriation** artist who constructs complex self-portraits modeled on images from art history, pop culture, and mass media, using photography, video, and performance. He caught the attention of the international art world in the 1980s with his digitally manipulated photographs of iconic paintings

15-31 • Dumb Type *pH*
1990–1991. Performance at Art in the Anchorage, New York. First performance Artspace Mumonkan / Kyoto, JAPAN, 1990, directed by Teiji Furuhashi.

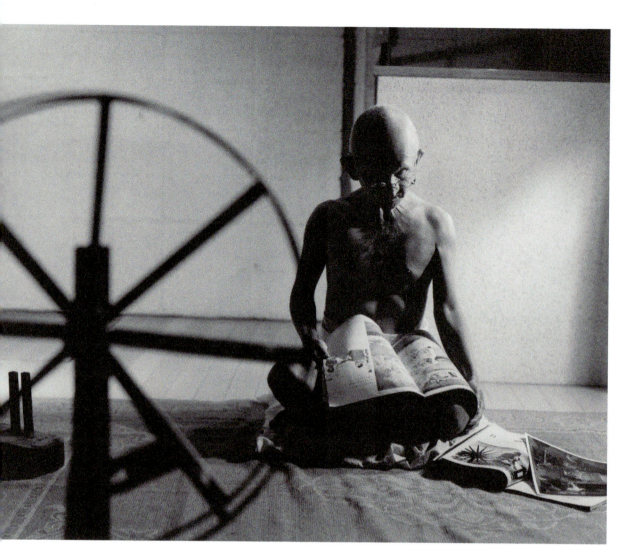

15–32 • Morimura Yasumasa *A REQUIEM: SPINNING A THREAD BETWEEN THE LIGHT AND THE EARTH/1946, INDIA* 2010. Gelatin silver print, 3'11¼" × 4'11" (1.2 × 1.5 m). Art Gallery of New South Wales, Sydney. Courtesy of the artist and Luhring Augustine, New York.

by European artists (see Compare, opposite). Morimura typically inserts himself into the pictures, displacing existing characters, thereby generating a host of interesting questions about cultural appropriation, globalization, racial prejudice, identity, and gender.

In Morimura's more recent self-portraits, the artist transforms chameleonlike into representations of Hollywood celebrities such as Marilyn Monroe and Michael Jackson, or political figures like Mao Zedong and Mahatma Gandhi (**FIG. 15-32**). Morimura's photograph of 2010 entitled *A Requiem: Spinning a Thread between the Light and the Earth/1946, India* pays homage to Margaret Bourke-White's 1946 photograph of Gandhi, featured in *Life* magazine (**FIG. 15-33**). In Morimura's self-portrait he masquerades as Gandhi, leader of the Indian independence movement and symbol of nonviolent resistance. Notice how "Gandhi" is looking at images of the Vietnam War (ended 1975), a conflict that happened years after Bourke-White took Gandhi's photograph. How does Morimura's portrayal of Gandhi alter the way we perceive India's national hero? What does the photograph's large scale imply? Morimura's multilayered works invite us to question both the "Big Picture" and seemingly insignificant details that expose the complexity and fallibility of being human.

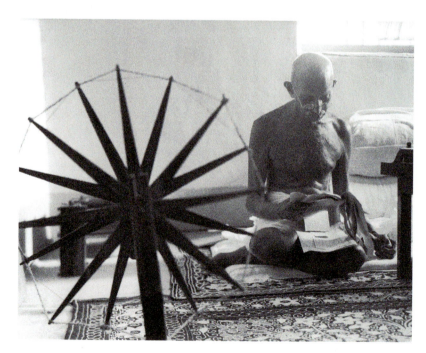

15-33 • Margaret Bourke-White *MAHATMA GANDHI AT HIS SPINNING WHEEL, POONA, INDIA* 1946. Photograph.

At first glance these two nudes, created about a century apart, appear strikingly similar. However, Manet's painting of *Olympia* (**FIG. 15–34**) is an oil painting and Morimura's image (**FIG. 15–35**) is a combination of photography and acrylic paint.

Both works raised eyebrows when first exhibited. Manet's *Olympia* was especially controversial in the late nineteenth century because he boldly depicted a confident-looking prostitute of his day rather than a submissive, anonymous figure disguised as a mythological goddess, Venus. Morimura pays homage to Manet's painting, now a classic, by inserting himself into the artwork as both the prostitute and the black servant who brings flowers from an admirer. In doing so, he generates important questions about sexuality, identity, and race.

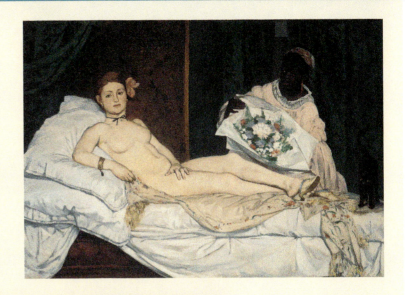

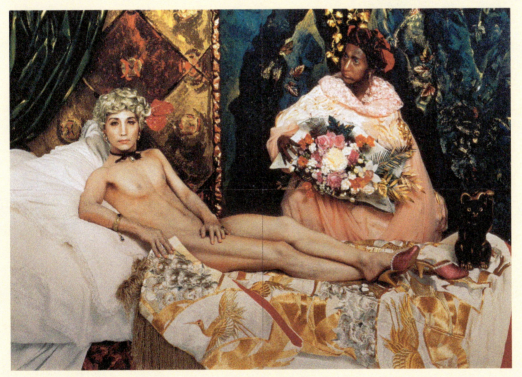

15–34 • Édouard Manet
OLYMPIA
1863. Oil on canvas, 4′3″ × 6′2¼″ (1.31 × 1.91 m). Musée d'Orsay, Paris.

15–35 • Morimura Yasumasa
PORTRAIT (FUTAGO)
1988. Photograph, chromogenic print with acrylic paint and gel, edition of 3: 94½ × 135″ (240 × 342.9 cm). Courtesy of the artist and Luhring Augustine, New York.

THINK ABOUT IT

1. Compare the working methods of both artists. How did Morimura create *Portrait (Futago)*?

2. What do these two images have in common? How are they different?

3. Why was Manet's *Olympia* considered so shocking in nineteenth-century France? Morimura's *Portrait (Futago)* (*Futago* means "twin") also provokes the modern viewer. Why?

4. Morimura's *Portrait (Futago)* is often viewed as a critique of Japan's love–hate relationship with Western culture. Discuss the validity of this observation with reference to Manet's *Olympia*.

5. Compare issues of sexuality and race in both images.

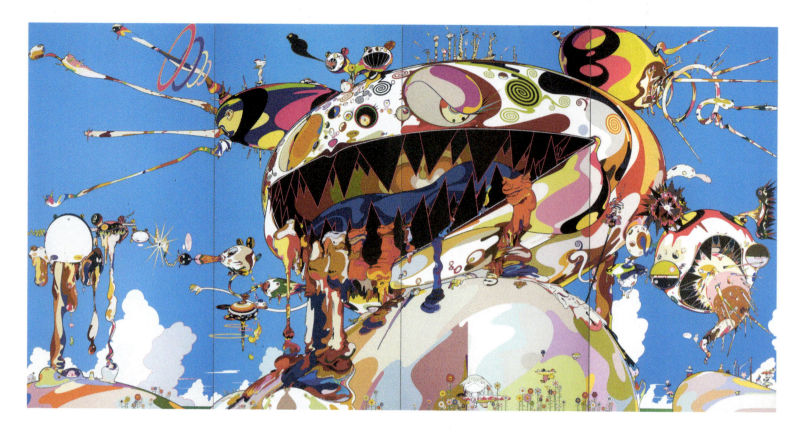

15-36 • Takashi Murakami
TAN TAN BO PUKING—A.K.A. GERO TAN
2002. Acrylic on canvas mounted on board, 141¾ × 283½ × 2⅝″ (360 × 720 × 6.7 cm). Courtesy Galerie Emmanuel Perrotin, Paris & Miami.

TAKASHI MURAKAMI

Artist, writer, cultural entrepreneur, Takashi Murakami (b. 1962) is one of Japan's most versatile, prolific, and successful contemporary artists. In addition to producing paintings and sculptures, he is also an installation artist and filmmaker. Murakami is well versed in art history and contemporary culture. Drawing inspiration from the bold patterns of *ukiyo-e* woodblock prints as well as Japan's popular world of *manga* (comics) and *anime* (animated cartoons), Murakami's brightly colored, glossy, cartoonlike paintings, described as "superflat" by the artist, and life-size figurines depicting *anime* characters eliminate distinctions between fine art and popular culture. In his painting entitled *Tan Tan Bo Puking—a.k.a. Gero Tan* (2002), Murakami explores Japan's infatuation with fantasy by creating his own cartoonish universe filled with exploding colors, while alluding to the darker aspects of the *otaku* (pop culture fanatics) lifestyle (**FIG. 15-36**). Saccharine cuteness—note the smiling flowers and colorful mushrooms—is combined with grotesque elements such as Tan Tan Bo, who resembles a deranged Mickey Mouse, vomiting.

In 2001, Murakami founded the art production company Kaikai Kiki, which lists among its goals "the production and promotion of artwork, the management and support of select young artists, general management of events and projects, and the production and promotion of merchandise."

15-37 • Yayoi Kusama ***MIRROR ROOM—PUMPKIN***
1991. Mirror-encased wooden cubicle, filled with soft sculptures of pumpkins, 6′6¾″ × 6′6¾″ × 6′6¾″ (2 × 2 × 2 m). Hara Museum of Contemporary Art, Tokyo. Courtesy Yayoi Kusama Studio Inc., Ota Fine Arts, Tokyo and Victoria Miro, London.

YAYOI KUSAMA

In 2006, Yayoi Kusama (b. 1929) became the first woman in Japan to be awarded the Praemium Imperiale, one of Japan's top prizes for artists of global distinction. Her outstanding artistic career spans many decades in both Japan and America, and her astonishing repertoire of work includes painting, sculpture, performance art, film, and installation. Kusama has struggled with mental illness since childhood, and in 1977 she became a voluntary resident in a Tokyo psychiatric institution, where she still lives today. She continues to create art in her studio, close to the facility.

Kusama once stated that she wished to obliterate the world with polka dots. Her trademark dots have covered canvases, sculptures, fabrics, and even naked bodies. Obsessively repeated round motifs also appear in her mirrored installations, such as *Mirror Room—Pumpkin*, created in 1991 (**FIG. 15-37**). The viewer looks into a carefully constructed room filled with spotted

pumpkin sculptures, duplicated endlessly in the mirror-lined walls. The pumpkin signifies a type of self-portrait, and through this disorienting artwork the spectator is offered a glimpse into Kusama's hallucinatory world.

In addition to suffering from mental illness, Kusama has also faced challenges as a female artist in a predominantly male art world, and as a Japanese woman living in America. These struggles both generate and inform her art, which at times can be achingly beautiful, as illustrated in the 2011 environmental installation *Infinity Mirrored Room Filled with the Brilliance of Life* (**FIG. 15-38**). The visitor entered a mirrored space filled with a galaxy of twinkling LED lights illuminating endless reflected forms, an invocation perhaps of Gutai artist Kazuo Shiraga's spirited call to nurture individuality and originality as a safeguard against totalitarianism:

> Each person should develop their own way of feeling, talking and painting....The stronger a person's will, the more the person can resist external forces. Contemporary intellect is fleeing from the darkness of the first half of the twentieth century and longing for a brighter world.

15-38 • Yayoi Kusama *INFINITY MIRRORED ROOM FILLED WITH THE BRILLIANCE OF LIFE*

Installation *Yayoi Kusama* at Tate Modern, London, 2012. Room with mirror, LED lights, water pool. 9'10 1/8 x 20'2 7/8" x 20'2 7/8" (300 x 617.5 x 617.5 cm). Courtesy Yayoi Kusama Studio Inc., Ota Fine Arts, Tokyo and Victoria Miro, London.

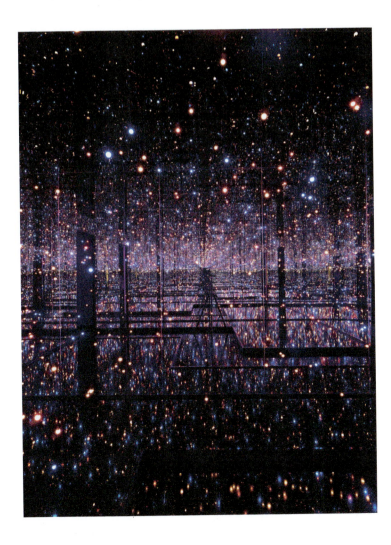

CROSS-CULTURAL EXPLORATIONS

15.1 Discuss the impact of Japanese wood-block prints (*ukiyo-e*) on nineteenth-century European art.

15.2 Korean *gisaeng* and Japanese *geisha* are often described as female entertainers. How accurate is this description? How are they portrayed in art? Do you see any gaps between how they are portrayed and the realities of their lives?

15.3 Discuss a selection of works by the Gutai Group and assess to what degree their avant-garde art pre-dated experimental developments in European and American art.

15.4 Japanese artist Morimura Yasumasa criticized contemporary Japanese art as "dancing to the tune of mass media, a handmaiden of fads and fashion, drunk on global strategies and commercialism and selling itself out; economic gain is now the only value, we are spiritually bankrupt." Do you think this is an accurate assessment of not just current developments in Japanese art but also contemporary art in other Asian countries?

Glossary

A

abstract a style of representation that rejects the accurate representation of reality or nature.

Abstract Expressionism an art movement that originated in America in the mid-twentieth century. Abstract Expressionist artists communicated ideas and emotions through non-traditional methods that emphasized spontaneity and improvisation, and non-representational compositions.

adept a person who has been initiated into a system of spiritual knowledge.

aedicule a decorative architectural frame, usually found around a niche, door, or window. An aedicule is made up of a pediment and entablature supported by columns or pilasters.

aisle a long, narrow space in the interior of a building, usually defined by a row of columns and a wall.

album leaf a small painting included as a leaf in an album of paintings; an important painting format in China.

allegory in a work of art, an image (or images) that symbolizes an idea, concept, or principle, often moral or religious.

Altaic a language family that includes the Turkic, Mongolian, and Tungusic language groups.

altar a table or stand used in religious ritual for offerings or sacrifices and/or for the location of religious icons.

alum lumps rock formations in landscape paintings of the **Dong-Ju tradition** that resemble lumps of potassium aluminum sulphate.

amulet an ornament or small piece of jewelry thought to give protection against evil, danger, or disease.

aniconic ("without image") term referring to the absence of a direct graphic representation of a deity, as in early Buddhist art.

animism the belief that everyone/everything has a soul or spirit, even inanimate objects and natural phenomena.

anthropomorphism the attribution of human characteristics or behavior to a god, animal, or object.

appropriation the practice by some artists of adopting images in their entirety from other works of art or from visual culture for use in their own creations. The act of recontextualizing the appropriated image allows the artist to critique both it and the time and place in which it was created.

apsara a beautiful, female, celestial being in Hindu and Buddhist mythology.

apsidal see **apse**

apse a large semicircular or polygonal (and usually vaulted) recess on an end wall of a building. Apsidal is the adjective describing the condition of having such a space.

aquatint a print resembling a watercolor, produced from a copper plate etched with nitric acid.

arcuate having the form of an arch; a building with arches.

arhat one category of enlightened being in Buddhism; in some traditions, one of the original disciples of the historic Buddha, said to remain in the world until the appearance of the Buddha of the Future.

artifact man-made object.

Aryan a people thought to have settled around 1500 BCE in ancient Iran and the northern Indian subcontinent. Some scholars dispute the idea that that the Sanskrit term *arya* ("noble" or "distinguished"), from which the English term derives, referred to a specific ethnic group; the term may have instead described a group of people of a special social status.

atelier the studio or workshop of a master artist or craftsmaker, often including junior associates and apprentices.

avatar an incarnation or manifestation of a deity on the earth in bodily form.

axe-cut strokes in Chinese painting, a triangular brushstroke that suggests the texture of wood chopped by an axe.

azurite a blue stone used to make **mineral pigments**.

B

barrel vault an elongated or continuous semicircular ceiling vault, shaped like a half-cylinder.

bay a unit of measurement consisting of the space between two columns.

bindi a decorative mark or jewel usually worn in the middle of the forehead, traditionally by married Hindu women.

blue-green landscape a style of Chinese **landscape** painting characterized by the prominent use of blue and green mineral pigments derived from **azurite** and **malachite**.

bodhisattva in Buddhism, a being who has attained enlightenment but chooses to remain in this world in order to help others advance spiritually. Also defined as a potential Buddha.

boneless a Chinese painting technique of laying down areas of wet ink or pigment without outlining them first.

boteh a stylized tear-drop shaped motif in Indian art, often found in textile decoration; also known in English as paisley.

bracket a structural element, typically appearing at the tops of columns, that provides support for the weight of a roof.

Brahma/Brahman in early Vedic tradition the name for the "supreme universal spirit" and in later Hinduism the name of the god of creation.

brahmin the term in Vedic and Hindu traditions for the priestly caste.

brocade a rich fabric, usually silk, woven with a raised pattern.

Bunjinga Japanese form of Chinese *wenrenhua* (literati painting). See also **literati**.

burial substitute a symbolic object buried in a tomb, usually created expressly for that purpose, that is intended to serve the tomb's occupant, as in the burial of figures of servants rather than living people.

bushido "the way of the warrior"; A code of conduct and moral principles developed by the Japanese samurai. *Bushido* stresses self-discipline, courage, and loyalty to one's lord.

C

calligraphy the art of writing; in China it is considered the highest art form.

canon body of works traditionally regarded as the most important or significant within a discipline or set of disciplines, such as the arts.

capital the sculpted block that tops a column.

carnelian a semiprecious stone consisting of an orange or orange-red variety of chalcedony.

cartouche a pictorial device in which a section is set off by a frame from the overall composition. It is most often used for inscriptions, but can also be used to divide up individual images or scenes.

castes the division of a society into distinct and hierarchically-organized social groupings; caste status is often hereditary.

casting a process of shaping molten metal.

celadon a term used to describe a wide variety of stoneware or porcelain wares with glazes that have some green in them. Chinese potters invented the first celadon glaze as early as the third century CE, and typically the glaze is a high-firing, transparent one whose principal coloring agent is an oxide of iron. Celadon glazes spread throughout Asia where they continue to be highly-prized today. Perhaps the most famous celadon wares were made in China and Korea from the twelfth to fourteenth centuries.

cenotaph a funerary monument commemorating an individual or group buried elsewhere.

chaitya a type of Buddhist temple in the form of a hall with a rounded end, housing a sacred shrine or stupa.

chattri literally meaning "umbrella," a term in Indian architecture for domed, unwalled pavilions or kiosks.

chiaroscuro an Italian word designating the contrast of dark and light in a painting, drawing, or print. Chiaroscuro creates spatial depth and volumetric forms through gradations in the intensity of light and shadow.

circumambulation the ritual of walking around a holy object, such as a Buddhist stupa.

citadel a fortress, typically on high ground, protecting or dominating a city.

cloud pattern spiral motifs that appear on ancient Chinese **artifacts**, particularly bronze vessels. Also known as **thunder pattern**.

cobalt a mineral that yields an intensely blue pigment.

coffer a recessed decorative panel used to decorate flat or vaulted ceilings. The use of coffers is called coffering.

colonnade a row of columns, supporting a straight lintel (as in a porch or portico) or a series of arches (an arcade).

colophon in China, an inscription mounted after a painting.

continuous narrative a method of telling a story visually in which one episode flows into the next.

contrapposto Italian term meaning "set against," used to describe the convention of representing a figure standing with most of its weight on one foot so that it seems to sway gently sideways at the hips, giving a sense of movement.

corbel, corbelled an early roofing and arching technique in which each course of stone projects slightly beyond the previous layer (a corbel) until the uppermost corbels meet.

courtesy name a name adopted by a Chinese person in adulthood and used in place of a given name.

cupola a small dome adorning a roof or ceiling.

cusped arches an arch made up of lobed or scalloped shapes.

D

daimyo literally "great name"; Japanese feudal lord.

devaraja literally "god king"; concept of kingship in Southeast Asia where the ruler is considered a manifestation of a deity (such as the Hindu Shiva).

divination the practice of foretelling the future.

Dong-Ju tradition a landscape painting style named for the painters Dong Yuan (d. 962) and Juran (fl. 960-985), typically featuring some of these elements: **hemp-fiber strokes**, **alum lumps**, dotting to indicate vegetation, and tree trunks exposed from root to tip.

E

earthenware a clay body that is fired at low temperatures and is porous.

emaki Japanese term for a handscroll.

F

façade the front of a building.

fengshui Chinese term literally meaning "wind and water," the art of choosing an auspicious site for new construction. Sometimes translated as geomancy.

finial an architectural ornament at the top of a roof.

flanged architectural term for a structure that has projecting ridges or ribs, often running longitudinally—as in a column.

Fudo Japanese name for a Buddhist deity known as the "Immovable One". He is one of the Kings of Light, who bring light and wisdom into the world. Fudo defeats evil with his dragon sword of wisdom and coils of rope, and is often shown seated on bare rocks against a fiery background. Flames signifying wisdom burn up hindrances and evils.

G

gabled (roof) a roof with two rectangular sections sloping outward and down from a ridgepole at the top, creating gables, or triangular areas of wall, at either end of the building.

Ganesh the elephant-headed son of Shiva and Parvati; he is the god of beginnings and the remover of obstacles.

garbhagriha from the Sanskrit word meaning "womb chamber," a small room or shrine in a Hindu temple containing a holy image.

genre a subject category in art.

genre painting a term used to loosely categorize paintings depicting scenes of everyday life, including (among others) domestic interiors, parties, inn scenes, and street scenes.

glaze a liquid suspension of minerals that is applied to a ceramic object after a first firing in order to impart a smooth and glossy finish, and, in the case of vessels, to make them watertight.

gopura the towering gateway to an Indian Hindu temple complex.

grave goods objects buried with a body for its sustenance in the afterlife.

Great Goddess term for the entity of which all female Hindu deities are manifestations.

groin vault a vault created by the intersection of two **barrel vaults** of equal size which creates four side compartments of identical size and shape.

guru a Hindu spiritual teacher or head of a religious sect.

Gyo a Korean school of Buddhism that emphasizes scriptural teaching.

H

handscroll a horizontally organized composition on paper or silk, designed to be gradually unrolled and viewed from right to left; an important painting format in China.

hanging scroll a vertically oriented composition meant to be displayed on a wall; an important painting format in China.

hangul the Korean phonetic alphabet, and Korea's official writing system since the late nineteenth century.

haniwa pottery forms, including cylinders, buildings, and human figures, that were placed on top of Japanese tombs or burial mounds during the Kofun period (300-552 CE).

hardstone a word that in the decorative arts or archaeology is used as a general term for semiprecious and precious gemstones.

hemp-fiber strokes long, ropy brushstrokes used to indicate texture in landscape paintings of the **Dong-Ju tradition**.

hieratic scale the practice of depicting elements as large or small depending on their relative importance. Also called hierarchical perspective.

hipped (roof) a roof with four trapezoidal sections sloping outward and down from a ridgepole at the top.

hipped-and-gabled (roof) a roof that is gabled at the top with hipping extending below it on all four sides.

I

iconography identifying and studying the subject matter and conventional symbols in works of art.

ikat type of fabric originating in India and which became popular in Southeast Asia. It is made using a decorative technique in which warp or weft threads, or both, are tie-dyed before weaving.

illustrated manuscript a manuscript decorated with paintings that are illustrations of the text.

Indo-Saracenic an architecrural term for buildings that combine native Indian traditions with those of Islamic and **neo-Gothic** styles.

inlay to set pieces of a material or materials into a surface to form a design.

installation contemporary art created at a specific site, especially a gallery or outdoor area, that has a complete and controlled environment.

International Style a functional style of twentieth-century architecture that is characterized chiefly by regular, unadorned geometric forms, open interiors, and the use of glass, steel, and reinforced concrete.

iwakura in Shinto, the site at which a *kami* has taken up residence. The *iwakura* is usually represented by a wooden shrine within an enclosure. The enclosure is accessed through a *torii* gate.

J

jamb in architecture, the vertical element found on both sides of an opening in a wall, and supporting an arch or lintel.

jataka in Buddhism, stories associated with the previous lives of Shakyamuni, the historical Buddha.

Jeongto a Korean term for Pure Land (Buddhist "paradise"). *Jeongto*, presided over by the Buddha Amitabha (Korean: Amita), is a transcendent blissful realm. Devotees who reach this paradise after death are able to attain Enlightenment without the burden of earthly troubles.

Jina literally "victor"; title given to Mahavira or to any of the twenty-four founding prophets of Jainism, who have successfully crossed the stream of time and made a path for others to follow.

joined-block technique developed in Japan, the joined-block wood sculpture technique (*yosegi zukuri*) is a method of constructing large-scale wooden sculpture. The entire work is constructed from individually-carved blocks of wood that are then joined together.

Jomon Japanese prehistoric period with dates from ca. 14,000-300 BCE. Archaeologists named the period Jomon ("cord markings") after the era's ceramic vessels that feature distinctive cord patterns.

K

Kabuki theatre a fusion of dance, drama, and music that developed during the fifteenth, sixteenth, and early seventeenth centuries in Japan. Still popular today, actors wearing sumptuous costumes and dramatic makeup entertain audiences with melodramatic plays based upon ancient legends, historical events, traditional stories, or sensational contemporary tales. Larger-than-life acting and lavish sets contribute to the spectacle.

kagura Shinto ritual dance and music.

kami Shinto spirits or deities.

kamikaze Japanese term that translates literally as "divine wind." During World War II Japanese suicide pilots (the *kamikaze*) crashed their bomb-filled planes into enemy targets, frequently ships.

kana two syllabaries—*hiragana* and *katakana* developed at the end of the eighth century to represent the syllable sounds of the Japanese language.

kanji Chinese characters that form the earliest and still integral part of Japan's written language.

Kannon the Bodhisattva of Compassion.

kara-e an early Japanese term for Chinese painting styles popular in Japan. See also *yamato-e*.

karma in Hinduism and Buddhism, the sum of a person's actions in this and previous states of existence, and which determines one's destiny in the next life.

Kegon (Chinese: Huayan) a school of Buddhism founded in China around 600 by Fazang and transmitted to Japan ca. 740. Kegon emphasizes the inter-connectedness of all living things, with the Buddha Vairochana at the center of this intermingling universe.

kimono literally "thing to wear"; a term for the traditional full-length Japanese robe.

kirikane a decorative technique using cut pieces of gold leaf, sometimes elaborately shaped, on paintings, sculptures, ceramics, and lacquerware.

koan questions or exchanges with a Zen master that cannot be understood or answered with rational thought.

Kofun name of an early Japanese period from ca. 300–552 that is named after the many large tombs (*ko* = old, *fun* = grave mound) that were built during this era.

kondo the main hall inside a Japanese Buddhist temple where the image(s) of the Buddha is housed.

Kongo Rikishi guardians of the Buddha.

kosode literally "small sleeves"; a modern term for all full-length robes made before the Meiji period (1868–1911).

Krishna one of **Vishnu**'s principal **avatars**, and a popular and prominent figure in Hindu belief portrayed variously as a mischievous infant, a model lover, and a divine hero.

kyogen a short, witty comedy performed in between Noh plays. Masks worn by kyogen actors often have cheerful, silly, and ugly faces to encourage laughter.

L

lacquer a medium made from the addition of pigments to the heated sap of the lacquer tree, native to southern and central China, and used to paint objects made of wood, cloth, or paper.

lakshanas a group of symbols in images of the Buddha that indicate his attainment of enlightenment, including the **urna**, **ushnisha**, and the webbing between the fingers and toes.

Lakshmi in Hinduism, the consort of **Vishnu** and one of the manifestations of the **Great Goddess**. She is the goddess of wealth, prosperity, and the embodiment of beauty.

landscape an important subject in East Asian art, typically including the elements of mountains and water (Ch. *shanshui*).

leather-hard in making ceramic objects, the state in which the clay has dried to the stiffness of leather, still retaining some dampness.

linga a phallus shape that symbolizes the power of the Hindu god Shiva.

lintel a horizontal element of any material carried by two or more vertical supports to form an opening.

Li-Guo tradition a landscape painting style named for the painters Li Cheng (919–967) and Guo Xi (ca. 1001–1090), typically featuring these elements: serpentine mountain ridges, trees with crab-claw branches, and representations of level distance.

literary name a name adopted by Chinese writers for literary endeavors.

literati classically educated scholars who typically belonged to the official class of men who served in the Chinese political bureaucracy. Sometimes described as scholar-officials.

loggia Italian term for a gallery. Often used as a corridor between buildings or around a courtyard, a loggia usually features an arcade or colonnade.

lost-wax casting a method of casting metal, such as bronze. A wax mold is covered with clay and plaster, then fired, thus melting the wax and leaving a hollow form. Molten metal is then poured into the hollow space and slowly cooled. When the hardened clay-and-plaster exterior shell is removed, a solid metal form remains to be smoothed and polished.

M

Ma-Xia school a group of painters working in the landscape styles of Ma Yuan (fl. ca. 1190–1230) and Xia Gui (fl. ca. 1180–1224), typically featuring some of these elements: **one-corner composition**, the use of ink wash, **axe-cut strokes**, and angular branches.

mace a heavy club.

madrasa an Islamic institution of higher learning, where teaching is focused on theology and law.

maebyeong a Korean term used to describe a type of vessel with a small mouth, broad shoulders, and narrow base.

magatama a curved jewel made from stone, often jade. *Magatama* are an important component of the regalia of Japan's rulers. An object of high status and adornment they are also found in other early Asian cultures, in particular that of Korea.

malachite a green stone used to make **mineral pigments**.

mandala an image of the cosmos represented by an arrangement of circles or concentric geometric shapes containing diagrams or images. Used for meditation and contemplation by Buddhists.

mandapa in a Hindu temple, an open hall dedicated to ritual worship.

mandate of heaven an ancient Chinese concept in which Heaven grants the ruler the right to rule. However, the right to rule is dependent upon the ruler's virtuous conduct.

mandorla an almond-shaped halo, typically extending around the body rather than just the head.

material culture objects suggestive of the culture of a particular group.

Manchu a member of a people originally living in Manchuria (now part of Northeast China).

masjid Arabic term meaning literally "place of prostration"; a mosque.

medium (plural **media**) the material from which a work of art is made.

megalith a large stone that forms a prehistoric monument.

mendicant one who practices begging.

Mi family style a landscape painting style named for the painters Mi Fu (1051–1107) and Mi Youren (1074–1151), typically featuring some of these elements: conical mountains, daubs or dots of wet ink, the use of ink wash, and negative space to suggest mist.

mihrab a recess or niche that distinguishes the wall oriented toward Mecca (*qibla*) in a mosque.

minaret a tower on or near a mosque from which Muslims are called to prayer.

mineral pigment colored **media** that derive from mineral sources, such as lead, **azurite**, **malachite**, cinnabar, or similar.

Miroku Bosatsu according to Buddhist tradition, Miroku Bosatsu (Sanskrit: Maitreya) is a bodhisattva who will appear on earth in the future to teach the *dharma* (Buddhist law). His appearance will coincide with a time when the teachings of the current Buddha (Gautama) have been neglected and forgotten. The prophecy is found in the canonical literature of all branches of Buddhism and some texts predict a series of dramatic events marking his arrival, such as oceans decreasing in size so Miroku can easily cross the waters.

mithuna an amorous male and female couple in Indian sculpture, usually found at the entrance to a sacred building. The *mithuna* symbolizes the harmony and fertility of life.

molding a shaped or sculpted strip with varying contours and patterns. Used as decoration on architecture, furniture, frames, and other objects.

monolithic formed of a single large block of stone.

mortise-and-tenon a method of joining two elements; A projecting pin (tenon) on one element fits snugly into a hole designed for it (mortise) on the other. Such joints are very strong and flexible.

motif a design element in a work of art, including compositional features or images.

mudra a symbolic hand gesture in Buddhist art that denotes certain behaviors, actions, or feelings.

mural a wall painting.

N

naturalism a style of representation that strives for the accurate representation of reality or nature. The adjectival form is naturalistic.

nave an open central area in the interior of a building, usually defined by columns on the periphery.

neo-Gothic a revival or adaptation of the medieval European Gothic architectural style.

nimbus the halo-like element framing the head of an image that indicates their divinity or sanctity.

nirvana the state achieved, in both Buddhism and Hindusim, once one has attained full enlightenment and extinguished all ignorance and desire.

Nyoirin Kannon the bodhisattva who grants wishes (a form of Kannon, the Bodhisattva of Compassion). He is usually portrayed with six arms holding various attributes such as the wish-granting jewel, lotus flower, and the wheel of Buddha's Law. When depicted as a deity with two arms he does not hold a jewel. Instead he may be portrayed in a distinctive seated posture with his crossed right leg resting at the ankle over his left leg.

O

obi a broad sash worn with a Japanese kimono.

oculus in architecture, a circular opening. Usually found either as a window or at the apex of a dome.

one-corner composition in Chinese painting, a composition weighted heavily toward one of the bottom corners, typically leaving negative space in the opposite corner that is ideal for an inscription.

orthodox according with received tradition; conventional.

overglaze decoration applied to a ceramic object over the glaze, using enamel.

oxidation exposure to oxygen.

oxidizing atmosphere in firing ceramics, a kiln atmosphere with an excess of oxygen.

P

pagoda the East Asian form of a **stupa**.

patina a crusty surface.

patron someone who commissions, funds, or sponsors a work of art. The act is referred to as patronage.

picturesque used to describe the "picturelike" qualities of landscape scenes popular in the eighteenth and nineteenth centuries in Europe.

piece-mold casting a method of casting metal, such as bronze. The process involves making a clay mold in pieces that can be connected.

pilgrim a person who journeys to a sacred place for religious reasons.

plain-outline style a painting style originating with Li Gonglin (ca. 1041-1106), in which elements are depicted with simple, unmodulated outlines and typically no use of color.

porcelain a type of extremely hard and fine white ceramic first made by Chinese potters in the eighth century CE. Made from a mixture of kaolin and petuntse, porcelain is fired at a very high temperature, and the final product has a translucent surface.

portico a projecting roof or porch supported by columns, often marking an entrance.

post-and-beam a technique of constructing buildings using vertical posts and horizontal beams, usually in wood and plaster.

pottery vessels or objects made out of clay; ceramics.

provenance an artwork's history of ownership.

putto (plural *putti*) a plump, naked little boy, often winged; common in European art.

Q

qibla the mosque wall oriented toward Mecca; indicated by the **mihrab**.

R

raigo the welcome to the Western paradise by Amida Buddha, and possibly one or more bodhisattvas, of a devotee after death.

reducing atmosphere in firing ceramics, a kiln atmosphere with reduced oxygen due to the introduction of smoke into the kiln.

register vertical level.

relic venerated object or body part associated with a holy figure, such as the Buddha.

relief design elements that project forward from the surface.

renga a collaborative form of poetry in Japan involving two or more poets who contribute verses in turn to compose one long poem.

repoussé a technique for working metal that involves hammering a sheet of metal in order to create a raised design on the opposite side.

Rinzai in Japan's medieval period, Zen was transmitted to Japan in two main forms: Rinzai and **Soto**. Rinzai, with its belief in the possibility of sudden Enlightenment, the effectiveness of the *koan* as teaching tool, and the ritual drinking of tea was especially well received by the *daimyo* (feudal lords) and shogun.

rosary Buddhist rosaries contain 108 beads believed to symbolize the 108 delusions that people can suffer from.

roundel any ornamental element with a circular format.

ruled-line style a method of using a straight-edge to depict buildings in paintings.

running-grass script style of calligraphy in which elements of the character are abbreviated or disappear in favor of a smooth and quick execution, appearing much like blades of grass or straw.

S

sala Indian architectural term indicating the **barrel-vaulted** roof of a temple in the southern Indian temple tradition.

samsara term in Buddhism and Hinduism for the eternal cycle of birth, suffering, death, and rebirth that can only be broken by extinction of all desire and ignorance.

samurai a member of the Japanese warrior class.

saptamatrika the "seven goddesses" who are each manifestations of the **Great Goddess** and are also the consorts of the seven principal gods of Hinduism.

seal an object of stone (such as **steatite**), metal, or wood carved at one end with an insignia or name that when stamped in ink or paste and then onto a surface (or when stamped into soft wax) leaves an impression of the insignia. In East Asian art, a seal is an artist's or collector's mark stamped on a painting, usually with **vermilion** paste.

Seon a Korean school of Buddhism that emphasizes meditation. Seon is often known in the West by the name of its Japanese equivalent: **Zen**.

seppuku (also known as *hara-kiri*) a method of committing ritual suicide through disembowelment. *Seppuku* was also practiced as a form of capital punishment.

shamanism a belief system focused on the shaman, a person believed to communicate with the spirit world (via an altered state) in order to heal the sick, practice divination, and control future events, among other tasks.

shamisen a Japanese musical instrument like a lute that was introduced from China.

shaykh an Islamic religious official or leader.

Shingon an Esoteric Buddhist sect in Japan that emphasizes the mystical abilities of priests who conduct arcane rituals, perform **mudras**, recite mantras, and meditate on **mandalas** to ensure the spiritual and material well-being of the laity.

Shinto Japan's indigenous belief system rooted in **shamanism** but later known as Shinto (Way of the Gods). Shinto, which evolved out of the needs of an early agrarian culture, initially functioned without scriptures, dogmas, devotional images, famous teachers, or elaborate structures.

Shiva one of the principal gods of Hinduism; he is the father of Ganesh, the consort of Parvati; he is both creator of life and destroyer of evil.

shogunate in Japan, the government, office, or rule of a shogun.

shoji in Japan, white translucent paper screens with wooden lattice frameworks.

single-point perspective represented objects appear to recede in space by being drawn progressively smaller and closer together towards a single point at the horizon line.

slip a mixture of clay and water used to join clay elements or to decorate ceramics before they are glazed and fired.

Socialist Realism a state-approved artistic style, developed in the Soviet Union and adopted in other countries with communist regimes, which promotes and glorifies the political and social ideals of communism. Hard working laborers and communist leaders are typically portrayed in a heroic or idealized manner.

Soto in Japan's medieval period, Zen was transmitted to Japan in two main forms: **Rinzai** and Soto. Soto, in advocating a balance of meditation and physical activity leading to moments of understanding and a more gradual Enlightenment, appealed in particular to the peasantry and the samurai of the provinces.

space-cell a cell-shaped enclosure containing pictorial elements, apparently set on a different plane of recession from the surrounding elements.

spandrel the area of wall between two arches, as in an arcade.

spatial recession the indication of objects receding from a foreground into a background.

splashed-ink style a painting method, strongly associated in East Asia with Chan or **Zen Buddhism**, that involves dripping or splashing ink and creating a composition around the resulting forms.

steatite also known as soapstone, it is a talc/schist rock that is relatively soft and can be easily shaped and modeled.

stele (plural **stelae**) an upright stone slab carved with inscriptions and images. Usually erected for commemorative purposes or as a grave marker.

stoneware a clay body that can be fired to a higher temperature than **earthenware** and is harder and nonporous. Stoneware occurs in a range of earth-toned colors, from white and tan to gray and black, with light gray predominating.

stucco a mixture of lime, sand, and other ingredients made into a material that can easily be molded or modeled. When dry, it produces a durable surface used for covering walls or for architectural sculpture and decoration.

stupa in Buddhist architecture, a dome-shaped structure erected as a shrine and containing sacred relics.

Sudhana an Indian youth who searched for enlightenment, and in his quest he learned from 53 spiritual masters, including Guanyin (the Bodhisattva of Compassion).

Sueki ware a type of elegant grey-green pottery first developed in Korea. Popular with the ruling classes, Sueki ware was introduced into Japan by Korean craftsmen during the fifth century. This high quality pottery, often used for ceremonial purposes, was turned on the wheel and fired at very high temperatures (over 1000 degrees centigrade). As a result, Sueki ware acquires an ash glaze due to the vitrification of matter from the kiln walls.

sutras sacred scriptures of Buddhism.

syncretism a process whereby artists assimilate and combine images and ideas from different cultural traditions, beliefs, and practices, giving them new meanings.

T

tableau a group of figures representing a scene from a story.

taotie a mask motif that appears on early Chinese artifacts, particularly in the Neolithic era and the Shang dynasty.

tarashikomi (the «dripping in» technique) a Japanese technique whereby ink and/or colors are applied to a previously painted surface that is still wet. This results in an atmospheric pooling of colors and mottled effects.

tatami a Japanese woven grass mat filled with straw. In Japan, a room's size is still measured by the number of *tatami* mats: for example, a six *tatami* room. A standard tatami mat is roughly six feet long, three feet wide and two inches thick (182 x 92 x 5.25 cm).

Tenjukoku a Buddhist paradise that includes components drawn from Chinese and Japanese folk traditions and cosmology.

terra-cotta unglazed **pottery**.

thunder pattern see **cloud pattern**.

torii entrance gate to a Shinto shrine.

trope term for a recurrent theme or convention in a genre or discipline of art.

tumulus funerary mound.

U

underglaze decoration, typically in **slip**, applied to a ceramic object before glazing.

unorthodox contrary to what is usual, traditional, or accepted.

urna the curl of hair on the forehead that is a characteristic mark of the Buddha. The *urna* is a symbol of divine wisdom.

ushnisha a rounded shape at the top of the head that is a characteristic mark of the Buddha. The *ushnisha* is a symbol of enlightenment.

V

vahana Sanskrit term meaning "vehicle" and indicating the animal or entity associated with a particular deity and on which they are often shown riding.

Vedas earliest known body of beliefs in the Indian subcontinent, believed to have been directly revealed by **Brahman**.

vermilion a red pigment made from the mineral cinnabar.

vihara a Sanskrit term meaning literally "for wanderers." A *vihara* is, in general, a Buddhist monastery. It also signifies monks' cells and gathering places in such a monastery.

Vishnu one of the principal gods of Hinduism who embodies the qualities of mercy and goodness; he is the creator of the universe and the (repeated) savior of mankind in the form of his ten **avatars**.

votive offering an object left as a ritual gift in a sacred place.

W

waka a Japanese poem of thirty-one syllables in five lines.

woodblock print a print made from one or more carved wooden blocks. In Japan, woodblock prints were made using multiple blocks carved in relief, usually with a block for each color in the finished print.

Wu School a group of painters working in the Suzhou area in the Ming dynasty (1368–1644).

Y

yamato-e early Japanese term for Japanese-style painting. See also *kara-e*.

yoga ancient system of religious practice in India predicated on bodily control and meditation.

yoroi suit of Japanese armor.

Z

zazen Zen meditation.

Zen Buddhism known as Chan in China, Zen Buddhism is a Japanese form of Buddhism that emphasizes meditation, intuition, and strict self-discipline.

Zhe School a loose affiliation of professional painters working in Zhejiang during the Ming dynasty (1368–1644). The painter Dai Jin (1368–1462) is credited as its founder.

Bibliography

Asian Art, General

Addiss, Stephen and Audrey Yoshiko Seo. *How to Look at Japanese Art*. New York: Harry Abrams Inc., 1996.

Addiss, Stephen, Gerald Groemer and Rimer, Thomas, eds. *Traditional Japanese Arts and Culture: An Illustrated Sourcebook*. Honolulu: University of Hawaii Press, 2006.

Akiyama, Terukazu. *Treasures of Asia: Japanese Painting*. New York: Rizzoli International Publications Inc., 1990.

Asher, Catherine B. and Cynthia Talbot. *India before Europe*. Cambridge: Cambridge University Press, 2006.

Barnes, Gina. *The Rise of Civilization in East Asia: The Archaeology of China, Korea and Japan*. London: Thames and Hudson, 1999.

Barnhart, Richard M., James Cahill, Wu Hung, Yang Xin, Nie Chongzheng and Lang Shaojun. *Three Thousand Years of Chinese Painting*. New Haven and London: Yale University Press; Beijing: Foreign Languages Press, 1997.

Blurton, T. Richard. *Hindu Art*. Cambridge, MA.: Harvard University Press, 1993.

Brown, Rebecca and Deborah Hutton eds. *Asian Art*. Oxford: Blackwell Publishing Ltd, 2006.

———. *A Companion to Asian Art and Architecture*. Malden, MA: Wiley-Blackwell, 2011.

Bush, Susan. *The Chinese Literati on Painting: Su Shih (1037-1101) to Tung Ch'i-ch'ang (1555-1636)*. Harvard-Yenching Institute Studies, no. 27. Cambridge, MA: Harvard University Press, 1971.

——— and Christian Murck, eds. *Theories of the Arts in China*. Princeton: Princeton University Press, 1983.

———, and Hsio-yen Shih, comp. and ed. *Early Chinese Texts on Painting*. Cambridge, MA: Harvard-Yenching Institute, Harvard University Press, 1985.

Center for the Art of East Asia. *Digital Scrolling Paintings Project*. Chicago: The University of Chicago, 2011. Available online: scrolls.uchicago.edu.

Chandra, Pramod. *On the Study of Indian Art*. Cambridge, MA: Published for the Asia Society by Harvard University Press, 1983.

Chang, Yang-mo. *Arts of Korea*. Judith G. Smith ed. New York: Metropolitan Museum of Art, 1998.

Clark, John. *Modern Asian Art*. Honolulu: University of Hawaii Press, 1998.

Coaldrake, William H. *Architecture and Authority in Japan*. London: Routledge, 1996.

De Bary, Wm. Theodore, Wing-tsit Chan, and Burton Watson, comp. *Sources of Chinese Tradition*. 2 vols. Introduction to Asian Civilizations. New York: Columbia University Press, 1960.

Dehejia, Vidya. *Indian Art*. London: Phaidon, 1997.

Delay, Nelly. *The Art and Culture of Japan*. New York: Harry N. Abrams, 1999.

Ebrey, Patricia Buckley. *The Cambridge Illustrated History of China*. 2nd edition. Cambridge: Cambridge University Press, 2010.

Eight Dynasties of Chinese Painting: The Collections of the Nelson Gallery-Atkins Museum, Kansas City, and The Cleveland Museum of Art. With essays by Wai-kam Ho, Sherman E. Lee, Laurence Sickman, and Marc F. Wilson. Cleveland: The Cleveland Museum of Art, 1980.

Fisher, Robert E. *Buddhist Art and Architecture*. World of Art. New York: Thames & Hudson, 1993.

Fong, Wen C. *Beyond Representation: Chinese Painting and Calligraphy 8th-14th Century*. New York: Metropolitan Museum of Art; New Haven: Yale University Press, 1992.

———, and James C.Y. Watt. *Possessing the Past: Treasures from the National Palace Museum, Taipei*. With contributions by Chang Lin-sheng, James Cahill, Wai-kam Ho, Maxwell K. Hearn, and Richard M. Barnhart. New York: The Metropolitan Museum of Art; Taipei: National Palace Museum, 1996.

Goswamy, B.N. *Essence of Indian Art*. San Francisco: Asian Art Museum, 1986.

Granoff, Phyllis and Koichi Shinohara, eds. *Images in Asian Religions: Texts and Contexts*. Vancouver: UBC Press, 2004.

Howard, Angela F. *Chinese Sculpture*. New Haven: Yale University Press; Beijing: Foreign Languages Press, 2006.

Huntington, Susan L. *The Art of Ancient India: Buddhist, Hindu, Jain*. Boston: Weatherhill, 1985.

Kakudo, Yoshiko. *The Art of Japan*. San Francisco: Asian Art Museum of San Francisco, 1991.

Kim-Renaud, Young-Key, ed. *Creative Women of Korea: the Fifteenth Through the Twentieth Centuries*. New York and London: M.E. Sharpe, 2004.

Ko, Dorothy, JaHyun Kim Haboush, and Joan Pigott, eds. *Women and Confucian Cultures in Premodern China, Korea, and Japan*. Berkeley: University of California Press, 2003.

Lee, Bae-yong, *Women in Korean History*. Seoul: Ewha Womans University Press, 2008.

Lee, Peter. *Sourcebook of Korean Civilization*. New York: Columbia University Press, 1993.

Lee, Sherman, ed. *China, 5,000 Years: Innovation and Transformation in the Arts*. New York: Solomon R. Guggenheim Museum, 1998.

Leidy, Denise Patry. *The Art of Buddhism: An Introduction to its History and Meaning*. Boston: Shambhala Publications Inc., 2008.

Lerner, Martin and Steven Kossak. *The Arts of South and Southeast Asia*. New York: Metropolitan Museum of Art, 1994.

Li, Chu-tsing, ed. *Artists and Patrons: Some Social and Economic Aspects of Chinese Painting*. Lawrence, KS: Kress Foundation Department of Art History, University of Kansas; Kansas City, MO: Nelson-Atkins Museum of Art, 1989.

Little, Stephen, with Shawn Eichman. *Taoism and the Arts of China*. With essays by Patricia Ebrey, Kristofer Schipper, Nancy Schatzman Steinhardt and Wu Hung. Chicago: The Art Institute of Chicago, 2000.

Mackenzie, Lynn. *Non-Western Art: A Brief Guide*. 2nd ed. Upper Saddle River, NJ: Pearson/Prentice Hall, 2001.

Mason, Penelope. *History of Japanese Art*. 2nd ed. Donald Dinwiddie rev. Upper Saddle River, NJ: Pearson/Prentice Hall, 2005.

McArthur, Meher. *The Arts of Asia: Materials, Techniques, Styles*. New York: Thames & Hudson, 2005.

———. *Reading Buddhist Art: An Illustrated Guide to Buddhist Signs and Symbols*. New York: Thames & Hudson, 2002.

Mckillop, Beth. *Korean Art and Design*. London: Victoria and Albert Museum, 1992.

Mitter, Partha. *Indian Art*. Oxford: Oxford University Press, 2001.

Mrázek, Jan, and Morgan Pitelka, eds. *What's the Use of Art? Asian Visual and Material Culture in Context*. Honolulu: University of Hawaii Press, 2008.

Murck, Christian F., ed. *Artists and Traditions: Uses of the Past in Chinese Culture*. Princeton: Princeton University Press, 1976.

Murase, Miyeko. *Bridge of Dreams: The Mary Griggs Burke Collection of Japanese Art*. New York: Metropolitan Museum of Art, 2000.

O'Brien, Elaine, Everlyn Nicodemus, Melissa Chiu, Benjamin Genocchio, Mary K. Coffey, and Roberto Tejada, eds. *Modern Art in Africa, Asia and Latin America: An Introduction to Global Modernisms*. Malden, MA: Wiley-Blackwell, 2013.

Pak, Youngsook, and Roderick Whitfield. *Buddhist Sculpture*. Handbook of Korean Art. London: Laurence King, 2003.

Sadao, Tsumeko and Stephanie Wada. *Discovering the Arts of Japan: A historical Overview*. London: Kodansha International Ltd., 2003.

Portal, Jane. *Korea Art and Archaeology*. London: British Museum, 2000.

Pratt, Keith. *Images of Asia: Korean Painting*. Oxford: Oxford University Press, 1995.

Sirén, Osvald. *Chinese Painting: Leading Masters and Principles*. 7 vols. London: Lund, Humphries and Company, 1956. Reprint. New York: Hacker Art Books, 1973.

———, trans. *The Chinese on the Art of Painting: Translations and Comments*. New York: Schocken Books, 1963.

Smith, Lawrence, Victor Harris, and Timothy Clark. *Japanese Masterpieces in the British Museum*. New York: Oxford University Press Inc., 1990.

Stanley-Baker, Joan. *Japanese Art*. New York: Thames and Hudson, 2000.

Steinhardt, Nancy S. *Chinese Imperial City Planning*. Honolulu: University of Hawaii Press, 1990.

———, ed. *Chinese Architecture*. New Haven: Yale University Press; Beijing: New World Press, 2002.

Sullivan, Michael. *The Meeting of Eastern and Western Art*. Revised and expanded edition. Berkeley and Los Angeles: University of California Press, 1989.

Thorp, Robert L., and Richard Ellis Vinograd. *Chinese Art and Culture*. Upper Saddle River, NJ: Prentice Hall; New York: Harry N. Abrams, 2001.

Varley, Paul. *Japanese Culture*. 4th ed. Honolulu: University of Hawaii Press, 2000.

Weidner, Marsha, Ellen Johnston Laing, Irving Yucheng Lo, Christina Chu, and James Robinson. *Views from a Jade Terrace: Chinese Women Artists 1300-1912*. Indianapolis: Indianapolis Museum of Art, 1988.

Weidner, Marsha, ed. *Flowering in the Shadows: Women in the History of Chinese and Japanese Painting*. Honolulu: University of Hawaii Press, 1990.

Wu Tung. *Tales from the Land of Dragons: 1,000 Years of Chinese Painting*. Boston: Museum of Fine Arts, 1997.

Yi, Song-mi. *Fragrance, Elegance, and Virtue: Korean Women in Traditional Arts and Humanities*. Seoul: Daewonsa Publishing Co., 2002.

Young, David and Michiko. *The Art of Japanese Architecture*. Tokyo: Tuttle Publishing, 2007.

Asian Art Journals

Archives of Asian Art. Annually. New York: Asia Society, 1945-.

Ars Orientalis: The Arts of Asia, Southeast Asia, and Islam. Annually. Ann Arbor: Univ. of Michigan Dept. of Art History, 1954-.

Art Asia Pacific. 6/year. Hong Kong: Art Asia Pacific, 1993-.

Art forum International. 10/year. New York: Art forum International Magazine Inc., 1962-.

Art Journal. Quarterly. New York: College Art Association, 1960-.

Artibus Asiae. Biannual. Zurich: Museum Rietberg, 1925-.

Artnews. 11/year. New York: Artnews LLC, 1902-.

Arts of Asia. 6/year. Hong Kong: Arts of Asia, 1970-.

Asian Art News. Bi-monthly. Hong Kong: Asian Art News, 1991-.

Flash Art International. Bimonthly. Trevi, Italy: Giancarlo Politi Editore, 1980-.

Koreana. Quarterly. Seoul: Korea Foundation, 1987-.

Orientations. 8/year. Hong Kong: Orientations Magazine Ltd., 1970-.

Woman's Art Journal. Semiannually. Philadelphia: Old City Publishing Inc., 1980-.

Asian Art on the Internet

Art History Resources: Resources for the Study of Art History: Part 16 – Asian Art arthistoryresources.net/ARTHLinks3.html

Asia for Educators: An Initiative of the Weatherhead East Asian Institute at Columbia University afe.easia.columbia.edu/

Journal for the study and exhibition of the arts of Asia. asianart.com

Introduction

Bogel, Cynthea J. "Situating Moving Objects: A Sino-Japanese Catalogue of Imported Items, 800 CE to the Present." In *What's the Use of Art? Asian Visual and Material Culture in Context*, Jan Mrázek and Morgan Pitelka eds., 142–76. Honolulu: University of Hawaii Press, 2008.

Clunas, Craig. *Superfluous Things: Material Culture and Social Status in Early Modern China*. Urbana, IL: University of Illinois Press, 1991.

Davis, Julie Nelson. *Utamaro and the Spectacle of Beauty*. Honolulu: University of Hawaii Press, 2007.

Dhar, Parul Pandhya. "Introduction—A History of Art History: The Indian Context." In *Indian Art History: Changing Perspectives*, Parul Pandhya Dhar ed., 1–32. New Delhi: National Museum Institute, 2011.

Fischer, Felice. *Ike Taiga and Tokuyama Gyokuran: Japanese Masters of the Brush*. Philadelphia: Philadelphia Museum of Art, 2007.

Hearn, Maxwell K. "An Early Ming Example of Multiples: Two Versions of *Elegant Gathering in the Apricot Garden*." In *Issues of Authenticity in Chinese Painting*, Judith G. Smith and Wen Fong eds., 221–56. New York: Metropolitan Museum of Art, 1999.

Lim, Jie-hyun. "The Configuration of Orient and Occident in the Global Chain of National Histories: Writing National Histories in Northeast Asia." In *Narrating the Nation: Representations in History, Media, and the Arts*, Stefan Berger, Linas Eriksonas, and Andrew Mycock eds., 290–308. New York and Oxford: Berghahn Books, 2008.

Welch, Stuart Cary. *Imperial Mughal Painting*. New York: George Braziller, 1978.

Chapter 1: The Rise of Cities and Birth of the Great Religions: Early Indian Art

Allchin, Bridget and Raymond. *The Rise of Civilization in India and Pakistan*. Cambridge: Cambridge University Press, 1982.

———, Neil Kreitman, and Elizabeth Errington, eds. *Gandharan Art in Context: East-West Exchanges at the Crossroads of Asia*. New Delhi: Regency Publications, 1997.

Aruz, Joan, ed. *Art of the First Cities*. New York: Metropolitan Museum of Art, 2003.

Asher, Frederick. "On Maurya Art." Reprinted in *A Companion to Asian Art and Architecture*, Rebecca Brown and Deborah Hutton eds., 421–44. Malden, MA: Blackwell Publishing, 2011.

Asher, Frederick and Walter Spink. "Maurya Figural Sculpture Reconsidered." *Ars Orientalis* 19 (1989), 1–25.

The Bhagavad Gita. Translated with a general introduction by Eknath Easwaran; chapter introduction by Diana Morrison. New Delhi: Penguin Books India, 1986.

Behl, Benoy K. *The Ajanta Caves*. New York: Harry N. Abrams, 1998.

Brancaccio, Pia. *The Buddhist Caves at Aurangabad: Transformations in Art and Religion*. Boston: Brill, 2011.

Chakrabarti, Dilip K. *A History of Indian Archaeology: From the Beginning to 1947*. New Delhi: Munshiram Manoharlal Publishers, 1998.

Coomaraswamy, A. K. "The Origin of the Buddha Image." *The Art Bulletin* 9/4 (June 1927): 287–329.

———. *Essays in Early Indian Architecture*. Edited and with an introduction by Michael W. Meister. New Delhi : Indira Gandhi National Centre for the Arts : Oxford University Press, 1992.

Cort, John E. *Framing the Jina: Narrative of Icons and Idols in Jain History*. Oxford: Oxford University Press, 2010.

Dallapiccola, Anna Libera, ed. *The Stupa: Its Religious, Historical and Architectural Significance*. Wiesbaden: Franz Steiner Verlag, 1980.

Dehejia, Vidya. "Aniconism and the Multivalence of Emblems." *Ars Orientalis* 21 (1991): 45–66.

———. "On Modes of Visual Narration in Early Buddhist Art." *The Art Bulletin* 72/3 (Sept. 1990): 374–392.

Granoff, Phyllis, editor. *Victorious Ones: Jain Images of Perfection*. New York: Rubin Museum of Art in association with Mapin Publishing, Ahmedabad, 2010.

Francis, H. T. and E. J. Thomas, eds. *Jataka Tales*. Cambridge: Cambridge University Press, 1916.

Huntington, Susan L. "Aniconism and the Multivalence of Emblems: Another Look." *Ars Orientalis* 22 (1992): 111–56.

———. "Lay Ritual in the Early Buddhist Art of India: More Evidence against the Aniconic Theory," J. Gonda Lecture. Royal Netherlands Academy of Arts and Sciences, 2013.

Kenoyer, Jonathan Mark. *Ancient Cities of the Indus Valley Civilization*. Oxford: Oxford University Press, 1998.

Kossak, Steven with an introduction by Martin Lerner. *The Arts of South and Southeast Asia*. New York: Metropolitan Museum of Art, 1994.

Mitter, Partha. *Indian Art*. Oxford: Oxford University Press, 2001.

Pal, Pratapaditya, ed. *The Peaceful Liberators: Jain Art from India*. Los Angeles: Los Angeles County Museum of Art, 1994.

Schopen, Gregory. "On Monks, Nuns and 'Vulgar' Practices: The Introduction of the Image Cult into Indian Buddhism." *Artibus Asiae* 49, No. 1/2 (1988–89): 153–68.

Simpson, St. John. *The Begram Hoard: Indian Ivories from Afghanistan*. London: The British Museum Press, 2011.

Spink, Walter. *Ajanta: History and Development*. Leiden and Boston: Brill, 2005.

Spink, Walter. "On the Development of Early Buddhist Art in India," *The Art Bulletin* 40/2 (June 1958), 95-104.

Chapter 2: Religious Art in the Age of Royal Patronage: the Medieval Period

Branfoot, Crispin. *Gods on the Move: Architecture and Ritual in the South Indian Temple*. London: Society for South Asian Studies, British Academy, 2007.

Cort, John E. "Dios como rey o asceta." In *La escultura en los templos indios: la arte de la devoción*, John Guy, ed. 170–76. Barcelona: Fundación la Caixa, 2007.

Cummins, Joan, ed. *Vishnu: Hinduism's Blue-Skinned Savior*. Nashville: Frist Center for the Visual Arts, 2011.

Dehejia, Vidhya. *Art of the Imperial Cholas*. New York: Columbia University Press, 1990.

————. "Reading Love Imagery on the Indian Temple." In *Love in Asian Art and Culture*, Washington DC: Arthur M. Sackler Gallery, Smithsonian Institution 1998: 96–113.

————, ed. *Devi: The Great Goddess*. Washington, DC: Arthur M. Sackler Gallery, 1999.

Desai, Devangana. *The Religious Imagery of Khajuraho*. Mumbai: Project for Indian Cultural Studies, 1996.

Eck, Diana. *Darsan: Seeing the Divine Image in India*. New York: Columbia University Press, 1998.

Glover, I. C. *Early Trade Between India and South-East Asia: A Link in the Development of a World Trading System*. Hull: University of Hull, 1989.

Guy, John. *Palm-Leaf and Paper: Illustrated Manuscripts of India and Southeast Asia*. With an essay by O. P. Agrawal. Melbourne: National Gallery of Victoria, 1982.

————. *Woven Cargoes: Indian Textiles in the East*. London: Thames and Hudson, 1998.

————. *Indian Temple Sculpture*. London: Victoria and Albert Museum, 2007.

Hardy, Adam. *Indian temple architecture: form and transformation: the Karnataka Dravida tradition, 7th to 13th centuries*. New Delhi: Indira Gandhi National Centre for the Arts: Abhinav Publications, 1995.

Harle, J. C. *Gupta Sculpture: Indian Sculpture of the Fourth to the Sixth Centuries A.D.* Oxford: Clarendon Press, 1974.

Huntington, Susan L. *The Art of Ancient India: Buddhist, Hindu, Jain*. Boston: Weatherhill, 1985.

Kaimal, Padma. "Playful Ambiguity and Political Authority in the Large Relief at Mamallapuram," *Ars Orientalis* 24 (1994), 1-27.

Kramrisch, Stella. *The Vishnudharmottara Part III: A Treatise On Indian Painting And Image-Making*. 2nd edition. Calcutta: Calcutta University Press, 1928.

————. *The Hindu Temple*. Calcutta: University of Calcutta, 1946.

————. *Manifestations of Shiva*. Philadelphia: Philadelphia Museum of Art, 1981.

Losty, J. P. *The Art of the Book in India*. London: The British Library, 1982.

Maxwell, Robyn. *Sari to Sarong: Five Hundred Years of Indian and Indonesian Textile Exchange*. Melbourne: National Gallery of Australia, 2003.

Meister, Michael. "Juncture and Conjunction: Punning and Temple Architecture." *Artibus Asiae* 41 (1979): 226–34.

————, ed. coordinated by M.A. Dhaky. *Encyclopaedia of Indian Temple Architecture*. Philadelphia: American Institute of Indian Studies : University of Pennsylvania Press, 1983-present.

Owen, Lisa N. *Carving Devotion in the Jain Caves at Ellora*. Leiden: Brill, 2012.

Sinha, Ajay J. *Imagining Architects: Creativity in the Religious Monuments of India*. Newark, DE: University of Delaware Press, 2000.

Williams, Joanna. *The Art of Gupta India: Empire and Province*. Princeton: Princeton University Press, 1982.

————. *The Two-Headed Deer: Illustrations of the Ramayana in Orissa*. Berkeley: University of California Press, 1996.

Chapter 3: India Opens to the World: The Early Modern Period

Aitken, Molly Emma. *The Intelligence of Tradition in Rajput Court Painting*. New Haven: Yale University Press, 2010.

Asher, Catherine B. *Architecture of Mughal India*. The New Cambridge History of India. Cambridge: Cambridge University Press, 1992.

Asher, Catherine B. and Cynthia Talbot. *India before Europe*. Cambridge: Cambridge University Press, 2006.

Ahmad, Nazir. *Zuhuri, Life and Works*. Allahabad: Khayaban, 1953.

Banerji, Naseem Ahmed. *The Architecture of the Adina Mosque in Pandua, India*. Lewiston: Edwin Mellen Press, 2002.

Beach, Milo Cleveland. *Mughal and Rajput Painting*. The New Cambridge History of India. Cambridge: Cambridge University Press, 1992.

———— and Ebba Koch. *King of the World: The Padshahnama: An Imperial Mughal Manuscript from the Royal Library, Windsor Castle*. London: Azimuth; Washington, DC: Sackler Gallery, 1997.

————, Eberhard Fischer and B.N. Goswamy. *Masters of Indian Painting*. Zurich: Artibus Asiae Publishers, 2011.

Brand, Michael and Glenn D. Lowry. *Akbar's India: Art from the Mughal City of Victory*. New York: The Asia Society Galleries, 1986.

Dallapicola, Anna. Catherine Glynn, and Robert Skelton. *Ragamala: Paintings from India*. London: Philip Wilson, 2011.

Dalrymple, William and Yuthika Sharma, eds. *Princes and Painters in Mughal Delhi, 1707-1857*. New York: Asia Society Museum in association with Yale University Press, 2012.

Diamond, Debra. *Garden and Cosmos: The Royal Paintings of Jodhpur*. London: Thames & Hudson, 2008.

Eaton, Richard, ed. *India's Islamic Traditions, 711–1750*. Oxford: Oxford University Press, 2003.

Ernst, Carl. "Historiographies of Islam in India," in *Eternal Garden: Mysticism, Hisotry, and Politics at a South Asian Sufi Center*. Albany: State University of New York Press, 1992.

Flood, Finbarr Barry. "Signs of Violence: Colonial Ethnographies and Indo-Islamic Monuments," *Art and Terror* 5 (2004), 20-51.

————. *Objects of Translation: Material Culture and Medieval "Hindu-Muslim" Encounter*. Princeton: Princeton University Press, 2009.

Fritz, John M. and George Michell. *Hampi*. Mumbai: India Book House Pvt. Ltd, 2003.

Flores, Jorge and Nuno Vassallo e Silva, eds. *Goa and the Great Mughal*. London: Scala, 2004.

Gittinger, Mattiebelle. *Master Dyers to the World: Technique and Trade in Early Indian Dyed Cotton Textiles*. Washington, DC: Textile Museum, 1982.

Goswamy, B.N. *Nainsukh of Guler: A Great Indian Painter from a Small Hill-State*. Zurich: Museum Rietberg, 1997.

Hasan, Perween. *Sultans and Mosques: The Early Muslim Architecture of Bangladesh*. London, I. B. Tauris, 2007.

Jackson, Peter. *The Delhi Sultanate: A Political and Military History*. Cambridge: Cambridge University Press, 2003.

The Jahangirnama: Memoirs of Jahangir, Emperor of India. Wheeler M. Thackston trans., ed., and annotated. Washington, DC: Freer Gallery of Art, Arthur M. Sackler Gallery; New York: Oxford University Press, 1999.

Koch, Ebba. *The Complete Taj Mahal and the Riverfront Gardens of Agra*. London: Thames and Hudson, 2006.

Kumar, Sunil. "Qutb and Modern Memory," in *The Partitions of Memory: The Afterlife of the Division of India* (Bloomington and Indianapolis: Indiana University Press, 2001), 140-82.

Lowry, Glenn D. "Humayun's Tomb: Form, Function and Meaning in Early Mughal Architecture," *Muqarnas* 4 (1987), 133-48.

Markel, Stephen, Tushara Bindu Gude, and Muzaffar Alam. *India's Fabled City: The Art of Courtly Lucknow*. Los Angeles: Los Angeles County Museum of Art, 2010.

Michell, George and Snehal Shah, eds. *Ahmadabad*. Bombay: Marg Publications, 1988.

Michell, George. *Architecture and Art of Southern India: Vijayanagara and the Successor States*. The New Cambridge History of India. Cambridge: Cambridge University Press, 1995.

———— and Mark Zebrowski. *The Architecture and Art of the Deccan Sultanates*. New York: Cambridge University Press, 1999.

————. *The Royal Palaces of India*. London: Thames and Hudson, 1994.

Ohri, Vishwa Chander and Roy C. Craven, editors. *Painters of the Pahari Schools*. Bombay: Marg Publications, 1998.

Patel, Alka. *Building Communities in Gujarat: Architecture and Society during the 12th through 14th centuries*. Leiden: Brill, 2004.

———— and Abha Narian Lambah, eds. *The Architecture of the Indian Sultanates*. Mumbai : Marg Publications on behalf of the National Centre for the Performing Arts, 2006.

Philon, Helen, ed. *Silent Splendour: Palaces of the Deccan, 14th-19th centuries*. Mumbai: Marg Publications on behalf of the National Centre for the Performing Arts, New Delhi; Distributed in India by Variety Book Depot, 2010.

Schmitz, Barbara. *After the Great Mughals: Painting in Delhi and the Regional Courts in the 18th and 19th centuries*. Mumbai: Marg Publications, 2002.

Seyller, John. *The Adventures of Hamza: Painting and Storytelling in Mughal India*. Washington, DC: Freer Gallery of Art: Arthur M. Sackler Gallery, Smithsonian Institution; London: Azimuth, 2002.

Stronge, Susan. *Painting for the Mughal Emperor: The Art of the Book, 1560-1660*. London: Victoria and Albert Museum, 2002.

Shokoohy, Mehrdad. *Bhadresvar: The Oldest Islamic Monuments in India*. Leiden: Brill, 1988.

Tillotson, Giles. *The Rajput Palaces: The Development of an Architectural Style, 1450–1750*. New Haven: Yale University Press, 1987.

Topsfield, Andrew. *Court Painting at Udaipur: Art under the Patronage of the Maharanas of Mewar*. Ascona: Artibus Asiae Publishers; Zurich: Museum Rietberg, 2001.

Wagoner, Philip B. "'Sultan among Hindu Kings': Dress, Titles, and the Islamicization of Hindu Culture at Vijayanagara," *Journal of Asian Studies* 55 (1996), 851–80.

Walker, Daniel. *Flowers Underfoot: Indian Carpets of the Mughal Era*. New York: Metropolitan Museum of Art, 1997.

Wright, Elaine. *Muraqqa': Imperial Mughal albums from the Chester Beatty Library*. Alexandria, Va.: Art Services International ; Hanover : Distributed by University Press of New England, 2008.

Zebrowski, Mark. *Deccani Painting*. London: Sotheby Publications; Berkeley: University of California Press, 1983.

Zebrowski, Mark. *Gold, Silver and Bronze from Mughal India*. London: Alexandria Press in association with Laurence King, 1997.

Chapter 4: India and the International Scene: The Modern and Contemporary Periods

Archer, Mildred. *Company Paintings: Indian Paintings of the British Period*. London: Victoria and Albert Museum, 1992.

———. *India and British Portraiture, 1770–1825*. London: Sotheby, Parke, Bernet, 1979.

——— and Toby Falk. *India Revealed: The Art and Adventures of James and William Fraser 1801–35*. London: Cassell, 1989.

Bean, Susan. *Midnight to the Boom: Painting in India after Independence*. Salem, MA: Peabody Essex Museum, 2013.

Curtis, William J. R. "Authenticity, Abstraction and the Ancient Sense: Le Corbusier's and Louis Kahn's Ideas of Parliament," *Perspecta* 12 (1983), 181–94.

Dadi, Iftikhar. *Modernism and the Art of Muslim South Asia*. Islamic Civilization and Muslim Networks, Carol W. Ernst and Bruce B. Lawrence eds. Chapel Hill: University of North Carolina Press, 2010.

De Almeida, Hermione and George H. Gilpin. *Indian Renaissance: British Romantic Art and the Prospect of India*. Aldershot, Hants, England; Burlington, VT: Ashgate, 2005.

Dehejia, Vidya. *India through the Lens, Photography 1840–1911*. Washington, DC: Smithsonian Institution, 2000.

Dewan, Deepali and Deborah Hutton. *Raja Deen Dayal: artist-photographer in 19th-century India*. New Delhi: Alkazi Collection of Photography in association with Mapin Pub., Ahmedabad, 2013.

Guha-Thakurta, Tapati. *The Making of a New 'Indian' Art: Artists, Aesthetics and Nationalism in Bengal, c. 1850-1920*. Reissue ed. Cambridge University Press; 2007.

Irving, Robert Grant. *Indian Summer: Lutyen, Baker and Imperial Delhi*. New Haven and London: Yale University Press, 1981.

Jaffer, Amin. *Furniture from British India and Ceylon: A Catalogue of the Collections in the Victoria and Albert Museum and the Peabody Essex Museum*. London: V&A Publications, 2001.

Kapur, Geeta. *Contemporary Indian Artists*. New Delhi: Vikas, 1978.

———. *When was Modernism: Essays on Contemporary Cultural Practice in India*. New Delhi: Manohar Publishers, 2000.

Lang, Jon, Madhavi Desai, and Miki Desai. *Architecture and Independence: The Search for Identity, India 1880 to 1980*. Delhi: Oxford University Press, 1997.

Metcalf, Thomas R. *An Imperial Vision: Indian Architecture and Britain's Raj*. Berkeley: University of California Press, 1989.

Mitter, Partha. *The Triumph of Modernism: India's Artists and the Avant-garde, 1922-47*. London: Reaktion, 2007.

———. *Art and Nationalism in Colonial India, 1850-1922*. Cambridge: Cambridge University Press, 1995.

Nasar, Hammad, ed. *Karkhana: a Contemporary Collaboration*. Ridgefield, CT: Aldrich Contemporary Art Museum and Green Cardamom, 2005.

O'Brien, Elaine, Everlyn Nicodemus, Melissa Chiu, Benjamin Genocchio, Mary K. Coffey, and Roberto Tejada, eds. *Modern Art in Africa, Asia and Latin America: An Introduction to Global Modernisms*. Chichester, West Sussex; Malden, MA: Wiley-Blackwell, 2013.

Patel, Divia, Laurie Benson, and Carol Cains. *Cinema India: The Art of Bollywood*. Melbourne: National Gallery of Victoria, 2007.

Quintanilla, Sonya Rhie. *Rhythms of India: The Art of Nalandalal Bose*. San Diego: San Diego Museum of Art, 2008.

Reilly, Maura and Linda Nochlin, *Global Feminisms*. Brooklyn, NY: Brooklyn Museum of Art, 2007.

Sen, Jayanti. *Looking Beyond: Graphics of Satyajit Ray*. New Delhi: Roli Books, 2012.

Tillotson, Giles. *The Tradition of Indian Architecture: Continuity, Controversy and Change since 1850*. New Haven and London: Yale University Press, 1980.

———. "The Indian Picturesque: Images of India in British Landscape Painting, 1780-1880," in *The Raj: India and the British, 1600-1947* (London: National Portrait Gallery Publications, 1990), 141-51.

Chapter 5: At the Crossroads: The Arts of Southeast Asia

Aung Thwin, Michael, *Pagan. The Origins of Modern Burma*. Hawaii: University of Hawaii Press, 1985.

Barbier, Jean Paul and Douglas Newton, eds. *Islands and Ancestors. Indigenous Styles of Southeast Asia*. New York: Metropolitan Museum of Art, 1988.

Barnes, Ruth and Mary Hunt Kahlenberg, eds. *Five Centuries of Indonesian Textiles*. New York: Prestel, 2010.

Boisselier, Jean. *The Heritage of Thai Sculpture*. New York and Tokyo: Weatherhill, 1974.

Doanh, Ngo Van. *Cham Sculpture*. Hanoi: VNA Publishing, 1988.

Fontein, Jan, *The Sculpture of Indonesia*. Washington, DC: National Gallery of Art, 1990.

Galloway, Charlotte. "Ways of Seeing a Pyu, Mon and Dvaravati Artistic Continuum." *Bulletin of the Indo-Pacific Prehistory Association* 30 (2010): 70–78.

Guillon, Emmanuel. *Cham Art. Treasures From the Da Nang Museum, Vietnam*. London: Thames & Hudson, 2001.

Higham, Charles and Rachanie Thosarat. *Early Thailand From Prehistory to Sukhothai*. Bangkok: River Books, 2012.

———. "The Dating Game and the Saga of Ban Chiang." *World Archaeology*, 52. Available online: www.world-archaeology.com/world/asia/thailand/charles-higham-the-dating-game-and-the-saga-of-ban-chiang/.

Hudson, B. *The Origins of Bagan. The Archaeological Landscape of Upper Burma to AD 1300*. University of Sydney. Available online: hdl.handle.net/2123/638.

Isaacs, Ralph and T. Richard Blurton. *Visions from the Golden Land. Burma and the Art of Lacquer*. London: British Museum Press, 2000.

Katz-Harris, Felicia. *Inside the Puppet Box. A Performance Collection of Wayang Kulit at the Museum of International Folk Art*. Santa Fe, NM: Museum of International Folk Art, 2010.

Kerlogue, Fiona, *Arts of Southeast Asia*. London: Thames and Hudson, 2004.

Krairiksh, Piriya. *The Roots of Thai Art*. Bangkok: River Books, 2012.

Manguin, Pierre-Yves. "The Archaeology of the Early Maritime Polities of Southeast Asia." In *Southeast Asia: From Prehistory to History*, I. C. Glover and P. Bellwood eds., 282–313. London: Routledge/Curzon, 2004.

Maxwell, Robyn. *Textiles of Southeast Asia. Tradition, Trade and Transformation*. Melbourne: Australian National Gallery, Oxford University Press, 1990.

Miksic, John. *Borobudur. Golden Tales of the Buddha*. Berkeley: Periplus, 1990.

Moore, Elizabeth H. *Early Landscapes of Myanmar*. Bangkok: River Books, 2007.

Onians, John, ed. *Atlas of World Art*. London: Laurence King Publishing, 2004.

Perry, W. J. *The Megalithic Culture of Indonesia*. London: Publications of the University of Manchester, 1918.

Rodgers, Susan. *Power and Gold. Jewelry from Indonesia, Malaysia and the Philippines*. Geneva: Barbier-Mueller Museum, 1983.

Rooney, Dawn F. *Ancient Sukhothai. Thailand's Cultural Heritage*. Bangkok: River Books, 2008.

———. *Angkor. An Introduction to the Temples*. Hong Kong: Odyssey Publications, 2006.

Rovedo, Vittorio. *Khmer Mythology: Secrets of Angkor*. New York: Weatherhill, 1998.

Schweyer, Anne-Valérie. *Ancient Vietnam. History, Art and Archaeology*. Bangkok: River Books, 2011.

Skilling, Peter, "Buddhism and the Circulation of Ritual in Early Peninsular Southeast Asia." In *Early Interactions between South and Southeast Asia: Reflections on Cross-Cultural Exchange*, Pierre-Yves Manguin, A. Mani, and Geoff Wade eds., 371–84. Singapore: Institute of Southeast Asian Studies; New Delhi: Manohar (Nalanda-Sriwijaya Series 2, gen. eds. Tansen Sen and Geoff Wade), 2011.

Tarling, Nicholas, ed. *The Cambridge History of Southeast Asia vol. 1: From Early Times to c. 1800*. Cambridge: Cambridge University Press, 1992.

Tingley, Nancy. *Arts of Ancient Vietnam. From River Plain to Open Sea*. New York: Asia Society; Houston: Museum of Fine Arts, 2009.

Waterson, Roxana. *The Living House. An Anthropology of Architecture in South-East Asia.* Oxford: Oxford University Press, 1990.

Chapter 6: Ritual and Elite Arts: The Neolithic Period to the First Empires

Allan, Sarah. *The Shape of the Turtle: Myth, Art, and Cosmos in Early China.* Albany: State University of New York Press, 1991.

Bagley, Robert W. *Ancient Sichuan: Treasures from a Lost Civilization.* Seattle: Seattle Art Museum; Princeton: Princeton University Press, 2001.

———. "Anyang Mold-Making and the Decorated Model." *Artibus Asiae* 69, no. 1 (2009): 39–90.

———. "Sacrificial Pits of the Shang Period at Sanxingdui in Guanghan County, Sichuan Province." *Arts Asiatiques* 43 (1988): 78–86.

———. *Shang Ritual Bronzes in the Arthur M. Sackler Collection.* Vol. 1 of *Ancient Chinese Bronzes in the Arthur M. Sackler Collection.* Washington, DC: Arthur M. Sackler Foundation; Cambridge, MA: Arthur M. Sackler Museum, Harvard University, 1987.

Barbieri-Low, Anthony J. *Artisans in Early Imperial China.* Seattle: University of Washington Press, 2007.

———. *Computer Reconstruction of the "Wu Family Shrines" Cemetery Site.* Santa Barbara, CA: University of California at Santa Barbara, 2005. Available online: www.history.ucsb.edu/faculty/barbierilow/Research/ComputerRecon.html.

Barnes, Gina L. and Guo Dashun. "The Ritual Landscape of 'Boar Mountain' Basin: The Niuheliang Site Complex of North-Eastern China." *World Archaeology* 28, no. 2 (October 1996): 209–19.

Chang, K. C. "The Animal in Shang and Chou Bronze Art." *Harvard Journal of Asiatic Studies* 41, no. 2 (December 1981): 527–54.

———. *The Archaeology of Ancient China.* 4th ed. New Haven: Yale University Press, 1986.

———. *Shang Civilization.* New Haven: Yale University Press, 1980.

Chen Fang-mei. "The Stylistic Development of Shang and Zhou Bronze Bells." Rob Linrothe trans. In *Style in the East Asian Tradition,* Rosemary E. Scott and Graham Hutt eds., 19–37. Colloquies on Art & Archaeology in Asia, no. 14. London: School of Oriental and African Studies, University of London, 1987.

Childs-Johnson, Elizabeth. "Jades of the Hongshan Culture: The Dragon and Fertility Cult Worship." *Arts Asiatiques* 46 (1991): 82–95.

Confucius. *The Analects.* Translated with an introduction by D. C. Lau. New York: Penguin Books, 1979.

Cook, Constance A. and John S. Major. *Defining Chu: Image and Reality in Ancient China.* Honolulu: University of Hawaii Press, 1999.

Fong, Wen, ed. *The Great Bronze Age of China: An Exhibition from the People's Republic of China.* New York: Metropolitan Museum of Art, 1980.

Hsu, Cho-yun and Katheryn M. Linduff. *Western Chou Civilization.* New Haven and London: Yale University Press, 1988.

Keightley, David N. *The Origins of Chinese Civilization.* Berkeley: University of California Press, 1983.

Kesner, Ladislav. "Likeness of No One: (Re)presenting the First Emperor's Army." *The Art Bulletin* 77, no. 1 (March 1995): 115–32.

———. "The *Taotie* Reconsidered: Meanings and Functions of Shang Theriomorphic Imagery." *Artibus Asiae* 51 (1991): 21–53.

Kuwayama, George, ed. *The Great Bronze Age of China: A Symposium.* Los Angeles: Los Angeles County Museum of Art, 1983.

Lao Tzu [Laozi]. *Tao Te Ching.* Translated with an introduction by D. C. Lau. New York: Penguin Books, 1963.

Lawton, Thomas, ed. *New Perspectives on Chu Culture During the Eastern Zhou Period.* Washington, DC: Smithsonian Institution, 1991.

Ledderose, Lothar. *Ten Thousand Things: Module and Mass Production in Chinese Art.* Princeton: Princeton University Press, 2000.

Little, Stephen with Shawn Eichman. *Taoism and the Arts of China.* With essays by Patricia Ebrey, Kristofer Schipper, Nancy Schatzman Steinhardt, and Wu Hung. Chicago: The Art Institute of Chicago, 2000.

Liu, Cary Y., Michael Nylan, and Anthony J. Barbieri-Low. *Recarving China's Past: Art, Archaeology, and Architecture of the "Wu Family Shrines."* Princeton: Princeton University Art Museum; New Haven: Yale University Press, 2005.

Loewe, Michael. *Ways to Paradise: The Chinese Quest for Immortality.* London: George Allen & Unwin, 1979.

Nelson, Sarah M. "The Development of Complexity in Prehistoric Northern China." *Sino-Platonic Papers,* no. 63 (December 1994): 1–17.

Nickel, Lukas. "Imperfect Symmetry: Rethinking Bronze-Casting Technology in Ancient China." *Artibus Asiae* 66, no. 1 (2006): 5–39.

Poor, Robert. "The Circle and the Square: Measure and Ritual in Ancient China." *Monumenta Serica* 43 (1995): 159–210.

Powers, Martin J. *Art and Political Expression in Early China.* New Haven and London: Yale University Press, 1991.

———. *Pattern and Person: Ornament, Society, and Self in Classical China.* Harvard East Asian Monographs, no. 262. Cambridge, MA: Harvard University Asia Center, 2006.

Rawson, Jessica. *Western Zhou Ritual Bronzes.* Vols. 2A–B of *Ancient Chinese Bronzes in the Arthur M. Sackler Collection.* Washington, DC: Arthur M. Sackler Foundation; Cambridge, MA: Arthur M. Sackler Museum, Harvard University, 1990.

Scott, Rosemary E., ed. *Chinese Jades.* Colloquies on Art and Archaeology in Asia, no. 18. London: Percival David Foundation of Chinese Art, 1997.

Silbergeld, Jerome. "Mawangdui, Excavated Materials, and Transmitted Texts: A Cautionary Note." *Early China* 8 (1982–83): 79–92.

So, Jenny F. *Eastern Zhou Ritual Bronzes from the Arthur M. Sackler Collection.* Vol. 3 of *Ancient Chinese Bronzes in the Arthur M. Sackler Collection.* Washington, DC: Arthur M. Sackler Foundation; Cambridge, MA: Arthur M. Sackler Museum, Harvard University, 1995.

Sung, Hou-mei. *Decoded Messages: The Symbolic Language of Chinese Animal Painting.* New Haven: Yale University Press, 2009.

Thorp, Robert L. "The Archaeology of Style at Anyang: Tomb 5 in Context." *Archives of Asian Art* 41 (1988): 47–69.

———. "Erlitou and the Search for the Xia." *Early China* 16 (1991): 3–38.

———. "Mountain Tombs and Jade Burial Suits: Preparations for Eternity in the Western Han." In *Ancient Mortuary Traditions of China: Papers on Chinese Ceramic Funerary Sculptures,* George Kuwayama ed. Los Angeles: Los Angeles County Museum of Art, 1991.

Tseng, Lillian Lan-ying. *Picturing Heaven in Early China.* Harvard East Asian Monographs, no. 336. Cambridge, MA: Harvard University Asia Center, 2011.

Wang, Eugene Yuejin. "Why Pictures in Tombs? Mawangdui Once More." *Orientations* 40, no. 2 (2009): 76–83.

Wu Hung. "Art in a Ritual Context: Rethinking Mawangdui." *Early China* 17 (1992): 111–44.

———. "From Temple to Tomb: Ancient Chinese Art and Religion in Transition." *Early China* 13 (1988): 78–115.

———. *Monumentality in Early Chinese Art and Architecture.* Stanford: Stanford University Press, 1996.

———. *The Wu Liang Shrine: The Ideology of Early Chinese Pictorial Art.* Stanford: Stanford University Press, 1989.

Wu, Xiaohong, Chi Zhang, Paul Goldberg, David Cohen, Yan Pan, Trina Arpin, and Ofer Bar-Yosef. "Early Pottery at 20,000 Years Ago in Xianrendong Cave, China." *Science* 336, no. 6089 (29 June 2012): 1696–1700.

Yang, Xiaoneng, ed. *The Golden Age of Chinese Archaeology: Celebrated Discoveries from the People's Republic of China.* London and New Haven: Yale University Press, 1999.

———, ed. *New Perspectives on China's Past: Chinese Archaeology in the Twentieth Century.* 2 vols. Kansas City: Nelson-Atkins Museum of Art; New Haven: Yale University Press, 2004.

Chapter 7: Looking Outward: The Six Dynasties and Sui and Tang Dynasties

Abe, Stanley K. "Art and Practice in a Fifth-Century Chinese Buddhist Cave Temple." *Ars Orientalis* (1990): 1–31.

———. "Provenance, Patronage, and Desire: Northern Wei Sculpture from Shaanxi Province." *Ars Orientalis* 31 (2001): 1–30.

Acker, William Reynolds Beal, trans. *Some T'ang and Pre-T'ang Texts on Chinese Painting.* Leiden, the Netherlands: E. J. Brill, 1954.

Cahill, Suzanne E. "Night-Shining White: Traces of a T'ang Horse in Two Media." *T'ang Studies* 4 (1986): 91–95.

Canepa, Matthew P. "Distant Displays of Power: Understanding Cross-Cultural Interaction Among the Elites of Rome, Sasanian Iran, and Sui-Tang China." *Ars Orientalis* 38 (2008): 121–54.

Center for the Art of East Asia. *Xiangtangshan Caves Project*. Chicago: The University of Chicago, 2004–. Available online: xts.uchicago.edu.

Cheng, Bonnie. "The Space Between: Locating 'Culture' in Artistic Exchange." *Ars Orientalis* 38 (2008): 81–120.

Dunhuang Academy. *Dunhuang Academy*. Available online: www.dha.ac.cn.

Eckfeld, Tonia. *Imperial Tombs in Tang China, 618–907: The Politics of Paradise*. London and New York: RoutledgeCurzon, 2005.

Fong, Mary H. "Four Chinese Royal Tombs of the Early Eighth Century." *Artibus Asiae* 35, no. 4 (1973): 307–34.

———. "Tang Tomb Murals Reviewed in the Light of Tang Texts on Painting." *Artibus Asiae* 45, no. 1 (1984): 35–72.

Goldberg, Stephen J. "Court Calligraphy of the Early T'ang Dynasty." *Artibus Asiae* 49, no. 3/4 (1988–89): 189–237.

Hay, John. "The Human Body as a Microcosmic Source of Macrocosmic Values in Calligraphy." In *Theories of the Arts in China*, Susan Bush and Christian Murck eds., 74–102. Princeton: Princeton University Press, 1983.

———. "Values and History in Chinese Painting, I: Hsieh Ho Revisited." *Res: Anthropology and Aesthetics* 6 (Autumn 1983): 71–111.

———. "Values and History in Chinese Painting, II: The Hierarchic Evolution of Structure." *Res: Anthropology and Aesthetics* 7/8 (Autumn 1984): 101–36.

Ho Ch'ing-ku. "The Artistic Achievement and Historical Position of Huai-su's Draft-Script Calligraphy." *T'ang Studies* 12 (1994): 97–116.

Howard, Angela F. "Buddhist Cave Sculpture of the Northern Qi Dynasty: Shaping a New Style, Formulating New Iconographies." *Archives of Asian Art* 45 (1996): 6–25.

Huntington, John C. "The Iconography and Iconology of the Tan Yao Caves at Yungang." *Oriental Art* 32 (1986): 142–60.

———. "A Note on Dunhuang Cave 17, 'The Library,' or Hong Bian's Reliquary Chamber." *Ars Orientalis* 16 (1986): 93–101.

Karetzky, Patricia E. "Wu Zetian and Buddhist Art of the Tang Dynasty." *T'ang Studies* 20–21 (2002–2003): 113–52.

Laing, Ellen Johnston. "Neo-Taoism and the 'Seven Sages of the Bamboo Grove' in Chinese Painting." *Artibus Asiae* 36, no. 1/2 (1974): 1–54.

Ledderose, Lothar. "Subject Matter in Early Chinese Painting Criticism." *Oriental Art* n.s. 19, no. 1 (Spring 1973): 69–81.

Lee, Sonya S. *Surviving Nirvana: Death of the Buddha in Chinese Visual Culture*. Hong Kong: Hong Kong University Press, 2010.

Leidy, Denise Patry, Donna K. Strahan, and Lawrence Becker. *Wisdom Embodied: Chinese Buddhist and Daoist Sculpture in the Metropolitan Museum of Art*. New York: Metropolitan Museum of Art, 2010.

Lingley, Kate A. "Naturalizing the Exotic: On the Changing Meanings of Ethnic Dress in Medieval China." *Ars Orientalis* 38 (2008): 50–80.

Liu, Cary Y., Dora C.Y. Ching, and Judith G. Smith, eds. *Character and Context in Chinese Calligraphy*. Princeton: Princeton University Press, 1999.

McCausland, Shane. *First Masterpiece of Chinese Painting: The Admonitions Scroll*. New York: George Braziller, 2003.

———, ed. *Gu Kaizhi and the Admonitions Scroll*. London: The British Museum, 2003.

McNair, Amy. *Donors of Longmen: Faith, Politics, and Patronage in Medieval Chinese Buddhist Sculpture*. Honolulu: University of Hawaii Press, 2007.

———. *The Upright Brush: Yan Zhenqing's Calligraphy and Song Literati Politics*. Honolulu: University of Hawaii Press, 1998.

Powers, Martin J. "Character (Ch'i) and Gesture (Shih) in Early Chinese Art and Criticism." In *Proceedings*, International Colloquium on Chinese Art History, 2:909–31. Taipei: National Palace Museum, 1991.

Schafer, Edward H. *The Golden Peaches of Samarkand: A Study of T'ang Exotics*. Berkeley: University of California Press, 1963.

Shih, Hsio-yen. "Poetry Illustration and the Works of Ku K'ai-chih." In *The Translation of Art: Essays on Chinese Painting and Poetry*, James C.Y. Watt ed., 6–29. Renditions, no. 6. Hong Kong: Centre for Translation Projects, The Chinese University of Hong Kong, 1976.

———. "Readings and Re-Readings of Narrative in Dunhuang Murals." *Artibus Asiae* 53, no. 1/2 (1993): 59–88.

Soper, Alexander C. "T'ang Ch'ao Ming Hua Lu. Celebrated Painters of the T'ang Dynasty by Chu Ching-hsuan of T'ang." *Artibus Asiae* 21, no. 3/4 (1958): 204–30.

———. "Yen Li-pen, Yen Li-te, Yen P'i, Yen Ch'ing: Three Generations in Three Dynasties." *Artibus Asiae* 51, no. 3/4 (1991): 199–206.

Spiro, Audrey. *Contemplating the Ancients: Aesthetic and Social Issues in Early Chinese Portraiture*. Berkeley and Los Angeles: University of California Press, 1990.

Sullivan, Michael. *Chinese Landscape Painting 2: The Sui and T'ang Dynasties*. Berkeley: University of California Press, 1980.

Tsiang, Katherine R. "Changing Patterns of Divinity and Reform in the Late Northern Wei." *The Art Bulletin* 84, no. 2 (2002): 222–45.

———. "Monumentalization of Buddhist Texts in the Northern Qi Dynasty: The Engraving of Sūtras in Stone at the Xiangtangshan Caves and Other Sites in the Sixth Century." *Artibus Asiae* 56, no. 3/4 (1996): 233–61.

Whitfield, Roderick and Anne Farrer. *Caves of the Thousand Buddhas: Chinese Art from the Silk Route*. New York: George Braziller, 1990.

Whitfield, Roderick, Susan Whitfield, and Neville Agnew. *Cave Temples of Mogao: Art and History on the Silk Road*. Los Angeles: The J. Paul Getty Trust, 2000.

Wong, Dorothy C. *Chinese Steles*. Honolulu: University of Hawaii Press, 2004.

Wu Hung, ed. *Between Han and Tang: Visual and Material Culture in a Transformative Period*. Beijing: Wenwu Press, 2003.

———, and Katherine R. Tsiang, eds. *Body and Face in Chinese Visual Culture*. Harvard East Asian Monographs, no. 239. Cambridge, MA: Harvard University Press, 2005.

Yang, Xiaoneng, ed. *New Perspectives on China's Past: Chinese Archaeology in the Twentieth Century*. 2 vols. Kansas City: Nelson-Atkins Museum of Art; New Haven: Yale University Press, 2004.

Yen, Chuan-ying. "The Decorative Motifs on Tang Dynasty Mirrors." *Cleveland Studies in the History of Art* 9 (2005): 1–10.

Chapter 8: Art, Conquest, and Identity: The Five Dynasties Period and Song and Yuan Dynasties

Allee, Stephen D., Joseph Chang, and Ingrid Larsen. *Song and Yuan Dynasty Painting and Calligraphy*. Washington, DC: Freer Gallery of Art, Smithsonian Institution, 2012. Available online: asia.si.edu/SongYuan/default.asp.

Barnhart, Richard. *Li Kung-lin's "Classic of Filial Piety."* With essays by Robert E. Harrist, Jr. and Hui-liang J. Chu. New York: The Metropolitan Museum of Art, 1993.

Bickford, Maggie. "Emperor Huizong and the Aesthetic of Agency." *Archives of Asian Art* 53 (2002–2003): 71–104.

Blanchard, Lara C.W. "A Scholar in the Company of Female Entertainers: Changing Notions of Integrity in Song to Ming Dynasty Painting." *NAN NÜ: Men, Women and Gender in China* 9, no. 2 (2007): 189–246.

——— and Kara J. Kenney. "Traces of Collaboration: Empress Yang's Captions for Xia Gui's *Twelve Views of Landscape*." *Critical Matrix: The Princeton Journal of Women, Gender and Culture* 18 (Fall 2009): 6–33.

Bol, Peter K. *"This Culture of Ours": Intellectual Transitions in T'ang and Sung China*. Stanford: Stanford University Press, 1991.

Cahill, James. *Hills Beyond a River: Chinese Painting of the Yüan Dynasty, 1279–1368*. New York: Weatherhill, 1976.

———. *An Index of Early Chinese Painters and Paintings: T'ang, Sung, and Yüan*. Berkeley: University of California Press, 1980.

———. *Three Alternative Histories of Chinese Painting*. Lawrence, KS: Spencer Museum of Art, University of Kansas, 1988.

Edwards, Richard. *The Heart of Ma Yuan: The Search for a Southern Song Aesthetic*. Hong Kong: Hong Kong University Press, 2011.

Egan, Ronald C. *Word, Image and Deed in the Life of Su Shi*. Harvard-Yenching Institute Monograph Series, no. 39. Cambridge, MA: Council on East Asian Studies, Harvard University, and the Harvard-Yenching Institute, 1994.

Ferguson, John C. "The Fu-ch'un Scroll of Huang Kung-wang." *Monumenta Serica* 7 (1942): 85–91.

Fong, Wen C. "Why Chinese Painting Is History." *The Art Bulletin* 85, no. 2 (June 2003): 259–264.

Hammers, Roslyn Lee. *Pictures of Tilling and Weaving: Art, Labor, and Technology in Song and Yuan China*. Hong Kong: Hong Kong University Press, 2011.

Harrist, Robert E., Jr. "Ch'ien Hsüan's *Pear Blossoms*: The Tradition of Flower Painting and Poetry from Sung to Yüan." *Metropolitan Museum Journal* 22 (1987): 53–70.

———. *Painting and Private Life in Eleventh-Century China: "Mountain Villa" by Li Gonglin*. Princeton: Princeton University Press, 1998.

Hay, John. "Poetic Space: Ch'ien Hsuan and the Association of Painting and Poetry." In *Words and Images: Chinese Poetry, Calligraphy, and Painting*, Alfreda Murck and Wen C. Fong eds., 173–98. New York: The Metropolitan Museum of Art; Princeton: Princeton University Press, 1991.

Hay, Jonathan. "The Mediating Work of Art." *The Art Bulletin* 89, no. 3 (September 2007): 435–59.

Jing, Anning. "The Portraits of Khubilai Khan and Chabi by Anige (1245–1306), a Nepali Artist at the Yuan Court." *Artibus Asiae* 54, no. 1/2 (1994): 40–86.

Kleinhenz, Henry J. "Porcelains for Imperial Use: The Sung Dynasty." *The Bulletin of the Cleveland Museum of Art* 65, no. 4 (April 1978): 135–50, 150a–150h.

Ledderose, Lothar. *Mi Fu and the Classical Tradition of Chinese Calligraphy*. Princeton: Princeton University Press, 1979.

Lee, De-nin D. "Fragments for Constructing a History of Southern Tang Painting." *Journal of Song-Yuan Studies* 34 (2004): 1–39.

———. *The Night Banquet: A Chinese Scroll through Time*. Seattle and London: University of Washington Press, 2010.

Lee, Hui-shu. *Empresses, Art, and Agency in Song Dynasty China*. Seattle: University of Washington Press, 2010.

Leung, Irene S. "The Frontier Imaginary in the Song Dynasty (960–1279): Revisiting Cai Yan's Barbarian Captivity and Return." Ph.D. diss., The University of Michigan, 2001.

Li, Chu-tsing. *The Autumn Colors on the Ch'iao and Hua Mountains: A Landscape by Chao Meng-fu*. Ascona: Artibus Asiae, 1965.

———. "The Role of Wu-hsing in Early Yüan Artistic Development under Mongol Rule." In *China under Mongol Rule*, John D. Langlois, Jr. ed., 331–70. Princeton: Princeton University Press, 1981.

Liu, Cary Y., and Dora C.Y. Ching, eds. *The Arts of Sung and Yüan: Ritual, Ethnicity and Style in Painting*. Princeton: The Art Museum, Princeton University, 1999.

McCausland, Shane. *Zhao Mengfu: Calligraphy and Painting for Khubilai's China*. Hong Kong: Hong Kong University Press, 2011.

Mowry, Robert D. *Fur, Tortoiseshell, and Partridge Feathers: Chinese Brown- and Black-Glazed Ceramics, 400–1400*. With contributions by Eugene Farrell and Nicole Coolidge Rousmaniere. Cambridge, MA: Harvard University Art Museums, 1996.

Murck, Alfreda. *Poetry and Painting in Song China: The Subtle Art of Dissent*. Harvard-Yenching Institute Monograph Series, no. 50. Cambridge, MA, and London: Harvard University Press, 2000.

Murray, Julia K. *Ma Hezhi and the Illustration of the "Book of Odes."* Cambridge: Cambridge University Press, 1993.

———. "Water under a Bridge: Further Thoughts on the Qingming Scroll." *Journal of Sung-Yuan Studies* 27 (1997): 99–107.

———. *Mirror of Morality: Chinese Narrative Illustration and Confucian Ideology*. Honolulu: University of Hawaii Press, 2007.

Powers, Martin J. "Discourses of Representation in Tenth and Eleventh Century China." In *The Art of Interpreting*, edited by Susan C. Scott, 88–127. Papers in Art History from the Pennsylvania State University, no. 9. University Park: The Department of Art History, The Pennsylvania State University, 1995.

———. "When Is a Landscape Like a Body?" In *Landscape, Culture, and Power in Chinese Society*, Wen-hsin Yeh ed., 1–22. China Research Monograph, 49. Berkeley, CA: Center for Chinese Studies, 1998.

Rorex, Robert A., and Wen Fong. *Eighteen Songs of a Nomad Flute: The Story of Lady Wen-chi, a Fourteenth Century Handscroll in the Metropolitan Museum of Art*. New York: Metropolitan Museum of Art, 1974.

Rossabi, Morris. "Kuan Tao-sheng: Woman Artist in Yüan China." *Bulletin of Sung-Yüan Studies* 21 (1989): 67–84.

Shih, Shou-chien. "The Mind Landscape of Hsieh Yu-yü." In *Images of the Mind: Selections from the Edward L. Elliott Family and John B. Elliott Collections of Chinese Calligraphy and Painting at The Art Museum, Princeton University*, Wen C. Fong, ed. 237–54. Princeton: The Art Museum, 1984.

Sturman, Peter C. "Confronting Dynastic Change: Painting after Mongol Reunification of North and South China." *Res: Anthropology and Aesthetics* 35 (Spring 1999): 142–69.

———. "Cranes above Kaifeng: The Auspicious Image at the Court of Huizong." *Ars Orientalis* 20 (1990): 33–68.

———. "The Donkey Rider as Icon: Li Cheng and Early Landscape Painting." *Artibus Asiae* 55, no. 1/2 (1995): 43–97.

———. *Mi Fu: Style and the Art of Calligraphy in Northern Song China*. New Haven: Yale University Press, 1997.

———. "Mi Youren and the Inherited Literati Tradition: Dimensions of Ink-Play." Ph.D. diss., Yale University, 1989.

Ts'ai Mei-fen. "A Discussion of Ting Ware with Unglazed Rims and Related Twelfth-Century Official Porcelains." In *Arts of the Sung and Yüan*, Maxwell K. Hearn and Judith G. Smith eds., 109–31. New York: Metropolitan Museum of Art, 1996.

Tsao, Hsingyuan. "Unraveling the Mystery of the Handscroll 'Qingming Shanghe Tu.'" *Journal of Song-Yuan Studies* 33 (2003): 155–79.

Vinograd, Richard. "Family Properties: Personal Context and Cultural Pattern in Wang Meng's *Pien Mountains* of A.D. 1366." *Ars Orientalis* 13 (1982): 1–29.

Watt, James C.Y. *The World of Khubilai Khan: Chinese Art in the Yuan Dynasty*. With essays by Maxwell K. Hearn, Denise Patry Leidy, Zhixin Jason Sun, John Guy, Joyce Denney, Birgitta Augustin, and Nancy S. Steinhardt. New York: The Metropolitan Museum of Art; New Haven and London: Yale University Press, 2010.

Chapter 9: The City and the Market in Chinese Art: The Ming and Qing Dynasties

Adshead, Samuel Adrian M. *Material Culture in Europe and China, 1400–1800: The Rise of Consumerism*. New York: St. Martin's Press, 1997.

Avril, Ellen. *Buddhist Art in Asia: A Web Version of the Hand-Held Tour of the Johnson Museum of Art Collection*. Ithaca, NY: Cornell University. Available online: museum.cornell.edu/buddhist/CornellOnline.swf.

Barnhart, Richard M. *Painters of the Great Ming: The Imperial Court and the Zhe School*. With essays by Mary Ann Rogers and Richard Stanley-Baker. Dallas: Dallas Museum of Art, 1993.

Berg, Daria. "Cultural Discourse on Xue Susu, a Courtesan in Late Ming China." *International Journal of Asian Studies* 6, no. 2 (2009): 171–200.

Brook, Timothy. *The Confusions of Pleasure: Commerce and Culture in Ming China*. Berkeley and Los Angeles: University of California Press, 1998.

Burnett, Katharine P. *Dimensions of Originality: Essays in Seventeenth-Century Chinese Art Criticism*. Hong Kong: Chinese University Press, 2012.

Cahill, James. *The Compelling Image: Nature and Style in Seventeenth-Century Chinese Painting*. Cambridge, MA: Harvard University Press, 1982.

———. *The Distant Mountains: Chinese Painting of the Late Ming Dynasty, 1570–1644*. New York: Weatherhill, 1982.

———. *The Painter's Practice: How Artists Lived and Worked in Traditional China*. New York: Columbia University Press, 1994.

———. *Parting at the Shore: Chinese Painting of the Early and Middle Ming Dynasty, 1368–1580*. New York: Weatherhill, 1978.

———. *Three Alternative Histories of Chinese Painting*. Lawrence, KS: Spencer Museum of Art, University of Kansas, 1988.

Carswell, John. *Blue and White: Chinese Porcelain and Its Impact on the Western World*. Chicago: David and Alfred Smart Gallery, University of Chicago, 1985.

Chaves, Jonathan. "'Meaning beyond the Painting': The Chinese Painter as Poet." In *Words and Images: Chinese Poetry, Calligraphy, and Painting*, Alfreda Murck and Wen C. Fong eds., 431–58. New York: The Metropolitan Museum of Art; Princeton: Princeton University Press, 1991.

Chou, Ju-hsi, and Claudia Brown. *The Elegant Brush: Chinese Painting under the Qianlong Emperor*. Phoenix, AZ: Phoenix Art Museum, 1985.

Clapp, Anne de Coursey. *Wen Cheng-Ming: The Ming Artist and Antiquity*. Supplementum, no. 34. Ascona: Artibus Asiae Publishers, 1975.

Clunas, Craig. *Fruitful Sites: Garden Culture in Ming Dynasty China*. Durham, NC: Duke University Press, 1996.

———. *Pictures and Visuality in Early Modern China*. Princeton: Princeton University Press, 1997.

———. *Superfluous Things: Material Culture and Social Status in Early Modern China*. Urbana, IL: University of Illinois Press, 1991.

Cort, Louise Allison, Jan Stuart, and Laurence C. S. Tam. *Joined Colors: Decoration and Meaning in Chinese Porcelain—Ceramics from Collectors in the Min Chiu Society, Hong Kong*. Washington, DC: Arthur M. Sackler Gallery, Smithsonian Institution, 1993.

Delbanco, Dawn Ho. "The Romance of the Western Chamber, Min Qiji's Album in Cologne." *Orientations* 14, no. 6 (June 1983): 12–23.

Edwards, Richard. *The Art of Wen Cheng-ming (1470–1559)*. Ann Arbor: University of Michigan Museum of Art, 1976.

———. *The Field of Stones: A Study of the Art of Shen Chou (1427–1509)*. Oriental Studies, no. 5. Washington, DC: Smithsonian Institution, Freer Gallery of Art, 1962.

Hay, Jonathan. *Shitao: Painting and Modernity in Early Qing China*. RES Monographs in Anthropology and Aesthetics. New York: Cambridge University Press, 2001.

Ho, Wai-kam. "The Literary Concepts of 'Picture-Like' (*Ju-hua*) and 'Picture-Idea' (*Hua-i*) in the Relationship between Painting and Poetry." In *Words and Images: Chinese Poetry, Calligraphy, and Painting*, Alfreda Murck and Wen C. Fong eds., 359–404. New York: The Metropolitan Museum of Art; Princeton: Princeton University Press, 1991.

———, ed. *The Century of Tung Ch'i-ch'ang*. 2 vols. Kansas City: Nelson-Atkins Museum of Art, 1992.

Hsü, Ginger Cheng-Chi. "Incarnations of the Blossoming Plum." *Ars Orientalis* 26 (1996): 23–45.

Ji Cheng. *The Craft of Gardens*. Translated by Alison Hardie. New Haven: Yale University Press, 1988.

Johnson, Linda Cooke. *Cities of Jiangnan in Late Imperial China*. SUNY Series in Chinese Local Studies. Albany: State University of New York Press, 1993.

Keswick, Maggie. *The Chinese Garden: History, Art and Architecture*. 3rd ed. Cambridge, MA: Harvard University Press, 2003.

Kim, Hongnam. *The Life of a Patron: Zhou Lianggong (1612–1672) and the Painters of Seventeenth-Century China*. New York: China Institute Gallery, 1996.

Laing, Ellen Johnston. "Erotic Themes and Romantic Heroines Depicted by Ch'iu Ying." *Archives of Asian Art* 49 (1996): 68–91.

———. "Qiu Ying's Depiction of Sima Guang's Duluo Yuan and the View from the Chinese Garden." *Oriental Art* 33 (Winter 1987/1988): 375–80.

———. "Sixteenth-Century Patterns of Art Patronage: Qiu Ying and the Xiang Family." *Journal of the American Oriental Society* 111, no. 1 (1991): 1–7.

———. "*Suzhou Pian* and Other Dubious Paintings in the Received *Oeuvre* of Qiu Ying." *Artibus Asiae* 59, no. 3/4 (2000): 265–95.

Li, Chu-tsing and James C. Y. Watt, eds. *The Chinese Scholar's Studio: Artistic Life in the Late Ming Period*. New York: Thames and Hudson, 1987.

Li, Wai-Yee. "The Collector, the Connoisseur, and Late-Ming Sensibility." *T'oung Pao* 81, no. 4/5. 2nd ser. (1995): 269–302.

Liscomb, Kathlyn. "Shen Zhou's Collection of Early Ming Paintings and the Origins of the Wu School's Eclectic Revivalism." *Artibus Asiae* 52, no. 3/4 (1992): 215–54.

Metropolitan Museum of Art, *Ming Garden*. Chicago: Home Vision, 1983.

Murck, Alfreda and Wen C. Fong. "A Chinese Garden Court: The Astor Court at the Metropolitan Museum of Art." *The Metropolitan Museum of Art Bulletin* n.s. 38, no. 3 (Winter 1980–81): 2–64.

Nelson, Susan E. "On through to the Beyond: The Peach Blossom Spring as Paradise." *Archives of Asian Art* 39 (1986): 23–47.

Ryor, Kathleen M. "Fleshly Desires and Bodily Deprivations: The Somatic Dimensions of Xu Wei's Flower Paintings." In *Body and Face in Chinese Visual Culture*, Wu Hung and Katherine R. Tsiang eds., 121–45. Cambridge, MA: Harvard University Press, 2005.

Shih-t'ao [Shitao 石濤]. *Enlightening Remarks on Painting (Hua yu lu 畫語錄)*. ca. 1700. Richard E. Strassberg trans. Pacific Asia Museum Monographs, no. 1. Pasadena: Pacific Asia Museum, 1989.

Tseng Yu-ho. "Women Painters of the Ming Dynasty." *Artibus Asiae* 53, no. 1/2 (1993): 249–61.

Vinograd, Richard. *Boundaries of the Self: Chinese Portraits 1600–1900*. Cambridge: Cambridge University Press, 1992.

Waldron, Arthur N. "The Problem of the Great Wall of China." *Harvard Journal of Asiatic Studies* 43, no. 2 (December 1983): 643–663.

Wang, Fang-yu and Richard M. Barnhart. *Master of the Lotus Garden: The Life and Art of Bada Shanren (1626–1705)*. New Haven: Yale University Press, 1990.

Watt, James C.Y., and Anne E. Wardwell. *When Silk Was Gold: Central Asian and Chinese Textiles*. New York: Metropolitan Museum of Art, 1997.

Wetzel, Jean. "Hidden Connections: Courtesans in the Art World of the Ming Dynasty." *Women's Studies* 31, no. 5 (September/October 2002): 645–69.

Chapter 10: The Push for Modernization: 1912 to the Present

Abe, Stanley K. "No Questions, No Answers: China and *A Book from the Sky*." *boundary 2* 25, no. 3 (Autumn 1998): 169–92.

Ai Weiwei. *Ai Weiwei: Dropping the Urn (Ceramic Works, 5000 BCE–2010 CE)*. Glenside, PA: Arcadia University Art Gallery, 2010.

Andrews, Julia F. *Painters and Politics in the People's Republic of China, 1949–1979*. Berkeley and Los Angeles: University of California Press, 1994.

Andrews, Julia F., and Kuiyi Shen. *A Century in Crisis: Modernity and Tradition in the Art of Twentieth-Century China*. New York: Guggenheim Museum, 1998.

Cai Guo-Qiang. *Cai Guo-Qiang*. Cai Studio, n.d. Available online: caiguoqiang.com.

China's New Art, Post-1989. Hong Kong: Hanart T Z Gallery, 1993.

Clark, John, ed. *Chinese Art at the End of the Millennium: "Chinese-art.com" 1998–1999*. Hong Kong: New Art Media Limited, 2000.

Clarke, David. *Hong Kong Art: Culture and Decolonization*. Durham, NC: Duke University Press Books, 2001.

Crozier, Ralph C. *Art and Revolution in Modern China: The Lingnan (Cantonese) School of Painting, 1906–1951*. Berkeley: University of California Press, 1988.

Dal Lago, Francesca. "Personal Mao: Reshaping an Icon in Contemporary Chinese Art." *Art Journal* 58, no. 2 (Summer 1999): 46–59.

Donald, Stephanie, and Harriet Evan, eds. *Picturing Power in China: Posters of the Cultural Revolution*. London: Rowman and Littlefield, 1999.

Duara, Prasenjit. *Rescuing History from the Nation: Questioning Narratives of Modern China*. Chicago: University of Chicago Press, 1997.

Ellsworth, Robert Hatfield. *Later Chinese Painting and Calligraphy*. New York: Random House, 1987.

Erickson, Britta. *The Art of Xu Bing: Words without Meaning, Meaning without Words*. Washington, DC: Arthur M. Sackler Gallery, Smithsonian Institution; Seattle and London: University of Washington Press, 2001.

Fong, Wen C. *Between Two Cultures: Late Nineteenth- and Twentieth-Century Paintings from the Robert H. Ellsworth Collection in the Metropolitan Museum of Art*. New York: The Metropolitan Museum of Art; New Haven and London: Yale University Press, 2001.

———. "The Modern Chinese Art Debate." *Artibus Asiae* 53, no. 1/2 (1993): 290–305.

Gao Minglu. *Total Modernity and the Avant-Garde in Twentieth-Century Chinese Art*. Cambridge, MA, and London: The MIT Press, 2011.

———. *The Wall: Reshaping Contemporary Chinese Art (Qiang: Zhongguo dangdai yishu de lishi yu bianjie 墙: 中国当代艺术的历史与边界)*. Buffalo, NY: Albright-Knox Art Gallery, 2005.

———, ed. *Inside/Out: New Chinese Art*. Berkeley: University of California Press, 1988.

Grosenick, Uta and Caspar H. Schübbe, eds. *China Art Book*. Köln: DuMont, 2007.

Gu, Wenda. *Wenda Gu*. Available www.wendagu.com.

Huangfu, Binghui, ed. *Text & Subtext: Contemporary Art and Asian Woman*. Singapore: Earl Lu Gallery, 2000.

Kao, Mayching, ed. *Twentieth-Century Chinese Painting*. Hong Kong and Oxford: Oxford University Press, 1988.

Kee, Joan. "What Is Feminist about Contemporary Asian Women's Art?" In *Global Feminisms: New Directions in Contemporary Art*, Maura Reilly and Linda Nochlin eds., 107–21. London and New York: Merrell, 2007.

Kuo, Jason C. *Art and Cultural Politics in Postwar Taiwan*. Seattle: University of Washington Press, 2000.

Laing, Ellen Johnston. *The Winking Owl: Art in the People's Republic of China*. Berkeley: University of California Press, 1988.

Li, Chu-tsing. *Trends in Modern Chinese Painting (The C. A. Drenowatz Collection)*. Artibus Asiae Supplementum, no. 36. Ascona: Artibus Asiae Publishers, 1979.

Lü Peng. *A History of Art in 20th-Century China*. Milan: Edizioni Charta, 2010.

Lu, Sheldon Hsiao-peng. "Art, Culture, and Cultural Criticism in Post-New China." *New Literary History* 28, no. 1 (Winter 1997): 111–33.

Minick, Scott and Jiao Ping. *Chinese Graphic Design in the Twentieth Century*. New York: Van Nostrand Reinhold, 1990.

Noth, Jochen, Wolfger Pöhlmann, and Kai Reschke, eds. *China Avant-Garde: Counter-Currents in Art and Culture*. Berlin: Haus der Kulteren der Welt, 1993; Hong Kong, Oxford, and New York: Oxford University Press, 1994.

Nuridsany, Michel and Marc Domage. *China Art Now.* Paris: Flammarion, 2004.

Powell, Patricia and Joseph Wong. "Propaganda Posters from the Chinese Cultural Revolution." *The Historian* 59, no. 4 (Summer 1997): 776–93.

Shi, Mingzheng. "From Imperial Gardens to Public Parks: The Transformation of Urban Space in Early Twentieth-Century Beijing." *Modern China* 24, no. 3 (July 1998): 219–54.

Silbergeld, Jerome. *China into Film: Frames of Reference in Contemporary Chinese Cinema.* London: Reaktion Books, 1999.

———. *Art and Artists of Twentieth-Century China.* Berkeley: University of California Press, 1996.

Tsao, Hsingyuan and Roger T. Ames, eds. *Xu Bing and Contemporary Chinese Art: Cultural and Philosophical Reflections.* Albany: State University of New York Press, 2011.

Vine, Richard. *New China, New Art.* Rev. ed. Munich, London, and New York: Prestel, 2011.

Wang, Eugene Y. "The Winking Owl: Visual Effect and Its Art Historical Thick Description." *Critical Inquiry* 26, no. 3 (Spring 2000): 435–73.

Wang Gongxin and Lin Tianmiao. *Wang Gongxin & Lin Tian Miao Website.* Available online: wanggongxin. com.

Wu Hung. *Remaking Beijing: Tiananmen Square and the Creation of a Political Space.* Chicago: University of Chicago Press, 2005.

———. *Transience: Chinese Experimental Art at the End of the Twentieth Century.* Chicago: University of Chicago Press, 1999.

———, ed. *Chinese Art at the Crossroads: Between Past and Future, Between East and West.* Hong Kong: New Art Media Limited, 2001.

Xu Bing. *Xu Bing.* Xu Bing Studio, 2009. Available online at xubing.com.

Zhang Zhen, ed. *The Urban Generation: Chinese Cinema and Society at the Turn of the Twenty-first Century.* Durham and London: Duke University Press, 2007.

Chapter 11: An Unknown Land, A People Divided: Korean Art from Prehistory to Present

Ciclitira, Serenella, ed. *Korean Eye: Contemporary Korean Art.* Milan: Skira Editore, 2010.

Cunningham, Michael et al. *Ink Paintings and Ash-glazed Ceramics: Medieval Calligraphy, Painting, and Ceramic Art from Japan and Korea.* Cleveland: Cleveland Museum of Art, 2000.

Ha, Tae-hung, and Grafton Mintz., trans. *Samguk Yusa: Legends and History of the Three Kingdoms of Ancient Korea.* Rockville, MD: Silk Pagoda, 2006.

Jeon, Ho-Tae. *The Dreams of the Living and Hopes of the Dead: Goguryeo Tomb Murals.* Seoul: Seoul National University Press, 2007.

——— and Tongbuga Yoksa Chaedan (Korea). *Koguryo, A Glorious Ancient Kingdom in Northeast Asia.* Seoul: Northeast Asian History Foundation, 2007.

Joe, Wanne. *A Cultural History of Modern Korea.* Seoul: Hollym Corporation, 2000.

Kang, Kyung-sook. *Korean Ceramics.* Seoul: The Korea Foundation, 2008.

Kang, Woobang, ed. *Eternal Images of Sakyamuni* Two Gilt-Bronze Korean National Treasures. Seoul: The Korea Foundation, 2008.

Kendall, Laurel. *Shamans, Nostalgias, and the IMF: South Korean Popular Religion in Motion.* Honolulu: University of Hawaii Press, 2009.

Kim, Bongryol. *The Secret Spirit of Korean Architecture.* London: Saffron Books, 2005.

Kim, Hongnam, ed. *Korean Arts of the Eighteenth Century: Splendor and Simplicity.* New York and Tokyo: The Asia Society Galleries in association with Weatherhill, Inc., 1993.

Kim, Jaeyeol. *White Porcelain and Punchong Ware.* Seoul: Yekyong Publishing Co., 2002.

Kim, Kumja Paik. *Goryeo Dynasty: Korea's Age of Enlightenment, 918-1392.* San Francisco: Asian Art Museum. San Francisco, 2003.

Kim, Lena, ed. *Koguryo Tomb Murals.* Seoul: ICOMOS-Korea, 2004.

Kim, Youngna. *20th Century Korean Art.* London: Laurence King Publishing Ltd., 2005.

Kim, Youngna. *Modern and Contemporary Art in Korea.* New Jersey: Hollym International Corporation, 2005.

Korean History: A Bibliography compiled by Kenneth Robinson. Available online: hawaii.edu/ korea/biblio/index.html

Kwak, Dong-seok ed. *Royal Ceramics of Goryeo Dynasty.* Seoul: National Museum of Korea, 2009.

Lee, Peter, trans., *A Korean Storyteller's Miscellany.* Princeton, New Jersey: Princeton University Press, 1989.

Lee, Soyoung et al. *Art of the Korean Renaissance 1400-1800.* New York: The Metropolitan Museum of Art, 2009.

Nelson, Sarah M., ed. *Ancient Queens Archaeological Explorations.* Walnut Creek, CA: Altamira Press, 2003.

Oh, Ju-seok. *The Art of Kim Hong-Do: A Great Court Painter of 18th Century Korea.* Seoul: Sol, 2005.

Portal, Jane. *Art Under Control in North Korea.* London: Reaktion Books Ltd, 2005.

Seth, Michael. *A Concise History of Korea From the Neolithic Period through the Nineteenth Century.* Oxford: Rowman & Littlefield Publishers, Inc., 2006.

———. *A Concise History of Modern Korea From the Late Nineteenth Century to the Present.* Plymouth: Rowman and Littlefield Publishers, Inc., 2010.

Sponberg, Alan and Helen Hardacre, eds. *Maitreya the Future Buddha.* Cambridge: Cambridge University Press, 1988.

Washizuka, Hiromitsu, Park Youngbok, and Kang Woo-bang. *Transmitting the Forms of Divinity: Early Buddhist Art from Korea and Japan.* Naomi Noble Richard ed. New York: Japan Society, 2003.

Wick-Kim, Miki. *Korean Contemporary Art.* New York: Prestel, 2012.

Yi, Song-mi. *Fragrance, Elegance, and Virtue: Korean Women in Traditional Arts and Humanities.* Seoul: Daewonsa Publishing Co., 2002.

Chapter 12: The Way of the Gods and the Path of the Buddha: Japanese Art from Prehistory to the Asuka Period

Aikens, C. Melvin and Takayama Higuchi. *Prehistory of Japan.* New York: Academic Press, 1982.

Aston, W. G., trans. *Nihongi: Chronicles of Japan from the Earliest Times to A.D. 697.* London: George Allen & Unwin, 1956.

A to Z Photo Dictionary of Japanese Buddhist Sculpture. Available online: www. onmarkproductions.com/html/buddhism.shtml.

Barnes, Gina L. *Protohistoric Yamato: Archaeology of the First Japanese State.* Ann Arbor: Center for Japanese Studies and the Museum of Anthropology of the University of Michigan, 1988.

Brown, Delmer M., ed. *The Cambridge History of Japan.* Vol. 1. Cambridge: Cambridge University Press, 1993.

Cali, Joseph and John Dougill. *Shinto Shrines: A Guide to the Sacred Sites of Japan's Ancient Religion.* Honolulu: University of Hawaii Press, 2013.

Collcutt, Martin, Marius Jansen, and Isao Kumakura. *Cultural Atlas of Japan.* New York: Facts on File Publications, 1988.

De Bary, Wm. Theodore, ed. *Sources of Japanese Tradition from Earliest times to 1600.* 2nd ed. New York: Columbia University Press, 2001.

Gorman, Michael S. F. *The Quest for Kibi and the True Origins of Japan.* Bangkok: Orchid Press, 1999.

Habu, Junko. *Ancient Jomon of Japan.* Cambridge: Cambridge University Press, 2004.

Harris, Victor, ed. *Shinto: The Sacred Art of Japan.* London: British Museum, 2001.

JAANUS: Terminology of Japanese Art and Architecture. Available online: aisf.or.jp/~jaanus.

Kenrick, Douglas Moore. *Jomon of Japan, the World's Oldest Pottery.* London: Kegan Paul International, 1995.

Kurata Bunsaku. *Horyu-ji: Temple of the Exalted Law.* W. Chie Ishibashi trans. New York: Japan Society, 1981.

Kiyotari Tsuboi, ed. *Recent Archaeological Discoveries in Japan.* Gina L. Barnes trans. Tokyo: The Centre for East Asian Cultural Studies, 1987.

Littleton, Scott. *Understanding Shinto.* London: Duncan Baird Publishers, 2002.

Mizoguchi Koji. *An Archaeological History of Japan: 30,000 BC to AD 700.* Philadelphia: University of Pennsylvania Press, 2002.

Mulhern, Chieko Irie, ed. *Heroic with Grace, Legendary Women of Japan.* New York: M. E. Sharpe Inc., 1991.

Naumann, Nelly. *Japanese Prehistory: The Material and Spiritual Culture of the Jomon Period.* Wiesbaden: Harrassowitz, 2000.

Nelson, John. *A Year in the Life of a Shinto Shrine.* Seattle: University of Washington Press, 1996.

Ono Sokyo. *Shinto: The Kami Way.* Tokyo: Charles Tuttle Company, 1992.

Peach, Lucinda. *Women and World Religions.* Upper Saddle River, NJ: Pearson/Prentice Hall, 2002.

Pearson, Richard et al., *Ancient Japan.* New York: Braziller, 1992.

Philippi, Donald, trans. *Kojiki*. Tokyo: University of Tokyo Press, 1968.

The Rise of a Great Tradition: Japanese Archaeological Ceramics from the Jomon through Heian Periods (10,500 BC–AD 1185). New York: Agency for Cultural Affairs, Government of Japan and Japan Society, 1990.

Sered, Susan. *Women of the Sacred Groves Divine Priestesses of Okinawa*. Oxford: Oxford University Press, 1999.

Shillony, Ben-Ami. *Enigma of the Emperors: Sacred Subservice in Japanese History*. Folkestone: Global Oriental Ltd., 2005.

Suzuki, David and Keibo Oiwa. *The Japan We Never Knew: A Journey of Discovery*. Toronto: Stoddart Publishing Company Ltd., 1996.

Suzuki Kakichi. *Early Buddhist Architecture in Japan*. Mary N. Parent and Nancy S. Steinhardt trans. New York: Kodansha International, 1980.

Warner, Langdon. *Japanese Sculpture of the Tempyo Period*. Cambridge, MA: Harvard University Press, 1959.

Wong, Dorothy C. and Eric M. Field, eds. *Horyuji Reconsidered*. Newcastle: Cambridge Scholars, 2008.

Chapter 13: External Influences and Internal Explorations: The Nara and Heian Periods

Aoki, Kazuo et al., eds. *Shoku nihongi* 5 vols. Tokyo: Yoshikawa Kobunkan, 1961.

Bowring, Richard. *Murasaki Shikibu Her Diary and Poetic Memoirs: A Translation and Study*. Princeton, New Jersey: Princeton University Press, 1982.

Cunningham, Michael R. *Buddhist Treasures from Nara*. Cleveland: Cleveland Museum of Art, 1998.

Hempel, Rose. *The Golden Age of Japan: 794–1192*. Katherine Watson trans. New York: Rizzoli International, 1983.

Ishida Hisatoyo. *Esoteric Buddhist Painting*. E. Dale Saunders trans. and adapt. New York: Kodansha International, 1987.

Izutsu, Shinryu and Shoryu Omori. *Sacred Treasures of Mount Koya: The Art of Japanese Shingon Buddhism*. Honolulu: Koyasan Reihokan Museum, 2002.

Kaneko S., trans. *The Treasure of the Shosoin*. Tokyo: Asahi Shimbun, 1965.

Keene, Donald ed. *Anthology of Japanese Literature: From the Earliest Era to the Mid-Nineteenth Century*. New York: Grove Press, 1960.

Kornicki, Peter. "The Hyakumanto Darani and the Origins of Printing in Eighth-century Japan." *International Journal of Asian Studies*, 9, (2012): 43–70.

Levy, Ian Hideo. *The Ten Thousand Leaves: A Translation of the Man'yoshu*. Princeton: Princeton University Press, 1981.

Matsumoto, Kaneo, ed. *The Treasures of the Shosoin: Musical Instruments, Dance Articles, Game Sets*. Kyoto: Shikosha Publishing Co., Ltd., 1991.

McCallum, Donald F. *The Four Great Temples: Buddhist Archaeology, Architecture, and Icons of Seventh-Century Japan*. Honolulu: University of Hawaii Press, 2009.

McCullough, Helen Craig, trans. *Tales of Ise*. Stanford: Stanford University Press, 1968.

———, trans. *Classical Japanese Prose: An Anthology*. Stanford: Stanford University Press, 1990.

Morris, Ivan. *The Tale of Genji Scroll*. Tokyo: Kodansha International, 1971.

——— *The World of the Shining Prince: Court Life in Ancient Japan*. New York: Alfred Knopf, 1975.

———, trans. *The Pillow Book of Sei Shonagon*. New York: Columbia University Press, 1991.

Mulhern, Chieko, ed. *Japanese Women Writers: A Bio-critical Sourcebook*. Westport, CT: Greenwood Press, 1994.

Murasaki Shikibu, *The Tale of Genji*, Royall Tyler trans. New York: Penguin Classics, 2002.

Murase, Miyeko. *The Tale of Genji: Legends and Paintings*. New York: Braziller, 2001.

Nara National Museum. *Special Exhibition: Women and Buddhism*. Nara: Nara National Museum, 2003.

Nishiwara, Kyotaro and Emily J. Sano. *The Great Age of Japanese Buddhist Sculpture, A.D. 60–1300*. Fort Worth, TX: Kimbell Art Museum, 1982.

Okazaki Joji. *Pure Land Buddhist Painting*. Elizabeth ten Grotenhuis trans. and adapt. New York: Kodansha International, 1977.

Ruch, Barbara, ed. *Engendering Faith: Women and Buddhism in Premodern Japan*. Ann Arbor: Centre for Japanese Studies, University of Michigan, 2002.

Ruch, Barbara and Patricia Fister et al., *A Hidden Heritage: Treasures of the Japanese Imperial Convents*, exh. Cat., The University Art Museum, Tokyo University of the Arts. Tokyo, 2009.

Sansom George. "The Imperial Edicts in the Shoku Nihongi." *Transactions of the Asiatic Society of Japan* 2nd series.1 (1924): 5–40.

Sato Hiroaki, trans. *Japanese Women Poets: An Anthology*. London: M.E. Sharpe, 2008.

Sato, Hiroaki and Burton Watson, eds. and trans. *From the Country of Eight Islands: An Anthology of Japanese Poetry*. New York: Anchor Press, 1981.

Seidensticker, Edward, trans. *The Gossamer Years: A Diary by a Noblewoman of Heian Japan*. Tokyo: Tuttle, 1964.

Shively, Donald and William H. McCullough eds. *The Cambridge History of Japan, Vol. 2: Heian Japan*. Cambridge: Cambridge University Press, 1999.

Snellen, J.B., trans. "*Shoku Nihon-gi*, Chronicles of Japan from 697 to 791 A.D." *Transactions of the Asiatic Society of Japan* 11(1934), 14 (1937).

Ten Grotenhuis, Elizabeth. *Japanese Mandalas: Representations of Sacred Geography*. Honolulu: University of Hawaii Press, 1999.

Tisdale, Sallie. *Women of the Way*. San Francisco: Harper Collins Publishers, 2006.

Chapter 14: Strife and Serenity: Kamakura, Muromachi, and Momoyama Periods

Berry, Mary Elizabeth. *The Culture of Civil War in Kyoto*. Berkeley: University of California Press, 1994.

Berthier, Francois. *The Japanese Dry Landscape Garden: Reading Zen in the Rocks*. Chicago: The University of Chicago Press, 2000.

Cave, Philip. *Creating Japanese Gardens*. London: Aurum Press, 1997.

Collcutt, Martin. *Five Mountains: The Rinzai Zen Monastic Tradition in Medieval Japan*. Cambridge, MA: Harvard University Press, 1981.

Conlan, Thomas. *In Little Need of Divine Intervention: Takezaki Suenaga's Scrolls of the Mongol Invasions of Japan, Translation with Interpretive Essay*. New York: Cornell University East Asia Program, 2001.

Cooper, Michael, ed. *They Came To Japan: An Anthology of European Reports on Japan, 1543-1640*. Berkeley: University of California Press, 1965.

Court and Samurai in an Age of Transition. New York: Japan Society, 1990.

Cunningham, Michael. *The Triumph of Japanese Style: 16th Century Art in Japan*. Cleveland: Cleveland Museum of Art, 1991.

———, et al. *Ink Paintings and Ash-glazed Ceramics: Medieval Calligraphy, Painting, and Ceramic Art from Japan and Korea*. Cleveland: Cleveland Museum of Art, 2000.

Ellison, George and Bardwell L. Smith eds. *Warlords, Artists and Commoners: Japan in the Sixteenth Century*. Honolulu: University of Hawaii Press, 1981.

Fujioka Ryoichi, et al. *Tea Ceremony Utensils*. Louise Alison Cort trans. and adapt. New York: Weatherhill, 1973.

Graham, Patricia. *Tea of the Sages: The Art of Sencha*. Honolulu: University of Hawaii Press, 1999.

Graybill, Maribeth and Sadako Ohki. *Days of Discipline and Grace: Treasures from the Imperial Buddhist Convents of Kyoto*. New York: Institute for Medieval Japanese Studies, 1998.

Hall, John W. and Toyoda Takeshi, eds. *Japan in the Muromachi Age*. Berkeley: University of California Press, 1977.

Harris, Victor and Ken Matsushima. *Kamakura: The Renaissance of Japanese Sculpture 1185–1333*. London: British Museum, 1991.

Hickman, Money et al. *Japan's Golden Age: Momoyama*. New Haven: Yale University Press, 1996.

Hinago Motoo. *Japanese Castles*. William H. Coaldrake trans. New York: Kodansha International, 1986.

Interactive Heiji Scroll developed by Thomas Conlan. Available online: learn.bowdoin.edu/heijiscroll/.

Interactive Mongol Invasions of Japan Scrolls developed by Thomas Conlan. Available online: www.bowdoin.edu/mongol-scrolls/.

Introduction to Noh and Kyogen by the Japan Arts Council. Available online: www2.ntj.jac.go.jp/unesco/noh/en/index.html.

Kanazawa Hiroshi. *Japanese Ink Painting: Early Zen Masterpieces*. Barbara Ford trans. and adapt. New York: Kodansha International, 1979.

Kato, Etsuko. *The Tea Ceremony and Women's Empowerment in Modern Japan: Bodies Re-Presenting the Past*. New York: RoutledgeCurzon, 2004.

Keane, Marc. *Japanese Garden Design*. Tokyo: Charles Tuttle Publishing Co., Inc., 1996.

Keane, Marc. *The Japanese Tea Garden*. Berkeley: Stonebridge Press, 2009.

Keene, Donald. *Anthology of Japanese Literature: from the Earliest Era to the Mid-Nineteenth Century*. New York: Grove Weidenfeld, 1960.

———. *Seeds in the Heart: Japanese Literature from Earliest Times to the Late Sixteenth Century*. New York: Columbia University Press, 1999.

McCullough, Helen Craig, trans. *The Tale of the Heike*. Stanford: Stanford University Press, 1988.

Ogawa, Morihiro, ed. *Art of the Samurai: Japanese Arms and Armor 1156-1868*. New York: Metropolitan Museum of Art, 2009.

Ohki, Sadako. *Tea Culture of Japan*. New Haven: Yale University Press, 2009.

Parker, Joseph D. *Zen Buddhist Landscape Arts of Early Muromachi Japan*. Albany, NY: State University of New York Press, 1999.

Pitelka, Morgan, ed. *Japanese Tea Culture: Art, History and Practice*. New York: Routledge, 2003.

Rath, Eric. *The Ethos of Noh: Actors and their Art*. Cambridge, MA: Harvard Asia University Center, 2004.

Tanaka, Sen'o and Sendo Tanaka. *The Tea Ceremony*. 2nd Ed. New York: Kodansha International, 1998.

the-Noh.com: A website on the world of Noh theater: the-noh.com/.

Till, Barry. *Samurai: The Cultured Warrior*. Victoria, British Columbia: Sono Nis Press, 1984.

Udaka, Michishige. *The Secrets of Noh masks*. Tokyo: Kodansha International, 2010.

Varley, H. Paul and Kumakura Isao, eds. *Tea in Japan*. Honolulu: University of Hawaii Press, 1989.

Young, David and Michiko. *The Art of the Japanese Garden*. Tokyo: Periplus Editions (HK) Ltd., 2004.

Chapter 15: From Isolation to Internationalism: Edo Period to the Present

Addiss, Stephen, et al. *Japanese Ghosts and Demons*. New York: Braziller, 1985.

———, et al. *Japanese Quest for a New Vision*. Lawrence KS: Spencer Museum of Art, 1986.

Bognar, Botand. *New Japanese Architecture*. New York: Rizzoli International, 1991.

Calza, Gian Carlo. *Ukiyo-e*. New York: Phaidon Press, 2005.
De Bary, Wm. Theodore, ed. *Sources of Japanese Tradition 1600-2000*. 2nd ed. New York: Columbia University Press, 2006.

Clark, Timothy, et al. *The Dawn of the Floating World 1650–1765: Early Ukiyo-e Treasures from the Museum of Fine Arts, Boston*. London: Royal Academy of Arts, 2002.

Downer, Lesley. *Women of the Pleasure Quarters: The Secret History of the Geisha*. New York: Broadway Books, 2001.

Fischer, Felice and Kyoko Kinoshita et al. *Ike Taiga and Tokuyama Gyokuran: Japanese Masters of the Brush*. Philadelphia Museum of Art in association with Yale University Press, 2007.

Fister, Patricia. *Japanese Women Artists: 1600-1900*. Lawrence, KS: Spencer Museum of Art, 1988.

Fitzhugh, William and Chisato Dubreuil, eds. *Ainu: Spirit of a Northern People*. Washington, DC: Arctic Studies Center, National Museum of Natural History, Smithsonian Institution in association with University of Washington Press, 1999.

Gallagher, John. *Geisha: A Unique World of Tradition, Elegance and Art*. London: PRC Publishing, 2003.

Gluckman, Dale Carolyn and Sharon Sadako Takeda, eds. *When Art Became Fashion: Kosode in Edo Period Japan*. New York: Weatherhill, 1992.

Graham, Patricia J. *Faith and Power in Japanese Buddhist Art, 1600–2005*. Honolulu: University of Hawaii Press, 2007.

Guth, Christine. *Art of Edo Japan: The Artist and the City 1615–1868*. New Haven: Yale University Press, 2010.

Gravett, Paul. *Manga: Sixty Years of Japanese Comics*. London: Laurence King Publishing Ltd., 2004.

Jackson, Anna. *Japanese Country Textiles*. London: V & A Publications, 1997.

Kato, Mizuho and Ming Tiampo. *Electrifying Art: Atsuko Tanaka 1954-1968*. Vancouver: The Morris and Helen Belkin Art Gallery, 2004.

Kawahara Masahiko. *The Ceramic Art of Ogata Kenzan*. Richard L. Wilson trans. and adapt. New York: Kodansha International, 1985.

Kawatake, Toshio. *Kabuki*. Tokyo: The International House of Japan, 2003.

Kobayashi, Tadashi, and Lisa Rotondo-McCord. *An Enduring Vision: 17th to 20th Century Japanese Painting from the Gitter-Yelen Collection*. New Orleans: New Orleans Museum of Art, 2003.

Lane, Richard. *Hokusai*. London: Barrie and Jenkins, 1989.

Lillehoj, Elizabeth, ed. *Critical Perspectives on Classicism in Japanese Painting, 1600–1700*. Honolulu: University of Hawaii Press, 2004.

———. *Woman in the Eyes of Man: Images of Women in Japanese Art from the Field Museum*. Chicago: DePaul University Press, 1995.

Link, Howard A., et al. *Exquisite Visions: Rimpa Paintings from Japan*. Honolulu: Honolulu Academy of Arts, 1980.

Marks, Andreas. *Japanese Woodblock Prints: Artists, Publishers and Masterworks 1680-1900*. Tokyo: Tuttle Publishing, 2010.

McKelway, Matthew P. *Traditions Unbound: Groundbreaking Painters of Eighteenth-Century Kyoto*. San Francisco: Asian Art Museum–Chong-Moon Lee Center, 2005.

Meech, Julia and Jane Oliver. *Designed for Pleasure: The World of Edo Japan in Prints and Paintings, 1680–1860*. Seattle and New York: University of Washington Press in association with the Asia Society and Japanese Art Society of America, 2008.

Morris, Frances ed. *Yayoi Kusama*. London: Tate Publishing, 2012.

Munroe, Alexandra. *Japanese Art after 1945: Scream Against the Sky*. New York: Abrams, 1994.

Naito Akira and Nishikawa Takeshi. *Katsura, A Princely Retreat*. Charles S. Terry trans. New York: Kodansha International, 1977.

Newland, Amy Reigle, ed. *The Hotei Encyclopedia of Japanese Woodblock Prints*. 2 vols. Amsterdam: Hotei Publishing, 2005.

Okyo and the Maruyama Shijo School of Japanese Painting. St Louis: St Louis Art Museum, 1980.

Pekarik, Andrew J. *The Thirty-six Immortal Women Poets*. New York: Braziller, 1991.

Ponciroli, Virginia, ed. *Katsura Imperial Villa*. Milan: Electa Architecture, 2004.

Rousmaniere, Nicole, ed. *Crafting Beauty in Modern Japan: Celebrating Fifty Years of the Japan Traditional Art Crafts Exhibition*. Seattle: University of Washington Press, 2007.

Screech, Timon. *The Shogun's Painted Culture: Fear and Creativity in the Japanese States 1760–1829*. London: Reaktion Books, 2000.

———. *The Lens Within the Heart: The Western Scientific Gaze and Popular Imagery in Later Edo Japan*. 2nd ed. Honolulu: University of Hawaii Press, 2002.

———. *Sex and the Floating World: Erotic Images in Japan 1700-1820*. New York: Reaktion Books, 2008.

Seo, Audrey Yoshiko and Stephen Addiss. *The Sound of One Hand: Paintings and Calligraphy by Zen Master Hakuin*. Boston: Shambhala, 2010.

The Shogun Age Exhibition. Tokyo: The Shogun Age Exhibition Committee, 1983.

Singer, Robert T. and John T. Carpenter. *Edo, Art in Japan 1615–1868*. Washington, DC: National Gallery of Art, 1998.

The Sotatsu/Koetsu *Deer Scroll*. Available online: seattleartmuseum.org/exhibit/interactives/deerscroll/sam_deer.htm

Swinton, Elizabeth, et al, *The Women of the Pleasure Quarter: Japanese Paintings and Prints of the Floating World*. New York: Hudson Hills Press, 1996.

Takeuchi, Melinda. *Taiga's True Views: The Language of Landscape Painting in Eighteenth Century Japan*. Stanford: Stanford University Press, 1992.

Ueda Makoto. Literary and Art Theories of Japan. Cleveland: Case Western Reserve University Press, 1967.

Undercurrents in the Floating World: Censorship and Japanese Prints. New York: Asia Society Galleries, 1991.

Watson, William, ed. *The Great Japan Exhibition: Art of the Edo Period 1600–1868*. London: Royal Academy of Arts, 1981.

Weisberg, Gabriel P., et al. *Japonisme: Japanese Influence on French Art 1854–1910*. Celeveland: Cleveland Museum of Art, 1975.

Weston, Victoria. *The Rise of Modern Japanese Art*. Greenwich: Shorewood Fine Art Books, 1999.

Wilson, Richard. *The Art of Ogata Kenzan: Persona and Production in Japanese Ceramics*. New York: Weatherhill, 1991.

Wheelwright, Carolyn, ed. *Word in Flower: The Visualization of Classical Literature in Seventeenth Century Japan*. New Haven: Yale University Art Gallery, 1989.

Words in Motion: Modern Japanese Calligraphy. Tokyo: Yomiuri Shimbun, 1984.

Yamaguchi, Yumi. *Warriors of Art: A Guide to Contemporary Japanese Artists*. Wingfield, SA: Bookwise International, 2007.

Zinn, Howard. *The Bomb*. San Francisco: City Lights Books, 2010.

Zukowski, John ed. *Japan 2000: Architecture and Design for the Japanese Public*. Munich: Prestel, 1998.

Credits

Pearson Education, the authors, and the picture researchers wish to thank the institutions and individuals who have kindly provided photographic material for use in this book. Museum and gallery locations are given in the captions; other sources and copyright information is given below. While every effort has been made to trace the present copyright holders we apologize in advance for any unintentional omission or error and will be pleased to insert the appropriate acknowledgements in any subsequent edition.

Introduction: I-1 © 2013 Image copyright The Metropolitan Museum of Art/Art Resource/Scala, Florence; I-2 © Luca Tettoni; I-3, I-4, I-9 © 2013 Image copyright The Metropolitan Museum of Art/Art Resource/Scala, Florence; I-5 © Victoria and Albert Museum, London/V&A Images -All rights reserved; I-6 © Asian Art Museum, San Francisco. Used by permission; I-10 © Luca Tettoni; I-11 © The Trustees of the British Museum (1992,0525.60); I-12 © JTB Photo Communications, Inc./imagenavi.

Part One opener: Jean-Louis Nou /akg-images.

Chapter 1: 1-1 © 2013 Kimbell Art Museum, Fort Worth, Texas/Art Resource, NY/Scala, Florence 1986.06; 1-2 © Georg Helmes, Aachen; 1-3, 1-5, 1-10 © J.M. Kenoyer/Harappa.com, Courtesy Dept. of Archaeology and Museums, Govt. of Pakistan; 1-4 © Diego Lezama Orezzoli/Corbis; 1-6, 1-21 © 2013 Image copyright The Metropolitan Museum of Art/Art Resource/Scala, Florence; 1-7 National Museum of Karachi, Karachi, Pakistan/The Bridgeman Art Library; 1-8 De Agostini Picture Library/A. Dagli Orti/Scala, Florence; 1-9, 1-11 Jean-Louis Nou /akg-images; 1-13 Rick Asher; 1-14 R. & S. Michaud/akg-images; 1-15 Yogesh S. More/age fotostock/SuperStock; 1-Closer Look © Dinodia; 1-16, 1-19 © The Trustees of the British Museum; 1-17 Richard Ashworth/Robert Harding; 1-18 Ashmolean Museum, University of Oxford/The Bridgeman Art Library; 1-20 Photograph © 2014 Museum of Fine Arts, Boston; 1-22 Interfoto/akg-images; 1-23 Nikhilesh Haval/age fotostock/SuperStock; 1-24 © Frederic Soltan/Corbis; 1-25 © Luca Tettoni; 1-26 © Christine Osborne Pictures/Alamy; 1-27 Photo Scala, Florence; 1-30 © RMN-Grand Palais (musée Guimet, Paris)/Thierry Ollivier.

Chapter 2: 2-1 Werner Forman Archive, London; 2-2, 2-4, 2-6, 2-15, 2-Closer Look, 2-33 © 2013 Image copyright The Metropolitan Museum of Art/Art Resource/Scala, Florence; 2-3 Brooklyn Museum photograph, 2009; 2-5, 2-16, 2-21 © The Trustees of the British Museum; 2-7, 2-10, 2-13, 2-20, 2-25 © Dinodia; 2-8, 2-27 Rick Asher; 2-9 Jean-Louis Nou/akg-images; 2-11 © Jon Hicks/Corbis; 2-12 © 2008 Saurabh Chatterjee/Getty Images; 2-14 © Ocean/Corbis; 2-17 age fotostock/SuperStock; 2-18 © PhotosIndia.com/Getty Images; 2-19 © PhotosIndia com/Dinodia; 2-22 © Luca Tettoni; 2-23 © Balan Madhavan/SOUVENIRS/Alamy; 2-24 John Henry Claude Wilson/Robert Harding; 2-26 © Paul Panayiotou/Corbis; 2-28 © Wilmar Photography/Alamy; 2-32 © Jaro Poncar.

Chapter 3: 3-2 Ashok Sukumaran © Dorling Kindersley; 3-3 © Dan Saunders Photography/Alamy; 3-4 © Massimo Borchi/Atlantide Phototravel/Corbis; 3-5, 3-7, 3-20 Gerard Degeorge/akg-images; 3-6, 3-14, 3-19, 3-21 © Dinodia; 3-8 R. & S. Michaud/akg-images; 3-10, 3-45 © The British Library Board/Robana; 3-13 © Shashank Mehendale/ephotocorp/Alamy; 3-15, 3-29, 3-30, 3-Techniques, 3-34, 3-42 © 2013 Image copyright The Metropolitan Museum of Art/Art Resource/Scala, Florence; 3-16 Photographer Pernille Klemp; 3-17, 3-33, 3-37 © Victoria and Albert Museum, London/V&A Images -All rights reserved; 3-18 Pixtal/SuperStock; 3-22, 3-25 © Christophe Boisvieux/Corbis; 3-23 © Jeremy Graham/dbimages/Alamy; 3-24 R. & S. Michaud/akg-images; 3-26 © Joao Figueiredo/Getty Images; 3-27 © Philippe Lissac/Godong/Corbis; 3-28 Photo Scala, Florence/BPK, Bildagentur fur Kunst, Kultur und Geschichte, Berlin/Dietmar Katz; 3-31 Photograph © 2014 Museum of Fine Arts, Boston; 3-36 The Royal Collection © 2011 Her Majesty Queen Elizabeth II/The Bridgeman Art Library; 3-38 © The Trustees of the Chester Beatty Library, Dublin/The Bridgeman Art Library; 3-39 © Maharana of Mewar Charitable Foundation, Udaipur; 3-40 Sebastian Wasek/age fotostock/SuperStock; 3-41 © Danny Lehman/Corbis; 3-43 © Photo Rainer Wolfsberger; 3-44 © 2012 Sourav Ghosh/Getty Images.

Chapter 4: 4-3, 4-4, 4-Closer Look, 4-8, 4-9 © Victoria and Albert Museum, London/V&A Images -All rights reserved; 4-5 © The Trustees of the British Museum; 4-7 © Fine Arts Museums of San Francisco; 4-10 © 2013 Image copyright The Metropolitan Museum of Art/Art Resource/Scala, Florence; 4-11 © The British Library Board/Robana; 4-12 National Army Museum, London/The Bridgeman Art Library; 4-13 Photononstop/SuperStock; 4-14 © Jeremy Horner/Corbis; 4-15 © Akash Banerjee Photography/Getty Images;

4-19 © 2013 Artists Rights Society (ARS), New York/ADAGP, Paris/F.L.C. Photo © Bruno Morandi/Hemis/Corbis; 4-20, 4-21 © View Pictures/UIG/Getty Images; 4-22 photo courtesy of Sotheby's, © estate of V.S. Gaitonde; 4-23 Moviestore Collection/Rex Features; 4-25 © estate of Maqbook Fida Husain; 4-27 © Estate of Bhupen Khakar; 4-28 Photograph © Succession Raghubir Sing. courtesy The Metropolitan Museum of Art/Art Resource/Scala, Florence; 4-31 Photo Mike Bruce.

Chapter 5: 5-1 Peter Cook © Dorling Kindersley; 5-2 Olaf Schubert/Image Broker/Robert Harding; 5-3, 5-12, 5-21, 5-24 © Luca Tettoni; 5-4a Erich Lessing/akg-images; 5-4b Doremon (Creative Commons); 5-5 Photo Kaz Tsuruta, Asian Art Museum of San Francisco. Courtesy of the Dong Nai Museum; 5-7 © Barry Kusuma/Photolibrary/Getty Images; 5-8, 5-9 © 2013 Image copyright The Metropolitan Museum of Art/Art Resource/Scala, Florence; 5-11 © RMN-Grand Palais (musée Guimet, Paris)/Thierry Ollivier; 5-13 © Philippe Bourseiller/The Image Bank/Getty Images; 5-14, 5-20 Gerard Degeorge/akg-images; 5-15 © Philippe Crochet/Photonostop/Getty Images; 5-16 © Dirk Bakker/The Bridgeman Art Library; 5-17 Gerhard Zwerger-Schoner/Image Broker/Robert Harding; 5-18 © Jacques Sierpinski/Hemis/Corbis; 5-19 © Marc Dozier/Hemis/Corbis; 5-22 akg/Bildarchiv Steffens; 5-23 © The Trustees of the British Museum; 5-26 © 2013 Digital Image Museum Associates/LACMA/Art Resource NY/Scala, Florence; 5-27 Werner Forman Archive/Private Collection, London; 5-Closer Look © Victoria and Albert Museum, London/V&A Images -All rights reserved.

Part Two Opener: The Nelson-Atkins Museum of Art, Kansas City.

Chapter 6: 6-1 © James Montgomery/AWL Images/Getty Images; 6-2, 6-3, 6-5, 6-8, 6-10, 6-11, 6-14, 6-Closer Look, 6-25, 6-26, 6-28 Cultural Relics Publishing House, Beijing; 6-9 © The Trustees of the British Museum; 6-Technique Reproduction after Marilyn Stokstad and Michael W. Cothren, *Art History*, 5th ed. (Upper Saddle River, NJ, Pearson, 2014); 6-13 © 2013 Image copyright The Metropolitan Museum of Art/Art Resource/Scala, Florence; 6-16 The Nelson-Atkins Museum of Art, Kansas City. Photo John Lamberton; 6-18 © Ramon Manent/Corbis; 6-20 © Keren Su/China Span/Alamy; 6-22 PanoramaStock/Robert Harding; 6-23 O. Louis Mazzatenta/National Geographic/Getty Images; 6-27 © Asian Art & Archaeology, Inc./Corbis; 6-29, 6-30 Photo Bruce M. White © 2013. Princeton University Art Museum/Art Resource NY/Scala, Florence.

Chapter 7: 7-1 © Aflo Co. Ltd./Alamy; 7-2, 7-28 © The Trustees of the British Museum; 7-4 The Nelson-Atkins Museum of Art, Kansas City. Photo John Lamberton; 7-5, 7-9, 7-26 Cultural Relics Publishing House, Beijing; 7-6 © Chu Yong/Best View Stock/Alamy; 7-7, 7-Closer Look, 7-11, 7-31 © 2013 Image copyright The Metropolitan Museum of Art/Art Resource/Scala, Florence; 7-8 Werner Forman Archive, London; 7-12 Werner Forman Archive/National Palace Museum, Taipei; 7-13, 7-Techniques Reproduction after Robert L. Thorp and Richard Ellis Vinograd, *Chinese Art & Culture* (New York, Prentice Hall, 2001); 7-15 Reproduction after Nancy S. Steinhardt, ed., *Chinese Architecture* (New Haven, Yale University Press, 2002); 7-16 © Chu Yong/Getty Images; 7-17 © Robin Hanbury Tenison; 7-19 Photograph © 2014 Museum of Fine Arts, Boston; 7-20 Photo Malcolm Varon. © 2013 Image copyright The Metropolitan Museum of Art/Art Resource/Scala, Florence; 7-21 Photo Courtesy of the East Asian Library and the Visual Resources Center, the University of Chicago; 7-22 The Nelson-Atkins Museum of Art, Kansas City. Photo John Lamberton; 7-23 © Carl & Ann Purcell/Corbis; 7-24 Tao/Robert Harding; 7-27 Chen Zhao/livepine; 7-32 Photograph © 2014 Museum of Fine Arts, Boston.

Chapter 8: 8-1, 8-8 Photograph © 2014 Museum of Fine Arts, Boston; 8-5, 8-18 The Nelson-Atkins Museum of Art, Kansas City. Photo John Lamberton; 8-9 Art Collection 2/Alamy Stock Photo; 8-11 © The Trustees of the British Museum; 8-12, 8-14, 8-16, 8-17, 8-25 © 2013 Image copyright The Metropolitan Museum of Art/Art Resource/Scala, Florence; 8-13 Pictures from History; 8-Closer Look a&b Photograph © 2014 Museum of Fine Arts, Boston; 8-21 © Henry Westheim Photography/Alamy; 8-22 © Dennis Cox/Alamy.

Chapter 9: 9-2 View Stock/Getty Images; 9-3 Neale Clark/Robert Harding; 9-4 Reproduction after Nancy S. Steinhardt, ed., *Chinese Architecture* (New Haven and London, Yale University Press, 2002); 9-5 Gavin Hellier/Robert Harding; 9-6 Thinkstock; 9-7 Chris Greenwood; 9-9, 9-17, 9-25, 9-31 © 2013 Image copyright The Metropolitan Museum of Art/Art Resource/Scala, Florence/Photo Sheldan Collins; 9-Closer Look Foto ©Rheinisches Bildarchiv Köln; 9-16, 9-32 The Nelson-Atkins Museum of Art, Kansas City. Photo John Lamberton; 9-18 The Nelson-Atkins Museum of Art, Kansas City. Photo Jamieson Miller; 9-19 The Nelson-Atkins Museum of Art, Kansas City. Photo Robert Newcombe; 9-22 Photograph courtesy of the Herbert F. Johnson Museum, Cornell University. Acquired through the generosity of Judith Stoikov, Class of 1963, supplemented by the George and Mary Rockwell Fund, and gift of Warner L. Overton, by exchange; 9-24 © Asian Art Museum, San Francisco. Used by permission; 9-27 Museum Rietberg, Zürich © Photo Rainer Wolfsberger; 9-28 Photo Imaging Department © President and Fellows of Harvard College.

Chapter 10: 10-4 akg-images; 10-5, 10-7, 10-22 © 2013 Image copyright The Metropolitan Museum of Art/Art Resource/Scala, Florence; 10-11 Cultural Relics Publishing House, Beijing; 10-12 © estate of Li Keran; 10-13 ©Victoria and Albert Museum, London/V&A Images -All rights reserved; 10-15 © Luo Zhongli; 10-16 ©Wu Guanzhong estate, reproduced by permission of Sothebys; 10-21 © Centre Pompidou, MNAM-CCI, Dist. RMN-Grand Palais/Philippe Migeat. Photo © 2013 Artists Rights Society (ARS), New York/ProLitteris, Zurich; 10-22 © Estate of Tseng Yuho; 10.24 Photo by Masanobu Moriyama, courtesy Cai Studio; 10-25 a, b & c Photo Ai Weiwei; 10-26 Photo Kith Tak Ping Tsang.

Part Three Opener: © The Trustees of the British Museum.

Chapter 11: 11-1 DeAgostini Picture Library/The Art Archive; 11-2 Hanyang University Museum, South Korea/The Bridgeman Art Library; 11-3 Lawinc82 (Creative Commons Attribution-Share Alike 3.0); 11-4 Samsung Foundation of Culture, Korea; 11-5 Pictures from History; 11-7, 11-12 Photo Imaging Department © President and Fellows of Harvard College; 11-8 DeAgostini Picture Library/Scala, Florence; 11-9 © Steven Vidler/Eurasia Press/Corbis; 11-10 © Topic Photo Agency/Corbis; 11-11 Photo Professor Ro Myoungho; 11-13 Eye Ubiquitous/SuperStock ; 11-14 ©Victoria and Albert Museum, London/V&A Images -All rights reserved; 11-15 Photo DNP Art Communications Co. Ltd; 11-16 De Agostini Picture Library/akg-images; 11-17 Photononstop/SuperStock; 11-18 Richard Nebesky/Lonely Planet Images/Getty Images; 11-19 Photo Dale Quarrington; 11-20 Daderot (Creative Commons); 11-21 Photo Barry Shell ; 11-24 © 2013 Image copyright The Metropolitan Museum of Art/Art Resource/Scala, Florence; 11-26 © 2013 Digital Image Museum Associates/LACMA/Art Resource NY/Scala, Florence; 11-Closer Look akg-images/VISIOARS; 11-33 © Glyn Thomas/Alamy; 11-34 Max Desfor/AP/Press Association Images; 11-36 Mark Harris/The Image Bank/Getty Images; 11-37 Photo Jim Hoare; 11-38 © Philippe Agret/AFP/Getty Images; 11-39 © Park Seo-bo; 11-41, 11-42 © The Trustees of the British Museum; 11-42 © estate of Oh Yun, courtesy Mrs Oh Young-A and Gana Art Centre; 11-43 © estate of Paik Nam June; 11-44 © 2013 Photo Smithsonian American Art Museum/Art Resource/Scala, Florence. © estate of Paik Nam June; 11-47 © Lee Bull. Photo Watanabe Osamu. Courtesy Mori Art Museum.

Chapter 12: 12-1 © Ei Katsumata - FLP/Alamy; 12-2 © Beibaoke/Shutterstock, 12-20 © Jingu-shicho. Sengu Photo Library; 12-3 © Dorinda Neave; 12-4, 12-10 © Sakamoto Photo Research Laboratory/Corbis; 12-5 Kimbell Art Museum, Fort Worth, Texas/Art Resource, NY/Scala, Florence; 12-6 JTB Photo/SuperStock; 12-7 Tokyo National Museum/Granger Collection/The Art Archive; 12-8 Photo Nonakado, Akita; 12-9 Photo DNP Art Communications Co. Ltd; 12-12 Tokyo National Museum, Japan/De Agostini Picture Library/The Bridgeman Art Library; 12-13 © Beeboys/Shutterstock; 12-14 © The Trustees of the British Museum; 12-15 The Asahi Shimbun/Getty Images; 12-16, 12-17, 12-19 Photo DNP Art Communications Co. Ltd; 12-21 © DAJ/Getty Images; 12-22 Reproduction after Penelope Mason, *History of Japanese Art,* 2nd ed. (Upper Saddle River, NJ, Pearson, 2005); 12-23 © Ivan Vdovin/Alamy; 12-24 Gary Cross © Dorling Kindersley; 12-25 © CulturalEyes-Aus-GS/Alamy; 12-26, 12-Closer Look a&b, 12-29, 12-30 Photo Benrido Inc., Kyoto; 12-27 © G.Sioen/DeAgostini/Universal Images Group/Alamy; 12-28 Photo Askaen Co., Ltd, Nara.

Chapter 13: 13-1, 13-4 Photo Askaen Co., Ltd, Nara; 13-2, 13-Technique, 13-13, 13-24 Reproduction after Penelope Mason, *History of Japanese Art,* 2nd ed. (Upper Saddle River, NJ, Pearson, 2005); 13-3 Photo Imperial Household Agency; 13-5 Demetrio Carrasco © Dorling Kindersley; 13-6 © Luca Tettoni; 13-7 © Sankei/Getty Images; 13-10, 13-14a&b, 13-15 a&b Photo Benrido Inc., Kyoto; 13-11 Photo Nara National Museum; 13-18 © Shinichi Waki; 13-19 © Asia Images Group Pte Ltd/Alamy; 13-21 © Sakamoto Photo Research Laboratory/Corbis; 13-22, 13-26, 13-27 a&b Photo DNP Art Communications Co. Ltd.

Chapter 14: 14-1 Photograph © 2014 Museum of Fine Arts, Boston; 14-2, 14-9, 14-16, 14-24, 14-26, 14-31, 14-33, 14-36, 14-37 Photo DNP Art Communications Co. Ltd; 14-3, 14-22 © 2013 Image copyright The Metropolitan Museum of Art/Art Resource/Scala, Florence; 14-4, 14-8 Photo Nara National Museum; 14-5, 14-7 Photo Askaen Co., Ltd, Nara; 14-6 Photo Imaging Department © President and Fellows of Harvard College; 14-11, 14-32, 14-34 a&b Photo Imperial Household Agency; 14-12, 14-14, 14-38 Photo Benrido Inc., Kyoto; 14-18 © Burstein Collection/Corbis; 14-19 © Alex Ramsay/Alamy Stock Photo; 14-20 © Michael S.Yamashita/Corbis; 14-23 © Ishikawa Prefecture Tourist Association and Kanazawa Convention Bureau/© JNTO; 14-27 Gavin Hellier/Robert Harding; 14-28 Eurasia/Robert Harding; 14-29 Gary Cross © Dorling Kindersley; 14-30 Reproduction after Marilyn Stokstad and Michael W. Cothren, *Art History,* 5th ed.(Upper Saddle River, NJ: Pearson, 2014); 14-Closer Look Photo Minao Tabata. Courtesy Urasenke Tankokai Foundation, International Affairs Department; 14-39 Reproduced from Kazuo Nishi and Kazuo Hozumi, *Nihon Kenchiku no Katachi* (Shokokusha Publishing Co., Ltd., 1983); 14-42 © The Trustees of the British Museum.

Chapter 15: 15-1 Werner Forman Archive/Burke Collection, New York; 15-2 Gary Cross © Dorling Kindersley; 15-3, 15-4 Photo Imperial Household Agency; 15-5, 15-9, 15-19 Photo DNP Art Communications Co. Ltd; 15-6 Photo Seiji Shirono, National Institute for Cultural Properties, Tokyo; 15-10, 15-17 © 2013. Image copyright The Metropolitan Museum of Art/Art Resource/Scala, Florence; 51-11 DeAgostini Picture Library/The Art Archive; 15-12 © 2013 Digital Image Museum Associates/LACMA/Art Resource NY/Scala, Florence; 15-Techniques Reproduction after Penelope Mason, *History of Japanese Art,* 2nd ed. (Upper Saddle River, NJ, Pearson, 2005); 15-14, 15-16 Photography © The Art Institute of Chicago; 15-15, 15-Closer Look © The Trustees of the British Museum; 15-20 ©Victoria and Albert Museum, London/V&A Images -All rights reserved; 15-26 © Keystone/Getty Images; 15-27 Photo Japan/Robert Harding; 15-29 © Ryoji Ito; 15-31 Photo: Shiro Takatani + dumb type; 15-33 © Margaret Bourke-White/Time Life Pictures/Getty Images; 15-34 © Photo Josse, Paris; 15-36 © 2002 Takashi Murakami/Kaikai Kiki Co., Ltd. All Rights Reserved; 15-37 ©Yayoi Kusama; 15-38 ©Yayoi Kusama. Photography © Tate Photography, 2012, Marcus Leith and Andrew Dunkley.

Index

Figures in *italics* refer to illustrations.